LONG TIME COMING

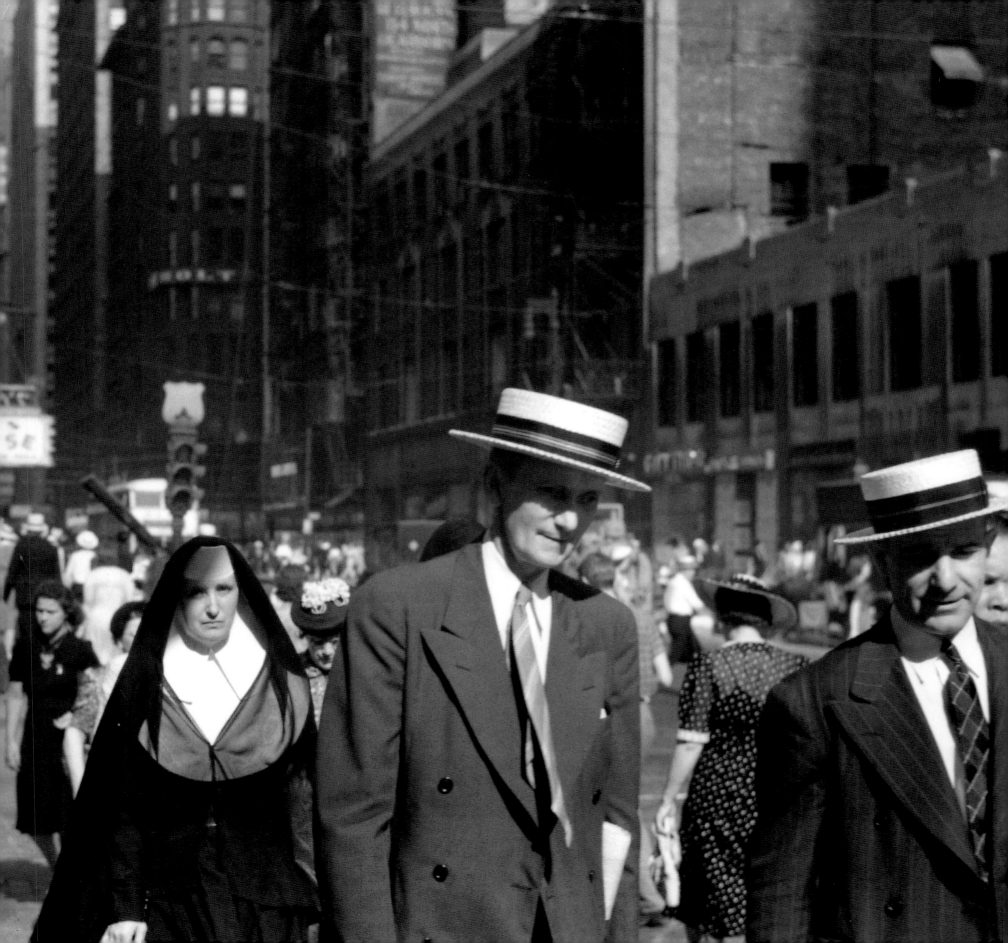

LONG TIME COMING

A PHOTOGRAPHIC PORTRAIT OF AMERICA, 1935–1943

MICHAEL LESY

W. W. NORTON & COMPANY · NEW YORK · LONDON

The text of this book is composed in Deepdene, designed by Frederic W. Goudy (1865–1947), with the display set in Agency Gothic and Bank Gothic, designed by Morris Fuller Benton (1872–1948).
Manufacturing by Mondadori Printing, Verona
Book design by Robert L. Wiser, Archetype Press, Washington, D.C.

Support for this project has been provided by Furthermore, the publication program of the J. M. Kaplan Fund, and by the Graham Foundation for Advanced Studies in the Fine Arts.

FRONT ENDPAPERS: *Heavy black clouds of dust rising over the Texas Panhandle, Texas,* Arthur Rothstein, March 1936

PAGE 2 (frontispiece): Untitled (Chicago), John Vachon, July 1941

PAGE 472 (opposite Notes): Untitled (Camden, New Jersey), Arthur Rothstein, October 1938

BACK ENDPAPERS: *Company houses and shacks, Pursglove, West Virginia,* Marion Post Wolcott, September 1938

Library of Congress Cataloging-in-Publication Data
Lesy, Michael, 1945–
 Long time coming: a photographic portrait of America, 1935–1943 / by Michael Lesy.
 p. cm.
 Work is based on photographs made between 1935 and 1943 by a team of photographers employed by the U.S. Farm Security Administration (FSA).
 Includes bibliographical references.
 ISBN 0-393-04943-4
 1. United States—Social life and customs—1918–1945—Pictorial works. 2. United States—Social conditions—1933–1945—Pictorial works. 3. United States—Rural conditions—Pictorial works. 4. Documentary photography—United States. I. United States. Farm Security Administration. II. Title.
E169 .L597 2002
973.91—dc21 2002016606

W.W. Norton & Company, Inc., 500 Fifth Avenue, New York, N.Y. 10110
www.wwnorton.com

W.W. Norton & Company Ltd., Castle House, 75/76 Wells Street, London W1T 3QT

1 2 3 4 5 6 7 8 9 0

FOR LISA

CONTENTS

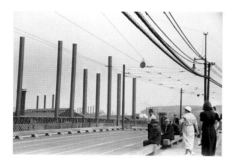
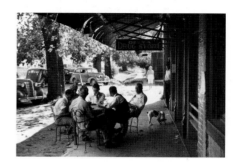
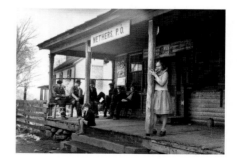

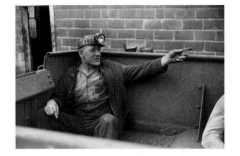

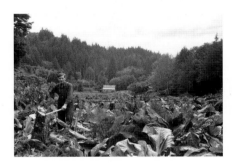

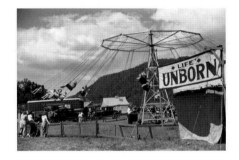

ACKNOWLEDGMENTS

I have many debts, material, intellectual, and emotional.

My thanks to *Furthermore*, the Publication Program of the J. M. Kaplan Fund, and to the Graham Foundation for Advanced Studies in the Fine Arts for their generous support. My thanks, also and always, to Hampshire College for its unfailing support.

The work of several scholars served as beacons as I made my way through a tangle of primary and secondary sources: Thomas Garver's *Just Before the War*; Hank O'Neal's *A Vision Shared*; Jack Harley's *Portrait of a Decade*; Carl Fleischhauer and Beverly Brannan's *Documenting America, 1935–1943*; Alan Trachtenberg's *Reading American Photographs*; and James Curtis's *Mind's Eye, Mind's Truth*. I am indebted to them for their original research and insights.

Pablo Delano, son of the Farm Security Administration (FSA) photographer Jack Delano, gave me information and understanding that no book could have communicated. Julie van Haaften at the Digital Library of the New York Public Library told me more than I could have discovered on my own about the Library's Picture Collection and its first director, Romana Javitz. Jerry Thompson shared his understanding of Walker Evans with me—an understanding that only the experience of friendship can provide. Paul Vanderbilt, my mentor, now long gone, was the first to tell me stories about the FSA photographer Edwin Rosskam.

At the Library of Congress, Beverly Brannan and Carol Johnson, both curators in the Prints and Photographs Division, were wonderfully well-informed and generous. Eva Shade in the Library's Photo Duplication Service made the masterful prints that are the basis of this book.

William Ferris, former chairman of the National Endowment for the Humanities, provided a timely forum for the presentation of this book as a work in progress. Paul Hendrickson, Nick Lemann, Greil Marcus, and Fred Ritchin all lent their support on behalf of the book's research and writing.

A variety of people critiqued the photo sequences and narrative text of this book. Aaron Berman, Roy Bunce, Jacqueline Hayden, Gregory Prince, Eric Schocket, Lisa Stoffer, and Steve Weisler—all colleagues at Hampshire College—provided critically important feedback. Ira Glass, Nick Lemann, Greil Marcus, and Fred Ritchin all took time to look, read, and comment. I am indebted to them for their candor, clarity, and generosity.

At *DoubleTake* magazine, Dr. Robert Coles gave me the opportunity, over the course of several years, to write about archival photographs. The practice such writing afforded trained me well. Dr. Coles was also kind enough to recommend me to James Mairs, senior editor and vice president at W. W. Norton. Mr. Mairs's support of this project and his personal kindness made this book possible.

Finally, I wish to honor my late wife, Elizabeth, who died tragically, before her time, soon after the research for this book began.

The photographs in this book are from an enormous collection of images made of the United States between 1935 and 1943 by photographers employed by the Farm Security Administration (FSA)—an obscure New Deal agency buried inside the Department of Agriculture. The FSA's mission, while it lasted, was to help poor farmers buy and run their own farms. An earlier incarnation of the FSA, an entity called the Resettlement Administration (RA), tried to help dispossessed farmers and unemployed factory workers by building planned communities for them and settling them there. The RA was the invention of an economics professor from Columbia University, Rexford Tugwell, who, with other professors from Columbia and Barnard College, formed part of Franklin D. Roosevelt's "Brain Trust." The RA, and Tugwell, lasted two years—long enough for Tugwell to hire his former teaching assistant, a man named Roy Stryker, and put him in charge of a group of photographers whose job, at least at first, was to make pictures of the people the RA intended to help.

As events, real and political, changed the agencies that housed Stryker and his photographers, the social agendas that shaped and legitimated their work also changed. By 1943, what had begun as an effort to document rural suffering in order to alleviate it became an effort to record the American Way of Life in order to defend it. As the bureaucracies that sheltered the photographers shifted, so did the roster of those photographers: more than forty photographers—with a core group of sixteen—came and went and came again as budgets shifted and jobs in the real world opened. By 1943, what some photohistorians have called Stryker's "team" had morphed and molted several times over. What didn't change was the boss. Part executive editor, part agent, part political dealmaker, part petty tyrant, Roy Stryker ran the FSA until a government propaganda agency called the Office of War Information (OWI) took over his work and eliminated his job.

Stryker lasted, but he was a different man when he left his job from when he began it. What changed him was the work: not the small work of memos and phone calls and conniving, but the big work, the work of building the monumental file of images, 145,000 frames of film, half printed, half unprinted, that remains as the common property of every citizen of the United States. How this work transformed Stryker is one of the central stories of this book.

The FSA's photographers would never have done the work they did—as a group—without Stryker, and Stryker would never have had a chance to accomplish what he did without Tugwell. Tugwell had the influence he had because Franklin Roosevelt had let Tugwell convince him of something he already believed: that the way to fix the U.S. economy was to first fix the farm economy. The deep ditch into which American agriculture had fallen by the time Roosevelt became governor of New York and the Brain Trusters had begun their pilgrimages to Albany to fill the governor's mind with their ideas—that ditch determined Tugwell's political fortunes and was the only reason that Stryker and his photographers ever got the chance to do what they did.

Briefly:

Starting in 1914, American farmers dug their own graves by doing what they did best: producing huge surpluses for export. During the World War, American farmers put more land under cultivation, bought more tractors to cultivate it, took out more loans to pay for everything, all so they could feed Europe and make money doing it. Once the Europeans stopped killing each other, and once huge producers like Canada and Australia and Argentina came back on line, surpluses built up and commodity prices collapsed. American farmers met the challenge by doing what they did best: they put more land (now marginal land with thin topsoil) under cultivation, they bought more tractors to cultivate it, they took out more loans to pay for everything, and . . . prices collapsed catastrophically. Banks foreclosed and then went under themselves; marginal farmers became tenants; tenants became itinerants. All this happened during the 1920s.

During the Twenties and Thirties, the U.S. Department of Agriculture (the USDA), had the strongest, ablest bureaucracy in the federal government.

9

The USDA had excellent field staffs, excellent regional staffs, excellent central staffs, excellent reporting and record keeping. The department worked well with the production-driven farm lobby, and the farm lobby worked well with it. Because the USDA was the sturdiest, strongest structure in government when Roosevelt first took office, it was the place where ambitious planners like Tugwell—who knew he needed a bureaucracy in order to change the world—sought to be. That said, the USDA's only problem, through the Hoover administration, was that all it knew how to do was to help, advise, and lobby on behalf of farmers who kept producing surpluses that buried them.

When Roosevelt took office, there were fifty million people who lived on the land. In 1934, the average farm family's per capita income was $167 (in 1934 dollars). Nine out of ten farmhouses had no indoor toilet; four out of five had no electricity. Farm women died nearly as often in childbirth, and their living children died nearly as often from epidemic disease and malnutrition, as they had in the last decades of the nineteenth century.[1] That, of course, was the good news. Because: the catastrophic collapse of commodity prices (farm income, severely depressed in the Twenties, fell another 60 percent between 1929 and 1933),[2] combined with desertification of farmland in states like the Dakotas, Oklahoma, and Texas (an ecological disaster caused by desperate farming practices made worse by a nearly Biblical drought), tore people out of the flimsy shacks the Census Bureau called "farmhouses" and sent them wandering.

Farmers amounted to only 30 percent of the U.S. workforce,[3] but Tugwell argued and Roosevelt believed that if the huge disparity between farm income and nonfarm income could be redressed (in 1928, average nonfarm income was four times greater than farm income),[4] then "balance would be restored" and the entire country would, sooner rather than later, recover. Behind the New Deal's "balance" slogan was this fact: the American Farmland was the equivalent of what would be later called a Third World nation. Just as in the nineteenth century export-oriented corn farmers and wheat growers had dreamed of making fortunes by feeding the "starving Chinese," so Tugwell and Roosevelt believed that once American farmers actually made decent money, they'd buy toilets and chairs and cars, and (once they had electricity) radios

and phonographs, and the Farmland would be a new, domestic, "export" market. Everyone would have money to spend; the factories would run again; the farm economy would be the new engine of growth. Happy Days.

Roosevelt and Tugwell and Agriculture Secretary Henry Wallace tried to engineer the farm recovery by persuading Congress to pass something called the Agriculture Adjustment Act (the AAA). The AAA worked its magic by doing something that was then entirely astonishing: it paid farmers—big operators and plantation owners—to withdraw land from cultivation. If they had crops, they were paid to plow them under. If they had livestock, they were paid to slaughter their animals. And if there were still too many pork bellies or bushels of wheat on the market, the government agreed to buy the surplus and store it, until such time as the market could absorb it without depressing prices. Roosevelt sprinkled even more magic dust: he inflated the economy. More money meant cheaper money. A good thing for debtors—especially farmers. William Jennings Bryan and his Cross of Gold Populists would have been proud of the new President.

There were, of course, some unintended consequences that Rexford Tugwell understood, anticipated, and had, more or less, knowingly precipitated: since big landowners, particularly plantation owners, didn't need to plant cotton or corn or sugar beets in order to make money, they didn't need to employ the same number of tenants or sharecroppers or migrant laborers. They fired their "employees" as if they were factory owners. Which, of course, they were.

The New Deal's farm policies increased the number of people who could no longer make even a marginal living on the land. Tugwell and Roosevelt and the AAA didn't create what came to be called the "American Exodus," but they certainly added people to it. Tugwell's Resettlement Administration existed to ameliorate a problem that his broader policies had aggravated. Like other government policies before and since, Tugwell's farm reforms offered the equivalent of aspirin to people whose heads had already been separated from their necks.

All this leads back to Roy Stryker and his group of photographers. They were a very small part of a set of policies whose intention was nothing less

than the social and economic reconstruction of the United States. Stryker and his photographers bore witness to suffering to which the government was, in part, complicit. When, in 1935, some of Tugwell's more liberal protégés inside the USDA tried to prevent or at least delay the eviction of tenants from Southern plantations, they were fired *en masse*. By 1937, Tugwell was forced out, too.

But not Stryker.

Compared with Tugwell and the Secretary of Agriculture and the President himself, with their grand plans to save the American people, Stryker and his photographers were nothing but bit players, sent onstage to distract the crowd while the crew moved the scenery and the stars steadied themselves for the next act. Stryker survived not just because he was a relatively skilled political player, but because the government could use the images his survey crew produced (and he disseminated) as evidence of its good intentions.

Sixty years later, agricultural allotments are as much a part of the American social, political, and economic landscape as Social Security benefits. The FSA's images have also lasted: decade by decade, they've been transferred from one information technology to another, from black-and-white file prints to microfilm and microfiche, then to videodisk, then to bits and bytes and pixels. They're online now, through the Library of Congress's "American Memory" website, available to anyone and everyone to see.

The FSA's photographs of desperate and dispossessed people, as edited by Stryker and reproduced over and over again by the media, have become American icons, but these images of suffering, affecting as they are, are only an outcropping, the tip of an enormous buried mountain range of ordinary life that the FSA recorded for posterity. This visual record of everyday existence, its commonalities and singularities, its mysteries and its truths, is the real subject of the FSA's enterprise. Like Whitman's great poem, the FSA File restores us to ourselves, returns us to each other, and reflects us, as it opens us to the space beyond.

The entire collection of images that Stryker's group of photographers made is now housed in the Library of Congress. It is officially known as the Farm Security Administration/Office of Information (FSA/OWI) Collection.

Curators at the Library of Congress have determined that a total of forty-four photographers worked for Stryker over the eight years he ran the survey project, but that only sixteen stayed long enough to take most of the pictures. Curators estimate that the total number of negatives (frames of film exposed and developed) made by all these photographers totaled 145,000 exposures, and that of this total, Stryker ordered a little more than half—77,000—to be printed and filed for use. Filed for use meant: (1) free use by any newspaper, magazine, book, publisher, or movie studio that wanted to reproduce them; and (2) open access, for the last sixty years, to any civilian who wanted to study the images and, for a modest fee, order reproductions of them.

The library's curators have made many inventories of the FSA/OWI Collection over the years, as they've preserved it and made it more and more accessible. They've discovered that even though the survey effort began in 1935, most of its images—91 percent of them—were made between 1937 and 1943. In fact, 74 percent of them were made between 1939 and 1943, as the United States followed the world into war. Just as important, even though by 1930, most Americans lived in cities and towns, only 25 percent of the images in the collection were made in places where 50,000 or more people lived.[1]

Although the images in this book seem, at first sight, to be as whole and as inevitable as snowflakes, they were, in fact, constructed, sometimes in an instant, sometimes in an instant and then after, through a series of choices, in tacit conjunctions of heart, mind, hope, doubt, denial—and public policy. Trying to understand and answer the how and why of the making of these images is the task of this book.

The book will also consider these questions:

If, by 1930, America was a nation of cities and towns, what images of urban life and town life made their way into the collection whose first name is "Farm"? And why did Stryker, as editorial judge, jury, and executioner (until 1940, Stryker punched holes through some negatives he didn't think were worth printing), decide to print and file some images and consign the rest to storage? What shaped Stryker's decisions? Were all the 68,000 images he didn't choose to print and file truly inferior to the 77,000 he did?

This book offers some answers by reproducing many rarely seen images of urban life—including rarely seen images made in 1938 in San Juan and Ponce, Puerto Rico. In addition, 20 percent of the images reproduced in this book existed only as negatives, stored away, unprinted and unseen. Until now.

Every "titled" image was given a caption by Roy Stryker and his staff. Those captions are quoted here verbatim. All "untitled" images reproduced in this book were given captions based on information from titled images adjacent to them, displayed as part of "virtual contact sheets," on the Library of Congress American Memory website.

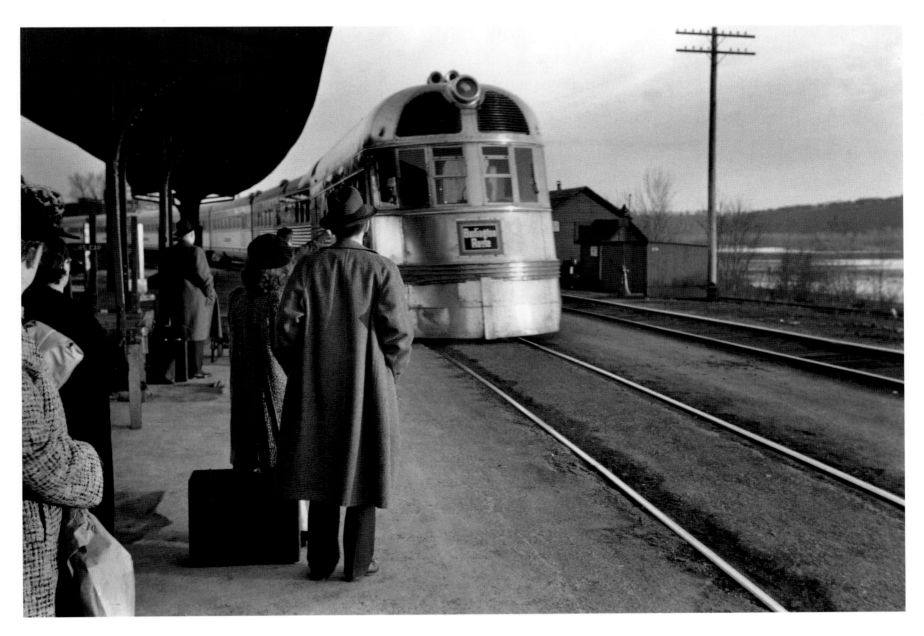

The Burlington Zephyr, East Dubuque, Illinois
JOHN VACHON, APRIL 1940

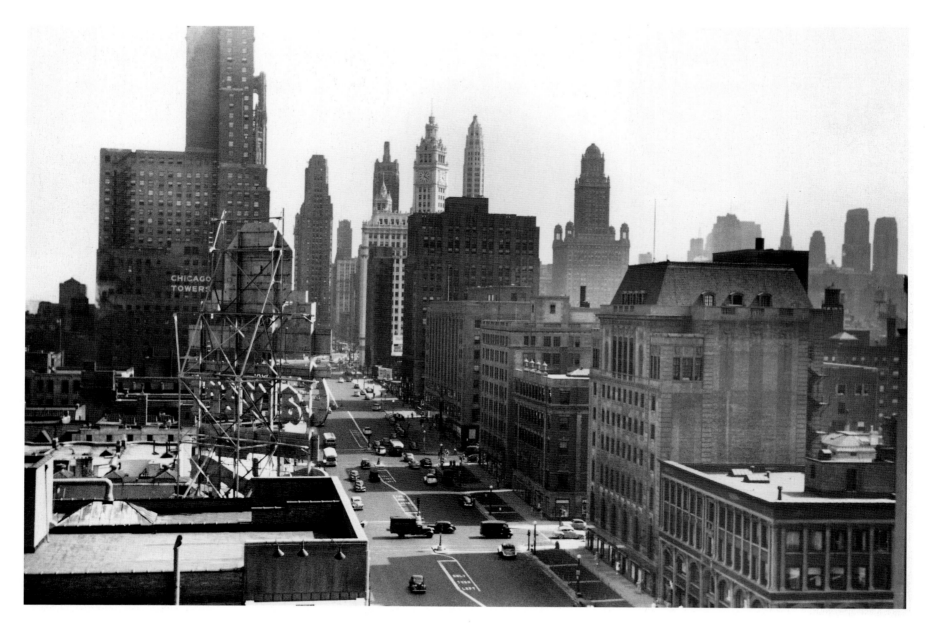

Chicago, Illinois

John Vachon, July 1941

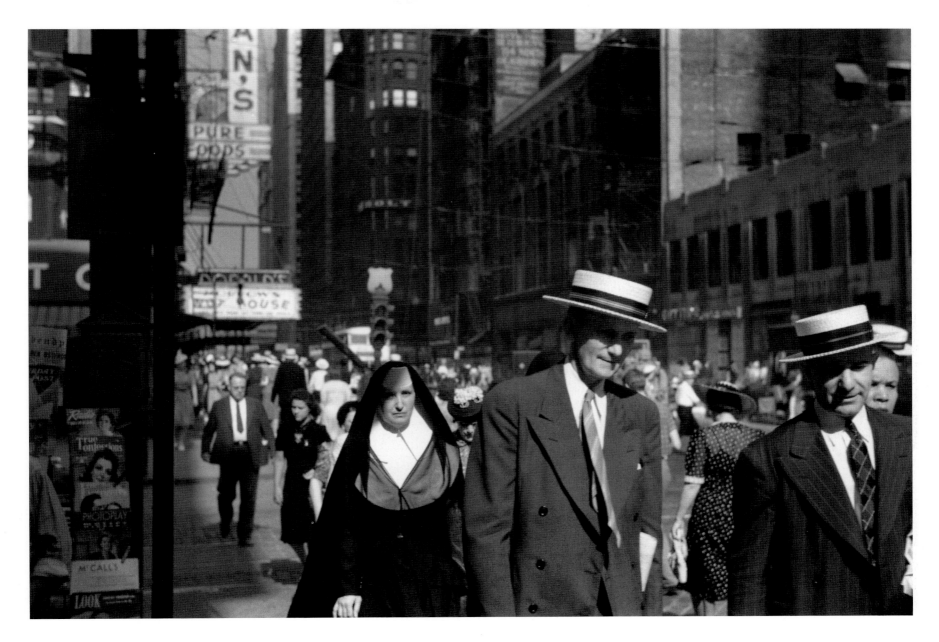

Untitled (Chicago)

JOHN VACHON, JULY 1941

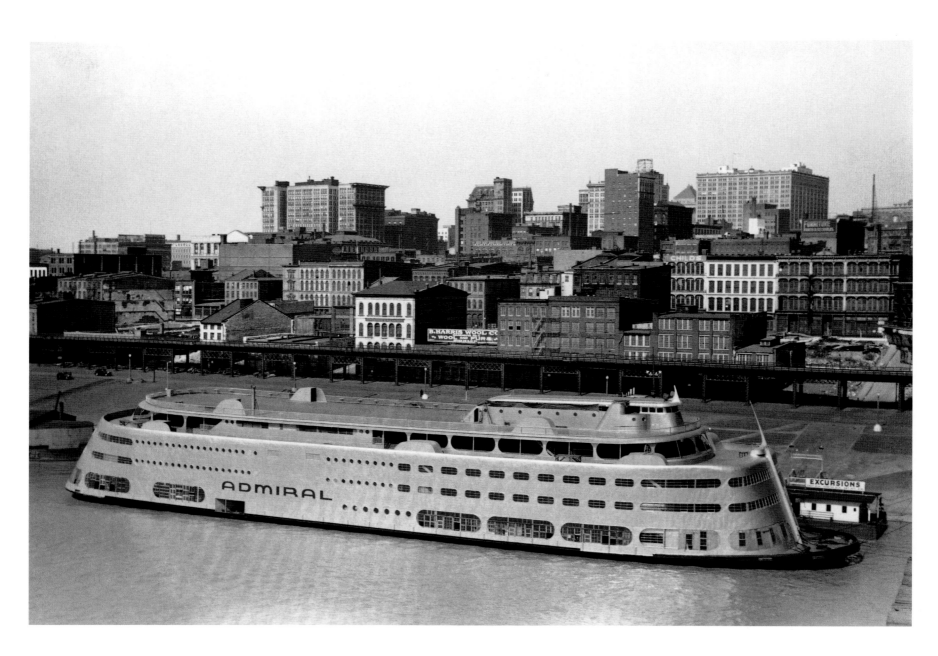

Modern riverboat, St. Louis, Missouri

John Vachon, May 1940

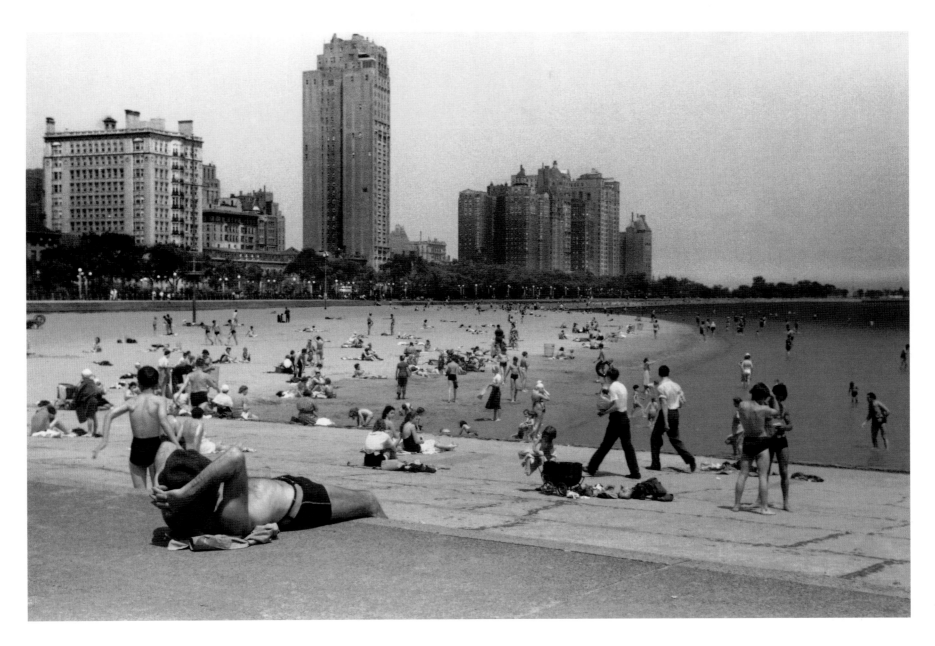

Public bathing beach, Chicago, Illinois. "Gold Coast" in background.
JOHN VACHON, JULY 1941

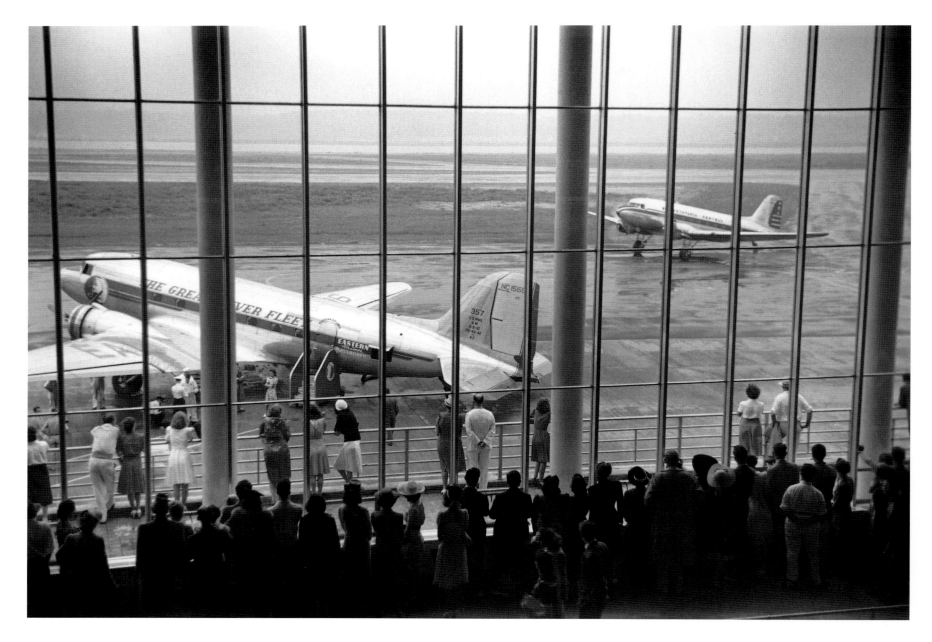

Visitors watching planes through the window of the main waiting room at the municipal airport in Washington, D.C.

Jack Delano, July 1941

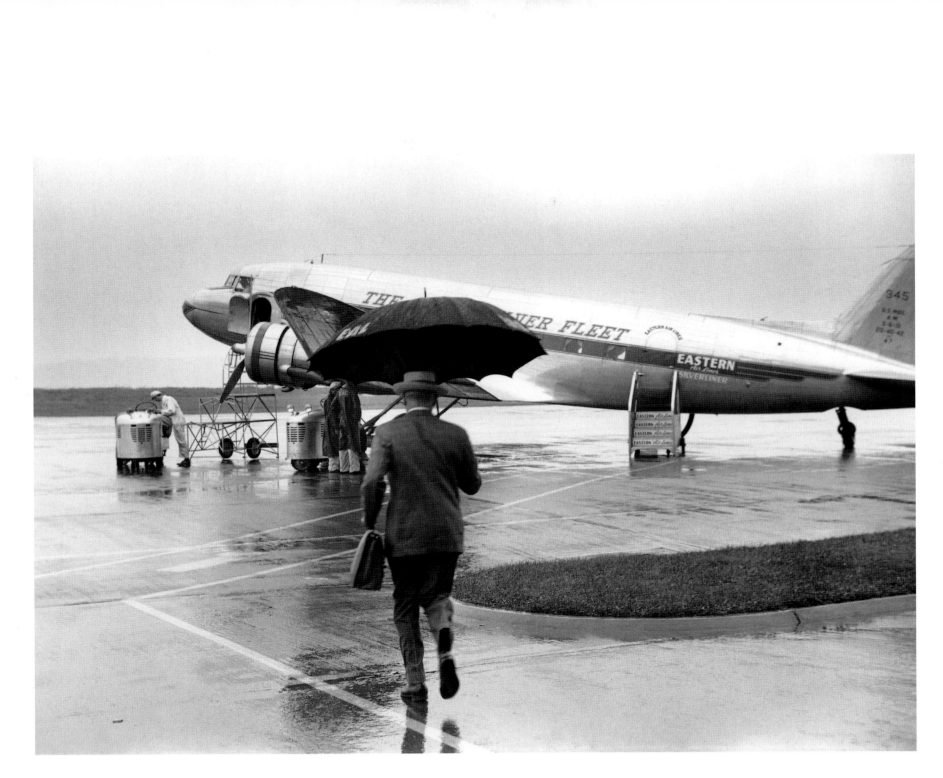

Passengers boarding a plane on a rainy day at the municipal airport in Washington, D.C.
JACK DELANO, JULY 1941

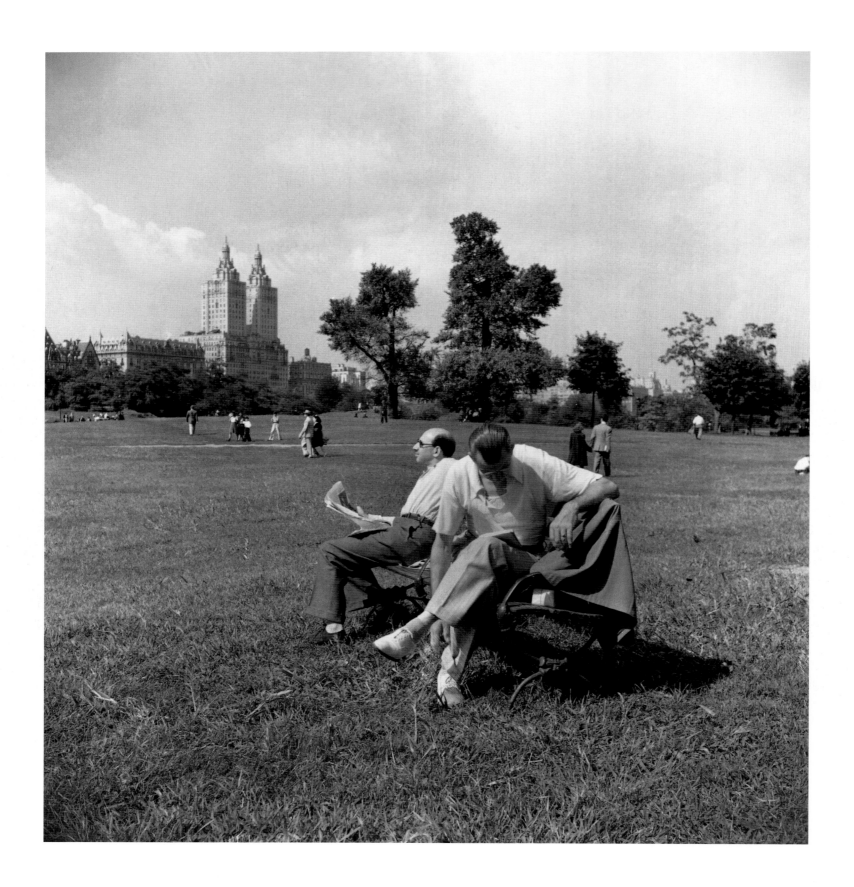

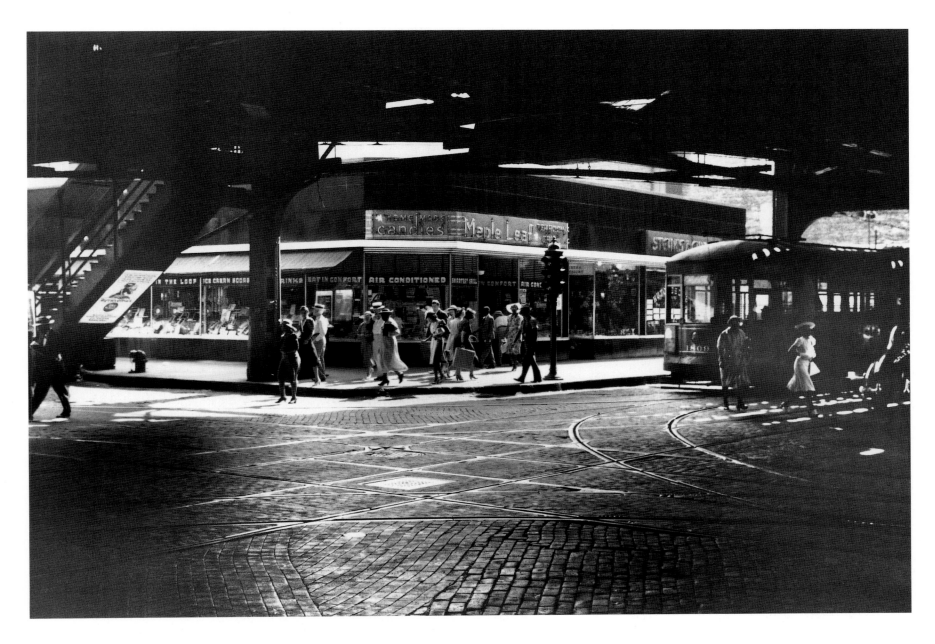

Above: Under the elevated railway, Chicago, Illinois
John Vachon, July 1940

Opposite: Central Park Common on Sunday, New York City, New York
Marjory Collins, September 1942

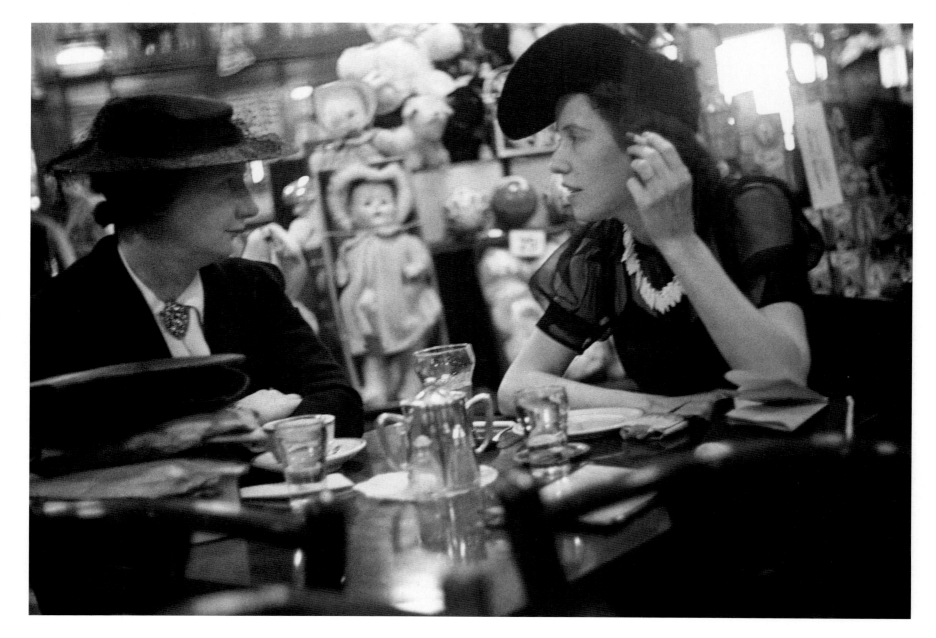

Untitled (Washington, D.C.)
DAVID MYERS [DAVID MOFFAT], 1939

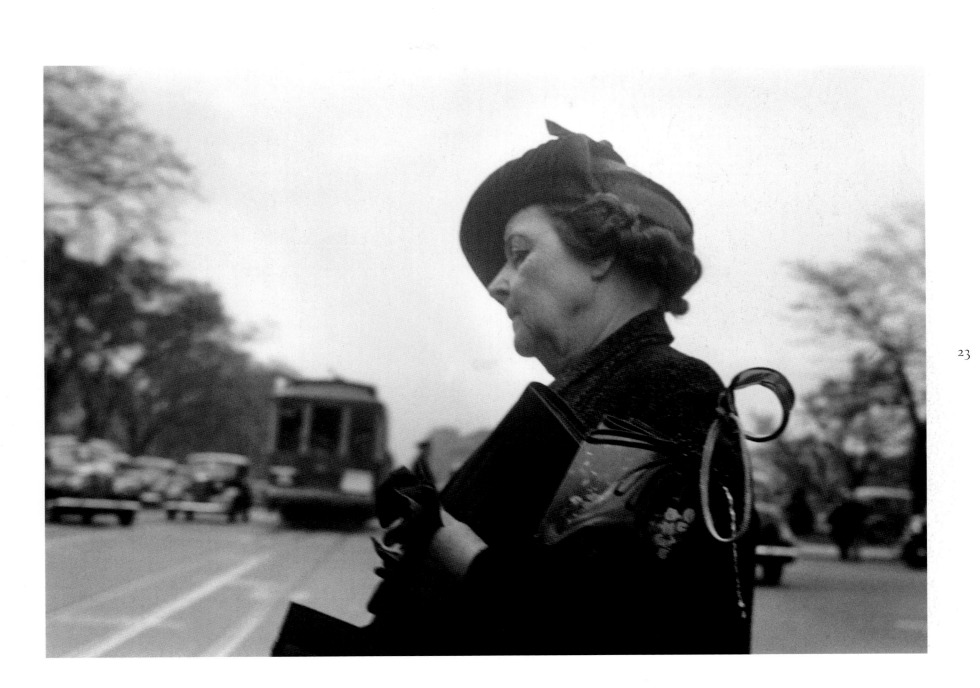

Untitled (Washington, D.C.)
DAVID MYERS [DAVID MOFFAT], 1939

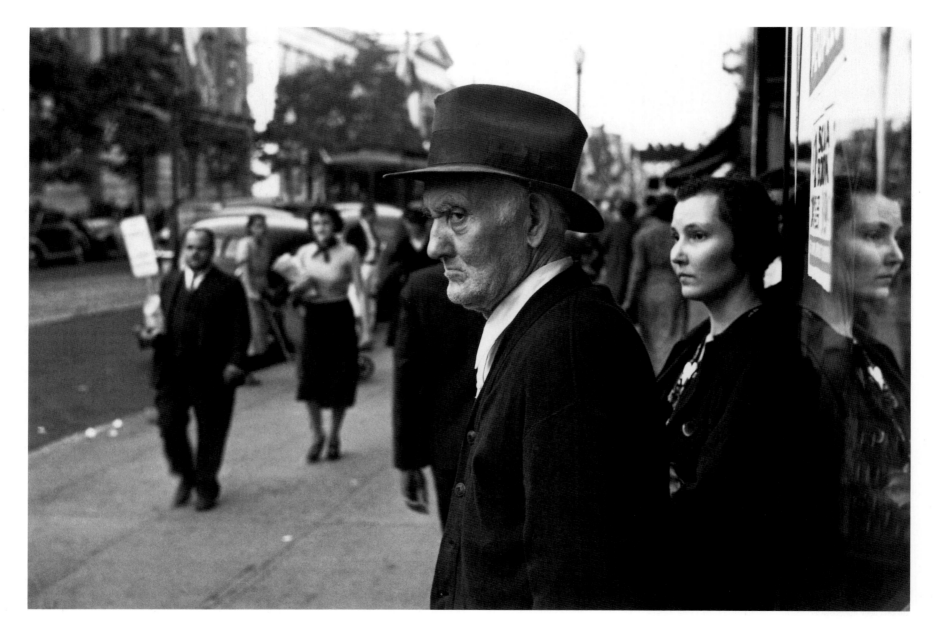

Street Scene, Washington, D.C.
JOHN VACHON, DECEMBER 1937

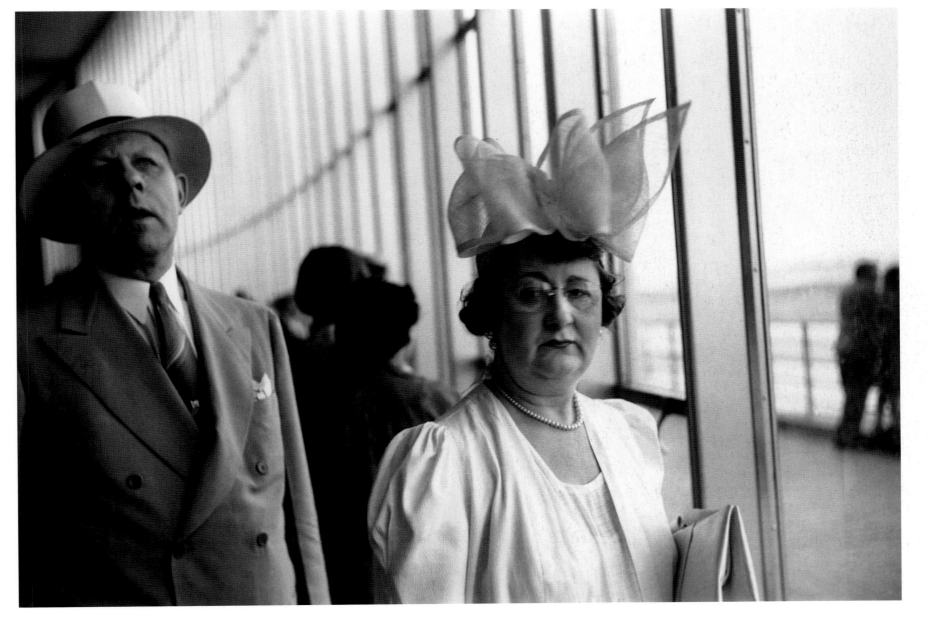

Lobby, Washington Municipal Airport

Jack Delano, July 1941

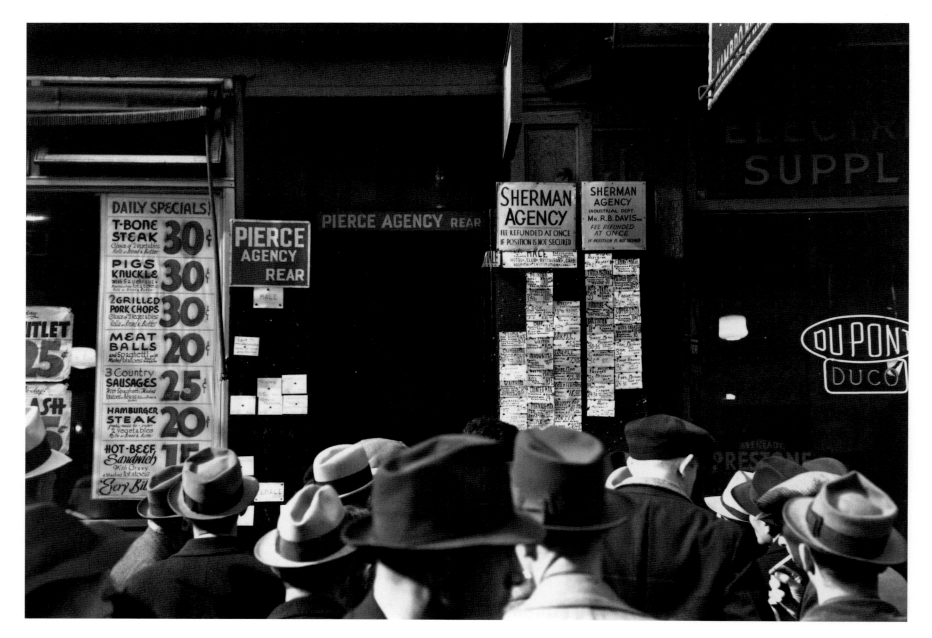

Employment Agency on Sixth Avenue, New York City, New York

Arthur Rothstein, December 1937

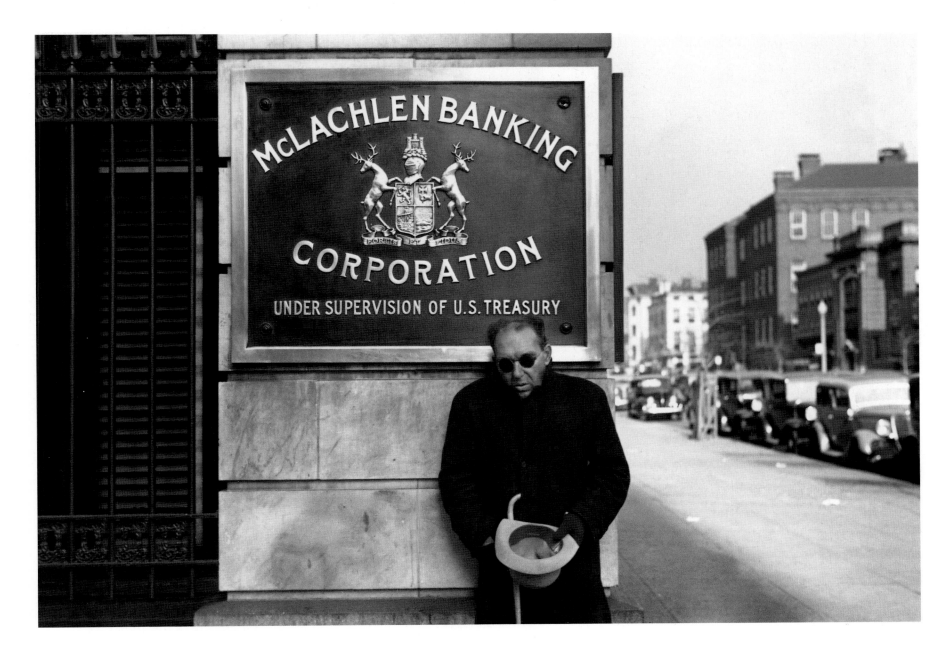

Blind beggar, Washington, D.C.

JOHN VACHON, NOVEMBER 1937

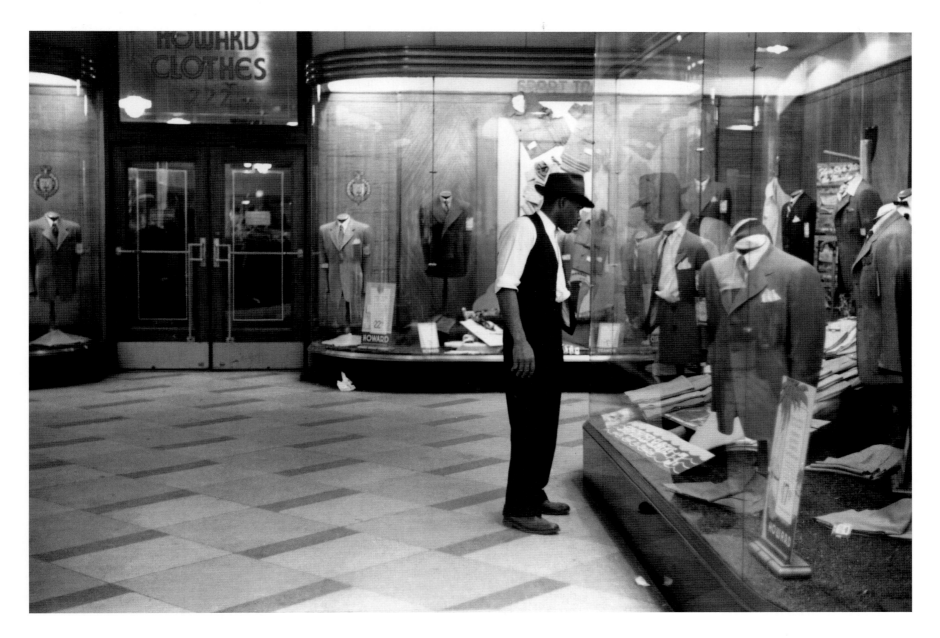

29

ABOVE: Window shopping, Chicago, Illinois
JOHN VACHON, JULY 1941

OPPOSITE: Taxicab driver along riverfront, Saint Louis, Missouri
ARTHUR ROTHSTEIN, MARCH 1936

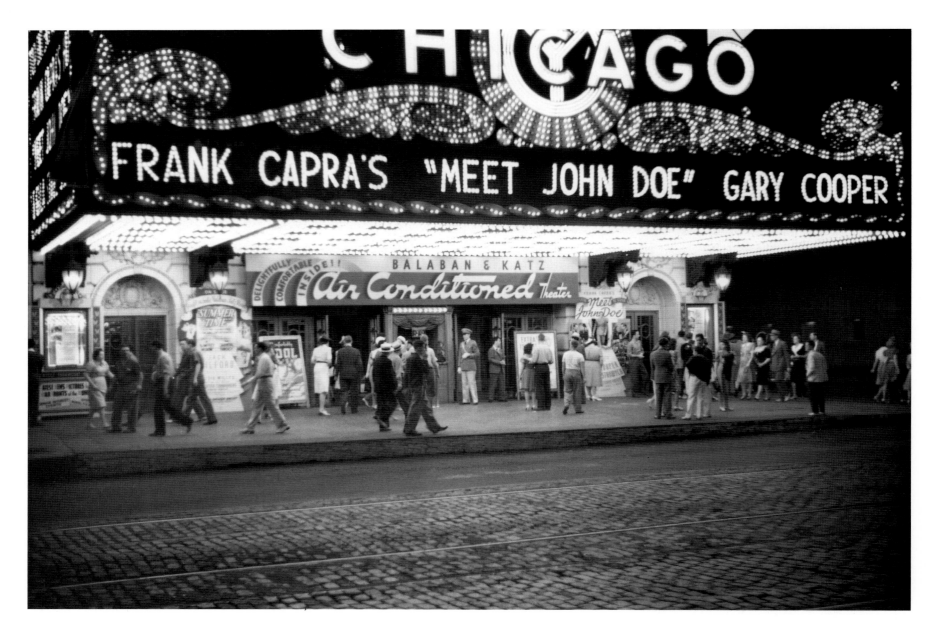

Seating now in all parts of the house, Chicago, Illinois

JOHN VACHON, JULY 1941

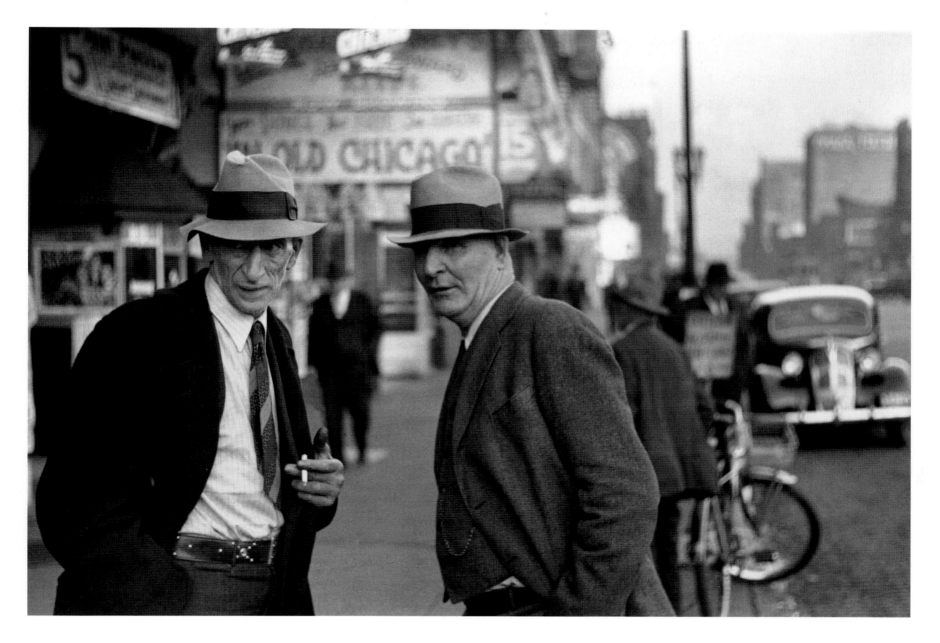

Men on Lower Douglas Street, Omaha, Nebraska
JOHN VACHON, NOVEMBER 1938

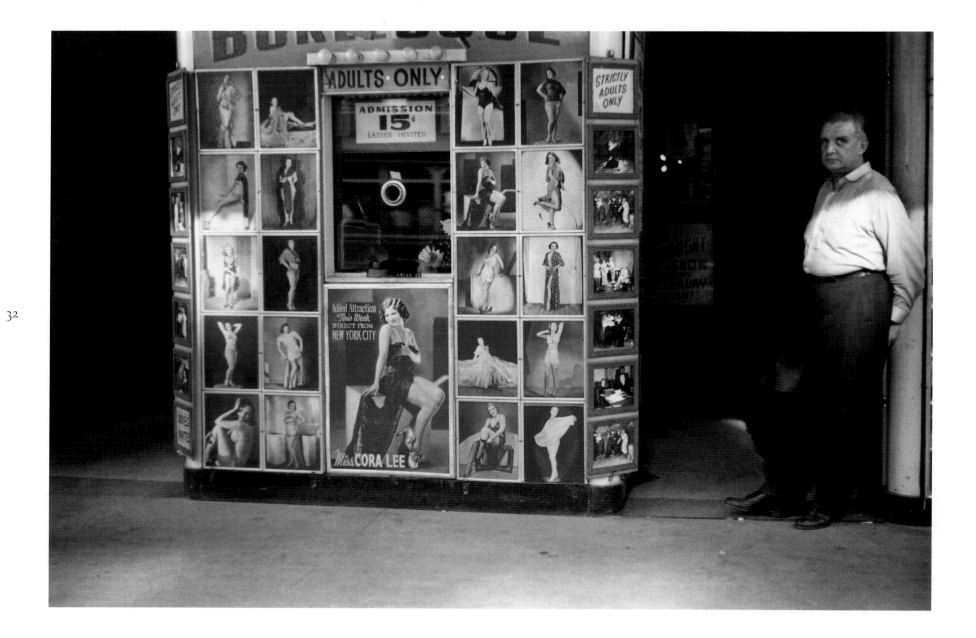

Burlesque house, South State Street, Chicago, Illinois
JOHN VACHON, JULY 1941

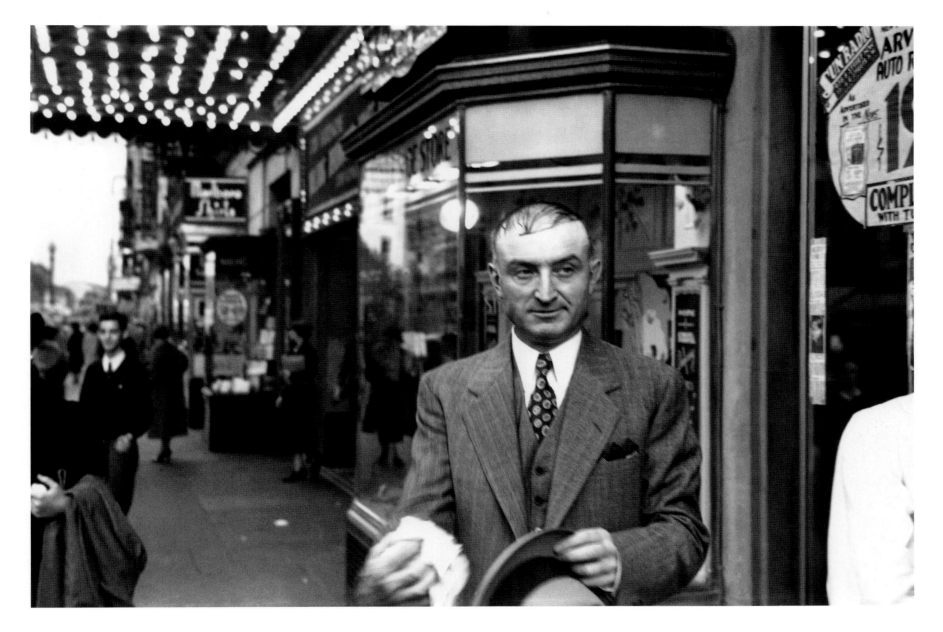

Man on the street, Washington, D.C.

JOHN VACHON, DECEMBER 1937

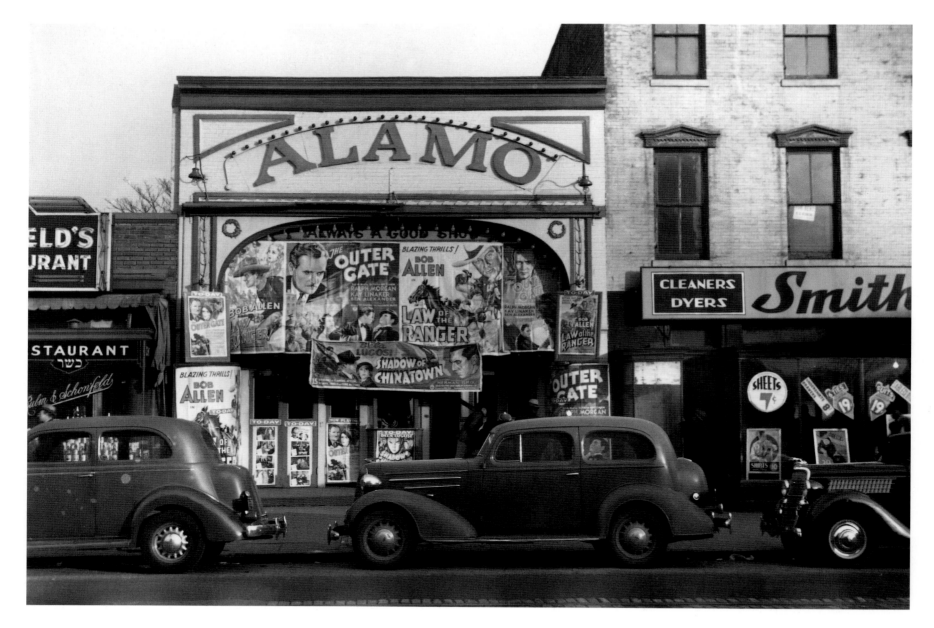

Untitled (Washington, D.C.)
JOHN VACHON, DECEMBER, 1937

Street scene, Washington, D.C. Proprietor of a tombstone shop.
JOHN VACHON, NOVEMBER 1937

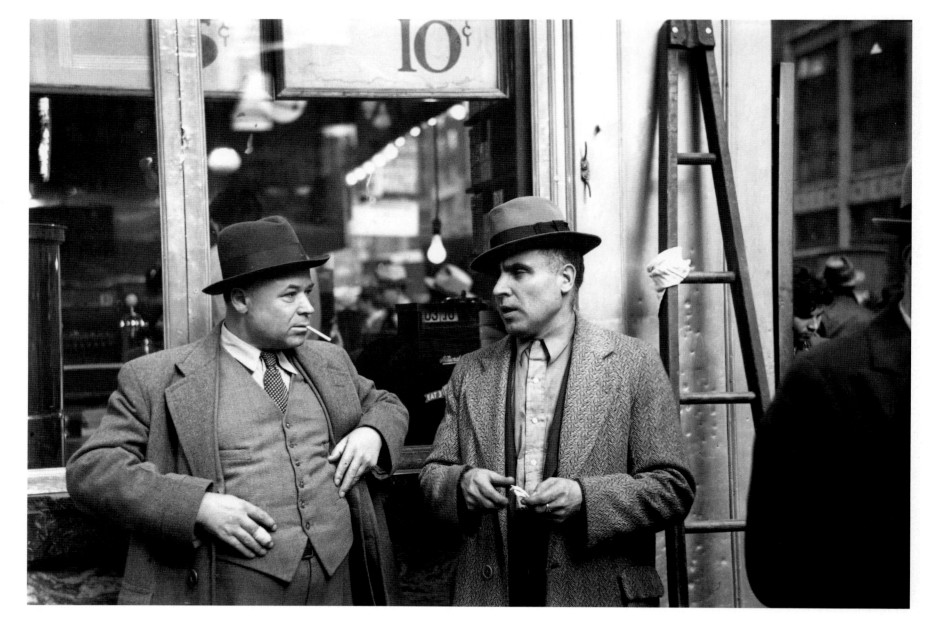

Two men in conversation, 7th Avenue near 38th Street, New York City

RUSSELL LEE, NOVEMBER 1936

Street scene at 38th Street and 7th Avenue, New York City
RUSSELL LEE, NOVEMBER 1936

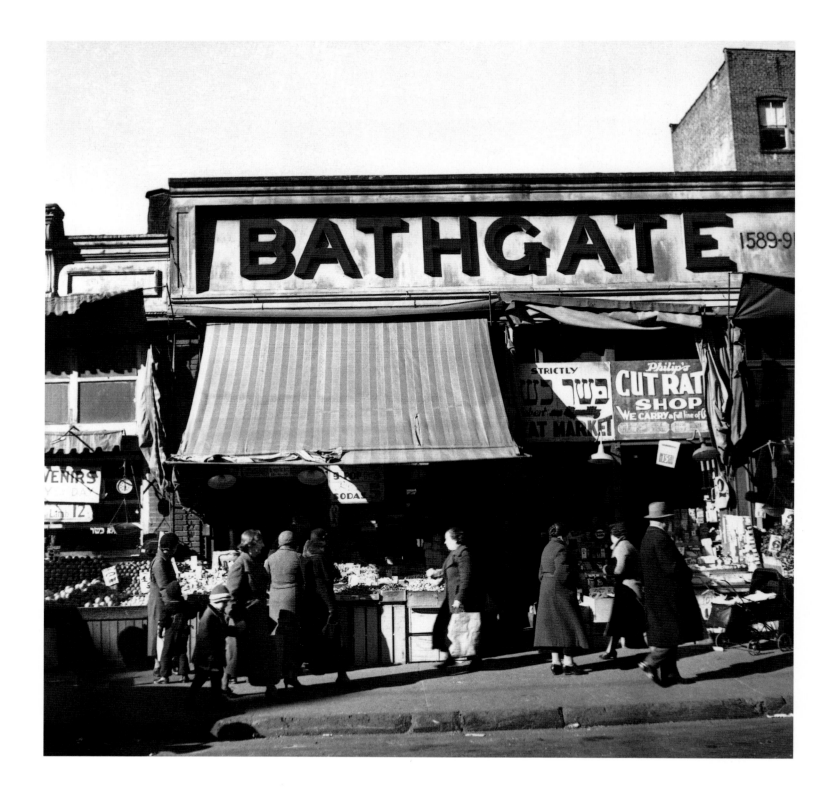

Scene along Bathgate Avenue in the Bronx, a section from which many of the New Jersey homesteaders have come, New York

ARTHUR ROTHSTEIN, DECEMBER 1936

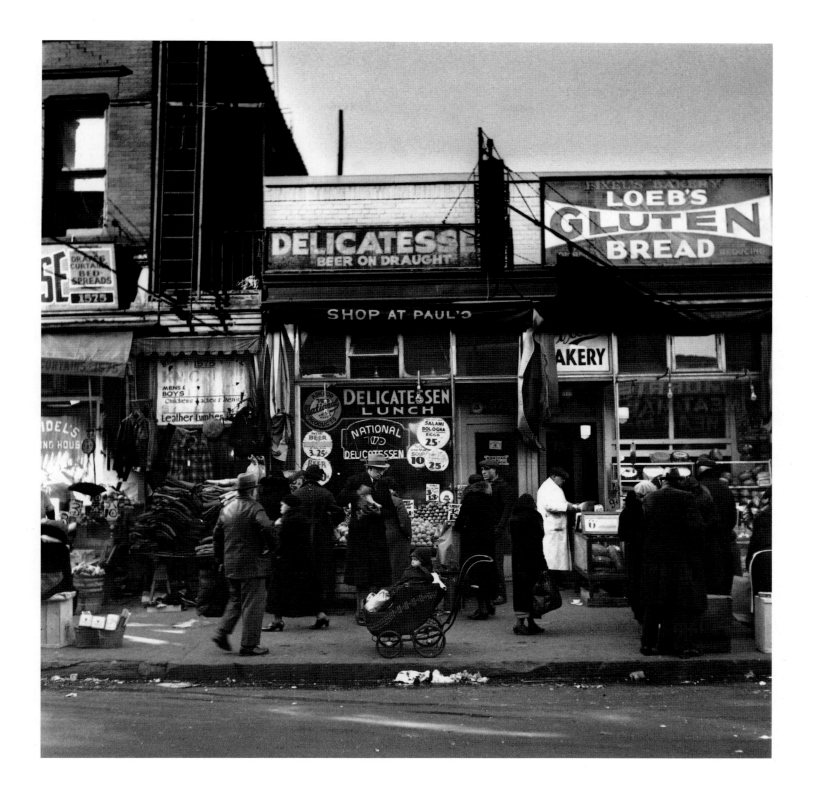

Scene along Bathgate Avenue in the Bronx, a section from which many of the New Jersey homesteaders have come
ARTHUR ROTHSTEIN, DECEMBER 1936

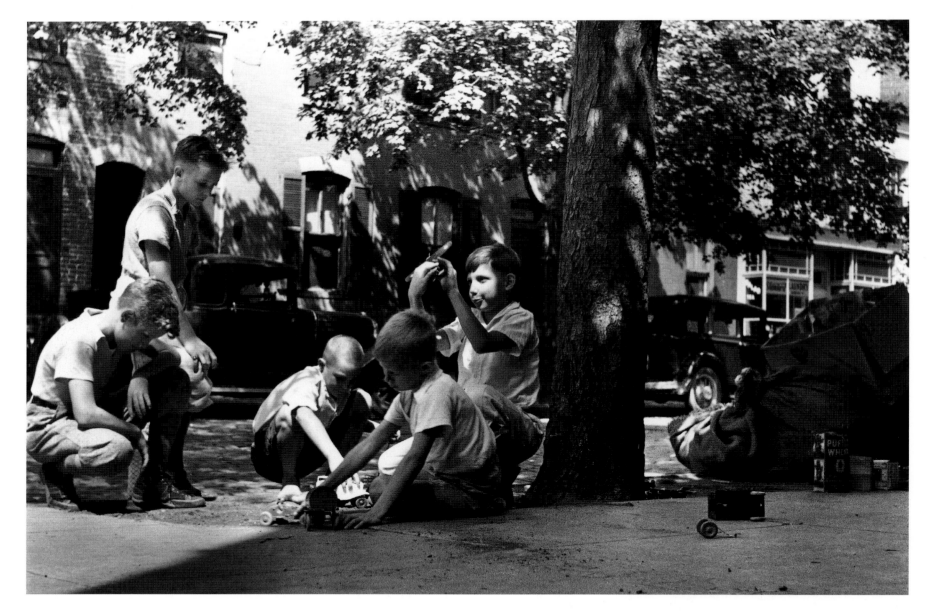

Untitled (Children at play on street, Georgetown, Washington, D.C.)
CARL MYDANS, SEPTEMBER 1935

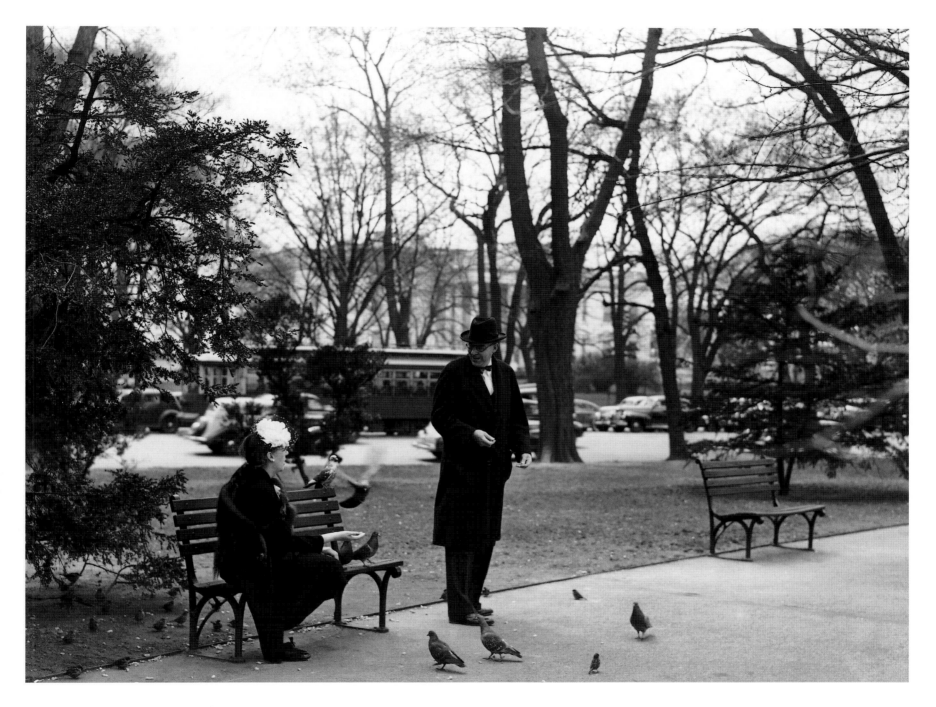

Sunday in the park, Washington, D.C.
MARTHA MCMILLAN ROBERTS, MAY 1941

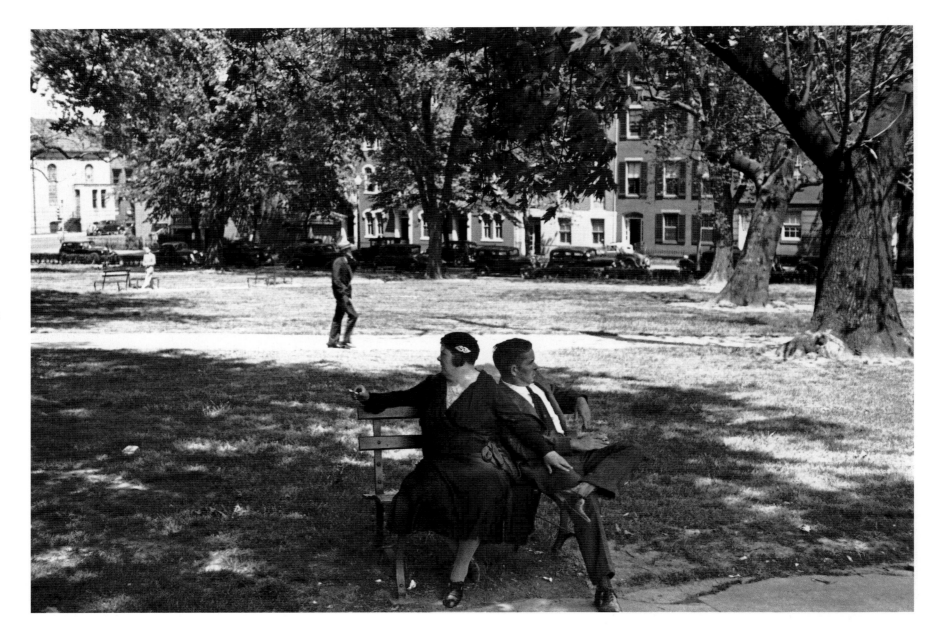

Untitled (Washington, D.C.)

John Vachon, April 1937

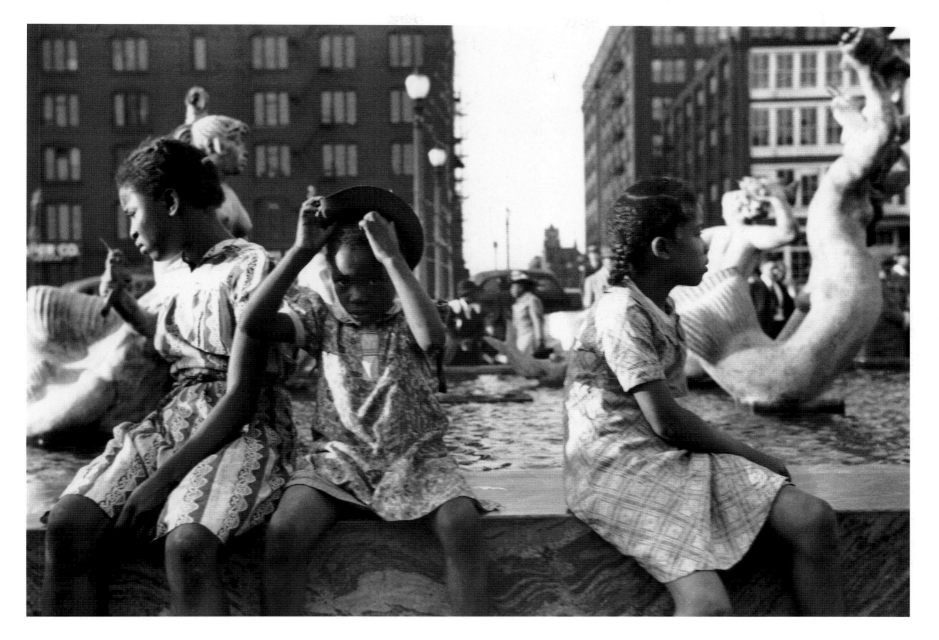

Untitled (Fountain in front of Union Station, St. Louis, Missouri)
JOHN VACHON, MAY, 1940

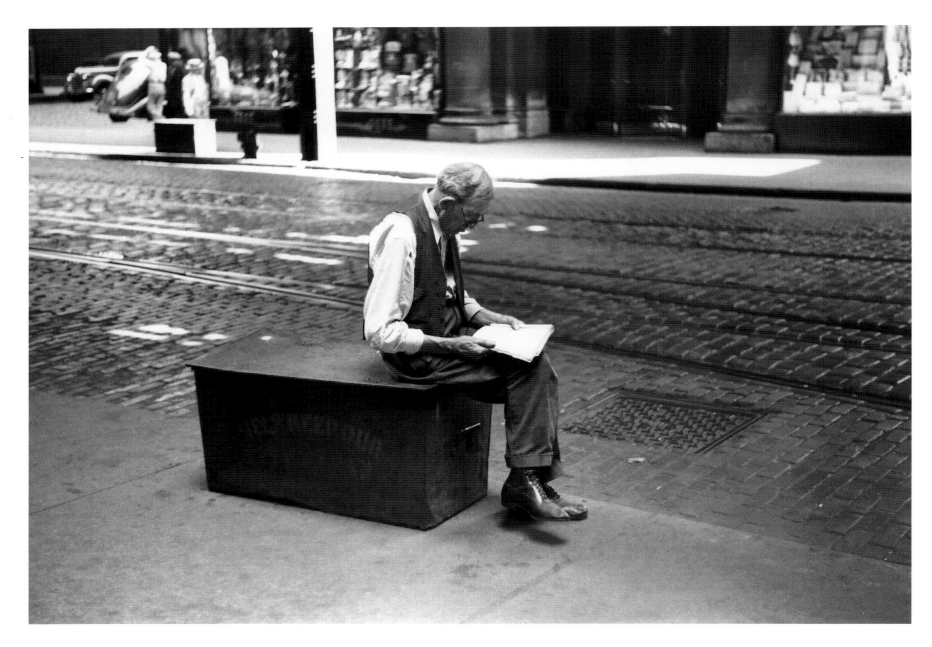

Man waiting for street car, Chicago, Illinois
JOHN VACHON, JULY 1940

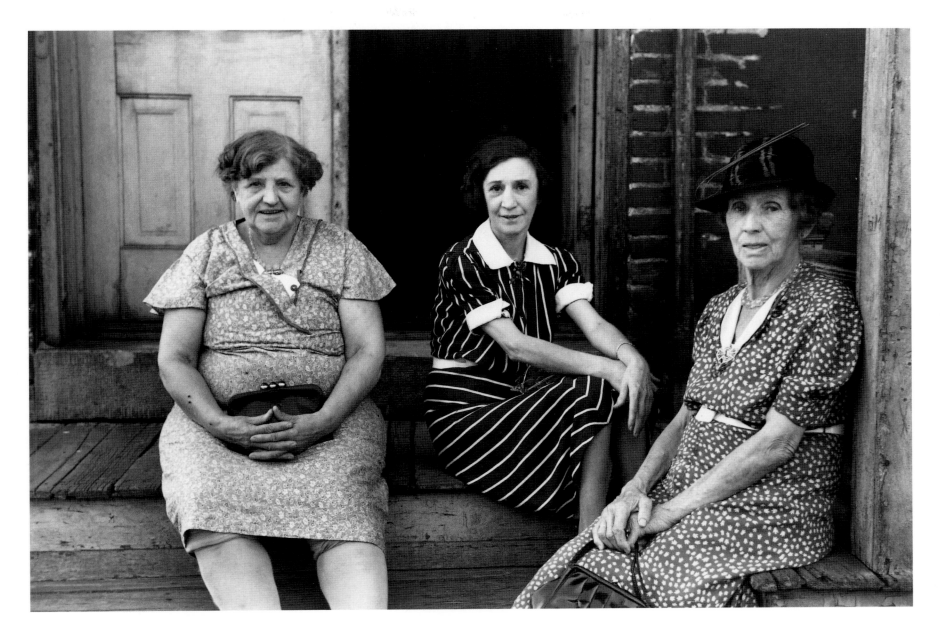

Ladies who live in rooming house, St. Paul, Minnesota

John Vachon, September 1939

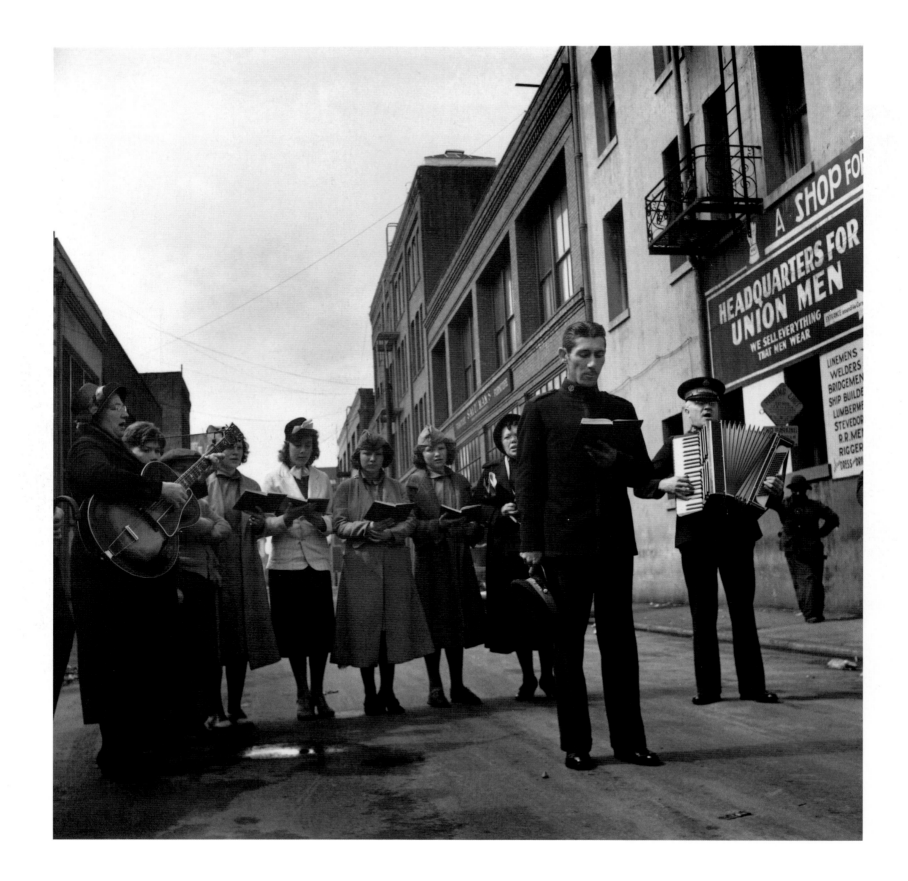

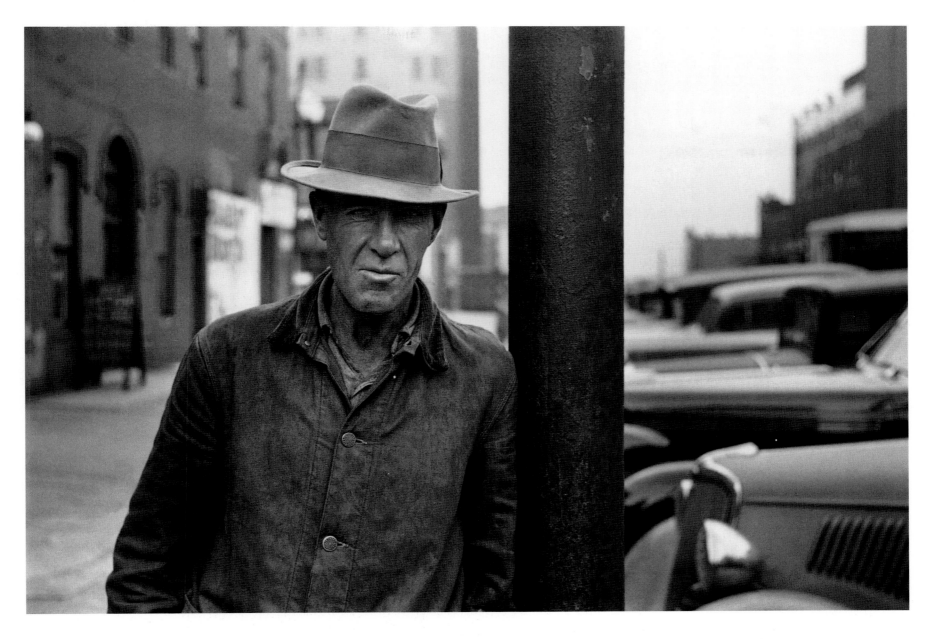

ABOVE: Unemployed man, Omaha, Nebraska

JOHN VACHON, NOVEMBER 1938

OPPOSITE: At Minna Street the army forms a semi-circle and sings to attract a crowd. Salvation Army, San Francisco, California.

DOROTHEA LANGE, APRIL 1939

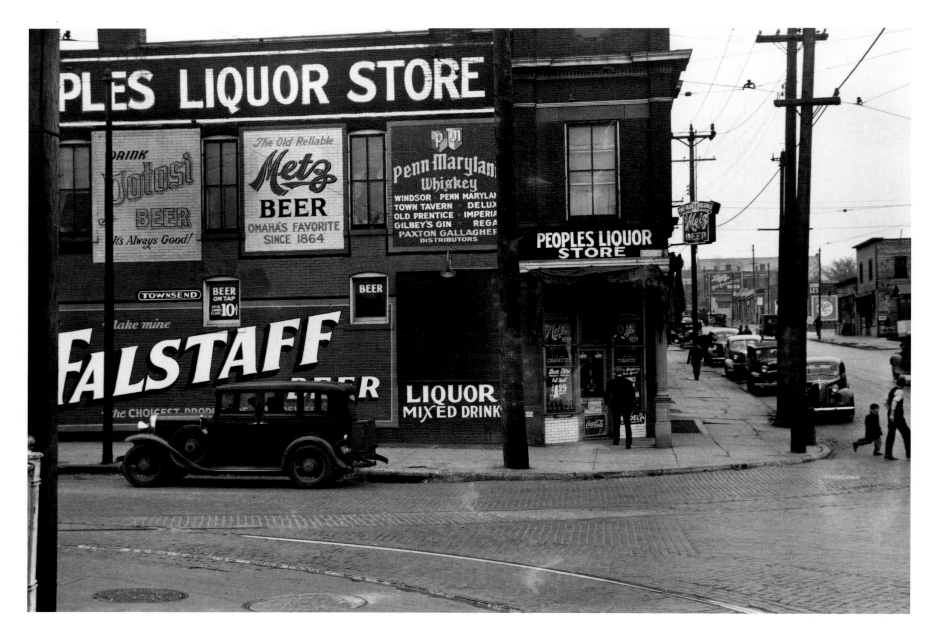

Untitled (Omaha, Nebraska)

John Vachon, November, 1938

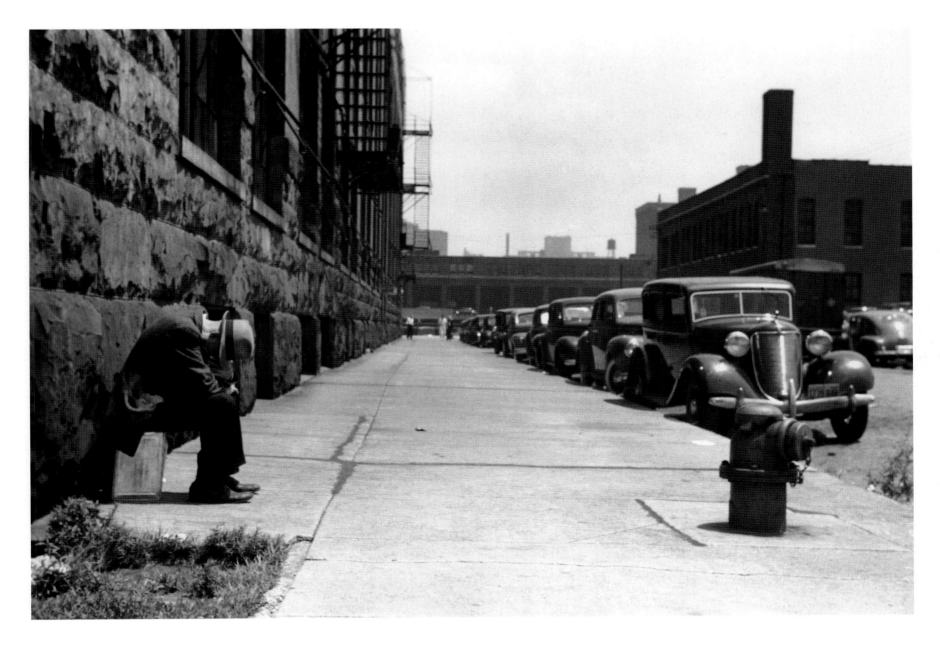

Chicago, Illinois
JOHN VACHON, JULY 1941

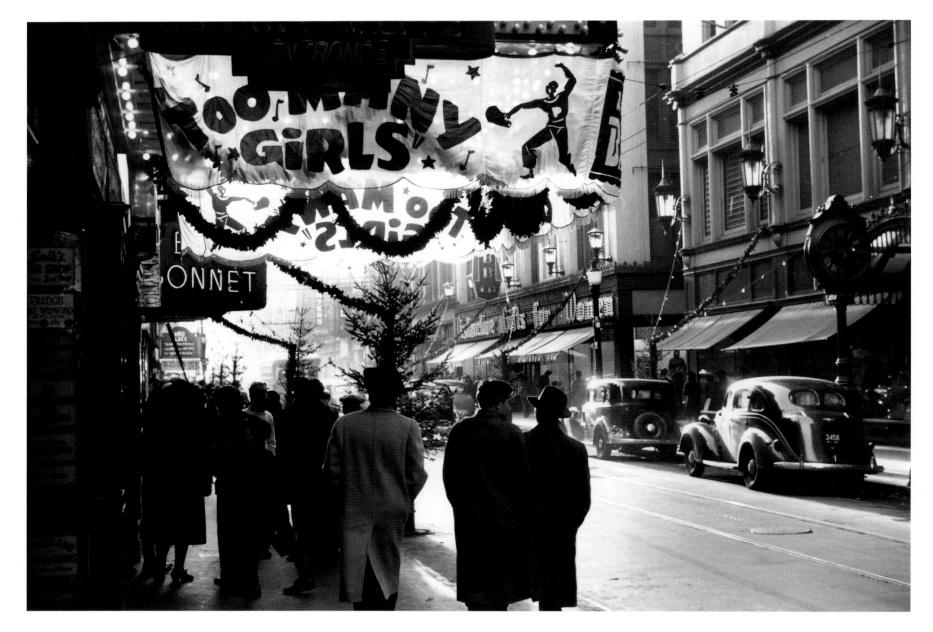

Crowds in downtown section of Providence, Rhode Island

Jack Delano, December 1940

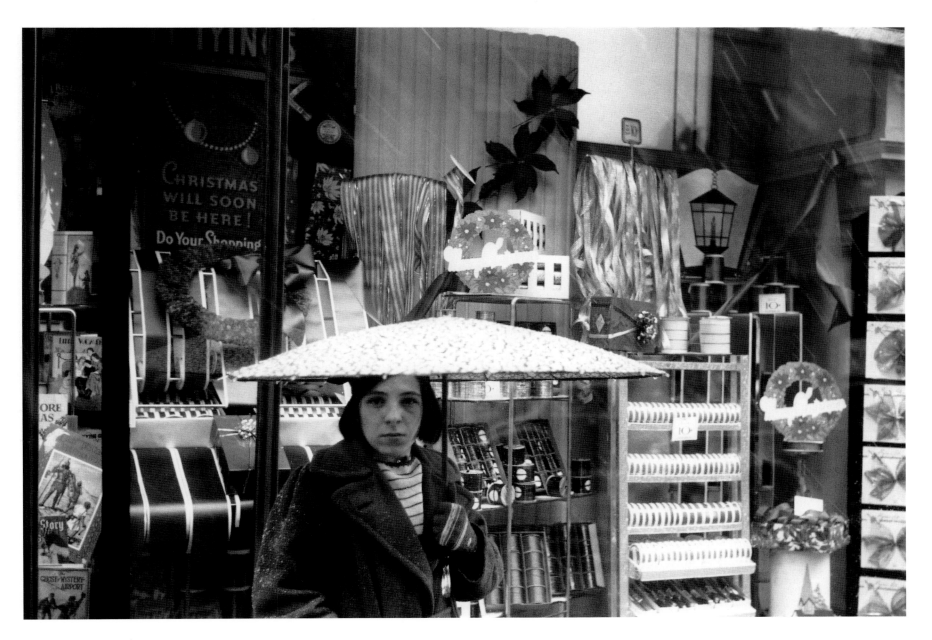

Waiting for a bus on a rainy day in Providence, Rhode Island
JACK DELANO, DECEMBER 1940

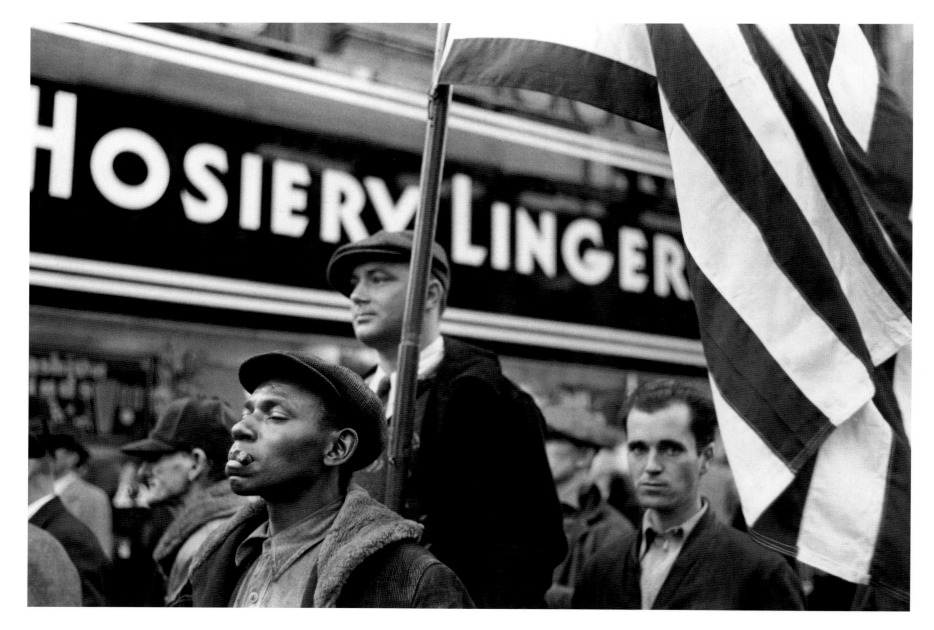

Watching Armistice Day parade, Omaha, Nebraska

John Vachon, November 1938

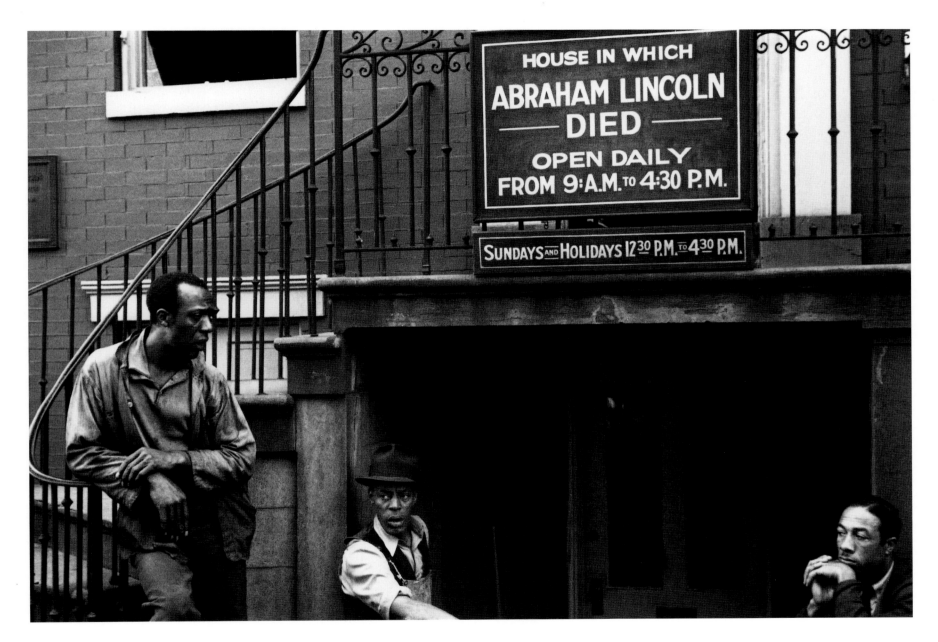

Washington, D.C., house where Lincoln died. Negroes out front.

JOHN VACHON, DECEMBER 1937

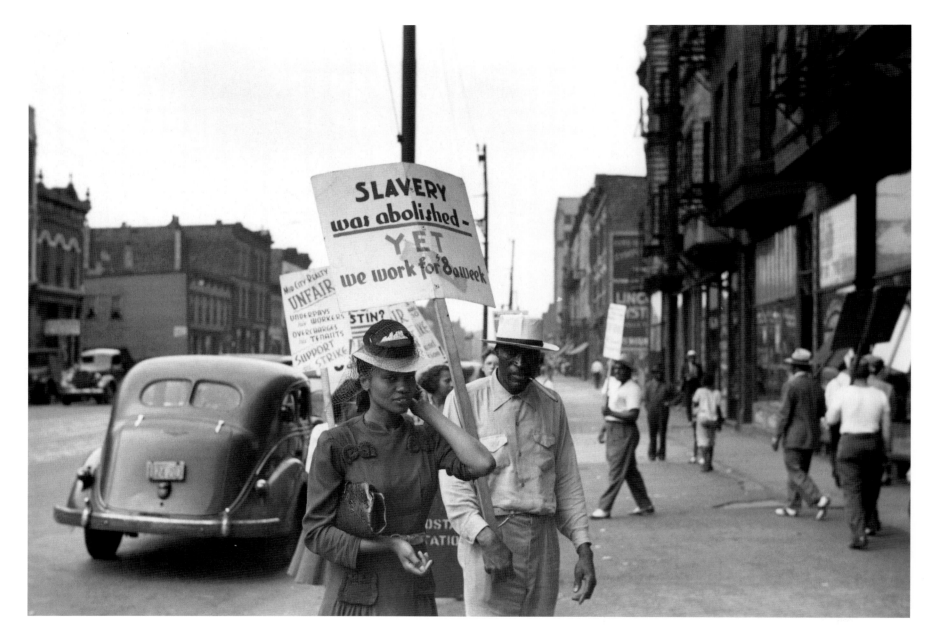

Picket line at Mid-City Realty Company, South Chicago, Illinois

John Vachon, July 1941

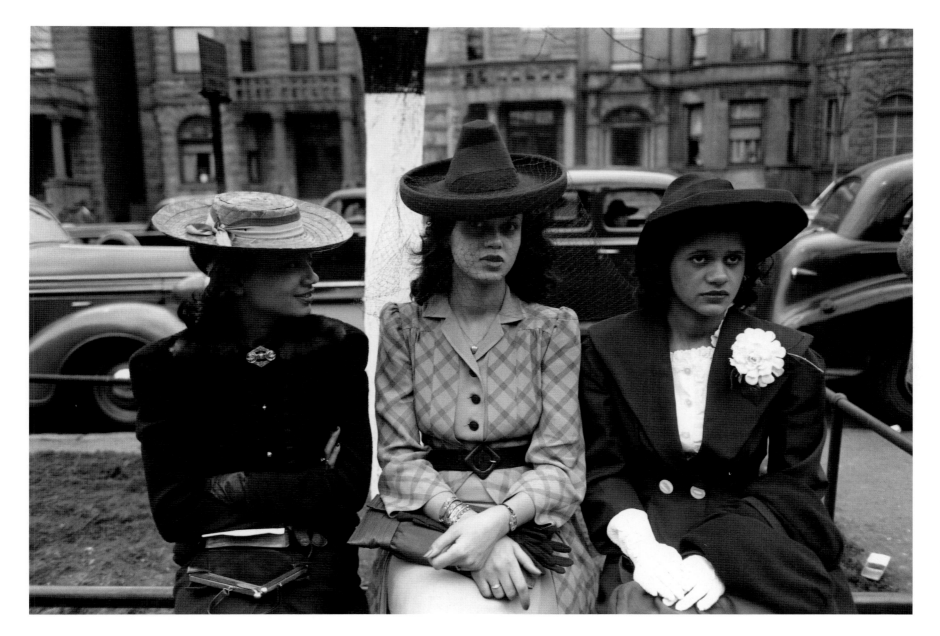

Girls waiting for Episcopal Church to end to they can see the processional, South Side of Chicago, Illinois

RUSSELL LEE, APRIL 1941

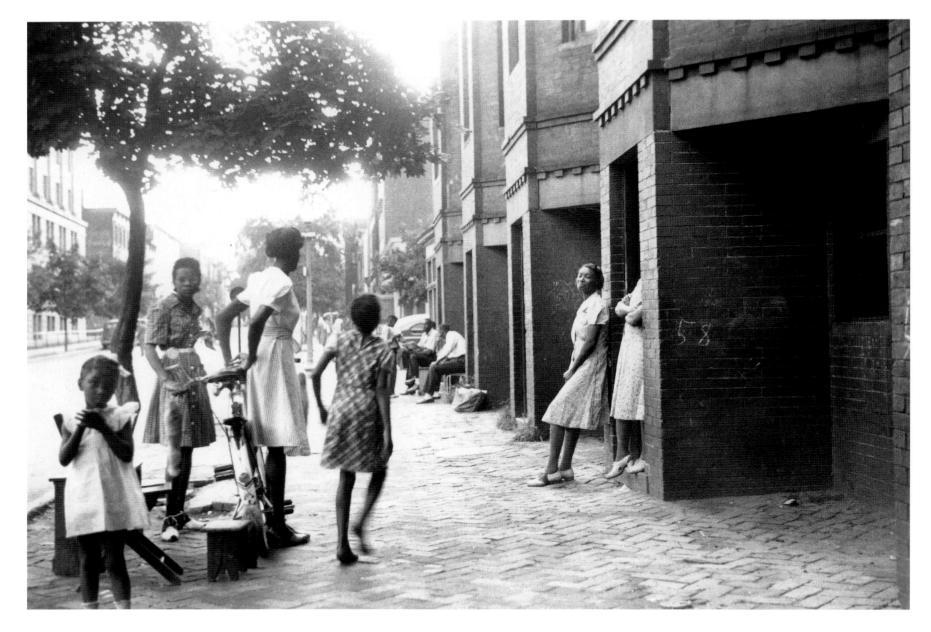

Street scene, Negro section, Washington, D.C.
EDWIN ROSSKAM, JULY 1941

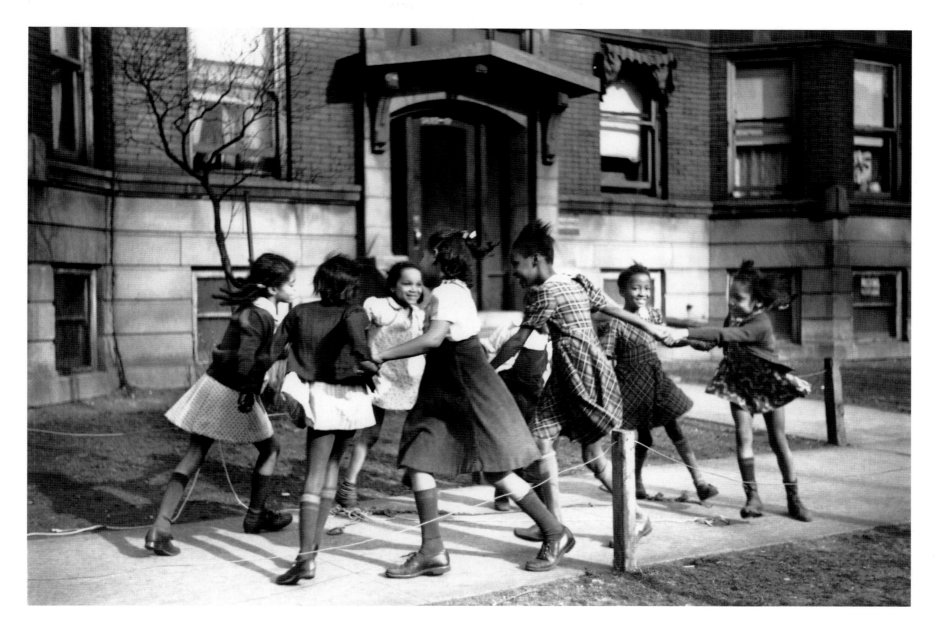

Untitled (Children playing ring around a rosie in one of the better neighborhoods, Black Belt, Chicago, Illinois)
EDWIN ROSSKAM, APRIL 1941

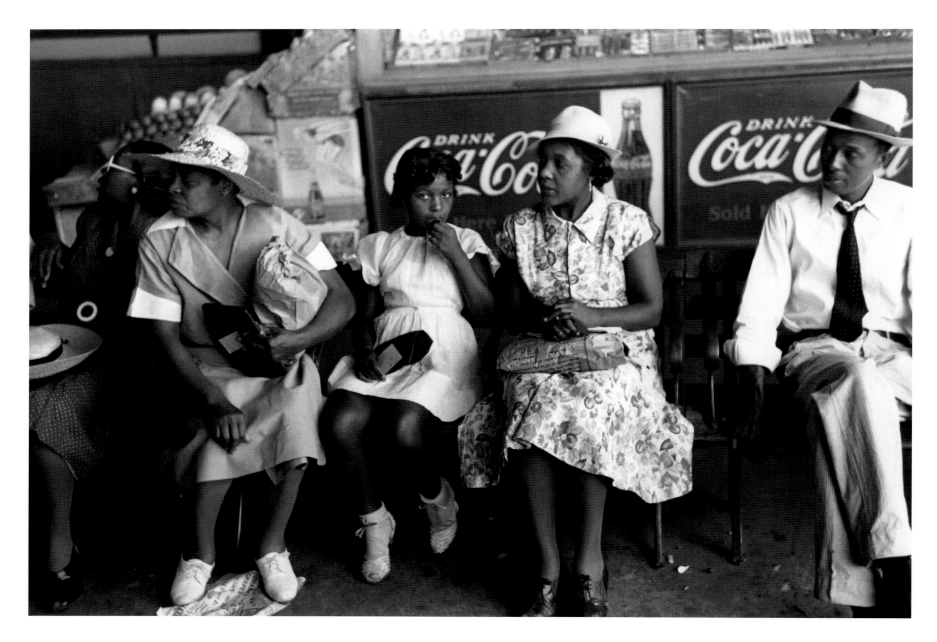

Negroes waiting at streetcar terminal for cars, Oklahoma City, Oklahoma

RUSSELL LEE, JULY 1939

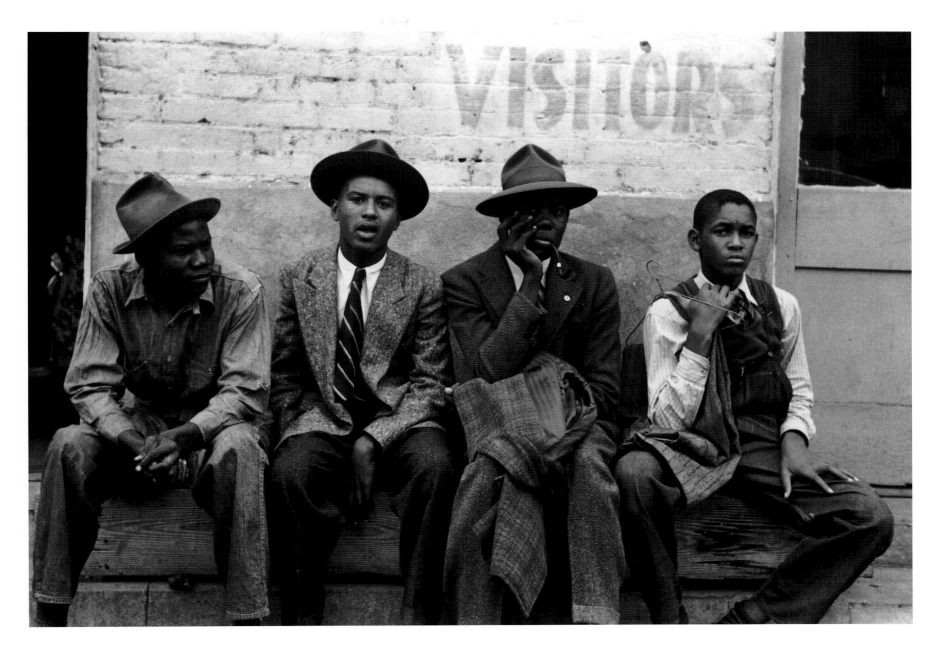

Negro boys sitting on bench on street, Waco, Texas
RUSSELL LEE, NOVEMBER 1939

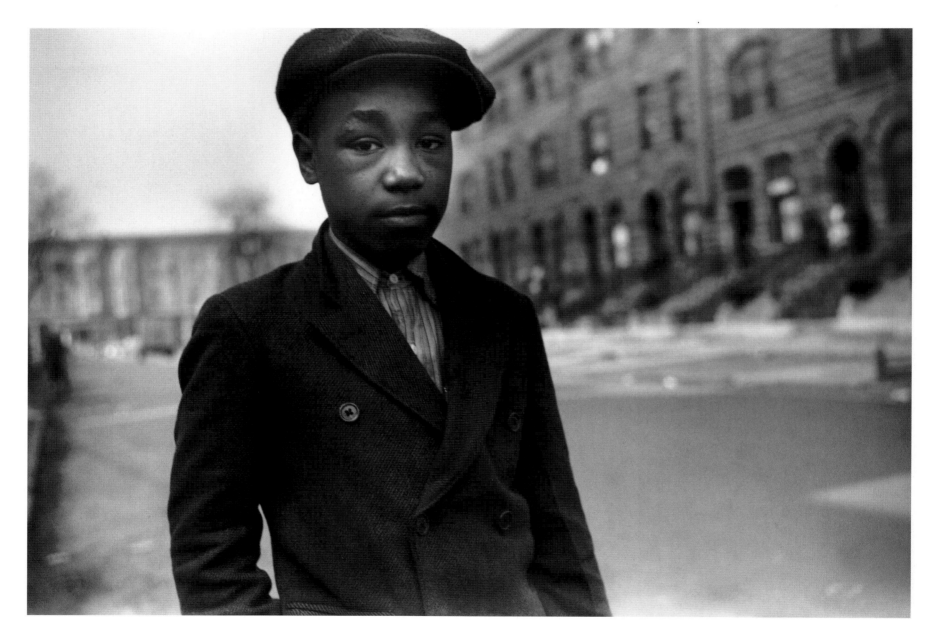

Untitled (Chicago, Illinois)

Edwin Rosskam, July 1941

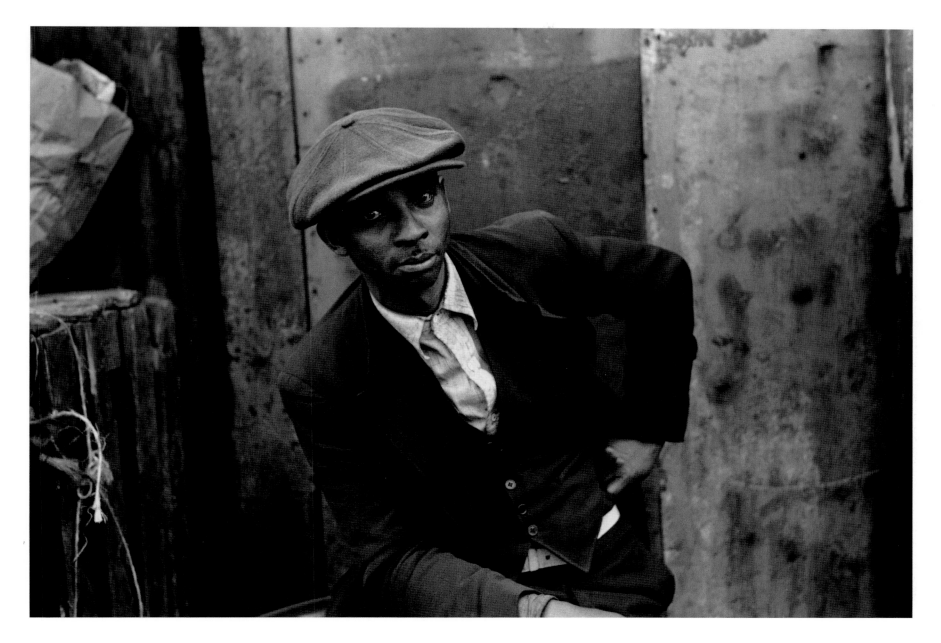

Untitled (Chicago, Illinois)
Edwin Rosskam, July 1941

62

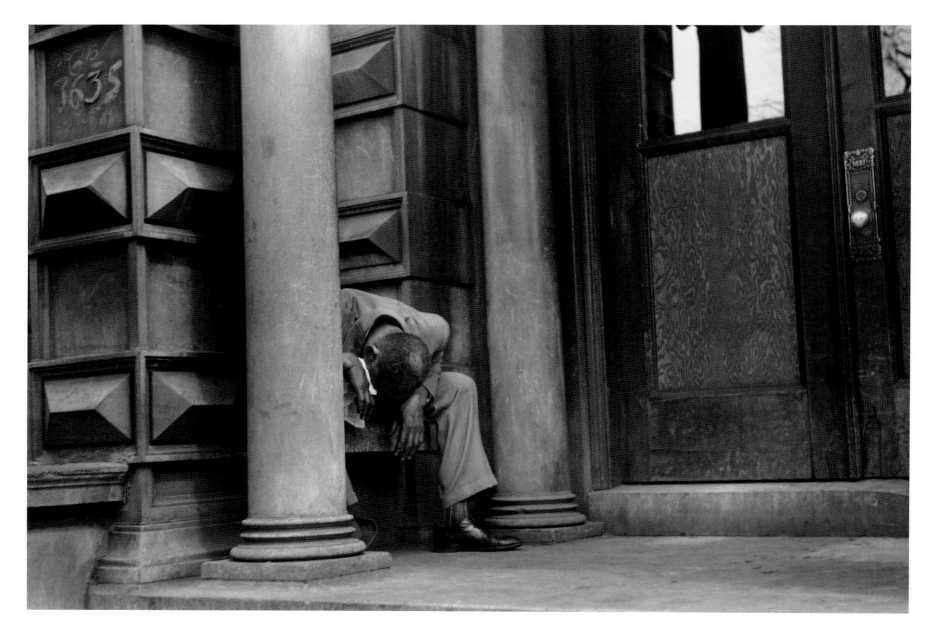

Entrance to apartment house in the Black Belt, Chicago, Illinois
Edwin Rosskam, April 1941

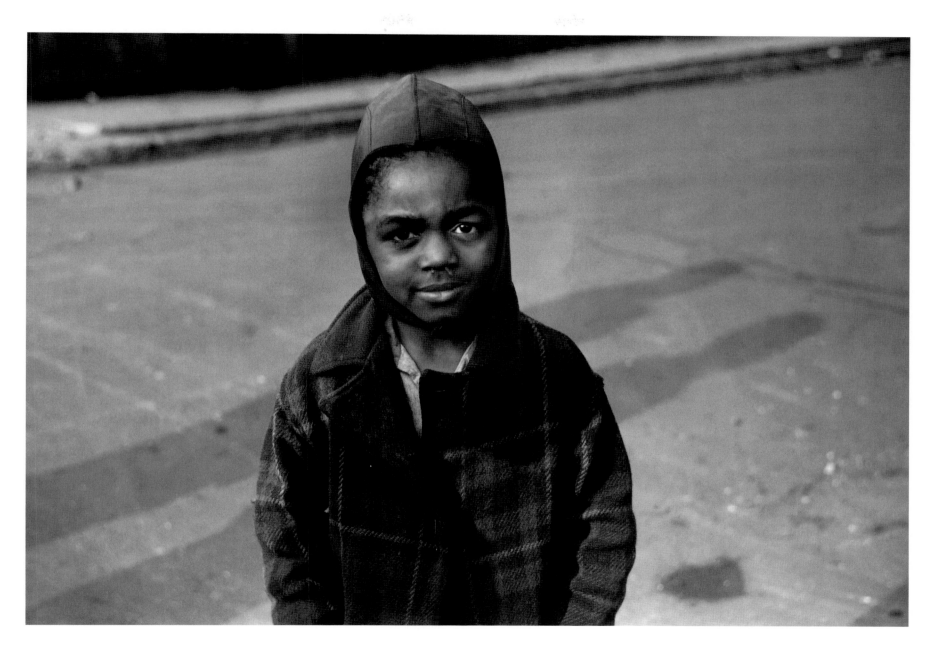

Untitled (Street Urchin, Black Belt, Chicago, Illnois)
EDWIN ROSSKAM, APRIL 1941

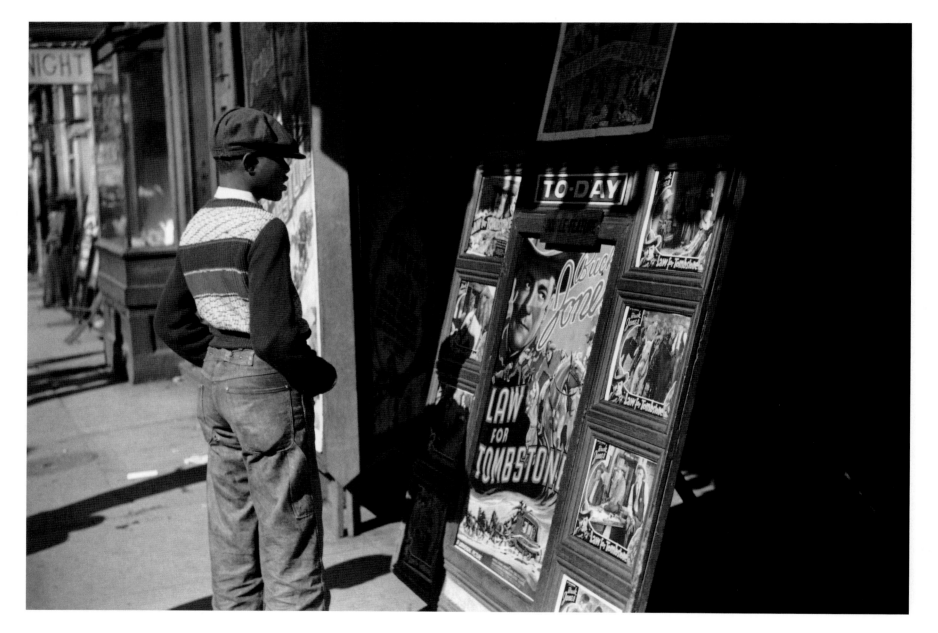

64

Entrance to a movie house, Beale Street, Memphis, Tennessee
MARION POST WOLCOTT, OCTOBER? 1939

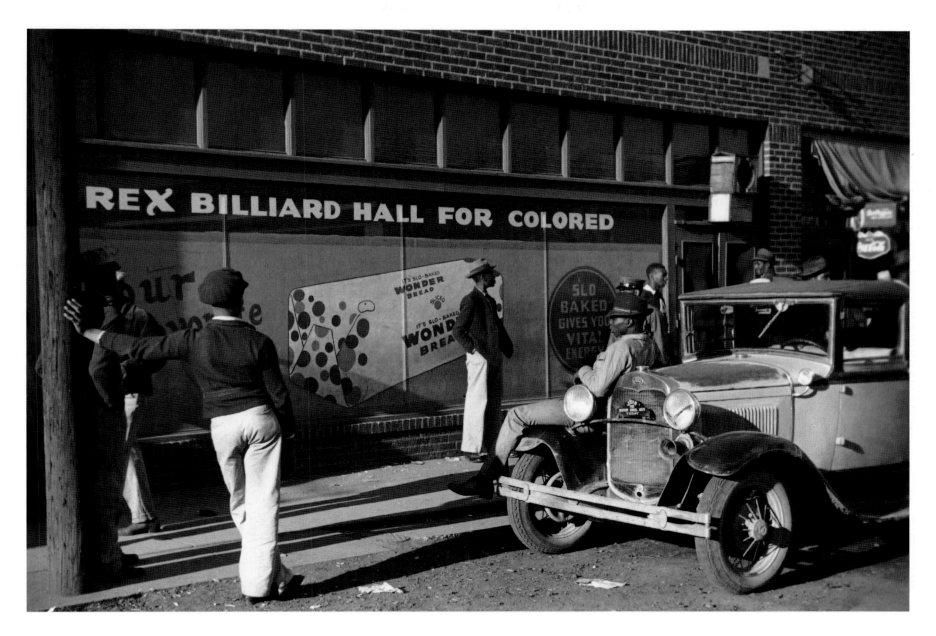

Beale Street, Memphis, Tennessee
Marion Post Wolcott, October? 1939

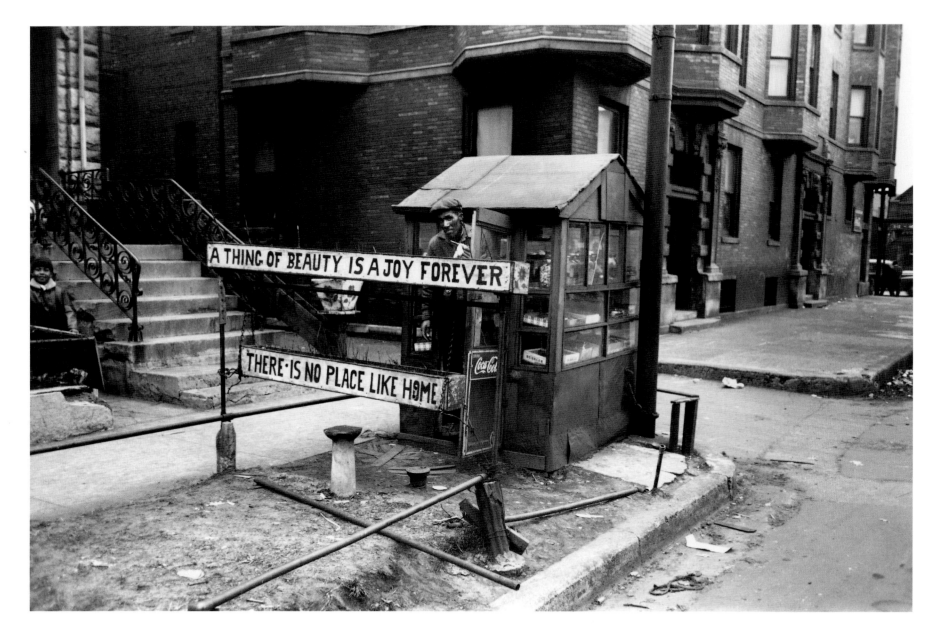

Untitled (South Side of Chicago, Illinois)

RUSSELL LEE, APRIL 1941

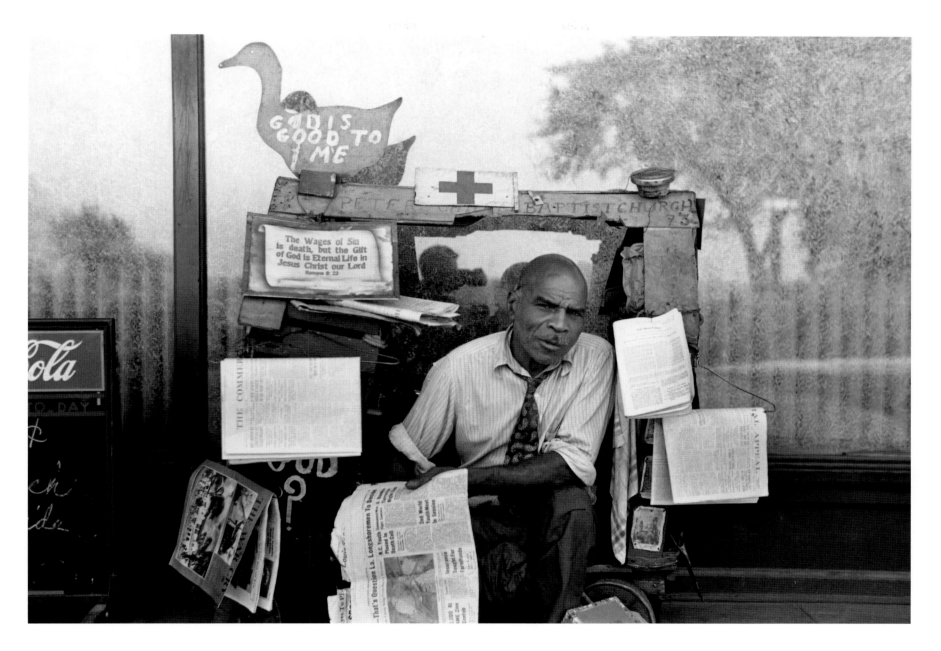

Newsstand, Memphis, Tennessee
RUSSELL LEE, SEPTEMBER 1938

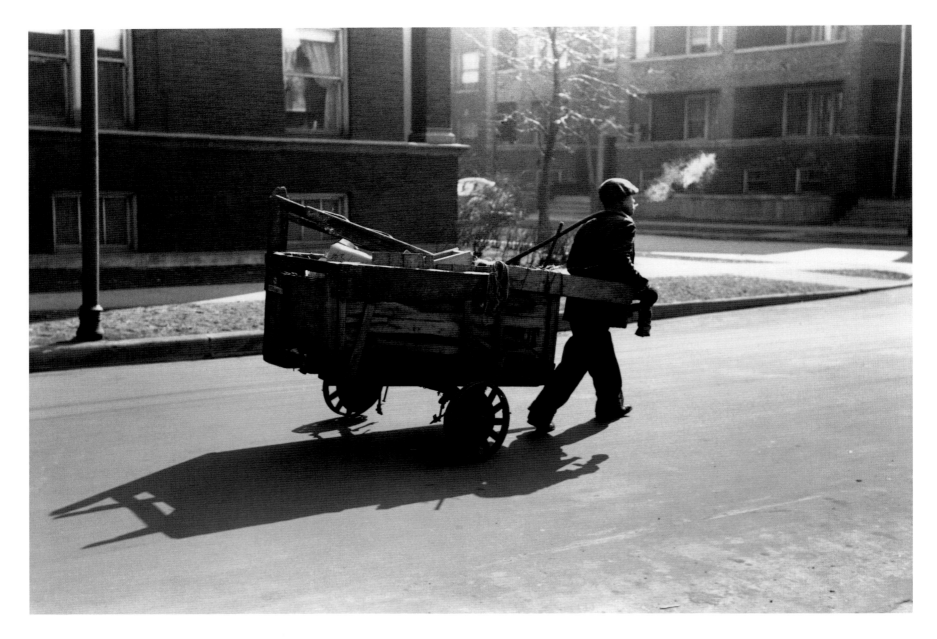

Man-drawn carts are common on South Side of Chicago, Illinois

Russell Lee, April 1941

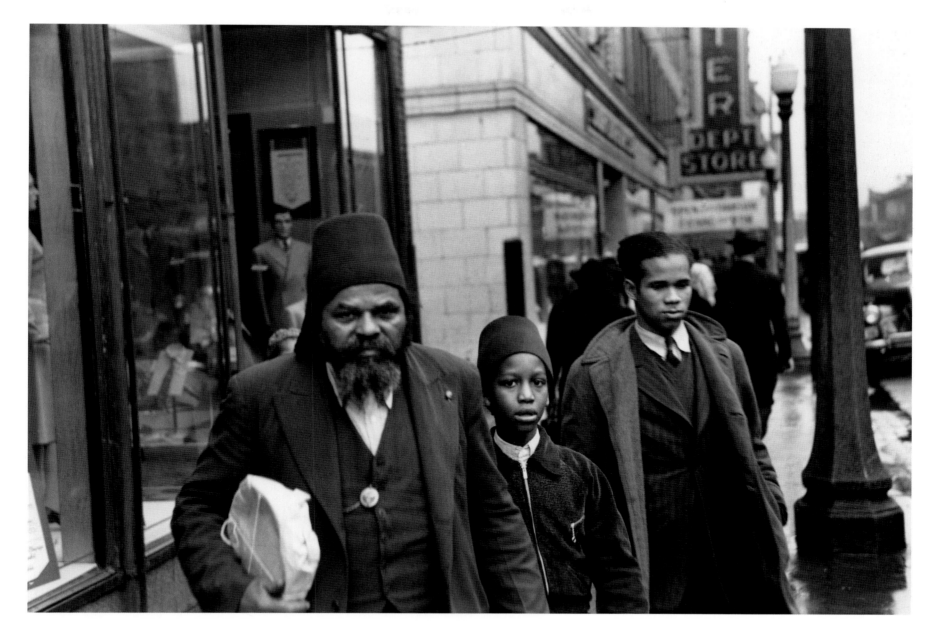

Members of the Moors, a Negro religious group of Chcago, Illinois
RUSSELL LEE, APRIL 1941

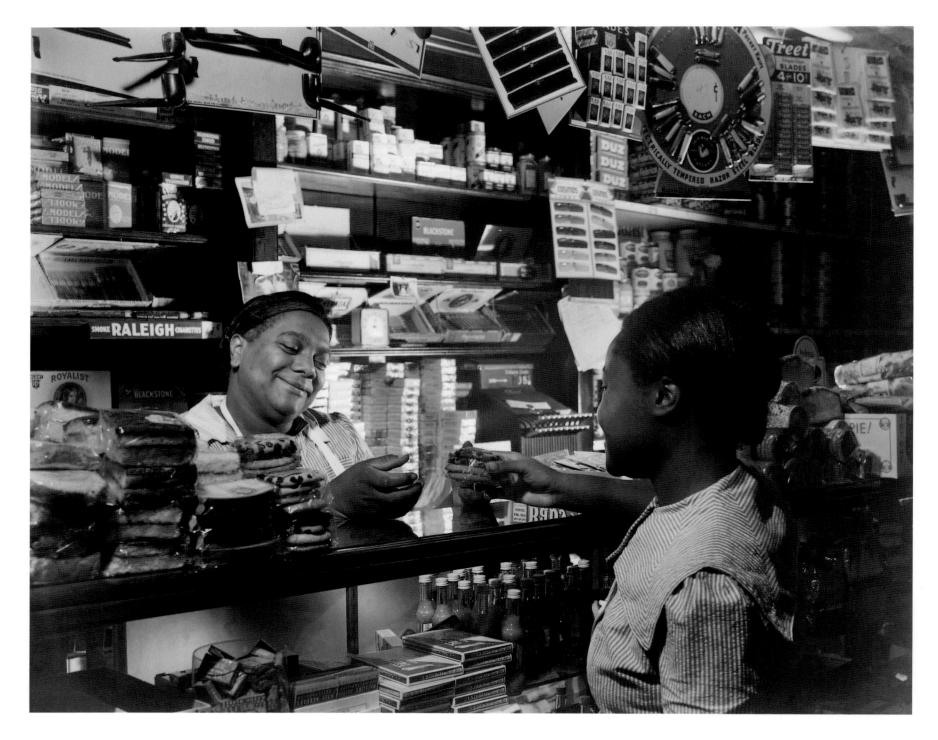

70

Washington, D.C. Clerk waiting on a customer in the store owned by Mr. J. Benjamin

Gordon Parks, August 1942

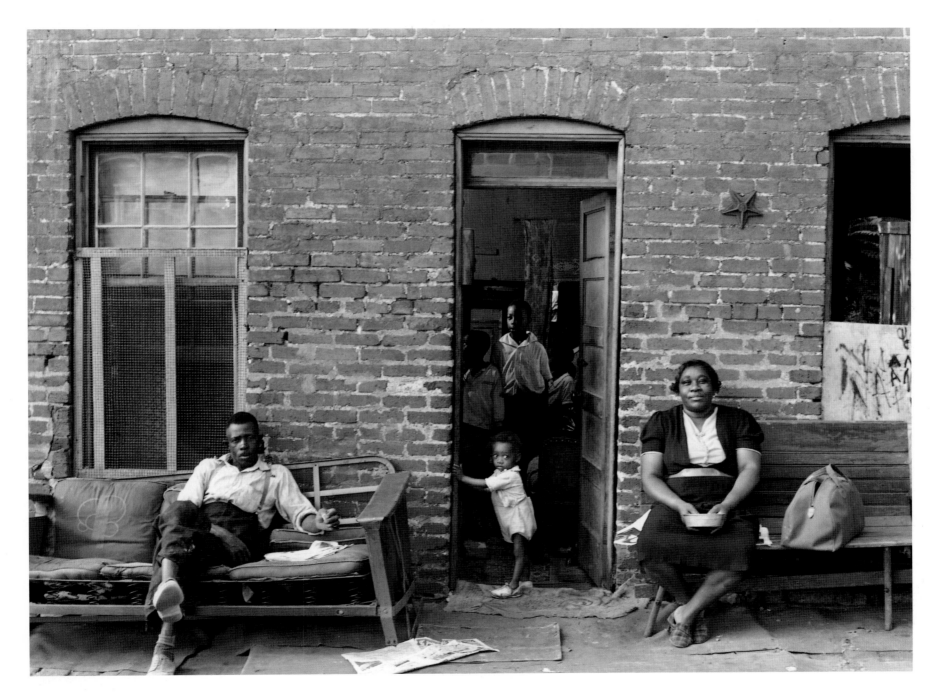

Negro family and their home in one of the alley dwelling sections, Washington, D.C.
EDWIN ROSSKAM, JULY 1941

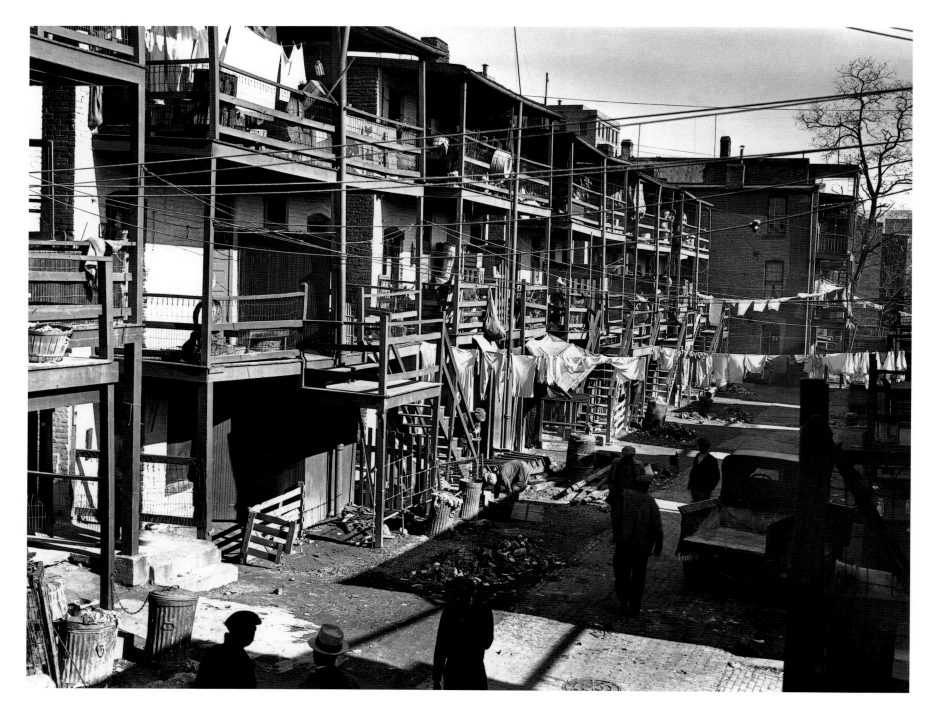

Slums, Washington, D.C.

CARL MYDANS, NOVEMBER 1935

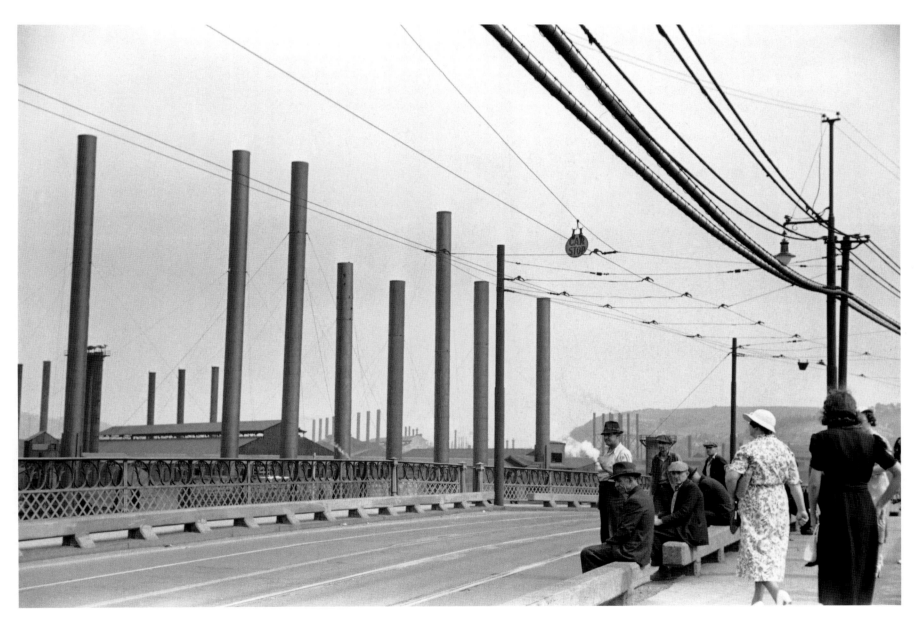

73

Waiting for streetcar after work, Pittsburgh, Pennsylvania

ARTHUR ROTHSTEIN, JULY 1938

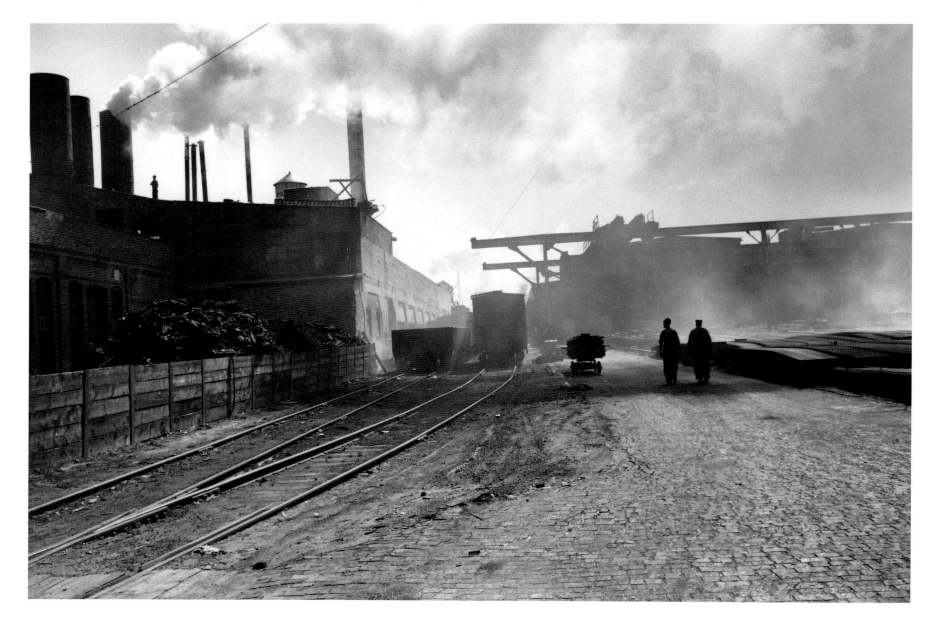

Tractor factory, Minneapolis, Minnesota

John Vachon, September 1939

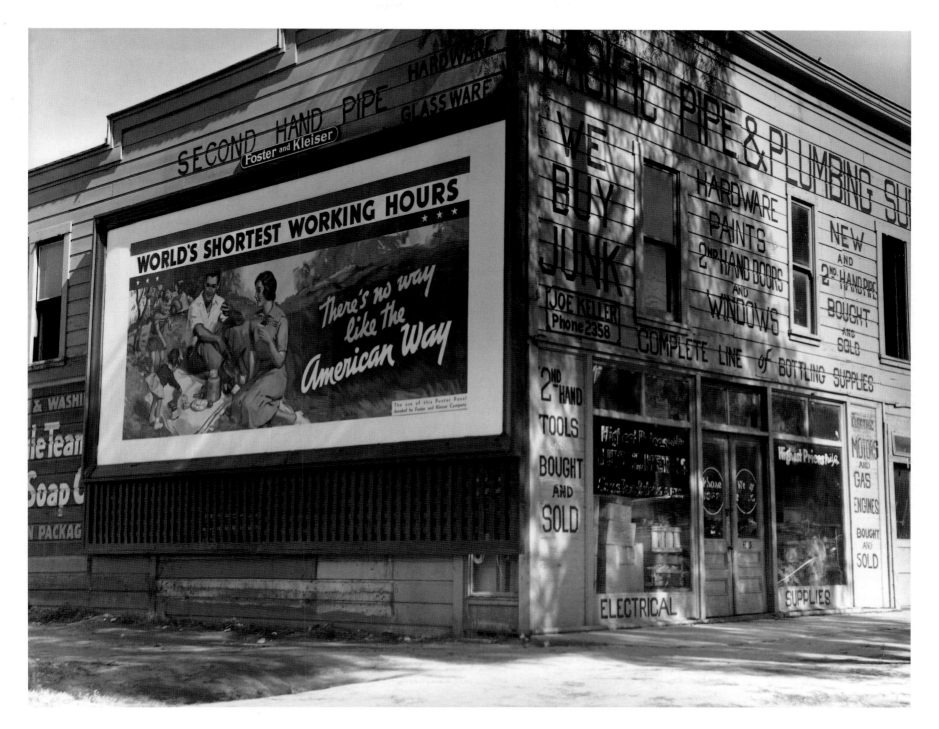

Billboard on U.S. Highway 99 in California. National advertising campaign sponsored by National Association of Manufacturers

Dorothea Lange, March 1937

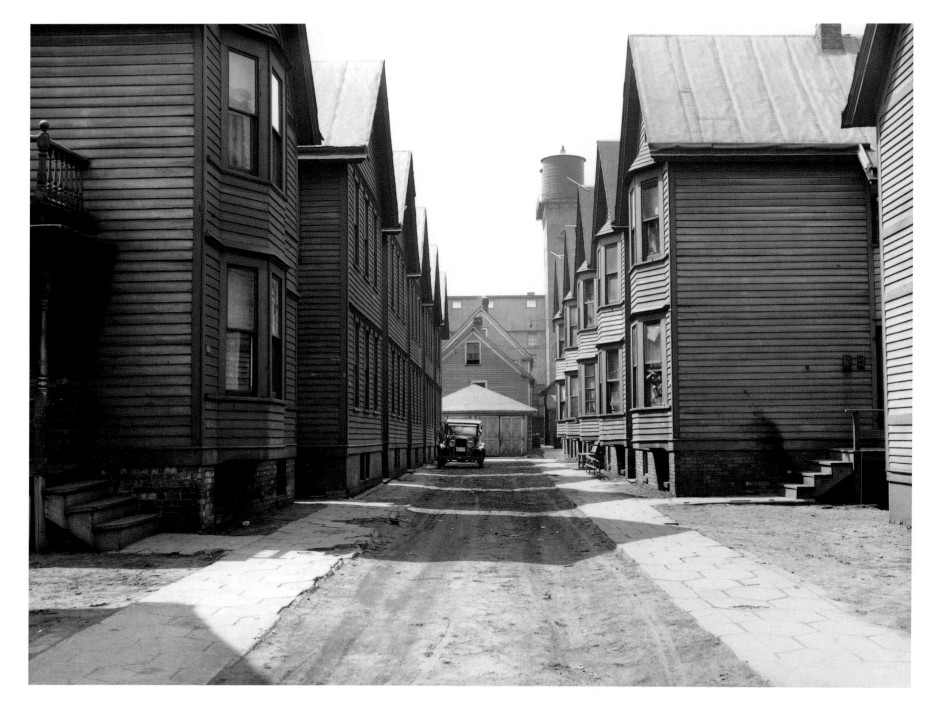

View from living quarters at 730 West Winnebago Street, looking towards alley, Milwaukee, Wisconsin

Carl Mydans, April 1936

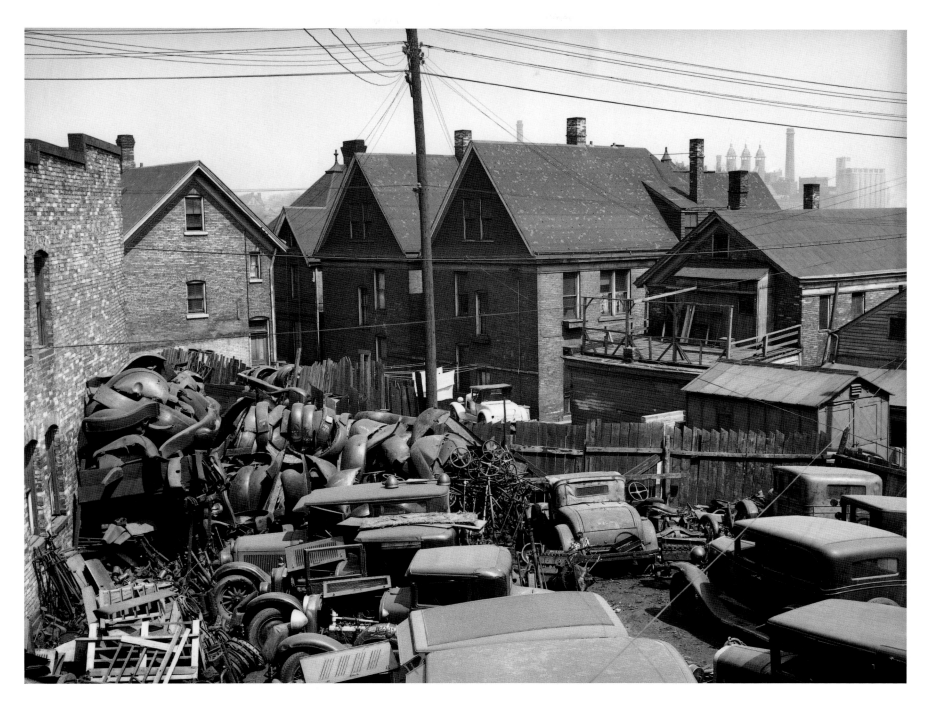

Junk, with living quarters close by, Milwaukee, Wisconsin

Carl Mydans, April 1936

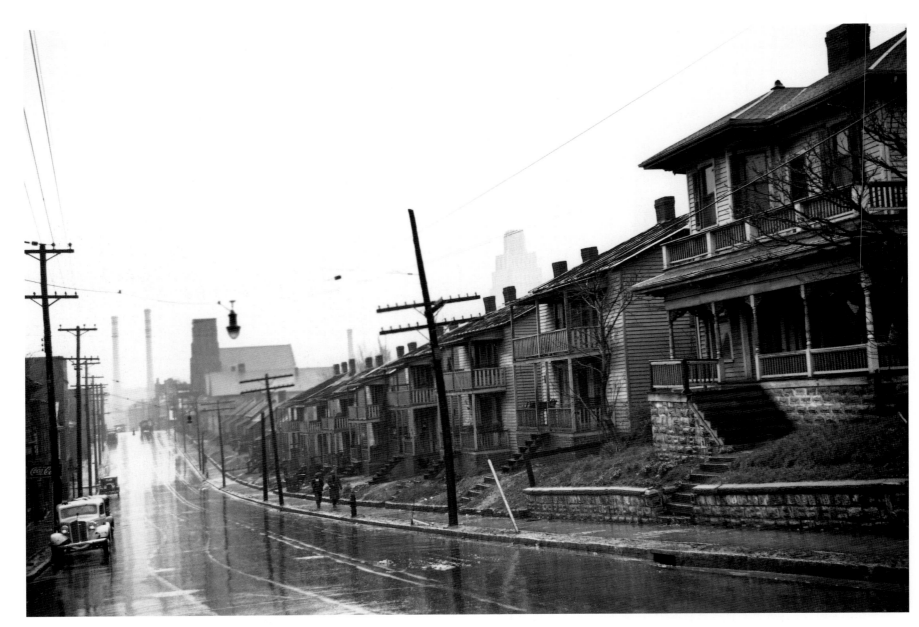

78

ABOVE: Untitled (place unknown)
WALKER EVANS, 1936?

OPPOSITE: Children's playground, St. Louis, Missouri
ARTHUR ROTHSTEIN, MARCH 1936

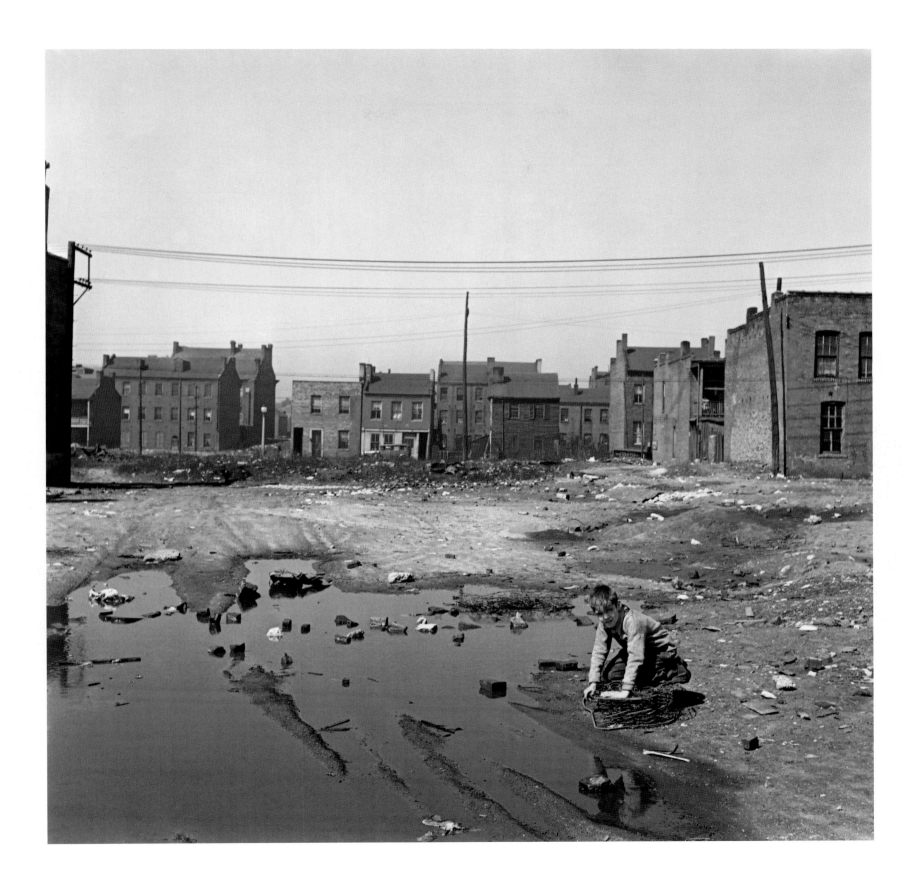

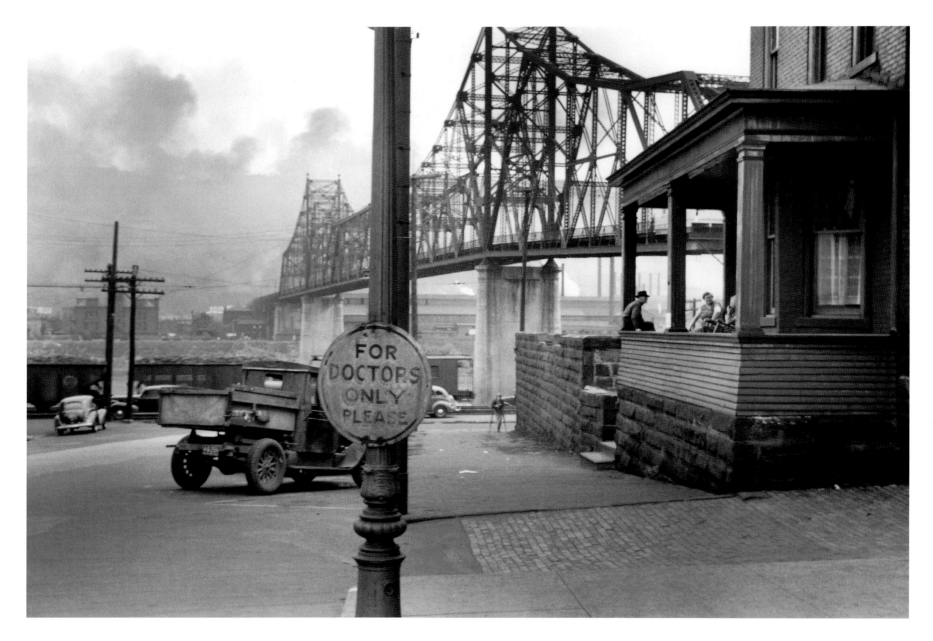

Untitled (Mansfield, Ohio)

John Vachon, July 1941

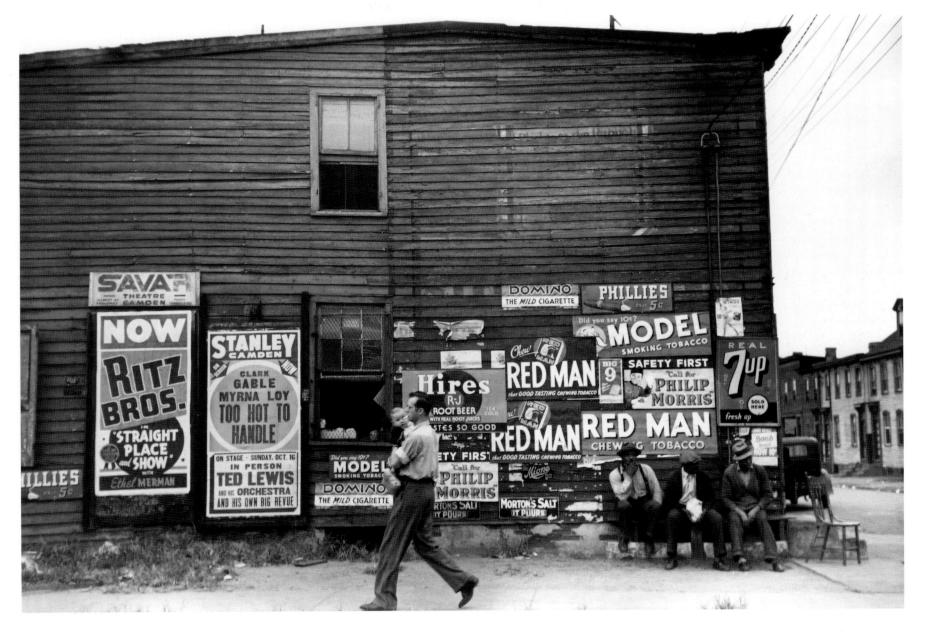

Untitled (Camden, New Jersey)

Arthur Rothstein, October 1938

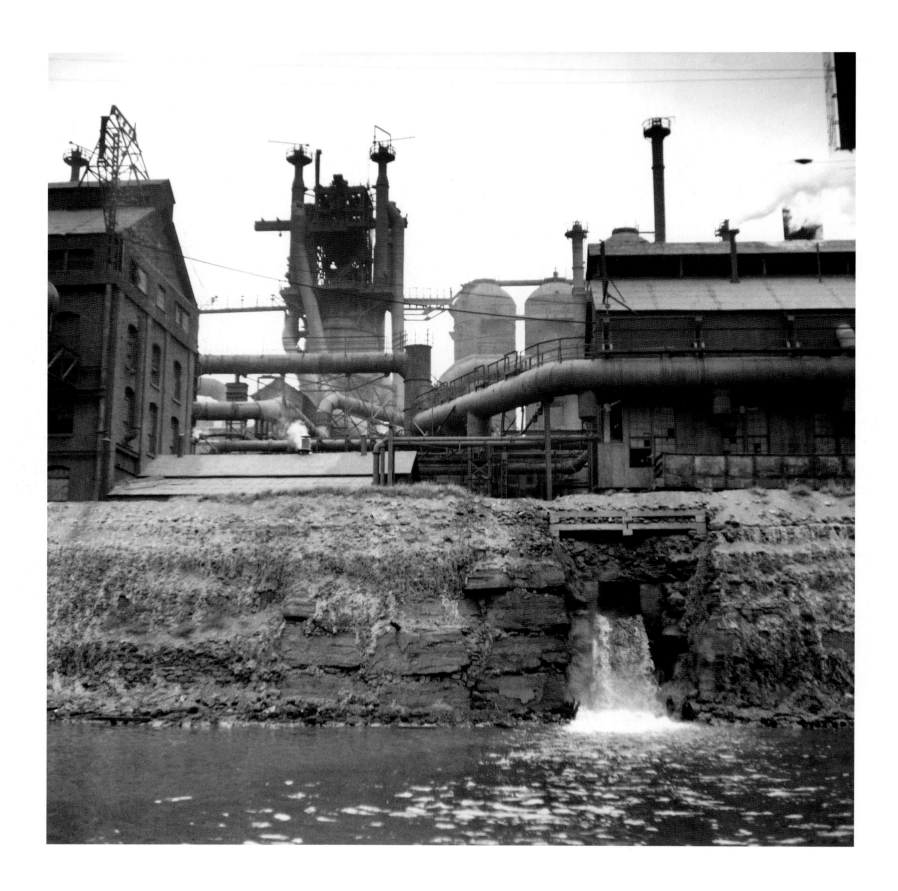

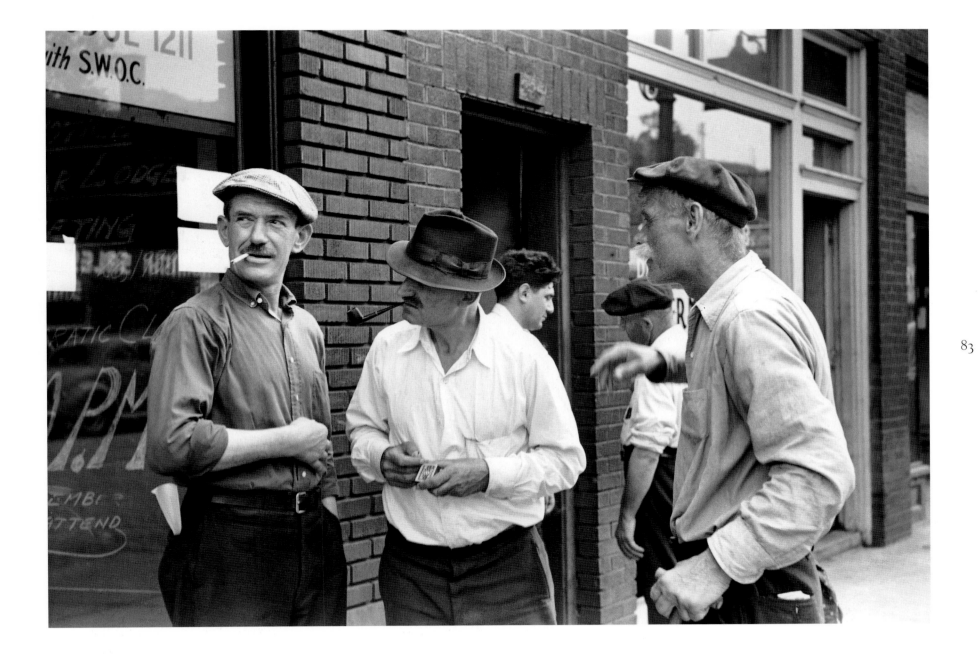

83

ABOVE: Steelworkers, Aliquippa, Pennsylvania
ARTHUR ROTHSTEIN, JULY 1938

OPPOSITE: Pittsburgh waterfront. Monongahela and Allegheny Rivers, Pennsylvania
ARTHUR ROTHSTEIN, SEPTEMBER 1936

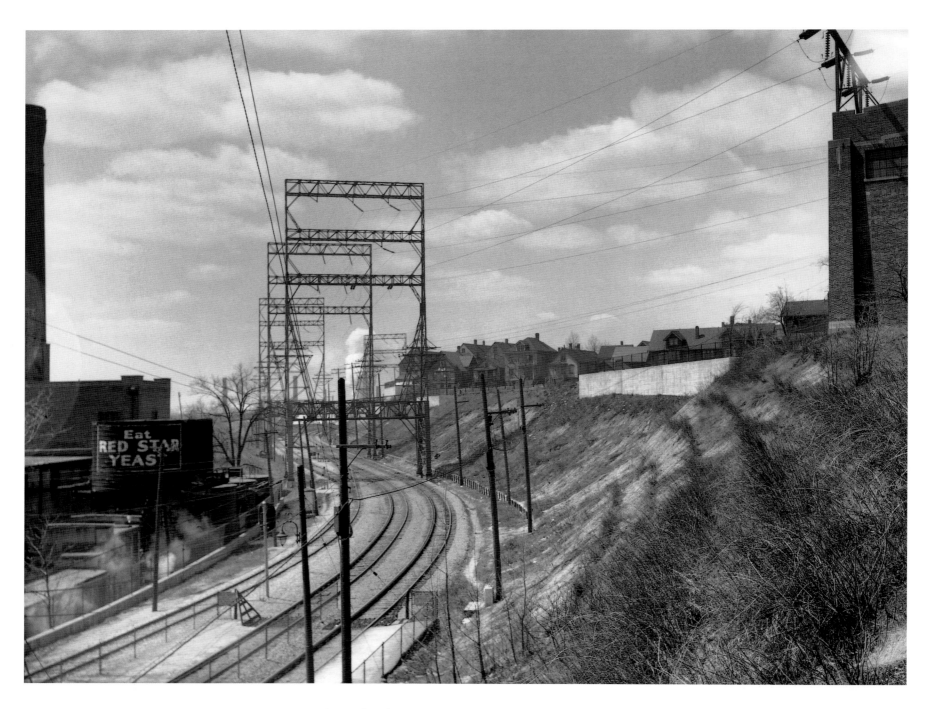

ABOVE: Housing alongside Chicago and Milwaukee Railroad, Milwaukee, Wisconsin
CARL MYDANS, APRIL 1936

OPPOSITE: A hobo "jungle" along riverfront, Saint Louis, Missouri
ARTHUR ROTHSTEIN, MARCH 1936

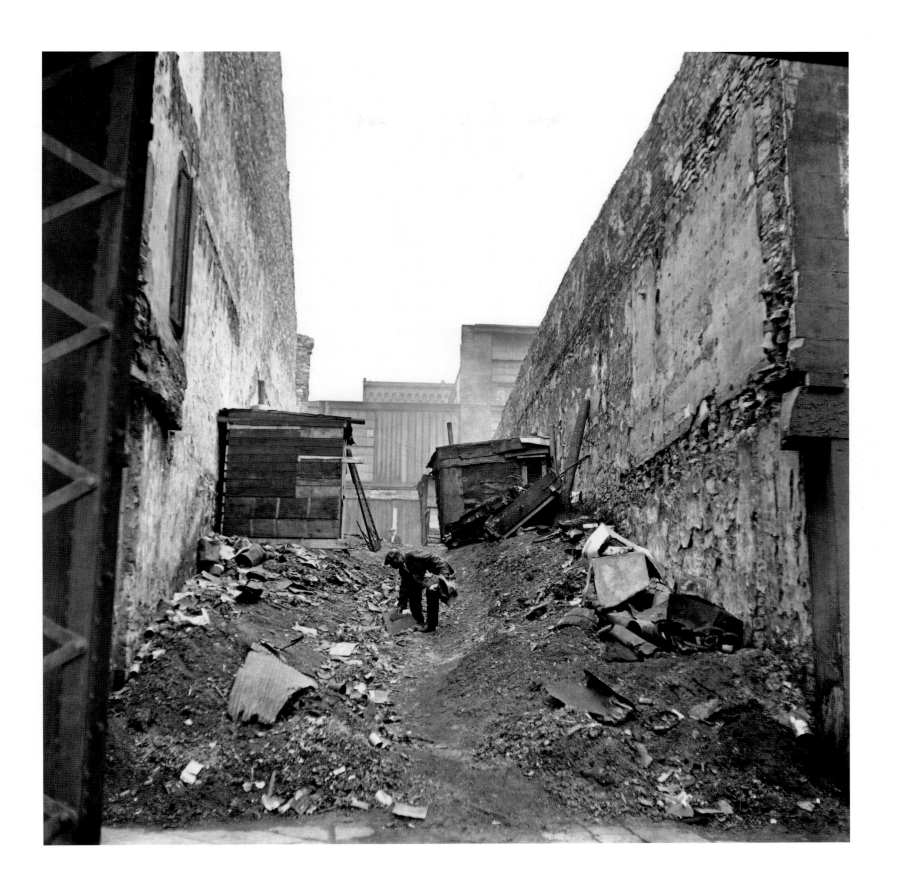

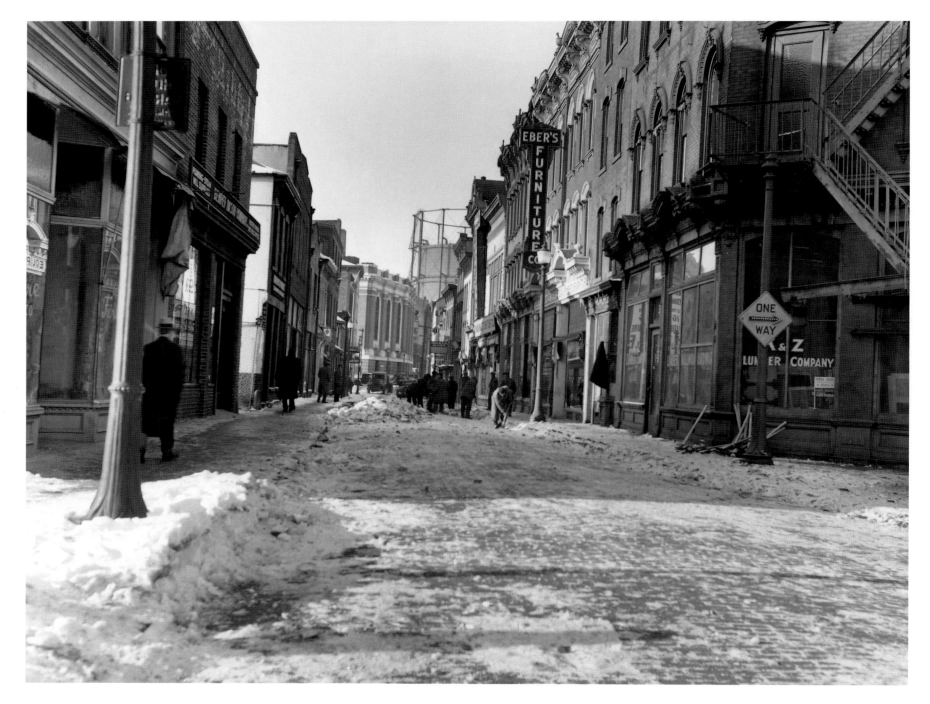

Narrow street in New Brunswick, New Jersey
CARL MYDANS, FEBRUARY 1936

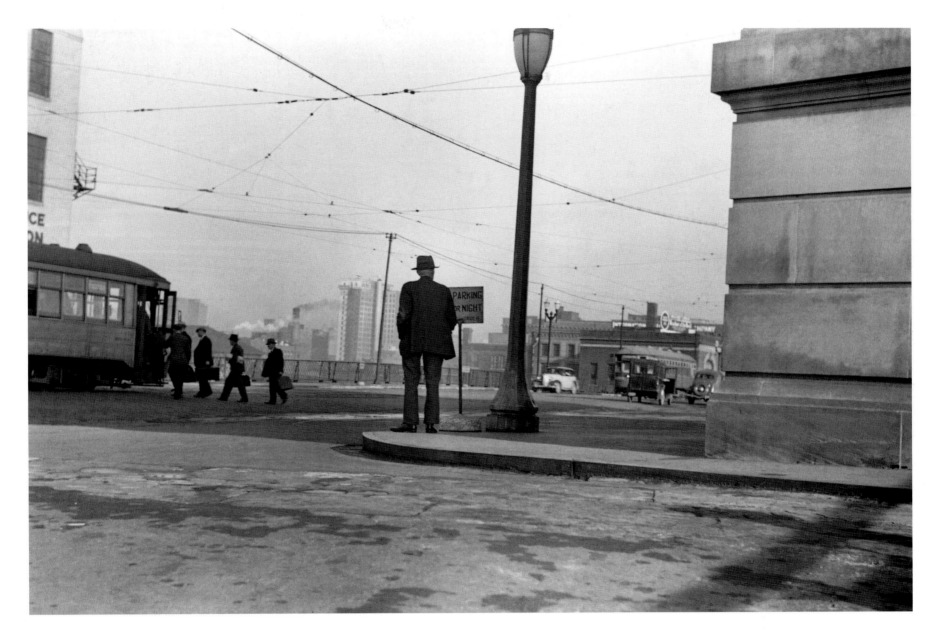

6:30 A.M. in front of Union Station, Omaha, Nebraska

JOHN VACHON, OCTOBER 1938

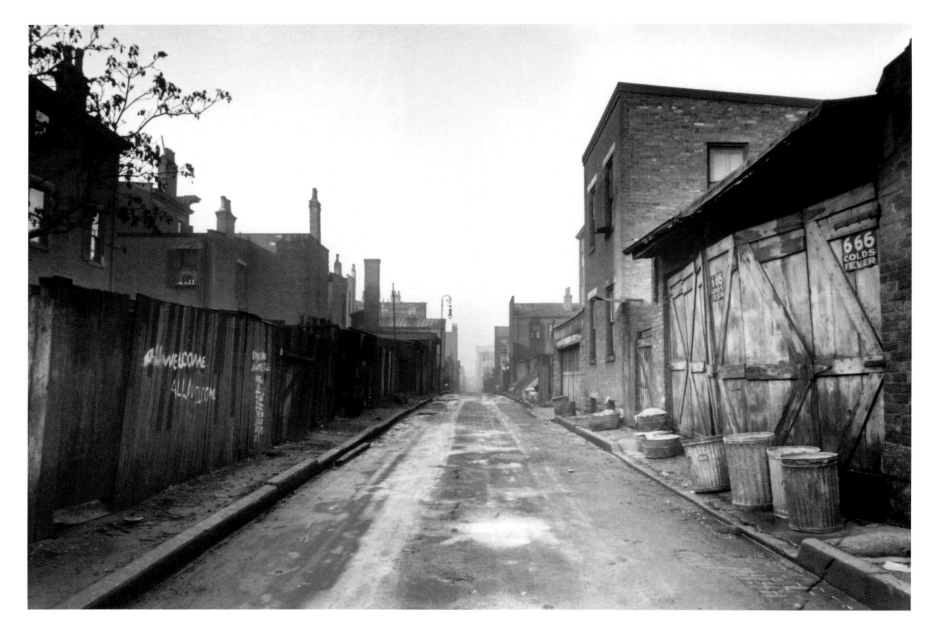

Van Horn Street, Hamilton County, Ohio

CARL MYDANS, DECEMBER 1935

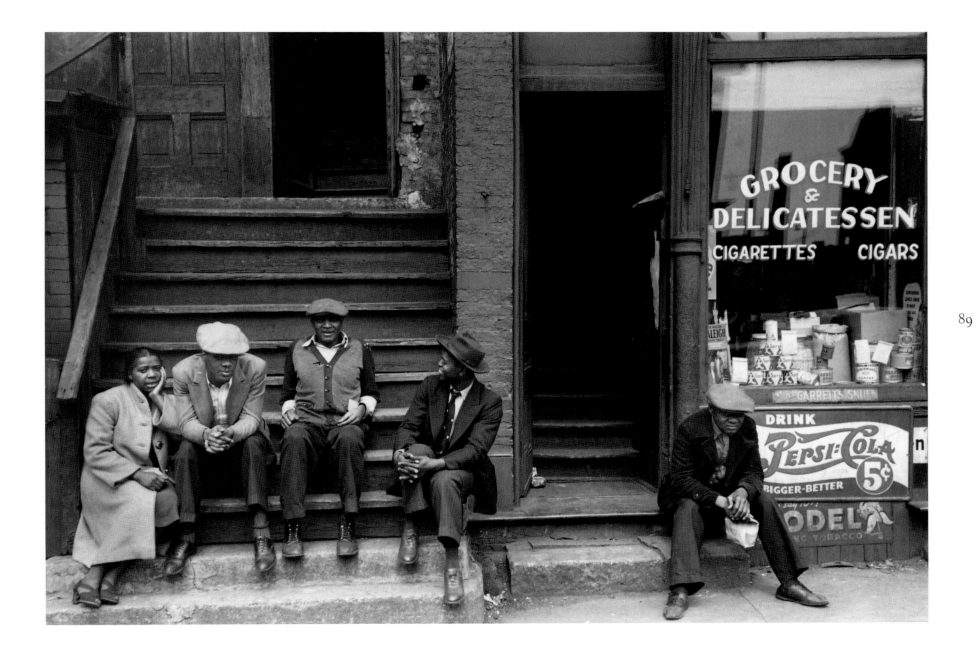

People sitting on front porches in Negro section of Chicago, Illinois
RUSSELL LEE, APRIL 1941

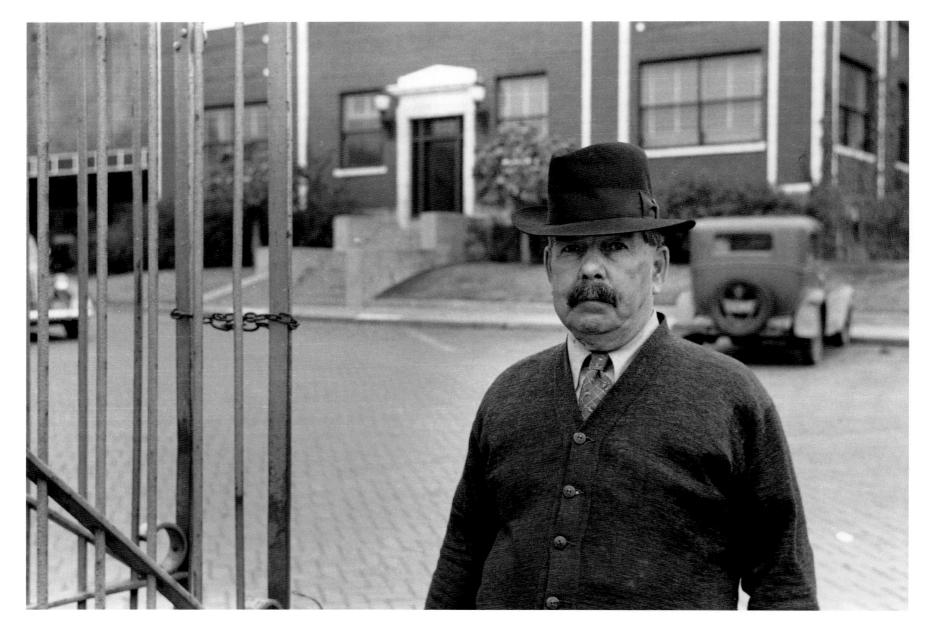

Watchman at Wilson Packing Plant, South Omaha, Nebraska

John Vachon, November 1938

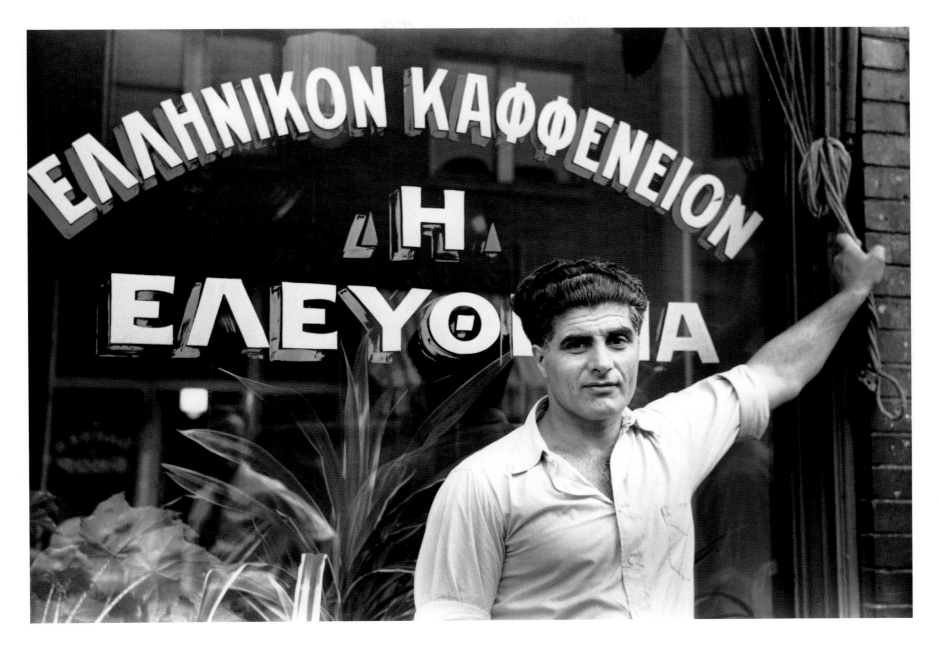

Proprietor of a Greek coffee shop, Aliquippa, Pennsylvania
Arthur Rothstein, July 1938

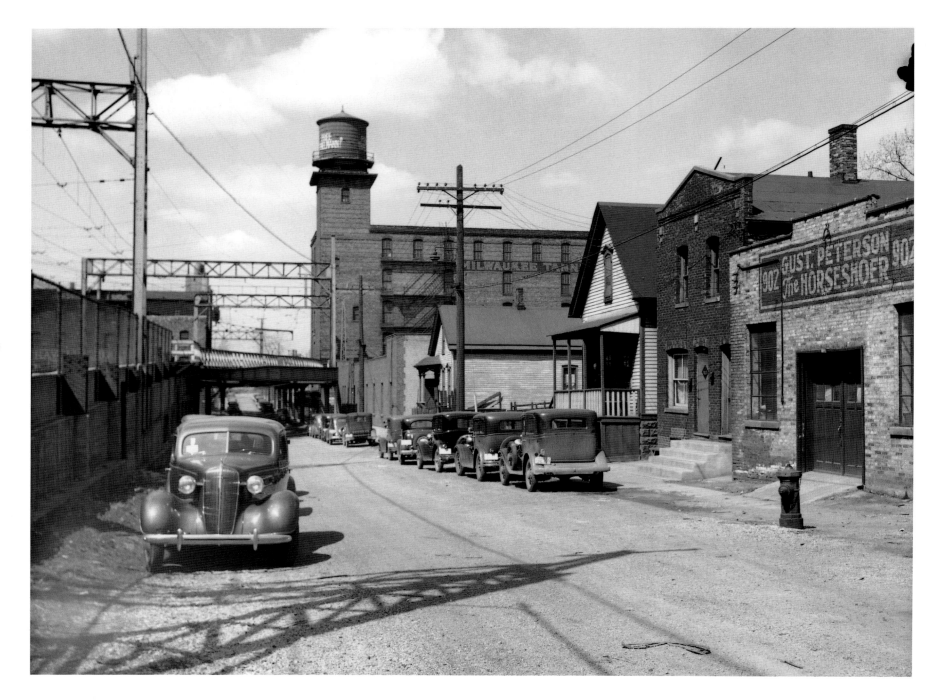

Group of houses at Detroit and Van Buren Streets, near electric railroad, Milkwaukee, Wisconsin

Carl Mydans, April 1936

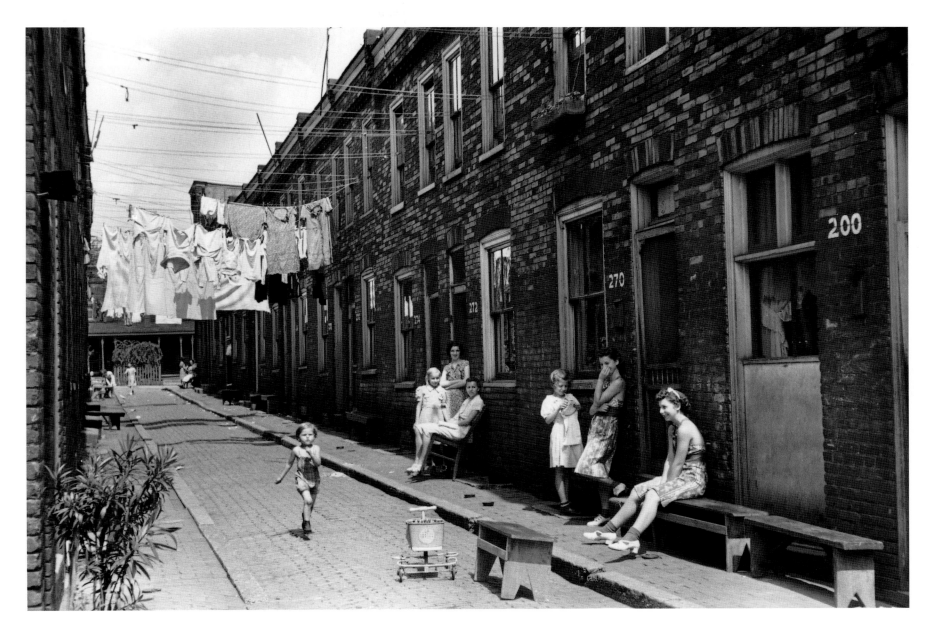

Housing conditions in Ambridge, Pennsylvania, home of the American Bridge Company
ARTHUR ROTHSTEIN, JULY 1938

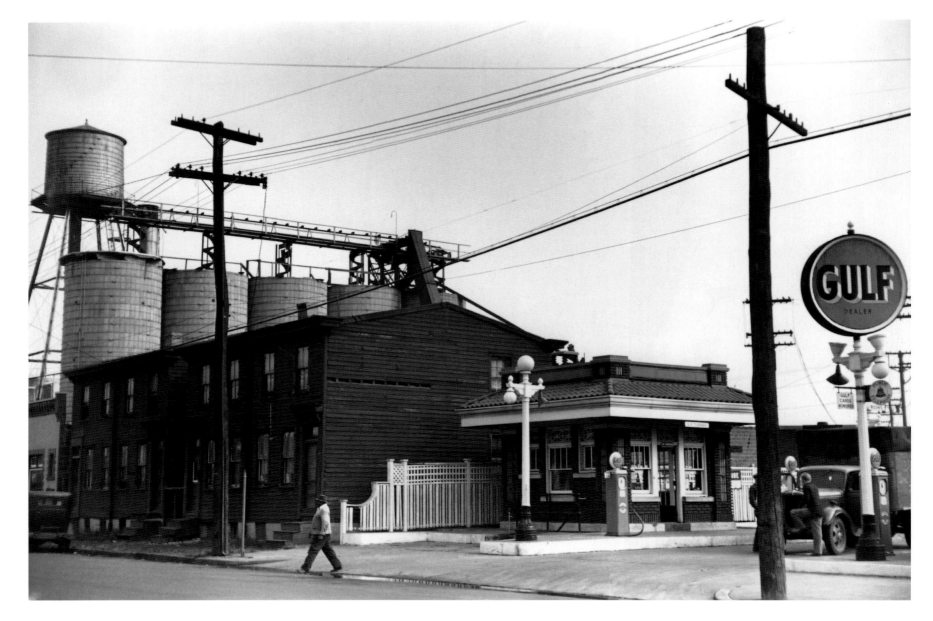

Street corner, South Second Street, Camden, New Jersey
Arthur Rothstein, October 1938

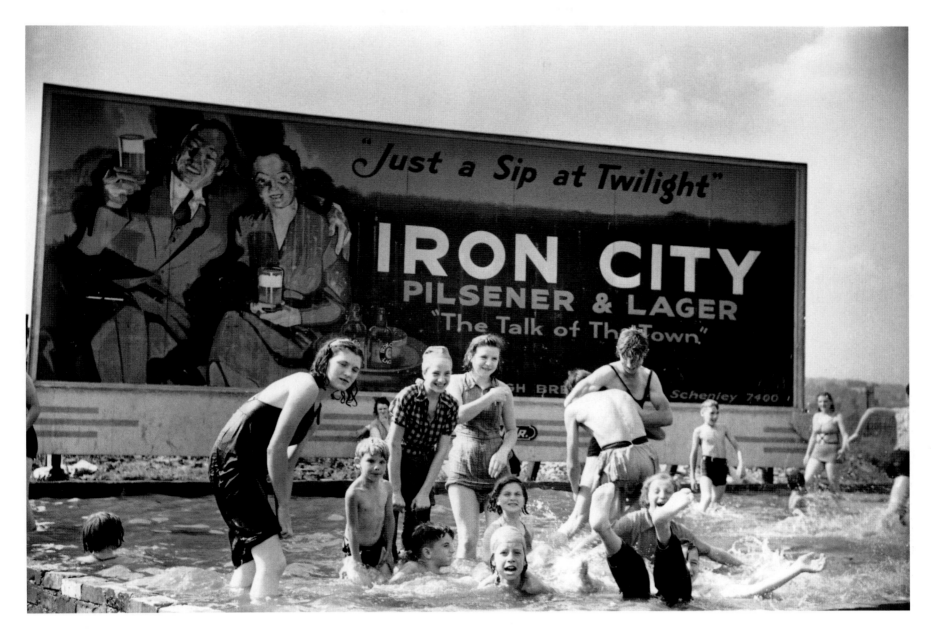

Homemade swimming pool for steelworkers' children, Pittsburgh, Pennsylvania
Arthur Rothstein, July 1938

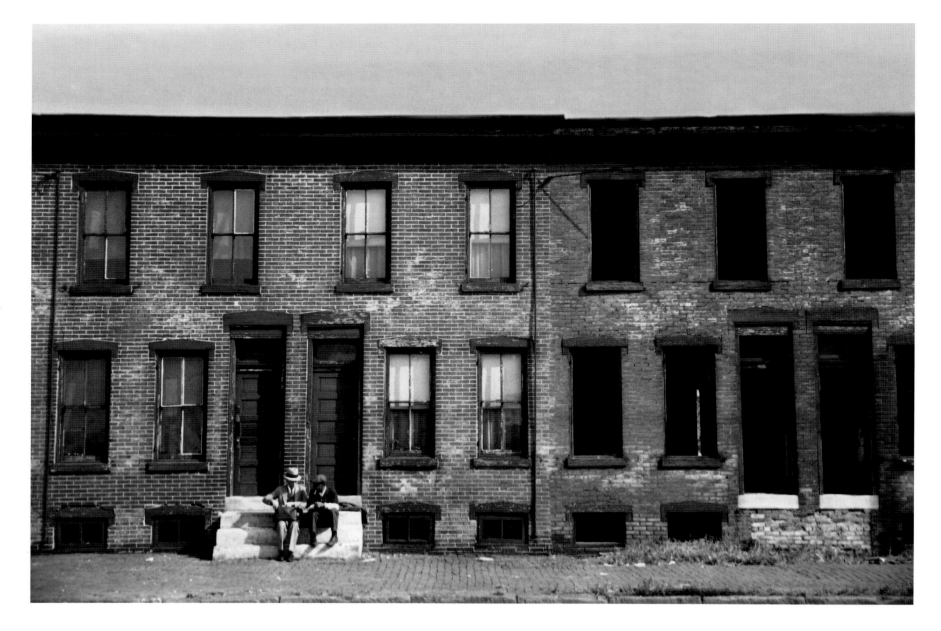

Factory workers' homes, Camden, New Jersey
ARTHUR ROTHSTEIN, OCTOBER 1938

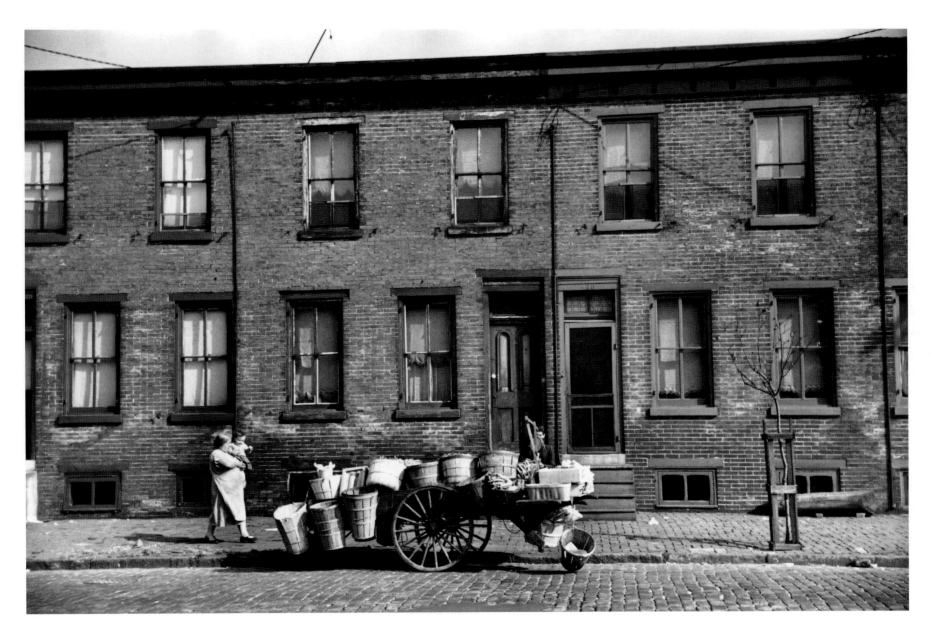

Factory workers' homes, Camden, New Jersey
ARTHUR ROTHSTEIN, OCTOBER 1938

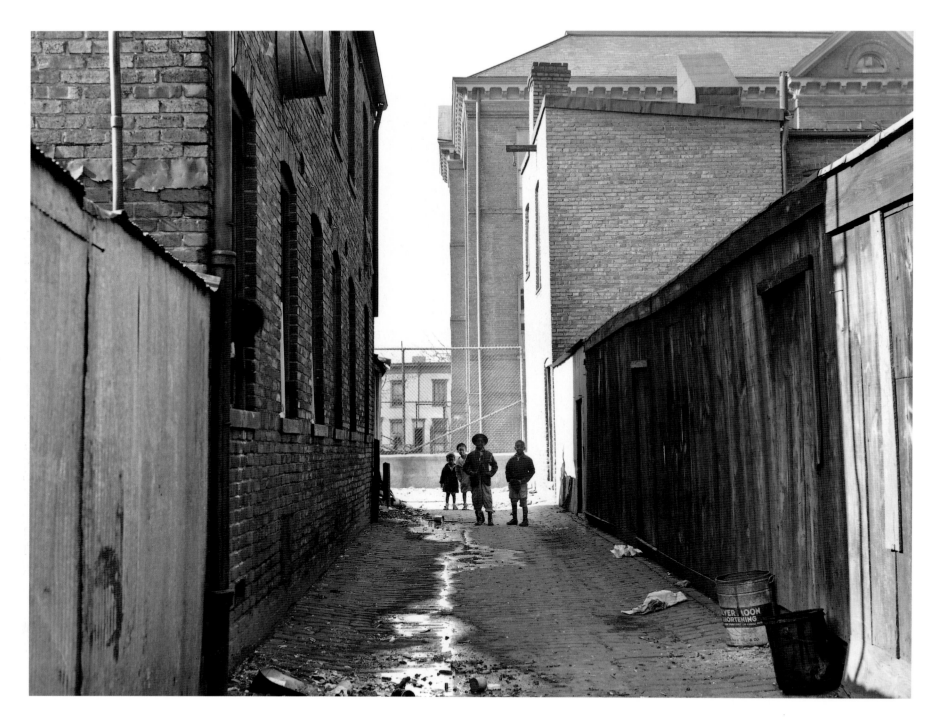

Alley near L Street, N.W., with Blake School in background, Washington, D.C.
CARL MYDANS, NOVEMBER 1935

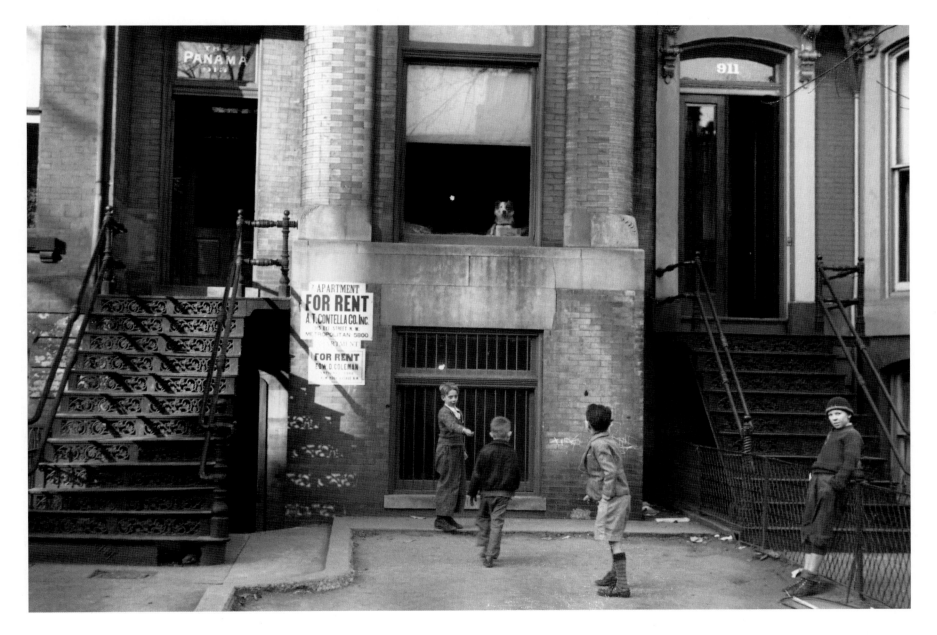

Untitled (Washington, D.C.)

John Vachon, April 1937

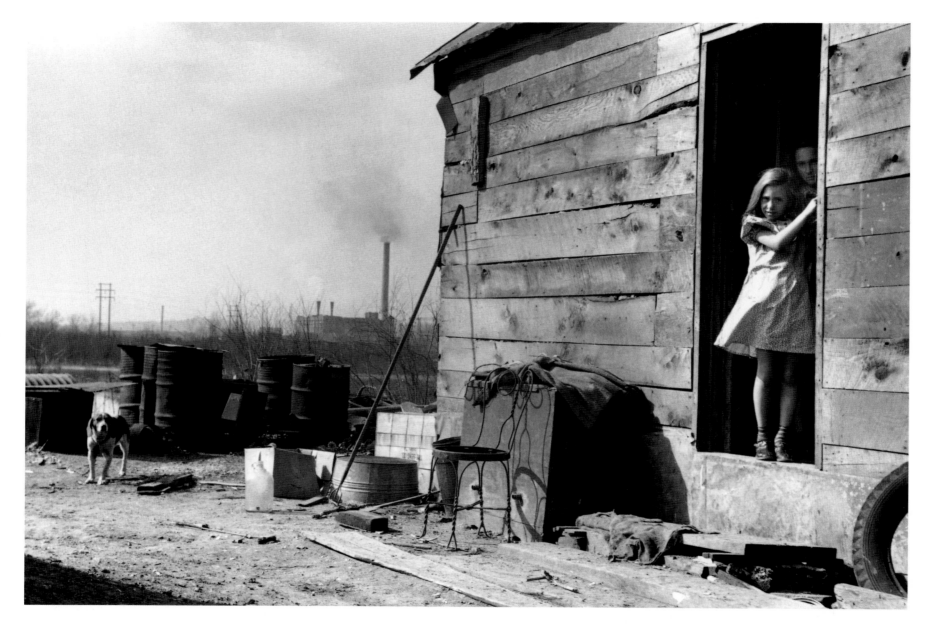

ABOVE: Untitled (Dubuque, Iowa)
JOHN VACHON, APRIL 1940

OPPOSITE: Child in workers' quarter of Puerto De Tierra, San Juan, Puerto Rico
EDWIN ROSSKAM, JANUARY 1938

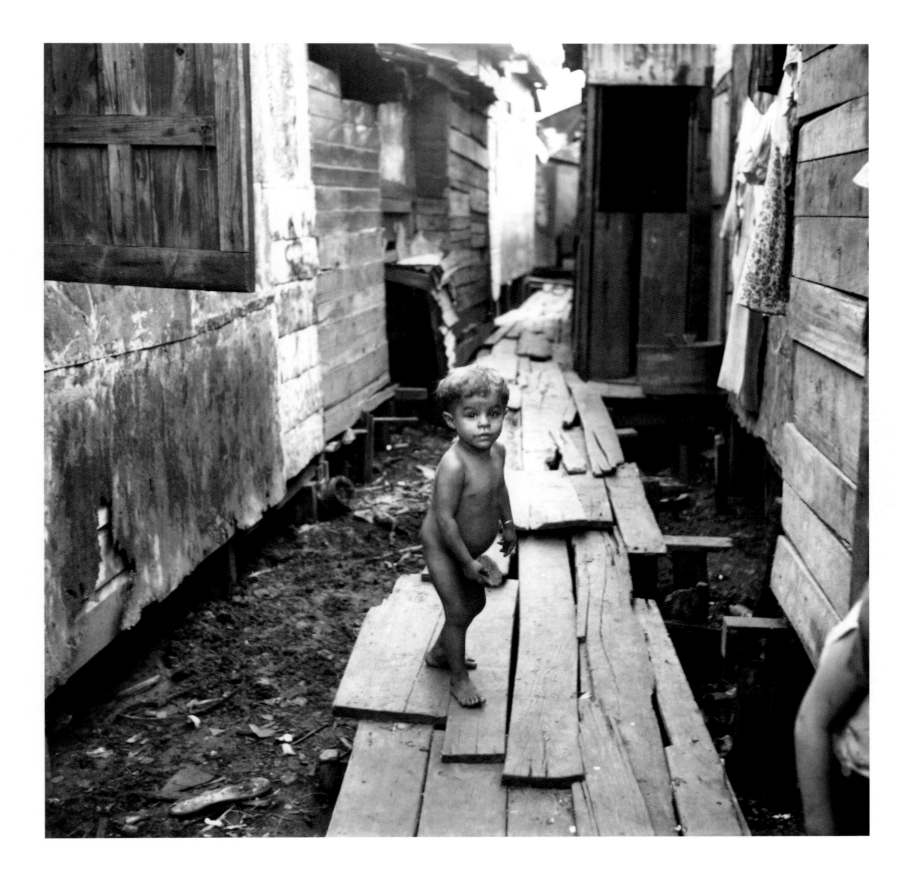

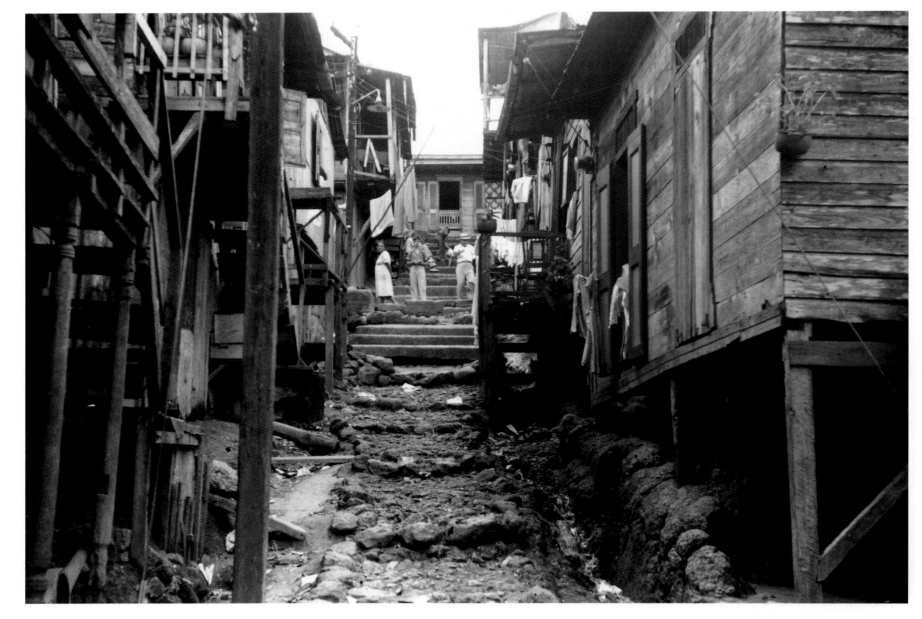

Untitled (Lares, Puerto Rico)

Jack Delano, January 1942

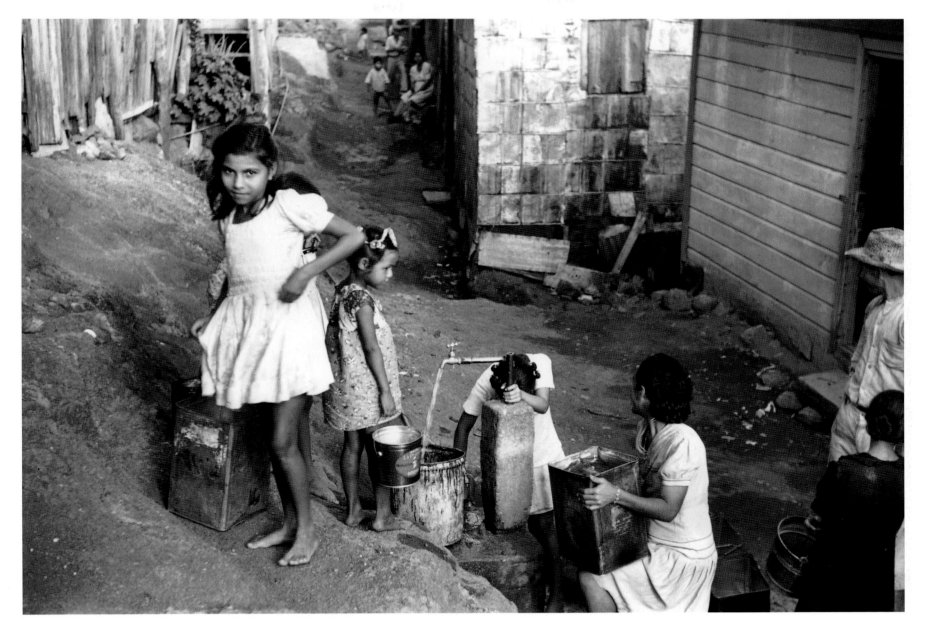

Children getting water from the faucet in the slum area in Yauco, Puerto Rico

Jack Delano, January 1942

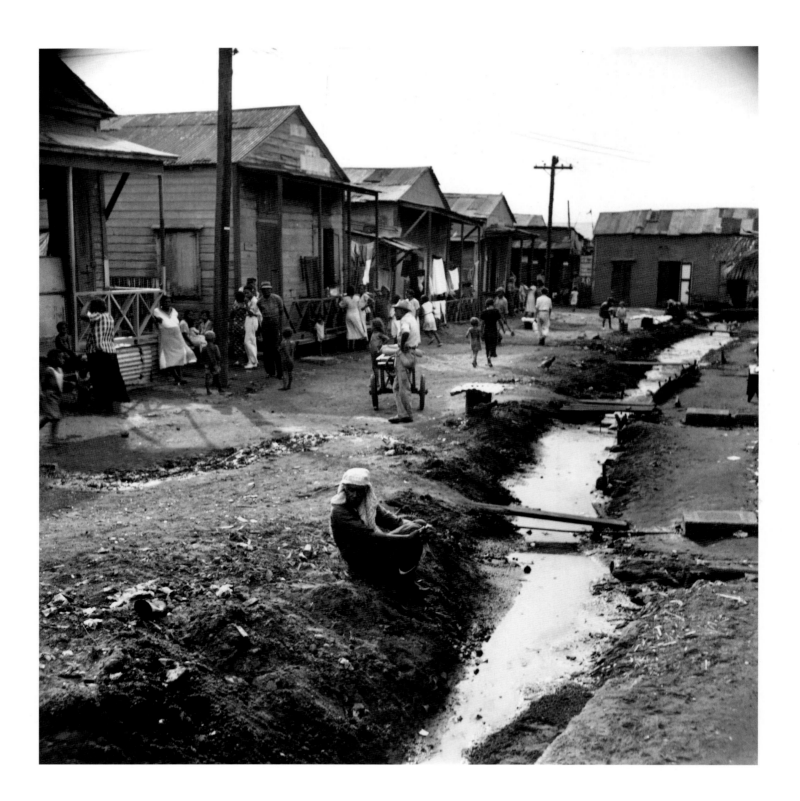

Street and open sewer in the workers' quarter of Porta De Tierra, San Juan, Puerto Rico
EDWIN ROSSKAM, JANUARY 1938

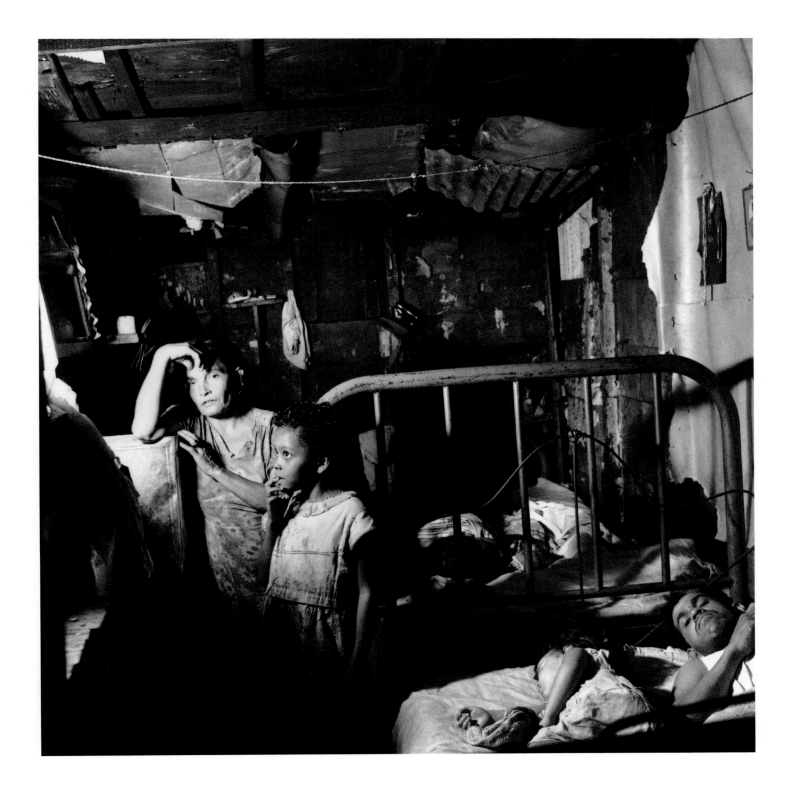

Interior of worker's shack, Porta de Tierra, San Juan, Puerto Rico
EDWIN ROSSKAM, JANUARY 1938

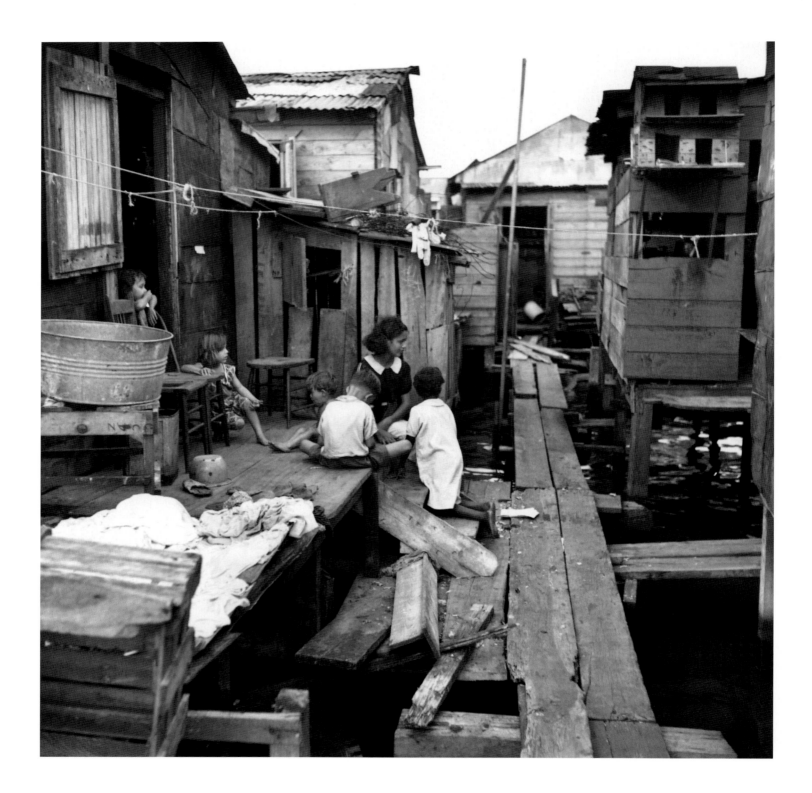

Shacks built over tidal swamp in the workers' quarter of Porta de Tierra, San Juan, Puerto Rico

EDWIN ROSSKAM, JANUARY 1938

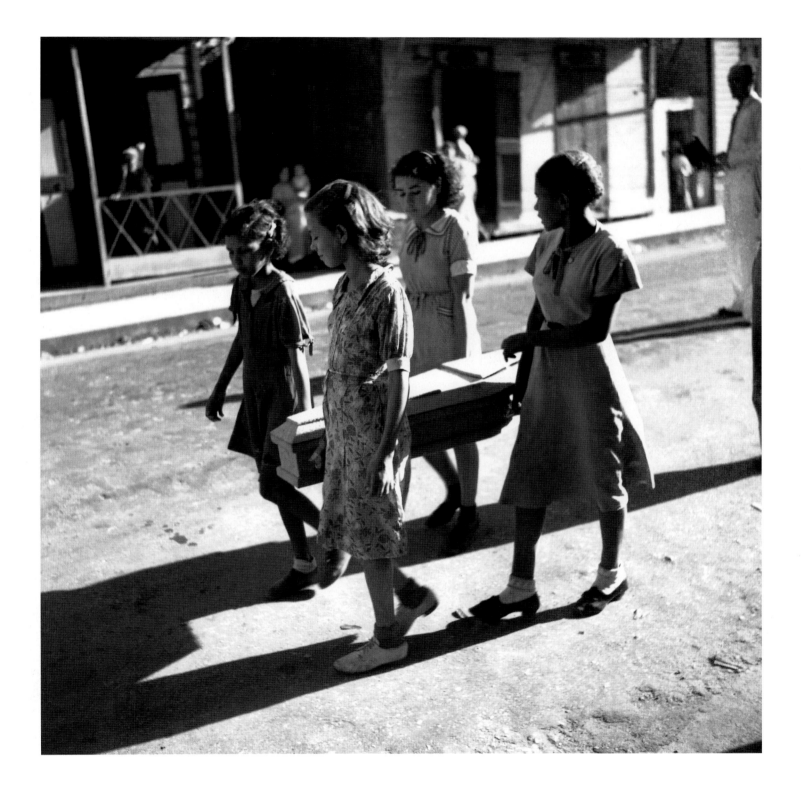

Funeral of a child, Ponce, Puerto Rico

Edwin Rosskam, January 1938

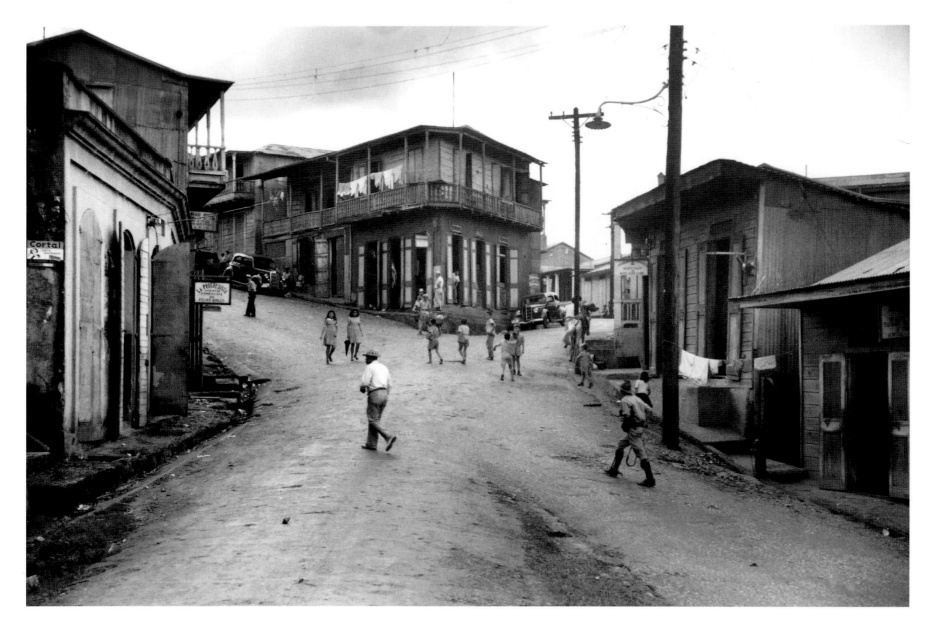

Untitled (Lares, Puerto Rico)

JACK DELANO, JANUARY 1942

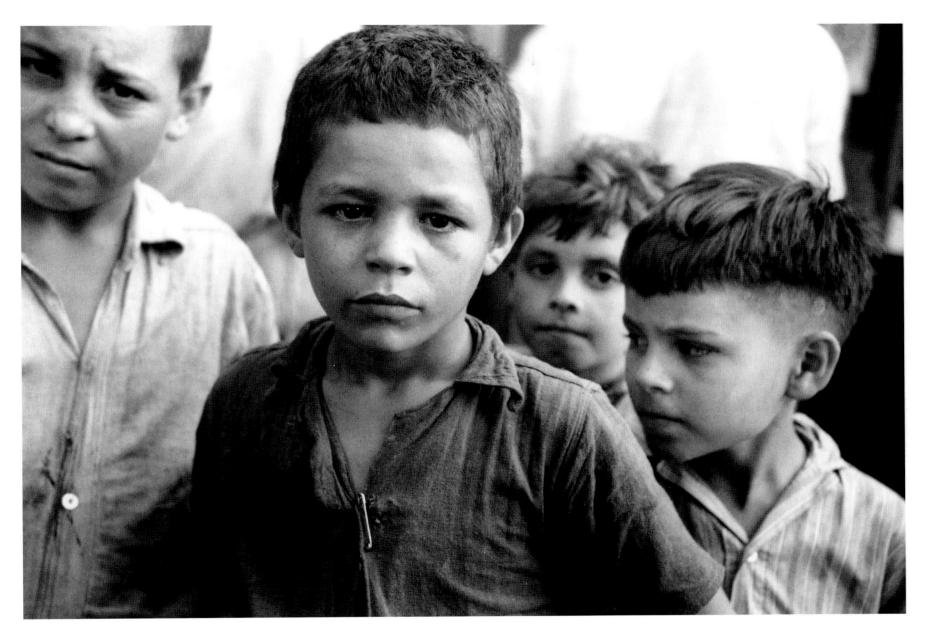

Children who were begging for pennies in the market in Rio Piedras, Puerto Rico
JACK DELANO, JANUARY 1942

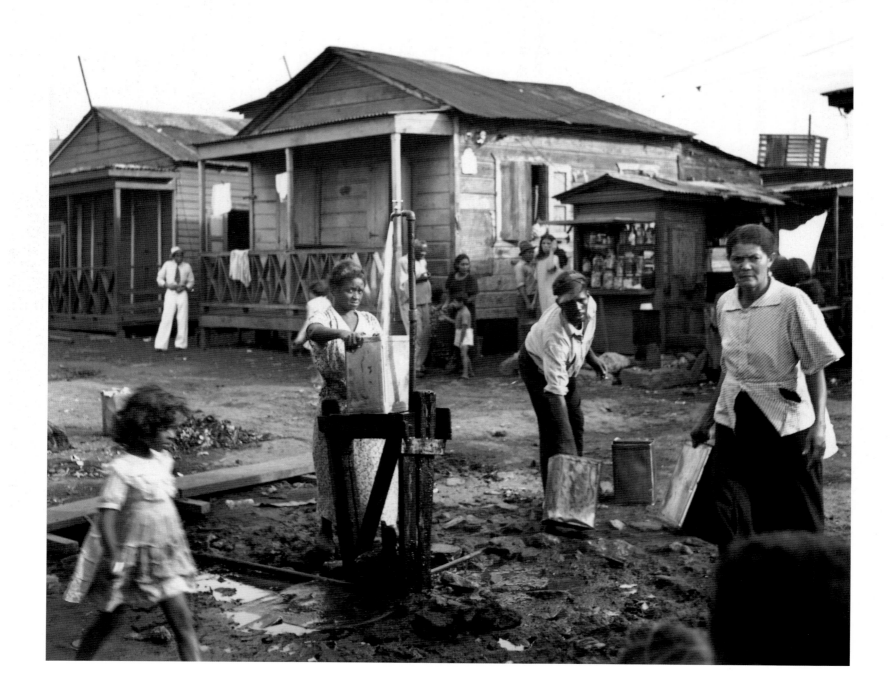

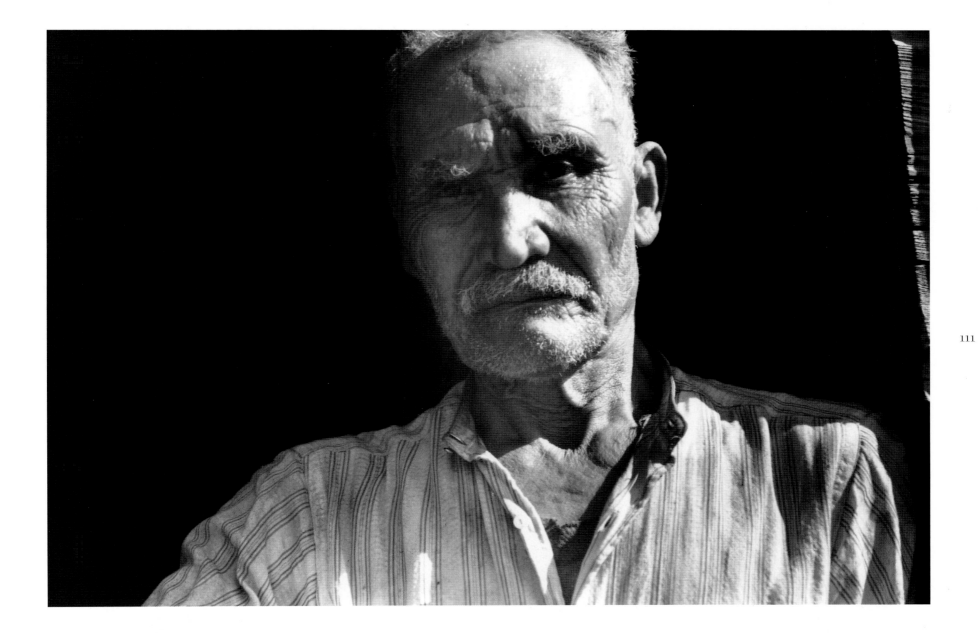

Above: Untitled (Ponce, Puerto Rico)

Jack Delano, December 1941

Opposite: Water supply in the workers' quarter of Porta de Tierra, San Juan, Puerto Rico

Edwin Rosskam, January 1938

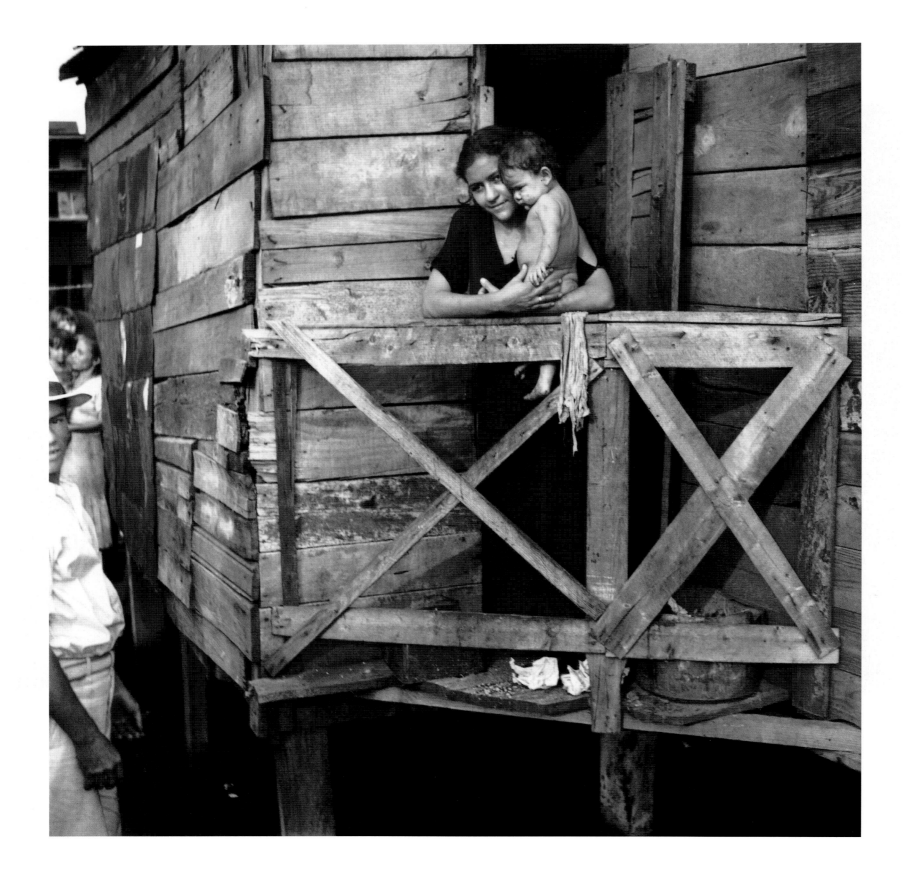

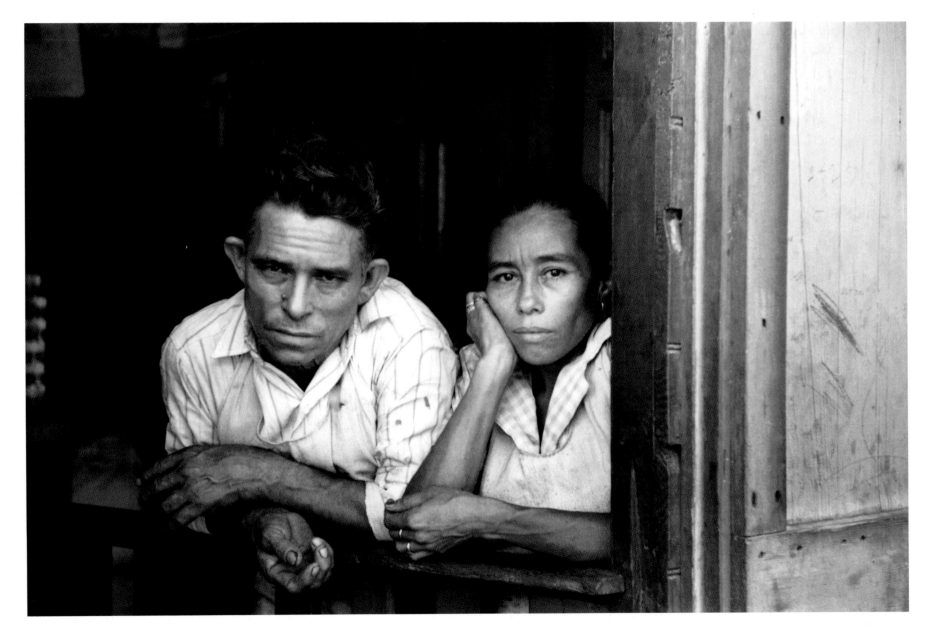

Above: Untitled (Storekeeper and his wife, slum known as "El Machuelitto," Ponce, Puerto Rico)
Jack Delano, December 1941

Opposite: In the workers' quarter of Porta de Tierra, San Juan, Puerto Rico
Edwin Rosskam, January 1938

Stryker's original job description read like the instructions a monarch might have given a naval explorer. In a sweeping declaration it authorized Stryker to "direct the activities of investigators, photographers, economists, sociologists, and statisticians engaged in the accumulation and compilation of reports . . . statistics, photographic materials, vital statistics, agricultural surveys, maps, and sketches necessary to make accurate descriptions of various phases of the Resettlement Administration, particularly with regard to the historical, sociological, and economic aspects of the several programs and their accomplishments."[1] The Resettlement Administration (known as the RA and later reincarnated as the Farm Security Administration or FSA), had been created in 1935 by executive fiat as an autonomous agency, *of* but not *in* the Department of Agriculture, a sort of duchy to be governed by Rexford Tugwell at the behest of the President. Since Duke Rex served King Franklin, the job description Tugwell wrote for Stryker paid him a noble salary ($5,600, 1935 dollars) and empowered him to do everything but print his own currency. If Stryker had been anyone else but Stryker, such leeway might have been dangerous, but Tugwell's fiat only confused him.

The only thing that Stryker had ever done before with photographs (or surveys, maps, or sketches) had been to find images to illustrate a college economic textbook (*American Economic Life*) that Tugwell, as chairman of Columbia's Economics department, had written in 1925 with a colleague in the Philosophy Department, Thomas Monro. Stryker had modeled his work on *North America*, a heavily illustrated geography book, written and edited by another Columbia academic, J. Russell Smith. Smith's book was a well-designed, amiably written, idiosyncratic collection of facts, statistics, anecdotes, and opinions. It displayed the prevalent racial and social prejudices of its era and those of its author, a proponent of the "science" of eugenics. (Excerpts from *North America* are reproduced later in the book.) Hailed as a breakthrough in the field of "human geography," *North America*, published the same year as Tugwell's text, would remain in print and in use into the 1960s. As Stryker struggled with his picture research and editing, Tugwell sent him to see Smith as *North America* made its way to press. Smith's book would have a lasting impact on Stryker; not only did Stryker imitate some of Smith's layouts, but ten years later in Washington, once he had figured out what he was to do, Stryker assigned *North America* as required reading to nearly every photographer he hired.

Three months into Stryker's new job, though, he was completely confused. Before Tugwell had hired him full-time, he'd brought Stryker to Washington in the summer of 1934 to work for a big reform agency (the Agricultural Adjustment Administration) inside the Department of Agriculture. Stryker suggested making a "picture source book" about American agriculture—a cross between Tugwell's economics text and a wonderfully illustrated encyclopedia of American history, published by Yale, called *The Pageant of America*. Tugwell approved the idea, and, for the next year, Stryker did the same thing he'd done before, but on a much larger scale: he looked through picture files (huge files compiled by the USDA's Agricultural Extension Service), selected images, and made copies. Making copies forty years before there were copy machines was a bit complicated: photographs had to be made of photographs. Since Stryker didn't know how to use a camera, he hired someone who did, a former student of his, Arthur Rothstein, whose plans to go to medical school had been obliterated by the Depression. Rothstein worked for a year making pictures of pictures. Nothing came of it, though: Stryker collected thousands of images, but left on his own, he had no idea what to do with them. Tugwell solved the problem by hiring Stryker full-time, and Stryker passed on the good luck by doing the same for Rothstein.

While Stryker tried to understand what he was supposed to do, he had Rothstein photograph every piece of paper that crossed Stryker's desk. Every once in a while, Stryker would make his way to Tugwell's office to talk to Grace Falk, Tugwell's secretary and his future second wife. "Now, look," Stryker would say, "I want about fifteen minutes of your time for a little discussion."

Falk would say, "All right."

Then Stryker would say, "Now, I want you to explain to me what I am doing."[2]

In 1965, Tugwell and Falk, by then long married, talked about Stryker and those conversations. Talked about them and laughed. "Yes," recalled Tugwell, "he would say, 'What does Rex want?'"

"'What is it that Rex wants,'" Mrs. Tugwell echoed. "I would say, 'Look, Roy, you are doing exactly what he [Rex] wants.'" This would satisfy Stryker for a few weeks, and then he'd have to come in again.

"About five years ago," Mrs. Tugwell recalled, "he called me up and said . . . 'I want to come out to see you and Rex, because I really want you to tell me what was the objective for the historical records.' He never did come out, actually. I just couldn't believe my ears because I had kidded him about it all through the years. I thought he was just kidding, but he was very serious about it. He still wanted to know what he was supposed to be doing. . . ."[3]

In fact, in 1935 all Stryker knew how to do was use other people's pictures to illustrate other people's books. For Tugwell's book, Stryker had used more than two hundred photographs. Seventy of them were by the same photographer, Lewis Hine, whose portraits of children damaged by work in mines and mills and farms had been used for decades in campaigns against child labor. Hine had absolutely nothing against editors (in particular, the editors of the magazine *Survey Graphic*) using his images combined with text in articles and displays on behalf of worthy causes, but he may have been a bit taken aback by the way Stryker used his photographs to serve Tugwell's essays: so heavily cropped and so ponderously captioned that their context and original intent were altered. That was all Stryker, an overage teaching assistant, knew how to do: choose and use; images as illustrations; pictures as teaching materials.

Of course, Stryker knew about Mathew Brady and how he had deployed a team of cameramen to photograph the Civil War. Stryker also knew about Jacob Riis and the way he had used his own photographs in *How the Other Half Lives* to indict New York slumlords. And, of course, Stryker knew Lewis Hine—knew Hine had traveled everywhere, year after year, making photographs as evidence against the use of children as tools. Stryker knew all these precedents, but he also knew that he himself was no photographer and that the economic and political agendas he served were Tugwell's.

It's not entirely clear how and why, after six months of stumbling and blundering, he and Tugwell decided that Stryker needed to take charge of the multiple photographic recording efforts going on inside Tugwell's little kingdom. By the fall of 1935, though, Tugwell issued a decree that Stryker would be the one and only person to decide who made pictures of what on behalf of the Resettlement Administration and its policies. Stryker ordered the faithful Rothstein to construct and equip a central photo lab. At the same time, Stryker learned who he'd inherited from other RA projects as his first photographers: Carl Mydans from a joint RA–Interior Department project; Ben Shahn from something called the "Special Skills" division, inside the RA itself; and Dorothea Lange from an RA link to the Federal Emergency Relief Administration in California. Early in October, Stryker himself hired Walker Evans—through connections Evans and his family and friends had made—as a "Senior Information Specialist."

What happened next would happen again and again and again as, over the next seven years, Stryker hired new photographers to replace people who'd quit, or moved to better jobs, or been fired.

The photographer Carl Mydans told this story about his encounter with his new boss:

"My assignment," Mydans recalled, "was to go South and 'do cotton.' I put my camera together and drew my film . . . and I came in to tell Roy Stryker I was on my way. He greeted me . . . and wished me luck and then he looked at me and said, 'By the way, what do you know about cotton?' I stopped and said, 'Not very much.'"[4]

Mydans didn't know much about cotton because he'd been raised in a little town on the Mystic River, north of Boston. He'd worked in a boatyard as a kid, then gone to college. In 1930 he graduated from Boston University's School of Journalism—in an era when the only journalism school most reporters attended was the local paper's city desk and the local bar around the corner. In Boston, Mydans had sold some freelance articles to the *Globe* and the *Herald*. His degree got him a job at a New York trade daily called the *American Banker*—just as the ground began to open under every banker's feet. Mydans bought a camera, learned how to take pictures, and sold a few of them—freelance, again—to *Time*. His connections at *Time* led him to the project with the Interior Department in Washington. Which is how he found himself confessing his ignorance to Stryker.

"'Sit down,' said Stryker," Mydans recalled. "He called in his secretary and said, 'Cancel Carl's transportation. He's going to stay here with me for a while.'" When Stryker had been a teaching assistant at Columbia, a student could leave—maybe even drop—his course. Not anymore. "We sat down," recalled Mydans, "and we talked almost all day about cotton. We went to

lunch, and we went to dinner, and we talked all night. He talked about cotton as a commercial product, the history of cotton in the South . . . how it affected areas outside the USA. . . ."[5]

Eventually, Stryker was satisfied and let Mydans leave. Mydans stayed on the road for four months. "I had never been in the South," Mydans said, "and it fascinated me." Plantation owners weren't pleased that a Northerner—especially a government agent with a Boston accent—was taking pictures of their sharecroppers, their commissary stores, and their cabins. "Photographing the life of the people and their working conditions while under frequent harassment and threat from the landowners . . . made each day's shooting exciting," Mydans said.[6]

Mydans resigned from the RA almost as soon as he returned to Washington: Mydans' connections at *Time* had been working on a secret project for Henry Luce. "Project X" turned out to be *Life* magazine; before its first issue appeared in the fall of 1936, *Life* hired Mydans as a staff photographer. For the next thirty years, the young man who'd thought harassment and threats were exciting walked into war zones, carrying a camera for *Life*. In 1941, in the Philippines, the Japanese captured Mydans. He survived two years in a POW camp. Freed in a prisoner exchange, Mydans went back to photographing war and its aftermath in Europe and Asia. In 1947, *Life* made him its Tokyo bureau chief.

The young man who didn't know much about cotton may have benefited from Stryker's tutorial, but events, combined with intelligence and alertness, were Mydans's best teachers. Stryker didn't understand that because he'd never been—and never would be—a photographer. Stryker's eyes were weak; the glasses he wore were as thick as soda bottles; but he loved to look at pictures. He'd learned how to edit them, but he'd never learned how to *make* them. Making and taking: a photographer stands with a camera, in the middle of events, like a starving man looking for a quarter or a hunter tracking game, waiting for something to find him at the very moment he finds it—that was a skill, and a lesson about coincidence that Stryker would never understand. For months before Mydans showed up at his door, Stryker had been confused about what he should do and how he should do it. He'd quieted and steadied himself by falling back on what he'd done before: he became a schoolteacher again. The failed "picture source book" about American agri-

culture haunted him like a phantom limb: years later, he told an interviewer that for a while at first, he made photo assignments as if he were still trying to illustrate that book.[7]

Between 1941 and 1943, when Stryker himself resigned from government, he hired a number of photographers. One was an African-American; one was an immigrant Jew; the third was a white single woman. Stryker "taught" these new people a variety of things in a variety of ways. Their stories and what Stryker taught them follow.

Five years after Mydans left for *Life*, the young photographer Gordon Parks applied to the FSA for a job. Parks had grown up poor on a farm on the Kansas/Missouri border. When Parks was sixteen, his mother died and his family fell apart. Parks' father sent him to Minneapolis to live with a married sister. Parks' brother-in-law threw him out of the house in the middle of winter. Parks rode streetcars from one end of the line to the other, day after day, for weeks. He nearly starved and he nearly died. From then on, he took any job he could find: he played piano in a brothel, waited tables in a rich men's club, mopped out a flophouse, delivered packages for a drug dealer. He was a good enough basketball player to tour with a semipro team called the House of David. He was a talented enough musician and composer to solo with the Larry Duncan orchestra.

By the time Parks was twenty-two, he was married and working as a waiter on a train that ran from St. Paul to Seattle. He scavenged magazines that passengers left behind, composed music, and read voraciously. In 1939, he recalled, he picked up a magazine with a portfolio of photographs "that I couldn't forget; they were of migrant workers. Dispossessed, beaten by the dust, storms, and floods. . . . The names of the photographers . . . stuck in my mind. . . . They all worked for the Farm Security Administration. . . . I took [the magazine] home and kept looking at those photographs and the names of the photographers. . . ."[8] He read Steinbeck's *In Dubious Battle* and Erskine Caldwell and Margaret Bourke-White's *You Have Seen Their Faces*. One day in Seattle, Parks bought an old camera in a pawnshop, and before his train left for St. Paul, he'd shot his first roll of film.

In St. Paul, he persuaded the most fashionable women's store in the city to let him photograph some of the store's dress models. The store was so pleased

by Parks' pictures that it displayed them in all its front windows. Marva Louis, the wife of the great boxer, saw Parks' photographs and invited him to come to Chicago to photograph a line of fashions she planned to market.

In Chicago, Parks found a studio in a WPA (Works Progress Administration) art center on the South Side. He began to photograph the people around him. "I got to know number runners and their hangouts. I sneaked pictures of men and boys gambling in … hallways. I saw two young black boys dying from each other's knife wounds … and then there were the churches, big ones, little and medium sized ones, scattered among the taverns, butcher shops, and mortuaries…."[9]

One of Parks' friends, a painter at the art center, told him he ought to apply for a Rosenwald Fellowship. Parks didn't know what that was. "It's a fund set up for exceptionally able spooks and white crackers," his friend told him.[10] Ralph Bunche, Zora Neal Hurston, and James Baldwin had been Rosenwald Fellows. Parks applied and won the first Rosenwald ever awarded to a photographer.

Parks remembered the FSA images he'd seen in the magazine from the train. "They were photographing poverty and I knew poverty so well," Parks said.[11] Parks decided to use his Rosenwald money to pay his own salary as an FSA photographer—if Stryker would hire him.

Years later, Parks told this story about his first encounter with the man who might—or might not—be his new boss:

"Roy, of course, put me through a very strict and revealing process in getting me acquainted with what was going on there, a very sharp, quick thing (at times I thought rather brutal), but he had to shape me up rather quickly. He used a method of taking my camera away from me the first days I got there and sending me out in Washington to the theatres and department stores and drug stores and so forth—and I had some rather miserable experiences…. Suddenly they were saying, 'We don't serve Negroes' ('Niggers' in some sections). 'You can't go to a picture show.' Or, 'No use stopping for we can't sell you a coat….' Roy more or less expected this…. I came back roaring mad and I wanted my camera and he said, 'For what?' And I said I wanted to expose some of this corruption down here, this discrimination. So he says, 'Well you sit down here and write me a little paper on how you intend to do this.' And I said 'Fine.' So I wrote several papers and brought them in, but he kept after me until he got me down to one simple little project…."[12]

In retrospect, Parks expressed a rueful gratitude for Stryker's harshness: "He could see I was as green as a pea," Parks recalled. Stryker was Parks' first "professional" photography teacher, and, like any self-taught young artist, Parks was inclined to believe that anyone with a title, especially a boss who conducted himself like a professor, knew more than he did. As to why Stryker was so hard on Parks: compared with the Congressional Dixiecrats who remained suspicious of the FSA's "snooping" and "meddling" long after Tugwell and his more "liberal" protégés left or were fired from the USDA, Stryker was no racist. But Stryker was a political animal: the Rosenwald Foundation had a "red" reputation. Hiring a young "Negro" whose salary was paid by Rosenwald could only add to the Dixiecrats' distrust. Stryker didn't need any more political problems than he had, especially one given him for free from the outside. All this may explain why he took it on himself to teach Parks about something that Parks already knew more about than he wanted to.

Before Parks left Chicago, Stryker asked the photographer Jack Delano to meet Parks and evaluate him. Delano went to an exhibition of Parks' work, and, of course, recommended him. This was not long after Delano himself had been hired. During the process, he experienced "the schoolteacher" for himself.

Delano, like Parks, was a musician and composer. He was also a painter who'd attended the prestigious Pennsylvania Academy of Art in Philadelphia. Delano's parents were Jewish immigrants from Ukraine. Their family name was Ovcharov; Delano was called Jasha; he was nine when his family came to America. In Russia, Delano's mother had been a dentist and had served as a medical officer in the Red Army; Delano's father had been a member of the local intelligentsia, a teacher of Russian and mathematics. In Philadelphia in 1924, the only work Delano's father could get was as an upholsterer; Delano's mother never learned to read English well enough to get a medical license.

Delano attended art school on a scholarship; in his third year, he was awarded a traveling grant and sailed for Europe. For four months, he studied the work of printmakers like Daumier; he sat spellbound gazing at Goyas, Breughels, and Van Goghs. He also bought a 35mm camera and began to take photographs.

In Delano's last year in art school, he changed his name to make himself more employable, but the only work he could find was as a photographer. The WPA

was pumping money into the arts community in Philadelphia. Artists formed a union; Delano joined it, and then applied to the WPA as a photographer. Miners in the coalfields west of Allentown were joining John Lewis' United Mine Workers Union. Delano applied for a WPA grant to photograph them.

He went to the coalfields and went down into the mines. He ate, drank, and lived with the miners and their families. He and a painter (Irene Esser, his future wife) made huge, mural-size prints from his negatives and hung them in the old railroad station near Philadelphia's city hall. The exhibit drew crowds and reviewers; best of all, the photographer Paul Strand came to the show, congratulated Delano, and told him he'd recommend him if he ever needed a job.

"It was about this time (1939)," Delano recalled, "that I began seeing the work of the Farm Security Administration photographers in such magazines as *Look*, *Survey Graphic*, and the *Saturday Review*.... The extraordinary images ... had a profound impact on me ... I was deeply moved.... It seemed to me that that was the kind of work I had tried to do in the Pennsylvania coal mines. I could think of no place I would rather work than at the FSA. With high hopes, I sent [my portfolio] to Roy Stryker.... A reply arrived in a few days, by telegram. It read: 'Sorry. No openings available. Good work. Do not give up hope. Read the following books. Roy Stryker.' Then followed a long list of books on economics, geography, history, sociology, and even a Department of Agriculture pamphlet on canning vegetables."[13]

Delano read as many of the books on Stryker's list as he could and kept writing him. Several months passed. Then Delano received a telegram: "'Arthur Rothstein resigned. Will work for *LOOK*. Position available. Salary 2300 a year plus per diem and mileage....' A letter followed the telegram. The letter began: 'The main thing on which I would like you to spend a little time is economics and geography. I recommend that you get a copy of J. Russell Smith's *North America* from the library.' "[14]

Delano was a remarkably talented man who devoted much of the last forty years of his life to the people of Puerto Rico, directing a variety of public health, public art, and public education programs there with his wife, Irene. He composed music and made photographs until he was eighty years old. The images he first made of the miners in Pennsylvania had been inspired, he said, by the paintings and drawings Van Gogh had made of Dutch peasants.

"I thought," Delano recalled, "I could portray ordinary working people in photographs with the same compassion and understanding that Van Gogh had shown...."[15]

Delano had lived with the people he depicted, but he'd also grown up and been raised by others just like them—"ordinary people ... people like my parents. I had always admired and respected [their] fortitude.... They worked hard, never complaining, never earning much money, always willing to make any sacrifice for the welfare of their children. I suppose it was from them that I learned to respect the dignity of ordinary hardworking people, a respect that was to last me the rest of my life.... I often thought that if members of the nobility could have their portraits painted ... my parents and people like them deserved no less."[16]

As for Mydans before him, experience, intelligence, empathy, and resilience were Delano's best teachers. As for Parks, the circumstances of Delano's own life gave him understanding. How much could a reading list teach him about hardship and sacrifice? What could J. Russell Smith teach a Russian Jew about immigrant dreams?

Finally, there was one other "new" photographer who was subject to Stryker's teaching. Like Delano, Marion Post came from Philadelphia, but unlike him, she'd been born and raised in Montclair, New Jersey, the youngest child of a well-respected physician and a beautiful and talented mother. When Post was thirteen, her parents' marriage exploded in a bitter divorce. Post's mother went to work for the birth control advocate Margaret Sanger, but Sanger eventually fired her, and she became a traveling sales representative for a variety of contraceptive manufacturers. Post's father had invested most of his money in the Florida land boom of the Twenties; in 1926, a hurricane ended the boom and destroyed the paper fortunes of thousands and thousands of investors, Dr. Post included. Marion was twenty when he died. All that remained was a small trust that paid stipends to Marion and her older sister Helen—but only as long as they remained in school.

As a girl, Post had attended a variety of public and private schools, but her father's trust never produced enough money to pay for her full-time college tuition. Instead, she took courses in dance and educational psychology at NYU; she worked as an apprentice and then as a teacher at a succession

of private progressive schools, one, in Cambridge, for the children of Harvard professors, the other, near Worcester, Massachusetts, for the children of textile mill owners. In another era, Post might have become a governess, a "young lady" of good manners and good breeding, fallen on hard times. Post's sister reacted to circumstances differently: she left the country, moved to Vienna, and studied photography. In 1933, Post followed her sister to Europe. After stopping in Paris to attend a friend's wedding, and then in Berlin to take classes in avant-garde dance, Post joined her sister in Vienna. Helen's teacher, Trude Fleishmann, became Post's teacher as well.

When Post was twenty-five, she decided to quit teaching and become a photographer. Back in New York, she enrolled in classes sponsored by the left-wing photographer's collective, the Photo League. The photographer and cinematographer Ralph Steiner invited Post to join the workshops and critiques he hosted in his studio. Steiner showed Post's work to Paul Strand, who, a few years later, would recommend her to Roy Stryker.

Before all that happened, though, Post needed a steady job. An editor at the Associated Press recommended her to the *Philadelphia Bulletin*. The *Bulletin* hired Post as the only "lady photographer" on its staff. Her assignments were the fodder of the paper's Women's Page: teas, charity balls, gallery openings, fashion shows. The men on the *Bulletin's* staff reacted to Post in two characteristic ways: one group tried to seduce her; the other tried to get her fired. After two years of fluff and harassment, Post went back to New York and told Steiner, "I'm sick of this job. I don't want to stay in photography if this is all I can do."[17]

Steiner understood: he took Post's portfolio to Washington and showed it to Stryker. Paul Strand followed up with a letter of recommendation. The two men were not just being nice: they had hired Post as the still photographer on the crew of their film *People of the Cumberland*. The same week (the second week of July, 1938) that Strand's letter reached Stryker, the *New York Times* used one of Post's Tennessee photographs on the cover of its Sunday magazine.

Stryker hired Post—provisionally, for three months. He gave her some "sociology books" to read.[18] He sat her down and left her for three hours to look through the FSA's picture files. Then he wrote her a letter:

"There is still another idea I raised with you the other day, that is the idea of your traveling in certain areas, alone. I know that you have had a great deal of experience in the field, and that you are quite competent to take care of yourself, but I do have grave doubts of the advisability of sending you, for instance, into certain sections of the South.... For example, negro people are put in a very difficult spot when white women attempt to interview or photograph them."

Before Stryker had fired Dorothea Lange in 1939, she had traveled throughout the South and photographed black men and black women, young and old, without receiving any such cautions from Stryker. The differences between Lange and Post were obvious: Lange was married and was accompanied by her husband, professor Paul Taylor; Lange was nearly as old as Stryker (Lange was born in 1895, Stryker in 1893); and—in her own words—Lange was a "semi-cripple." (She had contracted polio when she was seven. Five years later, her father deserted her family. Late in life, Lange said this about her disability: "No one who hasn't lived the life of a semi-cripple knows how much that means. I think it was perhaps the most important thing that happened to me, and formed me, guided me, instructed me, helped me, and humiliated me.")[19] In contrast, Post was a young, attractive, and single woman who had lived an itinerant life.

Just as Stryker would later try to teach Gordon Parks about racism, Stryker tried to teach Post, in this letter and others he sent her after he'd hired her full-time, about the consequences of something she deeply knew already: the power of Eros, the power of sex, and all the trouble it could cause. Post had not suddenly become young, single, and attractive the moment she'd met Stryker. She did not need Stryker to explain and to caution her about her sexuality. Post's mother had worked for Margaret Sanger; Post had survived two years of harassment and stereotyping at the *Bulletin*. Beyond that, Post was a politically progressive young woman. (After Post returned from Vienna, she became an active member of the League Against War and Fascism. Post and her sister, Helen, sponsored the immigration of Trude Fleishmann, their photography teacher, to the United States, as a refugee from Austrian anti-Semitism.) Post knew about lynchings; she knew about the Scottsboro Boys; she'd worked and traveled in Tennessee.

Post worked for the FSA until 1942, when she resigned to marry an official in the Department of Agriculture. Post stayed on the road and traveled as long and as hard as any of Stryker's photographers—including Russell Lee and Jack Delano, who traveled with their wives. In spite of Stryker's

doubts, Post worked often and successfully in the South, especially with sociologists affiliated with a research institute based in Chapel Hill. Post's car broke down on occasion, and toward the end, so did she. One of her last trips for the FSA was to Nebraska. Stryker sent her off, as usual, accompanied by a reading list.

Years after Post left the FSA, a biographer asked her what she remembered about Stryker: "What I remember most," Post said, "is the volatility. That roaring agitation. Yet seconds later … patience and sometimes … tenderness. I think he felt possessive of all of us. He could be so supportive, and he could be so damn tyrannical. I'll tell you what I remember about him. He always wanted me to photograph some damn rail fence or other…."[20]

The question is not how much harm Stryker's lectures, reading lists, and foolish presumptions did, but what they reveal about his habits of mind. Other essays in this book will describe the photo assignments and shooting scripts that followed his lectures and readings. Although these assignments were more open-ended than the orders *Life* and *Look* gave their photographers, Stryker as an "assignment editor" had some of the same attitudes towards "his" photographers as the most controlling Luce apparatchik. Marion Post Walcott's remark about rail fences alludes to a procedure governed by lists and categories and outlines that will be described later. For now, it's enough to understand that although Stryker loved to look at pictures, he loved to read even more. He'd learned about pictures by using them to make one book and by trying to make another. The schoolteacher part of him inhabited a dot-to-dot/page-to-page universe in which pictures illustrated ideas. Stryker wasn't exactly one-eyed or entirely left-brained, but he had trouble—so to speak—patting his head and rubbing his belly at the same time. Stryker understood an image's denotation better than its connotation. His photographers, and later the man Stryker hired as his "photo editor," understood both.

The schoolteacher "read this/do that" part of Stryker meddled with his photographers. The controlling, chain-of-command academic Stryker had learned to be at Columbia exasperated and infuriated them. Walker Evans and Dorothea Lange quit and were fired because they refused to listen to a boss of only modest imagination. Since the FSA was a collective enterprise, someone had to direct it, and—for better and for worse—that person was Roy Stryker: an overage instructor who continued to behave as if he were still Rexford Tugwell's teaching assistant.

The photographers Stryker lectured and hectored were remarkable people: canny, resilient, supple, and imaginative. Survivors—of hardship and harassment, racism, wrecked families, bad health. All discovered ways to use their damage to open themselves to the world. Stryker himself had had his share of hard times and hard luck.

In the end, the photographers needed Stryker just as he needed them. He bound them together, enabled them to serve something that was much, much bigger than anything they might have made alone. That thing was not the Roosevelt administration or "the American People," but something stranger: the File. The File—the accumulation of all they did—became a world. A world that Stryker was intent on building, image by image.

ITS PEOPLE AND THE RESOURCES, DEVELOPMENT, AND PROSPECTS OF THE CONTINENT AS AN AGRICULTURAL, INDUSTRIAL, AND COMMERCIAL AREA

BY J. RUSSELL SMITH

PROFESSOR OF ECONOMIC GEOGRAPHY, COLUMBIA UNIVERSITY

POPULATION OF NEW ENGLAND

New England is the land of a passing race. Newspapers often speak of Massachusetts and other New England states as though Yankees were their dominant human stock and Puritanism the dominant faith. Time was when this was true, but that time has passed. New England, especially southern New England, the region of manufactures, is the land of the recent immigrant.

From the settlement of Plymouth until 1800, the population was almost pure British, chiefly English stock.... For two and a quarter centuries, during the period of poverty and struggle, the Yankees increased, beat down the forest, won the fields, sailed the seas and went forth to populate Western commonwealths. Then came the era of manufactures, riches and prosperity. The Puritans, although they had dominated New England and most of the United States during nearly all of its history, ceased to bring forth many sons and daughters and have become a regretful but still potent minority in the land of the new immigrant.... [p. 96]

Yankee stock still has a few entrenched positions. Directors of banks are not elected by popular vote, and New England finance is in the hands of the old stock. So are most of the industries. So also is the long list of colleges and universities. No part of our country is so dotted with these visible signs of the effort to learn. State Universities have spread over the United States with many New Englanders in their faculties, but still hundreds of young people come each year from distant parts of the country to study in New England colleges ... The Puritan is striving to hand on the torch of learning, to transfer the culture and traditions of New England to the sons of the immigrant down the street....

Nowhere else in the United States is the public library so universally a part of the village equipment. The Boston Public Library, second in America only to the Congressional Library at Washington, is the pride of the city and no other city can rival it, although Boston is only seventh in population among the cities of the United States.... Critics may say that the successful Bostonian flies away to New York, and many call Boston the abandoned farm of literature but the report of *Who's Who* is highly suggestive of the continued vitality of New England. In the geographic classification, New York, the parasite of the nation, has twenty-seven pages, Massachusetts has ten pages, while such huge and weighty commonwealths as Pennsylvania and Illinois have but three pages each. Evidently there are still live brains, energy and ambition in Massachusetts. Perhaps the climate gives men these qualities. Perhaps the Yankees can transfer to the new stocks all that is worth transferring. Perhaps, also, they cannot. The real danger seems to be that they will transfer too much by giving these people the ideas that will cause them also to die out as the Puritan is dying out. [p. 100]

THE DEATH OF BRAINS

In recent decades education in America seems to have proved singularly fatal to the families of the highly educated. All statistical studies of the birth-rates of recent American college graduates show that their stock is melting away in New England and elsewhere in the United States about as fast as the Indian melted away before the white man's advance. Equally alarming are studies which show the excess of deaths over births of nearly all native American stocks in the United States, especially those living in the cities.

It seems plain that success and education in America have, within a short time period, produced voluntary limitation of numbers among the educated and well-to-do. This tends to the rapid decline in numbers of the

off-spring of the educated, the successful and capable—the stock without which civilization is impossible. Our present attempt to educate everyone speeds up the elimination of the capable. We now know enough of the operations of heredity to know that this process of survival of the least able will almost certainly reduce the average of human intelligence to a low level in a few generations if continued.

President Arthur E. Morgan, of Antioch College, thinks that the process of social organization, whereby a few brainy persons can control many, will enable us to get along with a smaller proportion of able people.... Thus far, humanitarianism (charity, medicine and education) has done much to save and aid the increase of the least valuable human stock, at the expense of the increase of the best—a service of most questionable ultimate utility to the nation and to civilization. [pp. 100–1]

THE ERIE CANAL BELT— NEW YORK TO BUFFALO

NEW YORK CITY—ITS CROWDS

In the spring of 1922 the New York *Tribune* reported that an old woman had died of fright on a subway platform in New York. After forty years of work, she and her immigrant husband had sold their farm and were returning to Czecho-Slovakia to live in retired ease in their native village. They stood in a jam of people on a New York subway platform. The train rushed up with a roar and stopped. People surged out, others surged in. Our immigrant couple tried to enter, but the man could only get his foot inside the door. The station guard grabbed the old man, and with hand on shoulder and knee on hip, pushed him into the car, and held him there while dragging the door shut. Away went the train, leaving the frightened old woman on the platform in a mass of strangers, who like herself had not been able to get on the car. She saw the red light of the train fade away in the darkness and fell dead from fright. How could a poor immigrant woman know that in New York they always load trains in that manner during the rush hour when everyone is going to work? The inhuman pressure of crowds! That is New York.... [p. 121]

NORTH ATLANTIC COAST PLAIN

POPULATION

It should be noted that in the southern part of this region about one-third of the people are negroes to whom the spasmodic labor of the truck-farm is more welcome than the continuous labor of dairying. In some sections August is an almost continuous picnic. The remainder of the population is chiefly native white.... [p. 175]

THE APPALACHIAN PLATEAU

This is a land of fried pork, fried squirrel and corn cakes or corn pone and beans. Corn is the mainstay. It is the chief crop, almost the only crop, of thousands of these mountain farms....

The private rifle is still used to settle personal difficulties, and family feuds, with plenty of killing, still survive.... [p. 218]

PITTSBURGH

Pittsburgh and the mill-towns in the various valleys within thirty miles contain 1,200,000 people. Industrially, it is a land of fire. Study the Pittsburgh district and you will have a mental picture of miles of coal-cars, of burning coke-ovens, smoke, dust, sweat, black hillsides, collieries, mine conveyors, railroad tracks, blackened steel plants, flaming furnaces, white-hot metal pouring, red-hot metal cooling, heavy rolls, pressing red-hot plates with roaring noise, shears cutting the plates into pieces, giant cranes lifting and dropping them with a clang. Highly perfected machinery replacing man's labor adds to the impression that here is a kind of mechanical volcano, if not indeed an inferno. As one rides through Connellsville, at night the fires from countless coke-ovens seem to line the track for miles—a land of fire. [p. 225]

THE MINE AND THE MINER

The typical mining community usually consists of a few superintendents who have some education and several hundred employees who are able to dig coal but who do not need any education at all. In many cases these miners know

little of the English language and practically nothing at all of American customs and ideals. They live in the company's houses, buy at the company's store, and have a little city of their own in the wilderness. One coal-mining district has negro labor. Most of the mining towns in the Allegheny Plateau are peopled by newly arrived immigrants from Europe (15–25% in western Pennsylvania). Towns in Cumberland Plateau are often filled with mountaineers who have come from the isolation of their mountain farms to experience the crowded conditions of a mining town where the valley is so narrow that the houses must be perched up on the side of the hill like bleacher seats around an athletic field. It is not difficult to see why the individualistic, independent, feudist mountaineer … cannot become at once a public-spirited townsman.

A community composed of mining towns planted in the wilderness where there are a few farms and no other industries lacks the variety needed for a good community. It also lacks that middle class of independent property-owning citizens which has long been the pride and hope of Anglo-Saxon democracy in both Britain and America. Lacking the conditions of democracy, it shows the result in undemocratic government…. [pp. 226–27]

THE COTTON BELT

The attitude of the two races toward each other is shown by the following stories: (1) A Northerner from the two-horse-plow or three-horse-plow country, seeing the negroes on a Southern plantation creeping across the field with a one-mule plow, asked the white man why he did not give the man a two-mule team. "What!" he exclaimed. "Let that lazy nigger waste *two* mules' time?" (2) "Marse Jeems," asked an old negro of a leading citizen, "what wuz you-all white folks havin' dat meetin' about terday up thaiah at de coht house?" "We're gettin' up a plan, Jim, to try and get some more white people to come and settle in this country." "Good Lordy, Marse Jeems, don't you do it! Please don't do it. Why, Marse Jeems, don't you know that us poh niggahs has got jest all we kin do now ter suppoht de white folks dat's heah already?" … A New Jersey pork breeder who years ago showed beautiful, round, well-bred porkers in a cotton state fair saw with amazement the premium put upon the razorback. He could not understand it at first. "You see, Mistah, them hawgs of yourn may be all right fer up Nawth where you come from, but they

ain't wuth five cents apiece heah. Youah hawgs ain't got no speed. Hawgs must have *speed*. Down heah, if a hawg can't beat a niggah to the swamp, he ain't wuth havin', for you won't have him long." [pp. 241–44]

THE POPULATION OF THE COTTON BELT

The people of the South admit a difference between themselves and the people of the Northern States. They confess that they have a desire not to duplicate the "Yankee" rate of speed and hustle and Yankee thrift. A delightful friend of mine in the South said: "The Yankees eat what they can't sell. We sell what we can't eat." There is a savor of truth in this. It is an admirable description of two points of view, and it is true that Southern fried chicken and hot corn pone have a better reputation as delicacies than the fried potatoes and cold wheat bread of the North…. The undeveloped condition of the South might also be attributed to the large proportion of negroes in the population. In the Coast Plain the proportion is often more than half, and South Carolina, being largely a Coast Plain state, has for many censuses shown a majority of negroes. The negro, with his low standard of living, his low rate of daily wage, has effectively kept the nineteenth and twentieth century European immigration out of the South. While the negro has done the bulk of the manual labor, his race is without experience in organizing industry or government or participating in democracy. Nearly all the burden of carrying civilization has been upon the white faction of the population. The large proportion of negroes has often caused social isolation for the white people as well as rural neglect, because whenever possible in many localities the whites have moved to town even if moving has resulted in financial loss and in the decline of the rented land.

Whatever the differences between the white and the black may be, the dark skin, geography's greatest curse to man, marks off the man of color and keeps him and his seed forever classified, and keeps him from receiving the treatment accorded to a white. This is true even if the negro chances to be similar in all cultural, intellectual and economic respects.

We hear much about negro shiftlessness and laziness, but, taking a long view, one of the most startling things about the negro is the amount of property he has managed to amass since his emancipation and the progress he has made. Perhaps this is a result of climate. The negro, coming from the tropics,

is in a climate that is more stimulating and invigorating than that from which he came. It is also a fact that the whites from northwest Europe are in a less invigorating climate than the one from which they came.... [pp. 261–63]

SUBTROPIC COASTS AND THE FLORIDA PENINSULA

THE FUTURE OF FLORIDA LANDS

Mr. R. D. Ward, of Harvard, one of the most diligent students of hygiene and climate in America, says: "Too long a sojourn in such a climate, may, however, lead to a marked toning down of the system, to loss of appetite, and to digestive and nervous difficulties." Mr. Howard Martin, of Illinois, says: "In plain English, you get lazy. I noticed it. The first two weeks I was there I ate oranges with enthusiasm. Then I got too tired to peel an orange and always bought tangerines; the skins pull off with about two motions. Then I got too lazy to handle the tangerines and ate kumquats the rest of my stay...." [p. 287]

THE CORN BELT

Mr. Henry Seidel Canby, editor of the *Saturday Review of Literature*, startled me by saying that the Middle West had produced the literature of despair. In explanation he pointed to the fact that this Eden was settled, particularly in Indiana, by many groups of people who entertained Utopian ideas for the revolution of the world by improved social organization. Others believed that mankind would receive enormous benefit by the practice and spread of their own particular religion, their own new kind of education, their own diet reform, etc. Two generations later their grandchildren found themselves in a world still unregenerate, and tortured by a terrible World War in which the grandsons of the Utopians had to take part. [pp. 307–9]

The Corn Belt small town may be termed inert. Except for the grain dealer, the coal dealer, the storekeeper and the garage man, its population consists chiefly of retired farmers and their families, most of whom live on fixed incomes, and are much more desirous of economy than keen about enterprise.... [p. 317]

THE SPRING WHEAT REGION

THE CENTER OF TROUBLES

Man is a land animal. The earth is his mother, but the sea seems to be his nurse, and the farther he is from Sea, his nurse, the worse he gets along with Earth, his mother. The sea, with its even-tempered water, tends to evenness of climate. The land, now hot, now cold, tends to extremes of climate. The greater the distance from the sea, the greater the extremes. Extremes make trouble. The Spring Wheat Belt is a land of climatic extremes, hot summer and cold winter, and of swift change. In the same year you may see –50 degrees F. and 100 degrees F. Devil's Lake, North Dakota, has zero one-fifth of the days of the year. One wonders why the Devil got the honor of the name.

The similar area in the Old World, the wide, flat, black, hot-cold plain of Central Asia, has for ages been as seat of trouble for that continent. There, as in America, the changeable climate was too much for the primitive farmer. Only the nomad, with his flocks, could survive. It was these nomads on their horses, taking flocks, wives and children with them, who battered at West Europe and Rome under the name of Scythian, Goth, Vandal, Hun, and, turning the other way, battered at China under the name of Tatar, Mongol, Manchu.... [p. 346]

LOWER LAKE REGION

Detroit grew like a mining town after a rich lode is struck and it shared many of the signs of the frontier town, both physical and psychological. Physically there was house shortage and extreme congestion.

Detroit got rich quick. This is a psychological as well as a financial fact. The mechanic who has suddenly become a millionaire and the workman whose wages have been doubled and trebled have an interesting and a conspicuous psychology. Publishers say that Detroit is a poor book market.

Detroit also has the mixed and foreign population of the boom-town. Its analysis shows the wide human pull of its prosperity and explains the need of the great efforts that have been made to teach English and to Americanize the population.... [pp. 381–82]

THE GREAT PLAINS

The Great Plains region is a land of tragedy. For two and a half centuries the white man had marched westward, conquering the land, settling and making successful homesteads and building up communities. Thus he worked his triumphant way from the Atlantic to central Kansas and Nebraska. On westward, into the region of the Great Plains, marched this army of settlers, but here the battle turned against them and they were thrown back by hundreds of thousands. But this battlefield of their defeat, of the triumph of their enemies is not marked by tablets, monuments, and the usual signs of victory. A lion does not write a book, nor does the weather erect a monument at the place where the pride of a woman was broken for the want of a pair of shoes, or where a man worked five years in vain to build a home and gave it up, bankrupt and whipped, or where a baby died for the want of good milk, or where the wife went insane from sheer monotony and blasted hope.... [p. 409] The Great Plains are a land that you love or you hate. In the winter come blizzards that are so blinding that you cannot see the length of your automobile and getting lost is most easy. In the spring there is usually a windstorm or two in many parts of the plain strong enough to blow half the water out of a bucket you may be carrying. All summer long the wind blows and blows, and the sunshine glares. If the rain comes it is in showers which are soon over. Meanwhile there is little else to do but watch the weather. Many a settler's wife has paced the floor of her shadeless little kitchen until she wore it through, and there is a high record of women's insanity in some parts of the plain.... [pp. 429–30]

VALLEY AND COAST
OF SOUTHERN CALIFORNIA

Los Angeles, the metropolis of southern California, is the center of the greatest tourist district in the United States, and of the world's moving-picture industry.... A man in San Francisco, the rival city, says: "Half of it is wind and the other half's water"—the "wind" being salesmanship, the "water" being irrigation. The two great California cities maintain a riotous rivalry.... [pp. 539–40]

The people of Southern California make you welcome, and try to make you feel at home. They take you to their picnics and parties in a whole-hearted way that is not to be found in the older communities of the East. Perhaps the visitor may be pardoned if sometimes he wonders if the whole thing is a conspiracy to sell, and if everybody he meets isn't to some degree at least an assistant advertising agent. The people really do sell their climate as the Swiss sell their Alps.... [p. 545]

CENTRAL CALIFORNIA

LABOR AND IMMIGRATION

It is easy to see how the immigration problem first assumed acute forms in California. The Oriental, willing to work longer hours than we, willing to live on less, could pay more for the land which he bought or leased. What race, what culture, shall own California? Shall it be the economically efficient Mongolian or the less economically efficient Caucasian? This question pressed for an answer. Since self-preservation is the first law of all nature, the answer is perfectly plain. It carries with it the explanation of the movement for the exclusion of the Chinese and Japanese, largely at the insistence of California and other Pacific states. It should be noted that the same feeling against the admission of foreign peoples whose standards of living are low has finally seized upon the whole country. The result has been the limitation of immigrants to numbers which we feel that we can absorb into the mass of our people.

The fruit industries of California have joined the lumber camps of the mountain in making manifest another social problem—that of floater labor. The grape-grower or peach-grower or apricot-grower who has no hired man at all for most of the year may need five or six helpers at harvest-time. He is very glad to see the floater or "itinerant" coming along in his decrepit Ford. He also, of necessity, welcomes the Indian, the Mexican, and the bum who beats his way on the freight-train. All these floaters are not particularly good for the social life of the rural community, where they are much more conspicuous than in the lumber camp far away in the forest or in the segregation of city slums.... [p. 587]

HUMAN ENERGY

Professor Ellsworth Huntington, of Yale, astride his thermometer, says that civilization depends upon certain temperatures.

Dr. Huntington's point about the climactic basis of civilization (explained at length in his epoch-making *Civilization and Climate*) is essentially as follows: A man feels more inclined to be active and he will do more physical work at a temperature of about 60 degrees (55 to 70 degrees) than when it is either colder or warmer. The second part of Huntington's theory is that a man's brain works best when the outdoor temperature is about 40 degrees. There is a third point to the Huntington findings; namely, man produces energy best if there comes every few days a change in weather, either to warmer or cooler. Changes in temperature wake men up and make them want to do things.

If Huntington's theory of climate ran contrary to the experiences of common men we might look at it askance, but everything that we know about history, including ... industrial history ... confirms this theory.... [pp. 612–13]

PEOPLES OF THE GULF AND CARIBBEAN

Clothing an entire family costs but little. Children often run naked in their earlier years even in the streets of the town. Blue overalls and factory shirts and home-made cotton dresses partially cover the older people. Shoes are not often necessary and usually are absent. Thus the cash income needed by the family is small indeed. If they live near the town, a few loads (woman, donkey, or perhaps man-loads) of produce sold in the market will supply it. So will a few days' work on some plantation. Sometimes a part of the ground planted to coffee, cacao or tobacco will yield a few hundredweights to bring in the needed funds.

THE SIMPLE LIFE AND THE POPULATION PROBLEM

This simplicity of existence has a profound influence on the population question. A woman can support the family if she has to, and the family solidarity that is so necessary to send children through high school and college in the United States and Europe is not needed; hence a different concept of family life has arisen or, perhaps one had better say, survived. The husband is not a necessity save for his company's sake, and that is often about all that the uneducated West Indian wife ever gets from her husband except for short periods. She supports the family, and if she wants to exchange husbands, why not? And if sometimes, in this process of swapping, the man gets two or three wives, it is merely an incident in the system. The more generous he is with his earnings the more wives he can collect.... The results of this more or less informal polygamy are two—first, the rapid increase and great density of population in many localities; and, second, the increase of the ablest element. This more rapid increase of the able may account for the good looks of the people. A Chicago woman, a graduate of the University of Wisconsin, living in Porto Plata, Santo Domingo, averred that she did not know there were so many Othellos alive as can be seen in the streets of that town. And I can personally testify to the good looks of the women.... [pp. 668–69]

VARIETIES OF PEOPLES AND THEIR CONDITION

Directly across the straits from ... Jamaica is Haiti, with a great mass of uneducated negroes who, since they threw off their French masters in the Napoleonic period, have unquestionably degenerated in what we call civilization. Rumors of cannibalism persist in coming out of Haiti.

A chunky-looking young negro in prison was shown to my friend, Lieutenant Gebhard, as the survivor of four who had made soup of an American aviator who had been forced to land. "Fat soup it was," he told Gebhard.

TRADE, PLACE AND FUTURE OF NORTH AMERICA

THE PLACE OF EUGENICS

Civilization has also "made the world safe for stupidity." (See *The New Decalogue of Science*, A. E. Wiggam.) Every recent study of the American birth-rate points to the disappearance of the stock with brains. We have developed the most amazing institutional systems for the care and preservation and attempted improvement of the feeble in both mind and body. If wayward and weak of mind, they have special homes for refuge. Hospitals assist them in giv-

ing birth. Skilled physicians care for the young bone-head. Nurses wait upon him. Devoted virgins in special schools strive to inject ideas where ideas will not go. Then we, who breed pigs and pups with great care, turn him loose to increase his kind and give him aid therein. If one of us is born brilliant we have nothing for him but an elaborate educational chain gang where we lock-step him with mediocrity. The man from the Moon might well think that we thought our civilization depended on the weak and the dull. It seems to be a peculiar irony that while we breed our animals up, we breed ourselves down.... The continuance of this civilization and its improvement through the utilization of the almost unbelievable powers now at hand is first of all a problem in eugenics. We need men big enough to use the new powers. It has been said of men in New York, which is typical of western civilization:

"Today we are at last coming to a realization that only by weeding out the weak-bodied, weak-willed parts of the community through some form of eugenic selection, and by seeing that people are adjusted to their physical environment, can we provide proper human material for the great tasks of civilization. We can scarcely avoid the conclusion that the building up of character is as much the work of the scientist as of the preacher, teacher, or philanthropist." (Ellsworth Huntington, *Geographical Review*, Sept. 1916)

The overtowering need of man today is a slight increase each generation in the average hereditary intelligence and self-control. If this can be built up a little as generations go by, we can put civilization on a permanent and improving basis. If we go the other way another era of primitive agriculture and natural selection awaits us. [pp. 808–9]

POWER—PERPETUAL AND UNLIMITED

The unlimited power seems to be within our reach in the West Indies, perhaps elsewhere. An engineer has pointed out the fact that ether is turned from a liquid to a gas at a temperature of less than eighty degrees Fahrenheit. Secondly, he points out that the warm surface waters of the South Atlantic, Caribbean and Gulf of Mexico have the necessary eighty degrees, and that 2,500 feet down these same seas have a temperature of forty degrees. All that is needed to develop power is to supply an ether engine with both kinds of water. One vaporizes the ether which then runs the engine and is condensed by the cold water. It is then ready to be heated again by the warm water—

and so on and on. This process is identical to that by which a condensing marine engine takes a limited amount of boiler-water at New York and repeatedly boils it with fire and condenses it with sea-water as it makes its way across the ocean. The whole West Indies is swept by trade-wind at a temperature year in and year out warm enough to run ether engines. At places on the Virgin Islands of the United States cold water for condensation can be had a half-mile from shore at a depth of 2,500 feet. Apparently there are similar places in the Bahamas and perhaps elsewhere. These islands might become power-plants of an almost unlimited extent and with perpetual supply of the "makings" as long as the sun holds out, the trade-winds blow and the cold water keeps replenishing itself from the abundant supplies at the poles. This opens a wide vista to speculation and invention. [p. 810]

THE CONQUEST OF TROPIC CLIMATE

A decade ago Mr. Ellsworth Huntington, in his book *Civilization and Climate*, advanced the claim that man's mind does best when the outdoor temperature is about forty degrees and his body does best when the outdoor temperature is sixty to seventy degrees. The same author has since followed this up with other studies ... all tending to show the great improvement of health and vigor that come to human beings at some temperatures and humidities rather than at others. Thus far we are continuing the practice of temperature and moisture control for dead pigs, but for man it has not become an object of serious experiment. Great is the resistance of the human mind to new ideas!

It seems to be perfectly clear, as a theoretical proposition, that we can build a large residential structure on a tropic shore in which conditions for health and vigor will be as good as those prevailing in northwestern Europe. There is no technical difficulty in enclosing a whole town under one roof, including playgrounds, stores and places of public assemblage. Here women and children might spend twenty to twenty-four hours a day. Men would spend the hours of sleep, of eating, of loafing, while in the mornings they might travel by motorbus a few miles out to the plantations where eight or ten hours a day in the tropic air might do them no more injury than results from eight or ten hours a day in freezing or zero weather in Minnesota.... [pp. 810–11]

Title page and excerpts from J. Russell Smith, North America *(Harcourt, Brace, 1925).*

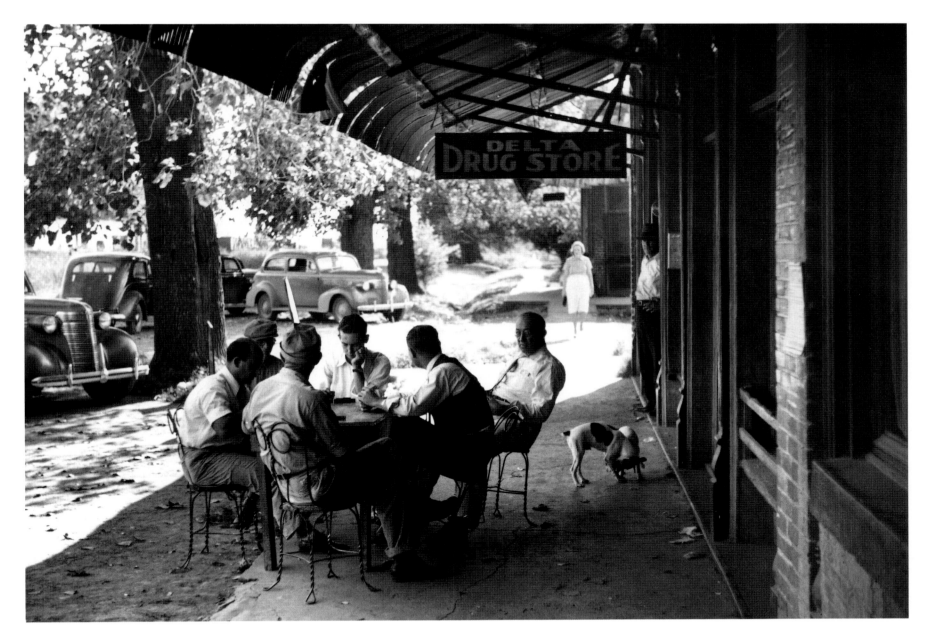

Playing dominoes or cards in front of drug store in center of town, in Mississippi Delta, Mississippi

Marion Post Wolcott, October? 1939

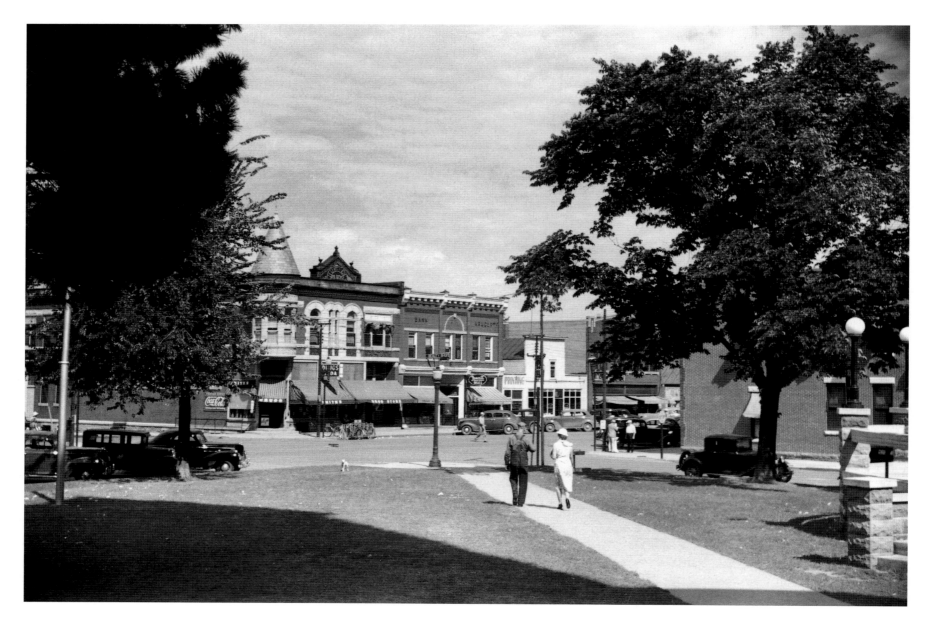

View from courthouse, Grundy Center, Iowa

ARTHUR ROTHSTEIN, SEPTEMBER 1939

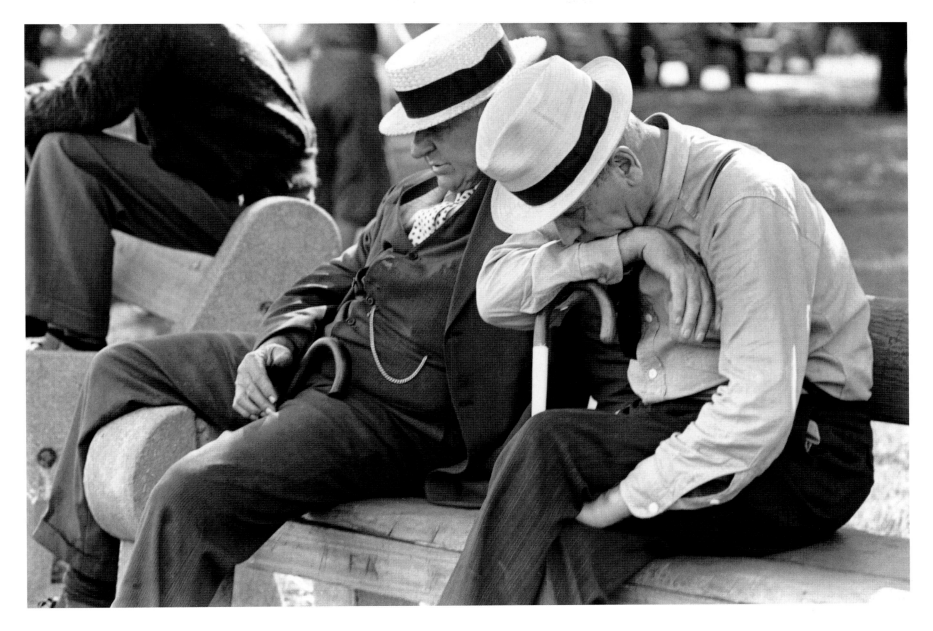

Men in park, Peoria, Illinois
ARTHUR ROTHSTEIN, MAY 1938

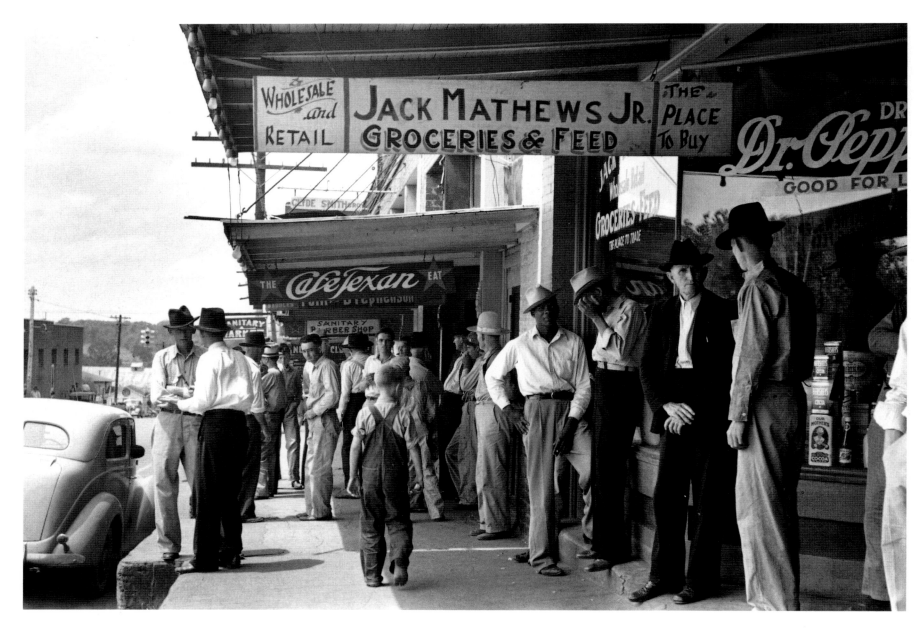

Street scene, San Augustine, Texas

RUSSELL LEE, APRIL 1939

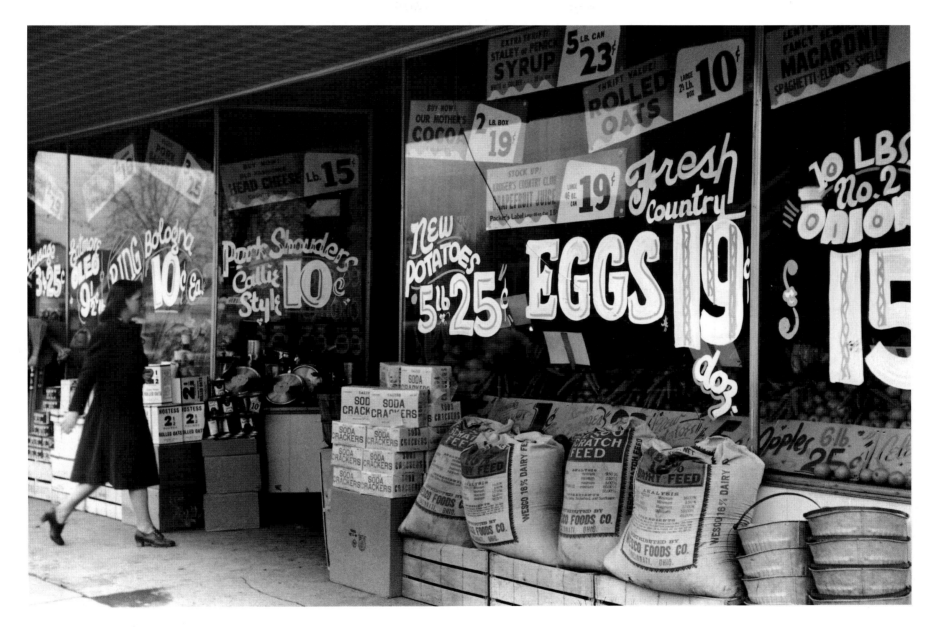

133

Grocery Store, Salem, Illinois

Arthur Rothstein, February 1940

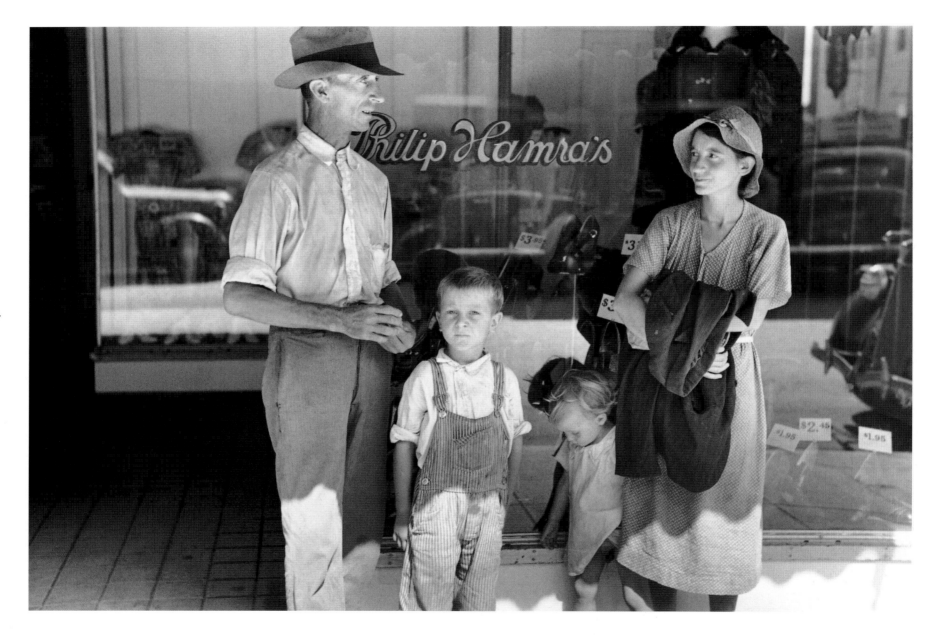

Farm family in town, Caruthersville, Missouri
RUSSELL LEE, AUGUST 1938

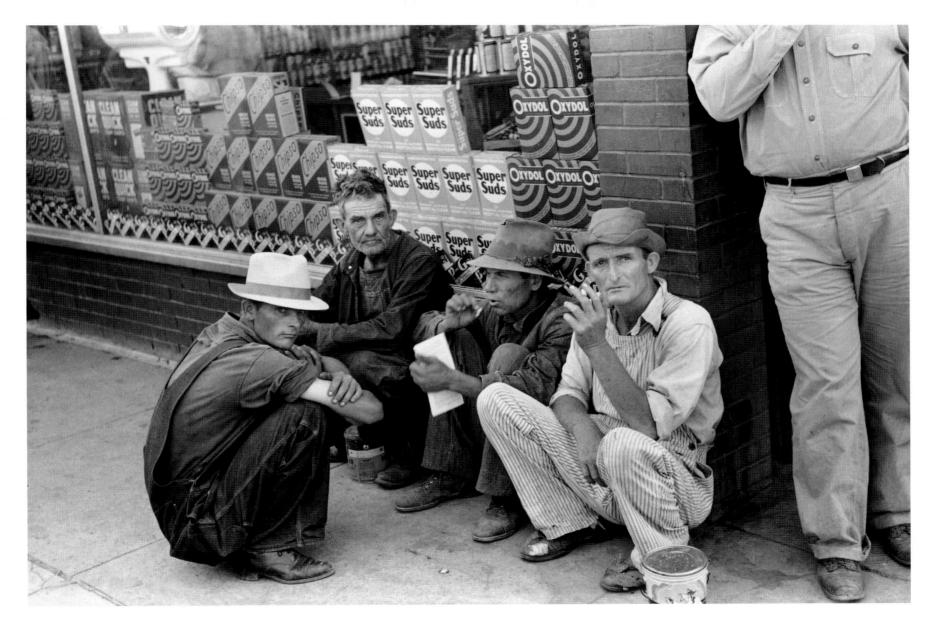

Farmers squatting on sidewalk, Caruthersville, Missouri
RUSSELL LEE, AUGUST 1938

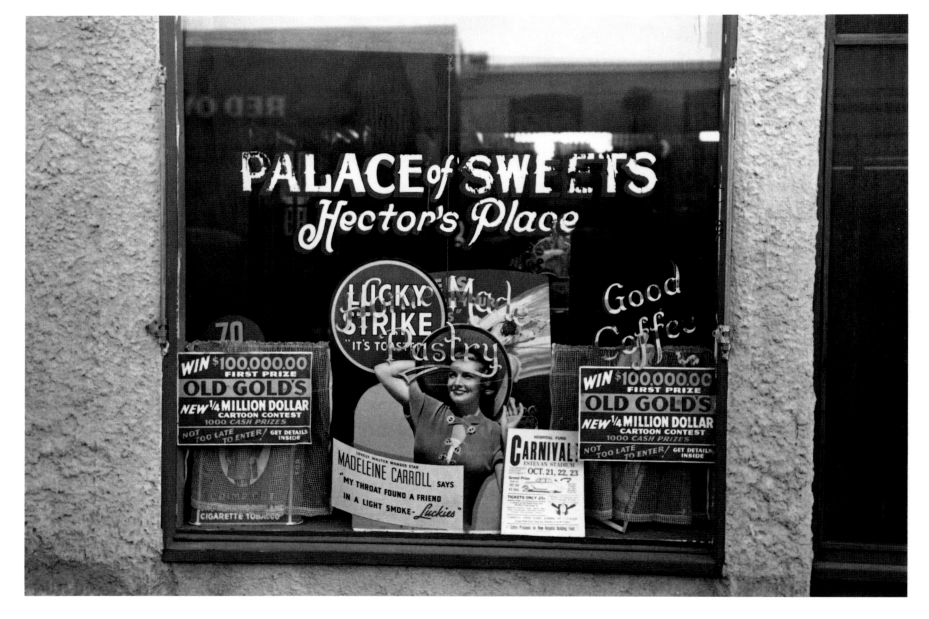

Store window, Crosby, North Dakota

RUSSELL LEE, NOVEMBER 1937

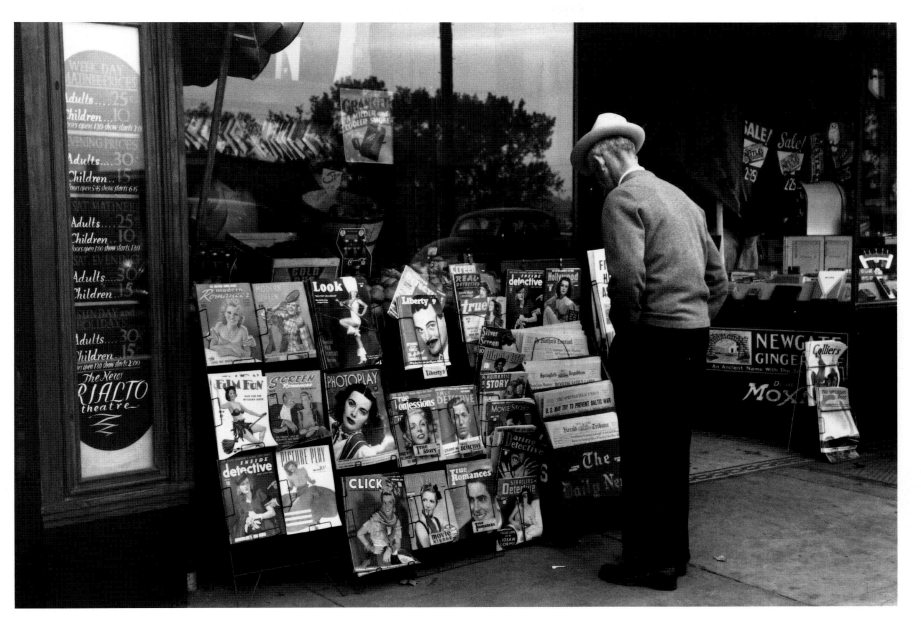

Magazine stand, Windsor Locks, Connecticut

RUSSELL LEE, OCTOBER 1939

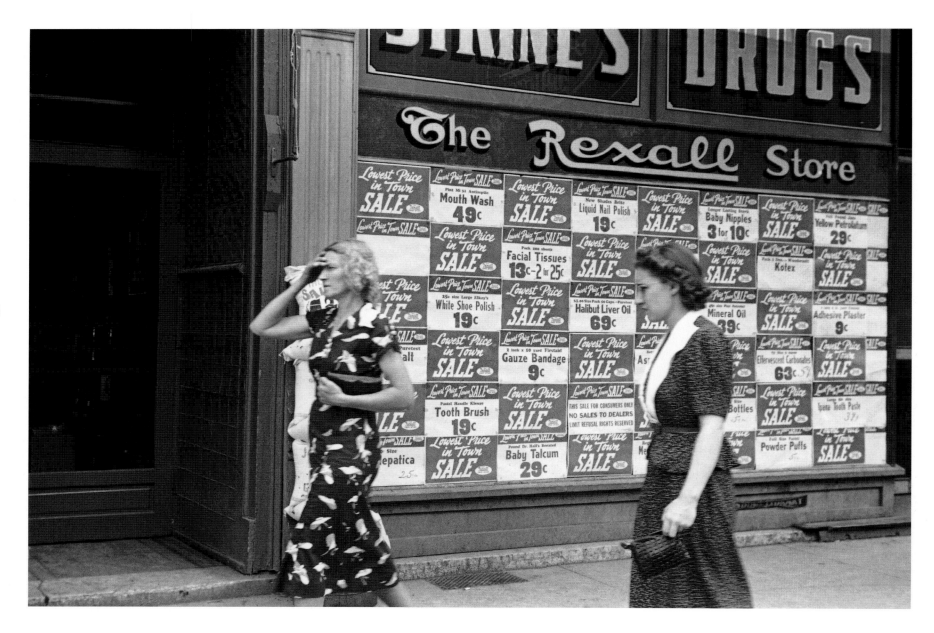

Drugstore window, Newark, Ohio
BEN SHAHN, SUMMER 1938

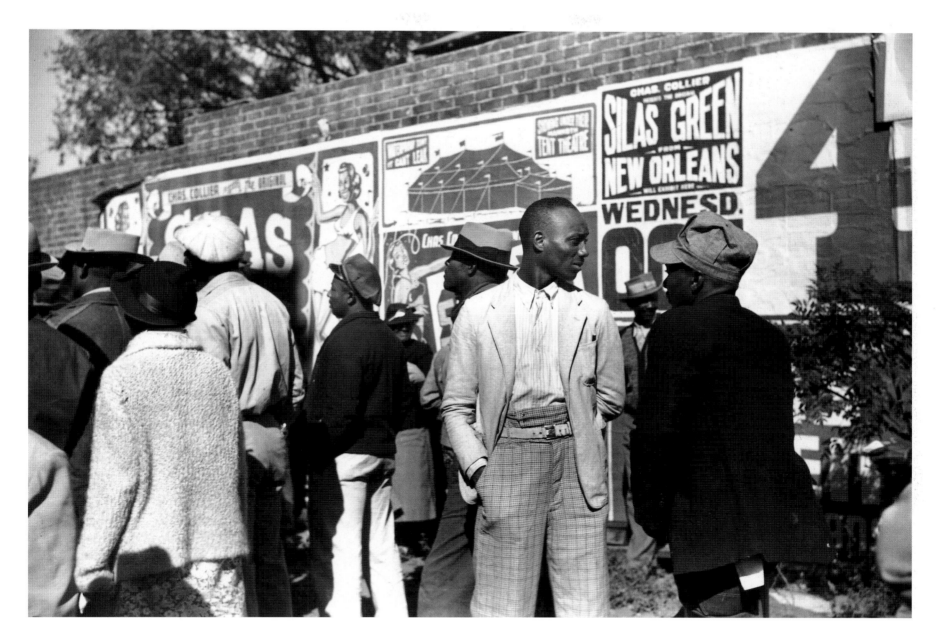

Some of the Negroes watching itinerant salesmen selling goods from his truck in the center of town on Saturday afternoon, Belzoni, Mississippi Delta, Mississippi

Marion Post Wolcott, October? 1939

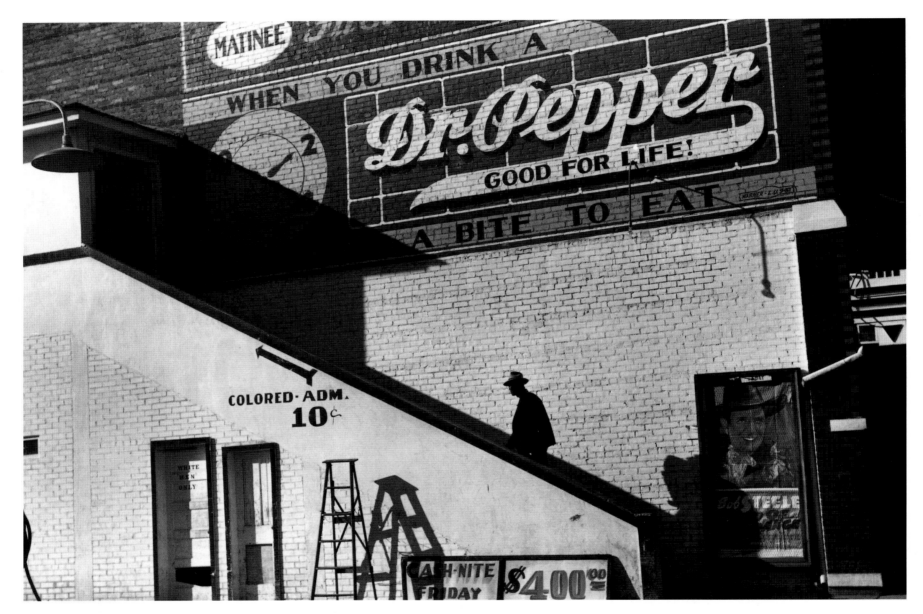

ABOVE: Negro going in colored entrance of movie house on Saturday afternoon, Belzoni, Mississippi Delta, Mississippi
MARION POST WOLCOTT, OCTOBER? 1939

OPPOSITE: In Memphis, Tennessee hundreds of colored laborers congregated near the bridge every morning at daylight in hopes of work chopping cotton on a plantation. They are hauled to and from work on trucks. "You can't live the commonest way on six bits a day. Not alone nor no way. A man like me can't get no foothold. It's a mighty tough old go. The people here in the morning are hungry, raggedy, but they don't make no hungry march."
DOROTHEA LANGE, JUNE 1938

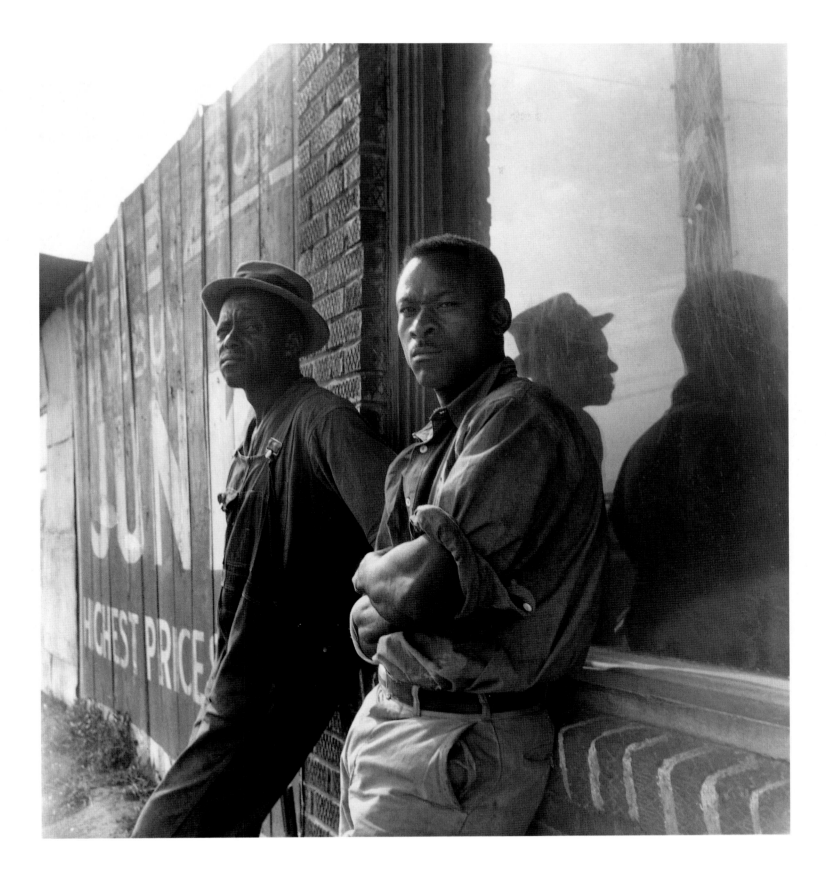

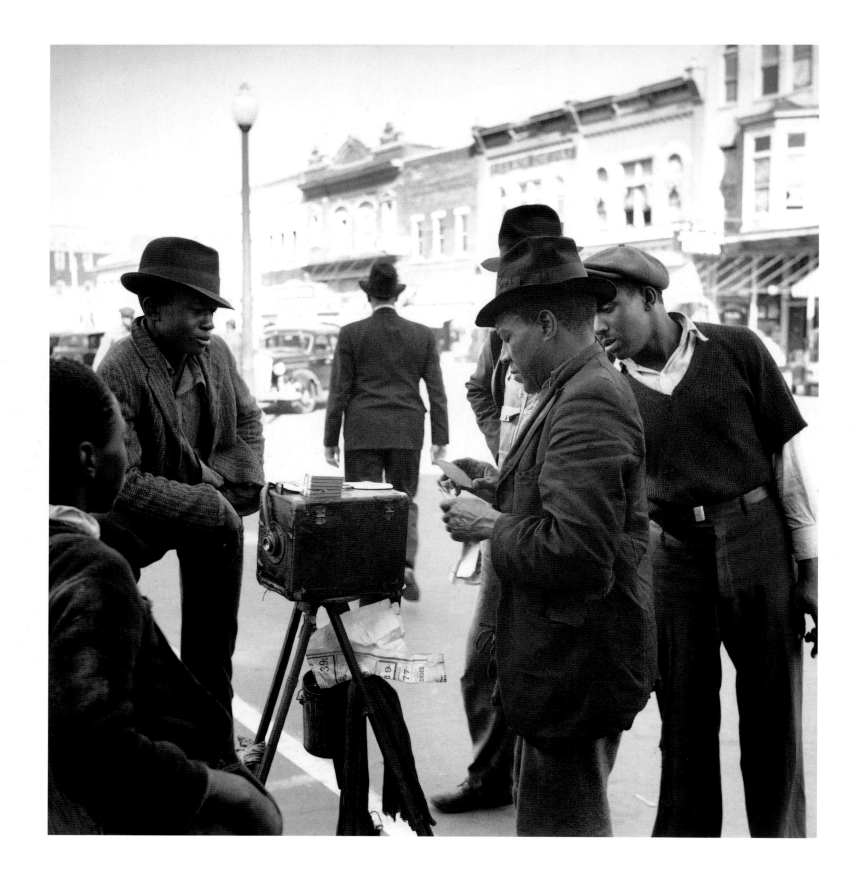

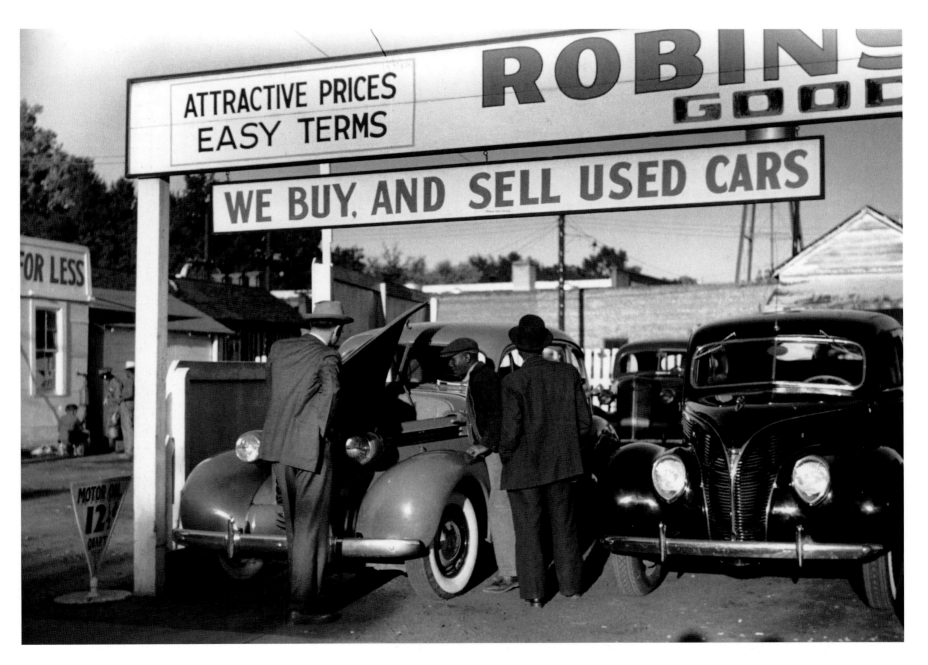

ABOVE: Used car lot, Clarksdale, Mississippi Delta, Mississippi. Big sales go on after cotton picking season to get the money cotton pickers have made. Many of the pickers buy new or used cars with their cotton money.
MARION POST WOLCOTT, OCTOBER? 1939

OPPOSITE: Street photographer, Smithfield, North Carolina
ARTHUR ROTHSTEIN, OCTOBER 1936

144

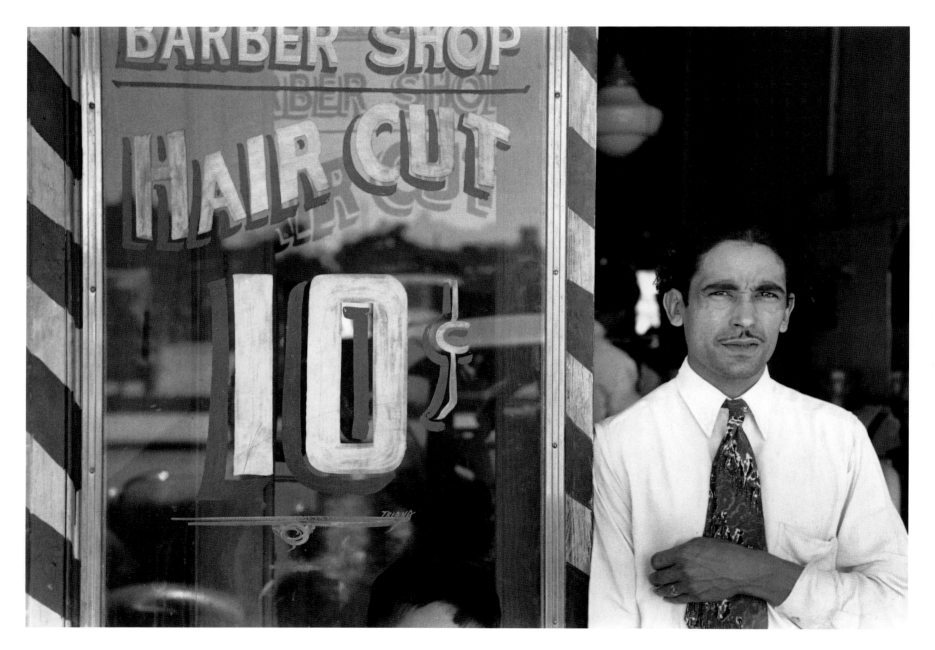

Mexican barber, San Antonio, Texas

Russell Lee, March 1939

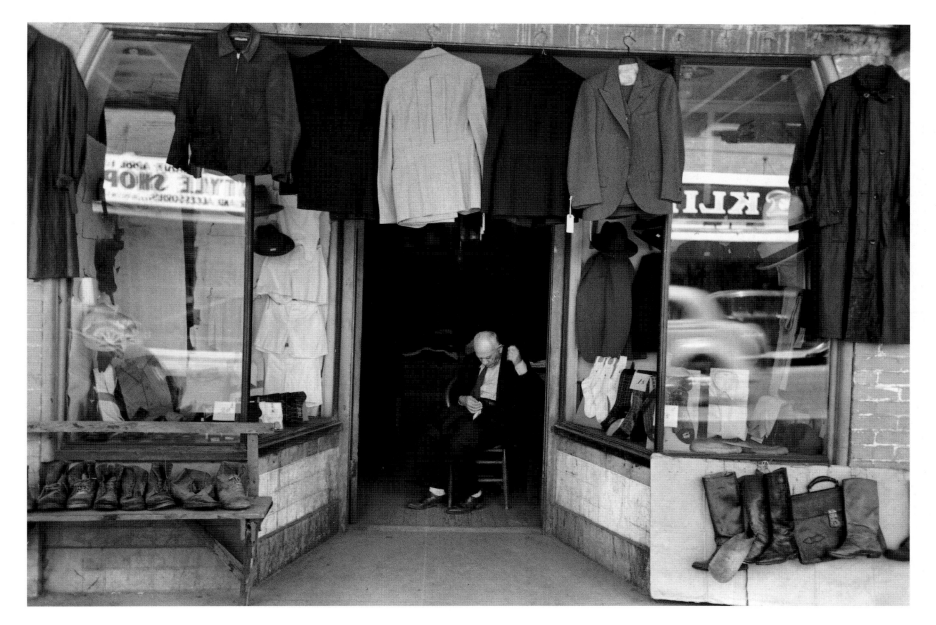

Clothing store with tailor in doorway, Mexican district, San Antonio, Texas
RUSSELL LEE, MARCH 1939

146

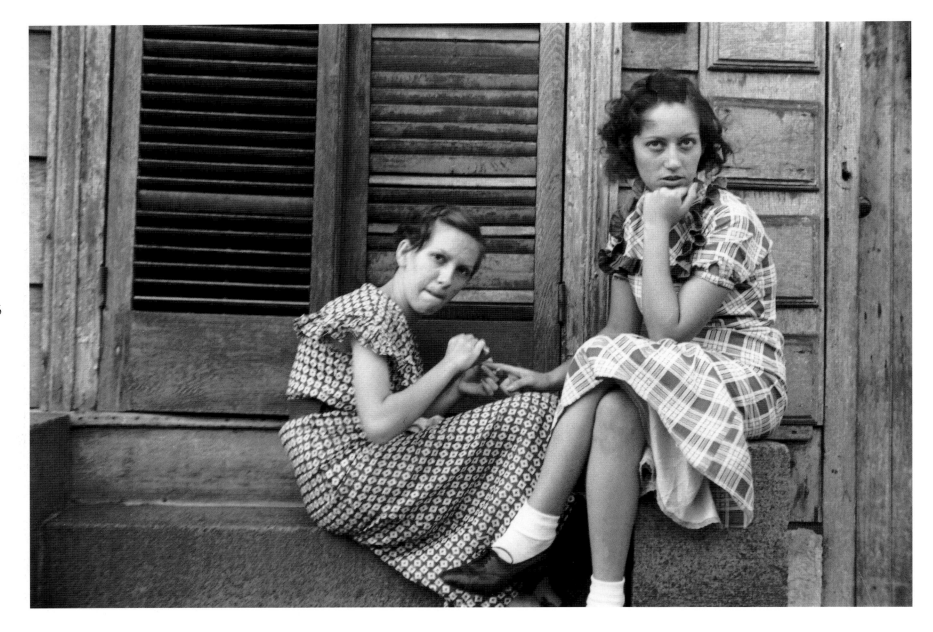

Young residents at Amite City, Louisiana

Ben Shahn, October 1935

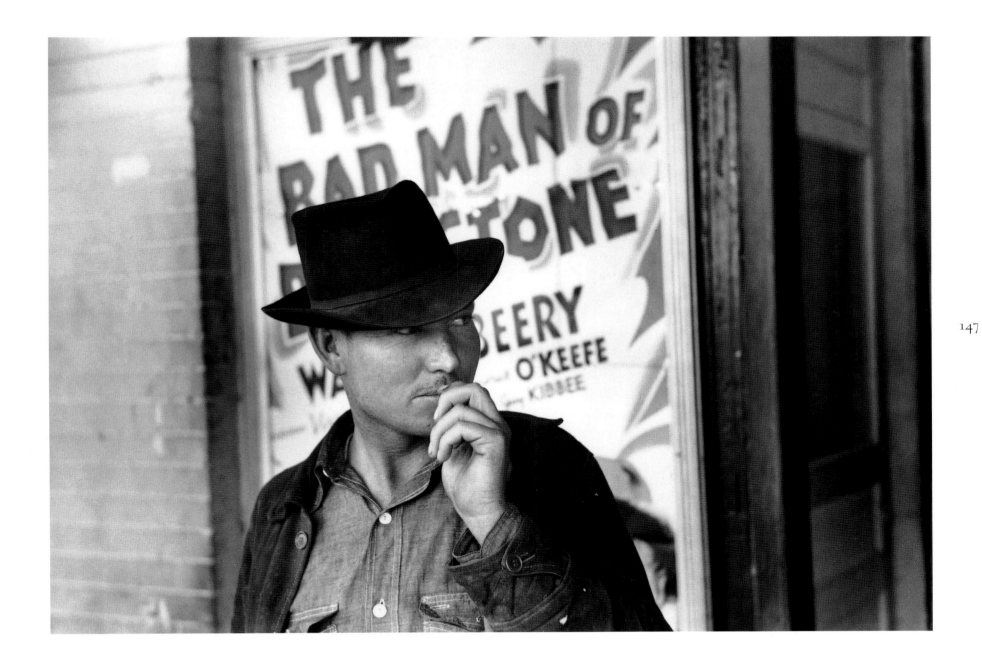

Man in front of movie theater, Waco, Texas

Russell Lee, November 1939

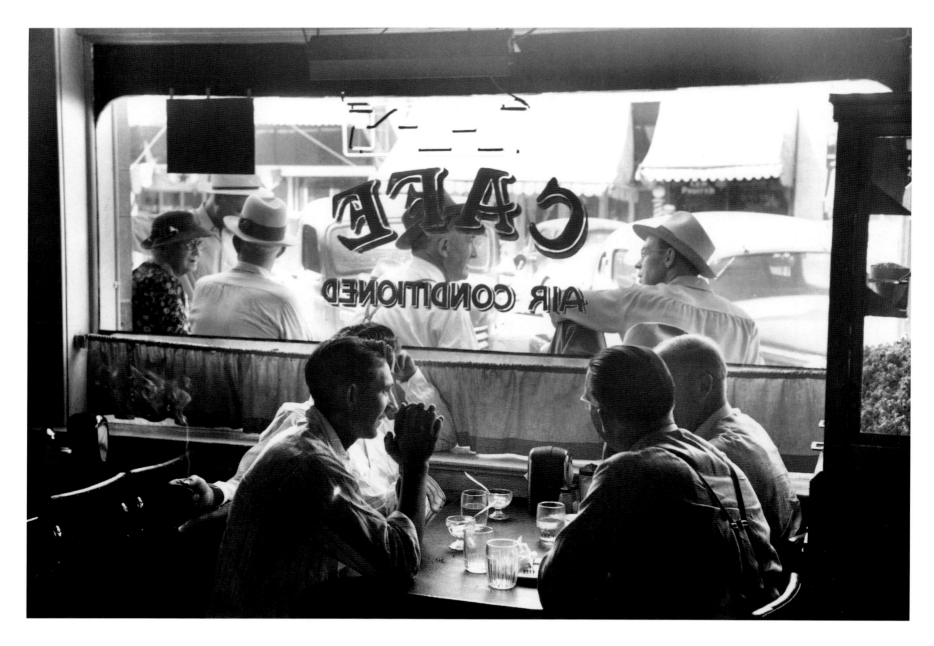

Cold drinks on the Fourth of July, Vale, Oregon

RUSSELL LEE, JULY 1941

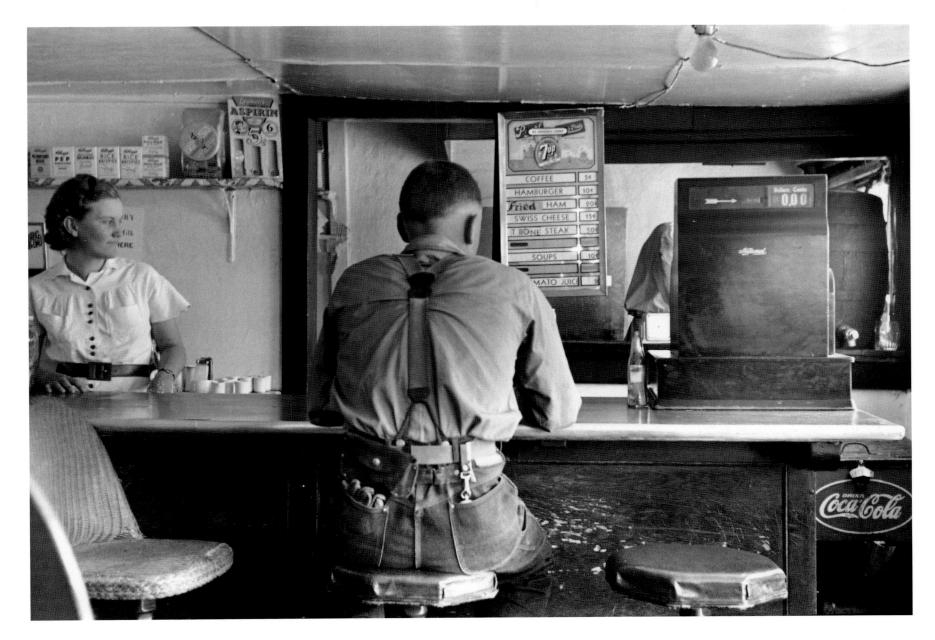

Man in hamburger stand, Alpine, Texas
RUSSELL LEE, MAY 1939

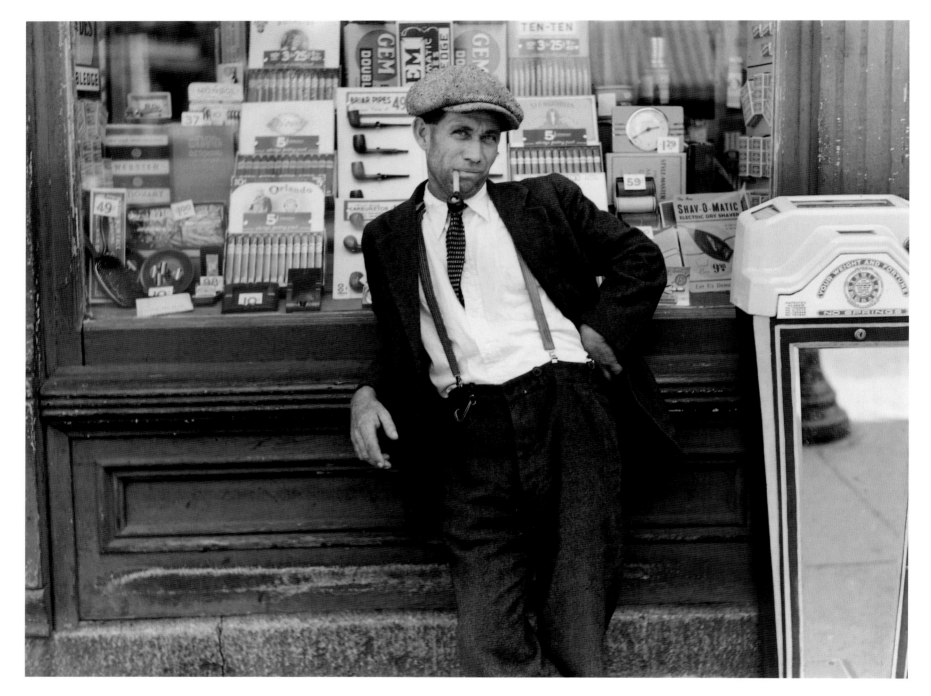

Man in front of drugstore, Dover, Delaware

JOHN VACHON, JULY 1938

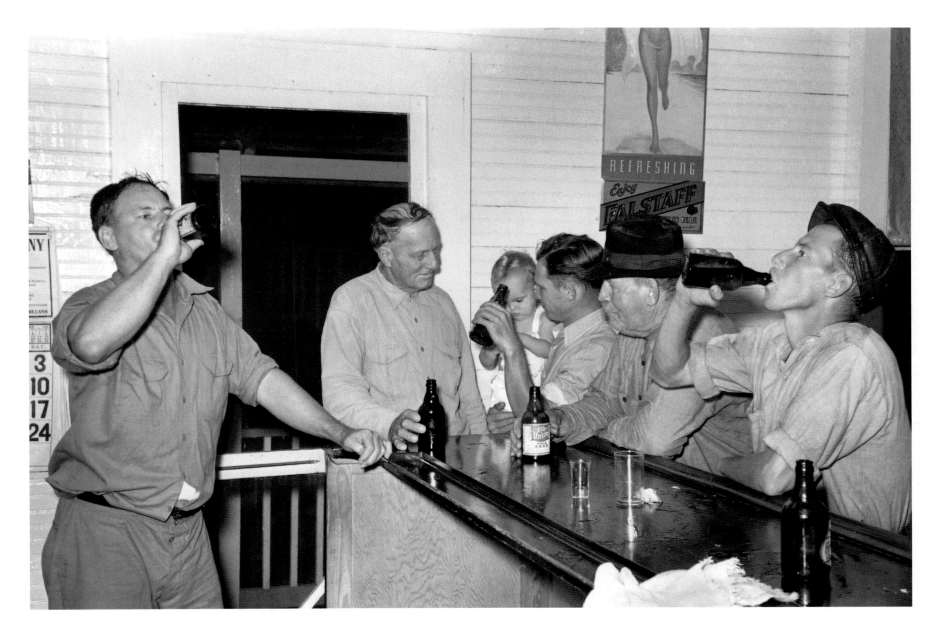

Drinking at the bar in Pilottown, Louisiana
RUSSELL LEE, SEPTEMBER 1938

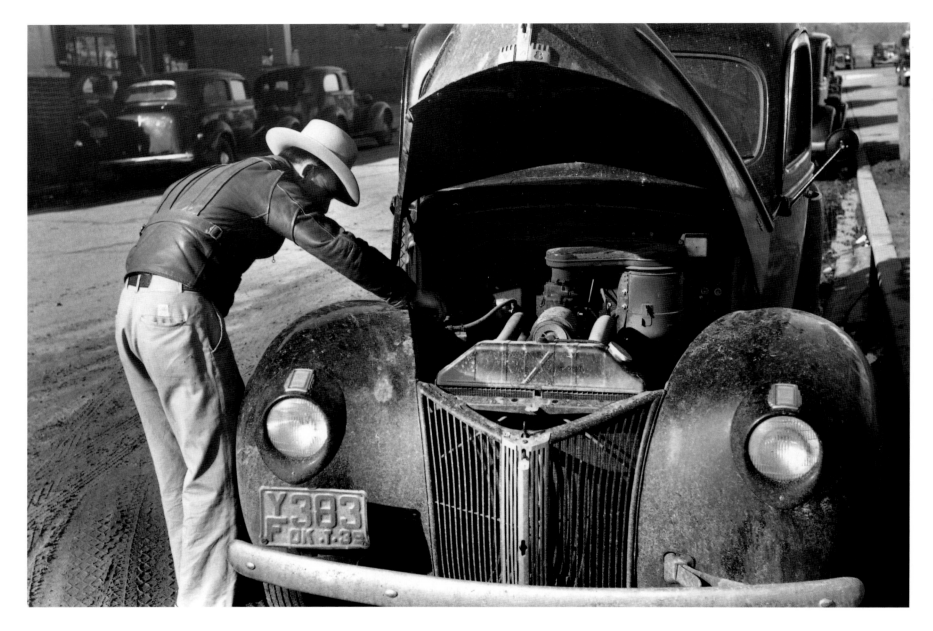

Farmer working on his car while he is in town, Eufaula, Oklahoma
RUSSELL LEE, FEBRUARY 1940

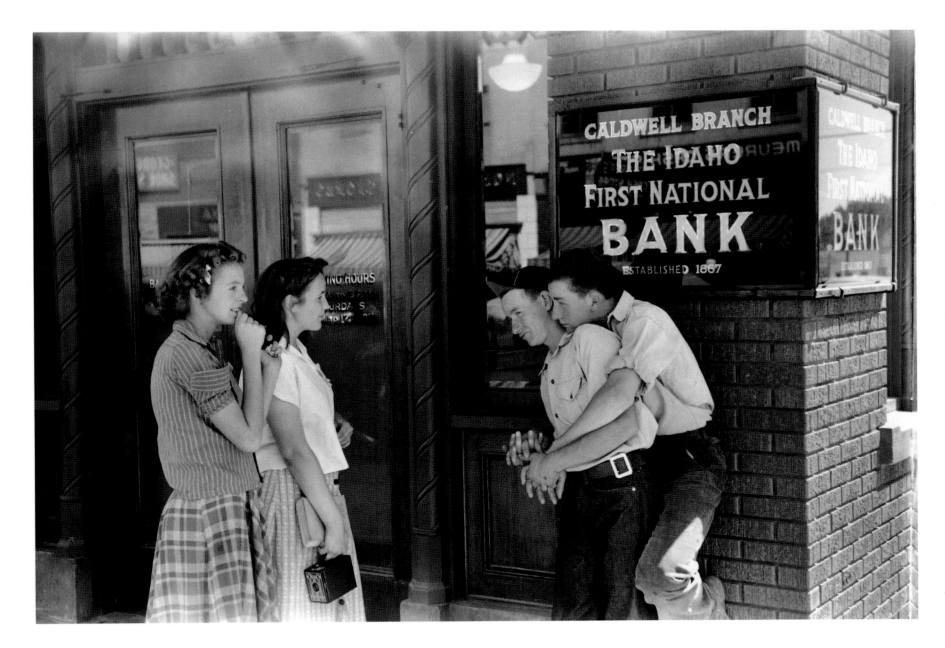

153

Boys and girls, Caldwell, Idaho
RUSSELL LEE, JUNE–JULY 1941

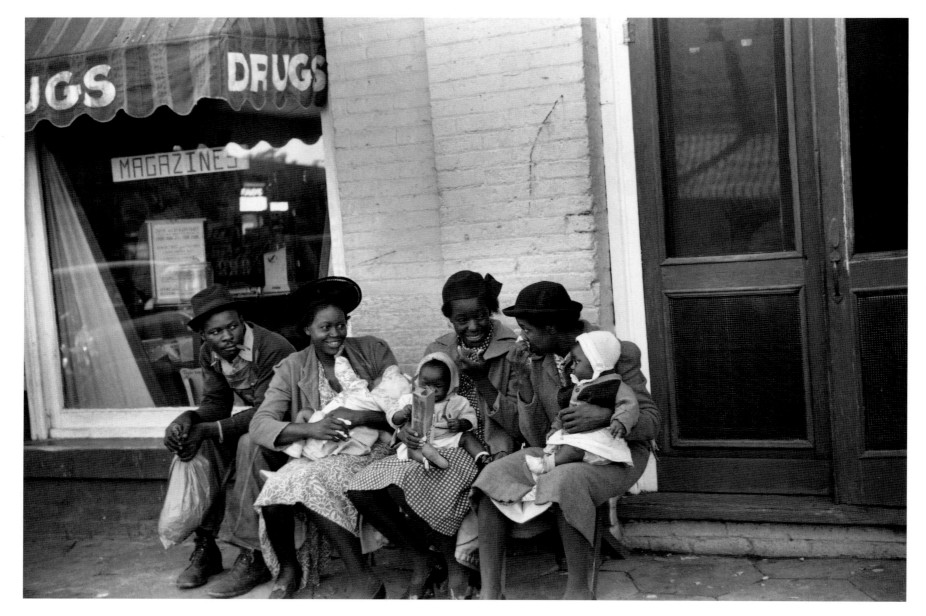

Street scene, Greensboro, Greene County, Georgia

Jack Delano, 1941

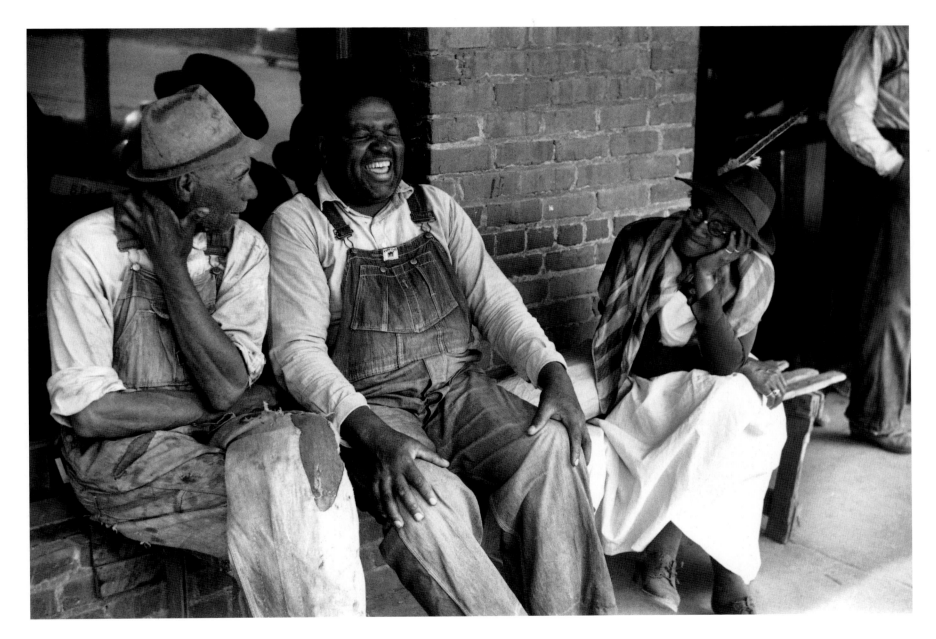

155

Saturday afternoon in Franklin, Heard County, Georgia

Jack Delano, April–May 1941

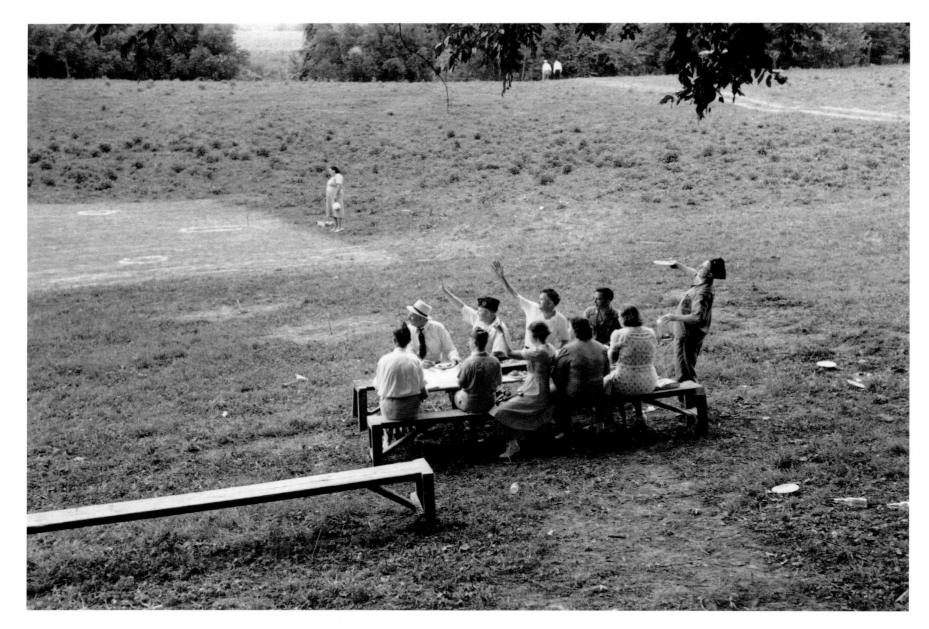

Legionnaires and their wives eating and drinking beer at American Legion fish fry, Oldham County, Post 39, near Louisville, Kentucky

Marion Post Wolcott, August? 1940

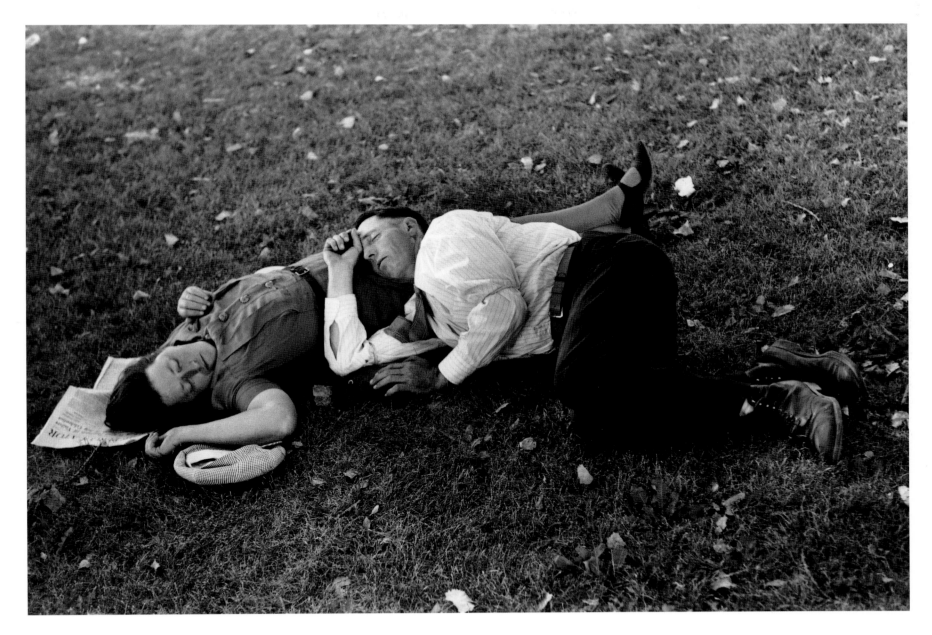

Tired picnickers, Fourth of July, Vale, Oregon

Russell Lee, July 1941

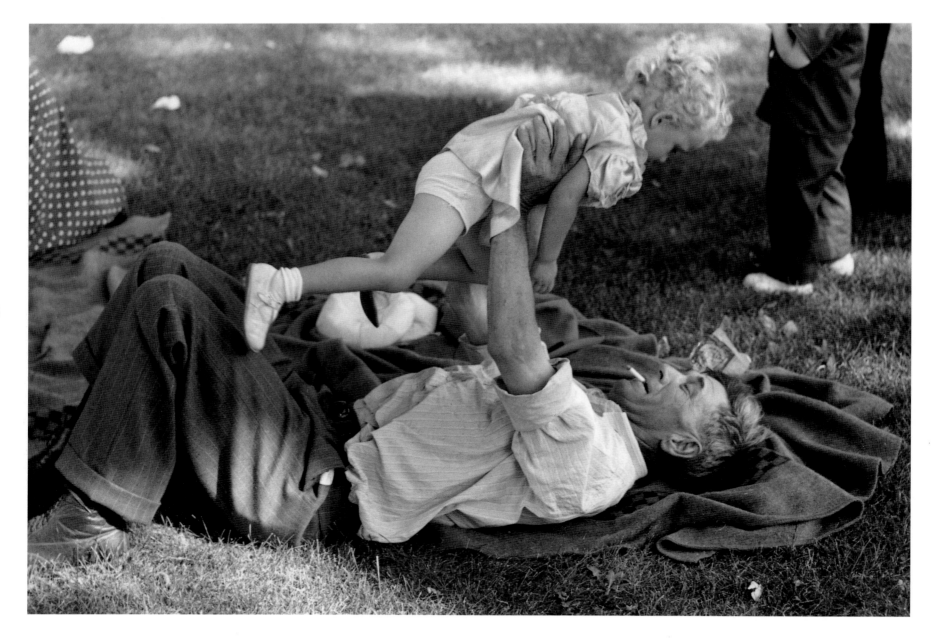

Untitled (Farmer with his granddaughter. Picnic in a park, Fourth of July, Vale, Oregon)
RUSSELL LEE, JULY 1941

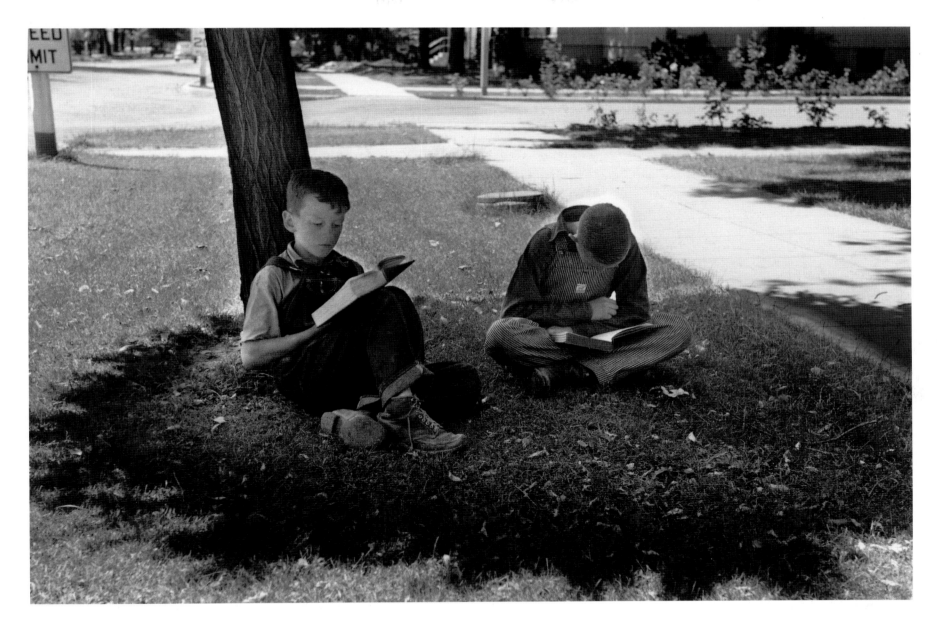

Boys read storybooks in the shade, Caldwell, Idaho
RUSSELL LEE, JULY 1941

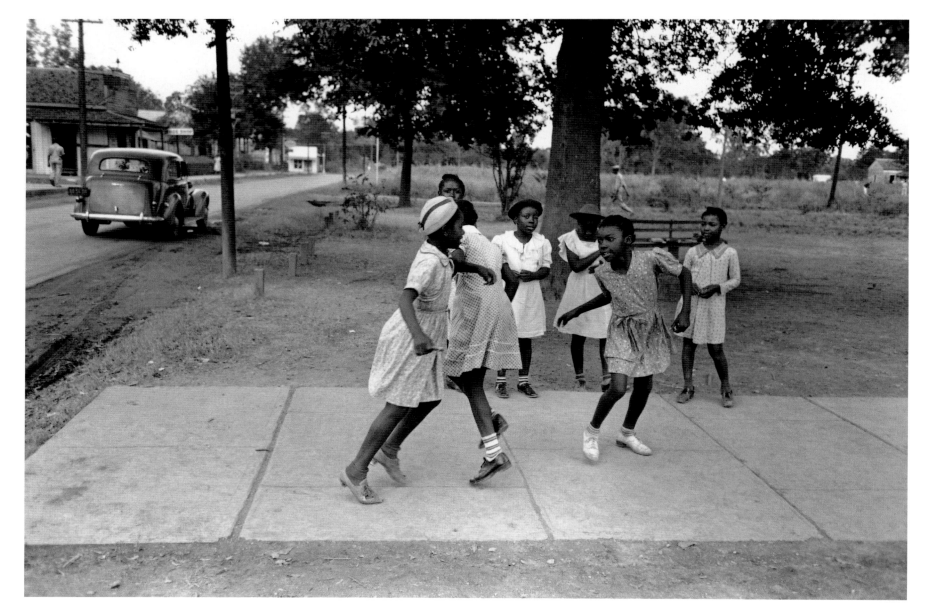

Little Negro girls playing, Lafayette, Louisiana
RUSSELL LEE, OCTOBER 1938

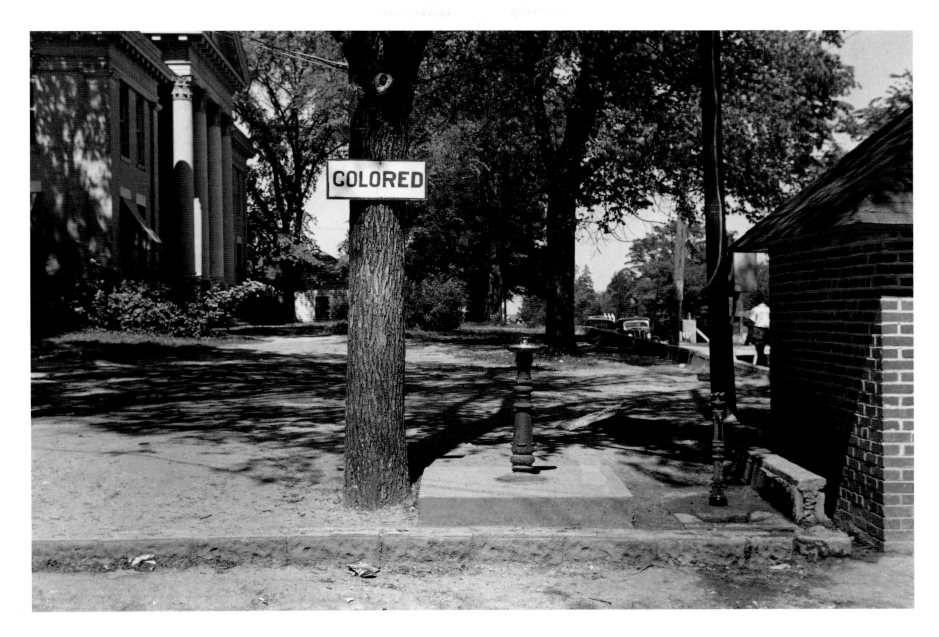

161

Untitled (Halifax, North Carolina)
John Vachon, April 1938

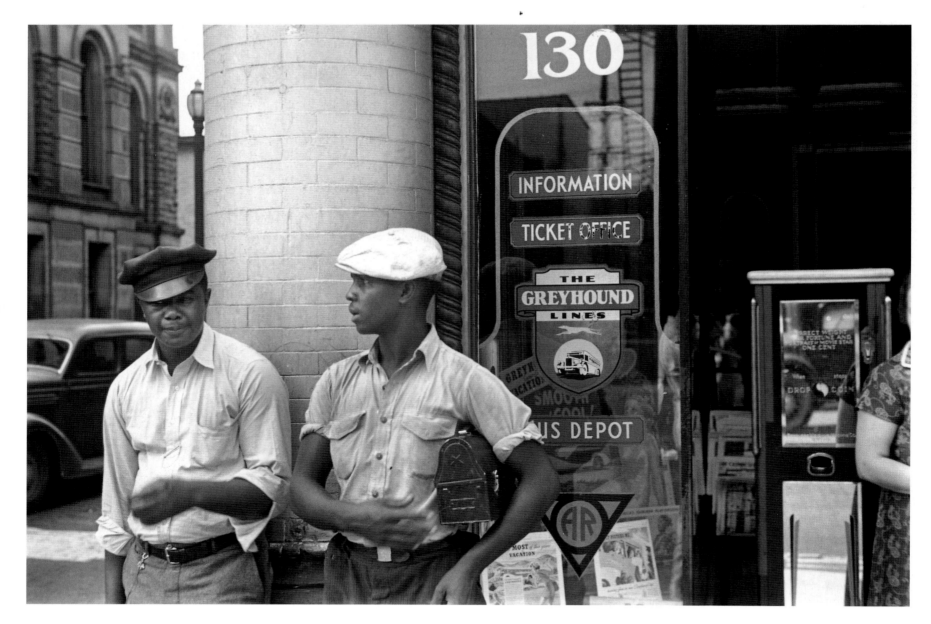

Bus station, Marion, Ohio

Ben Shahn, Summer 1938

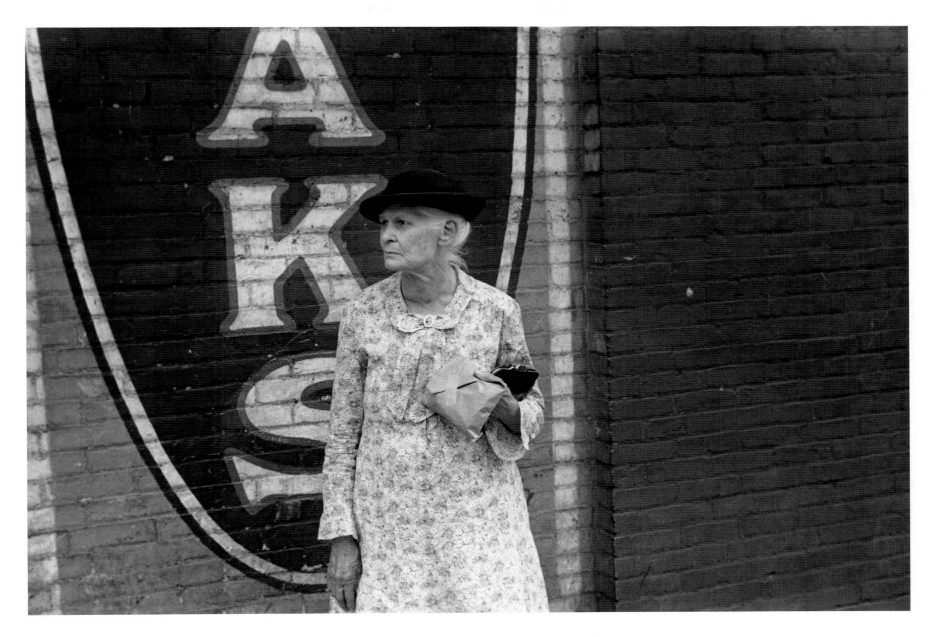

Untitled (Marysville, Ohio)

BEN SHAHN, SUMMER 1938

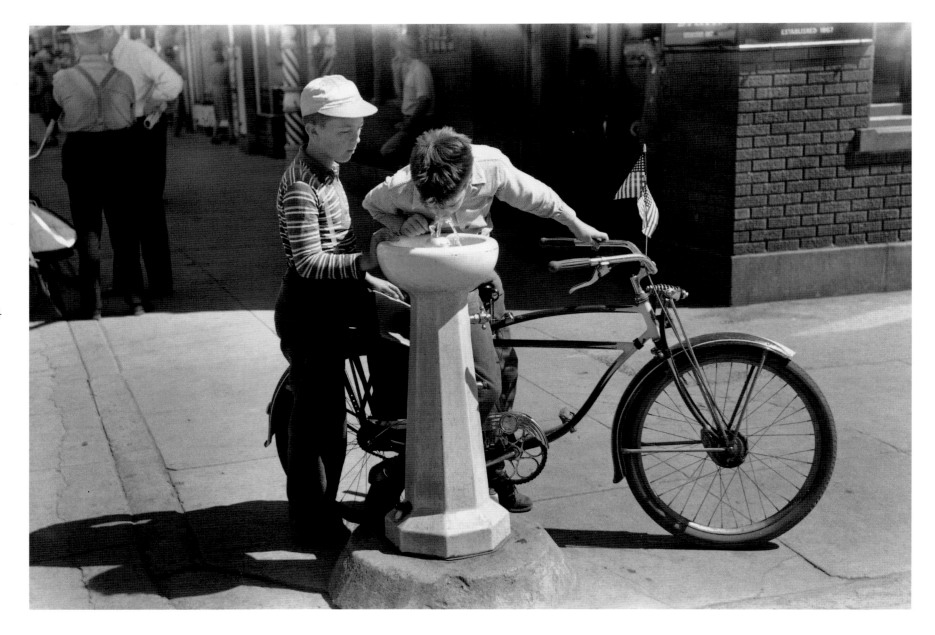

Water fountain, Caldwell, Idaho
RUSSELL LEE, JUNE–JULY 1941

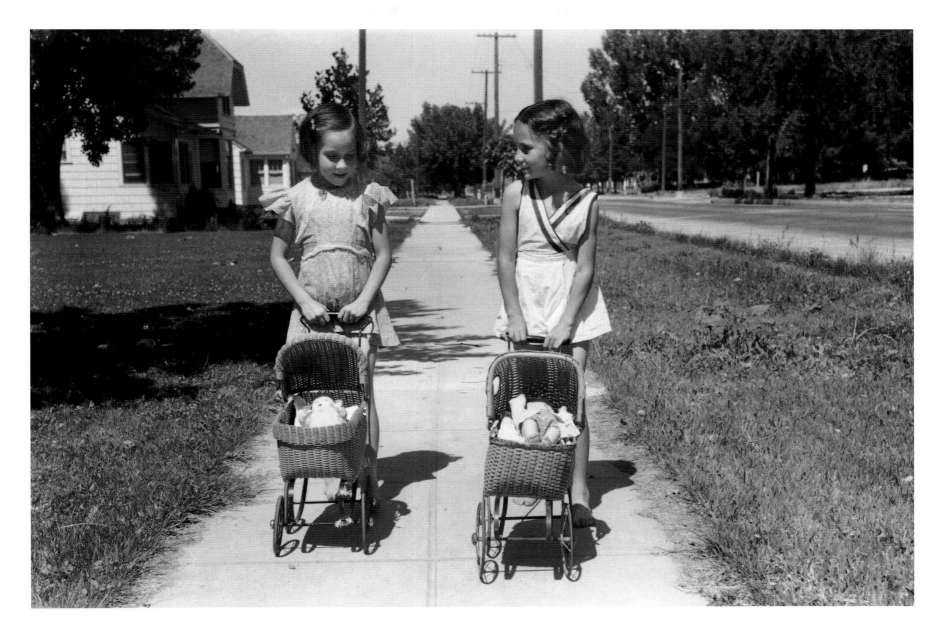

Little girls with their dolls and buggies, Caldwell, Idaho

RUSSELL LEE, JUNE–JULY 1941

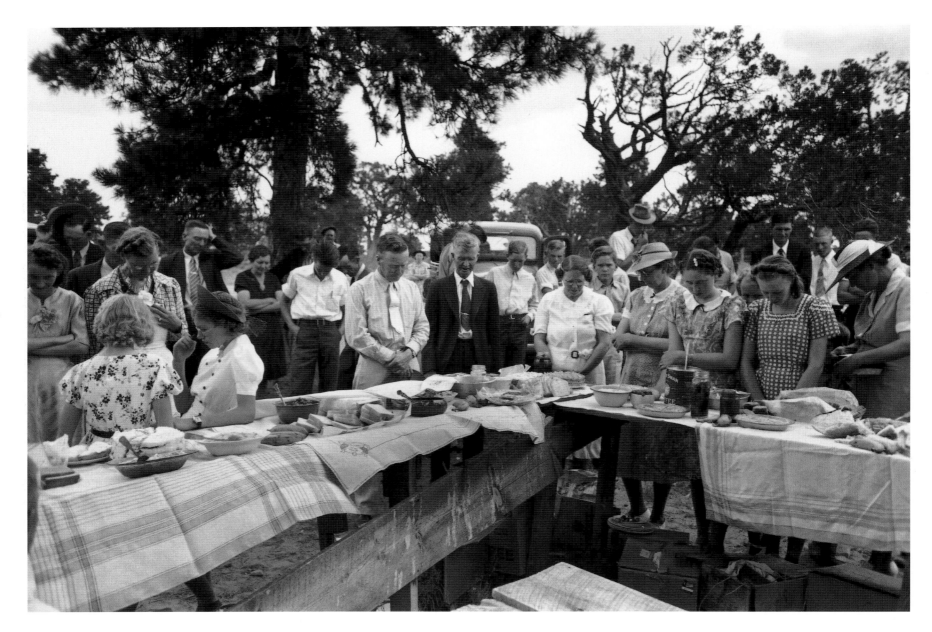

The blessing at dinner at the grounds at the all-day community sing, Pie Town, New Mexico

RUSSELL LEE, JUNE 1940

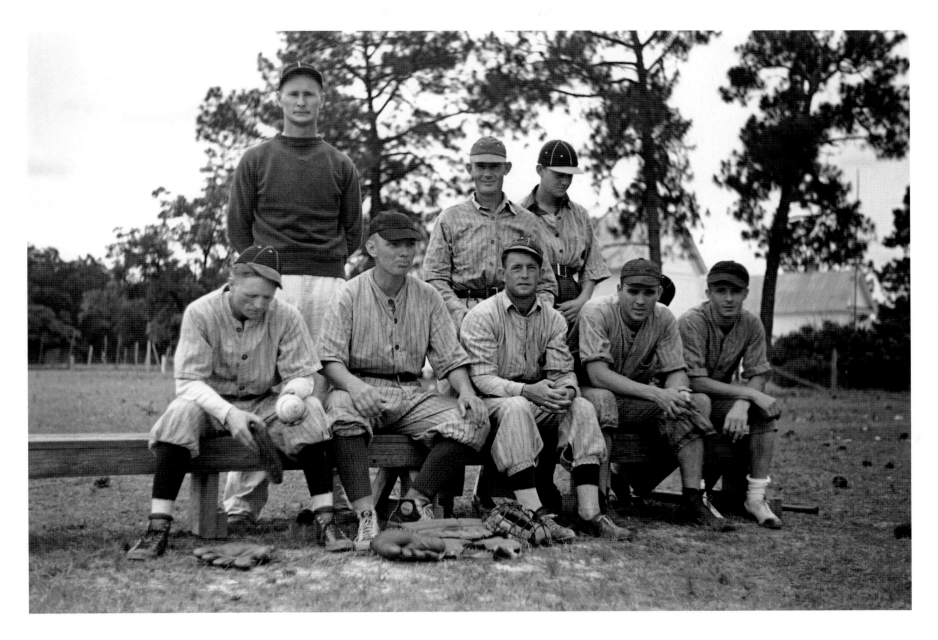

Ball team at Irwinville Farms, Georgia

John Vachon, May 1938

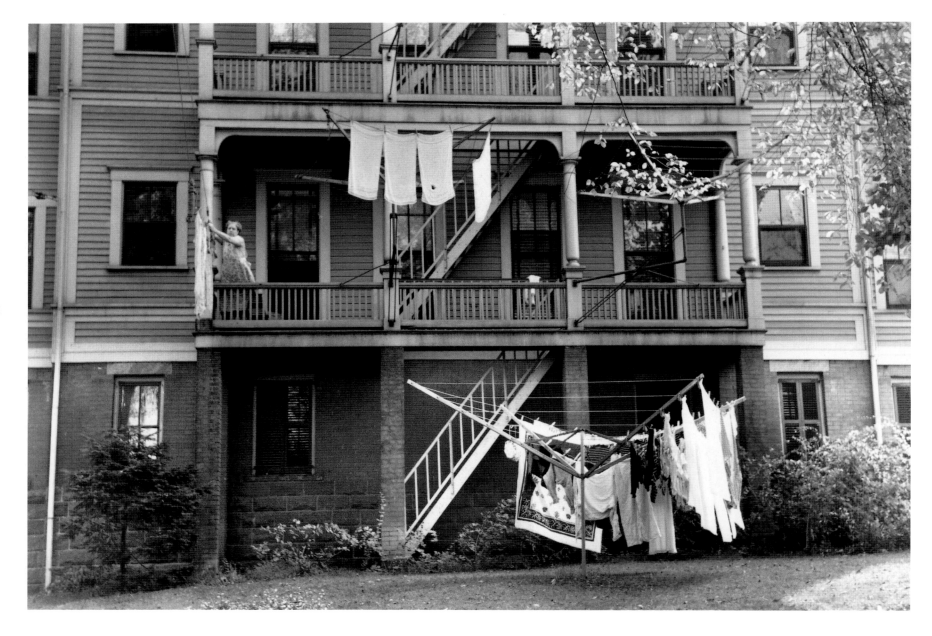

Rear of apartment house, Meriden, Connecticut

RUSSELL LEE, OCTOBER 1939

A bridge party on the lawn of a home in the outskirts of White River Junction, Vermont

Jack Delano, August 1941

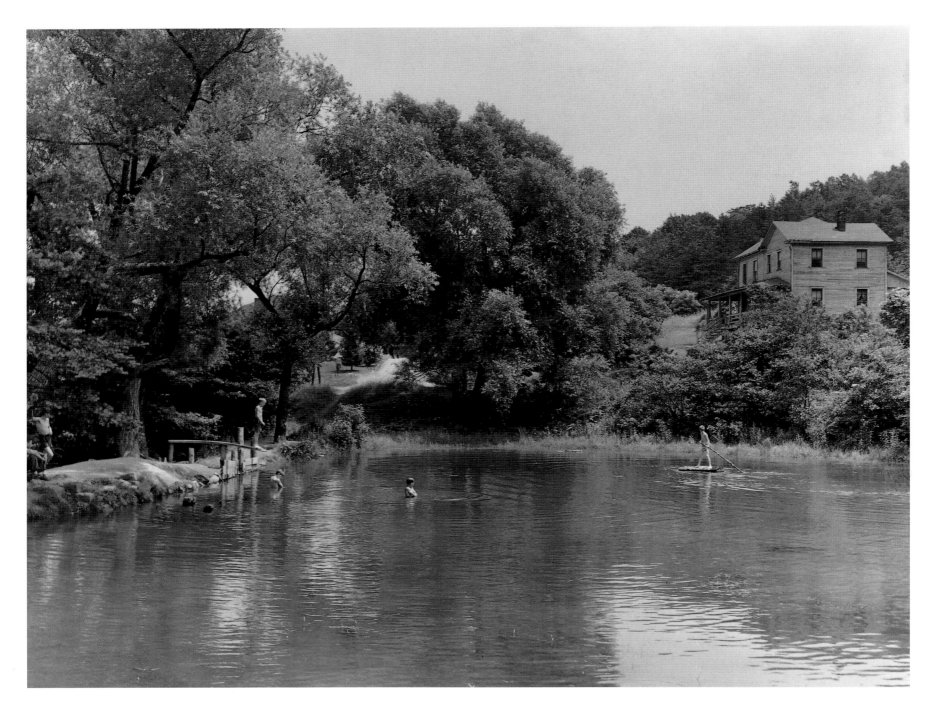

Swimming hole, Pine Grove Mills, Pennsylvania
EDWIN ROSSKAM, July 1941

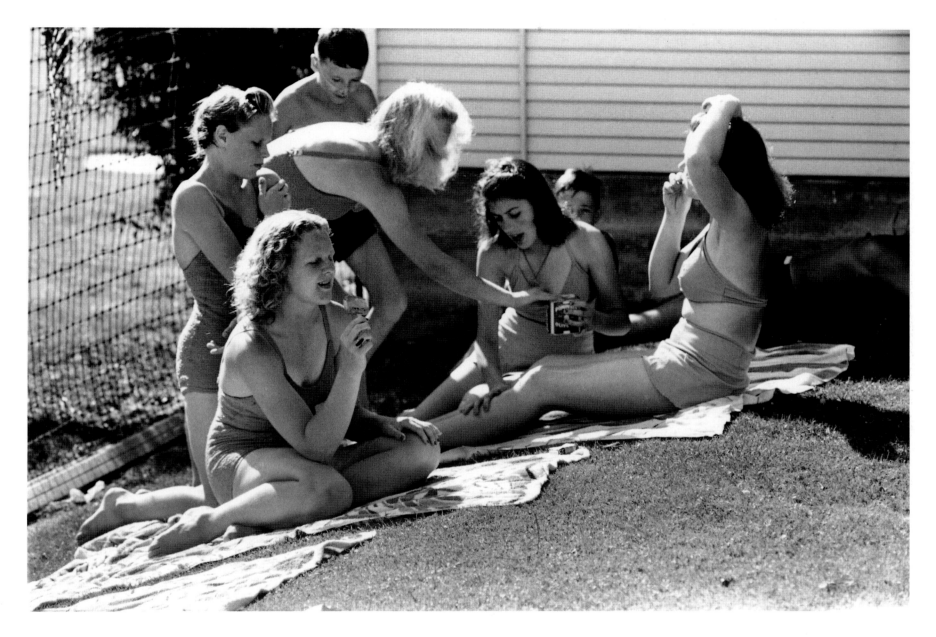

Sun bathers at the park swimming pool, Caldwell, Idaho

RUSSELL LEE, JULY 1941

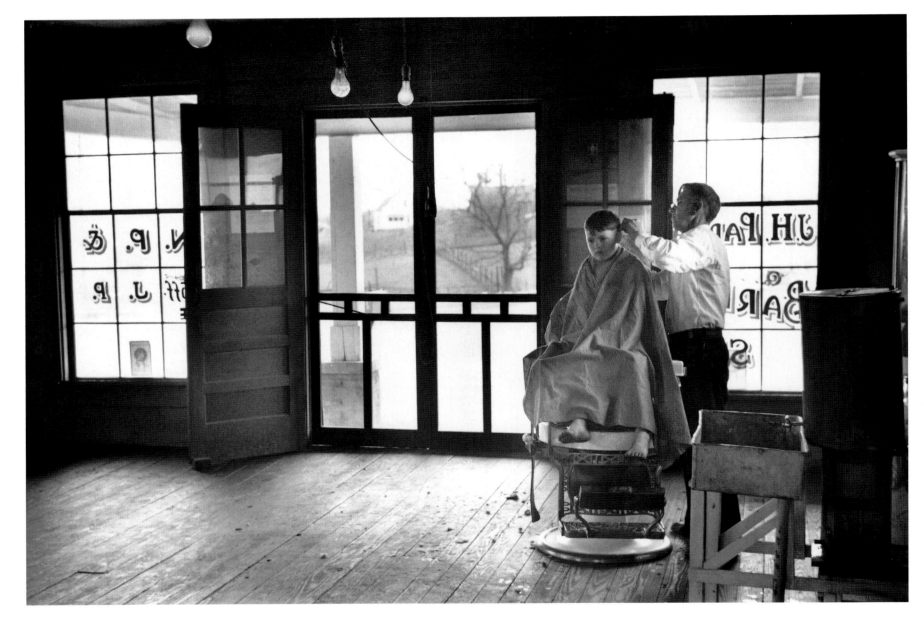

Mr. J. H. Parham, barber and notary public in Centralhatchee, Heard County, Georgia
JACK DELANO, APRIL–MAY 1941

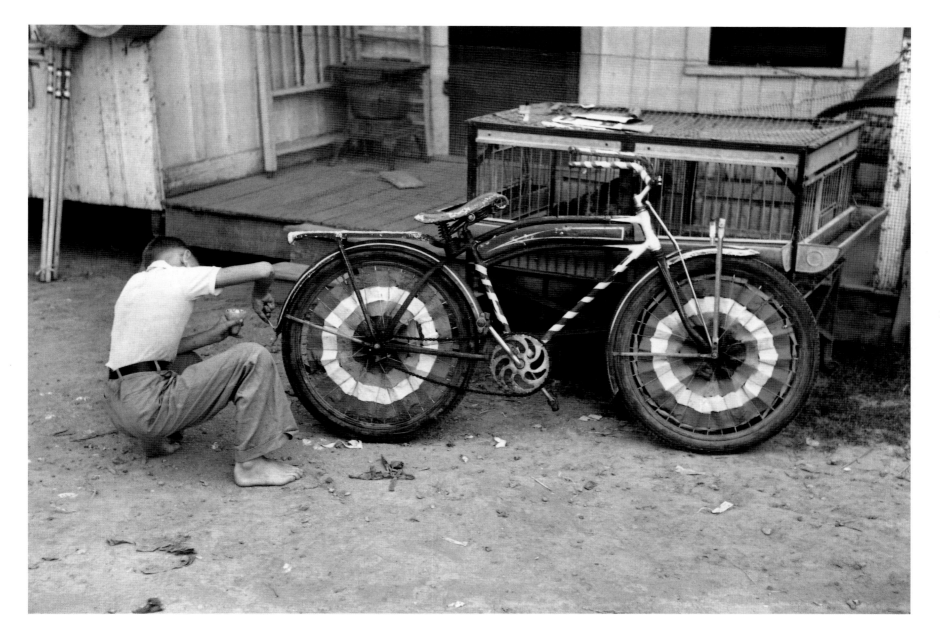

173

Untitled (Crowley, Louisiana)
Russell Lee, October 1936

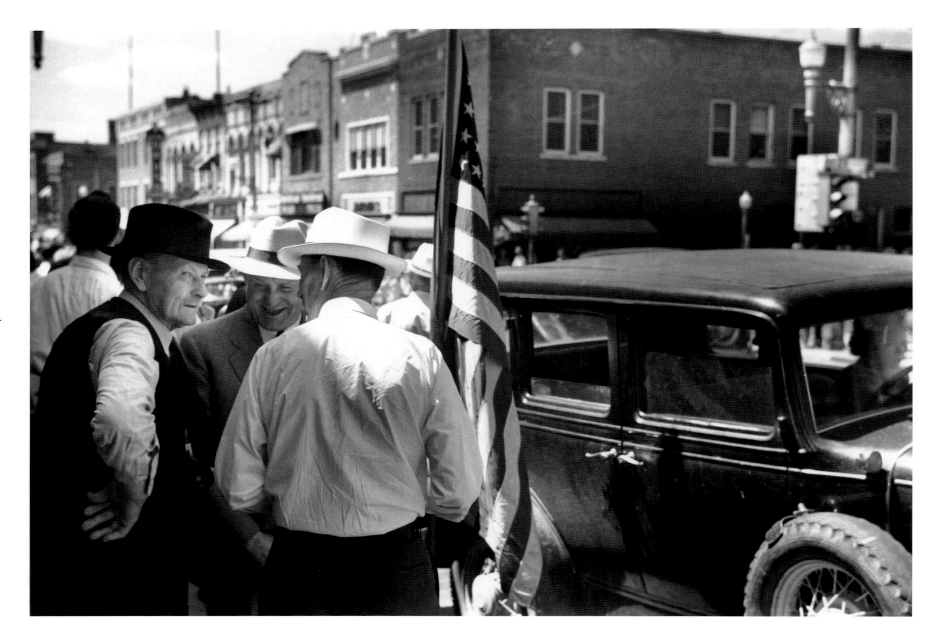

Untitled (Oconomowoc, Wisconsin)

John Vachon, July 1941

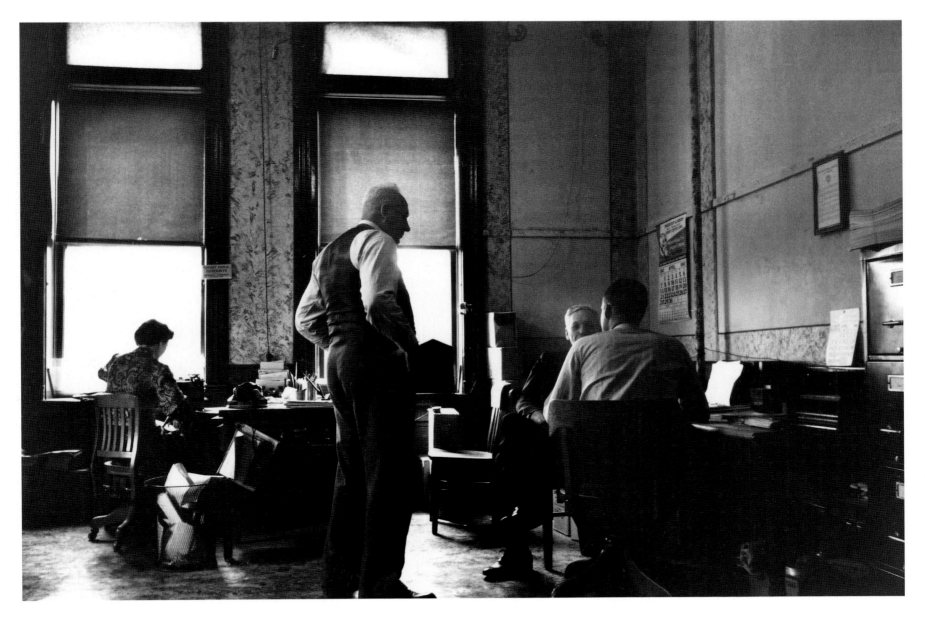

Untitled (Gundy County, Iowa)

John Vachon, April 1940

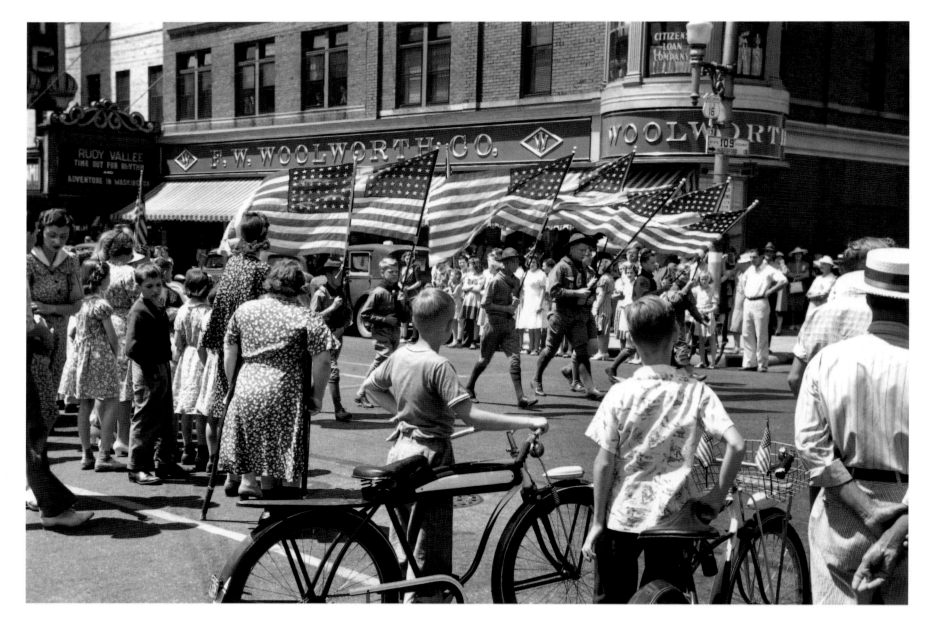

Fourth of July Parade, Watertown, Wisconsin

JOHN VACHON, JULY 1941

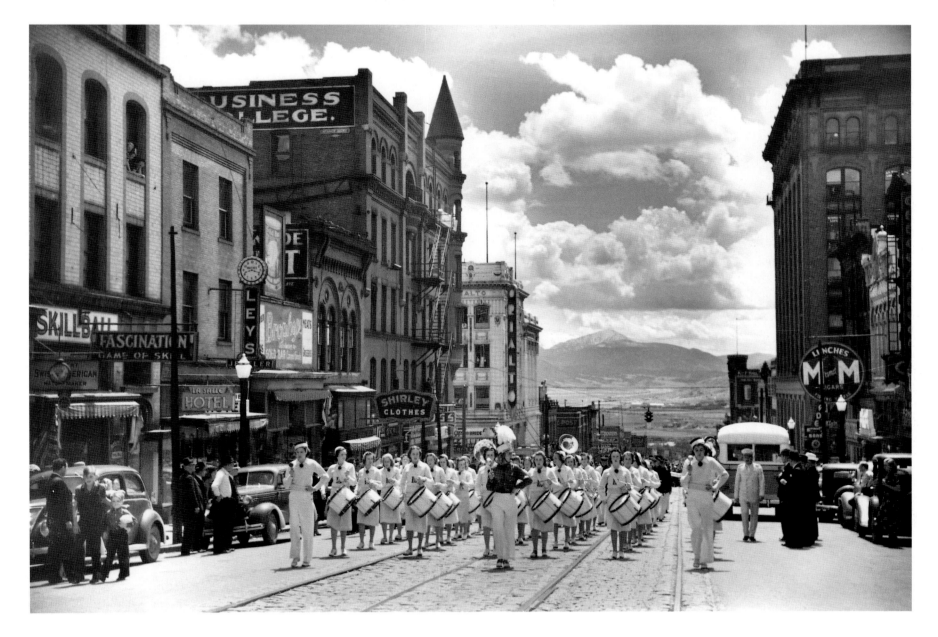

High school band parading up Montana Street, Butte, Montana
ARTHUR ROTHSTEIN, SUMMER 1939

Boys walking fence, Washington, Indiana
JOHN VACHON, JULY 1941

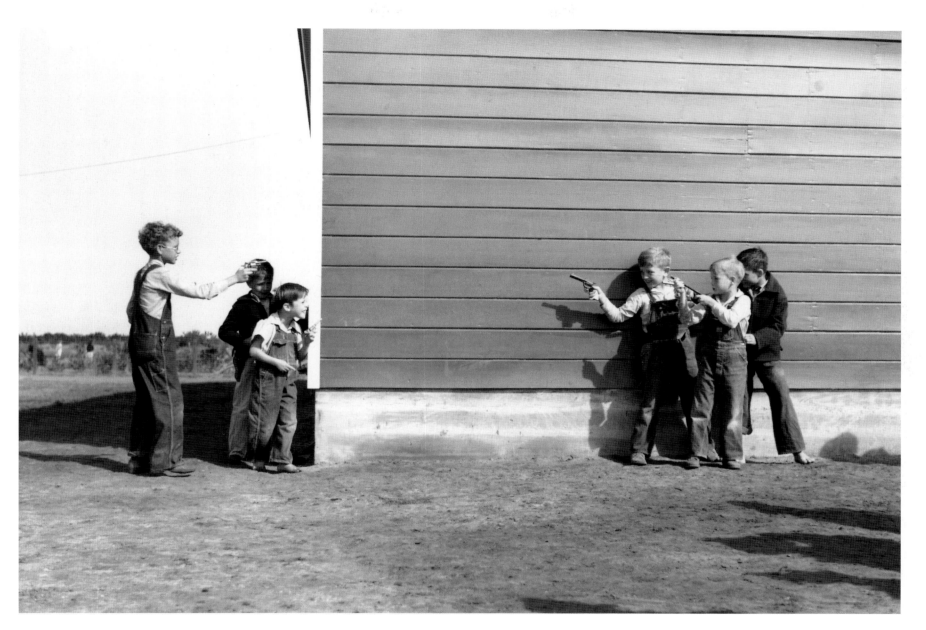

Cowboys and Indians: Schoolchildren, Farm Security Administration camp, Weslaco, Texas
ARTHUR ROTHSTEIN, JANUARY 1942

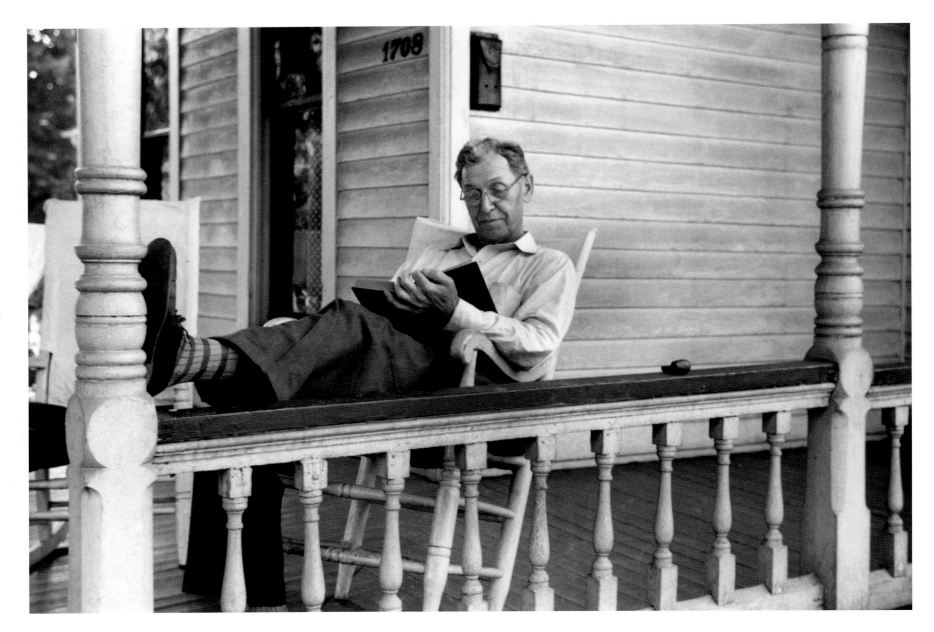

Front porch, Sunday afternoon, Vincennes, Indiana

John Vachon, July 1941

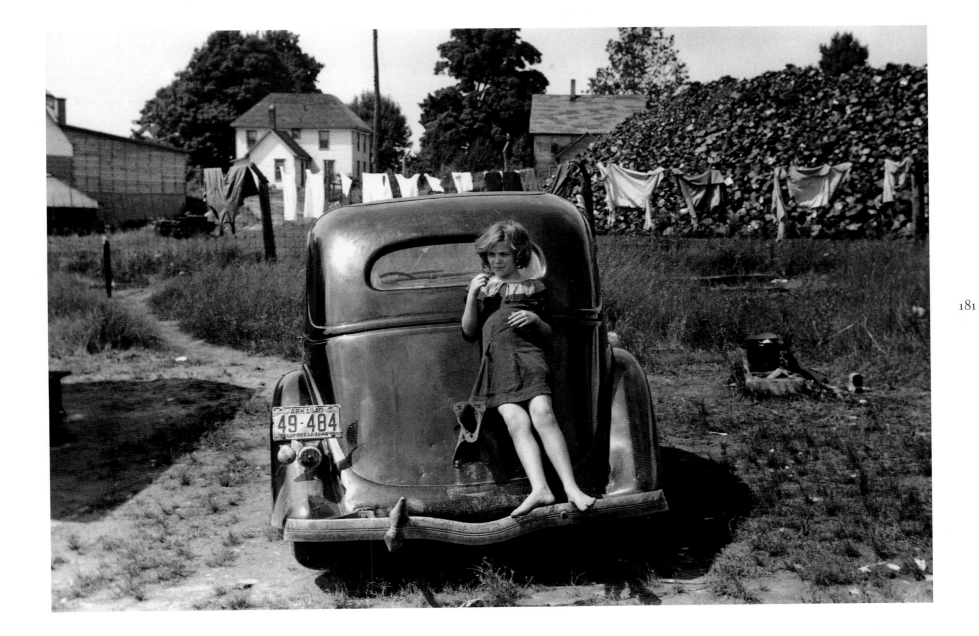

Untitled (Company housing, fruit-picking plant, Berrien County, Michigan)

John Vachon, July 1940

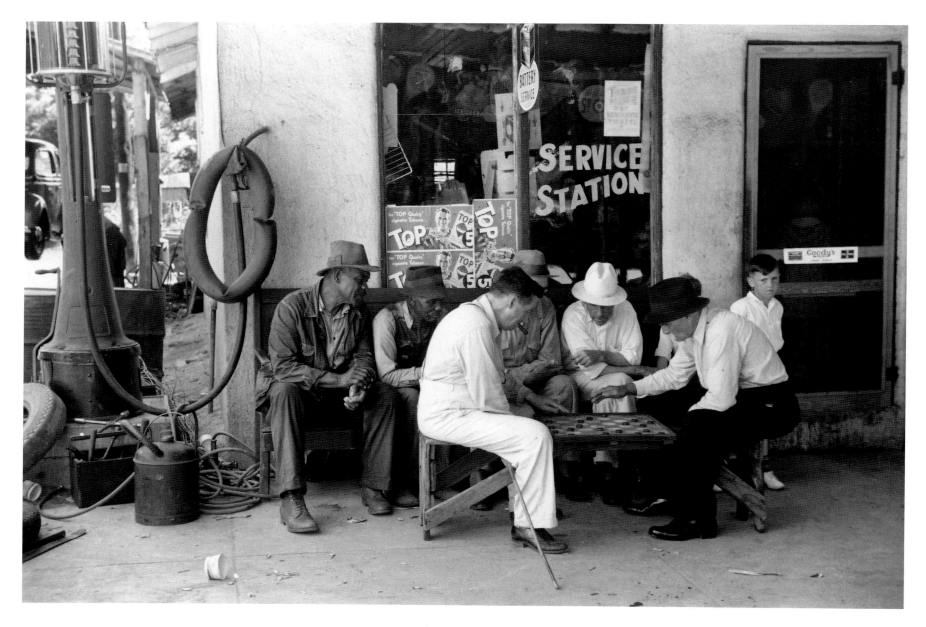

Greensboro, Greene County, Georgia. Playing checkers outside a service station on a Saturday afternoon.
Marion Post Wolcott, June? 1939

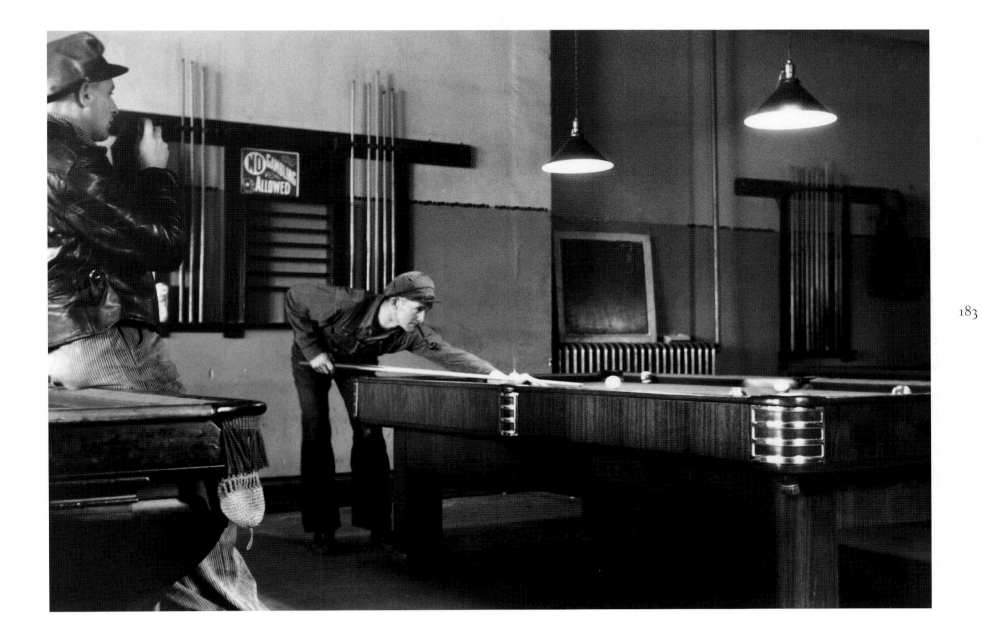

183

Untitled (Scranton, Iowa)

John Vachon, May 1940

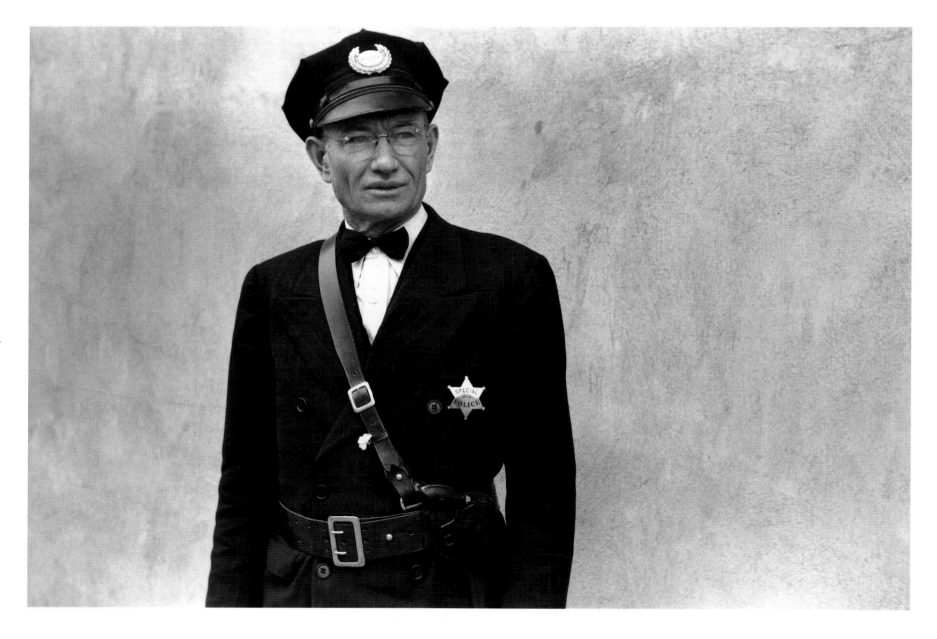

184

ABOVE: Untitled (Town policeman, Litchfield, Minnesota)

JOHN VACHON, SEPTEMBER 1939

OPPOSITE: Negro in Greenville, Mississippi

DOROTHEA LANGE, 1936

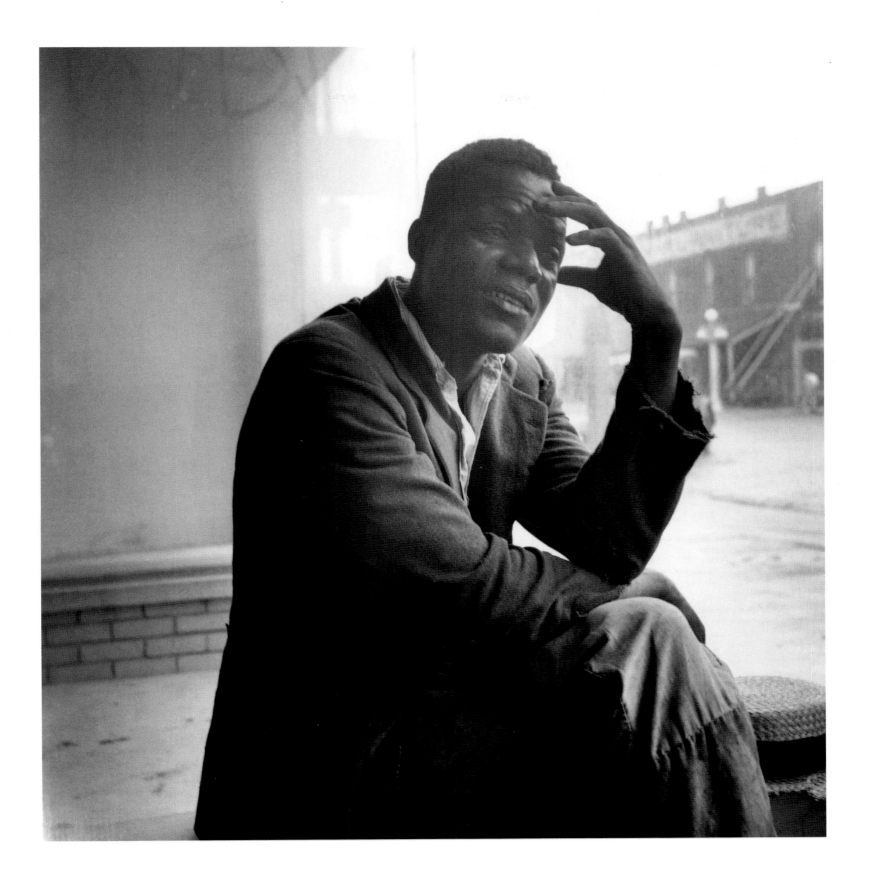

186

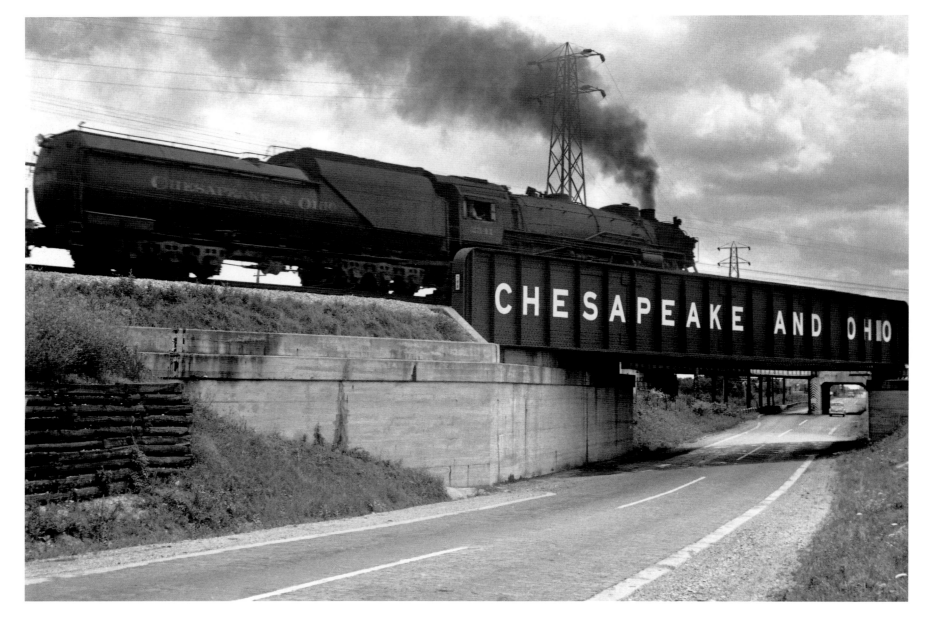

Underpass in central Ohio, Route 40
Ben Shahn, Summer 1938

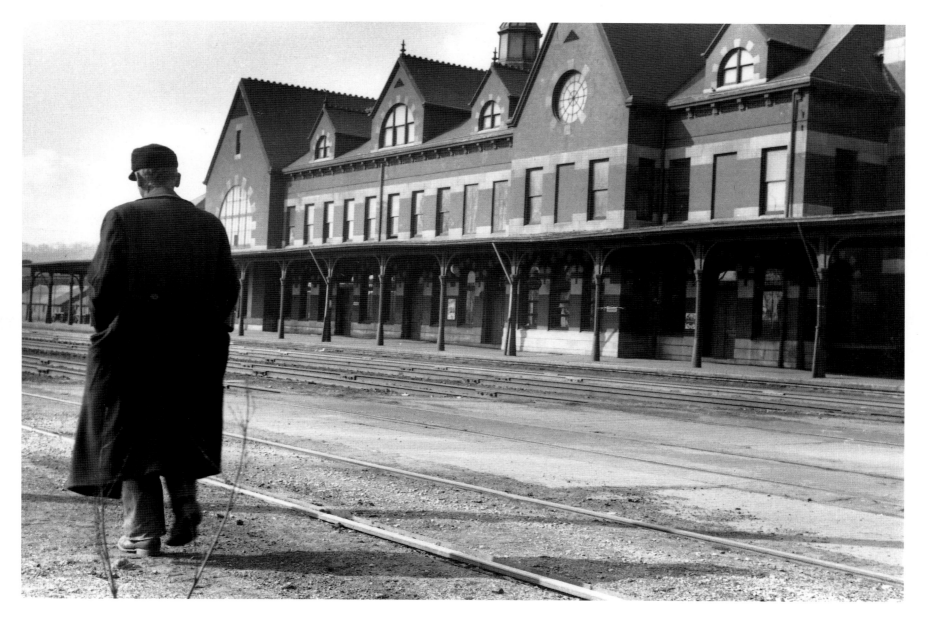

Untitled (Dubuque, Iowa)

John Vachon, April 1940

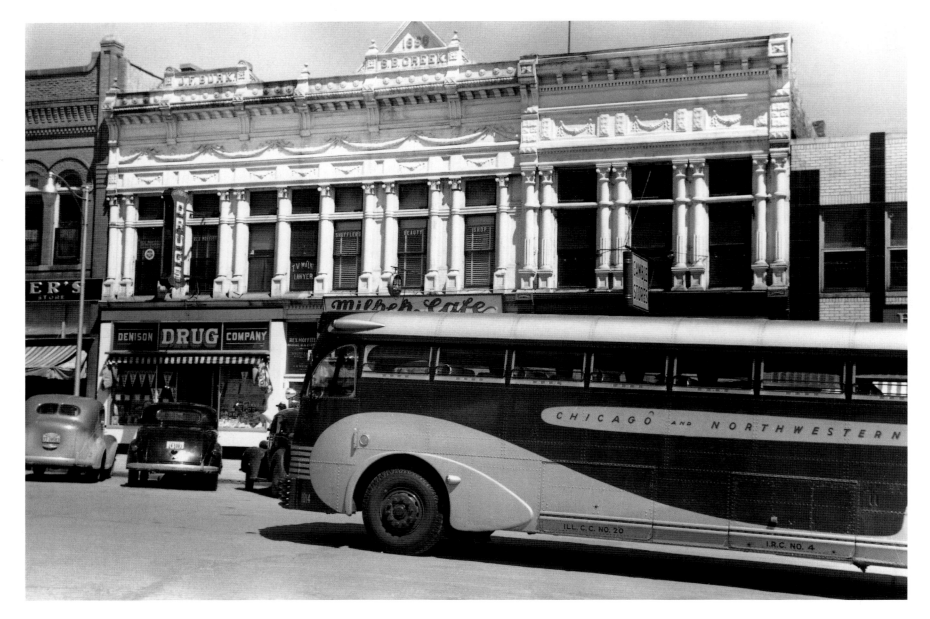

Bus going through Dubuque, Iowa

John Vachon, May 1940

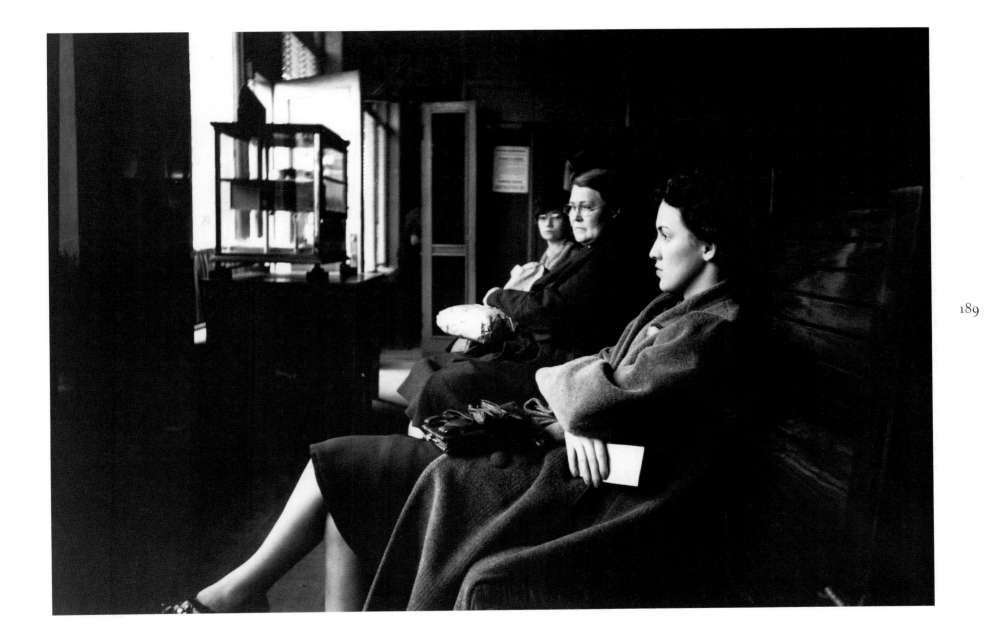

Untitled (Jasper County, Iowa)
JOHN VACHON, APRIL 1940

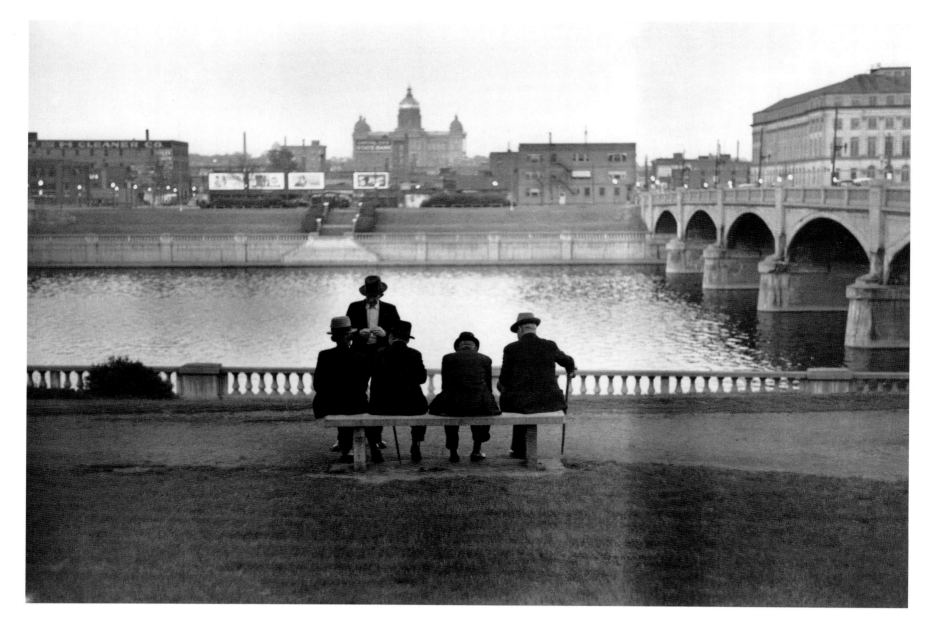

Men sitting on bench along Des Moines River, State capitol in background, Des Moines, Iowa

John Vachon, May 1940

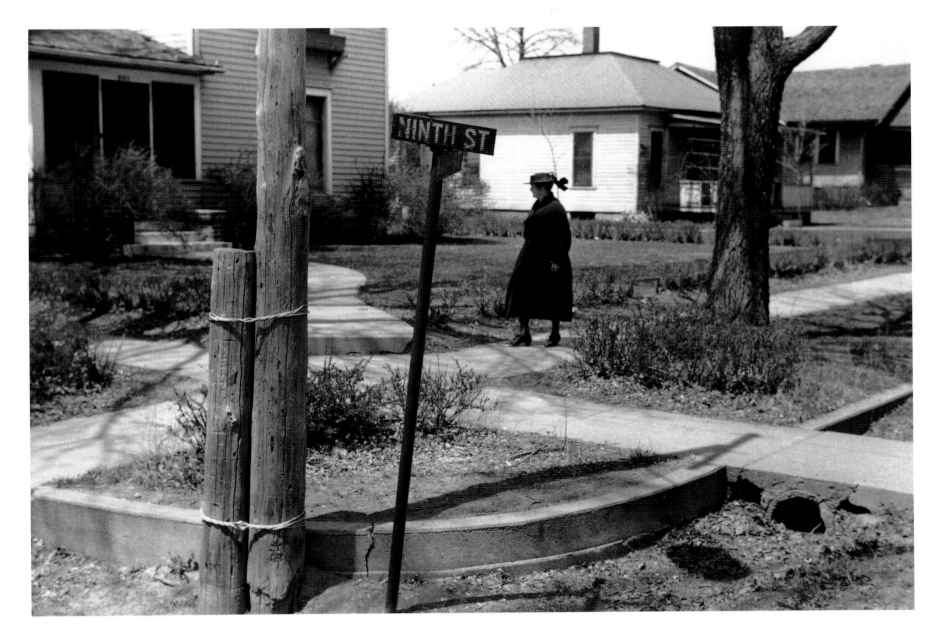

Residential street, Woodbine, Iowa

John Vachon, May 1940

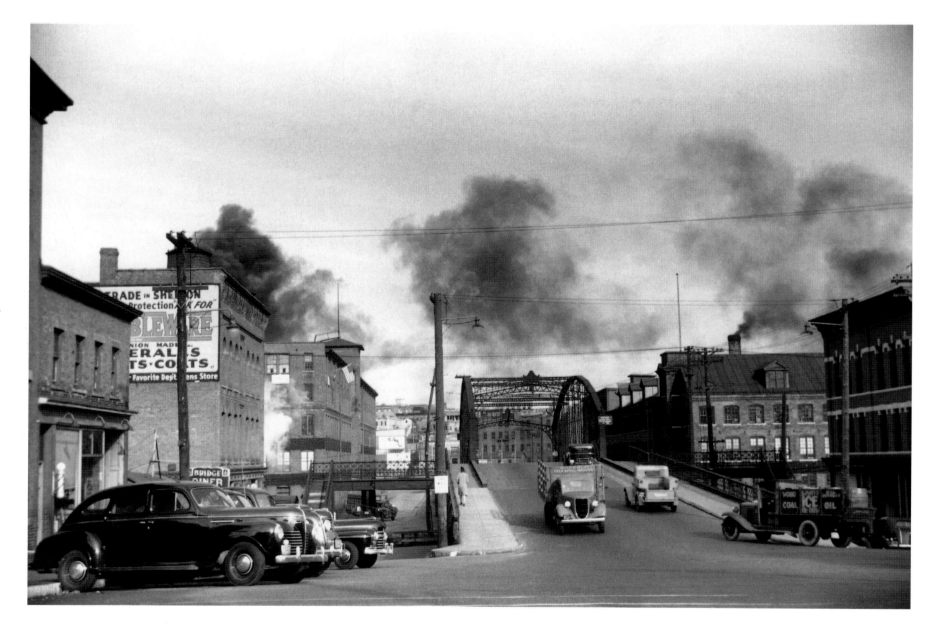

Untitled (Norwich, Connecticut)

Jack Delano, November 1940

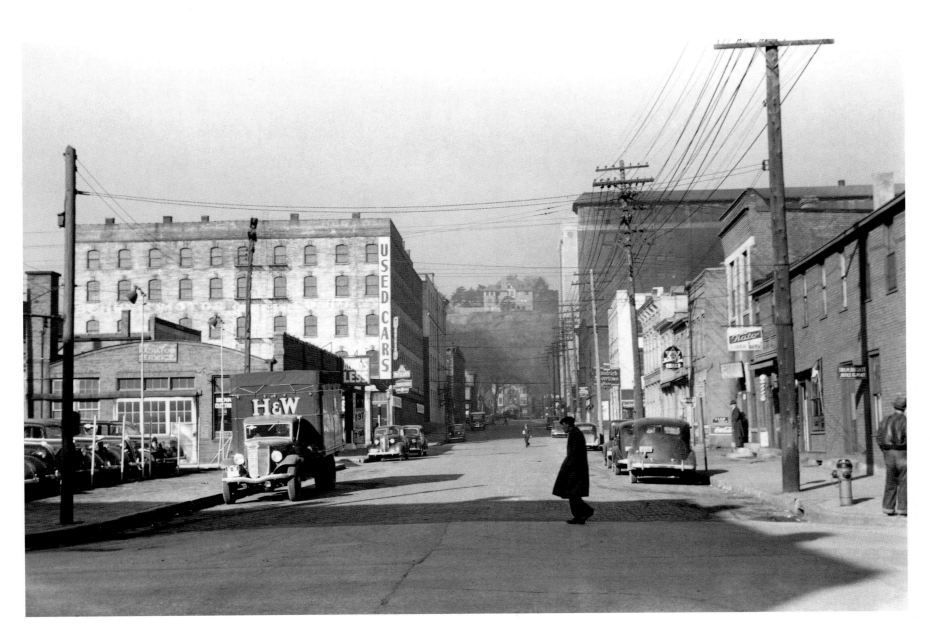

Business section, Dubuque, Iowa. The rich life in houses on the cliffs seen in the background.
JOHN VACHON, APRIL 1940

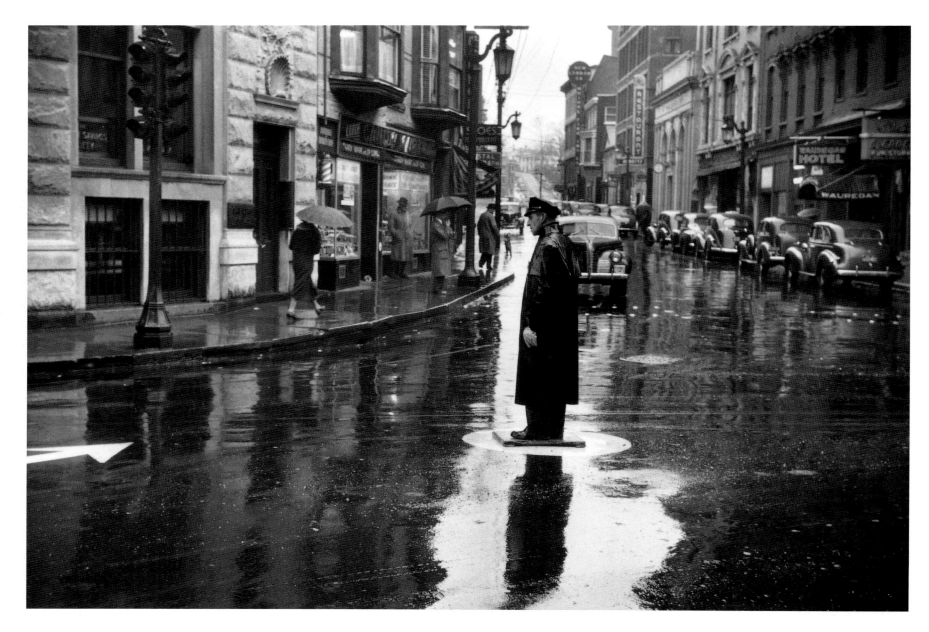

Street scene on a rainy day in Norwich, Connecticut

Jack Delano, November 1940

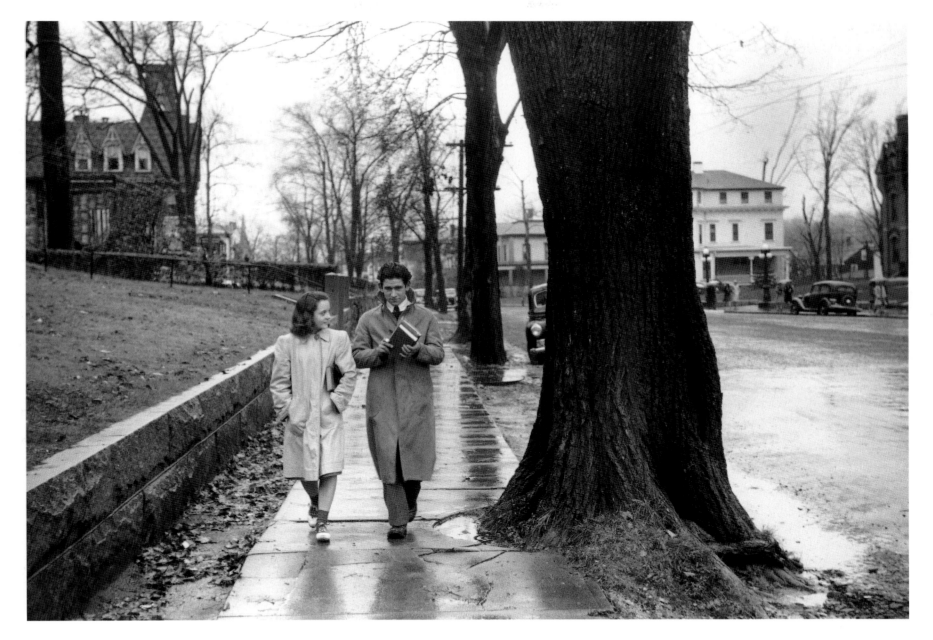

Coming home from school on a rainy day in Norwich, Connecticut

Jack Delano, November 1940

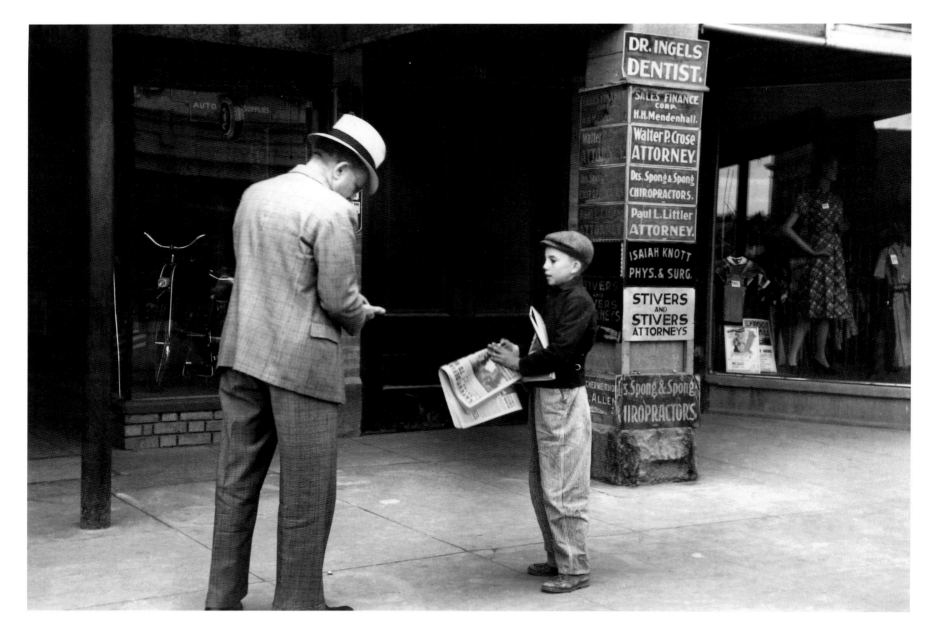

Newsboy on main street, Montrose, Colorado

ARTHUR ROTHSTEIN, OCTOBER 1939

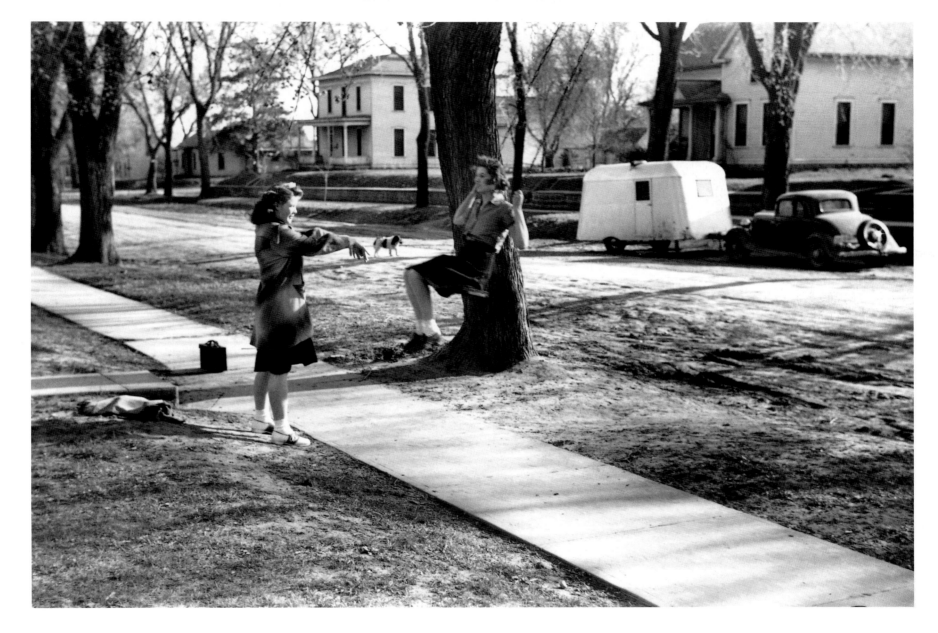

Residential street, Woodbine, Iowa

John Vachon, May 1940

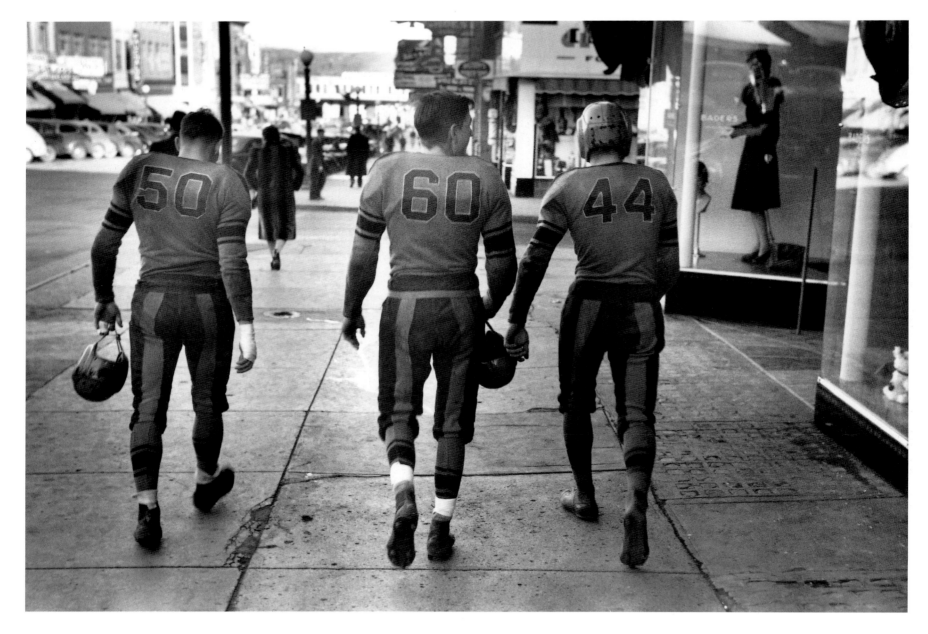

Football players, Minot, North Dakota
John Vachon, October 1940

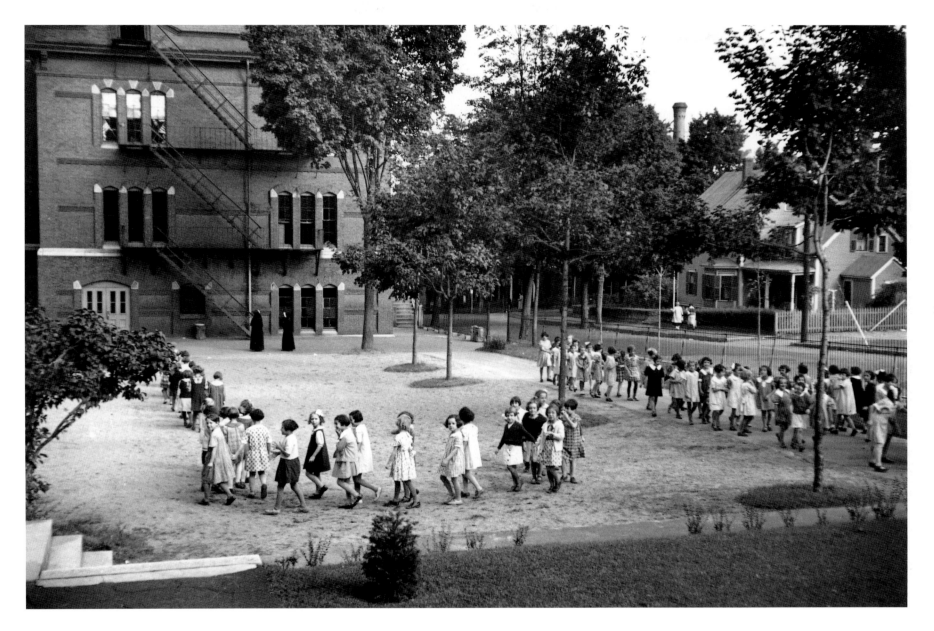

Untitled (Manchester, New Hampshire)
Carl Mydans, October 1936

Putting up storm windows, Hillsboro, North Dakota

John Vachon, October 1940

Nuns walking along a street in Burlington, Vermont

JACK DELANO, SEPTEMBER 1941

202

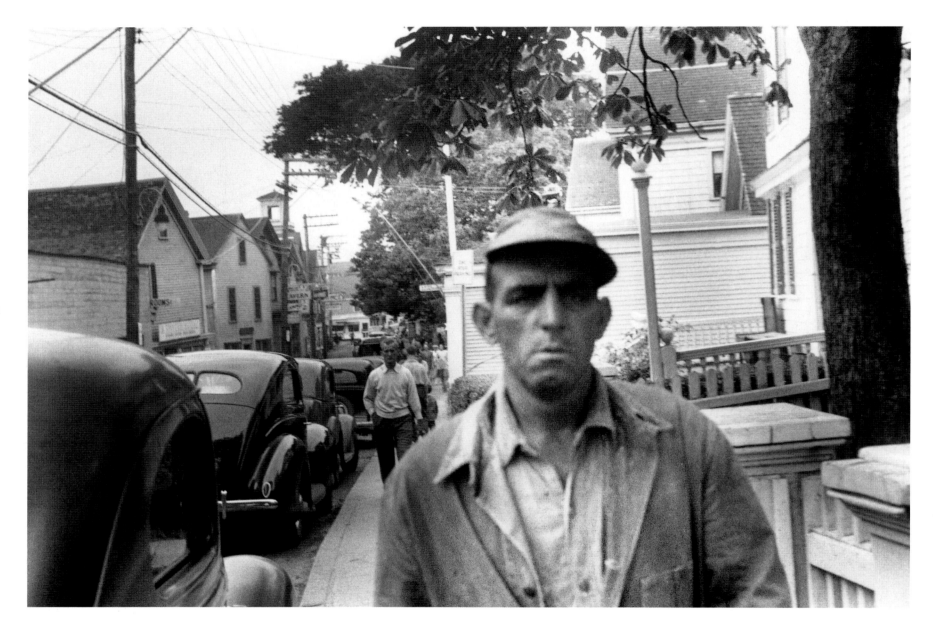

Untitled (Provincetown, Massachusetts)

Edwin Rosskam, August 1940

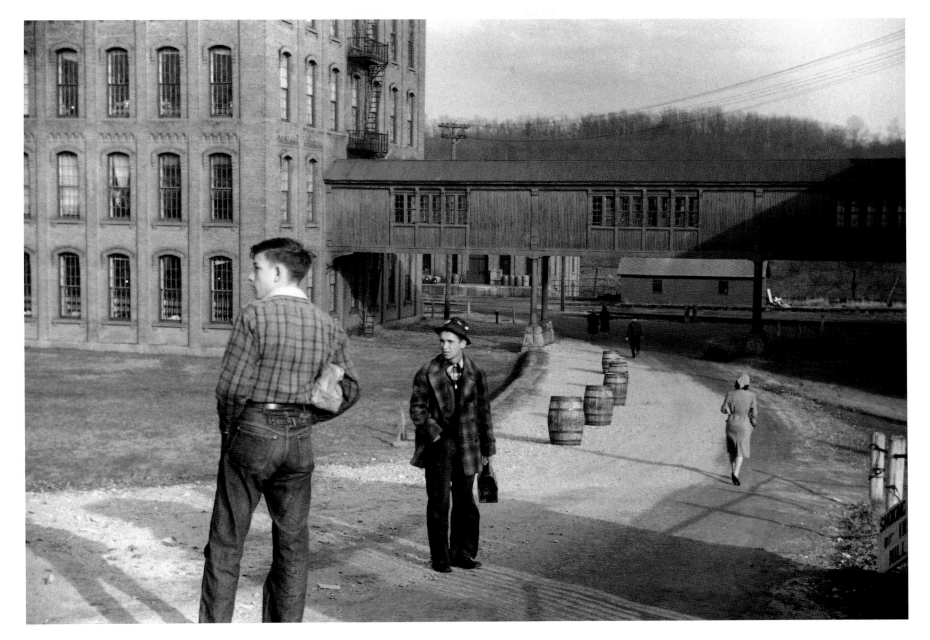

At the change of the shift at the Penomah Mills Inc., Taftville, Connecticut

Jack Delano, November 1940

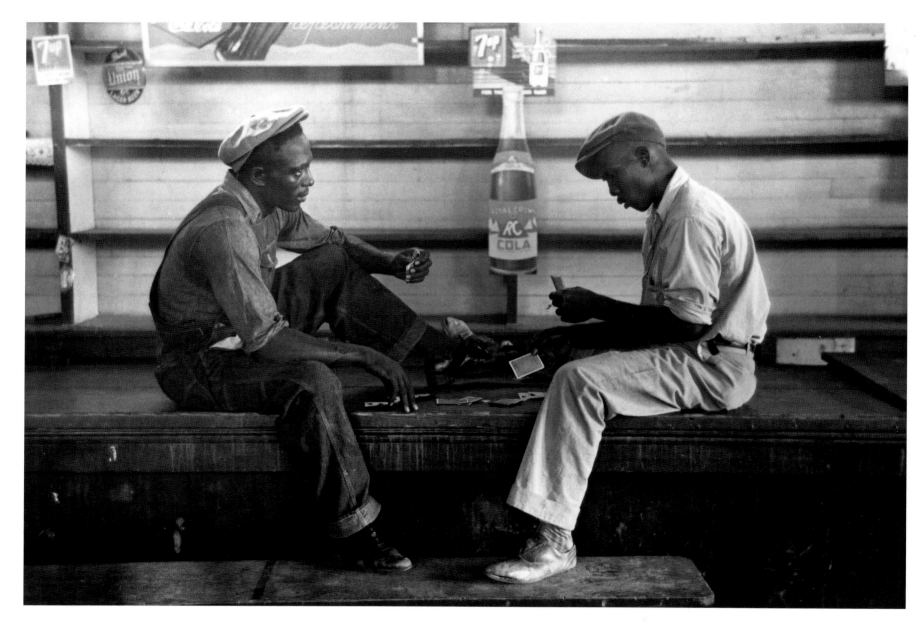

Untitled (Reserve, Louisiana)

Russell Lee, September 1938

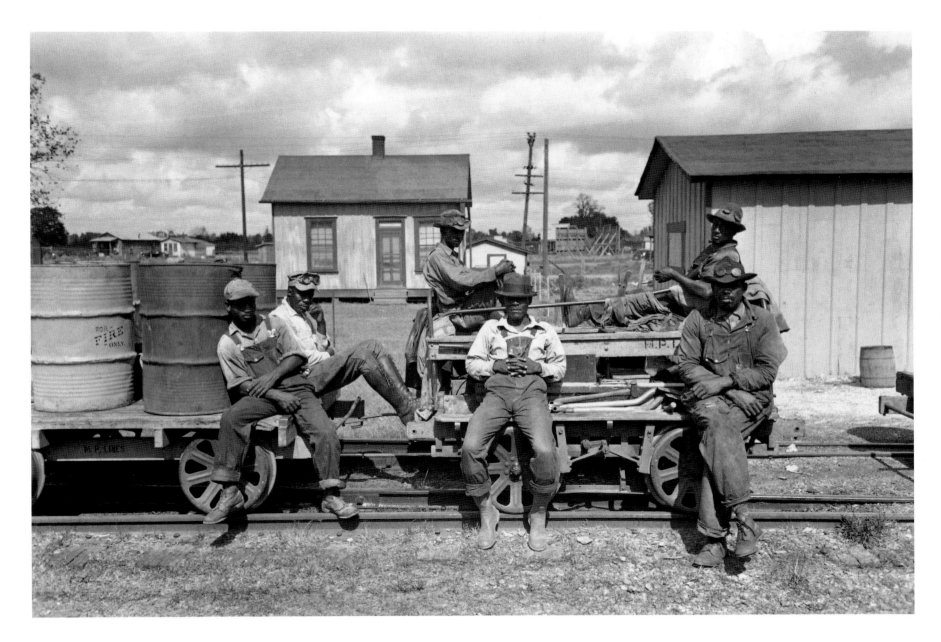

Railroad workers, Port Barre, Louisiana

Russell Lee, October 1938

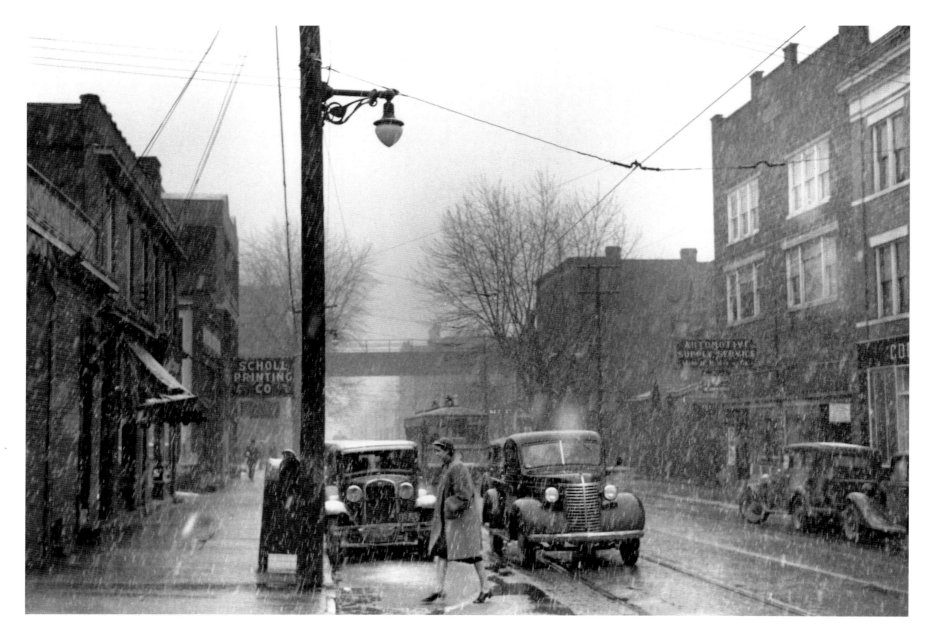

Snowstorm, Parkersburg, West Virginia

ARTHUR ROTHSTEIN, FEBRUARY 1940

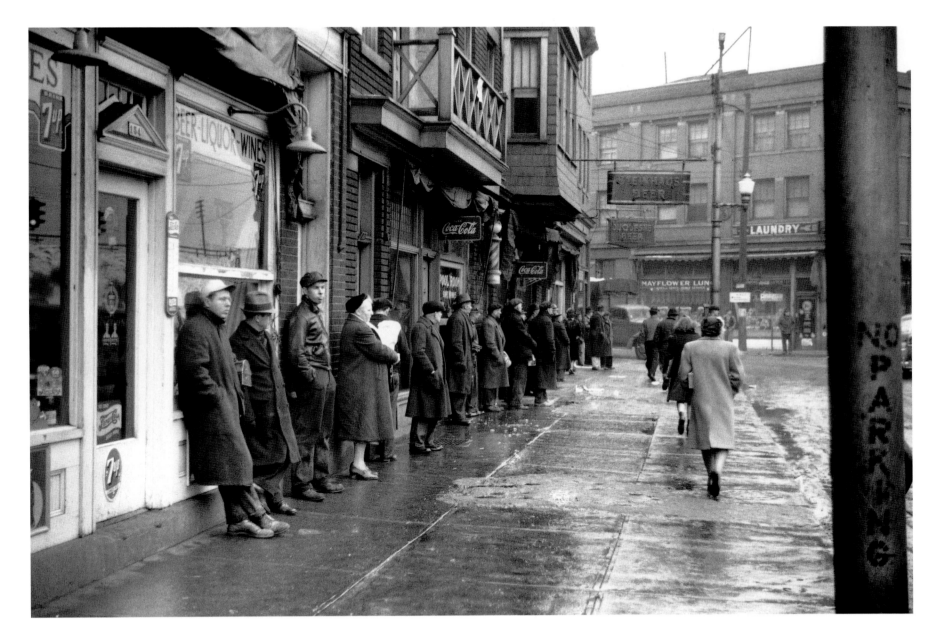

Waiting for buses in Aliquippa, Pennsylvania

Jack Delano, January 1941

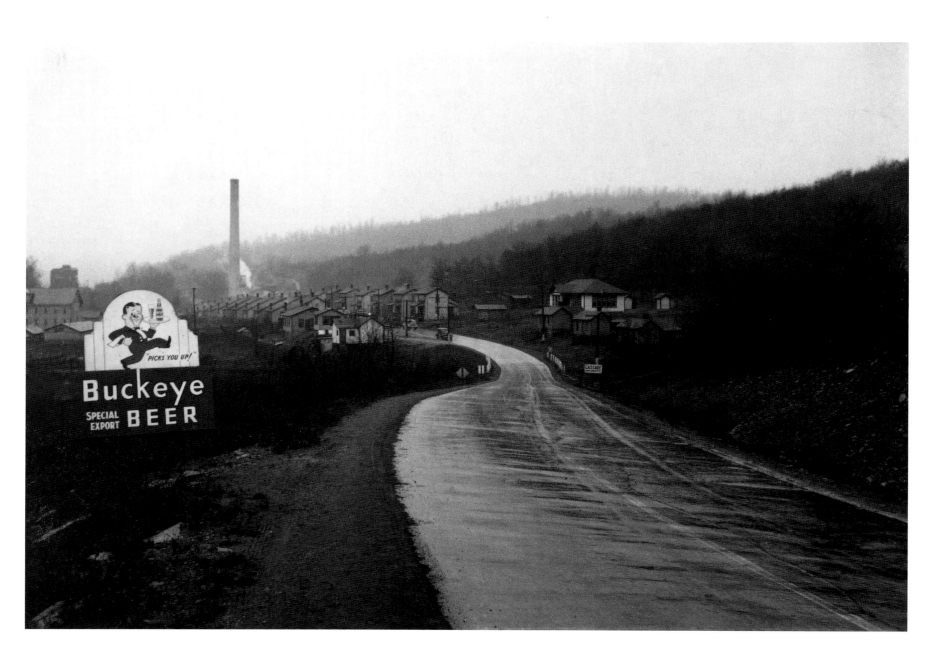

Untitled (Reedsville, West Virginia?)
Edwin Locke, December 1936

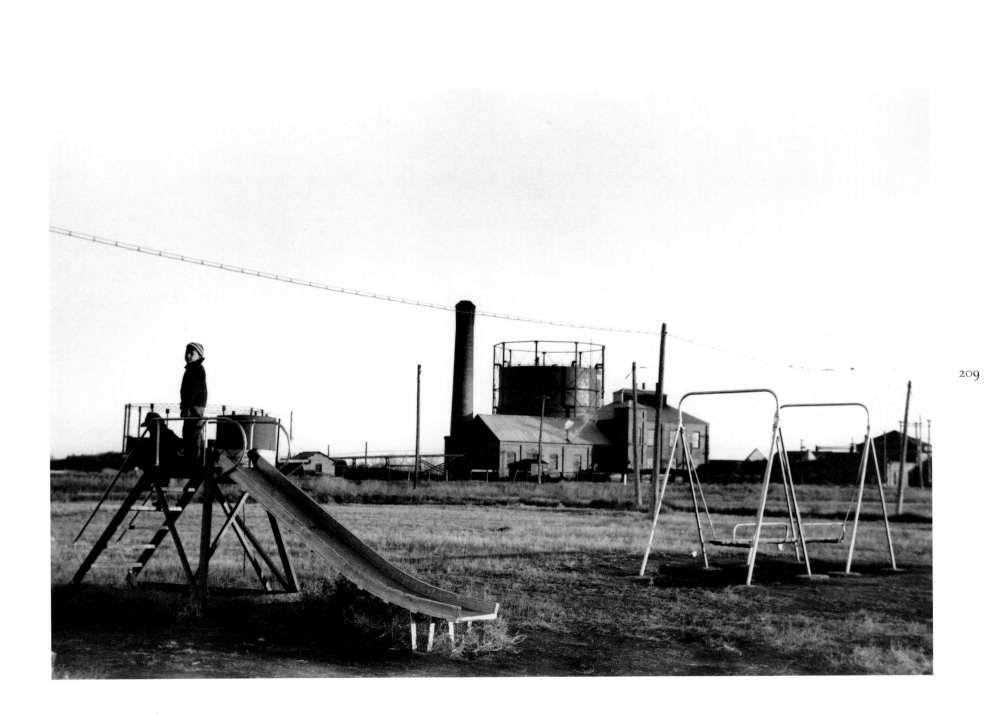

Untitled (Aberdeen, South Dakota)

John Vachon, November 1940

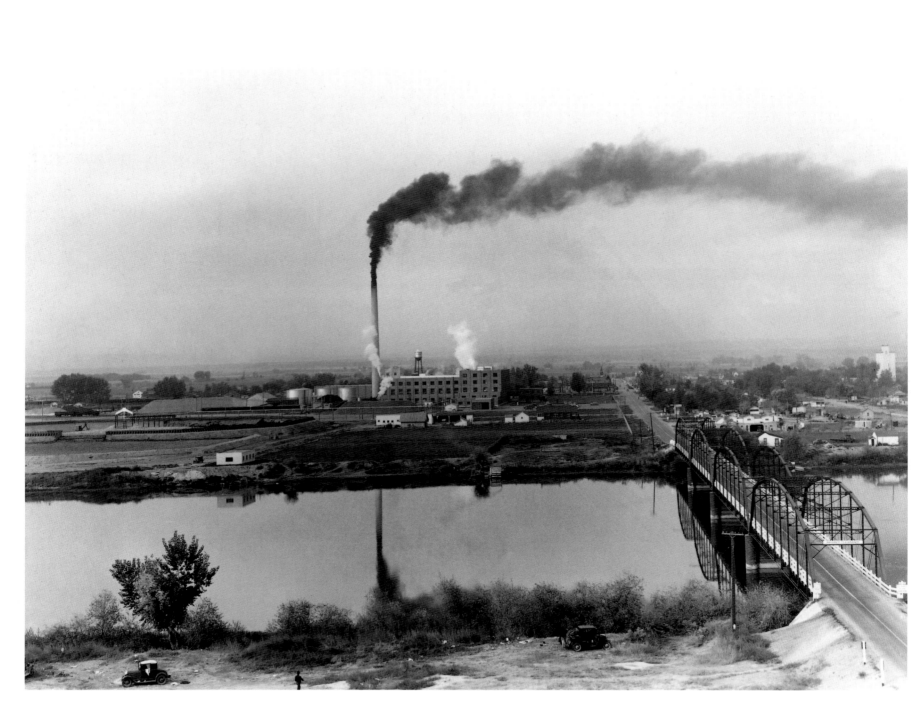

Sugar beet factory (Amalgamated Sugar Company) along Snake Rier, Nyssa, Malheur County, Oregon, a one-factory town
DOROTHEA LANGE, OCTOBER 1939

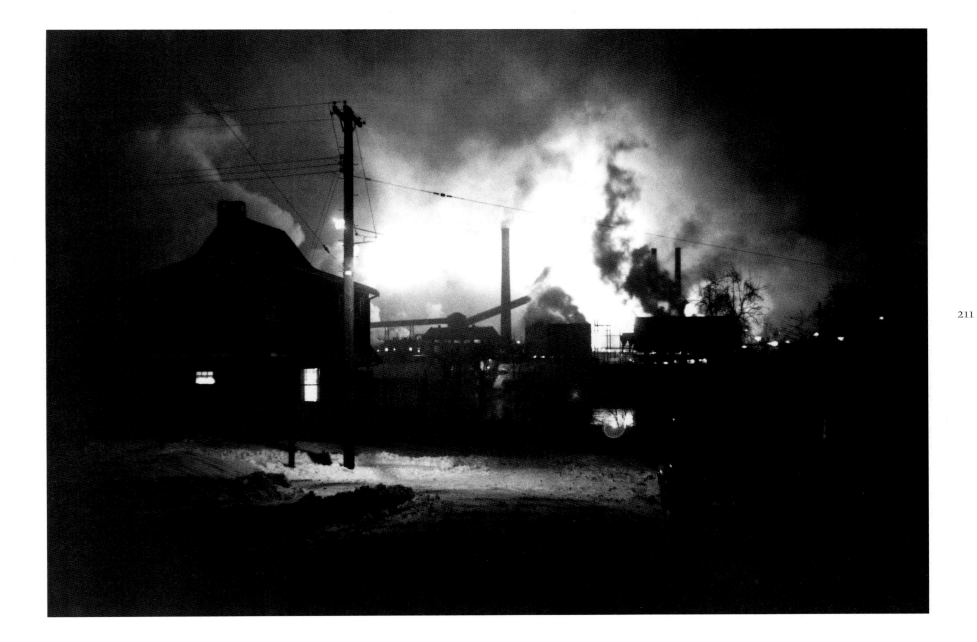

Untitled (Aliquippa, Pennsylvania)

Jack Delano, January 1941

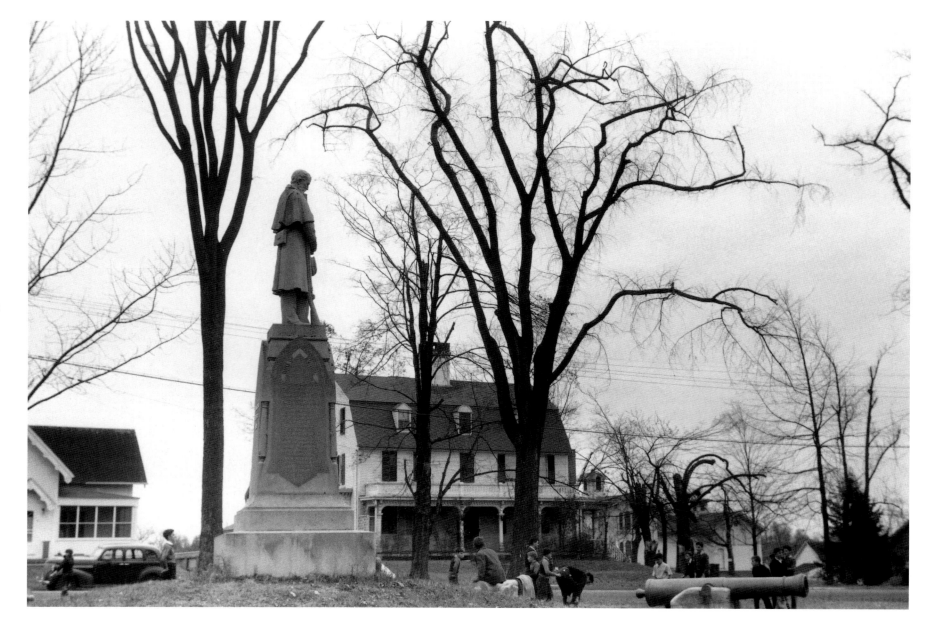

212

A square in Colchester, Connecticut

Jack Delano, November 1940

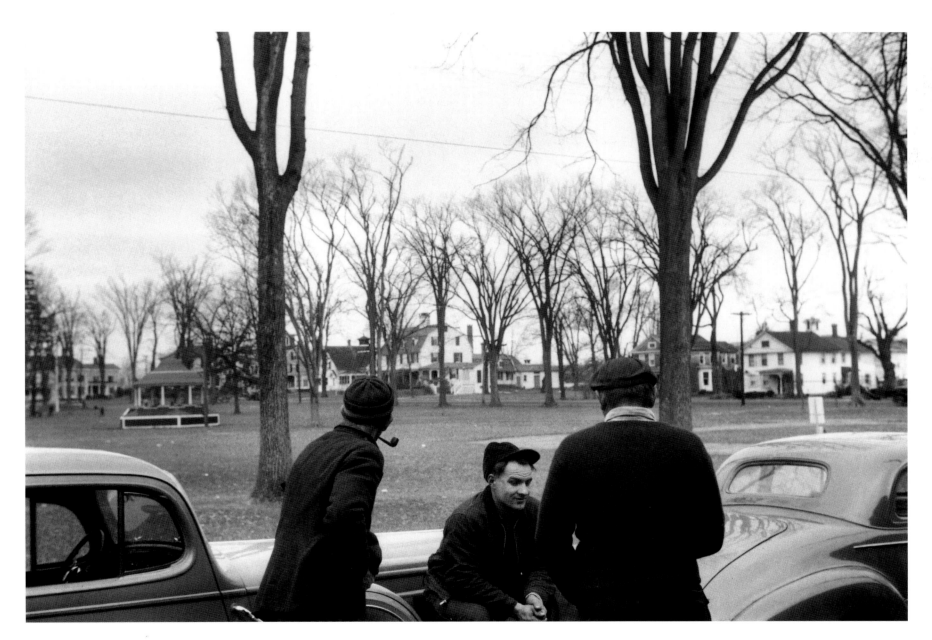

Men in front of the Colchester green, Colchester, Connecticut

Jack Delano, November 1940

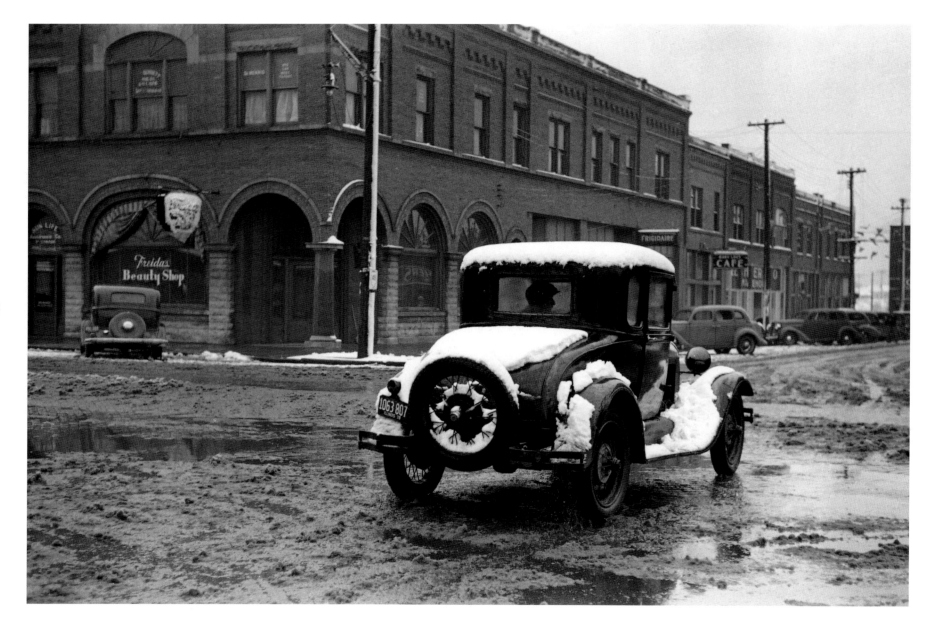

Untitled (Herrin, Illinois)

ARTHUR ROTHSTEIN, JANUARY 1939

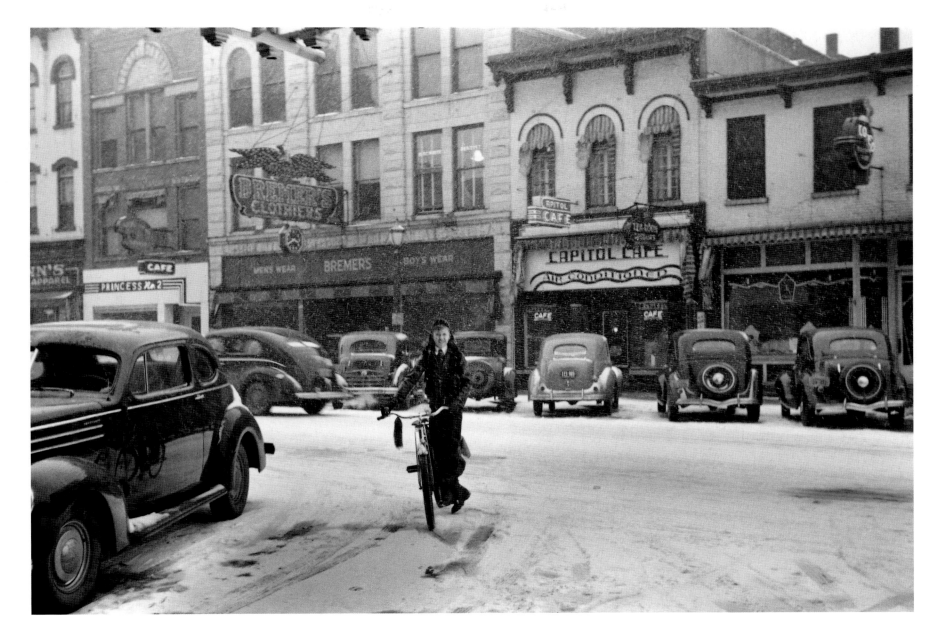

Main street, Iowa City, Iowa

ARTHUR ROTHSTEIN, FEBRUARY 1940

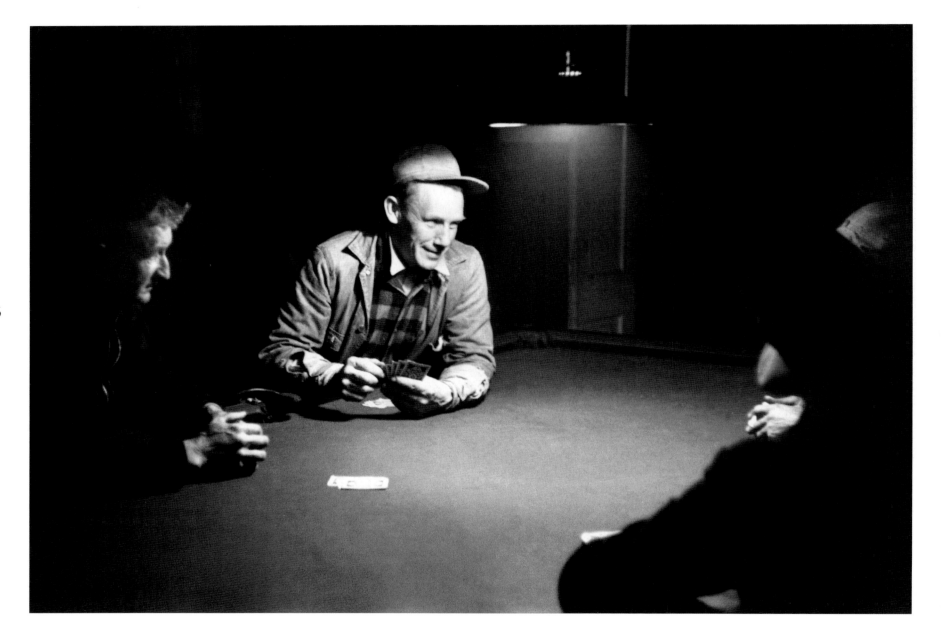

216

Farmers playing cards on a winter morning, Woodstock, Vermont

Marion Post Wolcott, March 1939 or 1940?

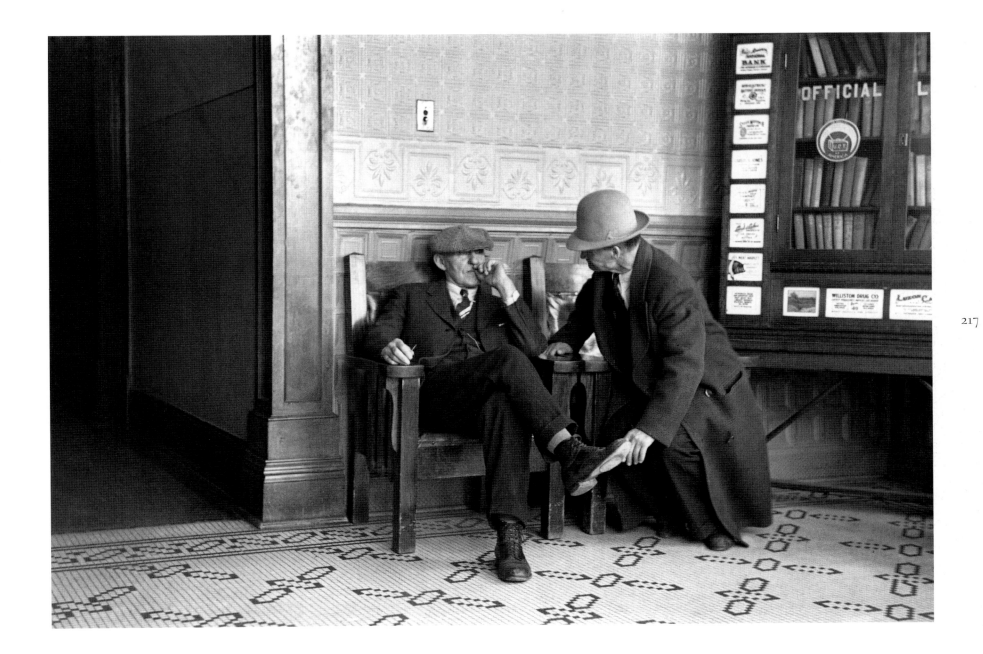

Men talking in the Great Northern Hotel, Williston, North Dakota
RUSSELL LEE, OCTOBER 1937

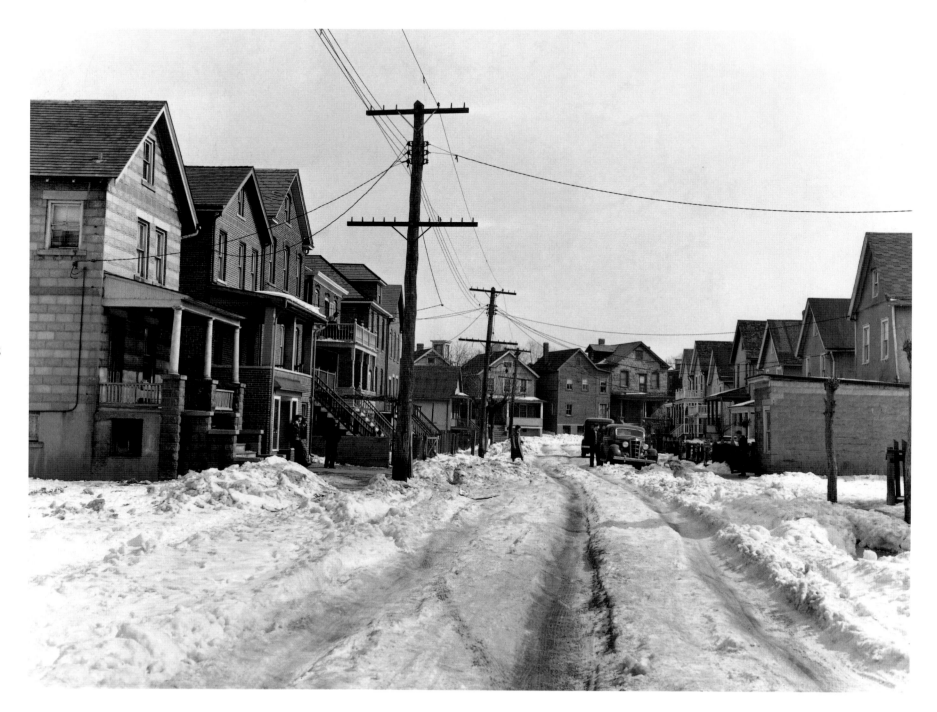

Street in Bound Brook, New Jersey, showing crowded condition
CARL MYDANS, FEBRUARY 1936

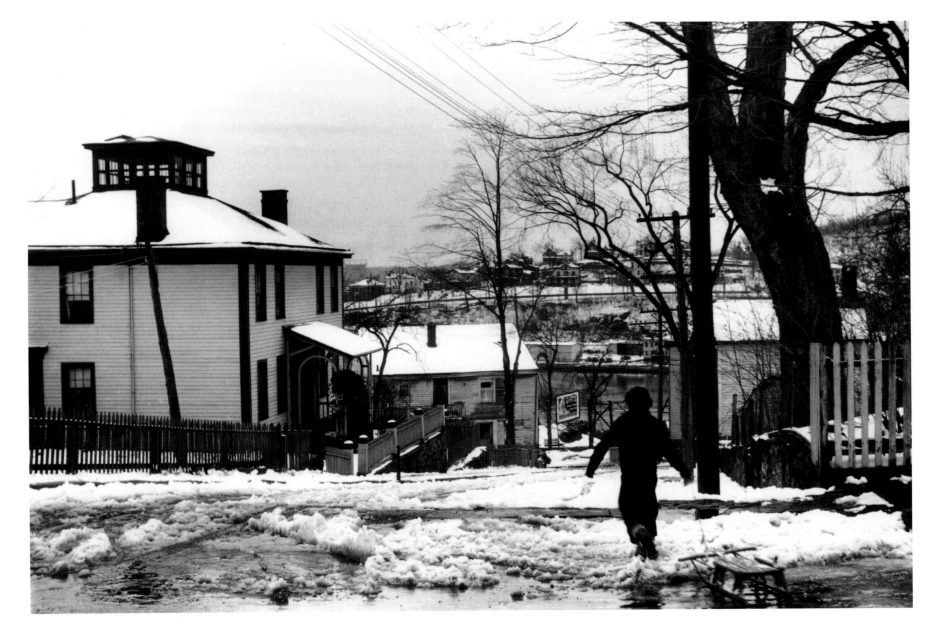

Untitled (Norwich, Connecticut)

JACK DELANO, NOVEMBER 1940

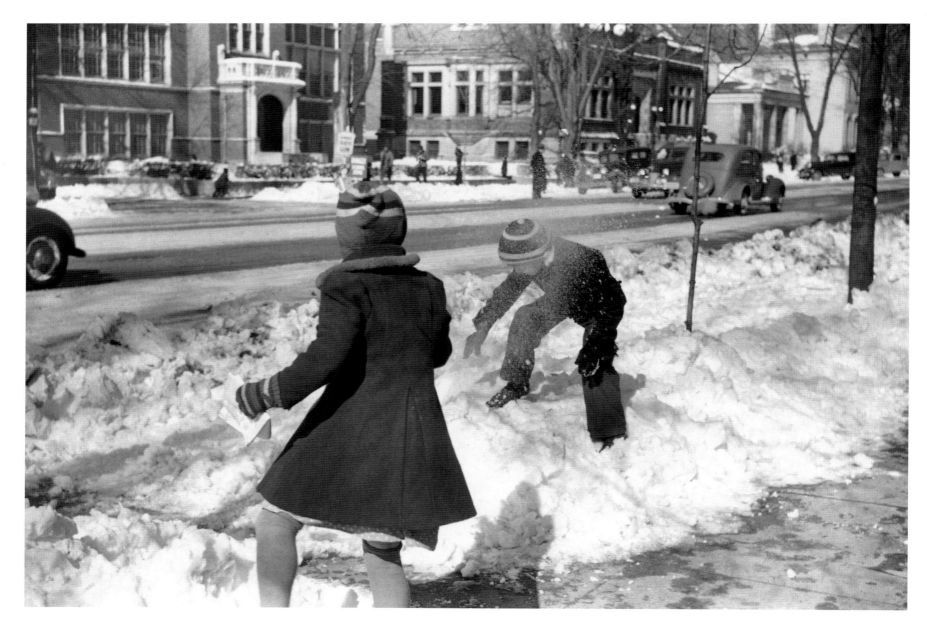

Children having snowball fight, Chillicothe, Ohio
ARTHUR ROTHSTEIN, FEBRUARY 1940

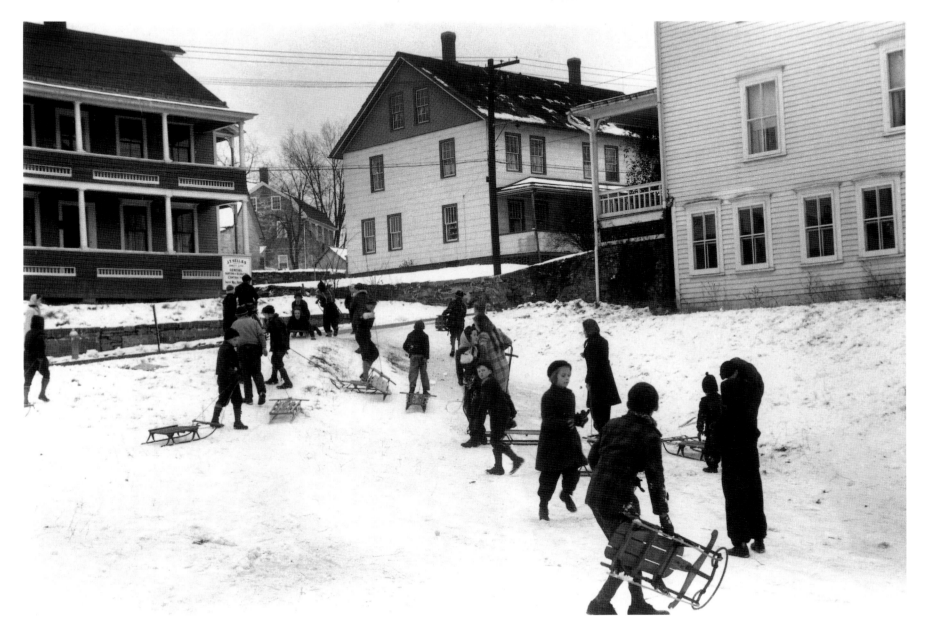

Children sledding, Jewett City, Connecticut

Jack Delano, November 1940

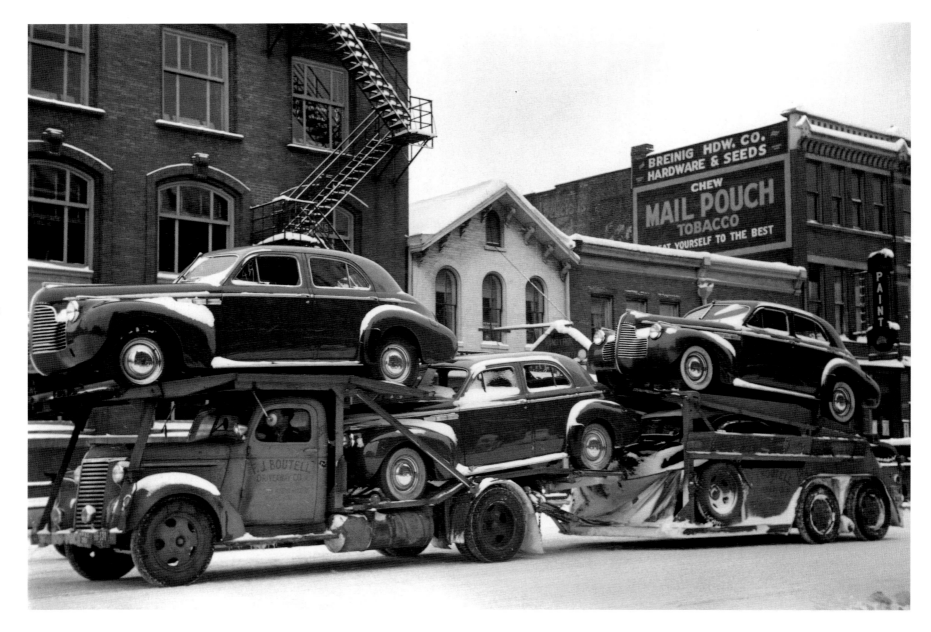

Auto transport, Chillicothe, Ohio

Arthur Rothstein, February 1940

assembly lines, plus frequent layoffs, combined with the relentless pressure of debt caused by the induced habit of buying on credit, had a devastating effect on the family life of an average worker: "The husband," wrote the Lynds, "must 'support' his family, but . . . recurrent 'hard times' made the support of their families periodically impossible for many workers; the wife must make a home for her husband and care for her children, but she is increasingly spending her days in gainful employment outside the home; husband and wife must cleave to each other in the sex relation, but fear of pregnancy frequently makes this relation a dread for one or both of them; affection between the two is regarded as the basis of marriage, but sometimes, in the day-to-day struggle, this seems to be a memory rather than a present help. Not one of the 68 working-class wives mentioned her husband in answering the question what gave her the courage to go on when thoroughly discouraged. More than one wife seems to think of her husband less as an individual than as a focus of problems and fears—anxiety about loss of job, disappointment over failure in promotion, fear of conception—the center of a whole complex of things to be avoided. To many husbands, their wives became associated with weariness, too many children, and other people's washings."[2]

It's not certain whether Stryker used *Middletown* in his survey course, but for Stryker, Lynd was more than just a prominent part of Columbia's intellectual landscape: the Lynds were among Stryker's closest friends and advisers. By 1935, they had gone back to Muncie to conduct more interviews and gather more data. Their *Middletown in Transition: A Study in Cultural Conflicts* would be published in 1937. What they found was even more dreary than what they described in 1929: the rich had grown richer; the poor poorer; divorces had decreased, but so had marriages and births. Muncie's population had increased from 36,500 to 50,000, but from 1927 to 1929 the number of suicides had doubled. One year after the Crash, suicides had increased again, by 30 percent. Unions were in disarray; businesses ran ads encouraging people to spend their way out of the Depression; magazines and movies pumped out even more escapist stories than they had during the Twenties. All this was fresh in Robert Lynd's mind as he sat and looked through Stryker's portfolio.

For thirty years after this conversation with Lynd, Stryker and the photographers who became close to him—people like Arthur Rothstein—wrote about this encounter as if it were a decisive intellectual moment—a Saul-on-the-road-to-Tarsus moment—that set the FSA on a new path.

The first "small town" shooting script Stryker issued to his photographers had the annotated title "Suggestions recently made by Robert Lynd for things which should be photographed as American Background." Photographic subject categories followed, divided by class and gender. For example: "The group activities of various income levels/The organized and unorganized activities of the various income groups/'Where can people meet?'/Well-to-do: Country clubs, Homes, Lodges/Poor: Beer Halls, Pool Halls, Saloons, Street Corners, Garages, Cigar Stores/Consider the same problem as applied to Women/Backyards: 'What do you see out the kitchen window?'/Various exhibit pictures could be taken in different towns and on the basis of different income groups/Pictures showing the relationship between time and the job: this would include such things as pictures taken of the same people every ten years, showing how people age in their work. . . . /'How do people look?' In towns of various sizes—1,500; 25,000 to 30,000; 100,000. Consider the same thing from a geographical standpoint. . . ."

Race, religion, and ethnicity were invisible in this shooting script, even though, in both *Middletown* books, the Lynds observed and described racism, anti-Semitism, xenophobia, and the influence of the Ku Klux Klan. How long this first, Lynd-inspired shooting script lasted and exactly when it was replaced by an undated, much longer one isn't known, but that next one, with its brief preface, became, in whole, in part, and in variations, *the* script that all of Stryker's photographers carried in their pockets, their notebooks, or the backs of their minds.

The new script began with a statement of purpose and a series of rhetorical questions:

"The ideal manner to conduct this study in photo documentation would be to concentrate on a series of carefully selected towns of about 5,000 population. These could be 'crossroad' towns, representative of the geographical area in which they are situated. . . . Is there a social and economic pattern, common to these towns of 5,000? . . . What are the common denominators of life in these towns? Can they be significantly portrayed with the camera?/The following check outline is presented with the hope that it may help in finding these 'denominators.'"

A long list follows; a list of eighteen headings (e.g., "The Square/The Common") and nearly two hundred subheadings (under "Other": "Restaurants and cafes/shots of windows showing menus and specials listed in the window/Interesting pictures could be obtained inside, showing counters, tables, slot machines, cigar cases, menus, and posters on the wall/Pictures of people eating at counters and tables/People who work in restaurants [get picture of the sign SHORT ORDER in restaurant window]").

Social class makes several brief appearances—first in a list of occupations that includes doctors and lawyers and newspapers, but not a single businessman, factory owner, manager, or worker; then in a reference to "Country Clubs" and the people who "amuse themselves" there; then in a suggestion to photograph "Home in the evening—how do people spend their evenings—show this at various income levels," and finally, at the very end, in a "Miscellaneous" category, with a reference to "Shacktown—try to get pictures of each town's slums." Religion appears only as a single category, labeled "Church." Race and ethnicity never appear in the entire, long script, even as possibilities. The volatile mix of struggle and smugness, the escapism and emotional numbing, the public inequities and the private despair that the Lynds found in the small city of Middletown have all been replaced with the egalitarian verities and predictabilities of a "crossroad town" of 5,000—a town closer in spirit to Thornton Wilder's "Grover's Corners" than to the "Zenith" of Sinclair Lewis' *Main Street*. A place as picturesque, but not nearly as complicated, as Frank Capra's "Bradford Falls," where Jimmy Stewart would nearly die and nearly be reborn. A nice place to live and raise a family. A modest little town that—by coincidence—was just about the same size as the town where Roy Stryker was raised. A hometown where he hadn't been able to earn a living; a place he hadn't seen in years.

Stryker wrote more than a dozen different shooting scripts and lists from 1936 until 1943. Some were very specific: one, issued to Arthur Rothstein for his trip to the South in the summer of 1939, reminded him of "Additions to be made to pictures in [our] Southern File . . . (1) Burial societies and funerals (2) Installment selling of furniture (3) The insurance agent (4) July 4–Sept. 15: Revival meetings—whites and blacks . . . (5) Negro lodges (6) Church festivals (7) Court day . . . (8) Mills—attracted to the South by low wages. . . ."

Another, just as specific, issued to Marion Post Walcott when she was

assigned to photograph "Winter in New England," listed the following "picture suggestions": "Looking down on [a] village from [a] hill, nearby. Look for opportunity to get view from 'turn of the road' which gives first glimpse of the village. Emphasize the church steeple." And: "the home . . . kitchen: cooking—making apple pie (get series of pictures showing making of pie—start with peeling apples)."

Other small town scripts—such as the ones reproduced here—were much more general, much more allusive, poetic, even, in their Walt Whitman–like associations. All were written by a man seated at a desk, in an office, in a bureau, in Washington. A man separated by time and ambition from his homeplace. All were lists made by a man remembering the way things were, and—he hoped—might still be. Scripts of longing.

What the photographers did with these lists varied from person to person, assignment to assignment, photographic encounter to encounter. Strong-willed, artistically and intellectually self-assured photographers like Dorothea Lange and Walker Evans had their own aesthetic and political agendas, and although—on many occasions—they did as Stryker asked, more often than not they paid less attention to his lists than to their own intuitions. As early as November 1935, months before Stryker met with Robert Lynd in New York, Evans had sent Stryker his own shooting script/itinerary in the form of a memo. The memo began with the words "Still photography, of general sociological nature," moved on to Pittsburgh ("emphasis on housing and home life of working class people"), and then to the Ohio Valley: "rural architecture," Evans wrote, "including . . . contemporary 'Middletown' subjects. . . ."[3] For two years, Evans used Stryker and Stryker used Evans, each for his own purposes, but each with increasing impatience and exasperation, until, in 1937, Evans quit and was fired. Lange—as willful and uncompromising as Evans, and, worse yet, the wife and coworker of an economist who far outranked Stryker—was laid off, rehired, laid off, and then, in 1939, finally fired. "I had to get rid of one photographer," Stryker explained, "and I got rid of the least cooperative one."[4] The photographs Evans and Lange made entered the files of the FSA and were studied by the younger, less experienced photographers who were hired after them. As aesthetic "accomplished facts," Lange's and Evans' images probably had more influence on the next generation of FSA pho-

tographers (people like Vachon, Delano, Post Walcott, and Parks) than all of Stryker's scripts and outlines.

There were some photographers, however, who gladly worked from Stryker's lists.

One of them was Russell Lee, a big, amiable, restless man who, as Stryker described him, "seemed to be able to stay on the road forever." Lee was the only one of Stryker's photographers who needed a job more than he needed the salary: Lee's mother's family owned several large farms in the rich cornland south of Chicago. All through the Depression, these farms produced enough income for Lee to live without needing to work. What Lee lacked, though, was a home and a homeplace: when he was five, his mother divorced his father; when he was ten, as he sat in his mother's car with her chauffeur, he saw her get killed as she crossed the street in the rain, on an errand. Trust attorneys, legal guardians, and Culver Military Academy followed. By the time Stryker hired him (to replace Carl Mydans, who'd left to join the staff of *Life* even before its first issue appeared), Lee had walked out of a stultifying management job in Kansas City, decided he wanted to become an artist, and then discovered he had no talent as a painter. After five years of drawing people with the same "dead pan expression" (as he described it), Lee bought himself an expensive camera because, as he said, "I wasn't a very good draftsman."

Lee's first FSA assignment, a six-week survey of three states in the Midwest, became a nine-month odyssey across much of the country's heartland. Lee was the kind of photographer—Stryker described him as a "taxonomist"—who wouldn't take a single picture if twenty would do. If Stryker sent Lee to photograph cornhusking, Lee methodically made pictures of the whole process, from stalk to wagon to silo; if Stryker asked him to take pictures of bootmaking, Lee recorded every stage of it, from the lasts to the leather, to the sewing and the stitchery, to the gluing and the nailing. After his first year of traveling, Lee lost his marriage; after another year of traveling, he found his second wife in New Orleans, while on assignment. He and

Jean became traveling companions and coworkers—one of four husband-and-wife teams (Lange and her husband, Paul Taylor; Edwin Rosskam and his wife, Louise; Jack Delano and his wife, Irene) who worked for Stryker over the course of the FSA.

In April 1939, when Lee and his wife were in Texas, Stryker wrote Lee a letter instructing him to choose a little town "within the general area of where you will be within the next three or four weeks" and document the place "quite thoroughly."[5] After Lee confirmed his own hunches with a professor at Texas A&M, he chose the village of San Augustine (population 1,249), in the hills of east Texas. A week in San Augustine produced 250 images that looked like illustrations of the categories and subcategories of Stryker's small town shooting script.

A year later, twenty of these verities were reproduced in a word-and-picture book called *Home Town*, its text written by the renowned American author Sherwood Anderson, its images selected and sequenced by the FSA's new photo editor and resident intellectual, Edwin Rosskam. Sherwood Anderson's *Winesburg, Ohio*, published in 1919, had been an unsettling collection of short stories and vignettes about the ravaged souls—the "grotesques," as Anderson called them—who inhabited the fictional Ohio town. In comparison, *Home Town* was a handsome piece of treacle, part stage set, part homily, written by a man past his prime.

The best and truest part of *Home Town* was its postscript, written by Edwin Rosskam about the file of images over which he and Stryker presided. "The existing coverage," wrote Rosskam, encompassed "the most permanent and the most fleeting, the most gay and the most tragic—the cow barn, the migrant's tent, the tractor in the field, and the jalopy on the road, the weathered faces of men [and] the faces of women . . . the faces and children and the faces of animals . . . —they are all here, photographed in their context, in relation to their environment. In rows of filing cabinets, they wait for today's planner and tomorrow's historian."[6]

SPRING:

Trees and flowers in bloom; cherry blossoms; tulips, jonquils, violets; lilies.

Young farm animals; colts, lambs, baby chicks.

Plowing and harrowing (fitting): with horses; by tractor.

Planting and sowing by hand: on small farm; large farm; small gardens and window boxes, business man coming home with garden implements.

Building houses: frame work of new house; new barn being painted; painting houses and fences and white washing picket fence.

Building and painting boats—overhauling boats: sail boats, motor boats, row boats and canoes.

House cleaning: beating carpets in yard; window washing; airing clothes on line and putting winter clothes away.

Spring clothes: on Easter parade; in shop displays; on models in fashion shows.

Small town: neighbors leaning over fences getting latest gossip; town sheriff sitting out in front of office in the sun.

Spring games: children playing marbles, flying kites; rolling hoops, and roller skating, rope skipping; fishing in the creek, first dip in the old swimming hole; children looking out of schoolroom window at budding trees; signs of spring: going to the zoo—the return of the birds (not robin); hurdy-gurdy, push cart man with flowers: signs pointing to cherry blossoms; slow steady rain; sign advertising bock beer.

Farmer and family perusing seed catalogue—mud on tires, on boots. Garden implements standing outside hardware store; reconditioning last year's implements.

SUMMER:

Threshing wheat: shots of vegetables on vines; tomatoes—ripe and large—in cluster. Picking strawberries; watermelons on barges, trucks and wagons being brought to.

Luggage at railway station: people going on vacations waiting for trains or boats; overstuffed suitcases.

Swim suits hanging on line in rows from largest to smallest one; people sitting on porch swings and resting in hammocks.

People fanning themselves in church—others perspiring in comfortable cool clothes. Outdoor concerts; street dances—dancing on terraces; garden parties—and teas.

City kids under fire hydrant spray. Thunder storms; freezing ice cream on back porch—delivering ice; electric fans; ads for sun burn preventatives and cures for indigestion.

People picnicking on hot dogs and pop—resting in shaded woods. Others overrun with flys and mosquitoes; man sleeping on grass—sun beaming down—newspaper or hat over face; people sleeping on fire escapes and in parks at night.

State and county fairs: prize cake and pie contest; judging livestock; sulky races.

Women shelling peas on back porch.

Kids selling homemade lemonade at homemade stand.

Baseball games. Tennis tournaments—golfing.

Flannel trousers; slacks, shorts, and bathing trunks. Crowded beaches; hot dog stands; roller coasters.

Crowded cars going out on the open road. Gas station attendant filling tank of open touring and convertible cars.

Rock gardens: sun parasols; beach umbrellas; Sandy shores with gently swelling waves; whitecaps showering spray over sailboat in distant horizon.

People standing in shade of trees and awnings. Open windows on street cars and buses; drinking water from spring or old well; shady spot along bank—sun on water beyond; swimming in pools, rivers, and creeks.

People mopping their brows—the mad rush for the country after working hours. The commuter's special and weekend trains crowded to overflowing. The ticket seller in a quandary—people in long lines to his window.

AUTUMN:

Harvest in the West: picking apples; digging potatoes; gathering nuts—preserving fruits, jellies, and making pickles. Hay stacks; corn stacks; corn drying in shed.

Husking bees. Barn dance; hay rides—Halloween—football games; making pies—mince meat and pumpkin; turkey dinners; picking feathers from the ducks.

Getting in coal. Taking down screens and awnings; open wood fires; hanging new winter drapes; church bazaars—art exhibits; ads for winter coats—tweed suits.

Display of school supplies. College "pep rally"; bonfire of dry leaves burning; theatre signs advertising opening performance of the season.

Barren landscapes; bare branches against fall clouds; geese flying high in flocks; duck blinds—hunting parties; raking leaves, fighting forest fires; lumber camp—at meal time; roasting corn.

Signs advertising cider; fruit packers at work in orchard.

From Roy Stryker Papers, Correspondence, Microfilm Series 2, Part C, Section 3, Photographic Archives, University of Louisville, Louisville, Ky.

Eating: ice cream cones; corn on the cob; watermelon—southern towns (see Missouri); picnics; barbeques; hot dogs—cokes in bottle.

Small town: Main Street; courthouse square; ice cream parlor; R.R. station—watching the train "go through"; sitting on the front porch; women visiting from porch to street; cutting the lawn; watering the lawn; eating ice cream cones; waiting for the bus; in the phone booth; hanging out washing in back yard; women talking over back fence; soda counter—high school kids.

City: park bench—sitting; waiting for street car; walking the dog; women with youngsters in park or sidewalk; kids games; sidewalk vendors; sidewalk shoe shine; at the beach; crowded section on hot day—shot of building with people at windows; baseball; bleachers; band concert; park on Sunday—people sitting and sleeping in newspapers; newsstand; washing on on roof; washing on lines—slums; Fifth Avenue bus; bus tours; window shopping; doorman getting taxi.

General: "fill'er up"—gas in car; "flats fixed"; traffic jam; detour sign; "Men Working." Washing car. Curb service. "Good Humors." Cop and speeder on highway. Car on side of road, jacked up—someone fixing flat tire; hitchhikers thumbing ride. Crap games. "Dime and Dance." Sand-lot baseball; college football; spectators; girls in fur coats—chrysanthemums; men with blankets; horse races: betting crowds. Orange drink. Bill posters; sign painters—crowd watching a window sign being painted. Sky writing. Paper in park after concert. Parade watching: ticker tape; sitting on curb. Roller skating—on sidewalk or street. Spooners—neckers; young couple walking along street—hand in hand, etc. Mowing the front-yard lawn. Shoe repair—"While You Wait." Delicatessen. Reading Sunday paper in park. Spring house cleaning in small town. Wagon hucksters: flowers and vegetables. Fishing. Ferry—scenes on the ferry. Auction: country city. Country fair.

229

By and large Middletown believes:

In being honest.

In being kind. In being friendly, a "good neighbor," and a "good fellow."

In being loyal, and a "booster, not a knocker."

In being successful.

In being an average man. "Practically all of us realize that we are common men, and we are prone to distrust and hate those whom we regard as uncommon."

In having character as more important than "having brains."

In being simple and unpretentious and never "putting on airs" or being a snob.

In prizing all things that are common and "real" and "wholesome." "There are beauties at your own doorstep comparable to those you find on long journeys."

In having "common sense."

In being "sound" and "steady."

In being a good sport and making friends with one's opponents. "It doesn't help to harbor grudges."

In being courageous and good-natured in the face of trouble and "making friends with one's luck."

In being, when in doubt, like other people.

In adhering, when problems arise, to tried practices that have "worked" in the past.

That "progress is the law of life," and therefore:

That evolution in society is "from the base and inferior to the beautiful and good."

That, since "progress means growth," increasing size indicates progress. In this connection Middletown tends to emphasize quantitative rather than qualitative changes, and absolute rather than relative numbers or size.

That "the natural and orderly processes of progress" should be followed.

That change is slow, and abrupt changes or the speeding up of changes through planning or revolutions is unnatural.

That "radicals" ("reds," "communists," "socialists," "atheists"—the terms are fairly interchangeable in Middletown) want to interfere with things and "wreck American civilization." "We condemn agitators who masquerade under the ideals guaranteed by our Constitution. We demand the deportation of alien Communists and Anarchists."

That "in the end those who follow the middle course prove to be the wisest. It's better to stick close to the middle of the road, to move slowly, and to avoid extremes."

That evils are inevitably present at many points but will largely cure themselves. "In the end all things will mend."

That no one can solve all his problems, and consequently it is a good rule not to dwell on them too much and not to worry. "It's better to avoid worry and to expect that things will come out all right." "The pendulum will swing back soon."

That good will solves most problems.

That optimism on our part helps the orderly forces making for progress. "The year 1936 will be a banner year because people believe it will be."

That within this process the individual must fend for himself and will in the long run get what he deserves, and therefore:

That character, honesty, and ability will tell.

That one should be enterprising; one should try to get ahead of one's fellows, but not "in an underhand way."

That one should be practical and efficient.

That one should be hardworking and persevering. "Hard work is the key to success." "Until a man has his family financially established, he should not go in for frills and isms."

That one should be thrifty and "deny oneself" reasonably. "If a man will not learn to save his own money, nobody will save for him."

That a man owes it to himself, to his family, and to society to "succeed."

That "the school of hard knocks is a good teacher," and one should learn to "grin and bear" temporary setbacks. "It took an early defeat to turn many a man into a success." "After all, hardship never hurts anyone who has the stuff in him."

That social welfare, in Middletown and elsewhere, is the result of the two

preceding factors working together—the natural law of progress and the individual law of initiative, hard work, and thrift—and therefore:

That any interference with either of the two is undesirable. "The Lord helps him who helps himself." "Congress," an editorial remarked sarcastically, "is now preparing for farm relief, while the wise farmer is out in the field relieving himself."

That society should not coddle the man who does not work hard and save, for if a man does not "get on" it is his own fault. "There is no such thing as a 'youth problem.' It is up to every boy and girl to solve his own problem in his own way."

That "the strongest and best should survive, for that is the law of nature, after all."

That people should have community spirit.

That they should be loyal, placing *their* family, *their* community, *their* state, and *their* nation first. "The best American foreign policy is any policy that places America first." "America first is merely common sense."

That "American ways" are better than "foreign ways."

That "big-city life" is inferior to Middletown life and undesirable. "Saturday-night crowds on [Middletown] streets," comments an editorial, "are radiantly clean as to person and clothes.... Saturday-night shopping becomes a holiday affair after they have bathed and put on their best garments at home.... [Middletown] is still a 'Saturday-night town,' and if big cities call us 'hicks' for that reason, let 'em."

That most foreigners are "inferior." "There is something to this Japanese menace. Let's have no argument about it, but just send those Japs back where they came from."

That Negroes are inferior.

That individual Jews may be all right but that as a race one doesn't care to mix too much with them.

That Middletown will always grow bigger and better.

That the fact that people live together in Middletown makes them a unit with common interests, and they should, therefore, all work together.

That American business will always lead the world. "Here in the United States, as nowhere else in the world, the little business and the big business exists side by side and are a testimonial to the soundness of the American way of life."

That the small businessman is the backbone of American business. "In no country in the world are there so many opportunities open to the little fellow as in the United States.... These small businesses are succeeding ... because they meet a public need." "A wise [Middletown] banker once said: 'I like to patronize a peanut stand because you only have one man to deal with and his only business is to sell peanuts.'"

That economic conditions are the result of a natural order which cannot be changed by man-made laws. "Henry Ford says that wages ought to be higher and goods cheaper. We agree with this, and let us add that we think it ought to be cooler in the summer and warmer in winter."

That depressions are regrettable but nevertheless a normal aspect of business. "Nothing can be done to stop depressions. It's just like a person who feels good one day and rotten the next."

That business can run its own affairs best and the government should keep its hands off business. "All these big schemes for planning by experts brought to Washington won't work."

That every man for himself is the right and necessary law of the business world, "tempered, of course, with judgment and fair dealing."

That competition is what makes progress and has made the United States great.

That the chance to grow rich is necessary to keep initiative alive. "Young folks today are seeking material advantage, which is just exactly what all of us have been seeking all our lives."

That "men won't work if they don't have to." "Work isn't fun. None of us would do a lick of work if he didn't have to."

That the poor-boy-to-president way is the American way to get ahead.

That ordinarily any man willing to work can get a job.

That a man "really gets what is coming to him in the United States."

That "any man who is willing to work hard and to be thrifty and improve his spare time can get to the top. That's the American way, and it's as true today as it ever was."

That it is a man's own fault if he is dependent in old age.

That the reason wages are not higher is because industry cannot afford to pay them. "Employers want to pay as high wages as they can, and they can be counted on to do so just as soon as they are able."

That the rich are, by and large, more intelligent and industrious than the poor. "That's why they are where they are."

That the captains of industry are social benefactors because they create employment. "Where'd all our jobs be if it wasn't for them?"

That capital is simply the accumulated savings of these people with foresight.

That if you "make it too easy" for the unemployed and people like that they will impose on you.

That nobody is really starving in the depression.

That capital and labor are partners and have basically the same interests. "It is a safe bet that if the average worker and employer could sit down calmly together and discuss their differences, a great deal more would be done to solve their difficulties than will be accomplished by politics or by extremists on either side."

That "the open shop is the American way."

That labor organization is unwise and un-American in that it takes away the worker's freedom and initiative, puts him under the control of outsiders, and seeks to point a gun at the head of business. "We wouldn't mind so much if our own people here would form their own unions without any of these outsiders coming in to stir up trouble."

That strikes are due to troublemakers' leading American workers astray.

That Middletown people should shop in Middletown. "Buy where you earn your money."

That the family is a sacred institution and the fundamental institution of our society.

That the monogamous family is the outcome of evolution from lower forms of life and is the final, divinely ordained form.

That sex was "given" to man for purposes of procreation, not for personal enjoyment.

That sexual relations before or outside of marriage are immoral.

That "men should behave like men, and women like women."

That women are better ("purer") than men.

That a married woman's place is first of all in the home, and any other activities should be secondary to "making a good home for her husband and children."

That men are more practical and efficient than women.

That most women cannot be expected to understand public problems as well as men.

That men tend to be tactless in personal relations and women are "better at such things."

That everybody loves children, and a woman who does not want children is "unnatural."

That married people owe it to society to have children.

That it is normal for parents to want their children to be "better off," to "have an easier time," than they themselves have had.

That childhood should be a happy time, "for after that, one's problems and worries begin." "Everyone with a drop of humanitarian blood believes that children are entitled to every possible happiness."

That parents should "give up things for their children," but "should maintain discipline and not spoil them."

That it is pleasant and desirable to "do things as a family."

That fathers do not understand children as well as mothers do.

That children should think on essential matters as their parents do.

That young people are often rebellious ("have queer ideas") but they "get over these things and settle down."

That home ownership is a good thing for the family and also makes for good citizenship.

That schools should teach the facts of past experience about which "sound, intelligent people agree."

That it is dangerous to acquaint children with points of view that question "the fundamentals."

That an education should be "practical," but at the same time, it is chiefly important as "broadening" one.

That too much education and contact with books and big ideas unfits a person for practical life.

That a college education is "a good thing."

But that a college man is no better than a non-college man and is likely to be less practical, and that college men must learn "life" to counteract their concentration on theory.

That girls that do not plan to be teachers do not ordinarily need as much education as boys.

That "you forget most of the things you learn in school." "Looking back over the years, it seems to me that at least half of the friends of my schoolday youth who have made good were dumbunnies.... Anyway they could not pile up points for honors unless it was an honor to sit someplace between the middle and the foot of the class."

That schoolteachers are usually people who couldn't make good in business.

That teaching school, particularly in the lower grades, is women's business.

That schools nowadays go in for too many frills.

That leisure is a fine thing, but work comes first.

That "all of us hope we'll get to the place sometime where we can work less and have more time to play."

But that it is wrong for a man to retire when he is still able to work. "What will he do with all his time?"

That having a hobby is "all very well if a person has time for that sort of thing and it doesn't interfere with his job."

That "red-blooded" physical sports are more normal recreations for a man than art, music, and literature.

That "culture and things like that" are more the business of women than of men.

That leisure is something you spend with people and a person is "queer" who enjoys solitary leisure.

That a person doesn't want to spend his leisure doing "heavy" things or things that remind him of the "unpleasant" side of life. "There are enough hard things in real life—books and plays should have a pleasant ending that leaves you feeling better."

But that leisure should be spent in wholesomely "worth-while" things and not be just idle or frivolous.

That it is better to be appreciative than discriminating. "If a person knows too much or is too critical it makes him a kill-joy or a snob not able to enjoy the things most people enjoy."

That anything widely acclaimed is pretty apt to be good; it is safer to trust the taste and judgment of the common man in most things rather than that of the specialist.

That Middletown wants to keep abreast of the good new things in the arts and literature, but it is not interested in anything freakish.

That "being artistic doesn't justify being immoral."

That smoking and drinking are more appropriate leisure activities for men than for women.

That it is more appropriate for well-to-do people to have automobiles and radios and to spend money on liquor than for poor people.

That it is a good thing for everyone to enjoy the fine, simple pleasures of life.

That "we folks out here dislike in our social life formality, society manners, delicate food, and the effete things of rich Eastern people."

That the American democratic form of government is the final and ideal form of government.

That the Constitution should not be fundamentally changed.

That Americans are the freest people in the world.

That America will always be the land of opportunity and the greatest and richest country in the world.

That England is the finest country in Europe.

That Washington and Lincoln were the greatest Americans. (Edison is sometimes linked with these two as the third great American.)

That only unpatriotic dreamers would think of changing the form of government that was "good enough for" Washington and Lincoln.

That socialism, communism, and fascism are disreputable and un-American.

That socialists and communists believe in dividing up existing wealth on a per-capita basis. "This is unworkable because within a year a comparatively few able persons would have the money again."

That radicalism makes for the destruction of the church and family, looseness of morals, and the stifling of individual initiative.

That only foreigners and long-haired troublemakers are radicals.

That the voters, in the main, really control the operation of the American government.

That newspapers give citizens "the facts."

That the two-party system is the "American way."

That it does not pay to throw away one's vote on a minority party.

That the government ownership is inefficient and more costly than private enterprise.

That the government should leave things to private initiative. "More business in government and less government in business." (Events since 1933 have been causing large numbers of people in the lower income brackets in Middletown to question this formerly widely held assumption, though the upper income brackets hold to it as tenaciously as ever.)

That high tariffs are desirable. "Secretary Hull's tariff policy is putting the American producer in the city and in the country in competition with the peasant and serf in Europe and Asia."

That taxes should be kept down.

That our government should leave Europe and the rest of the world alone.

That the United States should have large military and naval defenses to protect itself, but should not mix in European wars.

That pacifism is disreputable and un-American. "We're militaristic rather than pacifist out here-though of course we don't want wars."

That many public problems are too big for the voter to solve but that Congress can solve them.

That the "experts" just "gum up" the working of democracy.

That national problems can be solved by "letting nature take its course" or by passing laws.

That problems such as corruption in public office can be largely solved by electing better men to office.

That local problems such as crime can be ameliorated by putting people in jail and by imposing heavier sentences.

That, human nature being what it is, there will always be some graft in government but that despite this we are the best-governed nation in the world.

That organizations such as the American Legion and the D.A.R. represent a high order of Americanism.

That because of "poor, weak human nature" there will always be some people too lazy to work, too spendthrift to save, too shortsighted to plan. "Doesn't the Bible prove this when it says, 'The poor ye have always with you'?"

That charity will always be necessary. "For you wouldn't let a dog starve."

That in a real emergency anyone with any human feeling will "share his shirt with an unfortunate who needs it."

But that a "government dole" on a large scale is an entirely different thing from charity to an individual, and that "a paternalistic system which prescribes an exact method of aiding our unfortunate brothers and sisters is demoralizing."

That idleness and thriftlessness are only encouraged by making charity too easy.

That it "undermines a man's character" for him to get what he doesn't earn.

That it is a fine thing for rich people to be philanthropic.

That recipients of charity should be grateful.

That relief from public funds during the depression is a purely emergency matter to be abandoned as soon as possible, and that it is unthinkable for the United States to have anything resembling a permanent "dole."

That things like unemployment insurance are unnecessary because "in ordinary times any man willing to work can get a job"; and that they are demoralizing both to the recipient and to the businessman taxed to support them.

That Christianity is the final form of religion and all other religions are inferior to it.

But that what you believe is not so important as the kind of person you are.

That nobody would want to live in a community without churches, and everybody should, therefore, support the churches.

That churchgoing is sometimes a kind of nuisance, one of the things you do as a duty, but that the habit of churchgoing is a good thing and makes people better.

That there isn't much difference any longer between the different Protestant denominations.

But that Protestantism is superior to Catholicism.

That having a Pope is un-American and a Catholic should not be elected President of the United States.

That Jesus is the Son of God and what he said is true for all time.

That Jesus was the most perfect man who ever lived.

That God exists and runs the universe.

That there is a "hereafter." "It is unthinkable that people should just die and that be the end."

That God cannot be expected to intercede in the small things of life, but that through faith and prayer one may rely upon His assistance in the most important concerns of life.

That preachers are rather impractical people who wouldn't be likely to make really good in business.

That I wouldn't want my son to go into the ministry.

That preachers should stick to religion and not try to talk about business, public affairs, and other things "they don't know anything about."

Middletown is *against* the reverse of the things it is for. These need not be listed here, but they may be summarized by saying that Middletown is *against*:

Any strikingly divergent type of personality, especially the non-optimist, the non-joiner, the unfriendly person, and the pretentious person.

Any striking innovations in art, ideas, literature, though it tolerates these more if they are spectacular, episodic intrusions from without than if they are practiced within Middletown.

Any striking innovations in government, religion, education, the family.

Centralized government, bureaucracy, large-scale planning by government. "It's impossible to plan on a large scale. There are too many factors involved. It is best to leave it to individuals, who are likely to take a more normal or more natural course."

Anything that curtails money making.

Anybody who criticizes any fundamental institution.

People engaged in thinking about or working for change: social planners, intellectuals, professors, highbrows, radicals, Russians, pacifists, anybody who knows too much.

Foreigners, internationalists, and international bankers.

People who are not patriots—for city, state, and nation.

Non-Protestants, Jews, Negroes—as "not quite our sort."

People who stress the importance of sex, including those who favor the general dissemination of information about birth control.

People who buy things, do things, live in ways not customary for one of that income level.

Frills, notions, and anything fancy.

People and things that are fragile or sensitive rather than robust.

235

From Robert S. Lynd and Helen Merrell Lynd, Middletown in Transition: A Study in Cultural Conflicts (*Harcourt, Brace, 1937*), pp. 403–18.

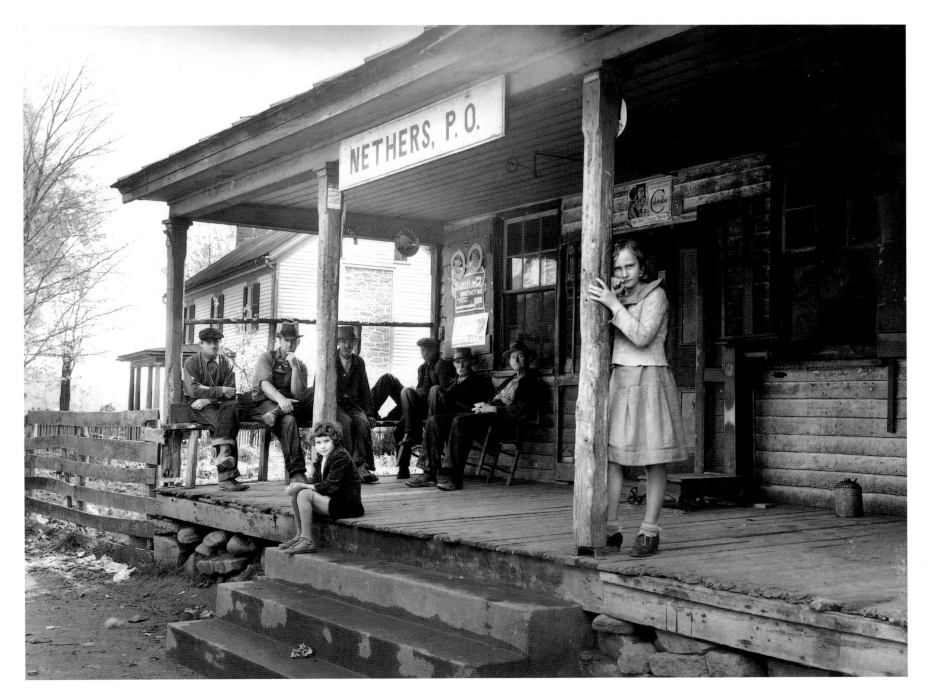

Post office at Nethers, Shenandoah National Park, Virginia

ARTHUR ROTHSTEIN, OCTOBER 1935

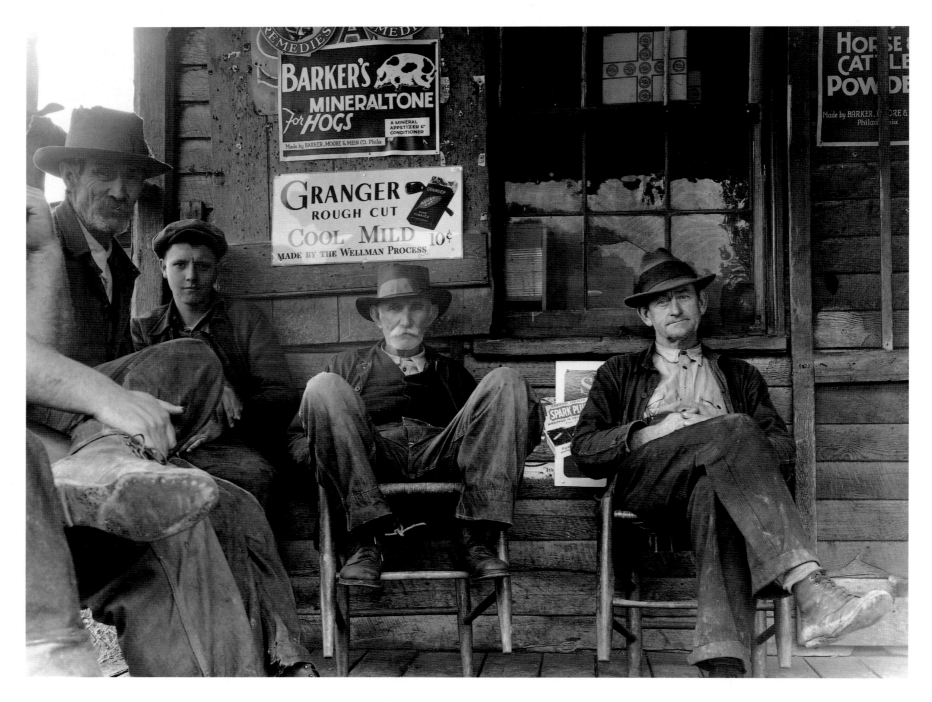

Above: Inhabitants of Nethers in front of post office, Virginia
Arthur Rothstein, October 1935

Opposite: Resettlement Administration man talking to mountain people on submarginal farm, Garrett County, Maryland
Arthur Rothstein, November 1936

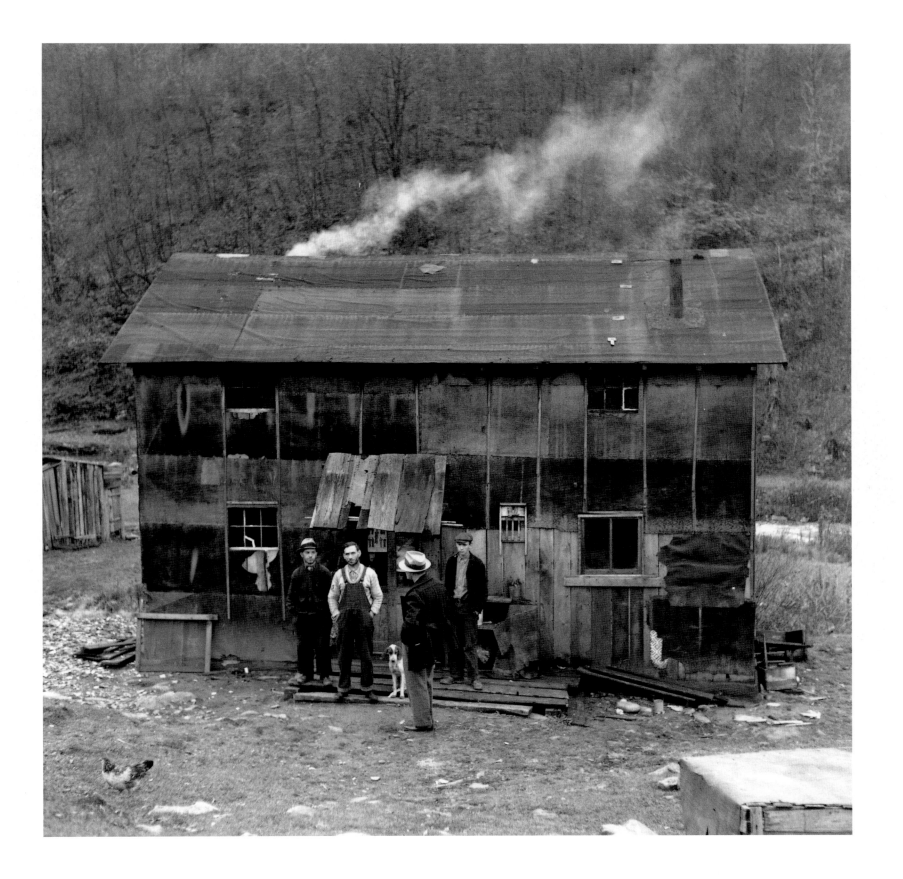

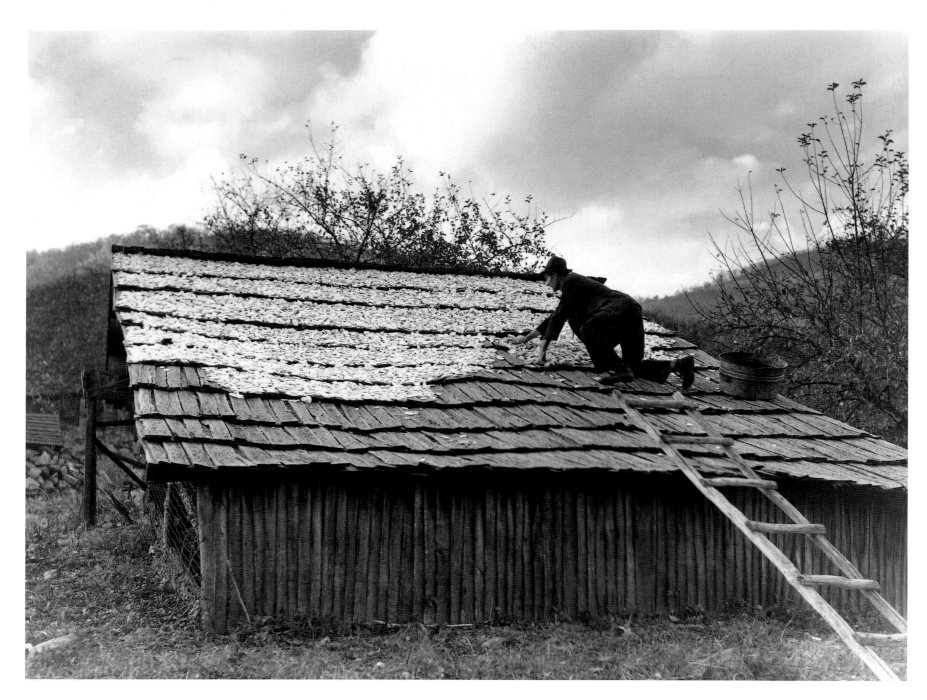

240

Spreading out apples to dry, Nicholson Hollow, Shenandoah National Park, Virginia
Arthur Rothstein, October 1935

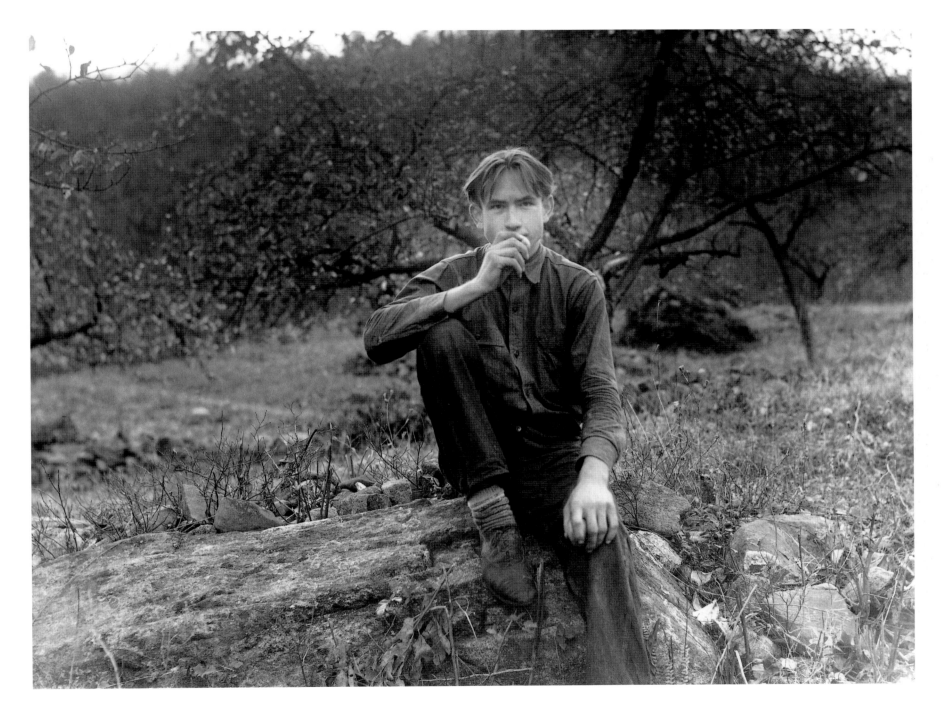

Adam Nicholson, Shenandoah National Park, Virginia

ARTHUR ROTHSTEIN, OCTOBER 1935

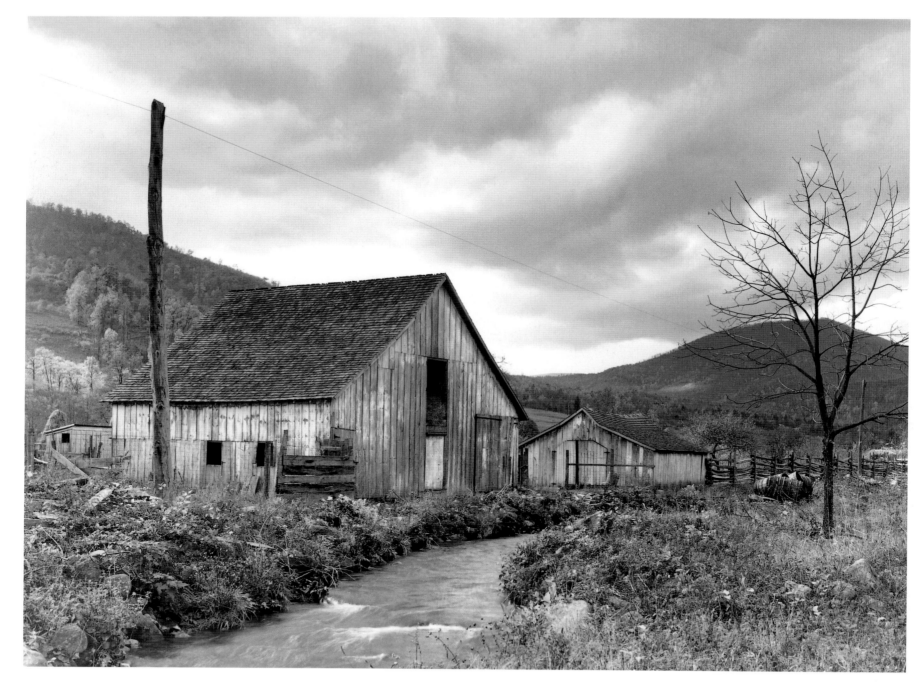

Barn on the banks of the Hughes River, Shenandoah National Park, Virginia
ARTHUR ROTHSTEIN, OCTOBER 1935

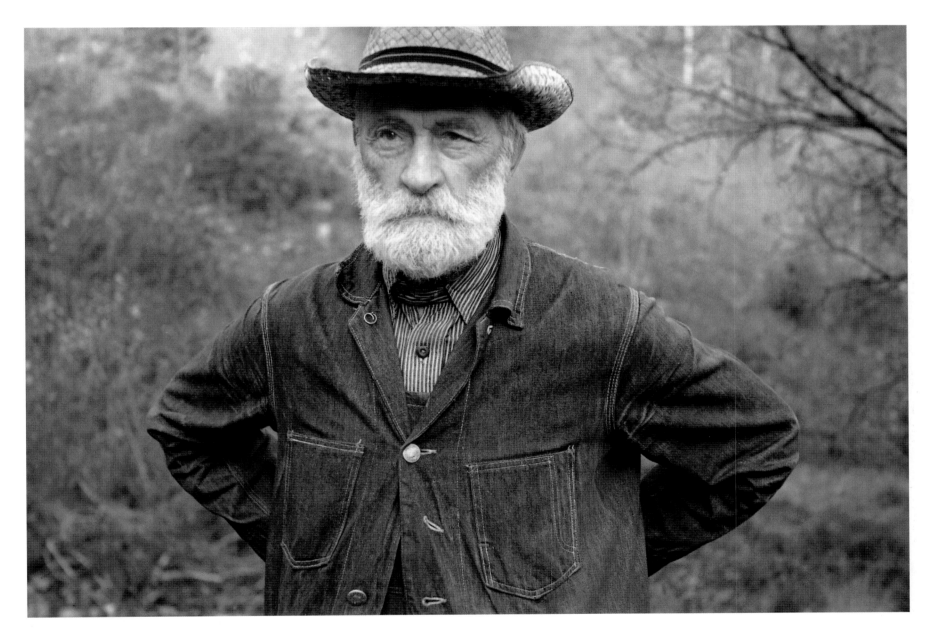

Untitled (Russ Nicholson, Nicholson Hollow, Virginia)
ARTHUR ROTHSTEIN, OCTOBER 1935

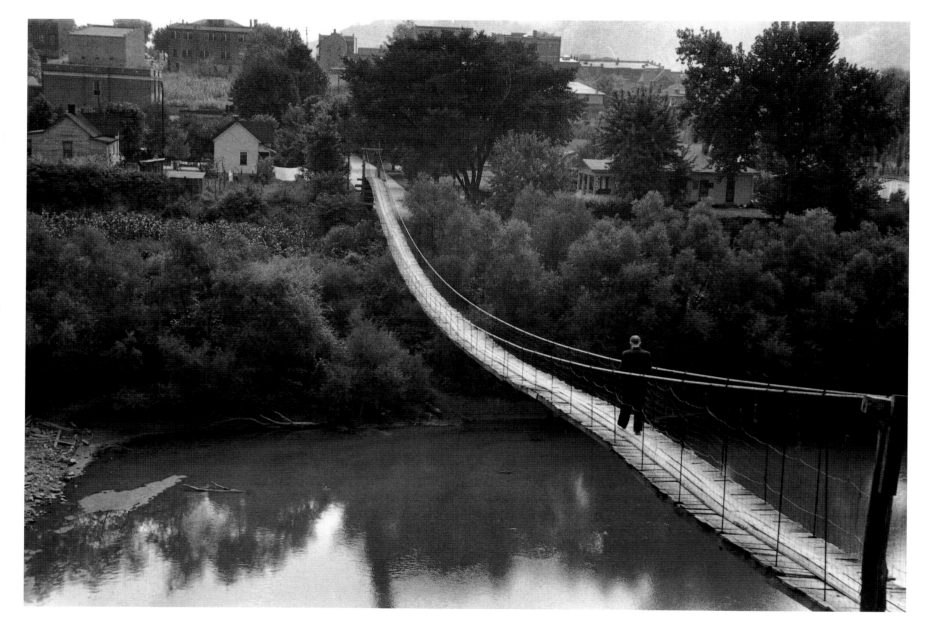

Untitled (Crossing the Kentucky River, Jackson, Breathitt County, Kentucky)
MARION POST WOLCOTT, AUGUST–SEPTEMBER? 1940

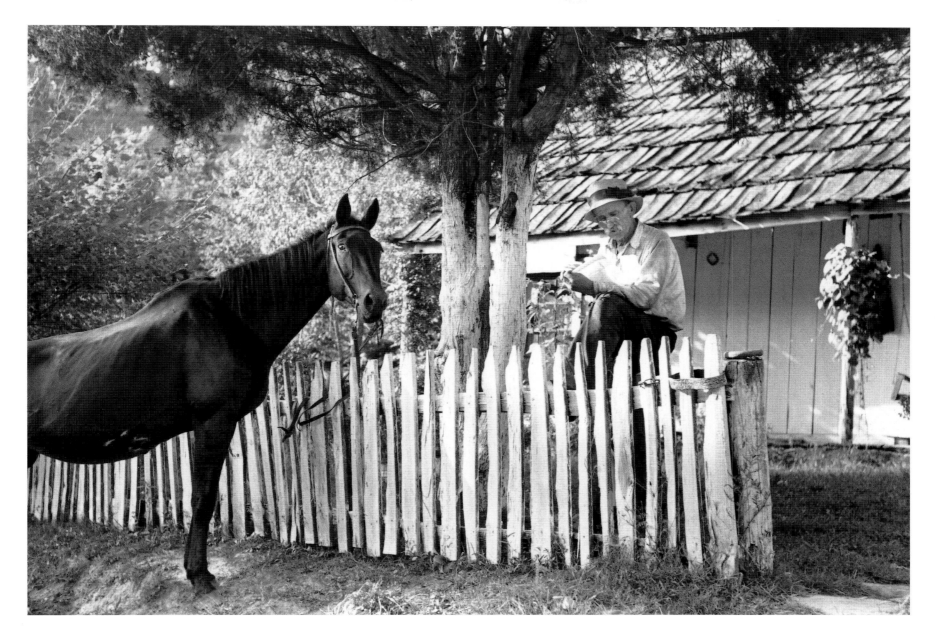

Untitled (Resident reading his mail, Frozen Creek, near Jackson, Kentucky)

MARION POST WOLCOTT, JULY? 1940

Road to Nicholson Hollow, Shenandoah National Park, Virginia

ARTHUR ROTHSTEIN, OCTOBER 1935

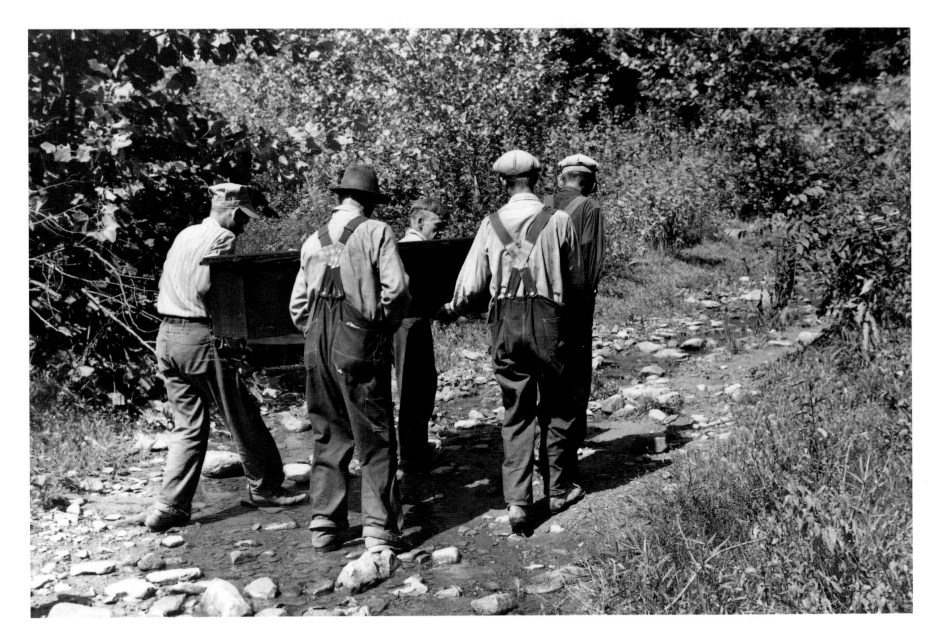

Mountain people carrying a homemade coffin up creek bed to the family plot on the hillside where it will be buried.
This section is too isolated to hold any formal funeral services immediately. Up South Fork of the Kentucky River near Jackson, Kentucky.
MARION POST WOLCOTT, SEPTEMBER? 1940

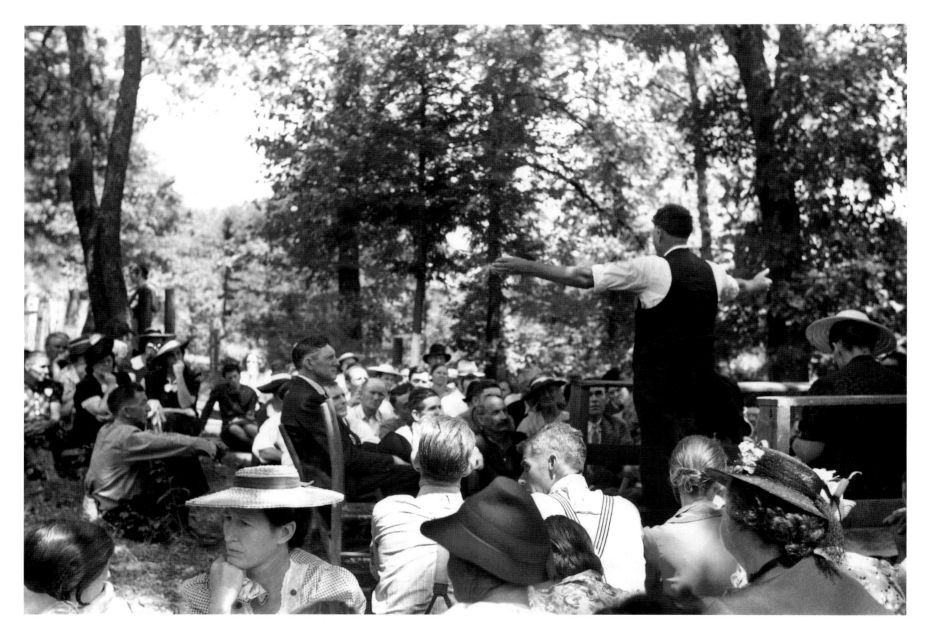

Preacher, relatives and friends of the deceased at a memorial meeting near Jackson, Breathitt County, Kentucky

MARION POST WOLCOTT, AUGUST? 1940

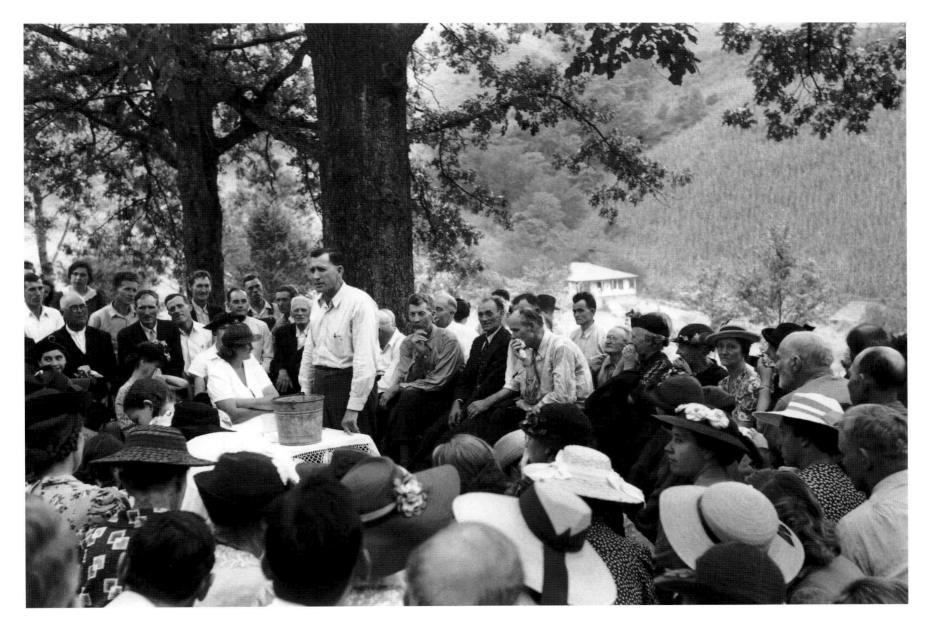

Preacher, relatives and friends of the deceased at a memorial meeting near Jackson, Breathitt County, Kentucky

MARION POST WOLCOTT, AUGUST? 1940

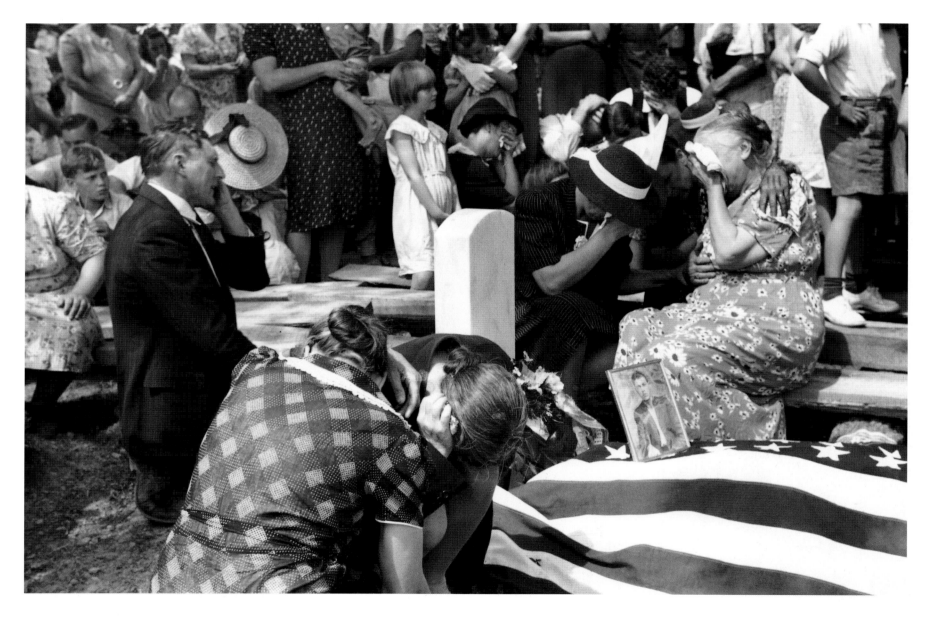

Untitled (Preacher praying, mother and widow and relatives weeping at the grave of the deceased.
Annual memorial meeting near Jackson, Breathitt County, Kentucky)
MARION POST WOLCOTT, AUGUST? 1940

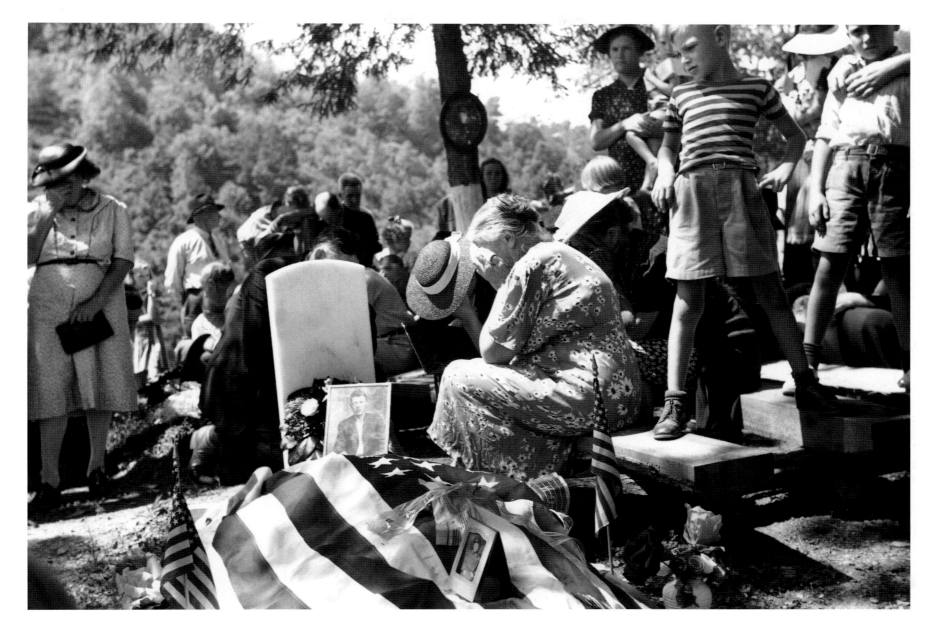

Untitled (Mother and relatives weeping at the grave of the deceased, memorial meeting, near Jackson, Breathitt County, Kentucky)
MARION POST WOLCOTT, AUGUST? 1940

252

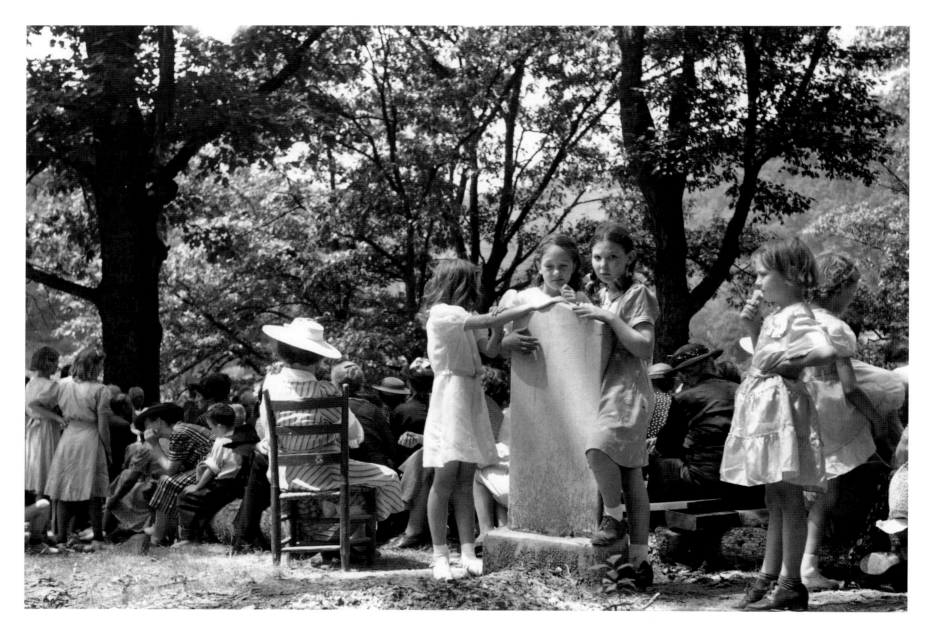

Friends of the deceased's family, at an annual memorial meeting in the family cemetary in the mountains near Jackson, Kentucky

MARION POST WOLCOTT, AUGUST? 1940

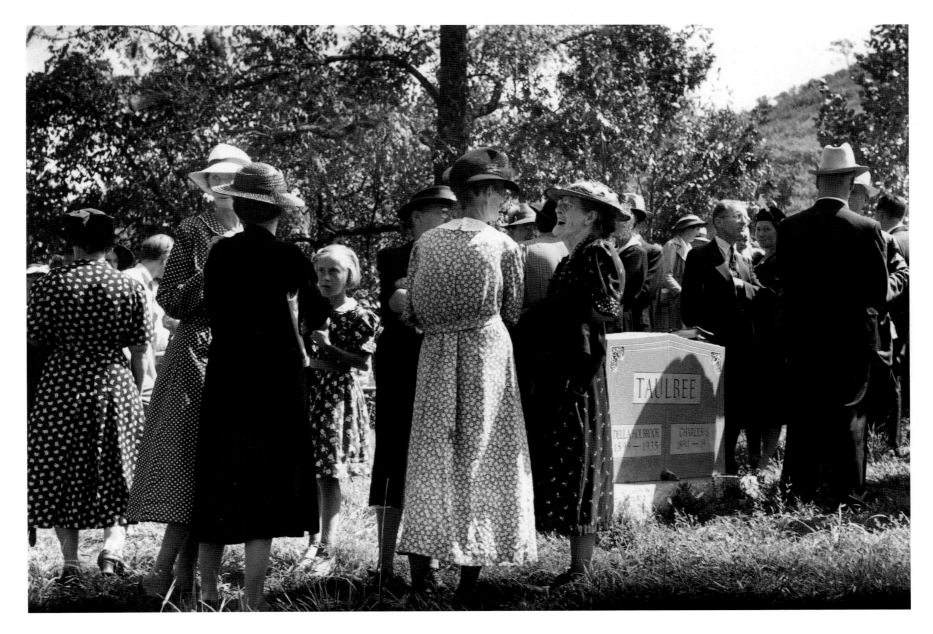

Friends and relatives of the deceased chatting after the memorial gathering is over. Up Frozen Creek, near Jackson, Breathitt County, Kentucky.
MARION POST WOLCOTT, AUGUST? 1940

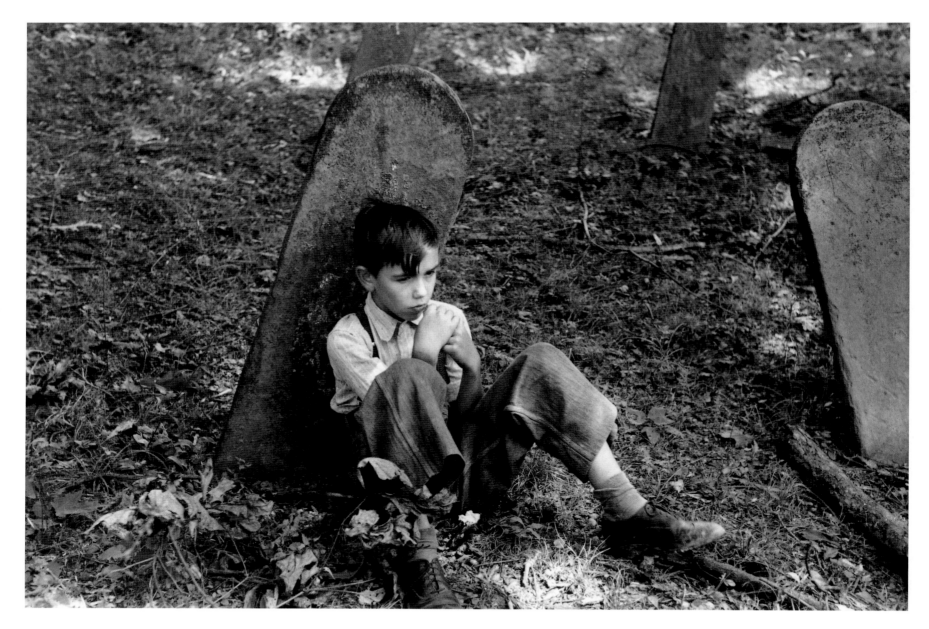

Son of one of the deceased's family at an annual memorial meeting in the family cemetary. In the mountains near Jackson, Kentucky.
MARION POST WOLCOTT, AUGUST? 1940

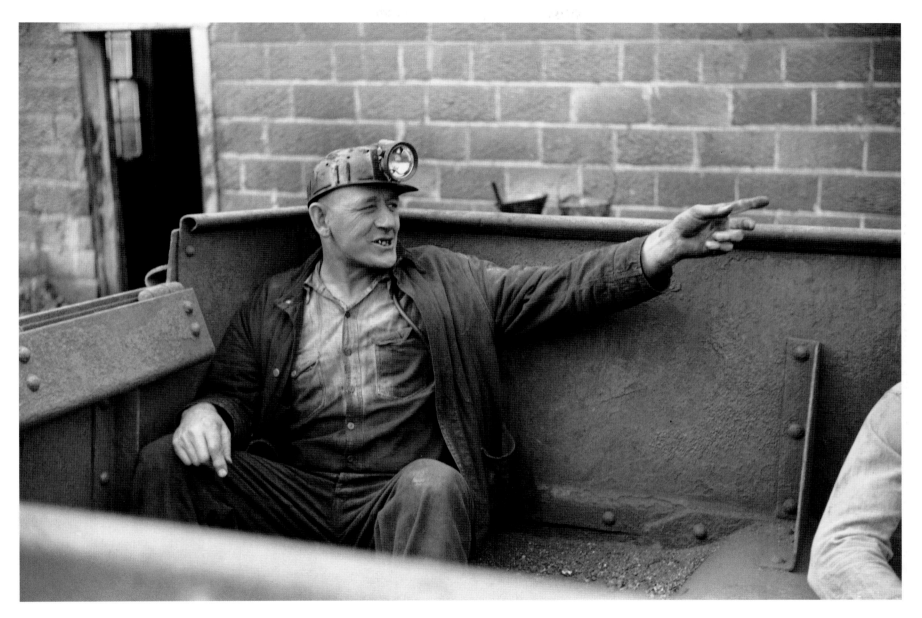

Coal miner waiting for car to go in on next trip, Maidsville, West Virginia

MARION POST WOLCOTT, SEPTEMBER 1938

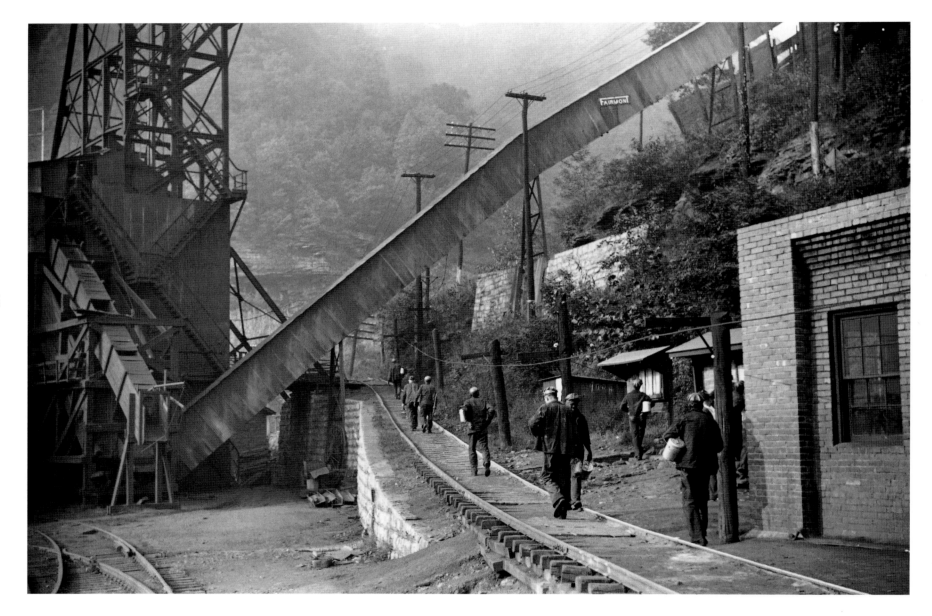

Miners starting home after work. Part of coal tipple shown at left. West Virginia.
MARION POST WOLCOTT, SEPTEMBER 1938

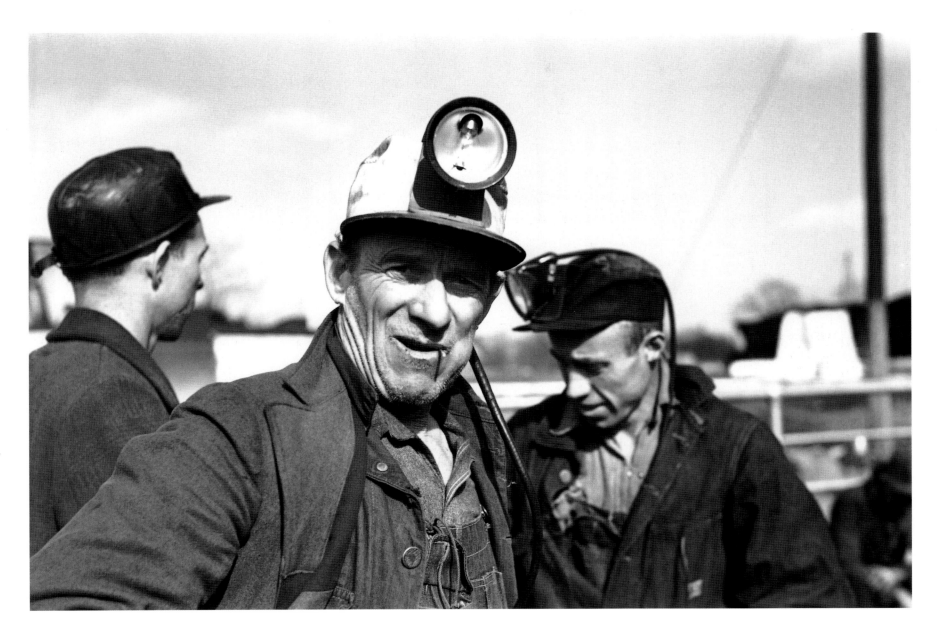

Coal miners, Birmingham, Alabama

ARTHUR ROTHSTEIN, FEBRUARY 1937

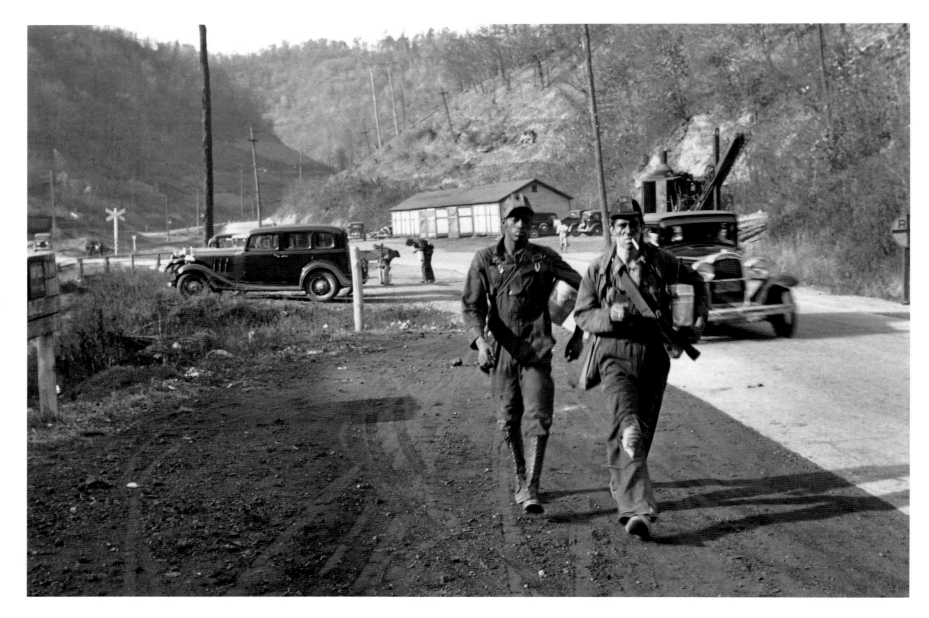

Untitled (Williamson, West Virginia)

BEN SHAHN, OCTOBER 1935

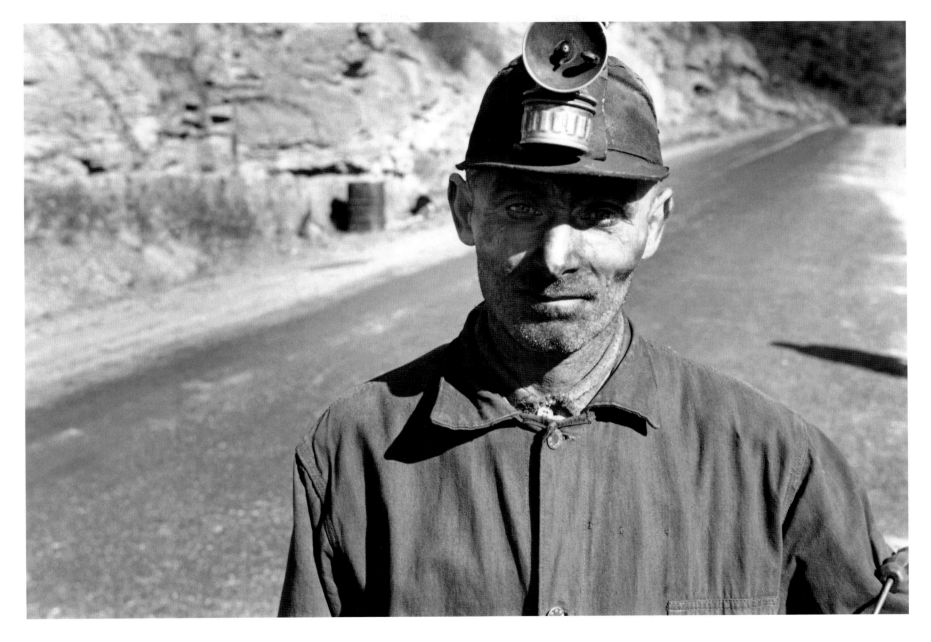

Miner at Freeze Fork, West Virginia

BEN SHAHN, OCTOBER 1935

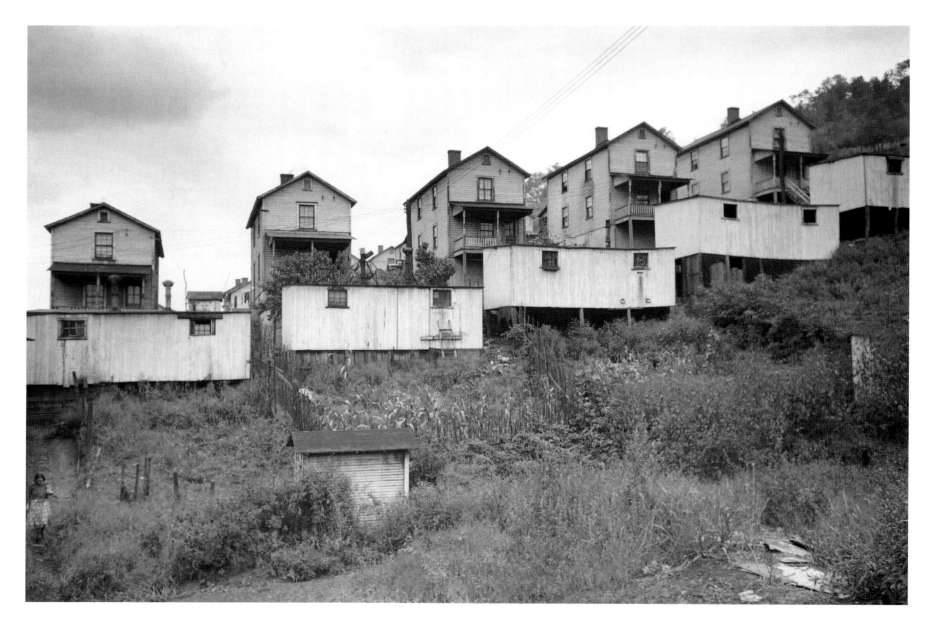

Company houses and shacks, Pursglove, West Virginia
MARION POST WOLCOTT, SEPTEMBER 1938

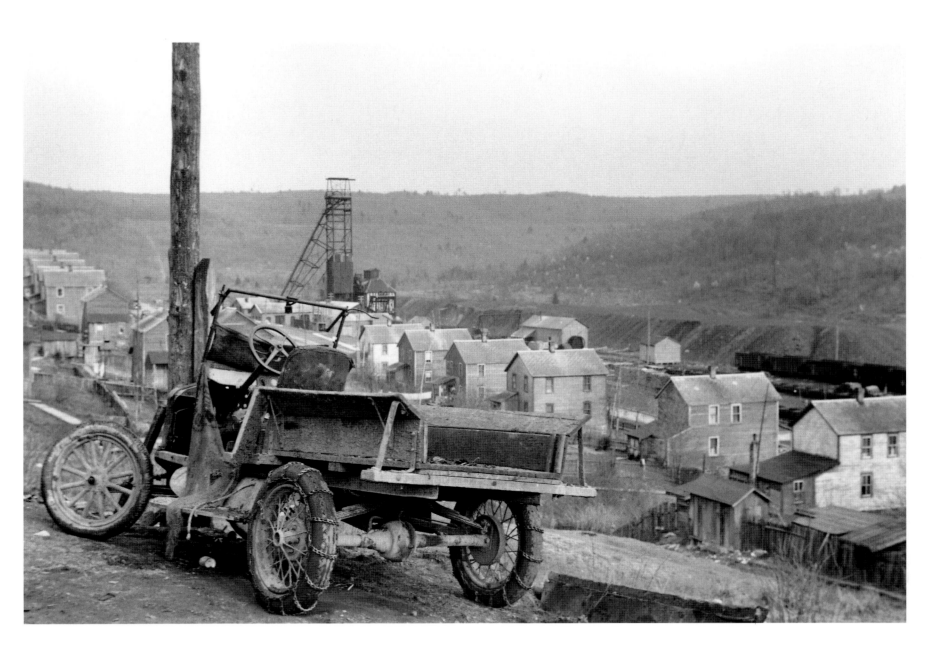

Company town, Kempton, West Virginia

John Vachon, May 1939

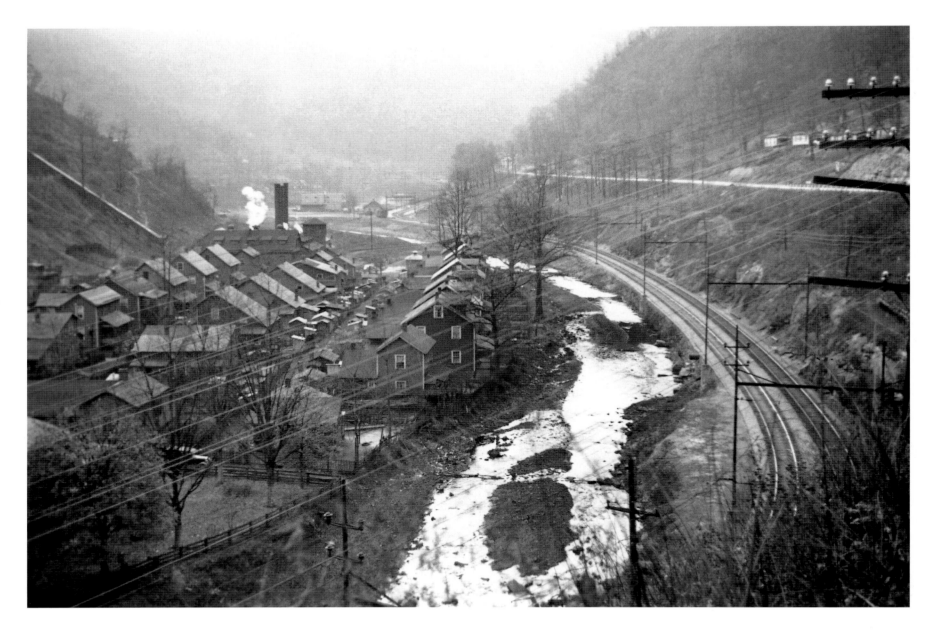

Kimball, West Virginia
BEN SHAHN, OCTOBER 1935

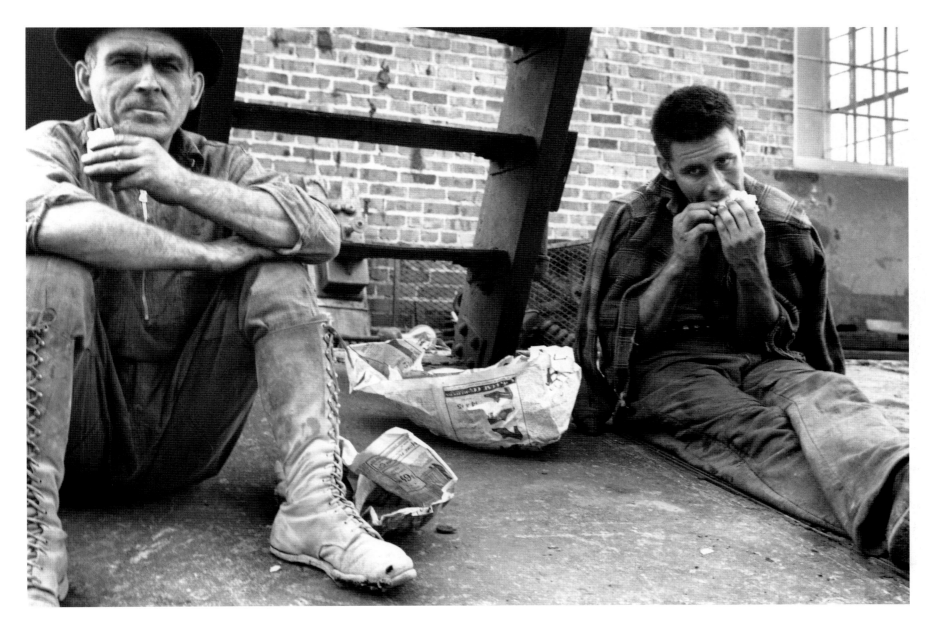

Miners at Calumet, Westmoreland County, Pennsylvania

BEN SHAHN, OCTOBER 1935

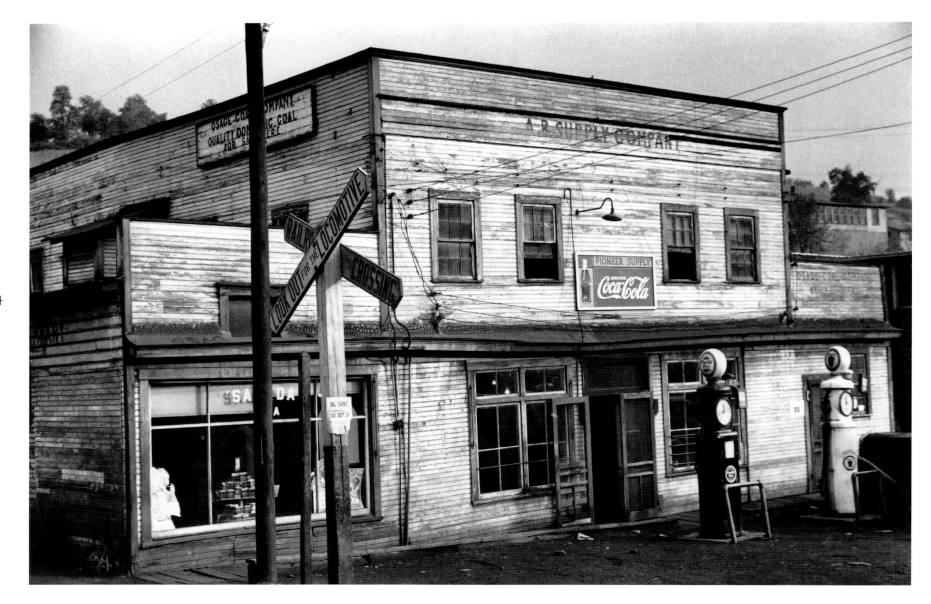

Company store, Osage, West Virginia. Sack of flour in A&P in same town costs sixty-nine cents and in company story costs one dollar and twenty-five cents.

MARION POST WOLCOTT, SEPTEMBER 1938

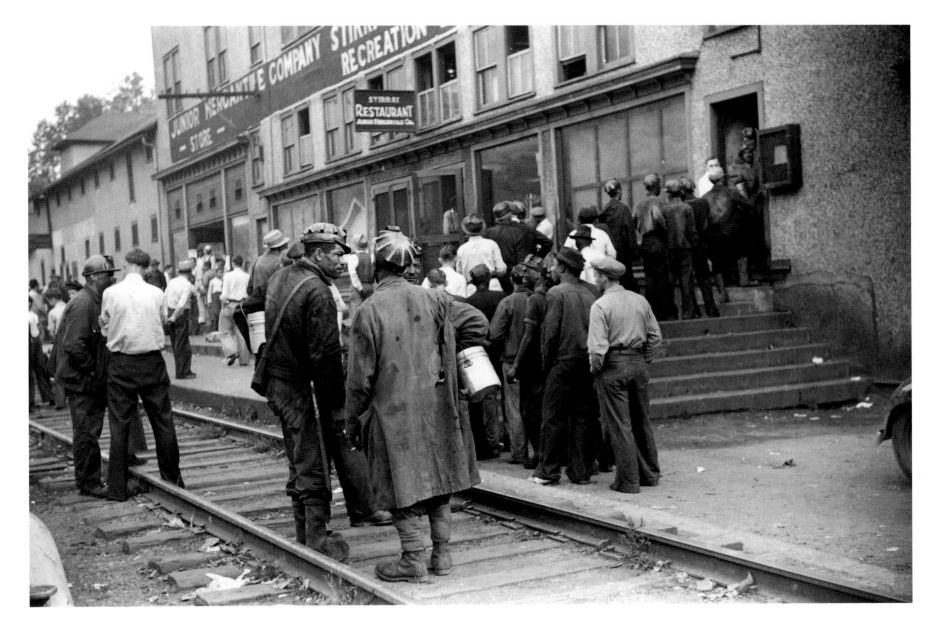

Payday, coal mining town, Omar, West Virginia

Marion Post Wolcott, September 1938

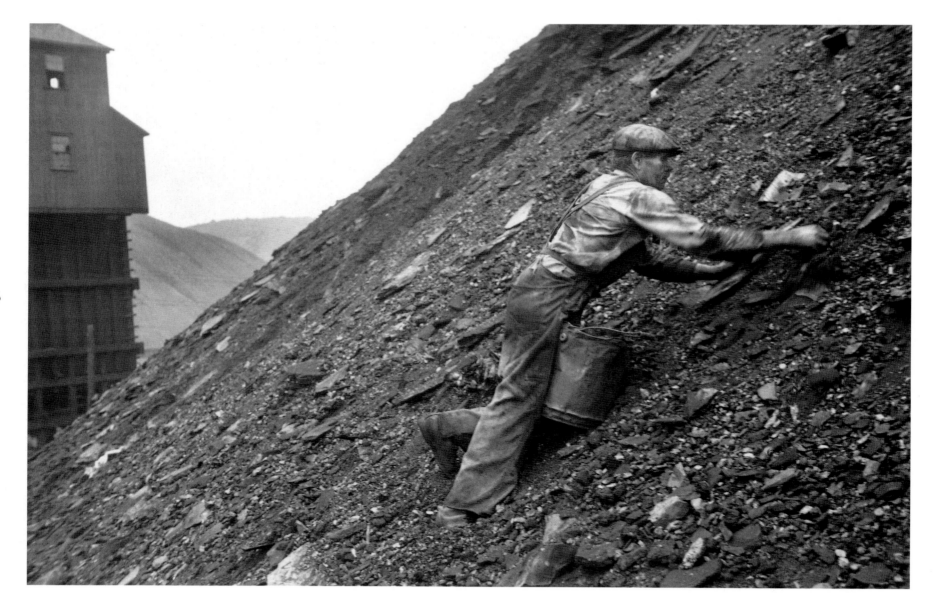

Man gathering good coal from the slag heaps at Nanty Glo, Pennsylvania
BEN SHAHN, 1937

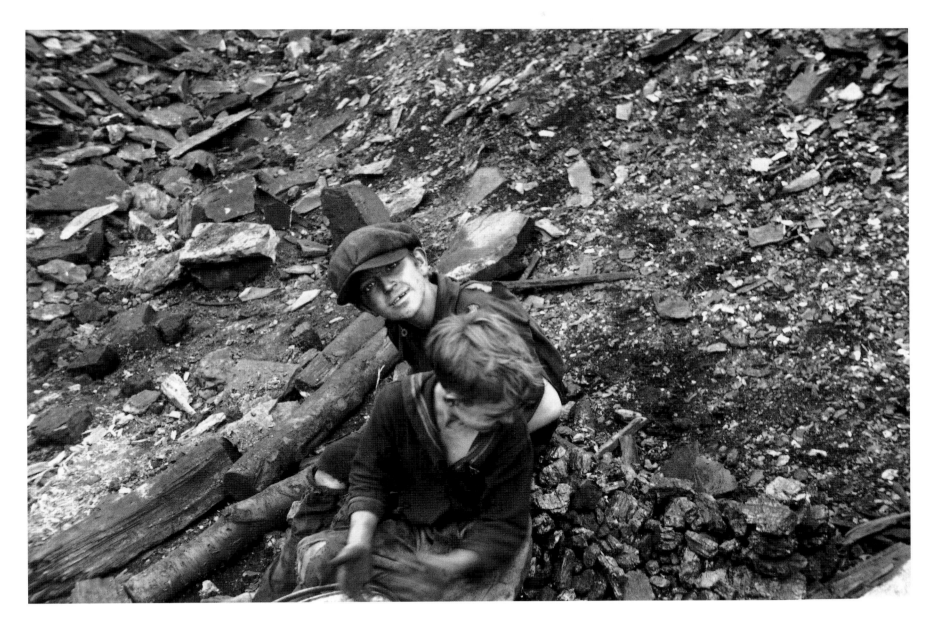

Young boys salvaging coal from the slag heaps, Nanty Glo, Pennsylvania

Ben Shahn, 1937

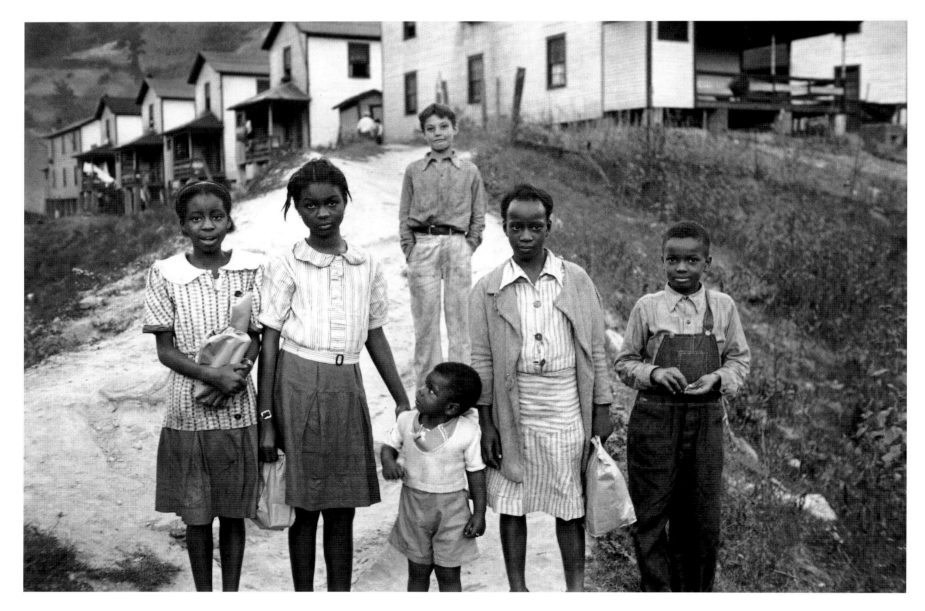

Omar, West Virginia

Ben Shahn, October 1935

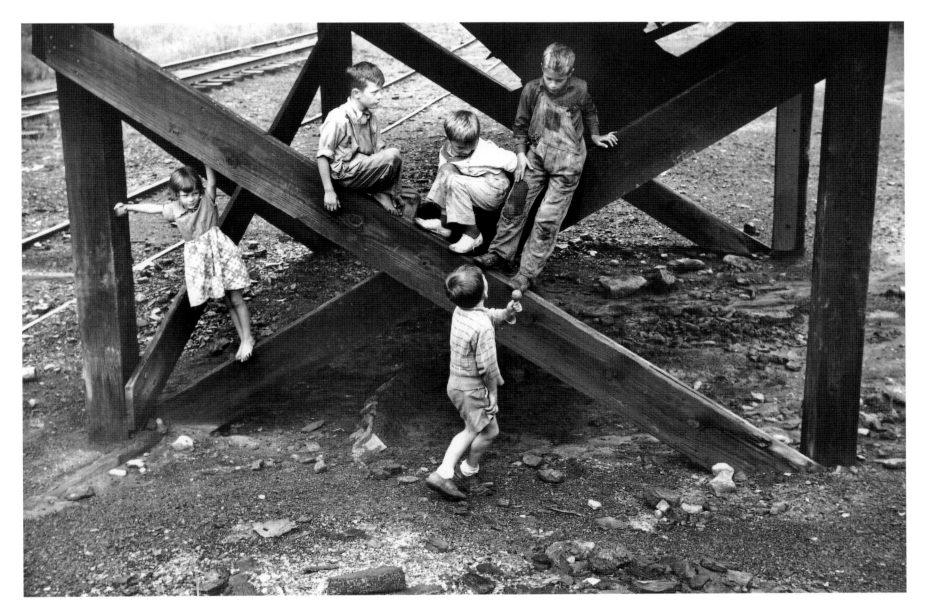

Children's favorite playground, around coal mine tipples, Pursglove, Scotts Run, West Virginia
MARION POST WOLCOTT, SEPTEMBER 1938

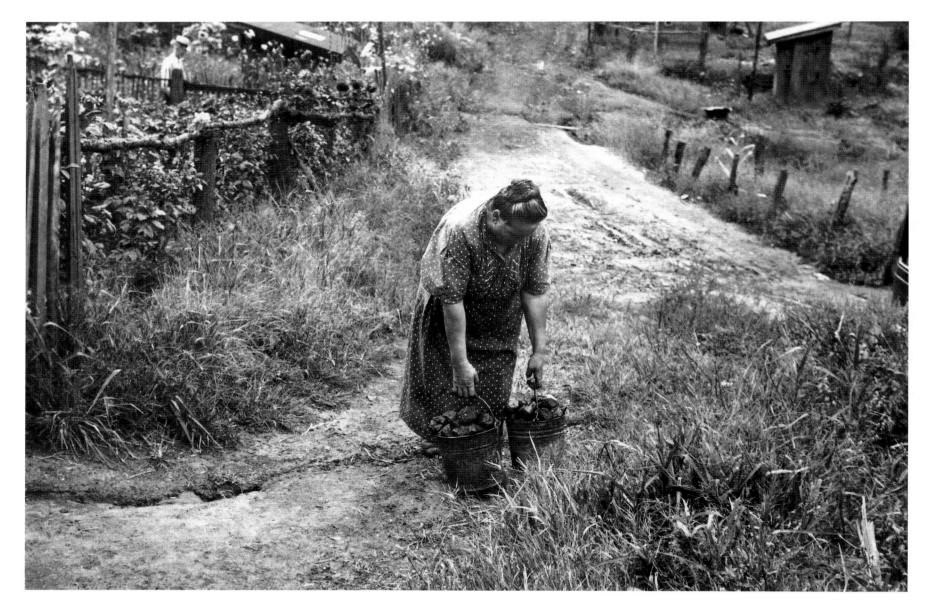

Hungarian miner's wife bringing home coal for the stove from slate pile, coal camp, Chaplin, West Virginia

MARION POST WOLCOTT, SEPTEMBER 1938

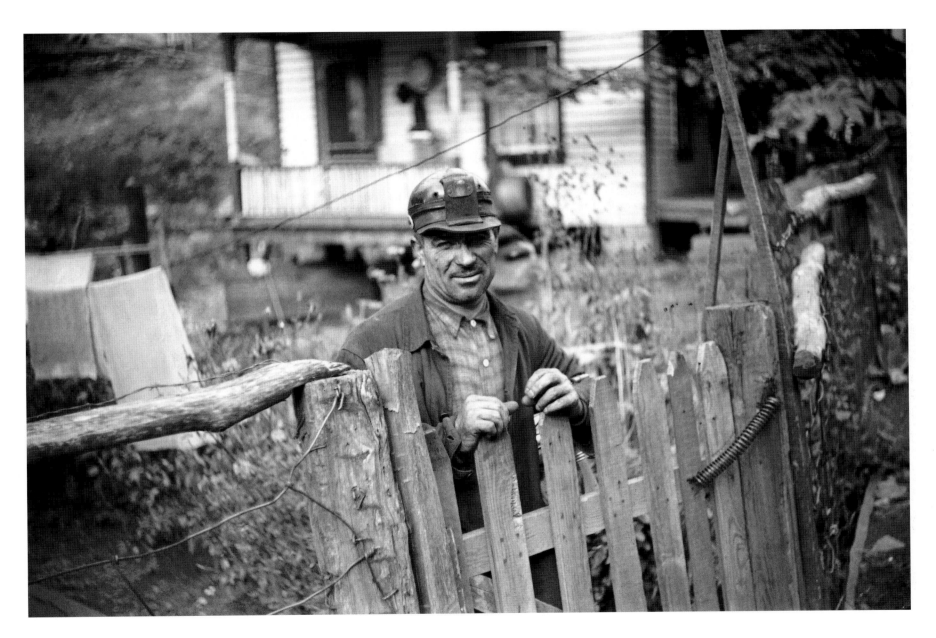

Miner (Russian), Caples, West Virginia
MARION POST WOLCOTT, SEPTEMBER 1938

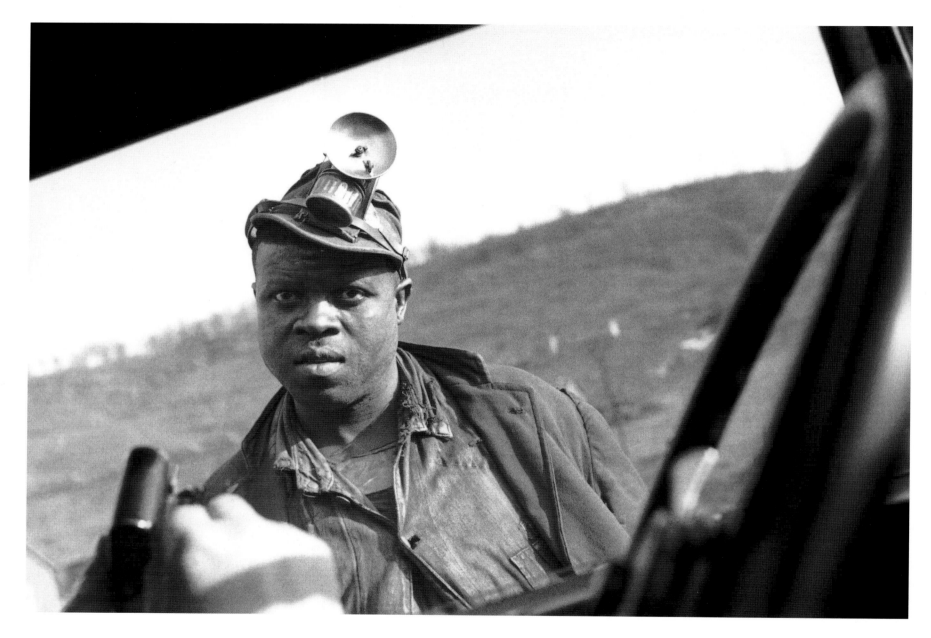

Untitled (Alabama)

Walker Evans, Summer 1938

Steam shovels, Cherokee County, Kansas

Arthur Rothstein, May 1936

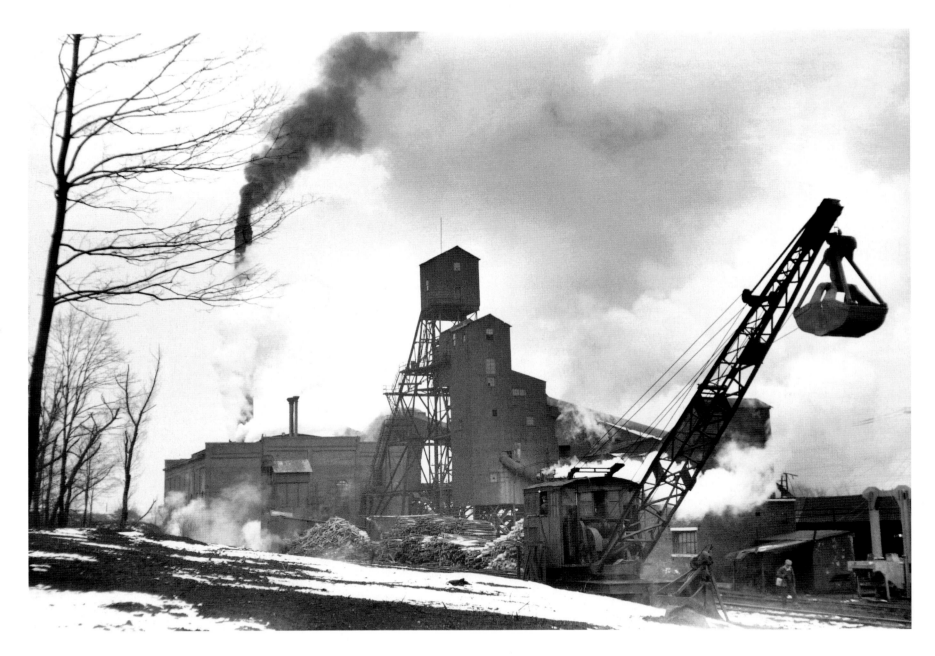

Orient No. 1, one of the largest coal mines in the world, Franklin County, Illinois

Arthur Rothstein, January 1939

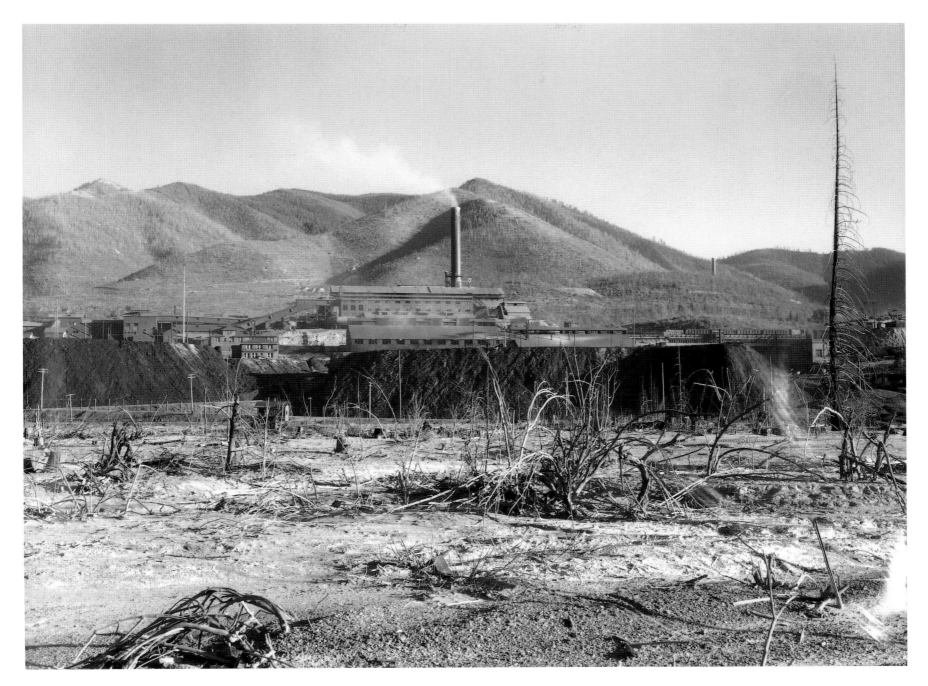

Largest lead mine in the world surrounded by destroyed trees, Kellogg, Idaho

Arthur Rothstein, July 1936

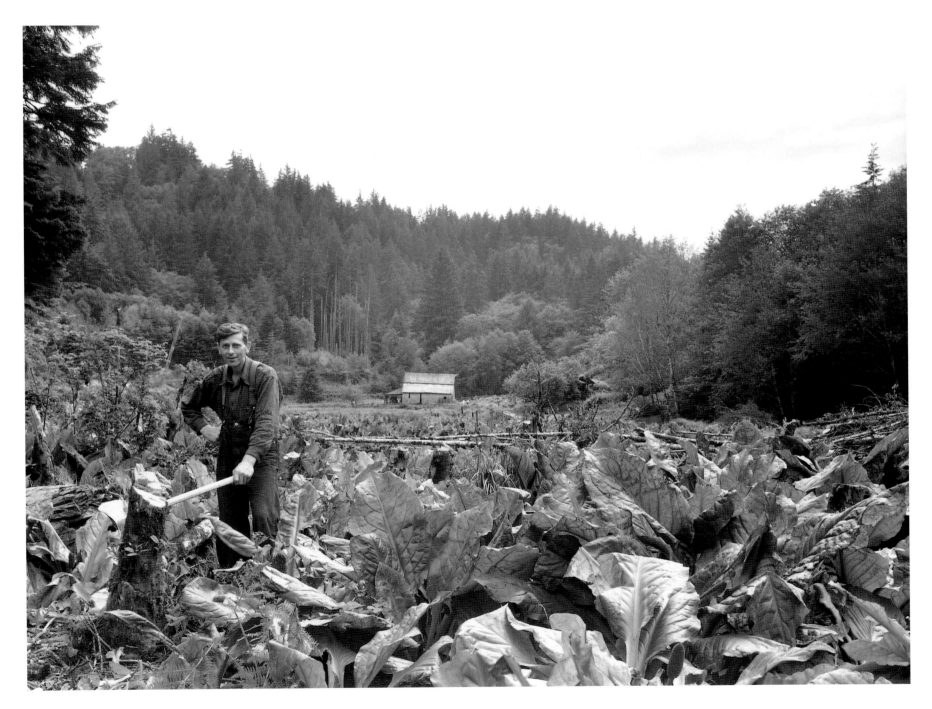

Skunk cabbage, ferns and alders keep this farmer in the hills hard at work as he attempts to clear an abandoned homestead, Oregon.
ARTHUR ROTHSTEIN, JUNE 1936

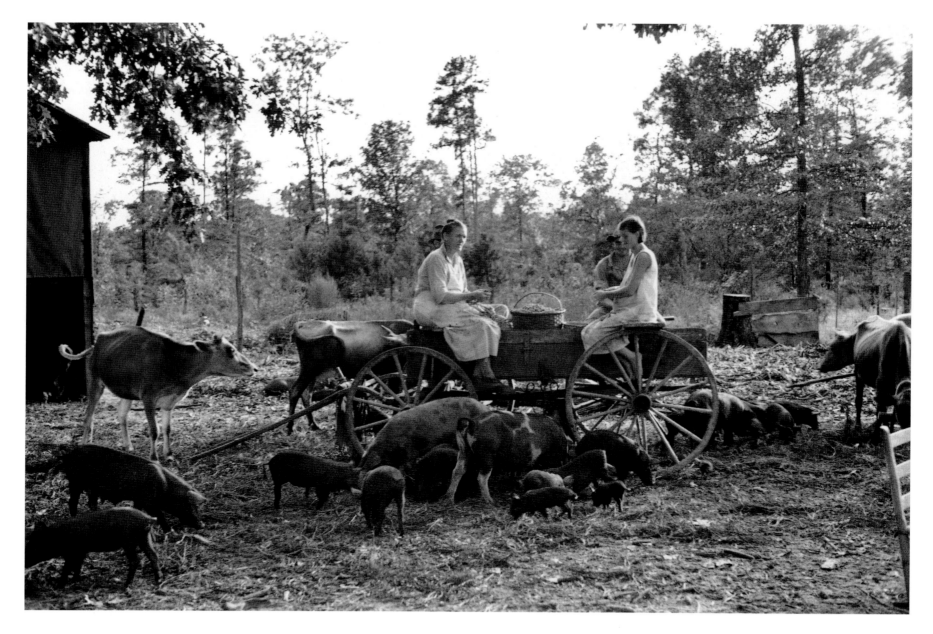

Shelling peanuts, Wolf Creek, Georgia

ARTHUR ROTHSTEIN, AUGUST 1935

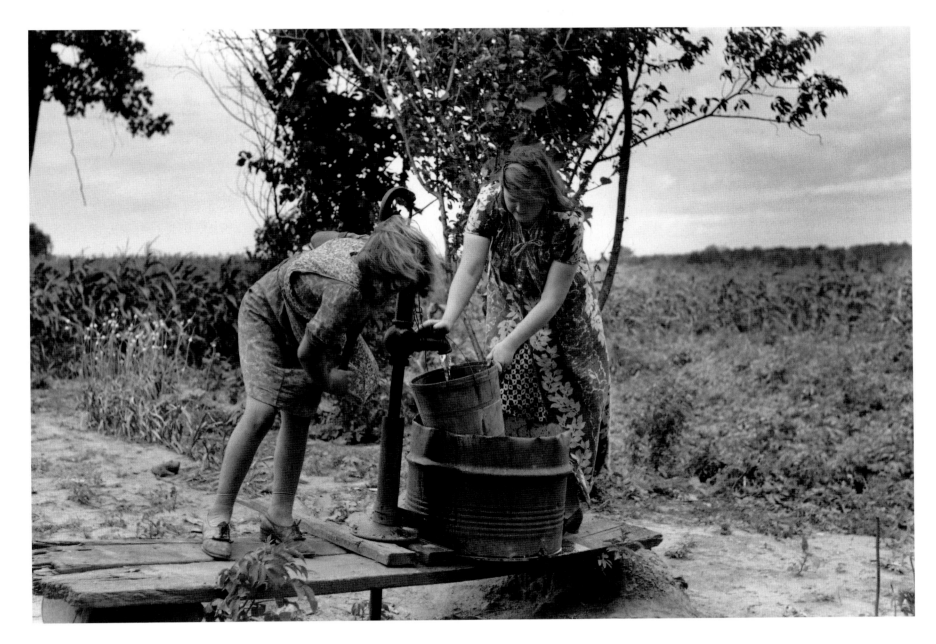

Pumping water near Muskogee, Oklahoma. Daughters of farmer about to migrate to California

RUSSELL LEE, JULY 1939

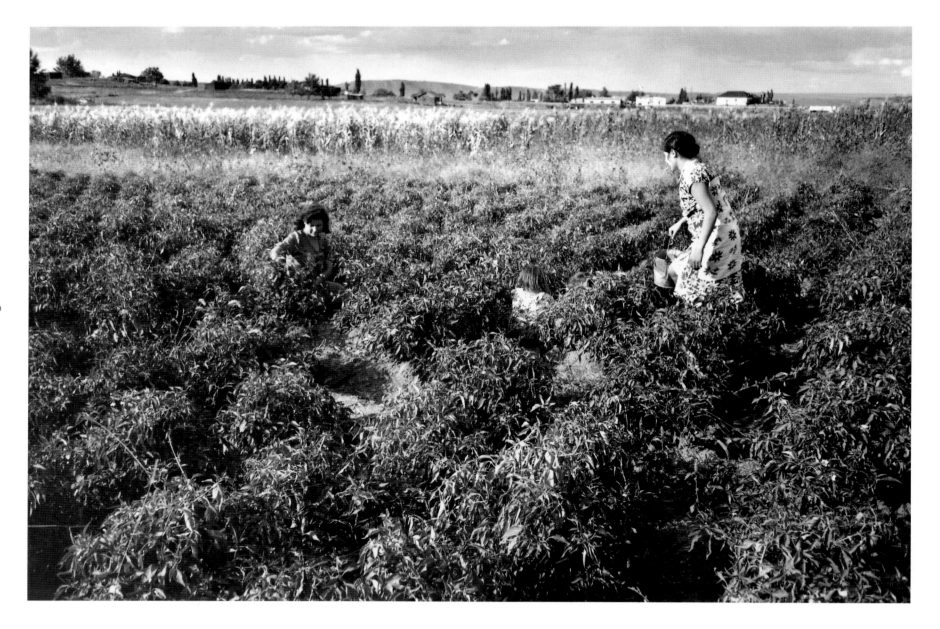

Spanish farmer's wife and daughter picking chili peppers, Concho, Arizona
RUSSELL LEE, SEPTEMBER 1940

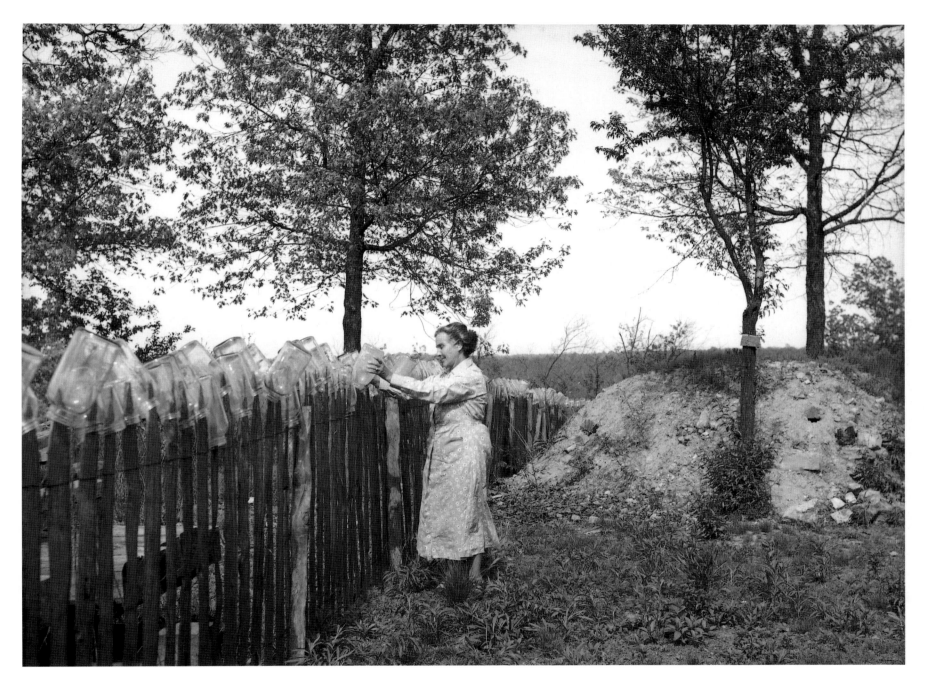

Drying jars at canning time, a house purchased for the Lake of the Ozarks project, Missouri

Carl Mydans, May 1936

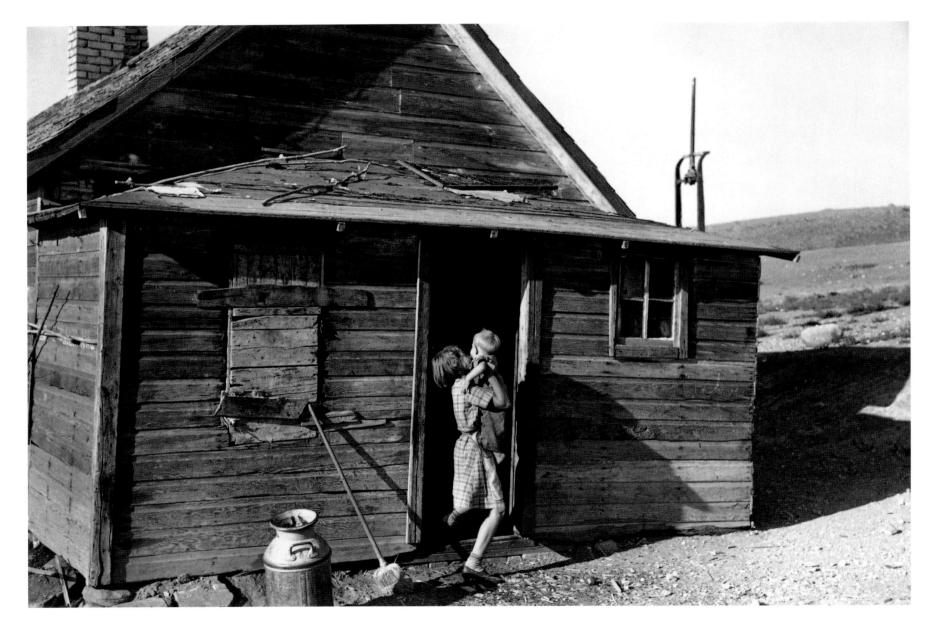

Children of Floyd Peaches, farmer, Williston (vicinity), North Dakota

RUSSELL LEE, SEPTEMBER 1937

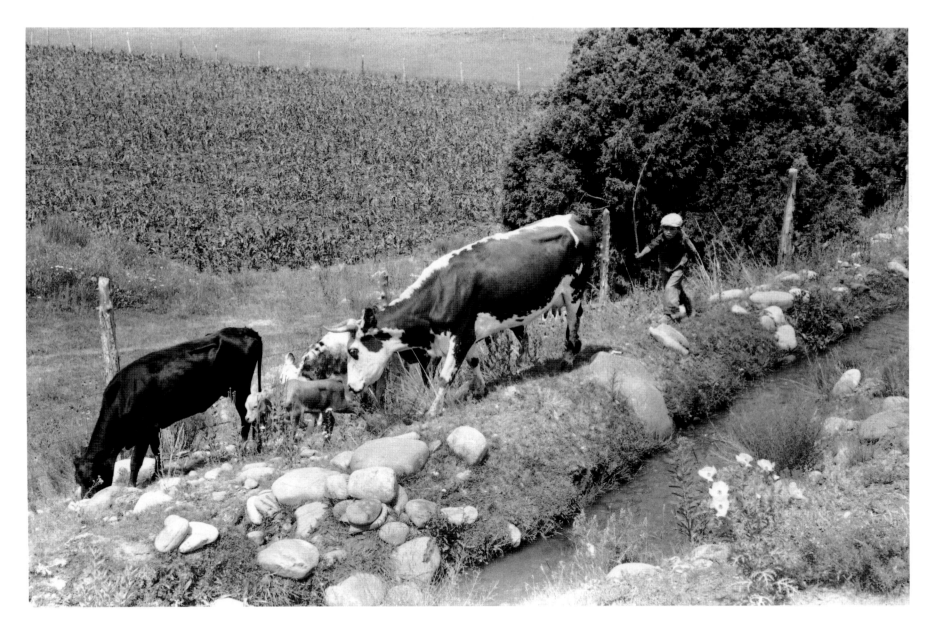

Child tending cows grazing along irrigation ditch, Penasco, New Mexico
RUSSELL LEE, JULY 1940

284

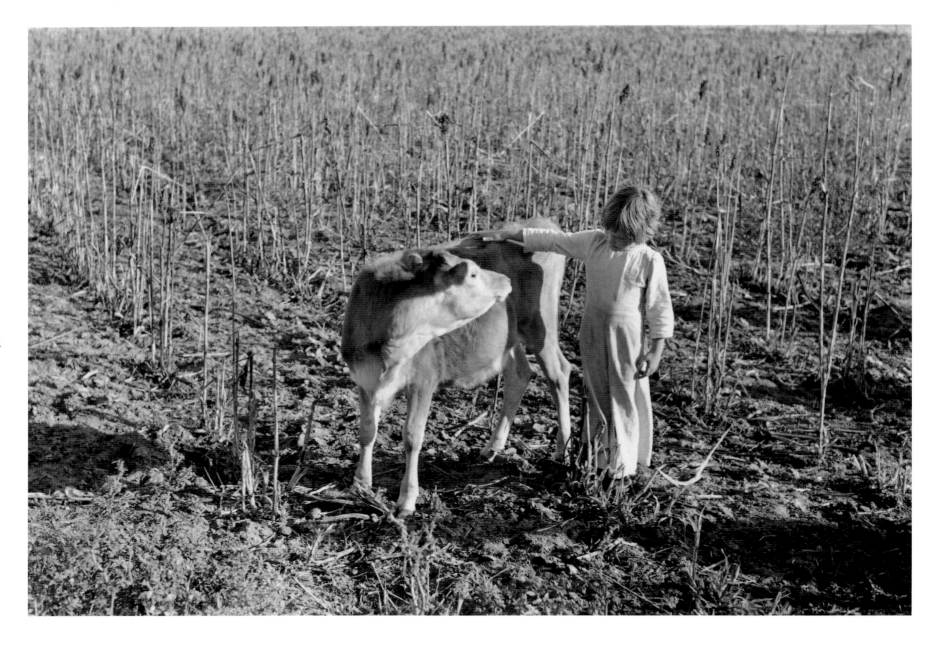

Above: Little girl petting calf, tenant purchase client near Welasco, Texas
Russell Lee, February 1935

Opposite: Farmer of Franklin County, Kansas
Arthur Rothstein, May 1936

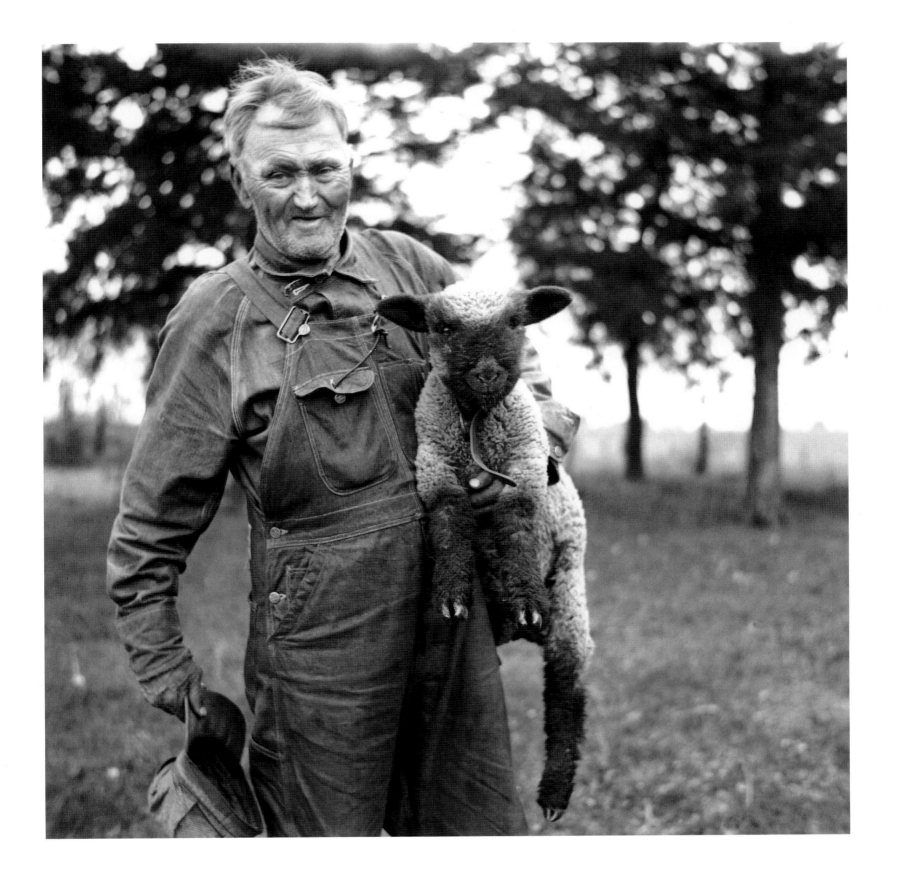

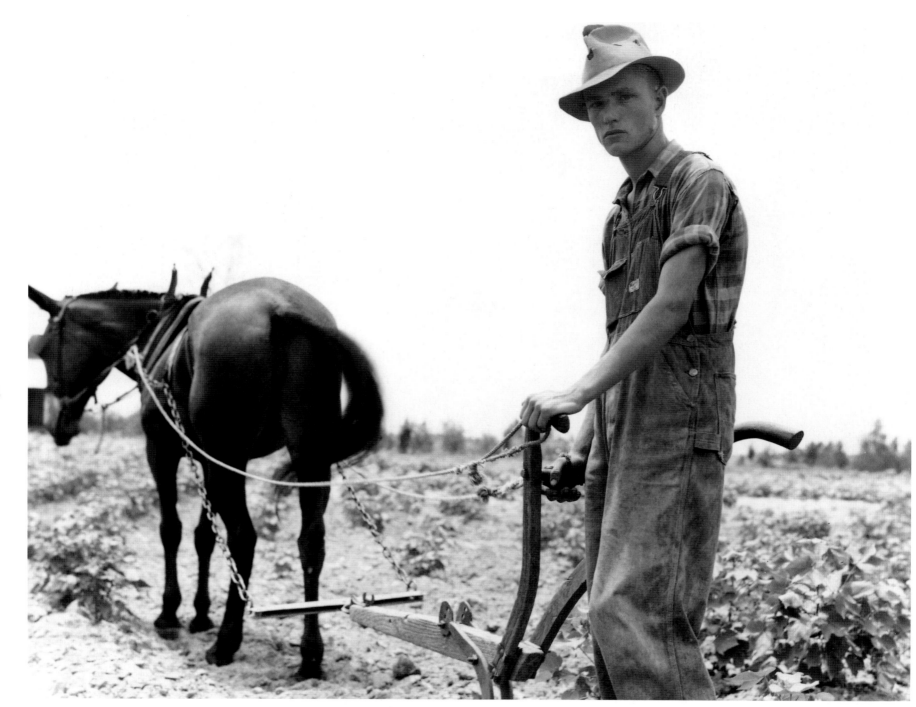

ABOVE: Son of sharecropper family at work in the cotton near Chesnee, South Carolina
DOROTHEA LANGE, JUNE 1937

OPPOSITE: The common method of removing stones from cutover land is by use of the crowbar. Near Caspian, Michigan
RUSSELL LEE, MAY 1937

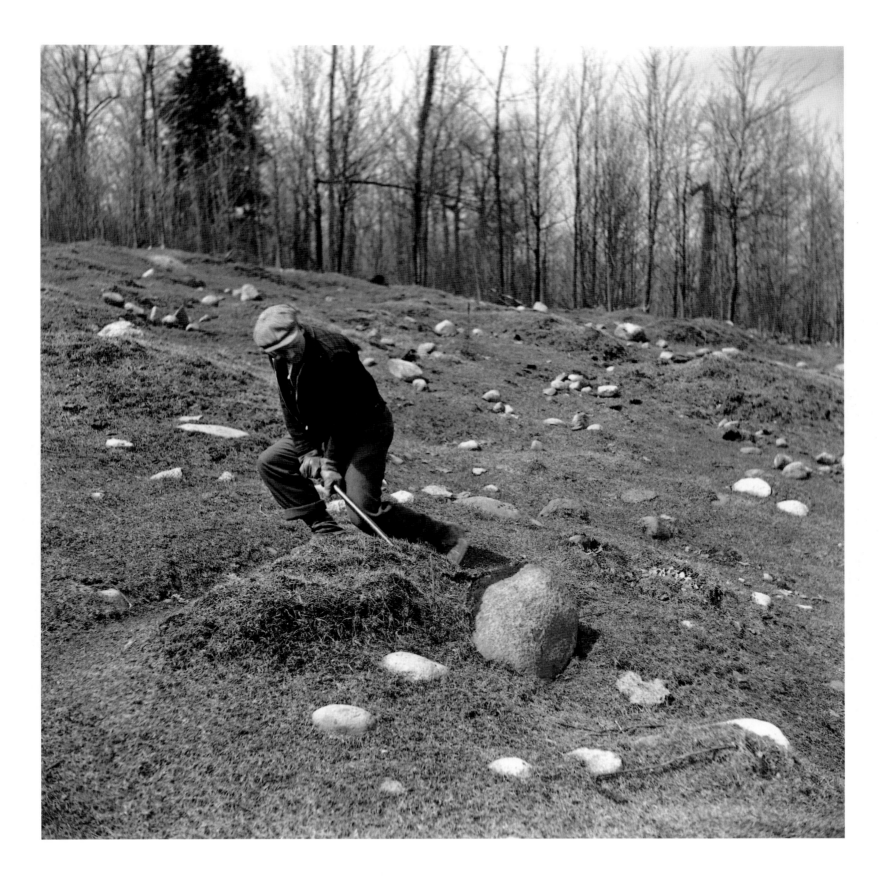

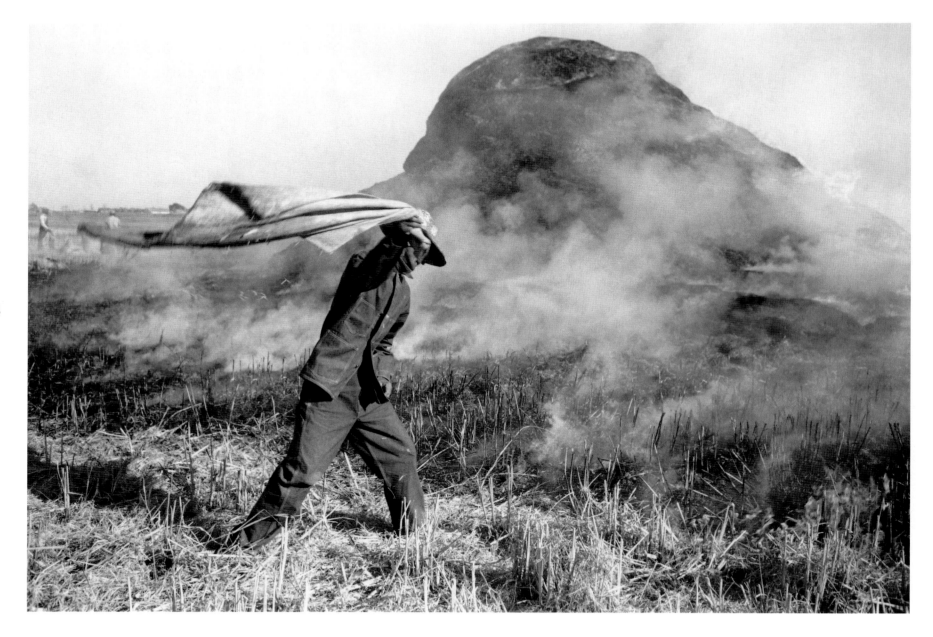

Fighting fire of rice straw sack in rice field near Crowley, Louisiana
RUSSELL LEE, SEPTEMBER 1938

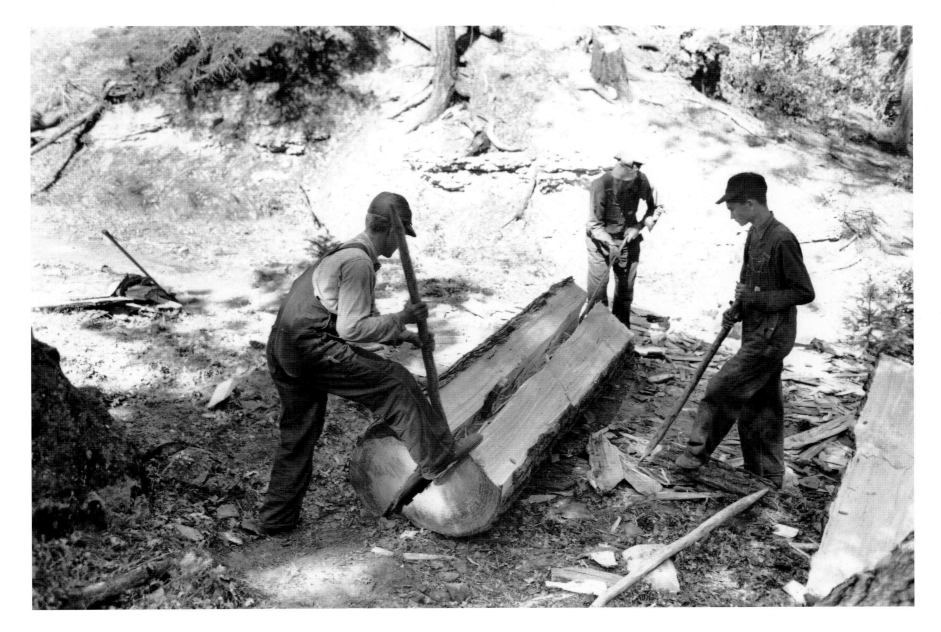

Splitting log, tie-cutting camp, Pie Town, New Mexico

RUSSELL LEE, JUNE 1940

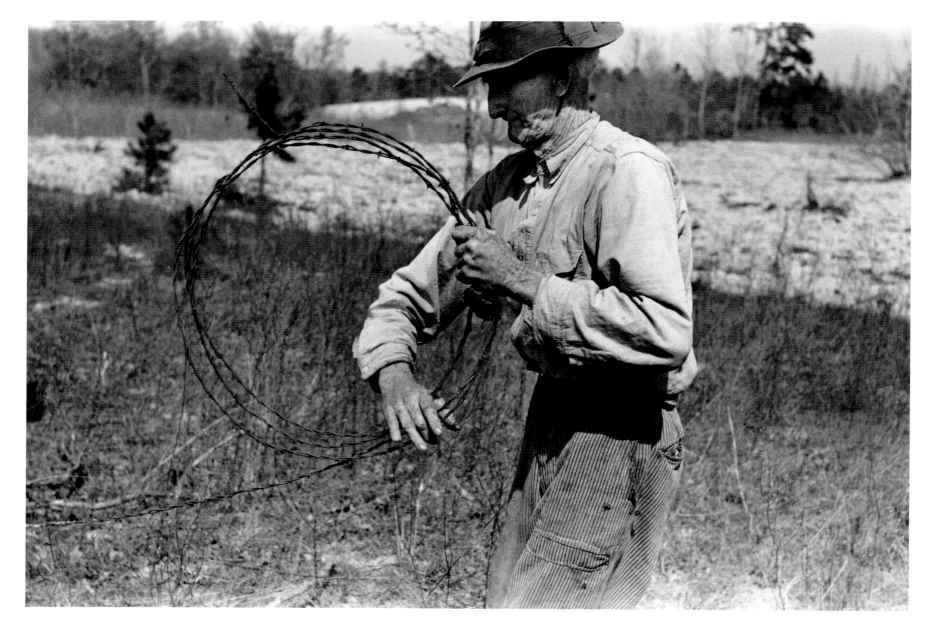

ABOVE: East Texas farm owner rolling up old barbed wire near Harleton, Texas
RUSSELL LEE, APRIL 1939

OPPOSITE: Tip Estes operating a tractor near Fowler, Indiana
RUSSELL LEE, APRIL 1937

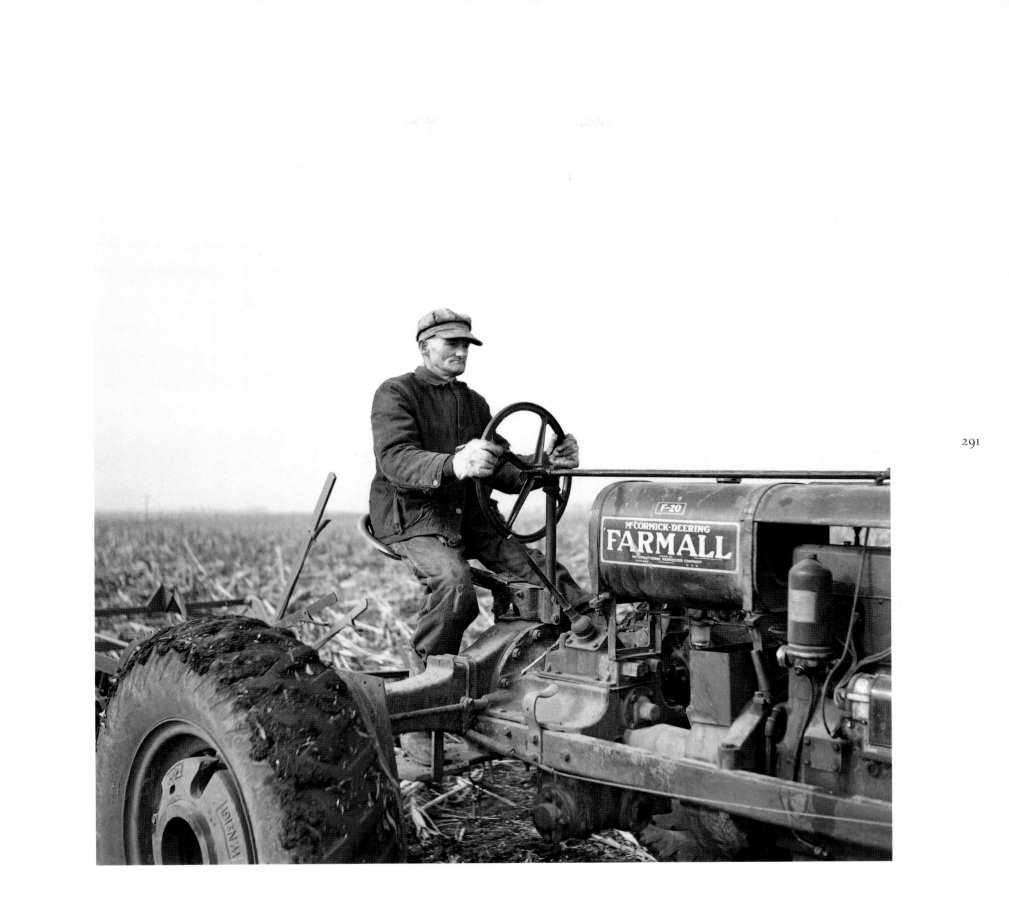

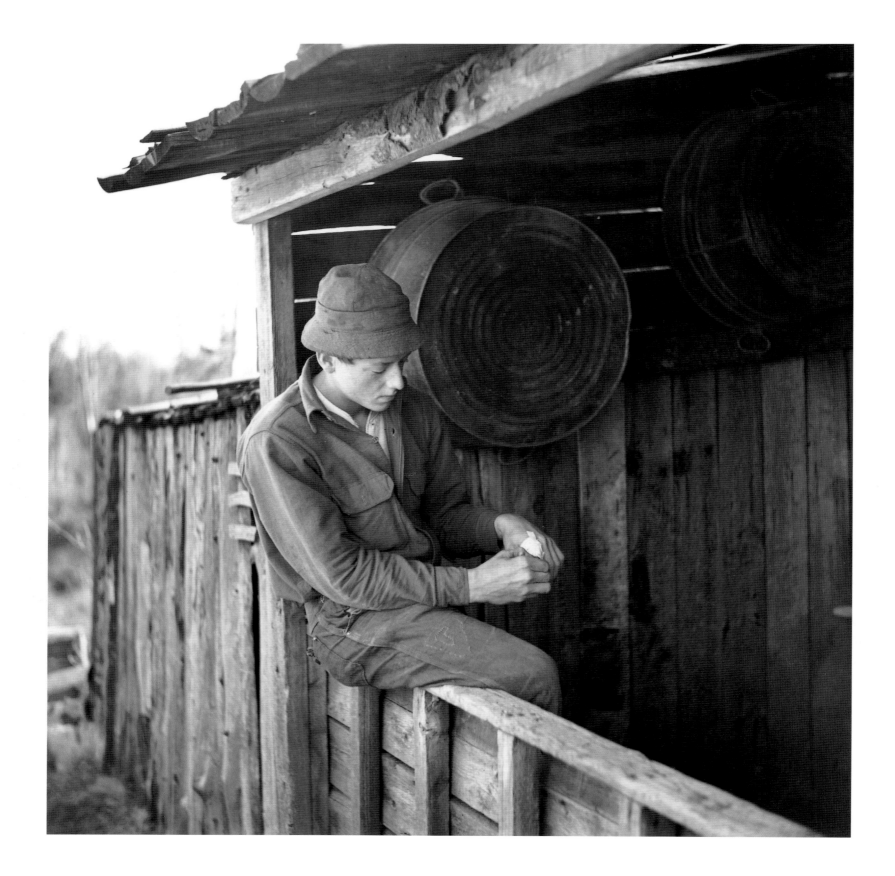

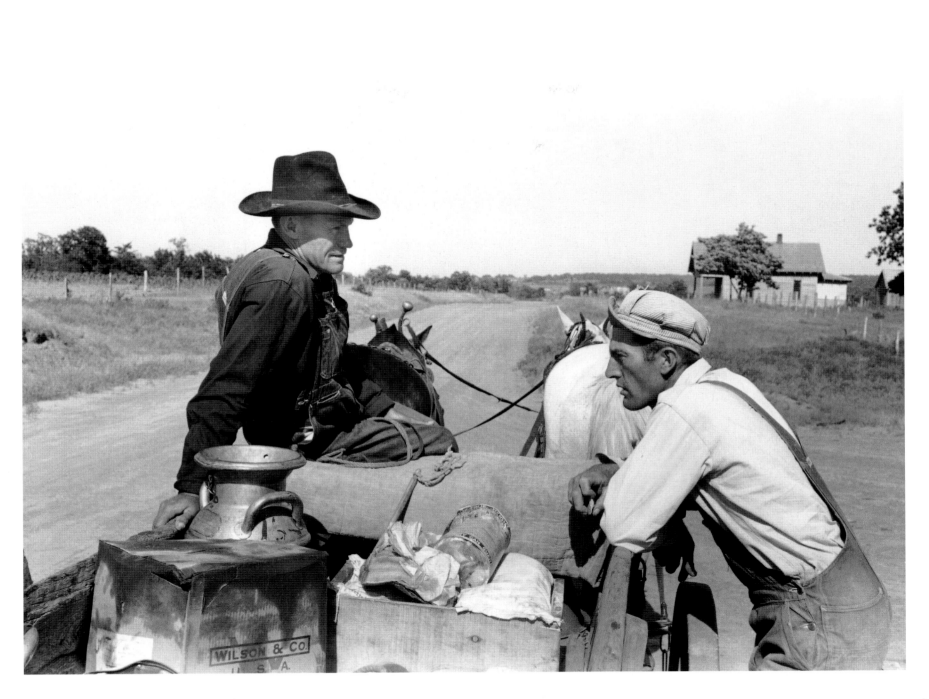

ABOVE: Farmers talking at crossroads grocery store in McIntosh County, Oklahoma
RUSSELL LEE, JUNE 1939

OPPOSITE: Son of William Sharrard, cutover farmer, near Silk Lake, Michigan, rolling a cigarette
RUSSELL LEE, MAY 1937

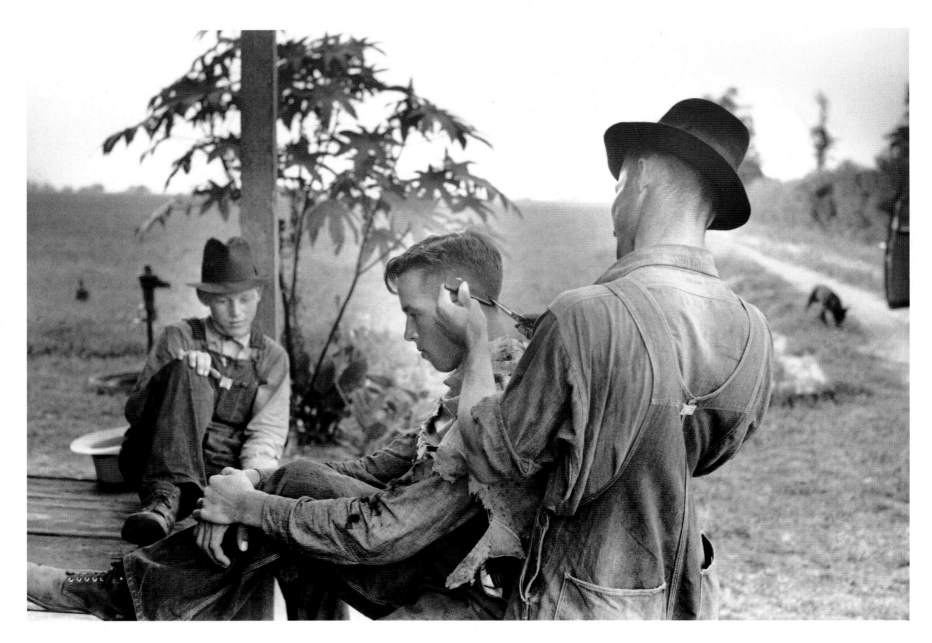

Farmer cutting his brother's hair, near Caruthersville, Missouri
RUSSELL LEE, AUGUST 1938

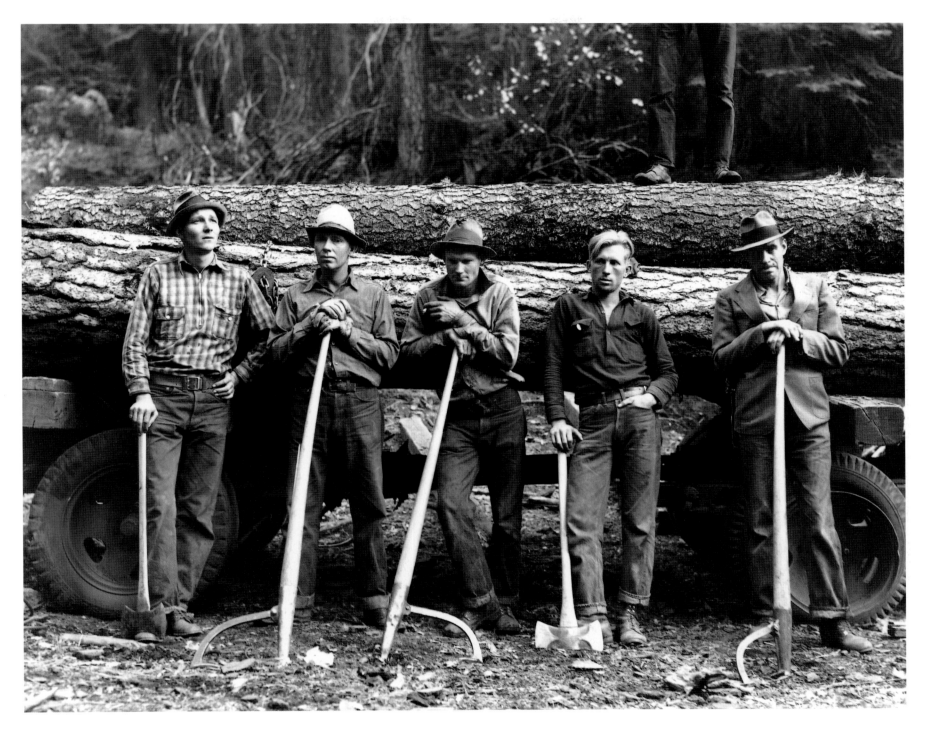

Five members of Ola self-help sawmill co-op, Gem County, Idaho

Dorothea Lange, October 1939

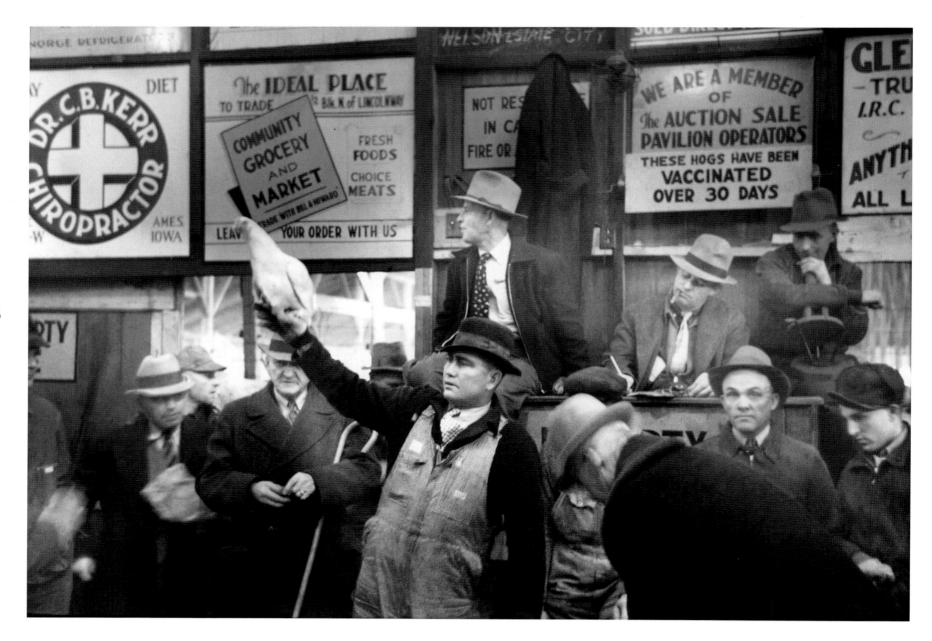

Untitled (Livestock auction, Ames, Iowa)
RUSSELL LEE, NOVEMBER 1936

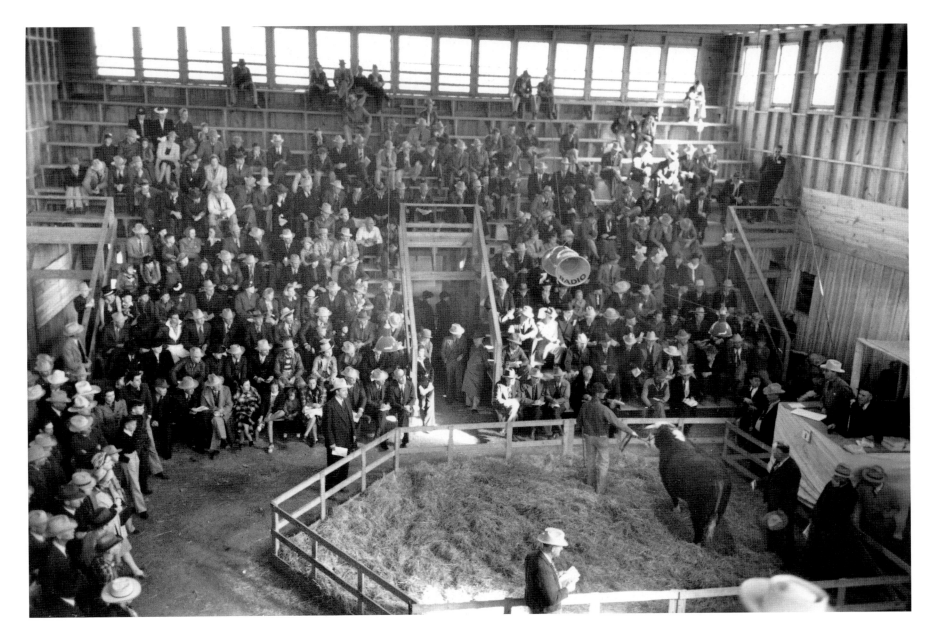

Crowd at the auction of the grand champion bull at the San Angelo Fat Stock Show, San Angelo, Texas

RUSSELL LEE, MARCH 1940

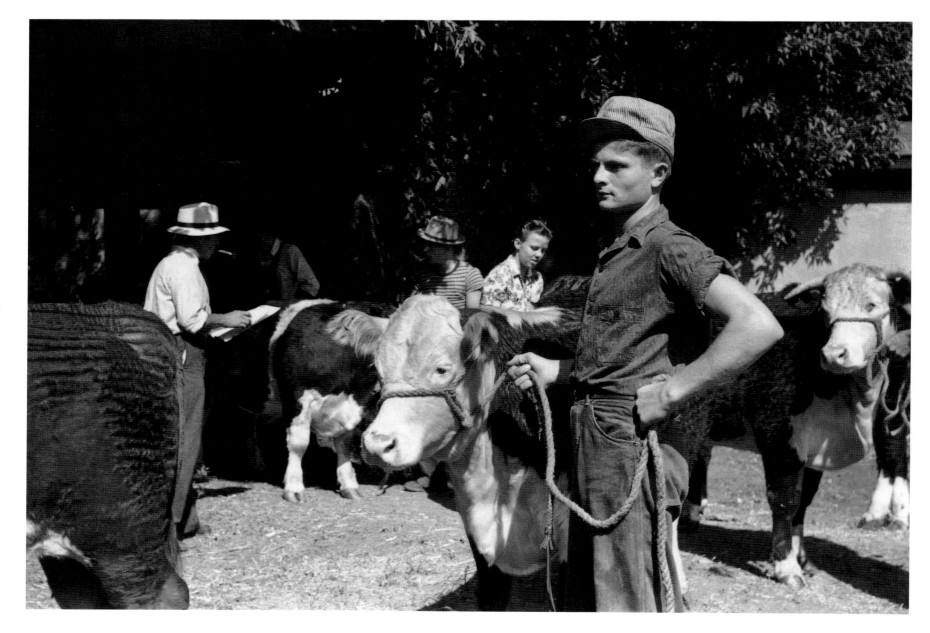

4-H Club boy waiting to have his calf auctioned off, Central Iowa 4-H Club fair, Marshalltown, Iowa

ARTHUR ROTHSTEIN, SEPTEMBER 1939

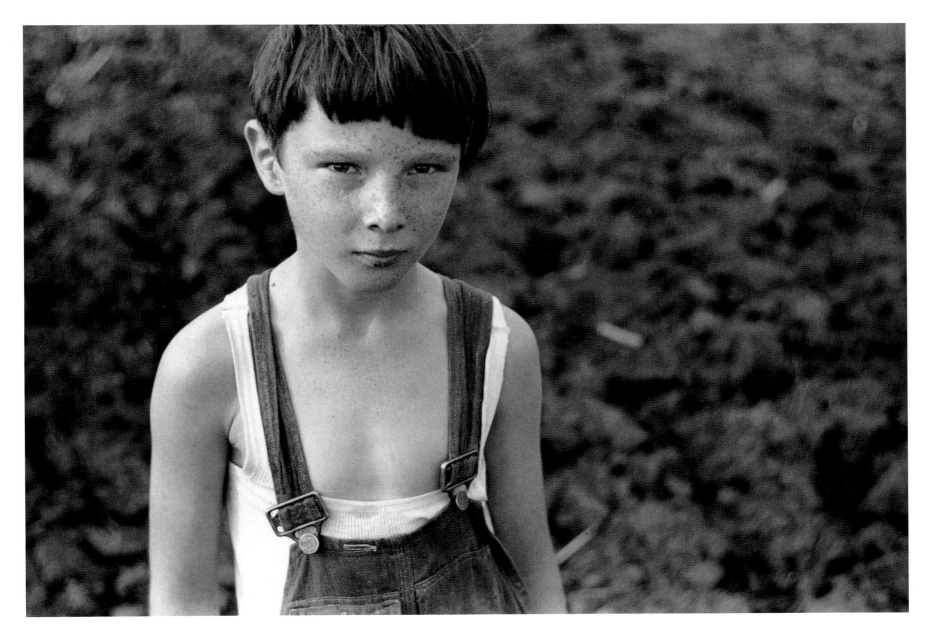

Coal miner's son at Granger Homesteads, Iowa

JOHN VACHON, MAY 1940

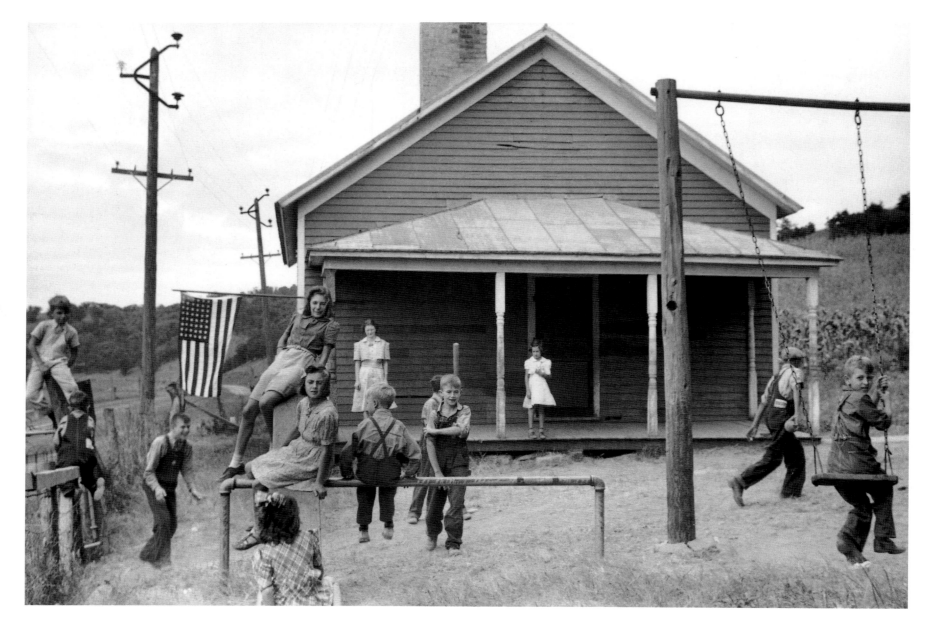

Rural school, Wisconsin
JOHN VACHON, SEPTEMBER 1939

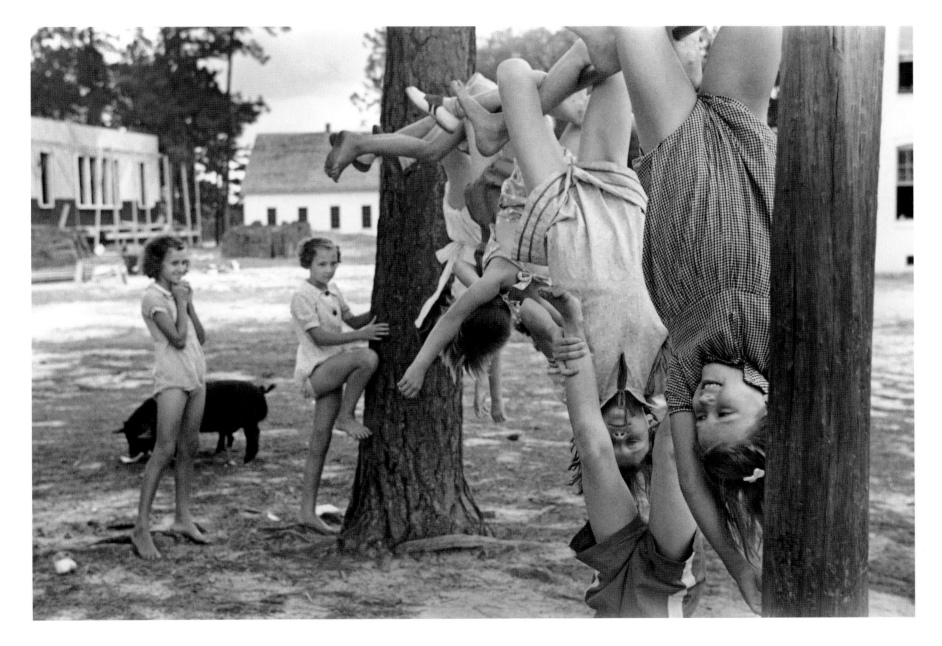

Untitled (Irwinville School, Georgia)

John Vachon, May 1938

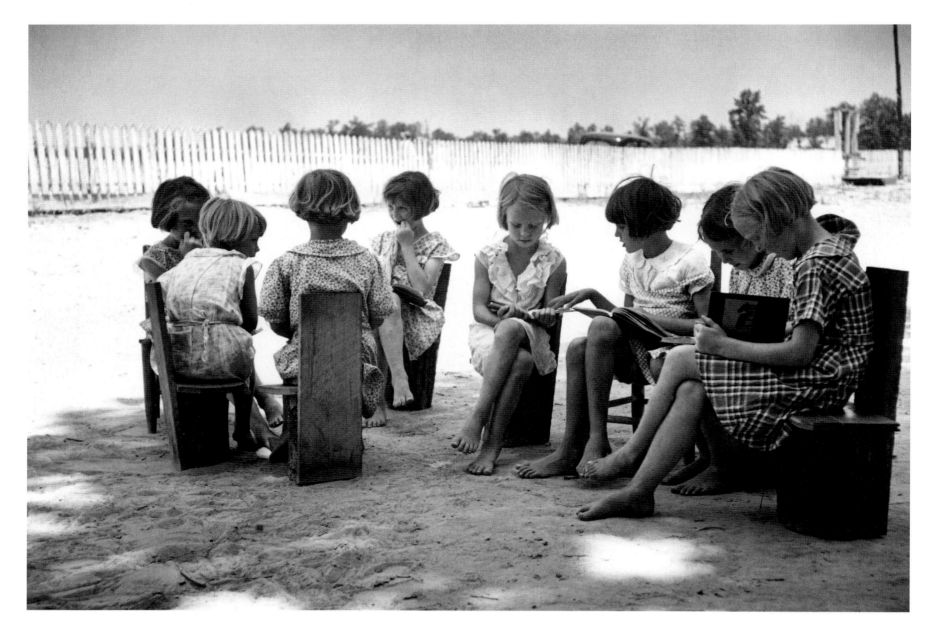

Untitled (School, Cumberland Mountain Farms, near Scottsboro, Alabama)
Carl Mydans, June 1936

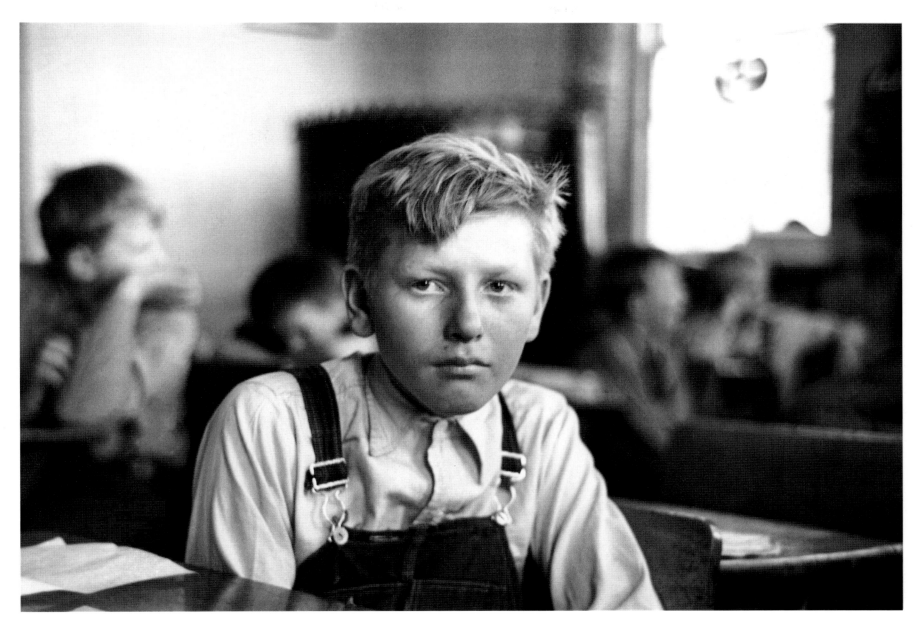

Pupil in rural school, Williams County, North Dakota

RUSSELL LEE, NOVEMBER 1937

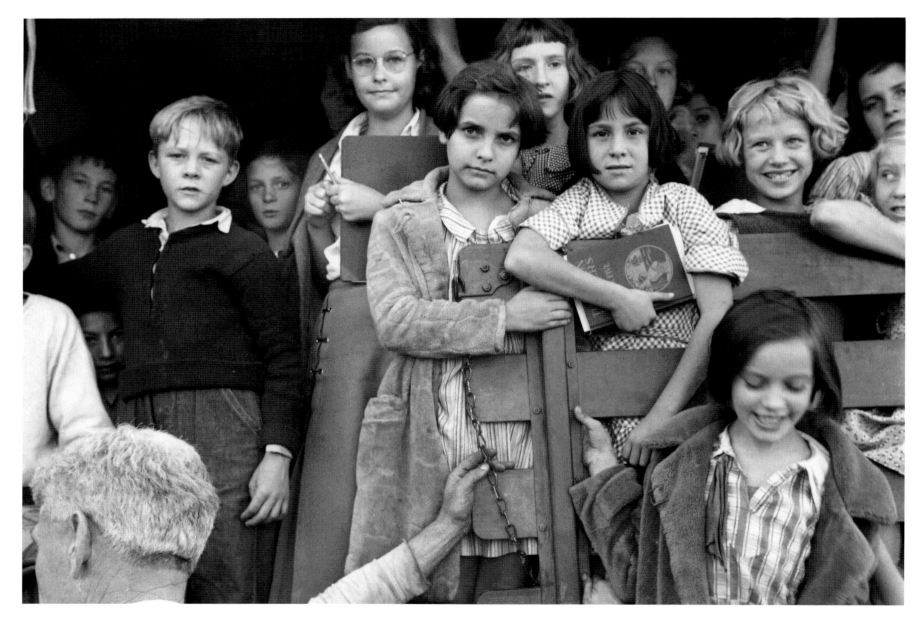

School youngsters, Red House, West Virginia
BEN SHAHN, OCTOBER 1935

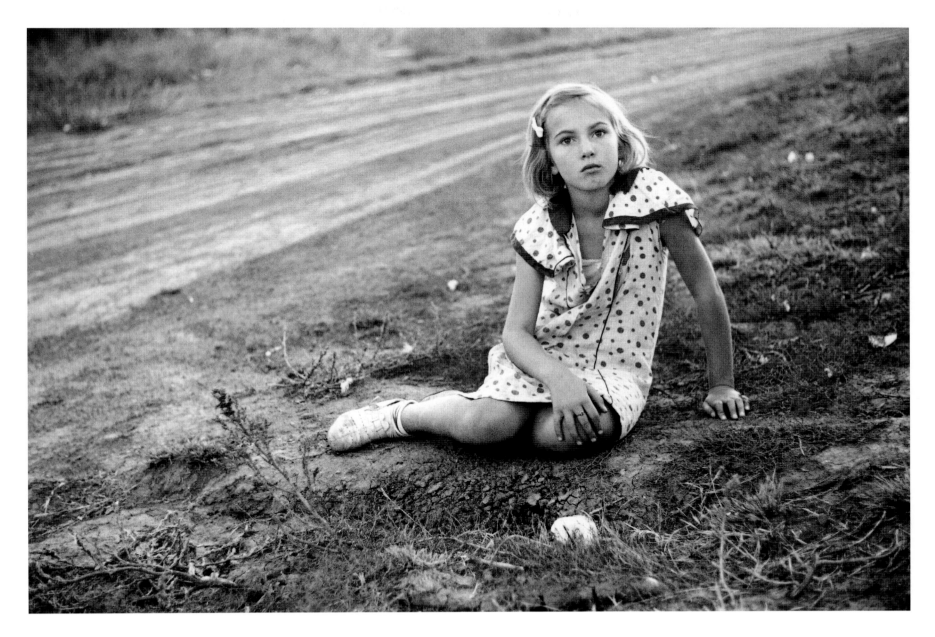

Farm girl, Seward County, Nebraska

John Vachon, October 1938

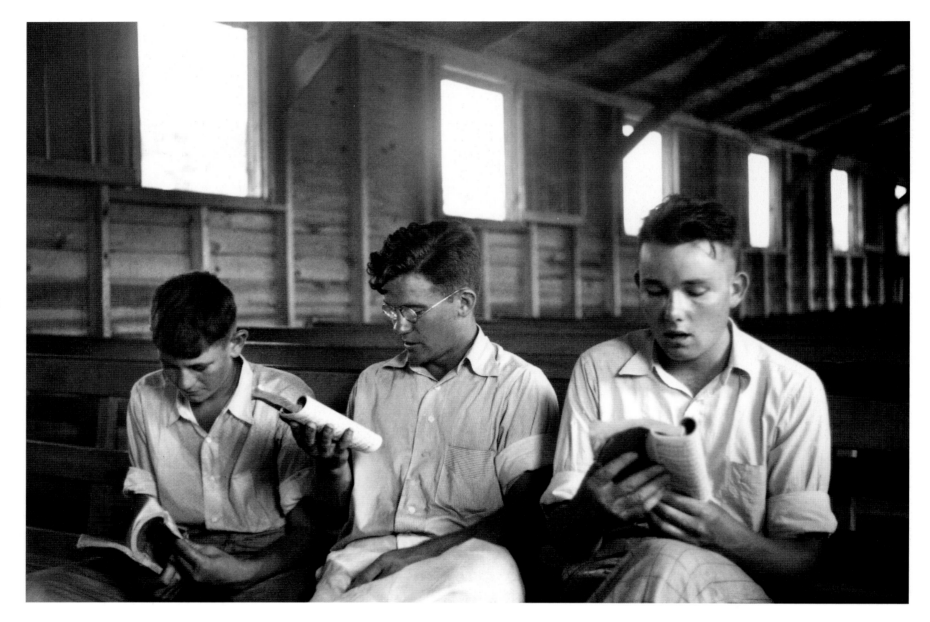

Untitled (Sunday school, Penderlea Homesteads, North Carolina)

Ben Shahn, 1937

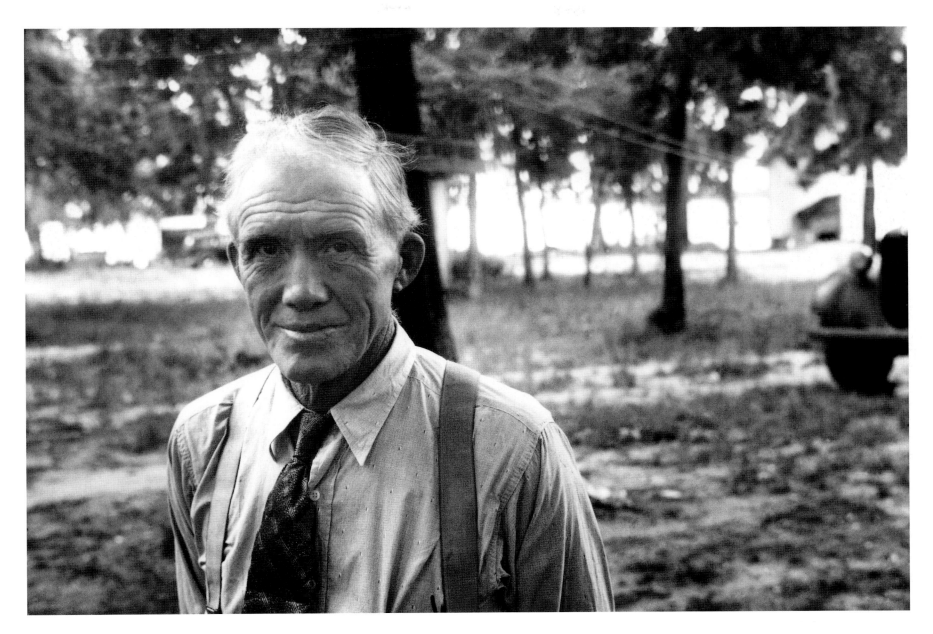

Untitled (Sunday school, Penderlea Homesteads, North Carolina)

BEN SHAHN, 1937

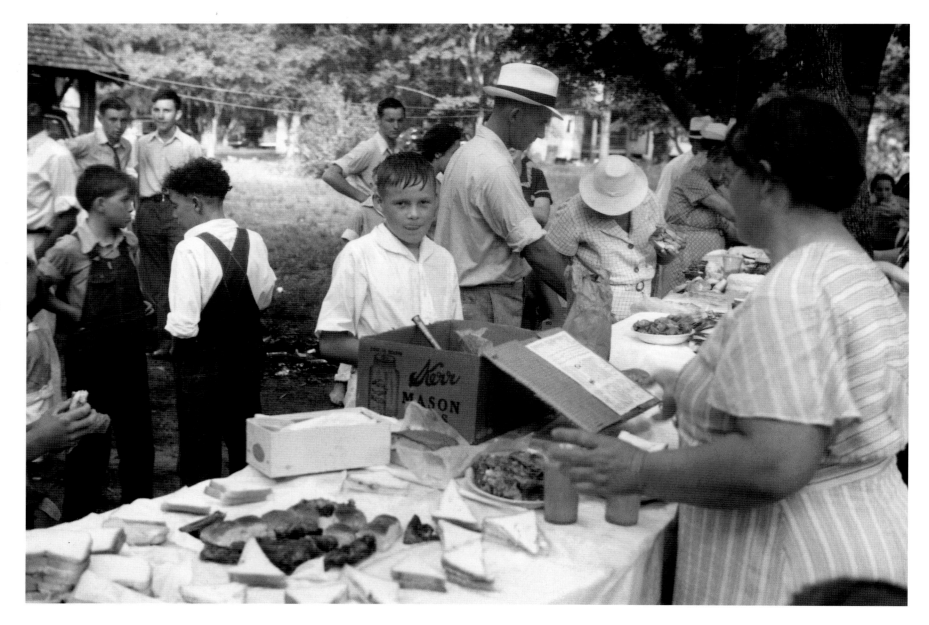

Untitled (Sunday school, Penderlea Homesteads, North Carolina)

Ben Shahn, 1937

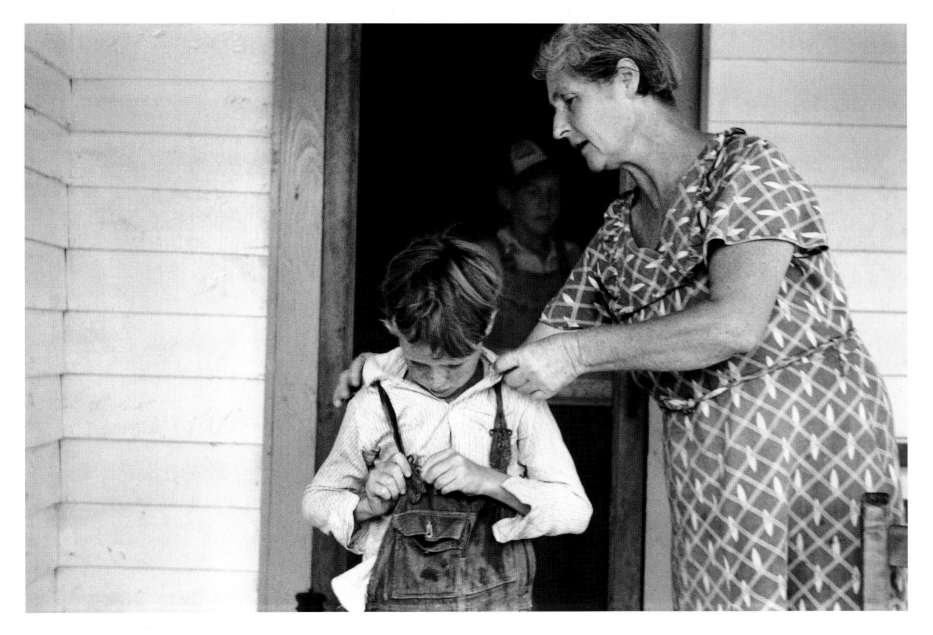

Untitled (Mississippi County, Arkansas)

Arthur Rothstein, August 1935

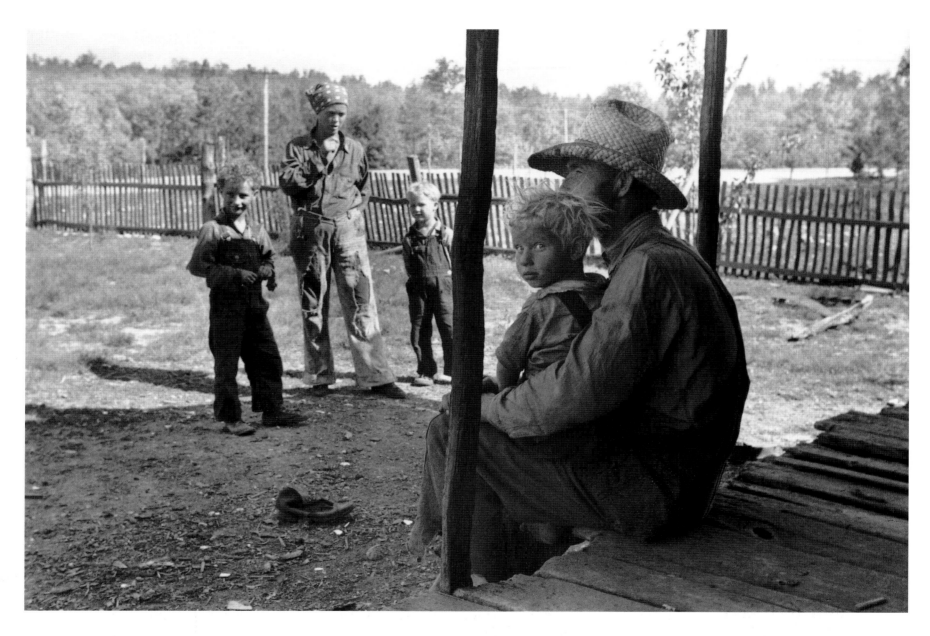

Above: Ozark farmer and family, Missouri
John Vachon, May 1940

Opposite: Untitled (West Texas tenant farmer and his son)
Dorothea Lange, June 1937

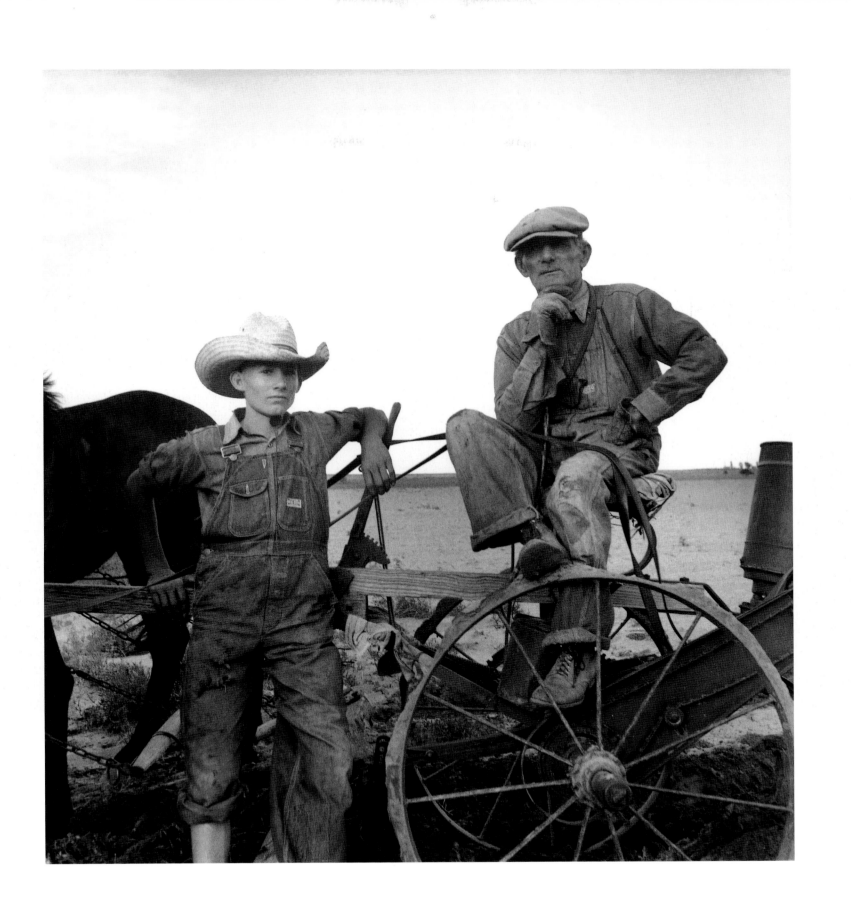

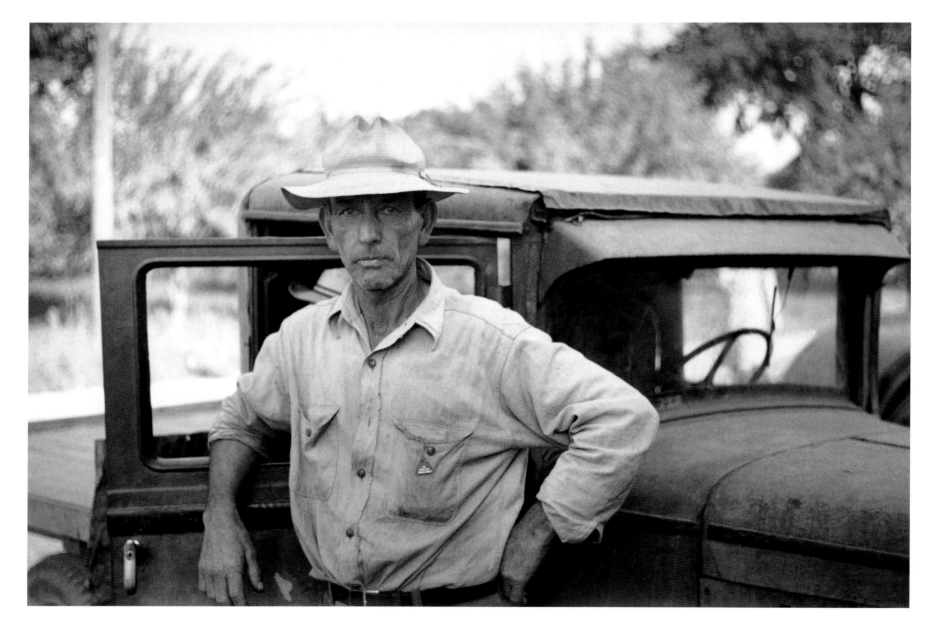

Untitled (Berrien County, Michigan)
JOHN VACHON, JULY 1940

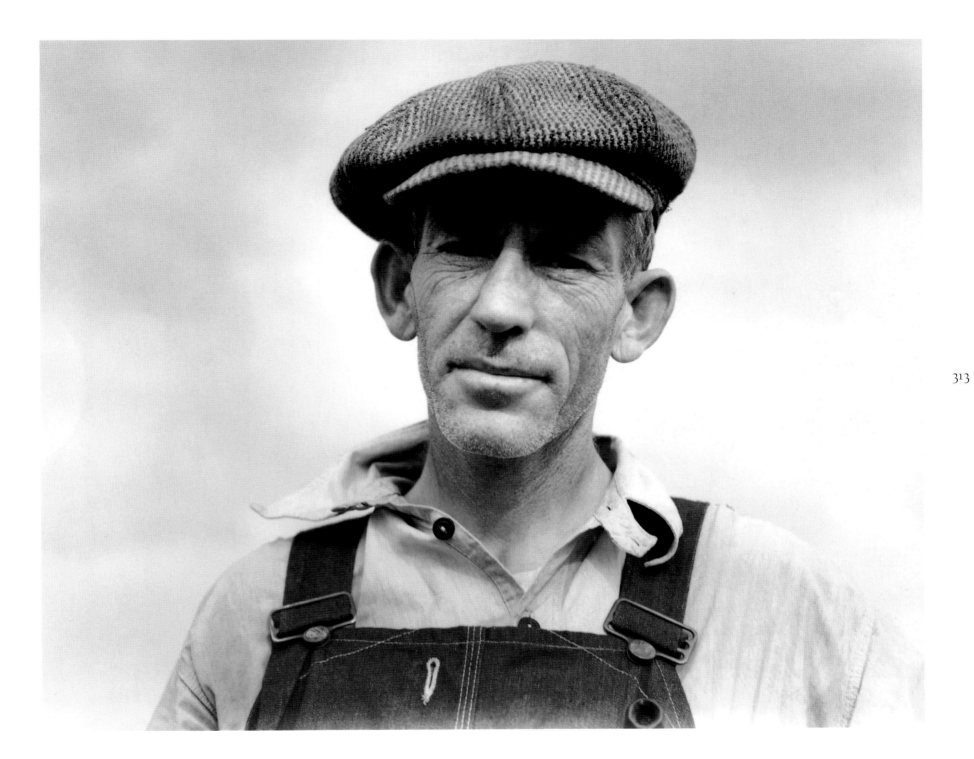

Father of landless sharecropper family, Macon County, Georgia
DOROTHEA LANGE, JULY 1937

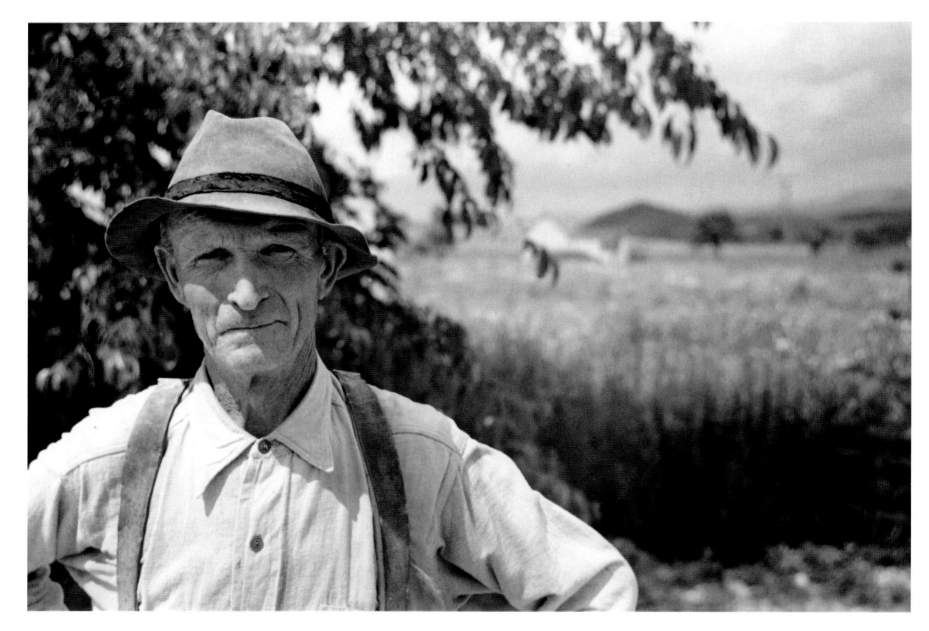

Homesteader, Tygart Valley Homesteads, West Virginia
JOHN VACHON, JUNE 1939

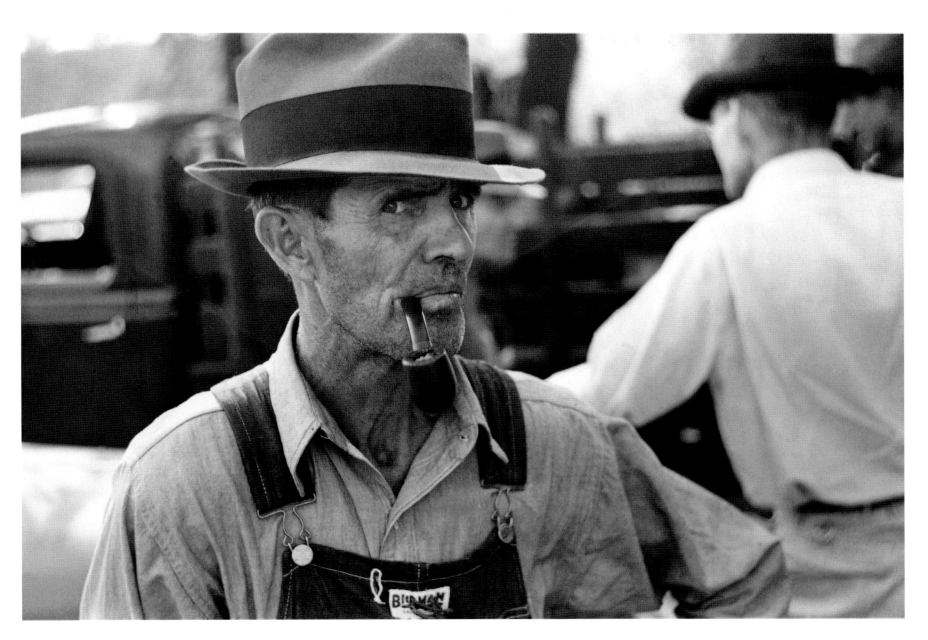

Farmer at the auction, Oskaloosa, Kansas

John Vachon, October 1938

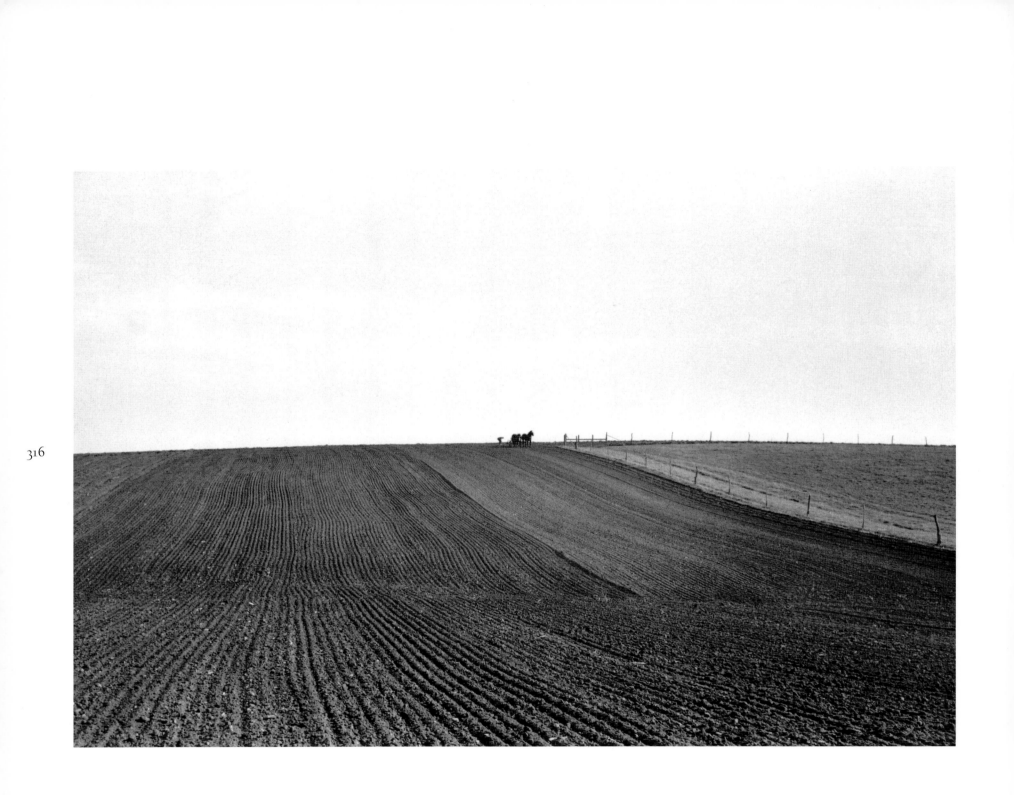

Corn planting, Jasper County, Iowa

John Vachon, May 1940

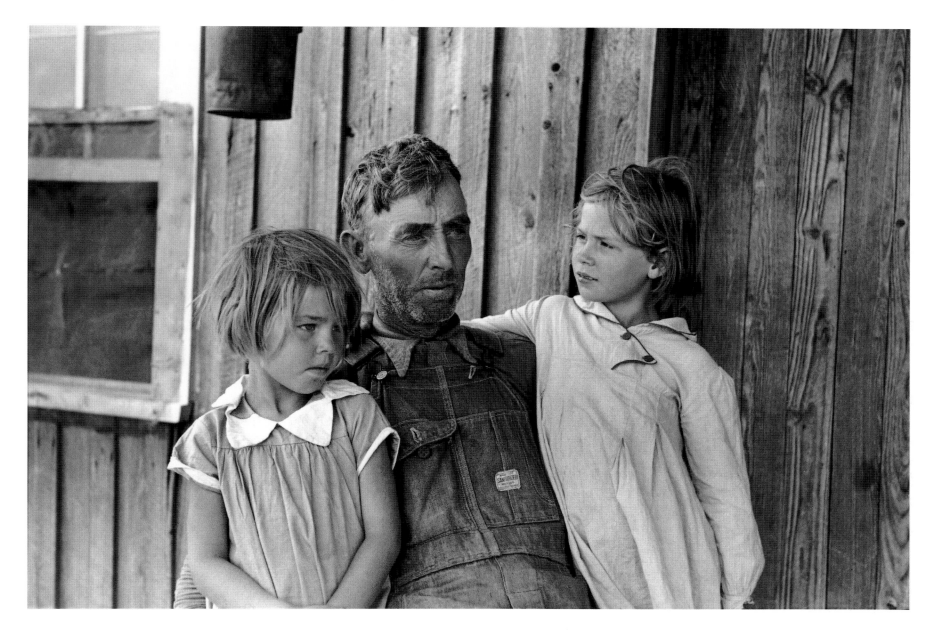

Sharecropper with two grandchildren, Southeast Missouri Farms
RUSSELL LEE, MAY 1938

"...Roy was a magnificent sponge for ideas...."

—*Edwin Rosskam interview, Archives of American Art*

The photographer Margaret Bourke-White got her start in Cleveland in the Twenties, photographing steel mills as if they were the temples at Luxor. By 1936, her eye, her ambition, and her clients had made Bourke-White one of the most visible and highly paid women in America. When the first issue of *Life* appeared in November 1936, a Bourke-White photograph of a gigantic dam in Montana was its cover. Although *Life* wasn't the first large-format magazine to use photographs as if they were text and to combine words and pictures to form powerful photoessays,[1] *Life* had an effect on the American media market comparable to an asteroid smashing into the earth.

Less than a year after *Life* published its first issue, Bourke-White and the writer Erskine Caldwell produced *You Have Seen Their Faces*, a book of pictures and prose that had roughly the same effect on book publishing as *Life* had had on magazines. Caldwell's best-selling novels, *Tobacco Road* (1932) and *God's Little Acre* (1933), had made him a media star equivalent to Bourke-White.[2] An expressive and expressionistic narrative indictment of poverty, racism, and disease in the rural South, Caldwell's prose, intercut with Bourke-White's nearly full-page portraits and cinematic photo sequences, produced a book unlike any that reviewers—and readers—had seen before. "An indication of what the book of the future will look like," wrote one reviewer. "A new art ... one that has to be judged by different standards than those that apply to painting and sculpture," wrote another. (All quotes are from Alan Trachtenberg's foreword to the 1995 University of Georgia edition of *You Have Seen Their Faces*.)

The dramatic and aesthetic narrative power of *You Have Seen Their Faces*, derived entirely from the way its design and production produced synergies between Caldwell's storytelling and Bourke-White's visual witness, had a number of significant publishing consequences.

The first consequence, visible in the correspondence excerpts later in this book (letters from Stryker to several of his photographers, particularly Russell Lee), was a contract for a word-and-picture book between the prestigious firm Harcourt, Brace & Co. and the eminent poet Archibald MacLeish, then an edi-

tor at *Fortune*. (MacLeish's epic poem *Conquistador* had won a Pulitzer in 1932. His *Collected Poems*—including "Ars Poetica" and "You, Andrew Marvell"—would be honored with another Pulitzer in 1953.) MacLeish traveled to Washington to immerse himself in the FSA File. Stryker responded by excerpting and sending five hundred images for MacLeish to meditate on and select from. The outcome of all this looking and choosing (and, as Stryker's letters show, assigning) was MacLeish's seminal *Land of the Free*, published in 1938.[3]

The second consequence of *You Have Seen Their Faces* was Harcourt's decision *not* to publish a book-length version of the text and images James Agee and Walker Evans had made after *Fortune* sent them to Alabama in 1936 to produce an article about sharecroppers and sharecropping.[4] The Agee/Evans book that grew from *Fortune*'s original assignment—their masterpiece, *Let Us Now Praise Famous Men*—would bounce from Harcourt to Harper's to Houghton Mifflin before it was published in 1941. While all this was—and was not—happening, the Museum of Modern Art honored Evans, in 1938, with a major exhibition of his work. Seventy of that exhibition's one hundred images had been made while Evans worked (or was on leave from) the FSA.[5]

The third consequence of *You Have Seen Their Faces* was John Steinbeck's 1938 visit to Washington to spend several days looking through the FSA's File. Steinbeck walked into the FSA fresh from the triumph of his *Of Mice and Men*. Steinbeck's Washington visit, combined with the weeks he spent in an FSA migrant labor camp near Bakersfield, became the basis of *The Grapes of Wrath*. The FSA correspondence that resulted from the huge impact of that book[6] is also reproduced here.

The fact that the FSA File attracted authors as lustrous as MacLeish and Steinbeck, publishing houses as prestigious as Harcourt, museums as influential as the Modern, and studios as powerful as Zanuck's—all this was proof that, two years after it began, the photo survey Stryker directed had tapped into the core of America's media culture.

There was one other consequence of *You Have Seen Their Faces*, a consequence not entirely visible in the letters Stryker sent to his photographers, but one that affected Stryker, the assignments he made, the way FSA images were disseminated, and—in the end—the content of the File itself. All this was the

result of Stryker's meeting with the photographer and writer Edwin Rosskam, and of Stryker's decision, in July 1939, to hire Rosskam as a "photo editor."

Rosskam and his wife, Louise, met Stryker in late 1938 when they walked into the FSA looking for photos to illustrate a word-and-picture book they were making about Washington. The Washington book was the second in a series of such books the Rosskams planned to make about ten big cities in the United States—books they intended to narrate with text by Rosskam and photographs he either made himself or found in collections like Stryker's. The Rosskams had already finished a book about San Francisco (Louise developed and printed Rosskam's photographs; they laid out and designed their books together). Both books were part of a deal Rosskam had made with a New York publisher—a German émigré named Koppel—to produce as many books about as many cities as the market would bear, all part of a series Rosskam called "The Face of America."

When Rosskam and Stryker laid eyes on one another, it was close to love at first sight: both men were dealmakers, both loved to read as much as they loved to look, and—whether they knew it the way they knew their own names—both were displaced people, far from home.

Rosskam had lived in Germany until he was fifteen. His parents were American Jews; his father's family were Philadelphia people, part of a merchant/manufacturing caste of Jews who had come to America before the Civil War. No one seems to know how and why Rosskam's parents moved to Germany, but when the Great War came, they were classified as enemy aliens and refused exit. "No unpleasantness," Rosskam recalled. "We just couldn't get out." Unpleasantness came later: rationing, revolution, and epidemic influenza. One of those things killed Rosskam's father. In 1919, Rosskam and his mother sailed home. But what was "home"? Rosskam spoke German, not English. He was an American who had grown up in enemy territory. He was also a boy without a father. "This is a rough situation to be in," he told an interviewer years later. "I was kind of driven on my own resources."[7]

Rosskam's resources were considerable: he learned English and finished high school in six months. He was accepted at Haverford College, but after a year transferred to art school—and not just any art school, but the Academy of Fine Arts in Philadelphia, the home of such renowned realists as Thomas Eakins and Robert Henri. Rosskam painted, and married a painter, and

together, like everyone who was young and artistic and had a bit of money, the couple went to Paris.

They lived in an apartment Le Corbusier had designed. They drank and gossiped at Le Dôme; the photographer André Kertész took their picture. Man Ray, the American surrealist (and mentor of Berenice Abbott, the champion of the photographer Eugene Atget), befriended them. Man Ray invited Rosskam to visit him in his darkroom; he taught Rosskam how to take photographs and develop them. Rosskam had a one-man show of his paintings, but photography hooked him. That's when his wife left him.

Rosskam decided that the best way to heal his broken heart was to retrace the journeys of the painter Paul Gauguin. But before Rosskam left Paris, he found a new lover and worked out a deal with the Museum of Anthropology to compile a French/Polynesian dictionary and take some photographs for the museum while abroad. Rosskam and his lover sailed to Martinique and then to Tahiti. His lover left him, but Rosskam stayed; for more than three years, he wrote articles, illustrated them with his photographs, and sold them to European magazines. In 1933 he came back to Philadelphia, got appendicitis, and met Louise.[8]

The Rosskams lived in New York and went to meetings and exhibitions at the Photo League, the left-wing photographer's cooperative, where they met artists like Aaron Suskind and Ralph Steiner. In 1936, Edwin and Louise got married and moved back to Philadelphia. Philadelphia was where Rosskam made his first American deal: he talked the Sunday supplement editors of a newspaper called the *Philadelphia Record* into giving him a page every week for a feature he called "Camera Tales of the Town." Rosskam took the photographs and wrote the copy; he and Louise laid out the page. He stayed at the *Record* for a year until being too close to his relatives drove him out of town.

To get out of town, Rosskam made a deal with Roger Butterfield, an editor for *Life*, to send him and Louise to Puerto Rico to cover the aftermath of a nationalist demonstration in San Juan that had been shot to pieces by the Army. The nationalists had gotten permission from the governor to demonstrate, but by the time they'd assembled, the governor had canceled their permit. Army troops fired into the crowd, killed several of them, and then put the survivors on trial for sedition. Rosskam spent months taking pictures of not just the trial but the slums of San Juan and Ponce. *Life* refused to print any of

Rosskam's images. (Rosskam would later donate all these photographs to the FSA, which incorporated them in its file. Several of these images are reproduced—for the first time—in this book.)

When *Life* walked away from the Puerto Rican pictures, the Rosskams came back to the United States and Rosskam made his next American deal—the deal that set him on the path to meet Stryker, the "Face of America" multibook deal with Koppel, the publisher, who happened to be an old family friend from Munich. Louise later recalled, "Gunter [Koppel] said to Edwin, 'Look, I'm here in America. I don't know how to get started. I don't have any ideas.' Edwin knew he had been in a book publishing company in Germany, so he told him to start a publishing company. Gunter wondered how he was supposed to do that...."9 Edwin, of course, was only too happy to explain: Edwin would make Gunter some books; Gunter would sell them. Gunter would become an American publisher. But books about what? Gunter wanted to know. Printing books—anyone could print books. Why would people buy them?

Rosskam went home and wrote Gunter some answers in the form of a proposal. A proposal that read like a manifesto.

"Plan to Document the Portrait of Contemporary Americans," Rosskam called it. "The American scene changes with a rapidity that surpasses Henry Adams' formula for the acceleration of history," Rosskam began. "Less than any other nation does America know and understand its tradition, its origins, its roots, its immediate past, its recent cultural morphology. [Until] that understanding is achieved, America can not hope to realize its destiny.... The plan for photographing and writing about contemporary America, as a document for the future, is to restrict the first year's researches to about ten major American cities, say, Boston, Pittsburgh, Chicago, Detroit, St. Louis.... The paradoxes, the anomalies, the illogicalities of life today ... contain the most vital material for future historians to examine." For two single-spaced pages, Rosskam stacked allusions one on top of the other: Berenice Abbott's two-year photographic survey of *Changing New York* (1935–37); Eugene Atget's enigmatic photographs of *fin de siècle* Paris; the "deplorable" editorial policies of *Life* magazine; the FSA's photographic survey of American rural life.10 It was enough for Gunter: Rosskam had some good ideas. Gunter wrote him a check; the Rosskams packed their equipment and headed for San Francisco.

Ten cities in one year may have been a bit ambitious, but, for now, consider Rosskam and Gunter's conversation—especially the part where Gunter says, "I don't have any ideas." The "no ideas" part helps explain why Stryker recognized something in Rosskam and Rosskam recognized something in Stryker. Rosskam saw yet another Gunter (before Gunter there had been *Life's* Butterfield, and before Butterfield . . .). What Stryker saw was the latest in a series of "idea men."

Stryker was no fool, but he was much better at identifying important ideas than having any of his own. Once Stryker recognized a big idea, whatever it was, he was fiercely single-minded in making it happen.

Stryker had first fallen under the influence of Rexford Tugwell's ideas when he'd taken a Utopian Socialism course from Tugwell as an overage undergraduate at Columbia. Before Tugwell, the idea man in Stryker's life had been a minister in Denver who had revealed the power of Walter Rauschenbach's "Social Gospel" to him; before the minister, it had been Stryker's own father—a Kansas Populist who'd "got religion"—a man who'd ordered his family to fall to their knees and pray as he invoked the Lord to damn Wall Street and the railroads and Standard Oil.

Tugwell remained a constant in Stryker's life for as long as Tugwell remained in government. But as Stryker groped around, at first trying to define his Washington mission, he fell under the influence of a succession of strong-minded men. First there was Evans (and Ben Shahn), then Robert Lynd, and then, as a consequence of Archibald MacLeish's making *In This Proud Land*, MacLeish himself and his sweeping vision of the nation and its predicament. (Correspondence between Stryker and MacLeish and the big plans they shared are described later in this book.) Stryker wasn't an empty man or a hollow one, but there was plenty of room in him for other people's ideas, and he was more than hospitable when they came to visit and then decided to stay for a while.

Stryker hired Rosskam at a salary ($3,200 in 1939 dollars) that was second only to his own.11 For that kind of money, there were some pressing practical things Stryker needed Rosskam to do. The first was to satisfy the avalanche of picture requests from newspapers and magazines: in 1935, the FSA, functioning as a photo agency, placed nearly two hundred images per month in newspapers and magazines; by 1940, the FSA was placing fourteen hundred

every month.[12] Many of these picture requests were for the same images over and over again; historians of the FSA estimate that there was a group of perhaps three hundred images that were printed and reprinted constantly—"classics" like Dorothea Lange's "Migrant Mother" or Arthur Rothstein's image of a father and his sons, dustblown and walking into the wind. *Grapes of Wrath* images of hard-luck farmers and raggedy children, and oh-so-grateful FSA clients, standing next to the plow or the mule that Mr. Roosevelt had helped them buy.

In 1936, Stryker had hired an out-of-work English literature graduate student from Catholic University named John Vachon, first as a messenger, then as a photo caption writer, then as a file clerk to help satisfy the growing number of picture requests. By the time Rosskam was hired, Vachon had begun to actually organize the File, geographically and by picture assignment.[13] Rosskam recalled, years later, that Stryker—once a college instructor, always a college instructor—used to give him and Vachon "pop quizzes" to test their picture memories; Stryker would randomly select ten pictures from the File, scatter them face up on a table, and then challenge them to name the photographer, the place, and the assignment. Rosskam and Vachon became the equivalent of the embodied books in Ray Bradbury's *Fahrenheit 451*, except that what they carried in their memories was not the whole of *Moby-Dick* but the File.[14]

The second thing Stryker wanted Rosskam to do was "to assist in the preparation of shooting scripts and the making of suggestions for photographic work in the field."[15] Almost every shooting script issued after Rosskam was hired bore Stryker's name or typed initials. A few scripts were anonymous (for example, a script about railroads, and another about the cattle industry). None had Rosskam's name on them. Still, in the Rosskam's 1965 interview for the Archives of American Art, Rosskam recalled that within three or four months of his coming to work, he began writing and sending scripts to photographers in the field. "For instance, Marion Post [Walcott] and some of the others, even Vachon and so on, would get shooting scripts from me, which were fairly well researched, long documents. I remember sending Marion out to do coverage of winter. Well, it must have been a twenty page shooting script of that." The detailed shooting scripts quoted earlier in this book—the one to Marion Post about a New England town, complete with church steeple and apple pie, and the other script, to Arthur Rothstein, about Southern mill towns, cheap labor,

revivals, funerals, and insurance collectors—these (and many others not quoted) may very well have been Rosskam's work.

Satisfying picture requests and ghostwriting shooting scripts (and, in addition, organizing traveling exhibitions of FSA images) were secondary to the single "Big Idea" Rosskam contributed to the FSA. In 1965, after Rosskam talked about writing shooting scripts, he went on to say: "Now by [the fall of 1939] . . . we were fully aware that our coverage amounted to more than the tragic dilemma of American agricultural living. . . . The whole rural scene and, finally, the urban scene, began to come in. When Dorothea [Lange] did her coverage of migration [in her book *American Exodus*], . . . she opened the door to the whole end of migration. . . . The coverage we did on that later. . . . I went out with Russell Lee to Chicago, and [we made photographs] that [were] used later in . . . [Richard Wright's] *Twelve Million Black Voices* . . . because [we] couldn't do migration without showing, finally, where migration went to. Migration went to the city."[16]

Rosskam's knowledge of and curiosity about city life were what had brought him to Washington in the first place. Lange may have been the first photographer to articulate the country/city link, but Rosskam carried city life (Munich, Paris, New York, Philadelphia, San Juan, San Francisco . . .) with him like a scent, like a perfume. Stryker was a small-town provincial, exiled to an office in Washington. Rosskam was exiled, too, but not from cities. City Mouse met Country Mouse; the two benefited each other. Rosskam's fascination with cities, combined with a knowledge of the File that soon matched Stryker's, gave him the power to persuade Stryker to broaden the FSA's scope.

It's true, of course, that Rosskam's first book deal at the FSA was for Sherwood Anderson's *Home Town*. It was Rosskam who recruited Anderson and then introduced him to Gunter, who published *Home Town*. In addition to selecting and editing the FSA photographs used to illustrate the book, Rosskam also edited Anderson's writing, reducing it from sixty thousand to twenty thousand words (all this was part of Rosskam's FSA job). It's also true that twenty-five years later, Rosskam claimed that of all the word and picture books he'd made back then, *Home Town* "was by far the best. For my money, much better than the book I did with Richard Wright, later."[17]

Rosskam was wrong about that: sixty years later, *Home Town* has become an artifact while *Twelve Million Black Voices* remains in print. Why Rosskam said

that, though, is worth considering: as a displaced person—a U.S. citizen who was more European than American—Rosskam may have yearned for the same "apple pie" certainties as his boss, the failed farmer, the ex-cowboy, far from home. Rosskam may also have been disingenuous in his 1965 interview. His reason may have been Richard Wright. For eight years before *Twelve Million Black Voices*, Wright had been a member of the American Communist Party, not just a "fellow traveler" but also an active defender of the Soviet Union. In spite of liquidations, purge trials, and Stalin's pact with Hitler, Wright defended the Party until it threw him out in 1944 for being "too independent." In the Fifties, Rosskam himself was accused of being a Communist and lost a job in Puerto Rico because of it. (In 1937, Rexford Tugwell was also accused of being a Communist. Newspapers called him a "red" and hounded him out of the Roosevelt administration.) Talking about *Home Town* as Rosskam did may have been his way of wrapping himself in the flag.

Still, the book deal Rosskam made with Viking Press in 1940 for *Twelve Million Black Voices* was significant. Viking was a far bigger, far more prestigious publisher than Gunter. More important, Richard Wright was a publishing phenomenon: within the first three weeks of the publication of Wright's *Notes of a Native Son* in March 1940, the book sold 200,000 copies. By the end of its first month, *Notes* was selling two thousand copies a *day*. By the end of April, it had passed *The Grapes of Wrath* on the best-seller list. All Rosskam had in hand when he approached Wright, other than a link to Viking, was a portfolio of FSA images. The pictures worked the same magic on Wright as they had on MacLeish and Steinbeck: Wright agreed to do the book and Rosskam had his first big American deal.

As Steinbeck and MacLeish had done, Wright came to Washington and immersed himself in the File. Stryker may have greeted Wright, officially, but it was the Rosskams, husband and wife, who served as Wright's guides into the collection. Wright wanted to trace the great migration of African-Americans from the South to the North, from plantations in the Delta to cities like New York and Chicago. Wright had deep and wide connections to the black community in Chicago. He wanted to write about the place and have photographs made of it.

Rosskam volunteered to go to Chicago and then, as he recalled, "I got Roy to allow Russell to come out and do the end of the migration [into] to Negro part of Chicago. We had a fascinating three weeks there.... Wright really knew that stuff cold; he knew ... everybody in the Negro world in Chicago.... I don't know if many white men had the opportunity to see it the way we saw it.... We did everything from the undertaker to the gangster."[18] Wright's final impassioned text was accompanied by 142 FSA images. Rosskam selected and edited all of them—including ones he made himself.

Wright carried Rosskam—and Rosskam carried the FSA—into an urban ghetto the survey otherwise might not have entered. As an extension of Stryker's "Crossroads Town" shooting script, Rosskam's "migration went to the city" idea linked the FSA to the "Face of America" manifesto Rosskam had written back in 1937. Of course, there were pictures of cities and city life in the File before, during, and after Rosskam's time with the FSA: Gordon Parks' modest portfolio of images of African-American life in Washington; Rothstein's pictures of Pittsburgh[19] and the Bronx; Mydan's photographs in Milwaukee; Lange's pictures in San Francisco; John Vachon's in Omaha and Chicago; Lee's in St. Louis and Oklahoma City; Post's in Miami and Memphis; Delano's in Washington and Providence; Moffat-Meyer's images in Washington. Taken together, though, images of city life constituted only a fraction of the File.[20]

"I knew we were lopsided," Rosskam said in 1965. "We had to get broader coverage.... I think we failed, of course, completely, in covering the big city. This little bit we did [was] because I happened to push Roy toward it at the end.... It's nothing in comparison to what there [was]—when you consider that [by] then ... the great migrations to the cities [were] in full swing.... Anybody could see that in a short time, the bulk of our population was going to be urban."

Rosskam's remarks aroused his interviewer, Richard Doud, who until then had been properly circumspect in his responses. "This is sheer speculation," the interviewer said, "but do you think that would have been the direction—had the File been allowed to go on?"

"I'm sure," Rosskam answered. "I'm sure of it."[21]

"After all, Stryker was not a photographer, he was an entrepreneur."
—*Romana Javitz, curator, Picture Collection,*
New York Public Library, 1929–68, interview, Archives of American Art

TO STRYKER, FROM CAPTAIN PEARCE, AN EDITOR OF HARCOURT, BRACE & CO., NEW YORK JUNE 7, 1937

I talked to MacLeish this morning about your proposal that he come down to Washington to go over a huge batch of illustrations before you proceed to select the 500 upon which the preliminary work will be done. MacLeish is, as you realize, busy as he can be, and yet he fully understands the difficulties you are facing. He therefore will plan to fly to Washington, next Monday or Tuesday … provided that you will be able to have things ready for him by that time.... It is no simple job that we are undertaking, but I feel more and more that it is worth all our efforts. You have just about the hardest job of all and I believe MacLeish appreciates that as fully as I do. Good luck to you.

TO RUSSELL LEE IN MINNEAPOLIS, FROM STRYKER, AUGUST 10, 1937

Incidentally, yesterday I had a call from Capt. Pearce, Harcourt Brace and Co., New York. He had just talked the day before with Arch. MacLeish.... MacLeish is now writing the text around the main set of pictures. He is now anxious to get good land pictures. Anything that will show the land, trees, grass, anything in the area west of the Ohio River and the Mississippi River. We are not doing anything special, but work on a general theme of things which will show this great empire as it now exists.... I wish I could be more specific, but until I can talk with MacLeish, that is impossible.

TO RUSSELL LEE, NO ADDRESS, FROM STRYKER, SEPTEMBER 27, 1937

Do not forget some pictures in the bus terminals in the little towns that you go through. These would be especially valuable to contrast with some which we are getting from the bus terminals like New York and Washington. I particularly want some which will show the variety of people who use the buses. Some of the little, dinky, dirty waiting rooms in the Midwest terminals should present some good photo opportunities.... In case you find a small town barber shop where they still have the individual [shaving cream] cups with Mr. Citizen's name on each cup. Also remember that the garage is today, a meeting place for political, agricultural, economic, and sexual discussion. A few pictures of the crowd hanging around these places are quite necessary for our American section of the file.

TO RUSSELL LEE IN WILLISTON, NORTH DAKOTA, OCTOBER 12, 1937

Pictures yet to look for on the MacLeish book. 1.) Photograph of great sweep of open land—meadows, trees, hills. 2.) The widest possible open country.... The pictures must not be dull or monotonous. Please work on this right away and send me copy as soon as possible. 3.) Best grass pictures possible.... 4.) Air view of regularly squared farm country.... 5.) Kitchen in the dust area with windows sealed with towels. This is to emphasize the conditions the women and children have to endure.... 6.) Look in the State Historical Society in Lincoln, Nebraska.... The request is, to quote MacLeish, 'A picture of early settlement in Mississippi Valley—ox teams in clearing...' 7.) Here is one I am sure you can get. To quote MacLeish: 'typical Midwestern four corners, with the church falling down, the store caving in, and the fences falling.'

TO DOROTHEA LANGE IN BERKELEY, OCTOBER 21, 1937

Did you get any pictures on your way west? Two pictures are needed for the MacLeish book … : 'Great sweep of open land, meadows, trees, hills, no houses or people on it.' 'Widest possible space of treeless, empty country.'

TO STRYKER FROM WALKER EVANS, NEW YORK, FEBRUARY 28, 1938 (EVANS WROTE THIS AFTER HARPER AND BROTHERS AGREED TO PUBLISH THE AGEE/EVANS BOOK THAT HARCOURT BRACE & CO. HAD TURNED DOWN)

Enclosed is request for official permission. OK. Aside from that, I wish you'd answer the questions I asked you.... I think it was only about roy-

alties and then I asked you what happened to the film [negatives] I wanted to borrow. . . . Roy, don't let this project become complicated. It needn't, and it could, like everything else in the govt. . . . Let's get on with it. There are always people in a bureaucracy . . . who'll obstruct you if you give them the chance. If you sail through this arrangement without fussing with details . . . it will be all right. I have learned from Harry Hopkins [the director first of the Federal Emergency Relief Administration and then of the Works Progress Administration; Hopkins was one of Roosevelt's closest assistants and adviser and was also an Evans family friend]. It's appalling sometimes and it works. . . . Hell, I could have written you a ten page letter about all this, how it was done partly after I left gov employ and at my own expense, how pictures were owned by former Resettlement Administration through complicated loan share–expense arrangement with *Fortune* . . . you know, all that stuff; and a corps. of white collars would have spent a month trying to find out whether you were going to get some credit or sell the New Deal's soul . . . or govt. in business or free silver or disembowelment of the Welsh clergy.

TO RUSSELL LEE IN LUFKIN, TEXAS, FROM STRYKER, APRIL 7, 1939

I believe we should now start a series of pictures showing the operation and life on somewhat better farms in the area in which you are now. We need these very much and they will serve a valuable purpose, to work in with the bad conditions which we have already covered very successfully. Furthermore, it is to our advantage to have a few pictures of the better situation in every state—protective coloring, you know! And, on top of that, what is the use of this whole situation if there is no way out? If the state of Texas has nothing better to offer on farming then the whole thing becomes hopeless. I don't think we ought to get too much of this, but perhaps . . . a couple of extended scenes of selected good farms in various sections would definitely be worthwhile. . . . Also, we need—and none of you folks seem to be getting for me—a few 'front cover' pictures. I know you don't walk into towns and pick them up, but keep an eye out for them. Put on the syrup and white clouds and play on sentiment.

TO ARTHUR ROTHSTEIN IN LA CROSSE, WISCONSIN, ON HIS WAY TO BOZEMAN, MONTANA, MAY 12, 1939

If you find an interesting town along the way, maybe you better take a little more time out and take a look at it. Also, highway stuff.

Life is illustrating *Grapes of Wrath*. We are trying to dig out pictures to help with the story. I have a suspicion that *Look* is also doing something similar, as they asked for pictures from the MacLeish book.

TO RUSSELL LEE, IN SPUR, TEXAS, MAY 17, 1939

Very glad to get your report on the Steinbeck book. Incidentally, this thing is getting awfully popular and I think it might be advisable for you to drop everything and follow the idea you have about shooting the material right in Oklahoma, for the next few weeks. We are going to need all the stuff we can get hold of. No shooting script will be needed since, as you say, the book cannot be improved upon. It is my idea that we can sell somebody (perhaps Viking Press) on the idea of a picture book to accompany this novel. The rights to the novel have been sold to Paramount [actually: Twentieth Century Fox] and I understand that production is about to start.

I am just bubbling over with ideas about how we can exploit the public excitement over this whole thing. . . . We should make all possible capital of it and solidify our position as far as we can.

TO ARTHUR ROTHSTEIN, IN GREAT FALLS, MONTANA, MAY 31, 1939

Going to New York today on the small town book—*U.S. Camera, Grapes of Wrath*—Viking Press. Will let you know the results when I come back. . . . We are going to need more pictures of America's 'great middle class' in our small town set, what they do, how they dress—interiors as well as exteriors.

TO RUSSELL LEE, IN AMARILLO, TEXAS, JUNE 22, 1939

We are putting all the steam we can on the Oklahoma pictures. First prints should be ready by the first of the week. . . . I am anxious to get this suff out to you, [have it] captioned, and back [to me] in order that *Look* may make a selection for a picture story on the Oklahoma part of *The Grapes of Wrath*.

TO RUSSELL LEE, IN AMARILLO, TEXAS, JUNE 29, 1939

I was in New York several days last week. Harcourt Brace have become very interested in the small town book. If there were a possibility that someone like Sherwood Anderson or William Allen White could do the text, they think something might be done with it.... In view of their desire to consider this thing, we must keep adding pictures of small town. We particularly need a few more things on the cheery side. As one man said when he looked over it, 'Where are the elm shaded streets?'—meaning that, after all, the American small town does have some pleasant angles to it. All of you must keep this very much in mind this summer, and send in everything you can possibly find—especially the things that seem so obvious to us.

TO ARTHUR ROTHSTEIN, IN DES MOINES, IOWA, AUGUST 26, 1939

Regarding your work while you are in Iowa: The main theme of your pictures should be corn.... These pictures should give some sense of corn as a lush crop ... the pictorial type of thing, telling of the good life that is built around this good land.... A good set of pictures of the corn farm where they have good barns and a good house ... Your pictures should include the family—sort of a day in the life of a corn farmer. If you have time, you should take the family into town, to their purchasing, their recreation, and, of course, their work inside the house and on the farm.

We need a good many pictures for our 'Faces of America' [traveling exhibition]. These should be farmers in the field and full length, showing faces and garb. Some of the farm women in work clothes, on back porches, feeding chickens, in their kitchens, farm people in town, Saturday afternoon pictures in towns (very important). Farmers purchasing, farmers in banks, farmers looking over machinery. Watch for Sunday church and the country church. Any farmer's picnics.... Emphasize the state fair as a farmer's fair ... keep your camera pointed at the rural side of it. Sprinkle in plenty of amusing and interesting things around concessions, races, etc....

TO ARTHUR ROTHSTEIN, IN DENVER, SEPTEMBER 29, 1937

Where are the pictures of the corn town? I haven't seen anything come through yet. Remember we still want some small town pictures. There are plenty of these you should have found in Iowa.

Here are special things you ought to watch for now: *Raking and burning leaves. Cleaning up the garden. Getting ready for winter.*

Don't forget *people on front porches*, either.

TO RUSSELL LEE, IN CORPUS CHRISTI, TEXAS, MARCH 19, 1940

Every so often, I am brought to the realization of the ruthlessness of the camera, particularly the way we have been using it: A lot of those people whose pictures you took do not realize how they are going to look in the eyes of the smug, smart city people when these pictures are reproduced. Of course, we could turn around and put the camera on the smug, smart city people and make them look ridiculous, too.

All quotations from FSA Office Files, 1935–44, Microfilm reels 1 through 8, Library of Congress.

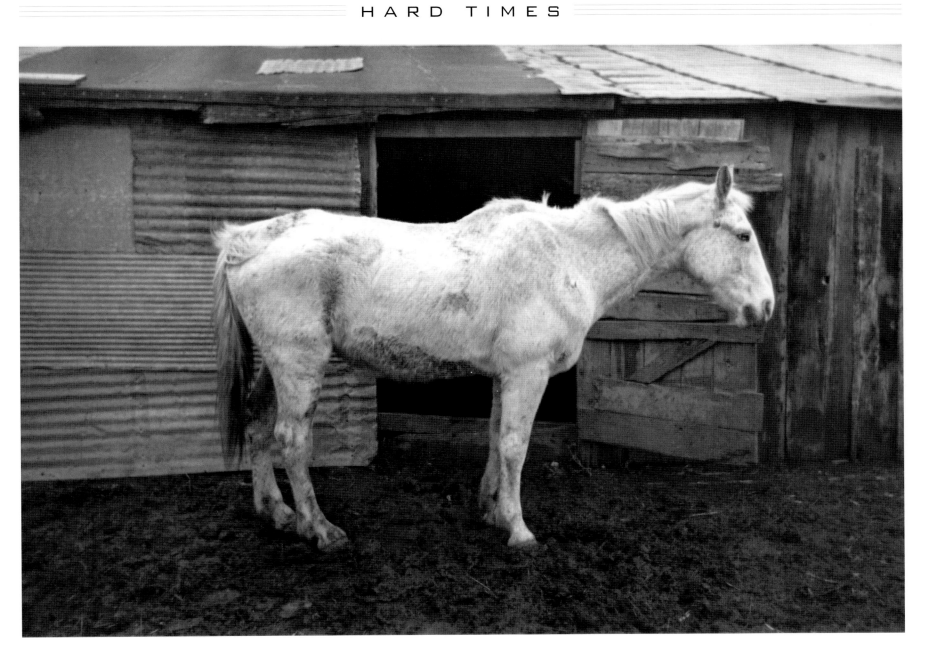

Untitled (Miller Township, Woodbury County, Iowa)

RUSSELL LEE, DECEMBER 1936

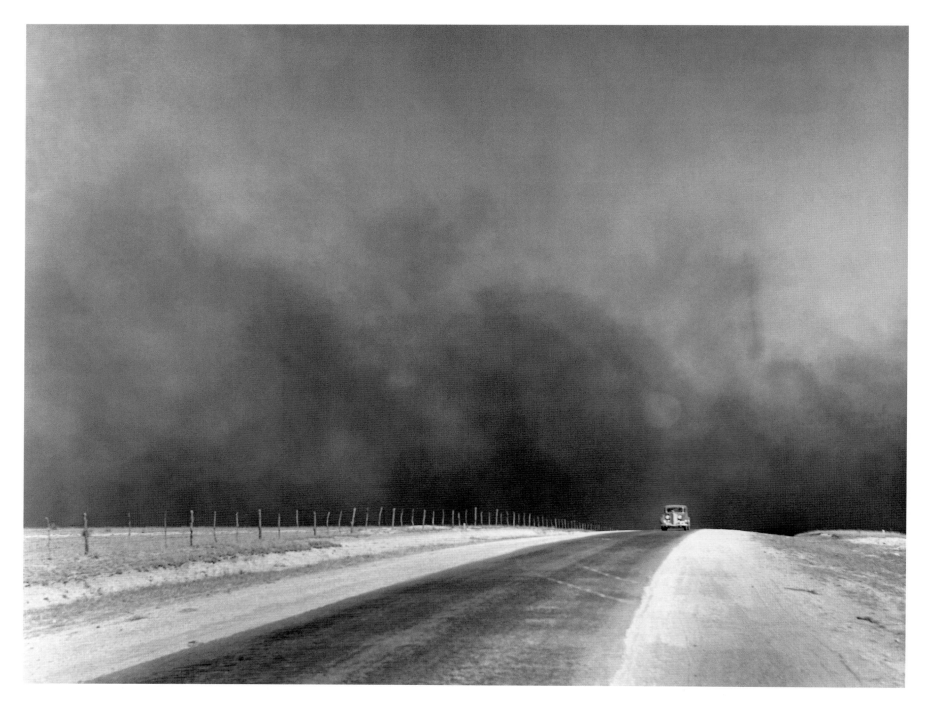

Above: Heavy black clouds of dust rising over the Texas Panhandle, Texas
ARTHUR ROTHSTEIN, MARCH 1936

OPPOSITE: Dust storm (note heavy metal signs blown out by wind), Amarillo, Texas
ARTHUR ROTHSTEIN, APRIL 1936

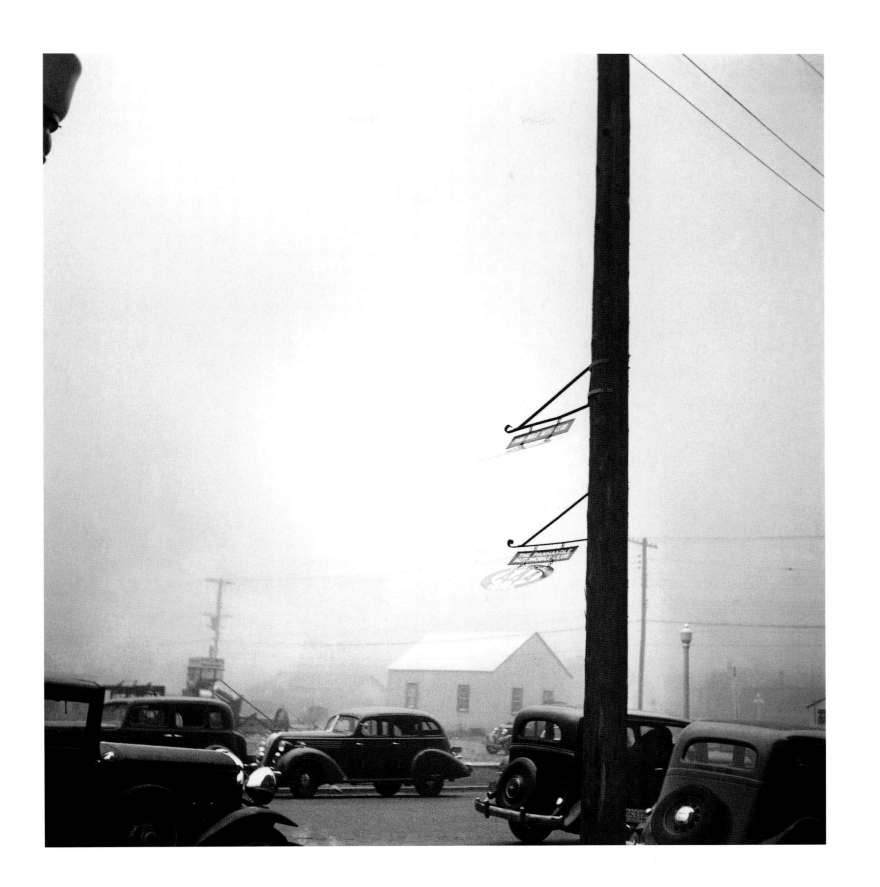

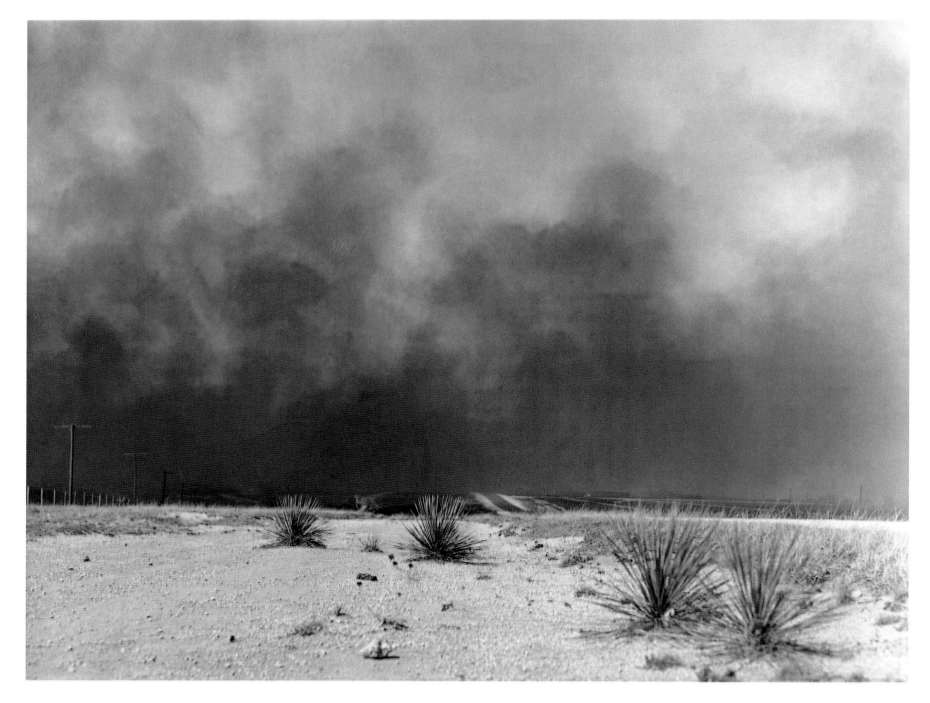

Heavy black clouds of dust rising over the Texas Panhandle, Texas
ARTHUR ROTHSTEIN, MARCH 1936

Untitled (Farm near Anthon, Iowa)

Russell Lee, December 1936

ABOVE: Furrowing against the wind to check the drift of sand, Dust Bowl, north of Dalhart, Texas
DOROTHEA LANGE, JUNE 1938

OPPOSITE: Napa Valley, California. More than twenty-five years a bindle-stiff. Walks from the mines to the lumber camps to the farms. The type that formed the backbone of the Industrial Workers of the World (IWW) in California before the war. Subject of Carleton Parker's "Studies on IWW"
DOROTHEA LANGE, DECEMBER 1938

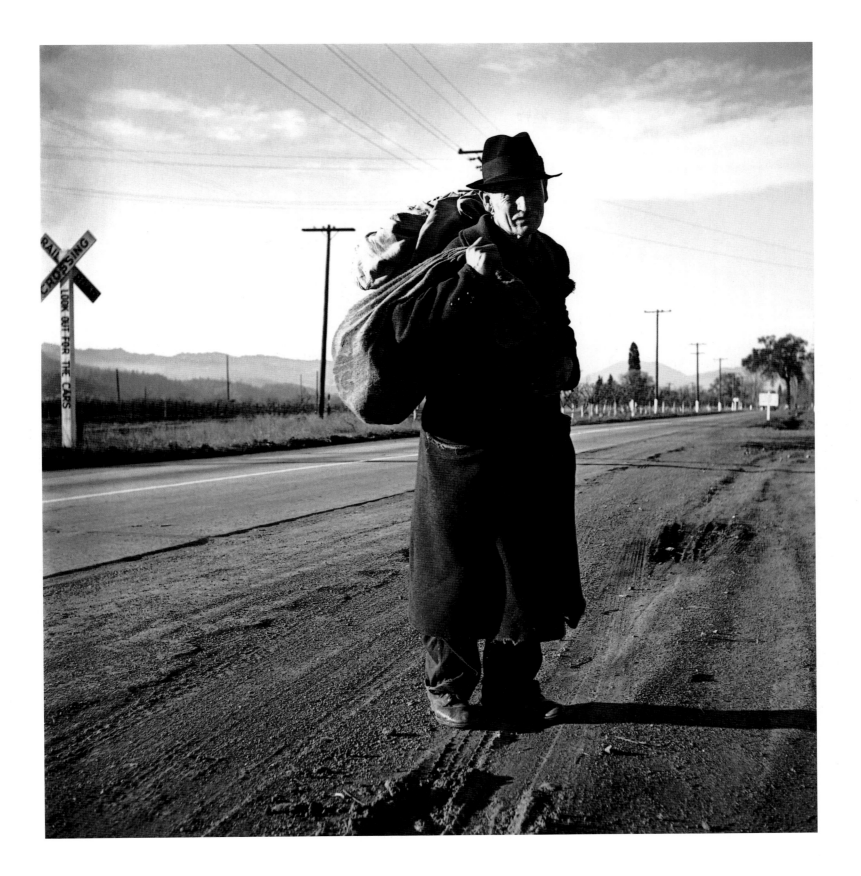

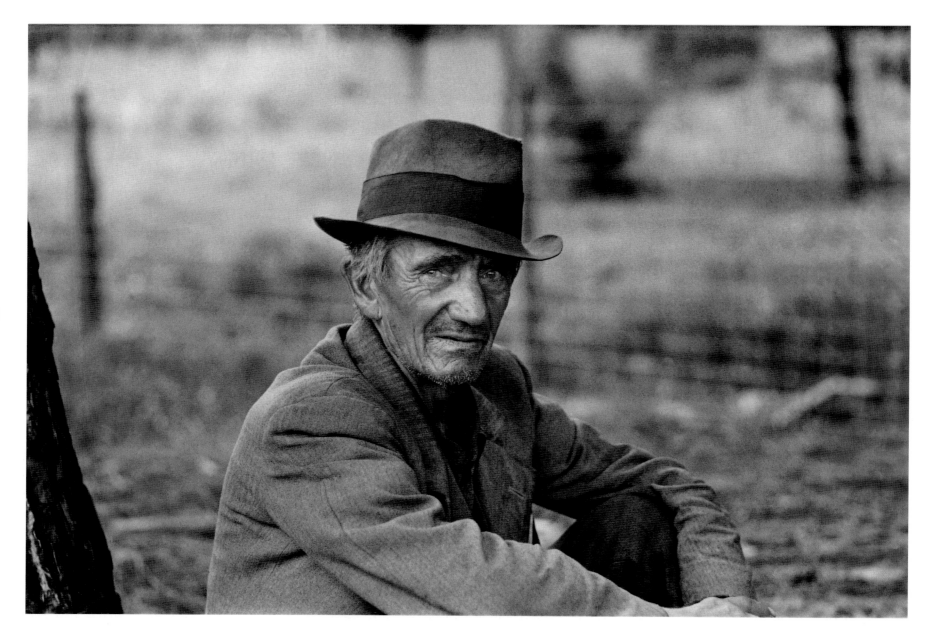

Migrant worker resting along roadside, Hancock County, Mississippi

RUSSELL LEE, OCTOBER 1938

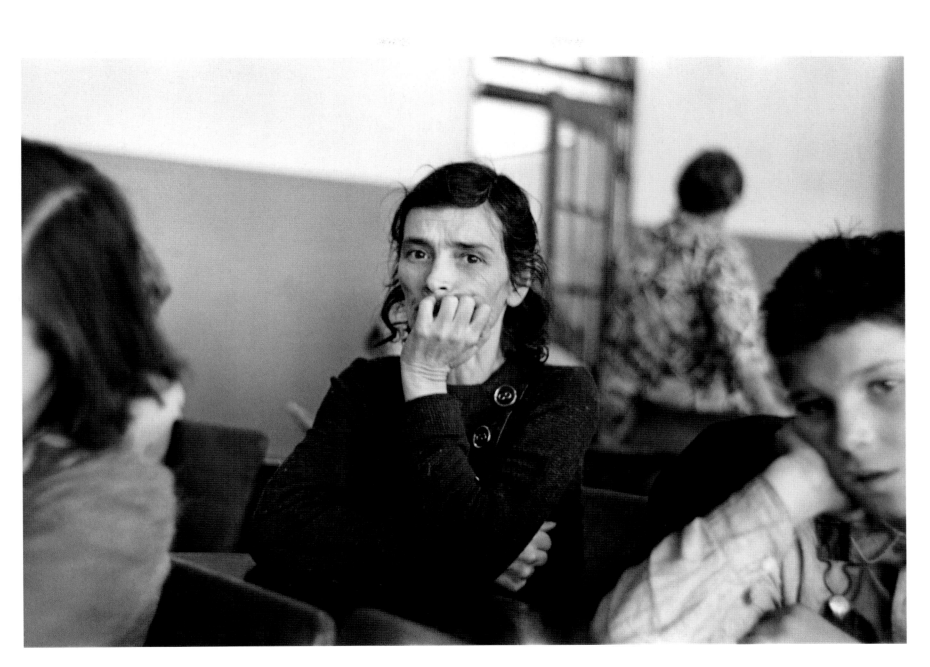

Woman flood refugee in schoolhouse at Sikeston, Missouri
RUSSELL LEE, JANUARY 1937

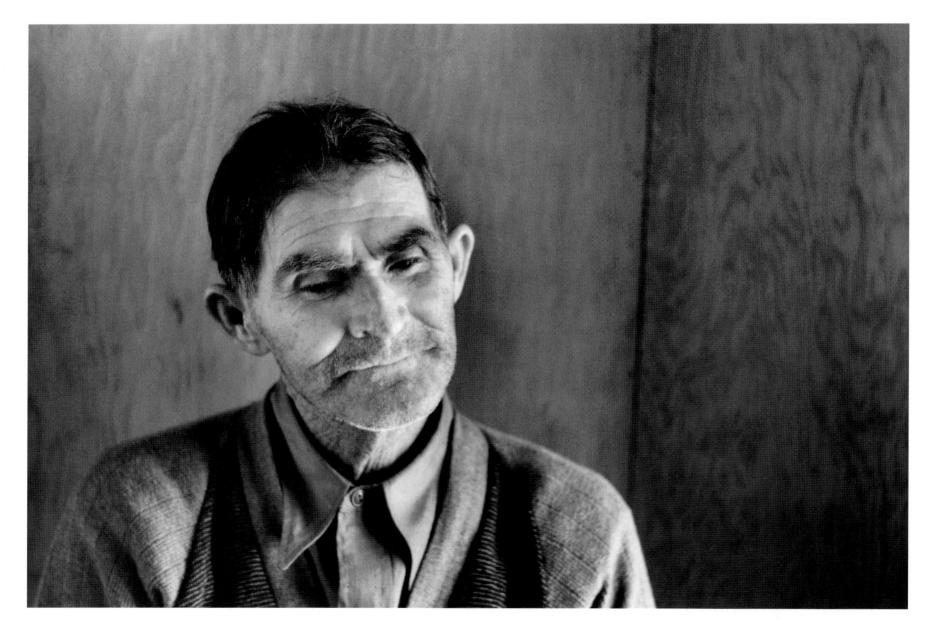

ABOVE: Untitled (Elementary school janitor, Weslaw, Texas)
ARTHUR ROTHSTEIN, FEBRUARY 1942

OPPOSITE: Evicted sharecropper, New Madrid County, Missouri
ARTHUR ROTHSTEIN, JANUARY 1939

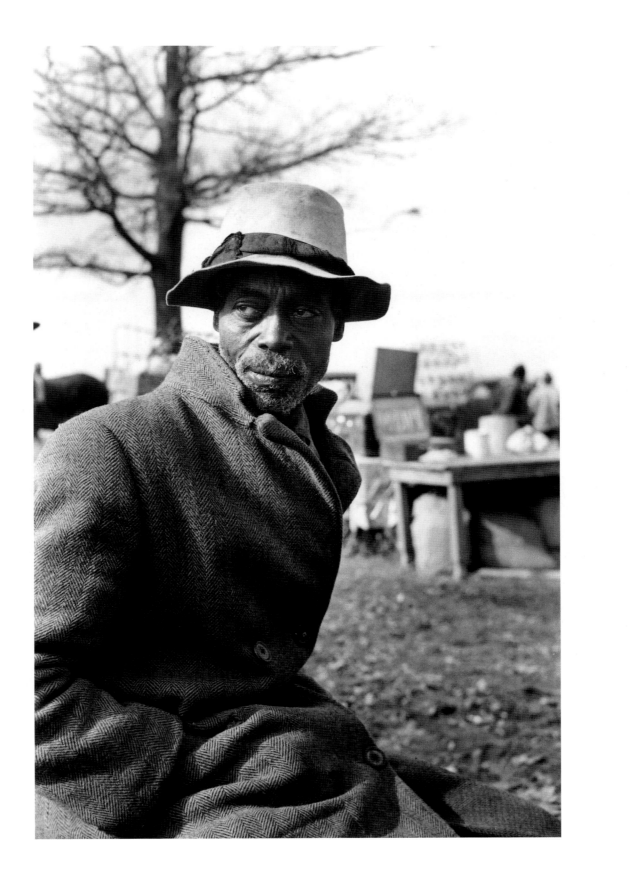

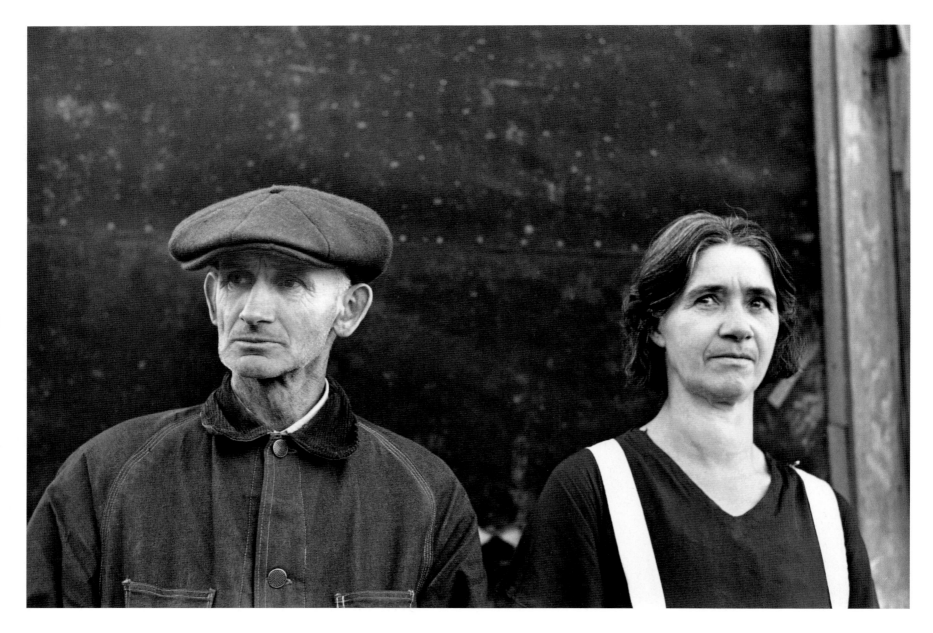

Untitled (Mr. and Mrs. Charles Banta, near Anthon, Iowa. Have groceries to last
for only 10 days unless they sell their livestock which is most essential for farming next spring)
RUSSELL LEE, DECEMBER 1936

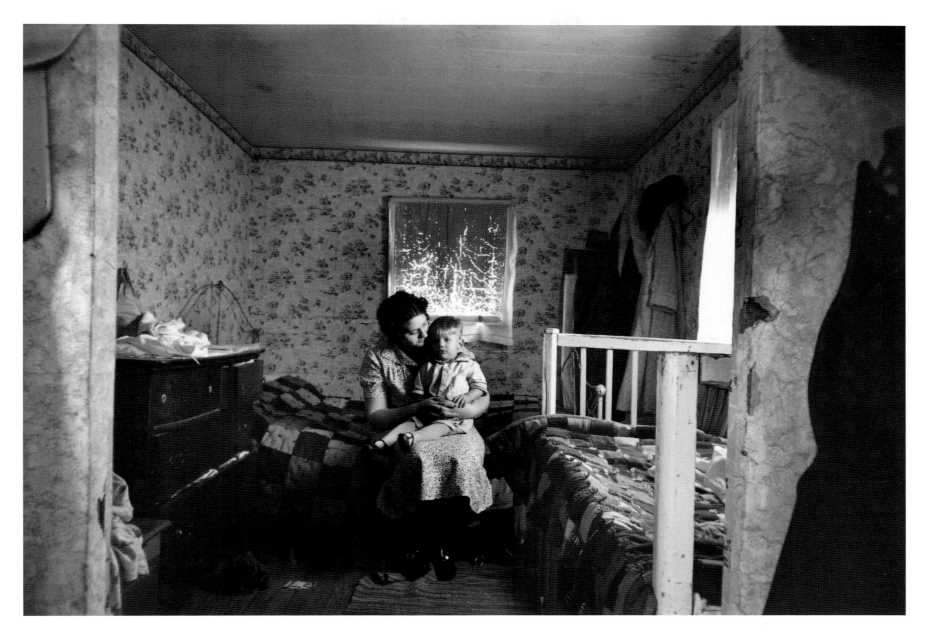

Mother and child in another bedroom of the Nissen shack near Dickens, Iowa
RUSSELL LEE, DECEMBER 1936

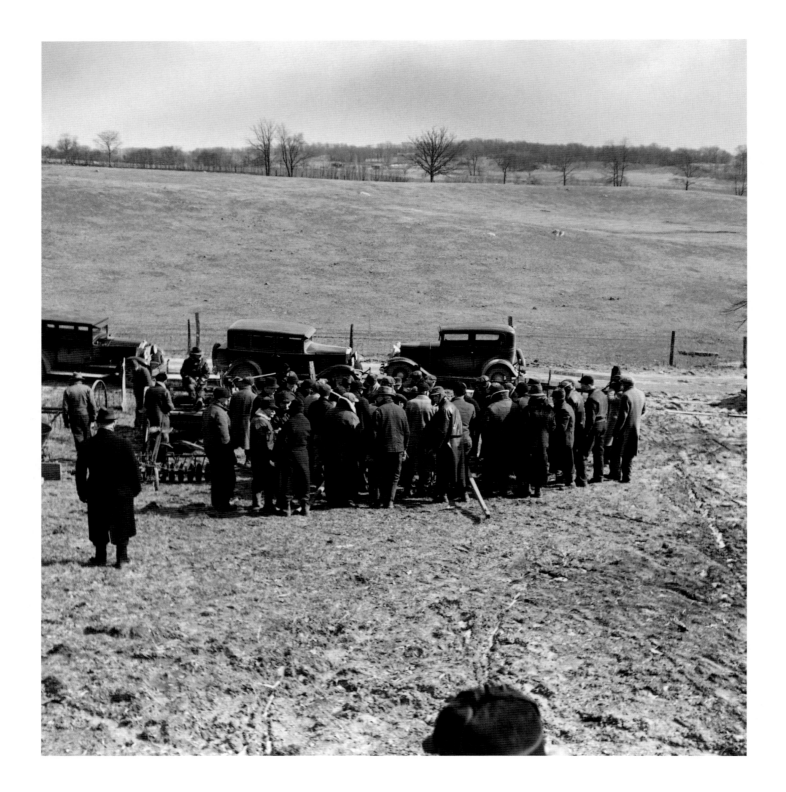

Farmers at the closing-out sale of Frank Sheroan, tenant farmer, near Montmorenci, Indiana
RUSSELL LEE, FEBRUARY 1937

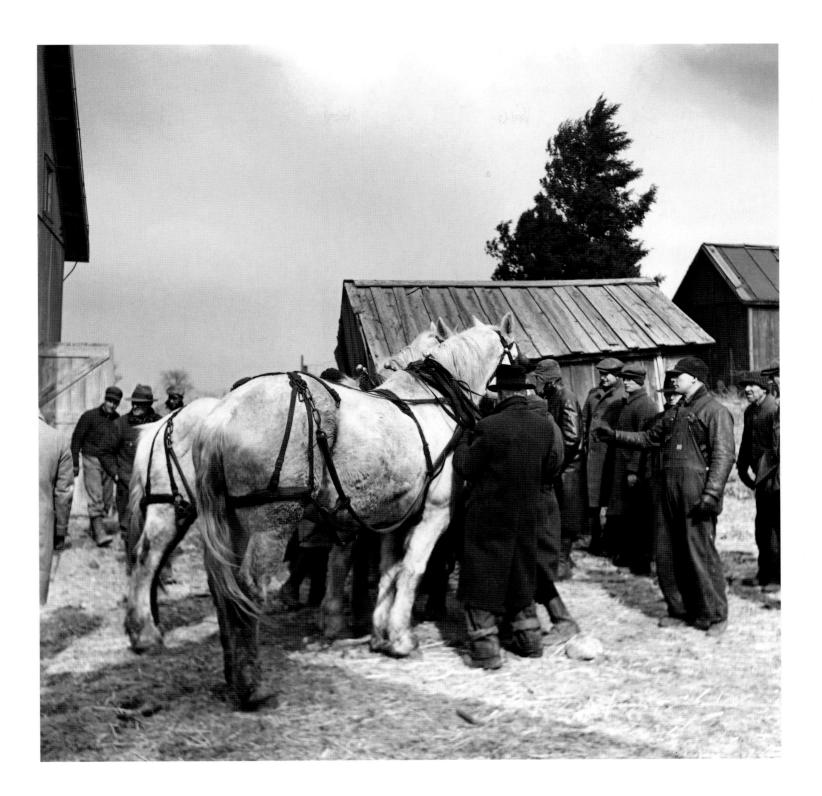

Auctioning off a team of horses at the closing-out sale of Frank Sheroan, tenant farmer, near Montmorenci, Indiana

RUSSELL LEE, FEBRUARY 1937

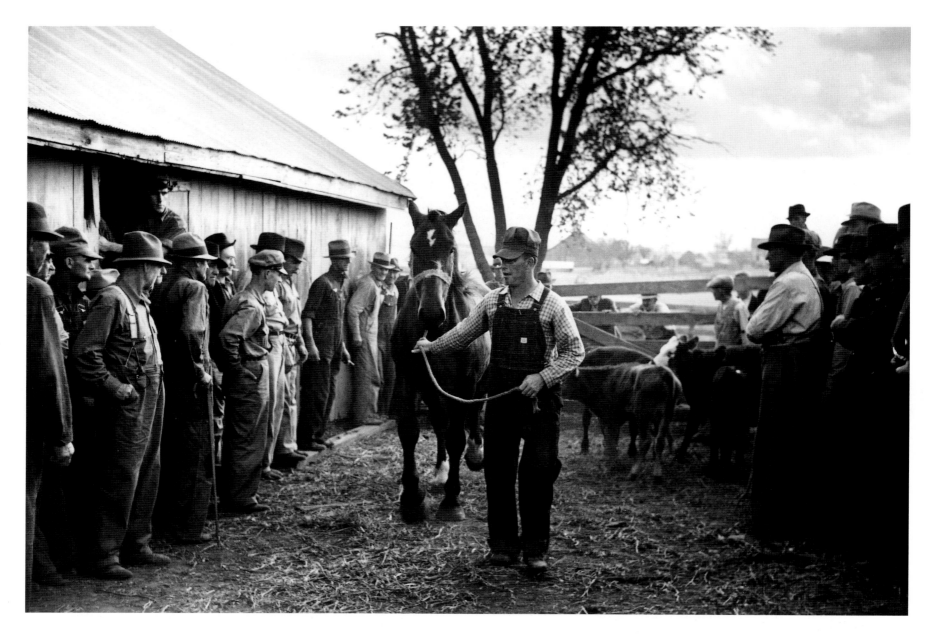

ABOVE: Horse is paraded before prospective buyers, farm sale, Pettis County, Missouri
ARTHUR ROTHSTEIN, NOVEMBER 1939

OPPOSITE: Three helpers at Frank Sheroan's closing-out sale near Montmorenci, Indiana
RUSSELL LEE, FEBRUARY 1937

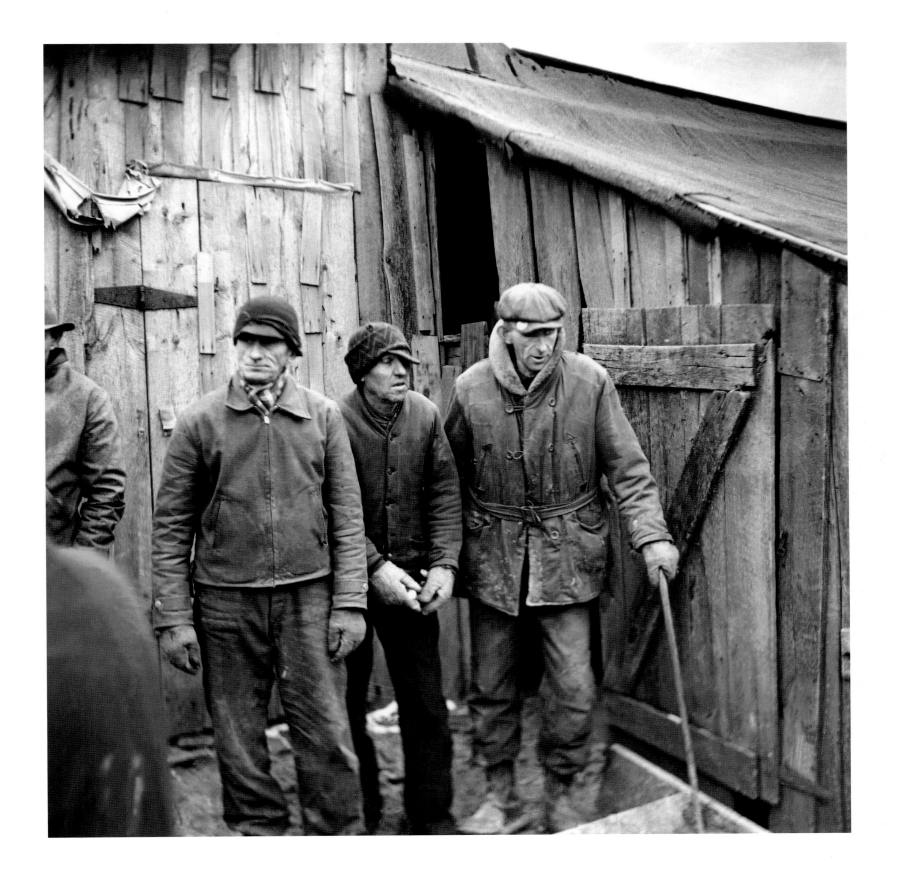

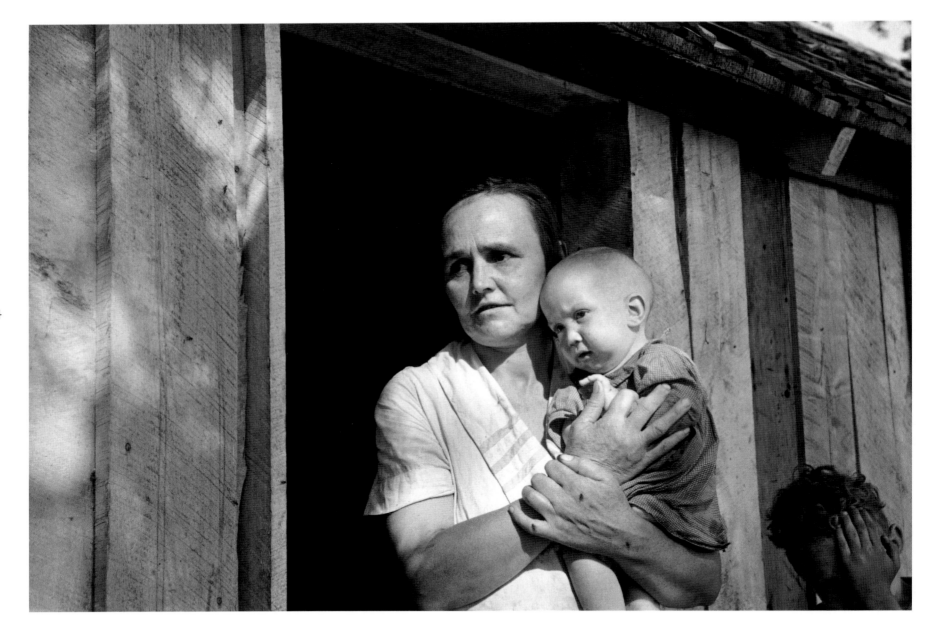

Wife and child of sharecropper, cutover farmer of Mississippi bottoms
RUSSELL LEE, MAY 1938

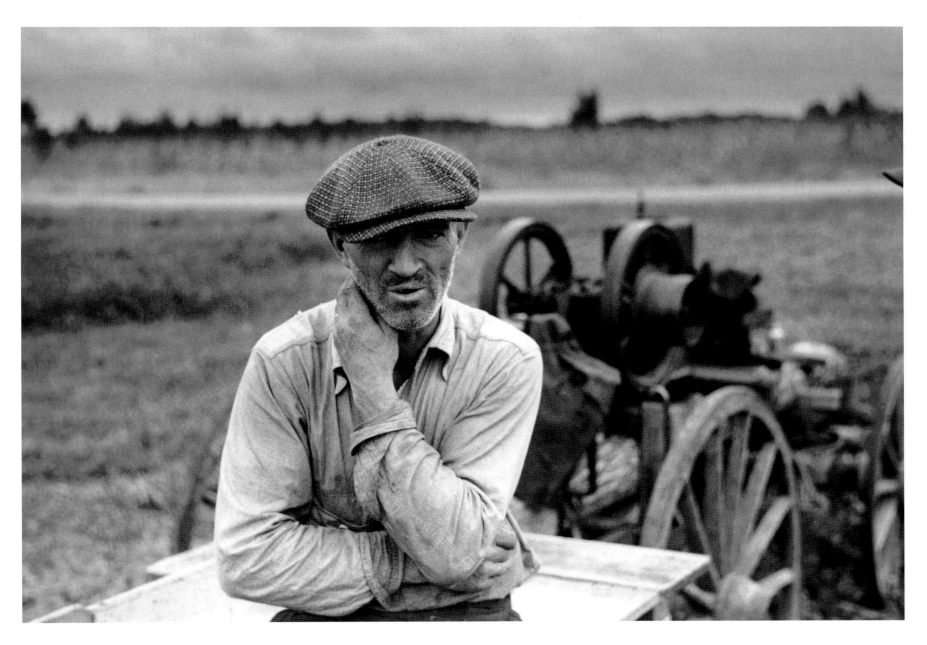

Untitled (Wisconsin?)

John Vachon, September 1939

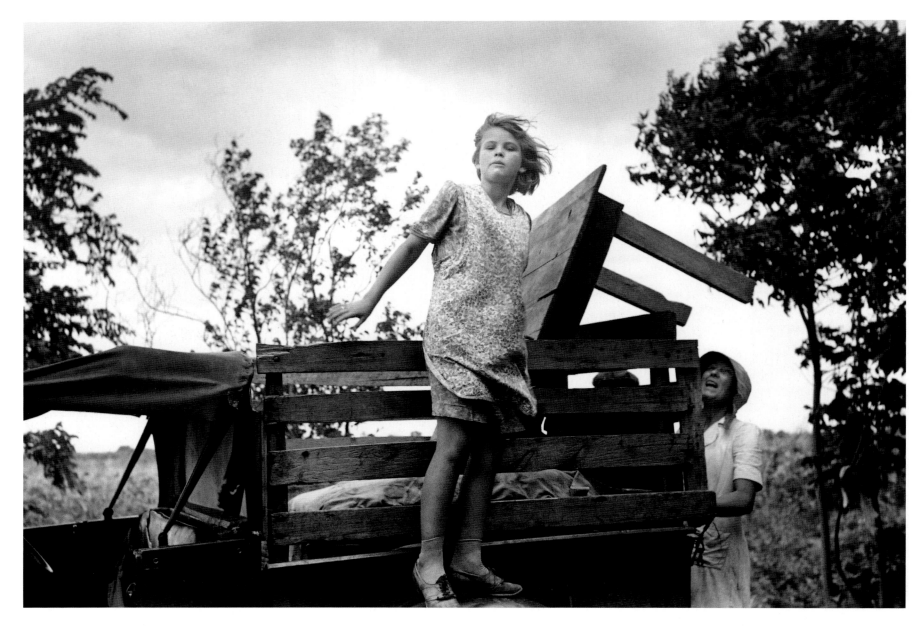

Untitled (Getting ready to leave for California, Muskogee, Oklahoma)
RUSSELL LEE, JULY 1939

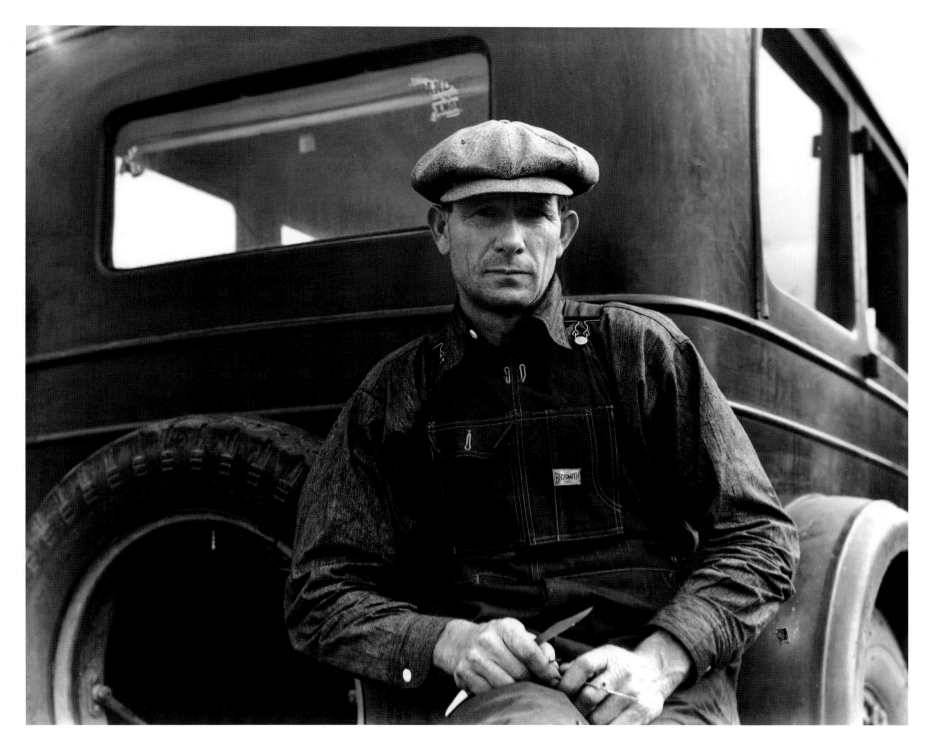

1936 drought refugee from Polk, Missouri, awaiting the opening of orange-picking season at Porterville, California

DOROTHEA LANGE, NOVEMBER 1936

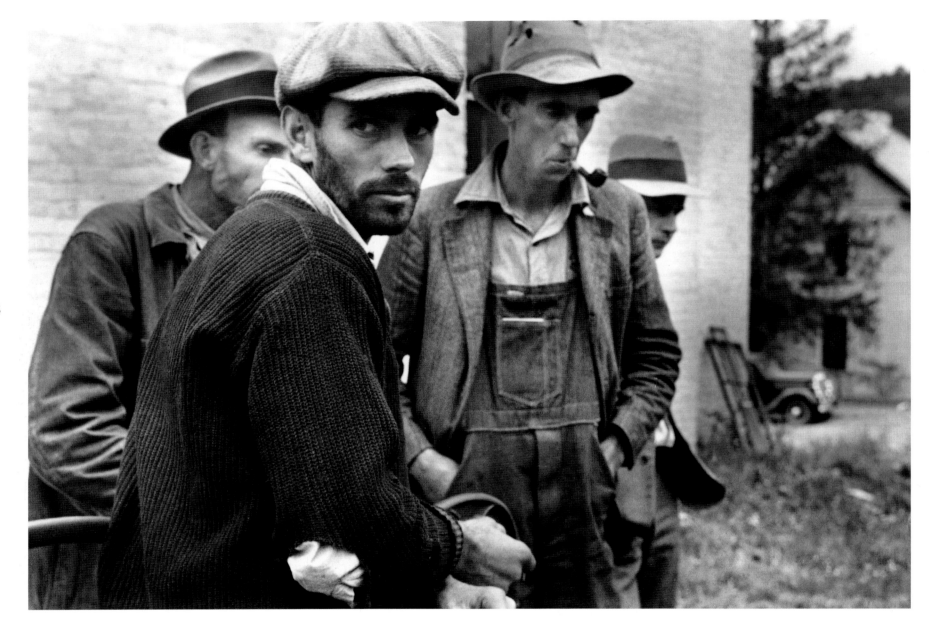

Maynardville, Tennessee

Ben Shahn, October 1935

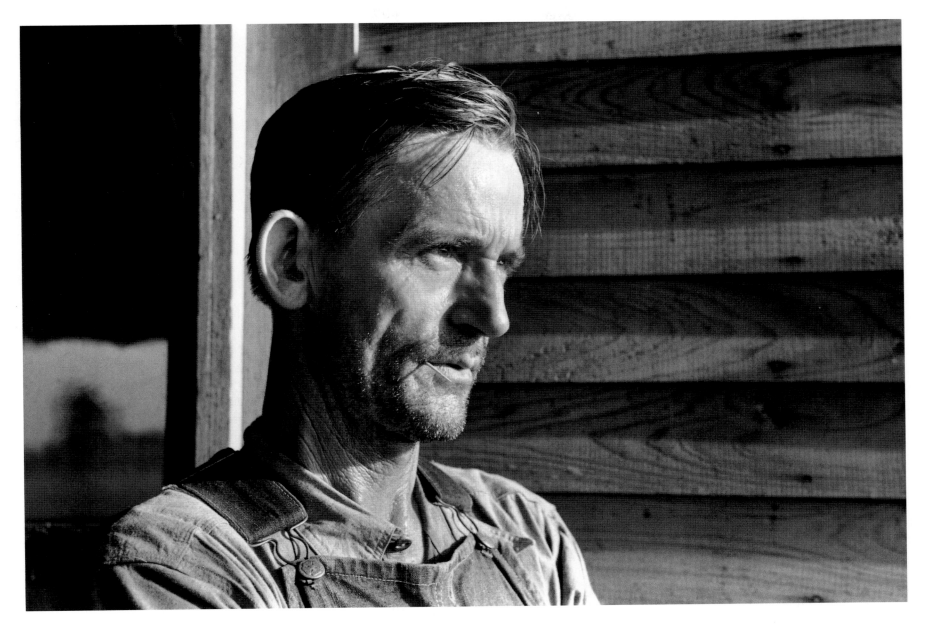

FSA client who will become owner-operator, Caruthersville, Missouri
RUSSELL LEE, AUGUST 1938

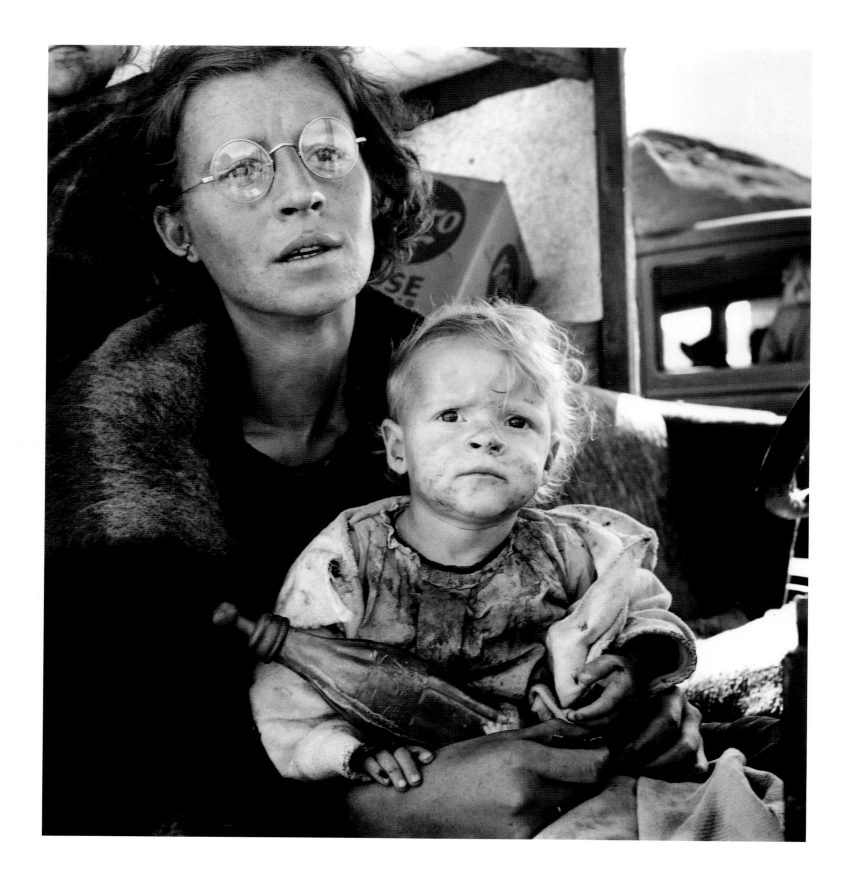

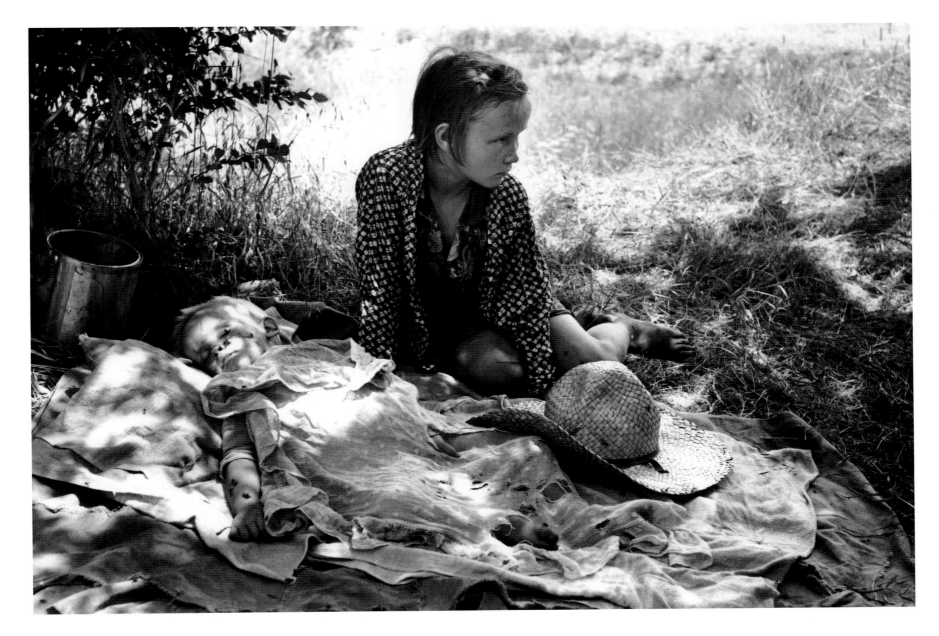

ABOVE: Children of agricultural day laborers camped by the roadside near Spiro, Oklahoma. There were no beds and no protection from the profusion of flies
RUSSELL LEE, JUNE 1939

OPPOSITE:: Mother and baby of family on the road. Tukelake, Siskiyou County, California
DOROTHEA LANGE, SEPTEMBER 1939

352

Detail of automobile of white migrant family with sack of salt on running board and leather-laced tire, Fort Gibson, Oklahoma

RUSSELL LEE, JUNE 1939

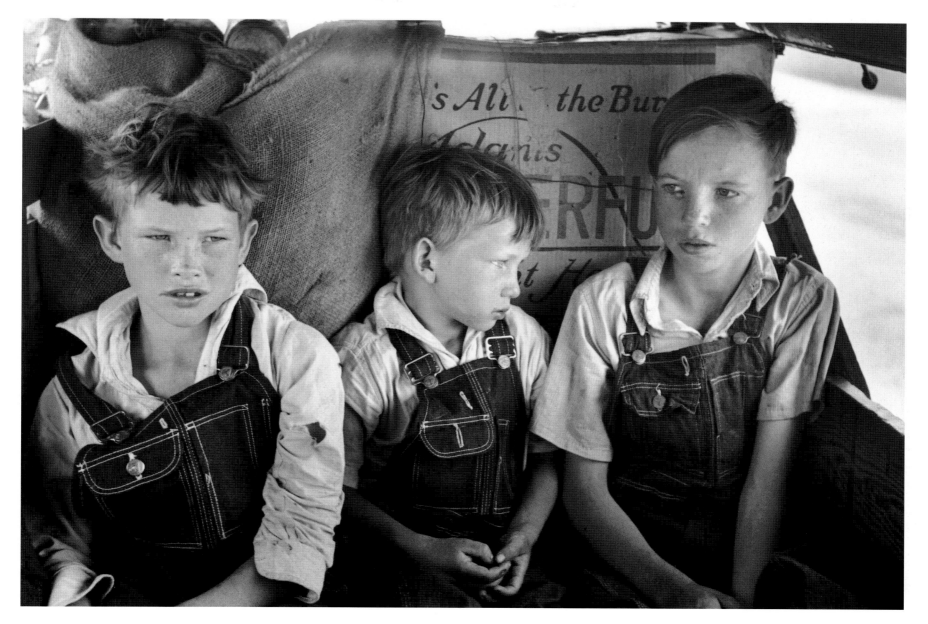

White migrant children sitting in back seat of family car east of Fort Gibson, Muskogee County, Oklahoma
RUSSELL LEE, JUNE 1939

354

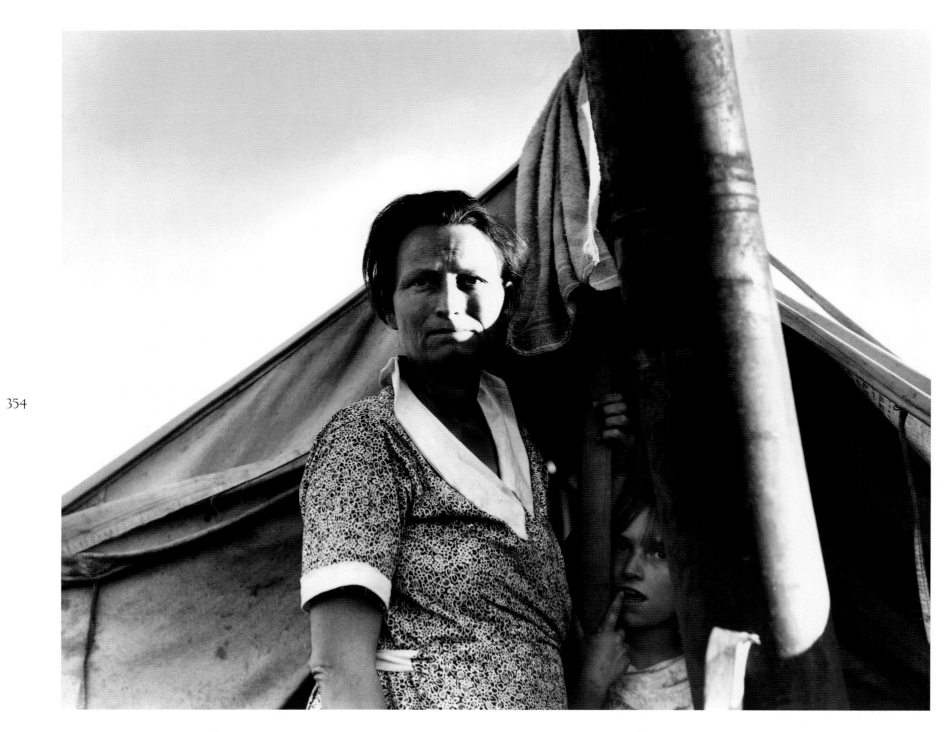

ABOVE: Untitled (Mother, unemployed family from Rio Grande Valley, Texas, camped out on a river bottom near Hottville, California)
DOROTHEA LANGE, MARCH 1937

OPPOSITE: Young cotton picker, Kern County migrant camp, California
DOROTHEA LANGE, NOVEMBER 1936

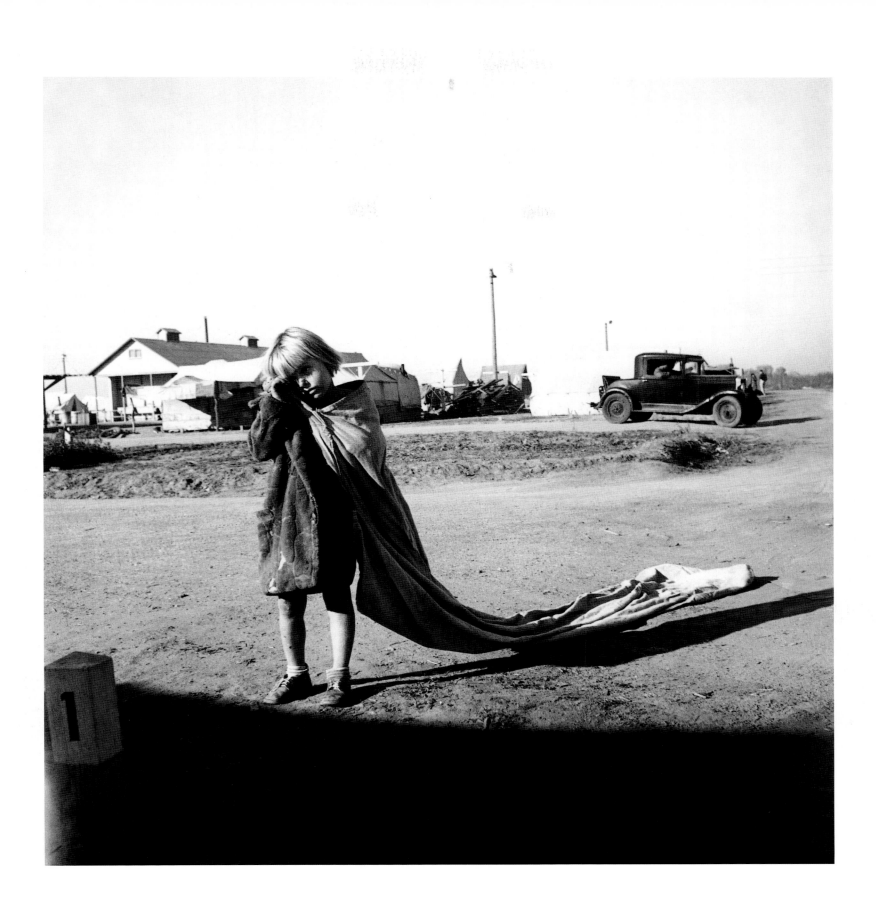

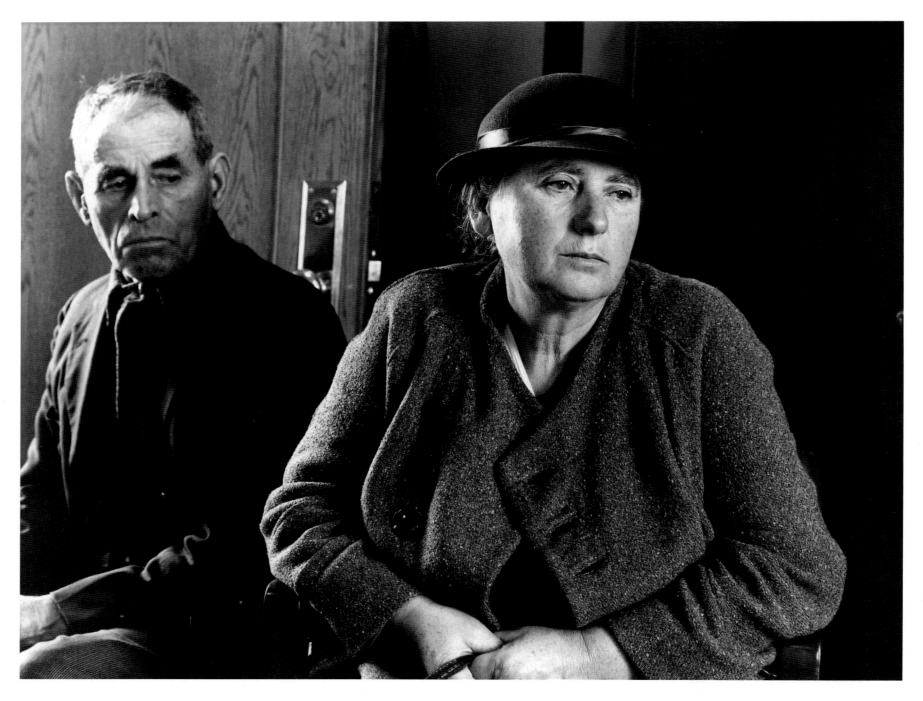

ABOVE: Farm woman, Tenant Purchase applicant, Stockton, California
DOROTHEA LANGE, DECEMBER 1938

OPPOSITE: Migrant woman from Arkansas living in contractor's camp near Westley, California.
She would prefer to live in a government camp, but the contractor system prevents, because of control over allocations of work
DOROTHEA LANGE, APRIL 1939

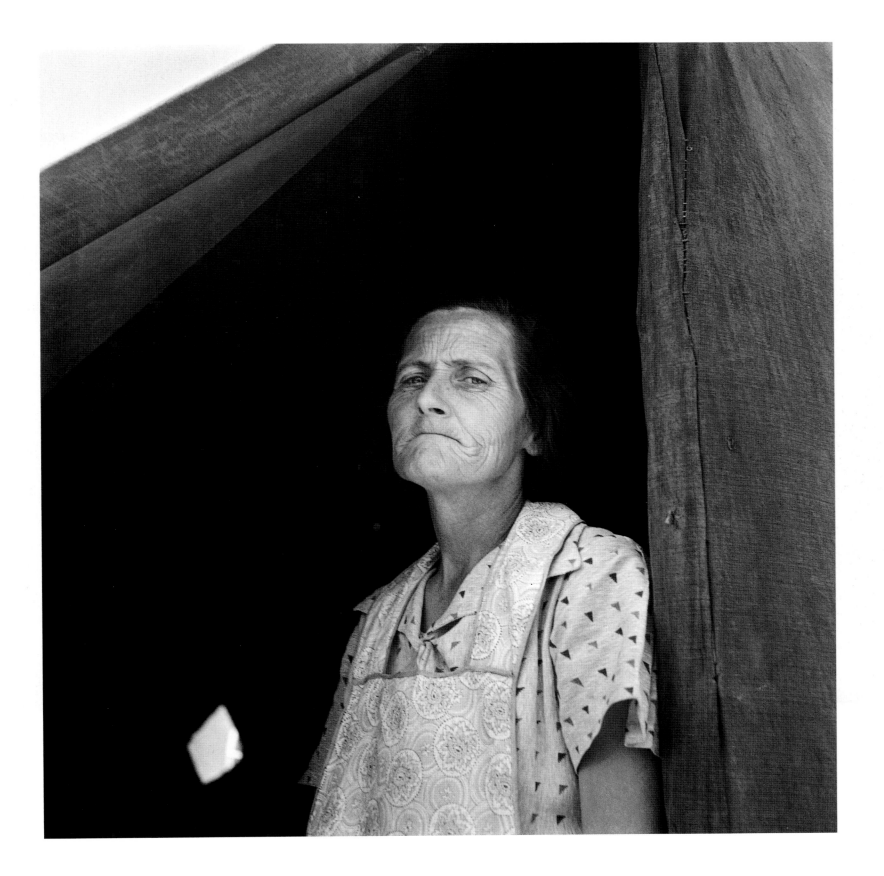

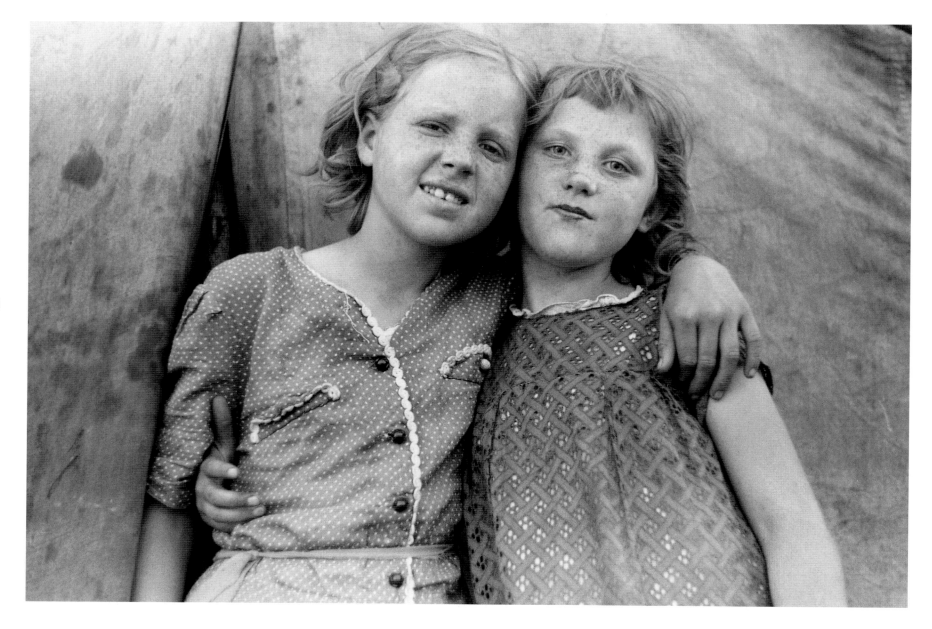

Migrant children, Berrien County, Michigan

John Vachon, July 1940

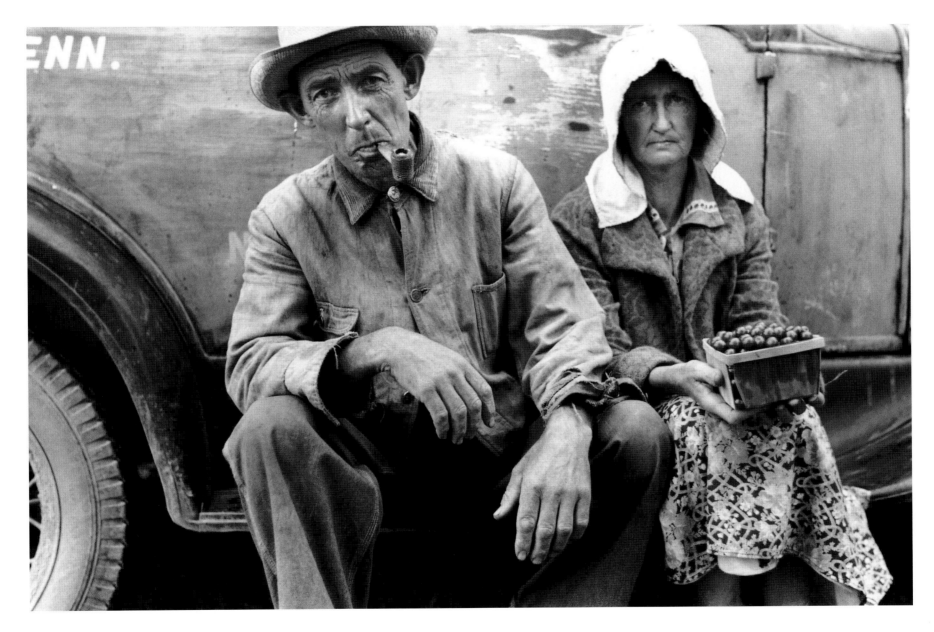

Untitled (Migrant fruit workers from Arkankas, Berrien County, Michigan)
JOHN VACHON, JULY 1940

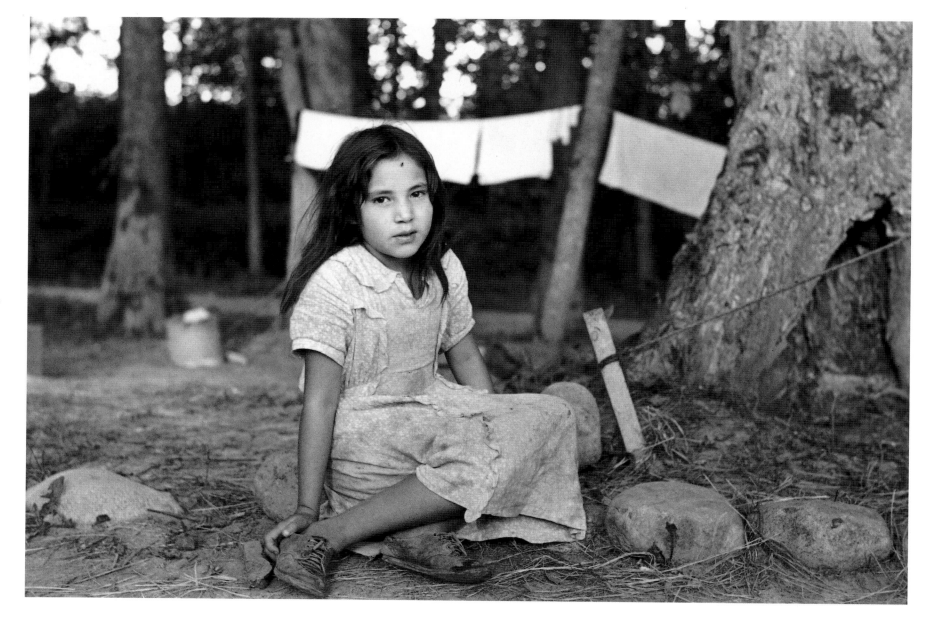

Indian girl, daughter of blueberry picker, near Little Fork, Minnesota
RUSSELL LEE, AUGUST 1937

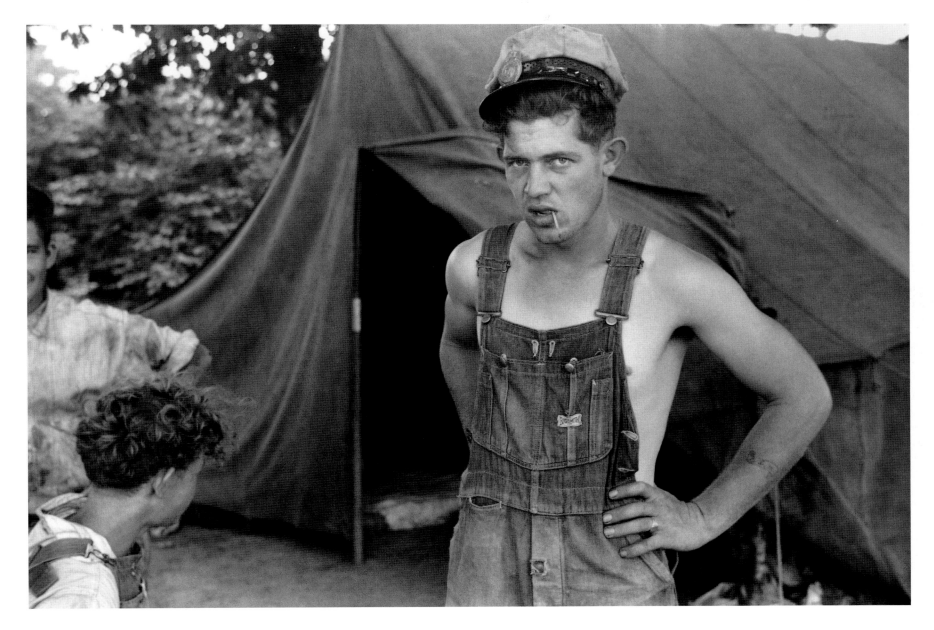

Untitled (Cherry picker, Berrien County, Michigan)
JOHN VACHON, JULY 1940

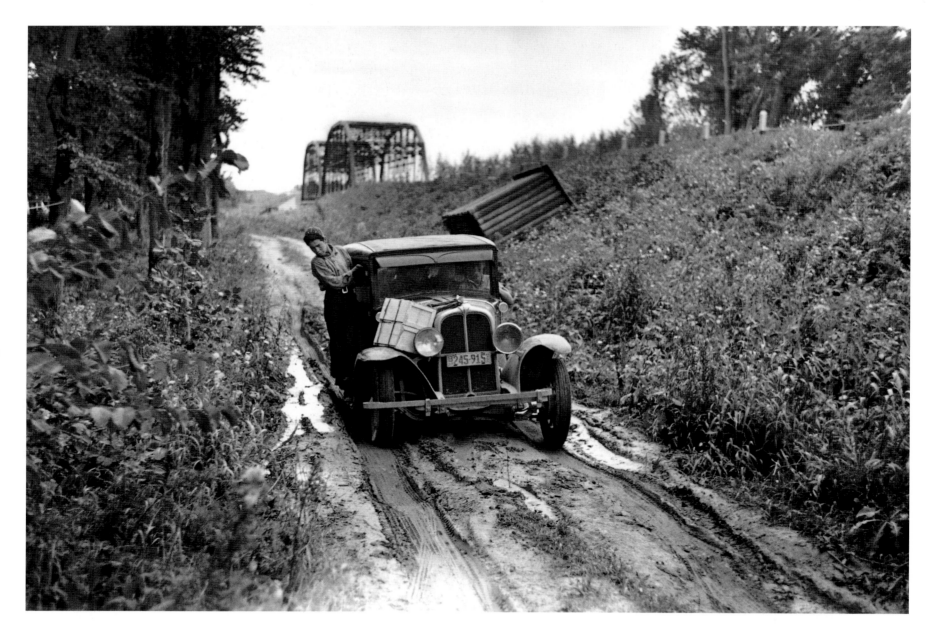

ABOVE: Indians on way to the berry fields near Little Fork, Minnesota
RUSSELL LEE, AUGUST 1937

OPPOSITE: Migratory boy in squatter camp. Has come to Yakima Valley for the third year to pick hops.
Mother: "You'd be surprised what that boy can pick." Washington, Yakima Valley
DOROTHEA LANGE, AUGUST 1939

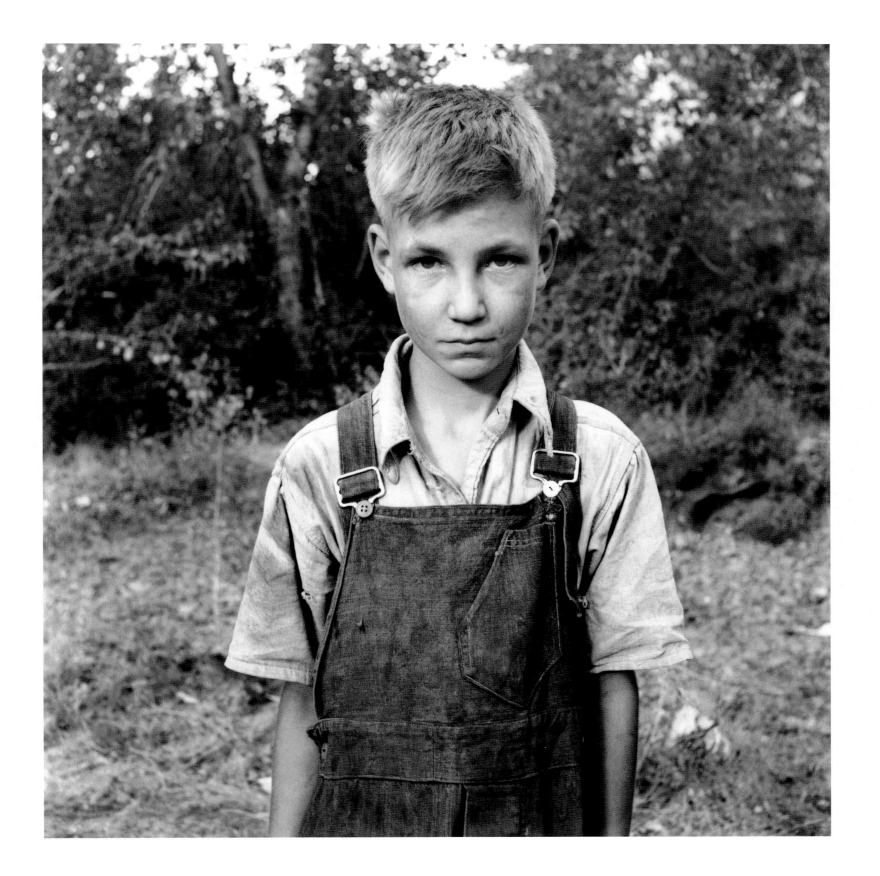

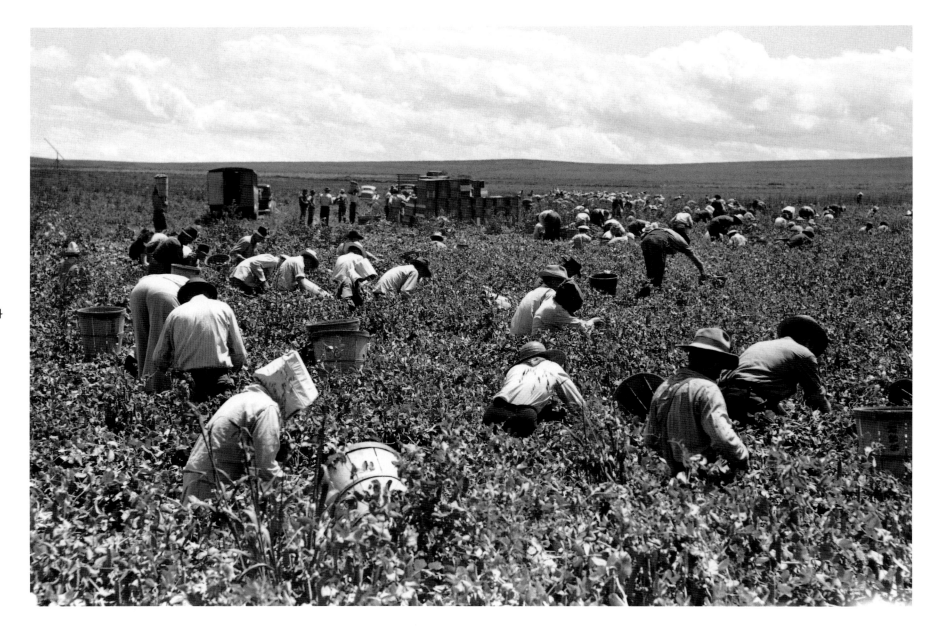

Labor contractor's crew picking peas, Nampa, Idaho
RUSSELL LEE, JUNE 1941

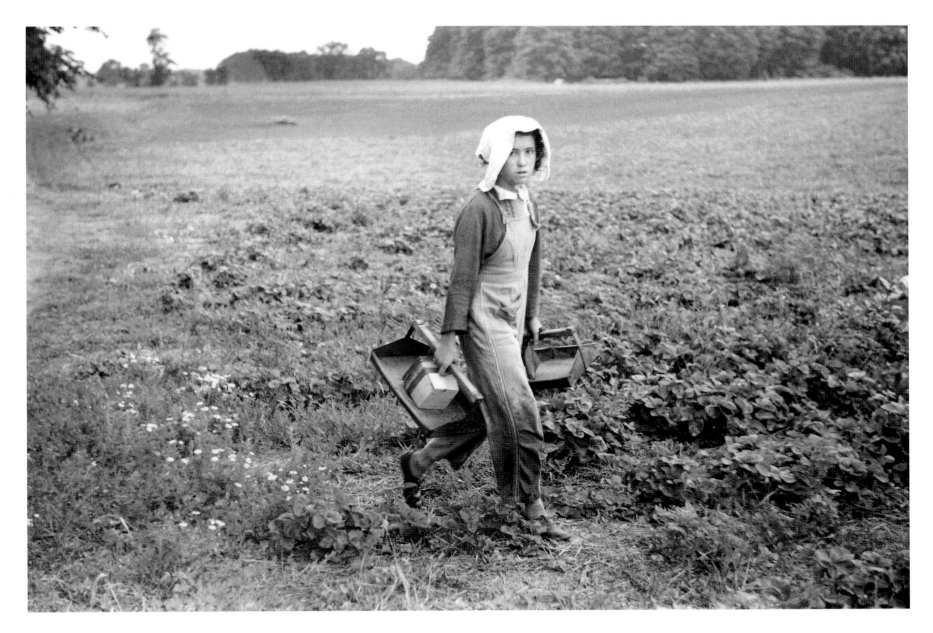

Migrant girl, strawberry picker, Berrien County, Michigan

JOHN VACHON, JULY 1940

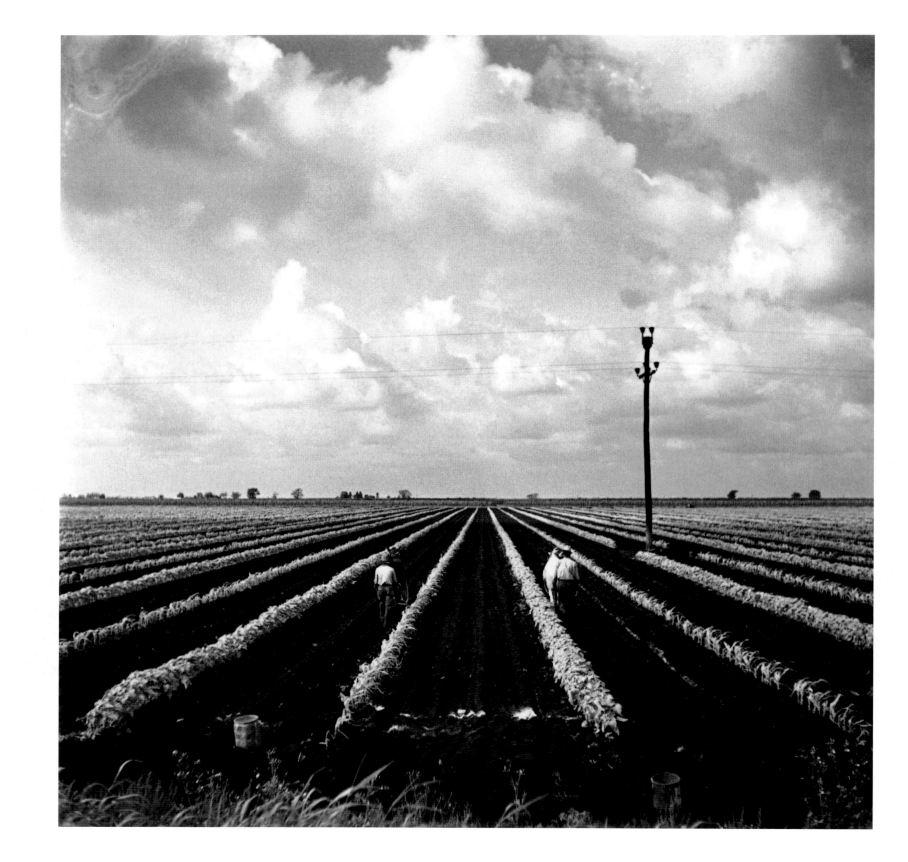

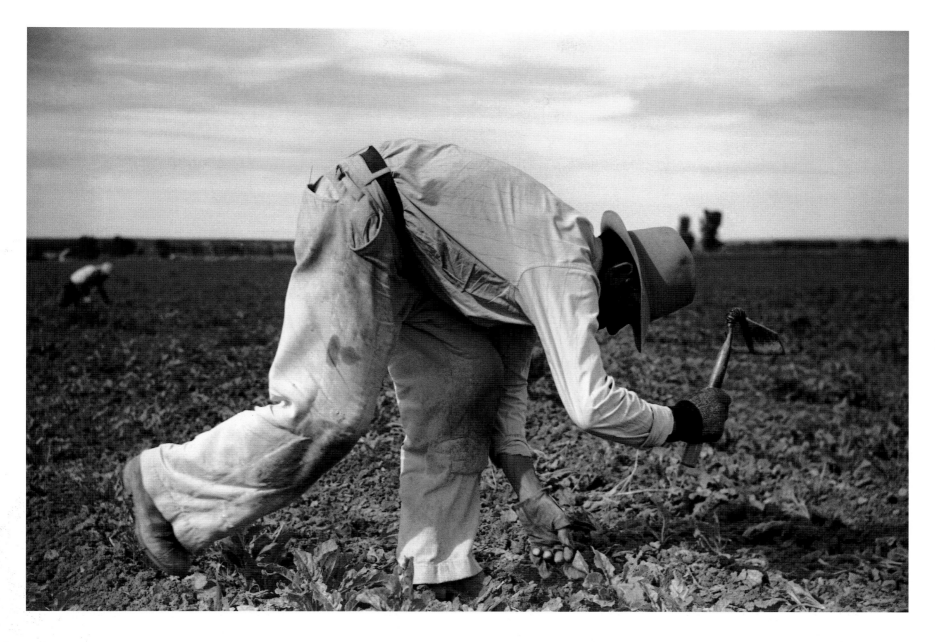

ABOVE: Chopping sugar beets, Treasure County, Montana
ARTHUR ROTHSTEIN, JUNE 1939

OPPOSITE: Planting beans near Belle Glade, Florida
ARTHUR ROTHSTEIN, JANUARY 1937

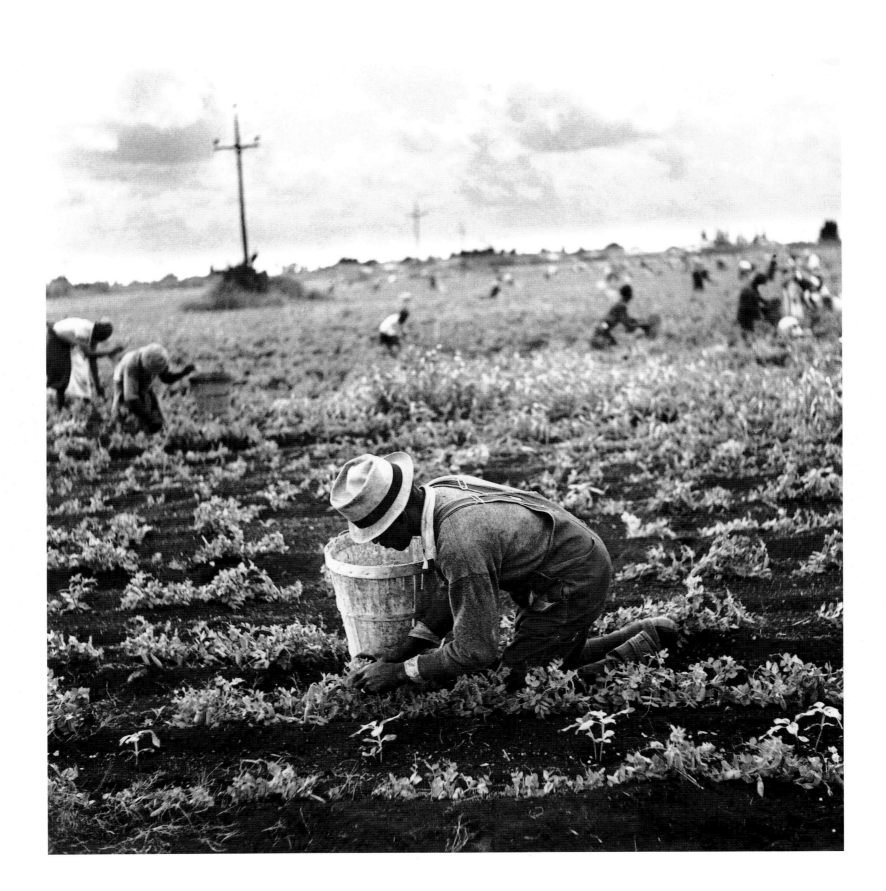

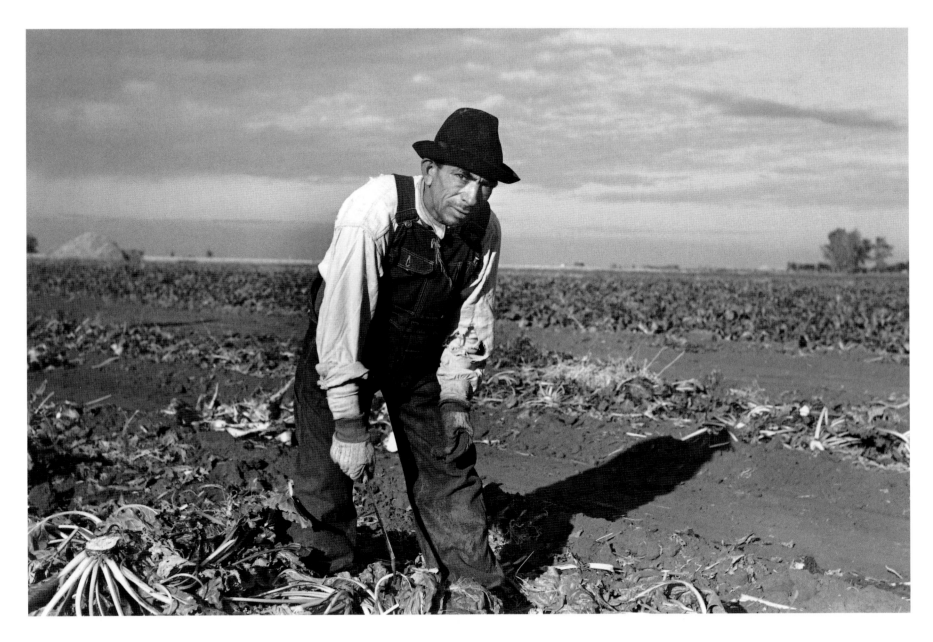

ABOVE: Mexican sugar beet worker, near Fisher, Minnesota
RUSSELL LEE, OCTOBER 1937

OPPOSITE: Picking beans, Belle Glade, Florida
ARTHUR ROTHSTEIN, JANUARY 1937

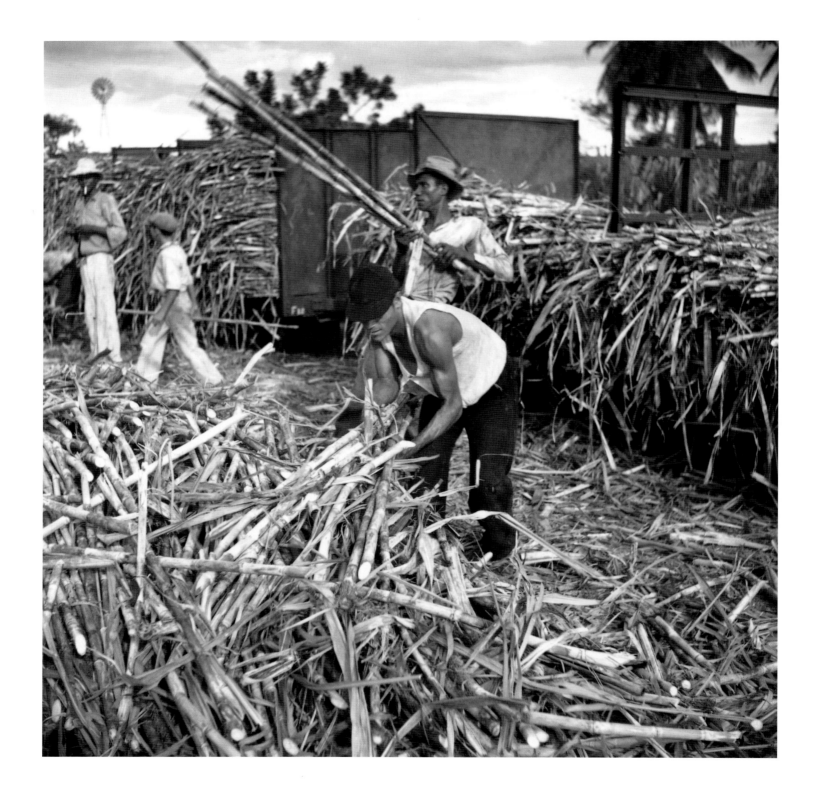

Sugar cane being loaded onto a train for transportation to the refinery, near Ponce, Puerto Rico

EDWIN ROSSKAM, JANUARY 1938

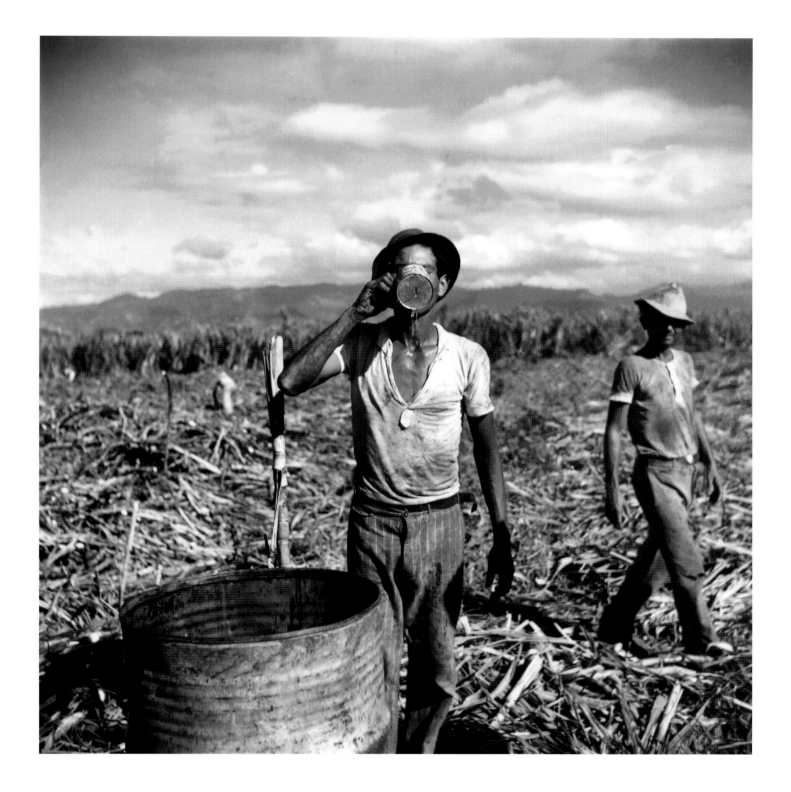

Ponce (vicinity), Puerto Rico, sugar worker taking a drink of water on a plantation
EDWIN ROSSKAM, JANUARY 1938

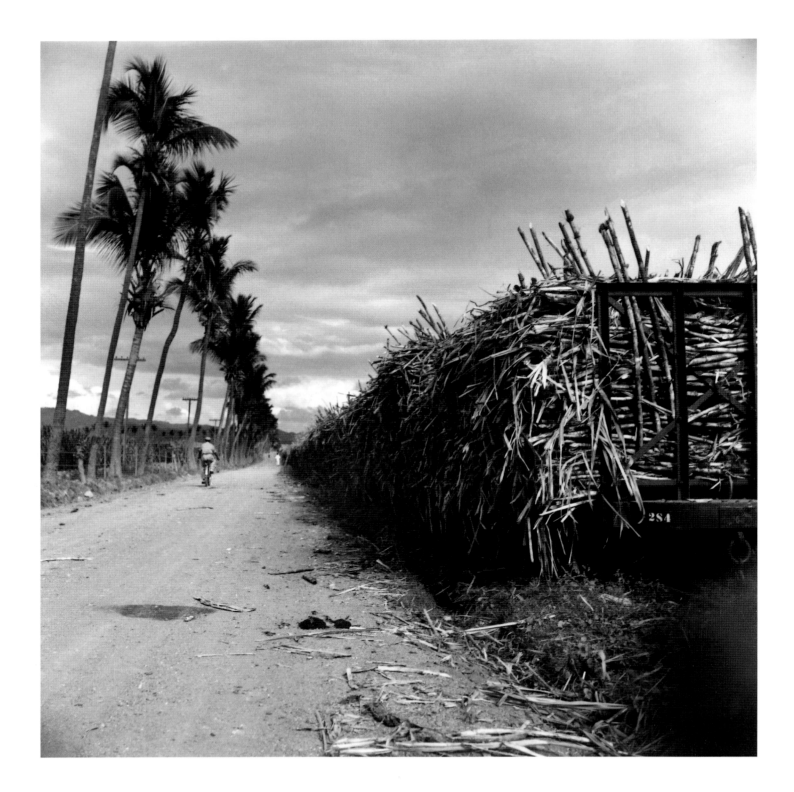

Train of flag cars loaded with sugar cane on a sugar plantation near Ponce, Puerto Rico
EDWIN ROSSKAM, JANUARY 1938

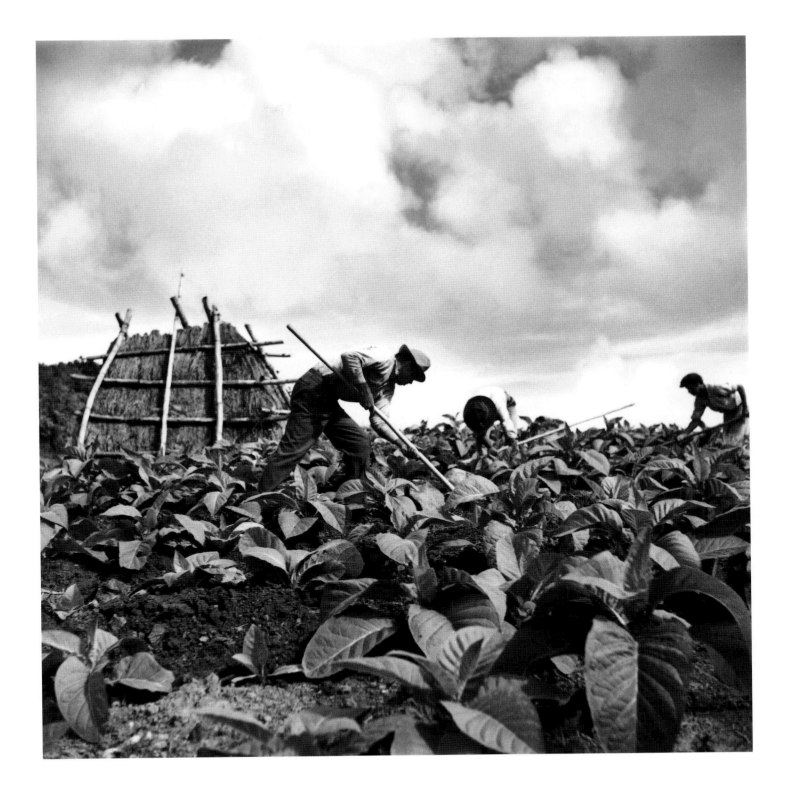

Workers in a tobacco field. The straw shed in the background is a hurricane shelter. Puerto Rico

Edwin Rosskam, January 1938

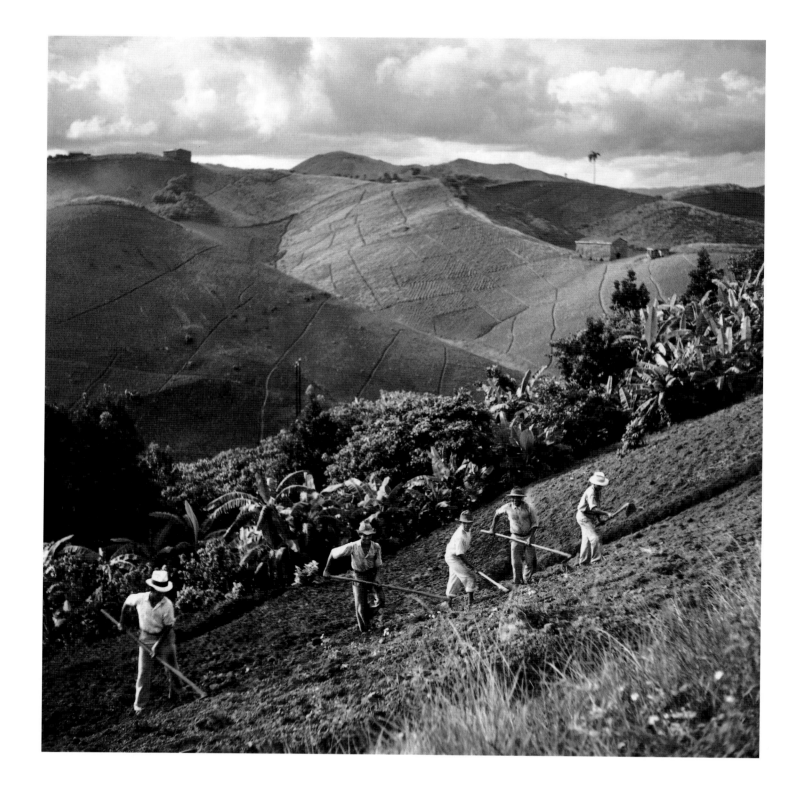

Hoeing a tobacco slope. No matter how steep, all of the hills in the picture are under cultivation. *Puerto Rico*
EDWIN ROSSKAM, JANUARY 1938

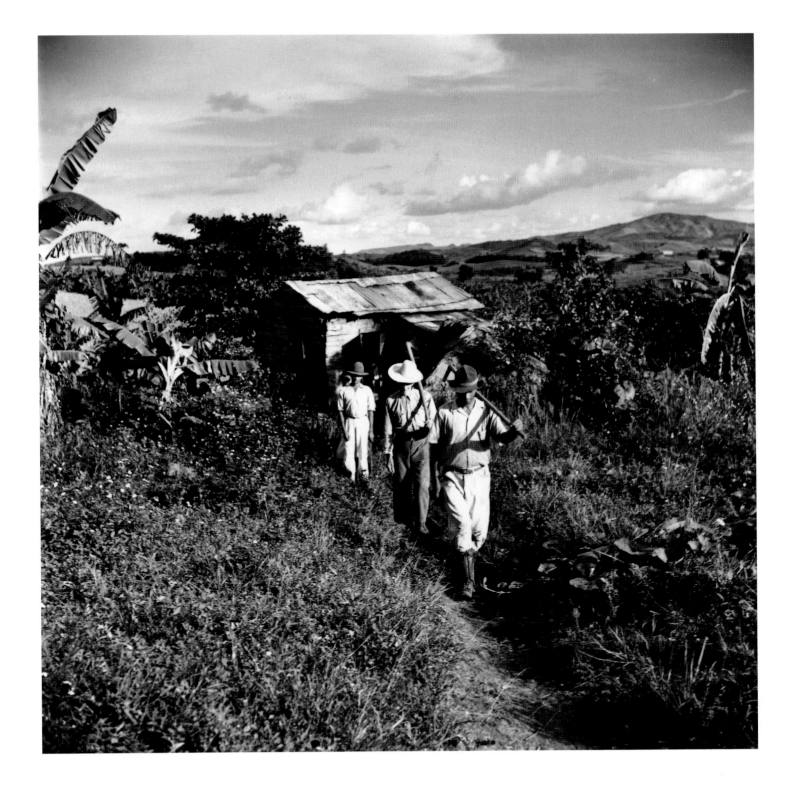

Cidra (vicinity), Puerto Rico. Jubaro tobacco workers leaving home for day labor in the fields
EDWIN ROSSKAM, JANUARY 1938

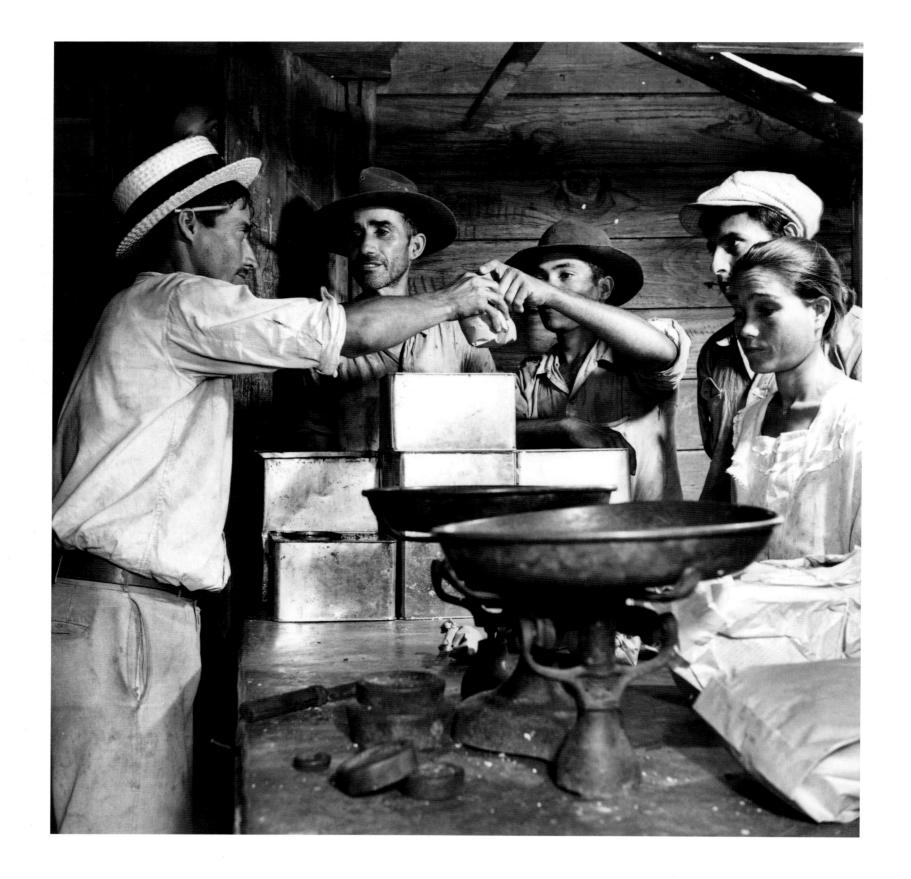

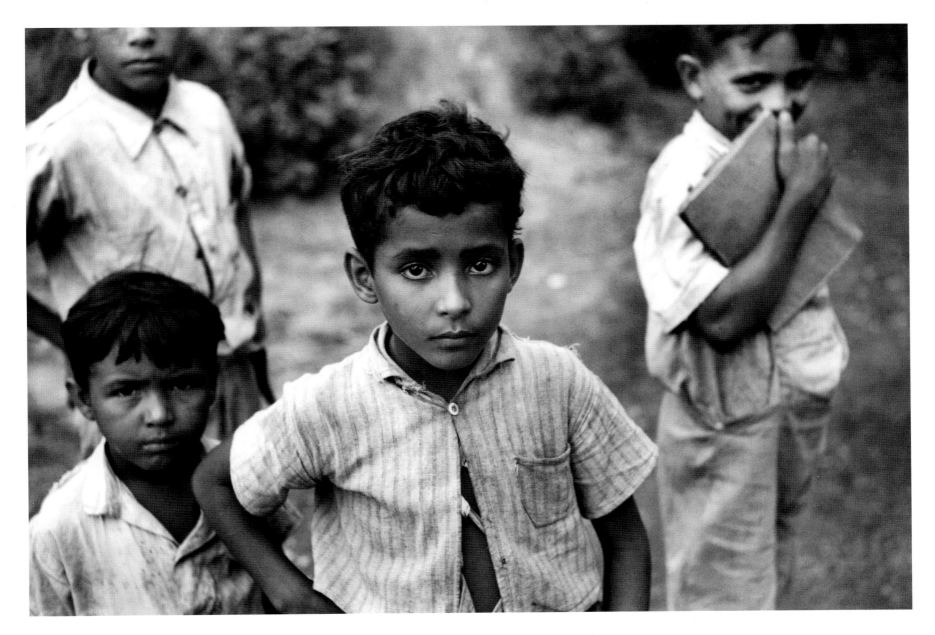

ABOVE: Children coming home from school on a road near Manati, Puerto Rico

JACK DELANO, DECEMBER 1941

OPPOSITE: Interior of country store in the hills, Puerto Rico

EDWIN ROSSKAM, JANUARY 1938

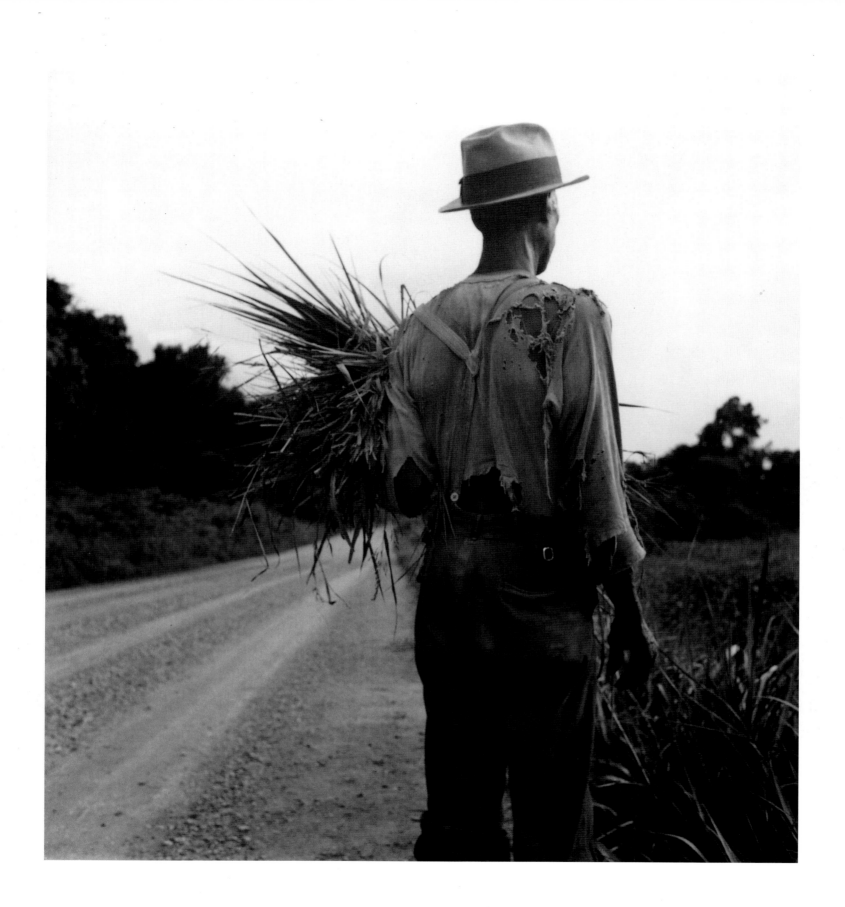

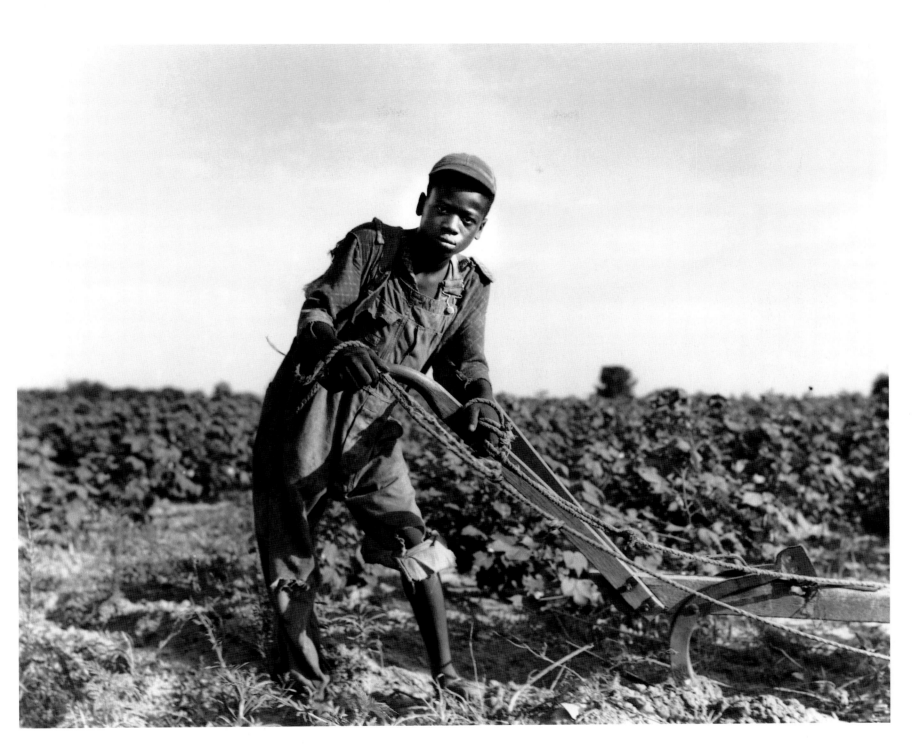

ABOVE: Thirteen-year-old sharecropper boy near Americus, Georgia
DOROTHEA LANGE, JULY 1937

OPPOSITE: Old time Negro living on cotton patch near Vicksburg, Mississippi
DOROTHEA LANGE, JULY 1936

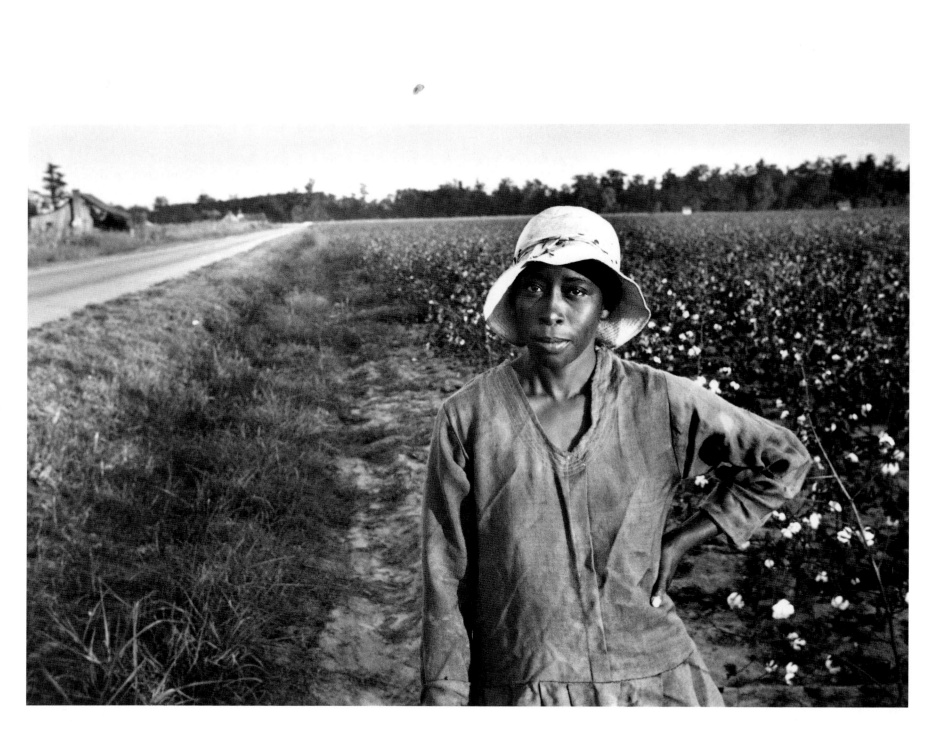

Untitled (Pulaski County, Arkansas)

BEN SHAHN, OCTOBER 1935

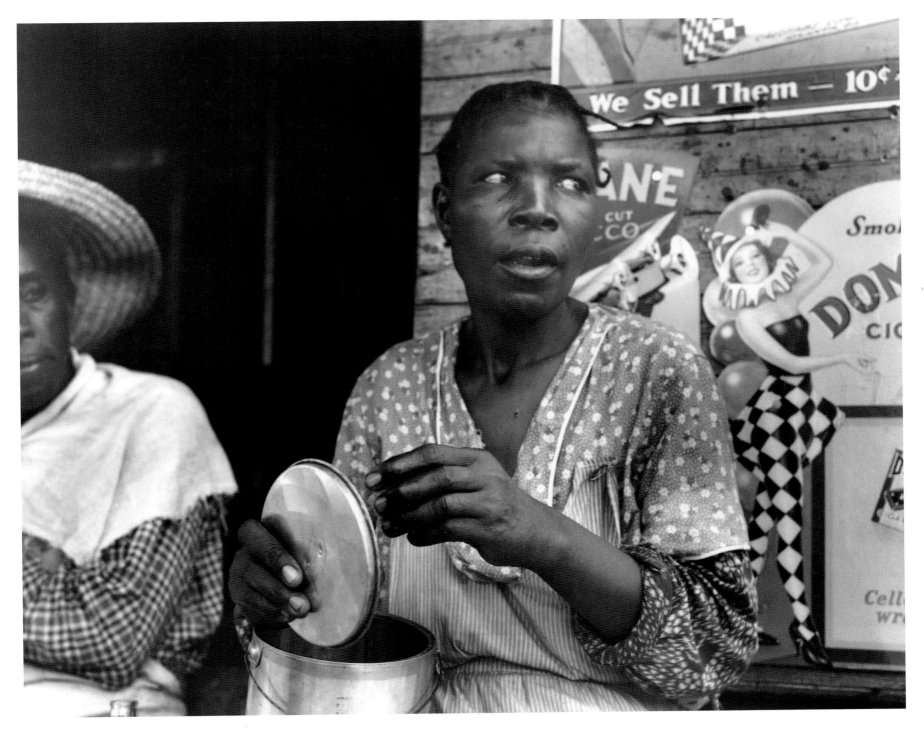

Peach picker, Muscella, Georgia

Dorothea Lange, July 1936

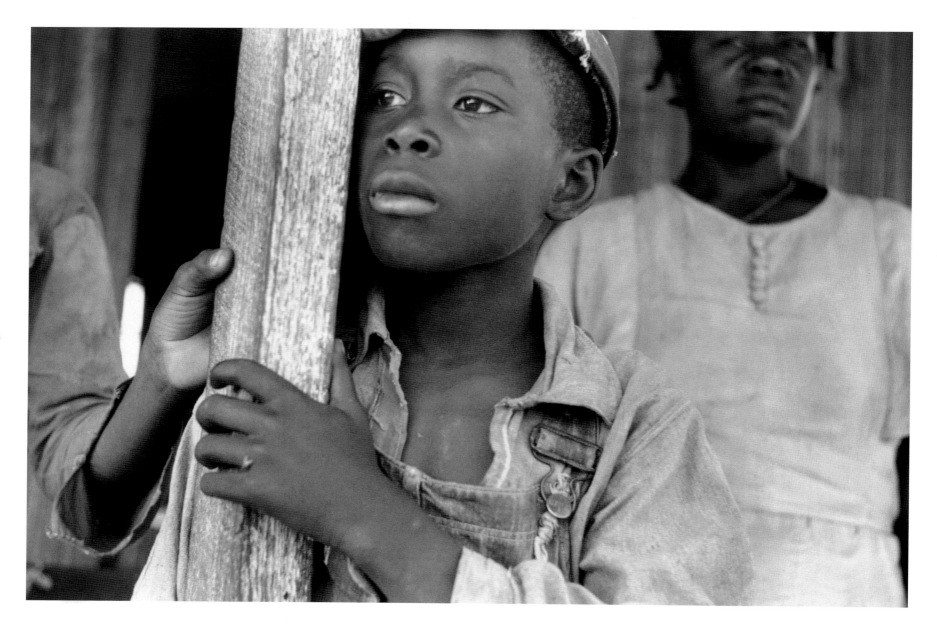

ABOVE: Untitled (Son of a tenant farmer, Greensboro, Alabama)
JACK DELANO, MAY 1941

OPPOSITE: Untitled (Tobacco farm family, Person County, North Carolina)
DOROTHEA LANGE, JULY 1939

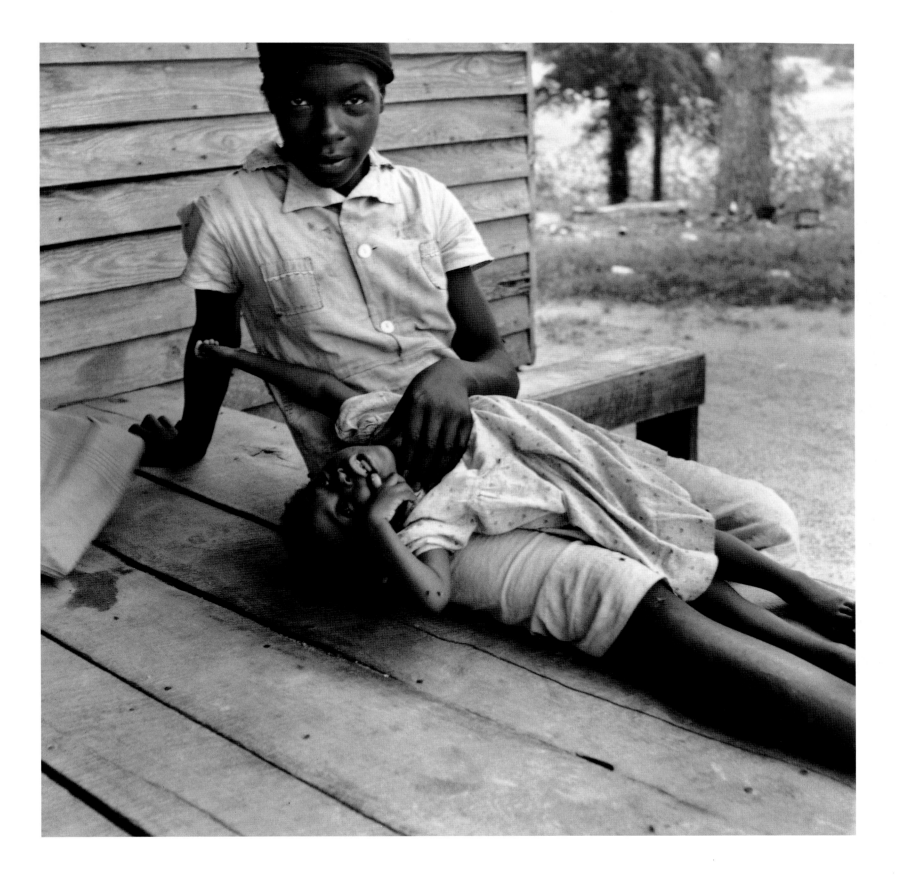

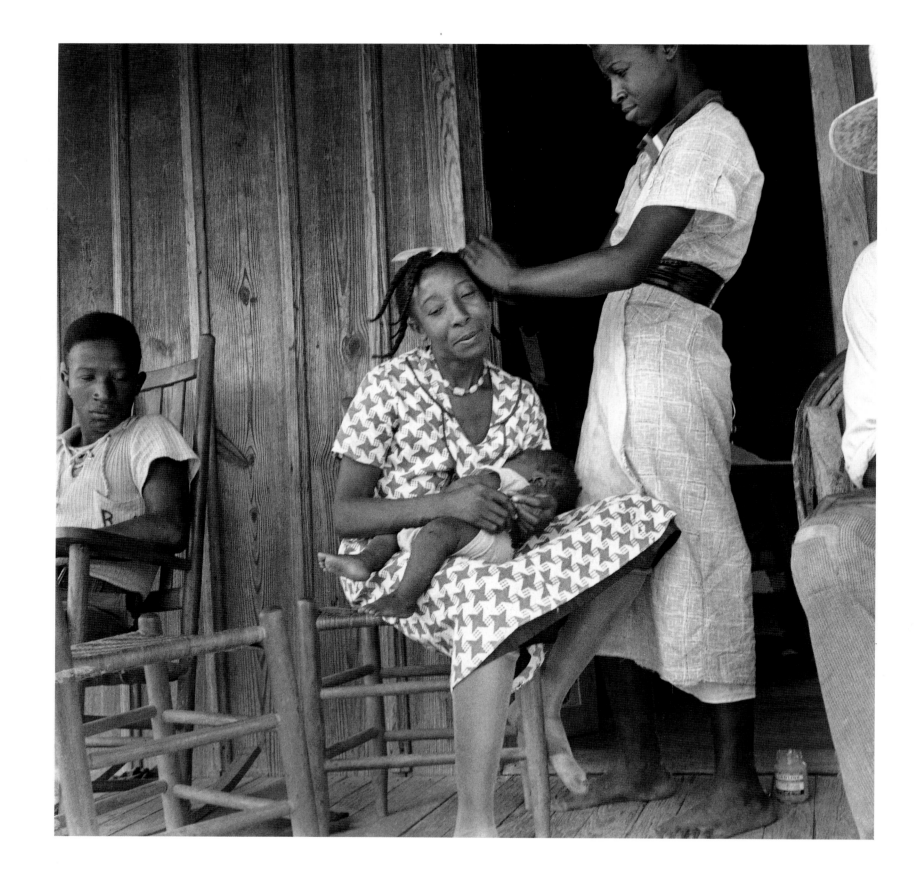

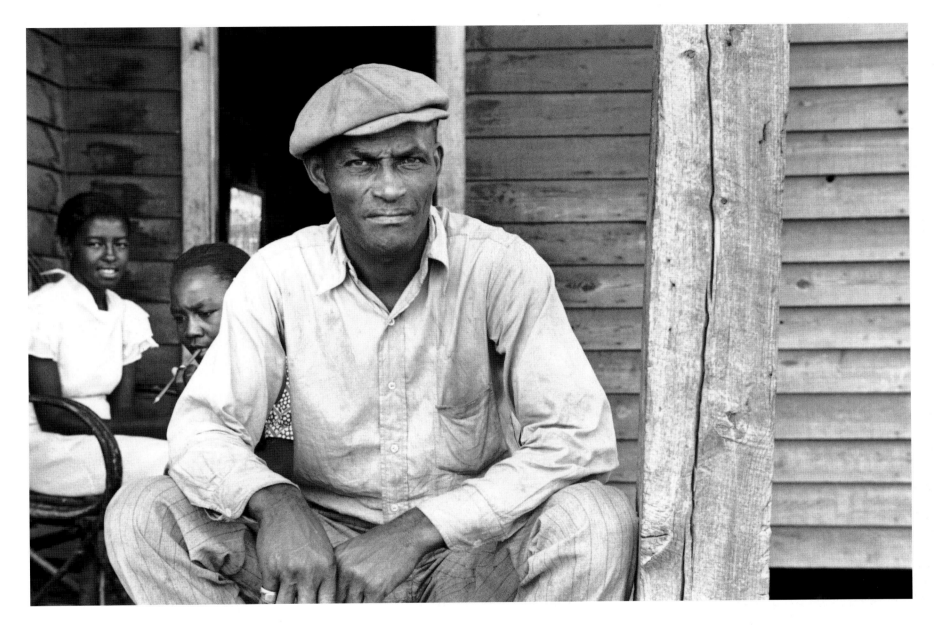

Above: Sharecropper on Sunday, Little Rock, Arkansas
Ben Shahn, October 1935

Opposite: Negro women near Earle, Arkansas
Dorothea Lange, July 1936

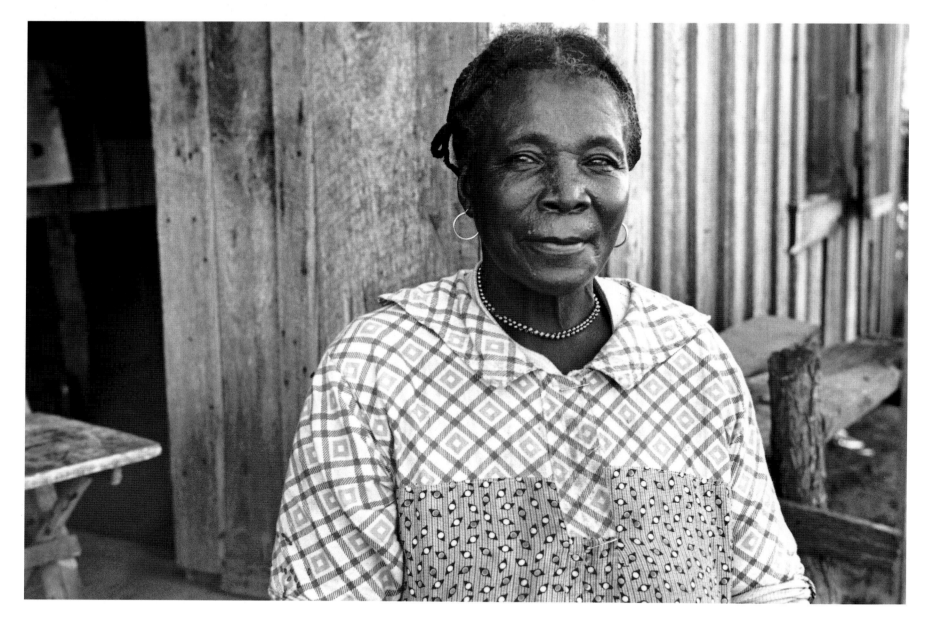

Wife of sharecropper, Pulaski County, Arkansas

BEN SHAHN, OCTOBER 1935

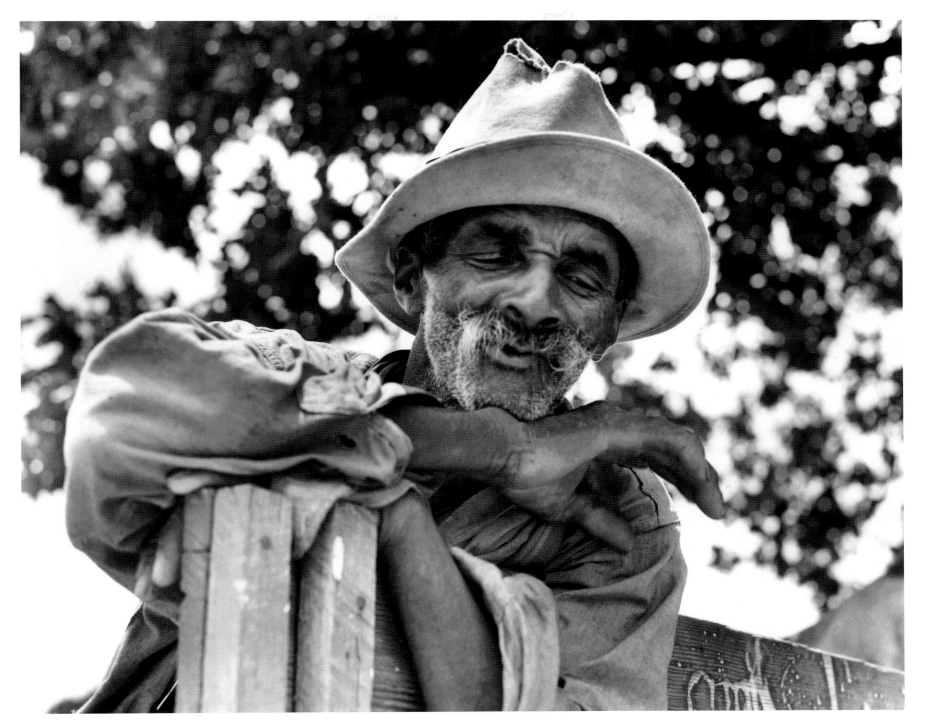

This man was born a slave in Greene County, Georgia

Dorothea Lange, July 1937

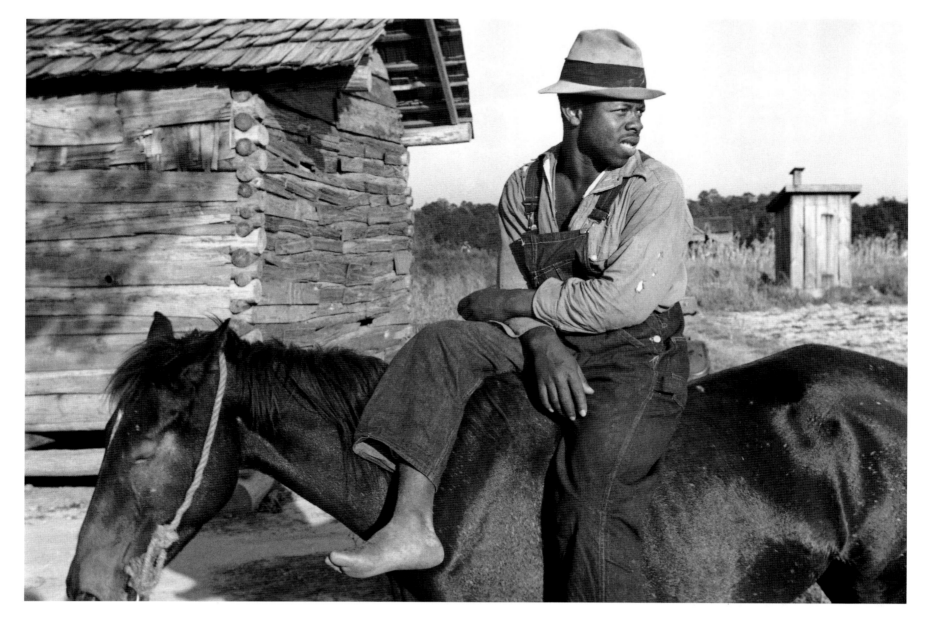

Strawberry picker, Hammond, Louisiana
BEN SHAHN, OCTOBER 1935

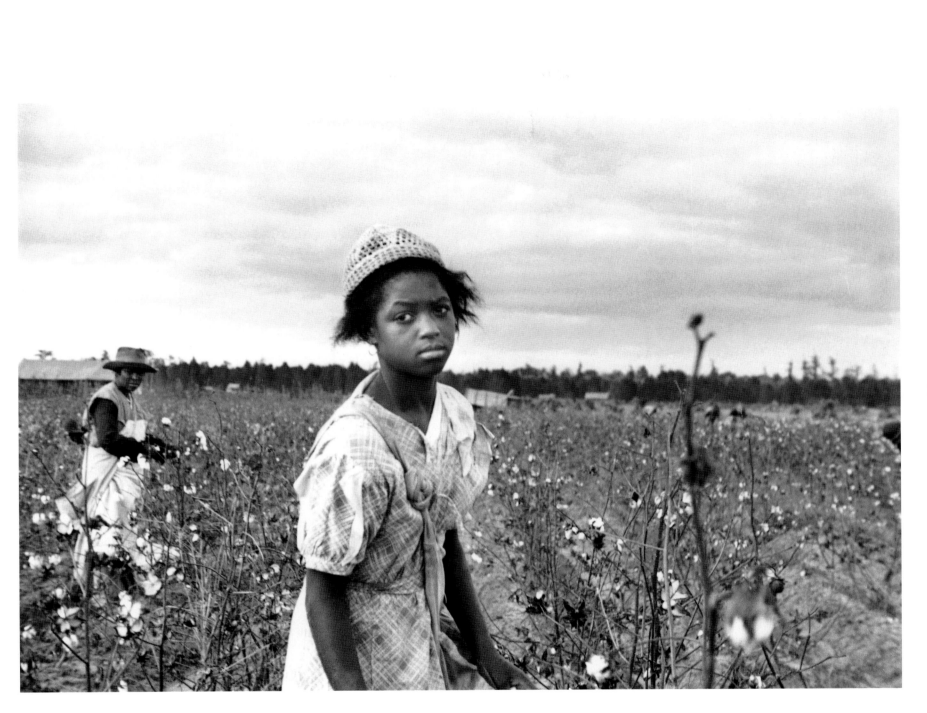

Picking cotton, Pulaski County, Arkansas

BEN SHAHN, OCTOBER 1935

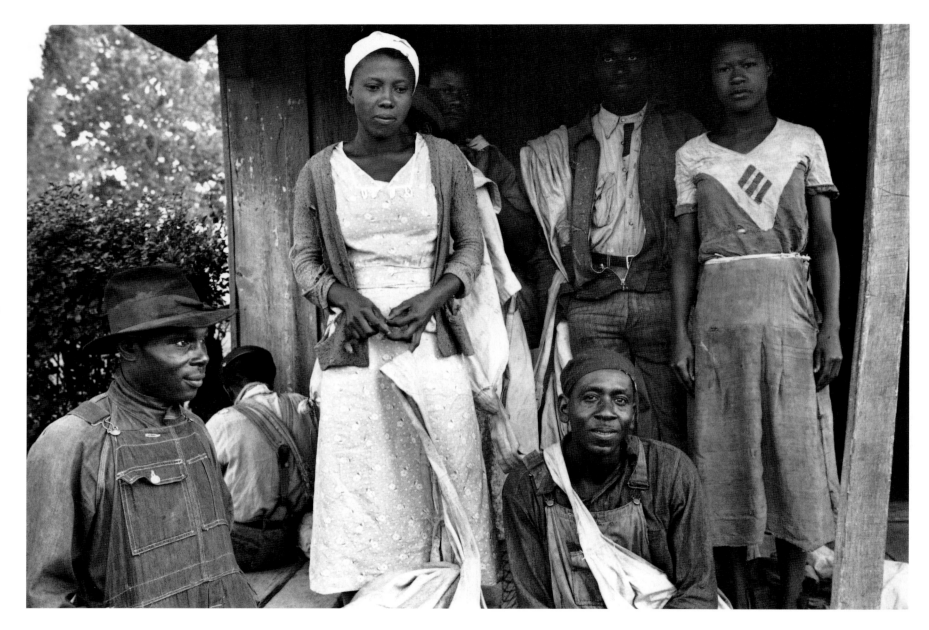

Arkansas cotton pickers

BEN SHAHN, OCTOBER 1935

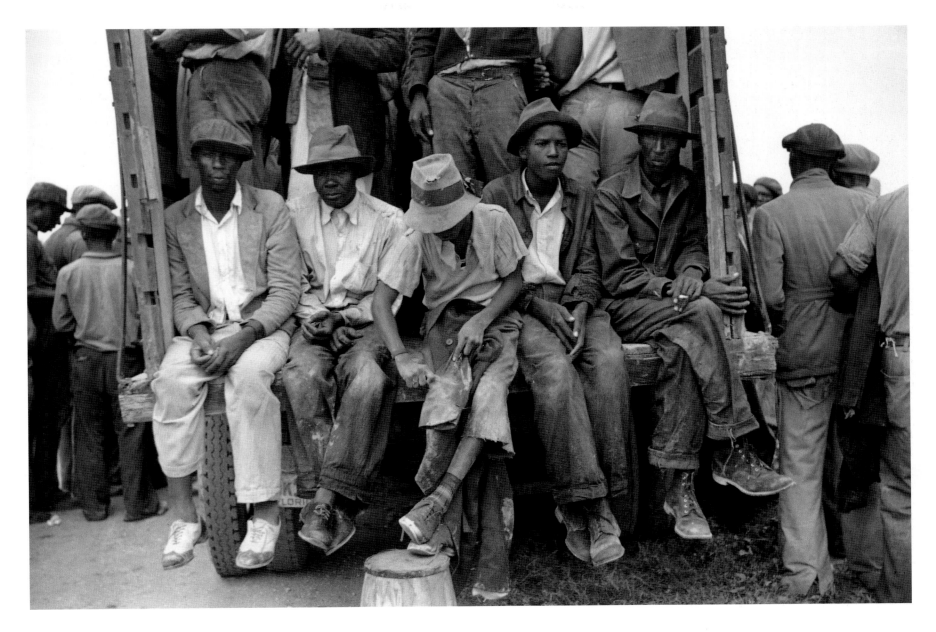

Vegetable workers, migrants, waiting after work to be paid near Homestead, Florida

Marion Post Wolcott, February? 1939

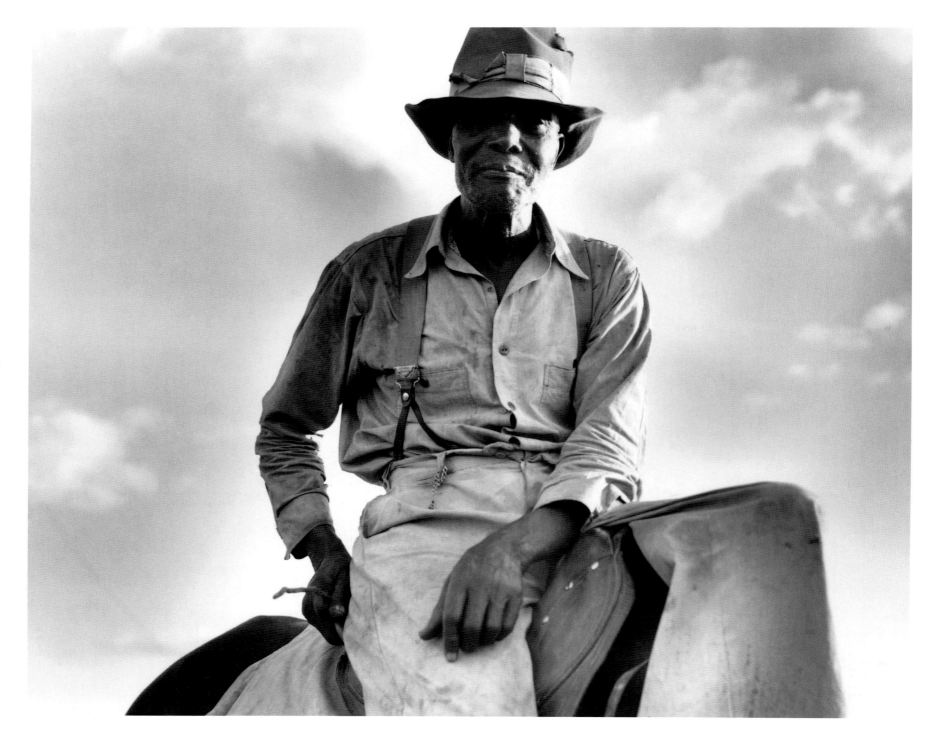

The riding boss, Aldridge Plantation, Mississippi
DOROTHEA LANGE, JUNE 1937

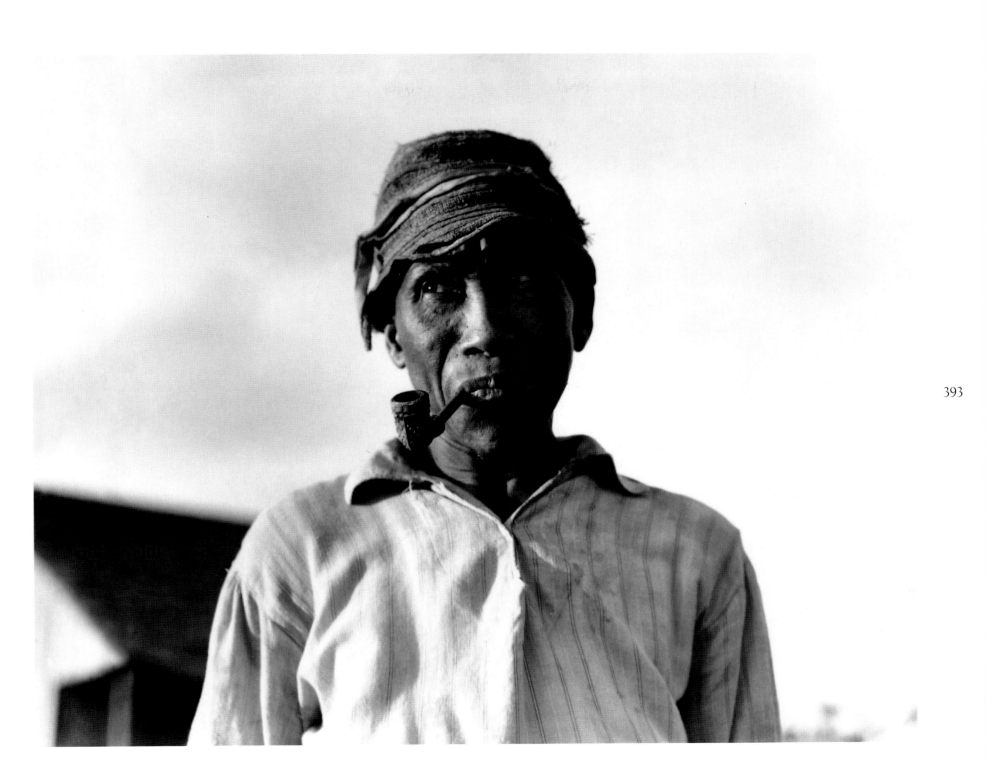

Old Negro. He hoes, picks cotton and is full of good humor. Aldridge Plantation, Mississippi
DOROTHEA LANGE, JUNE 1937

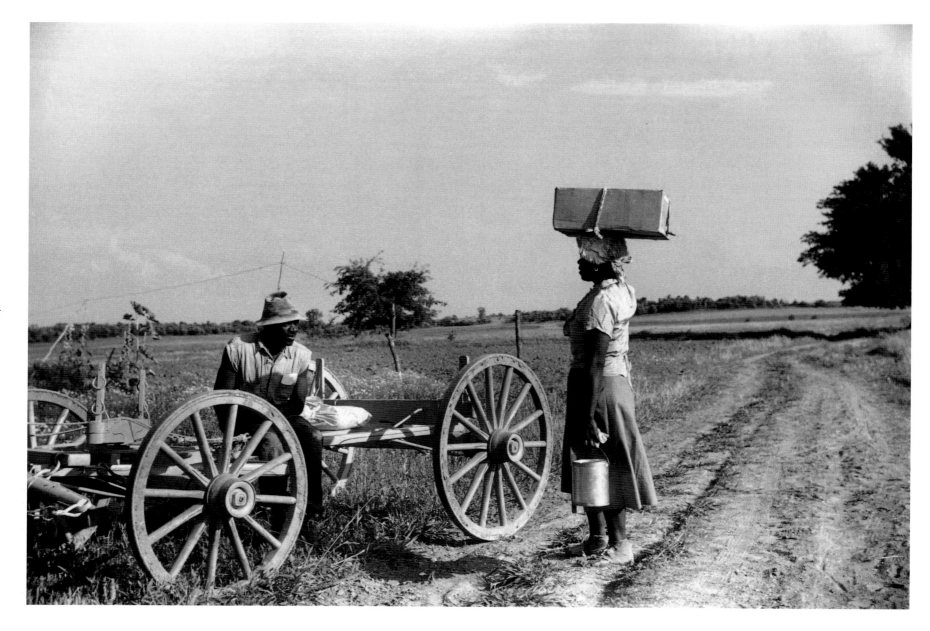

Along a road near Greensboro, Alabama

Jack Delano, May 1941

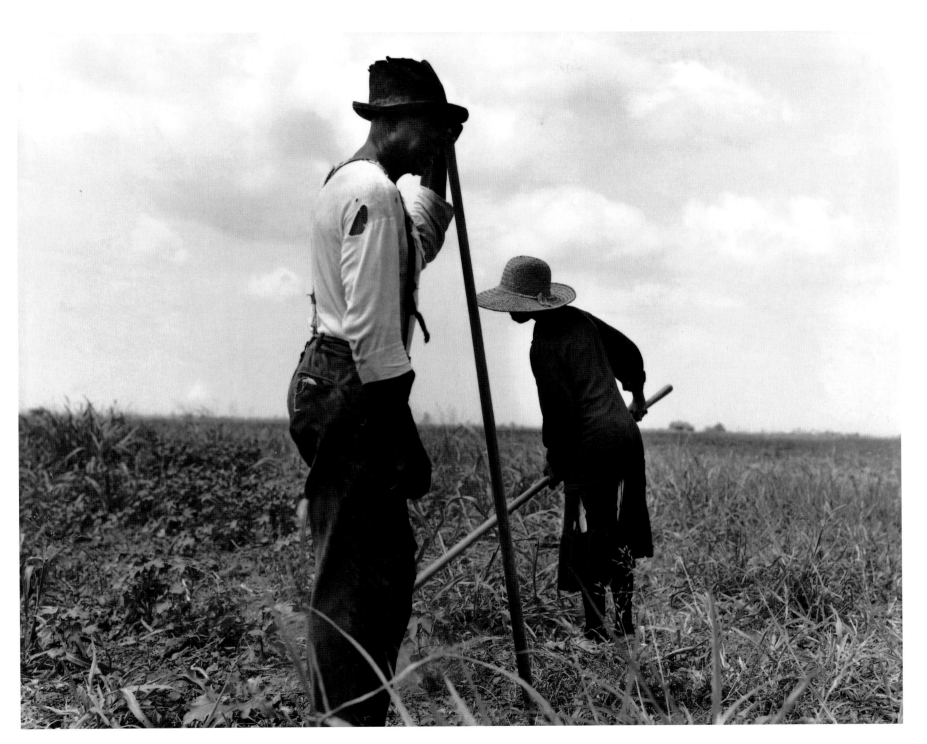

Cotton sharecroppers. Greene County, Georgia. They produce little, sell little, buy little.

DOROTHEA LANGE, JUNE 1937

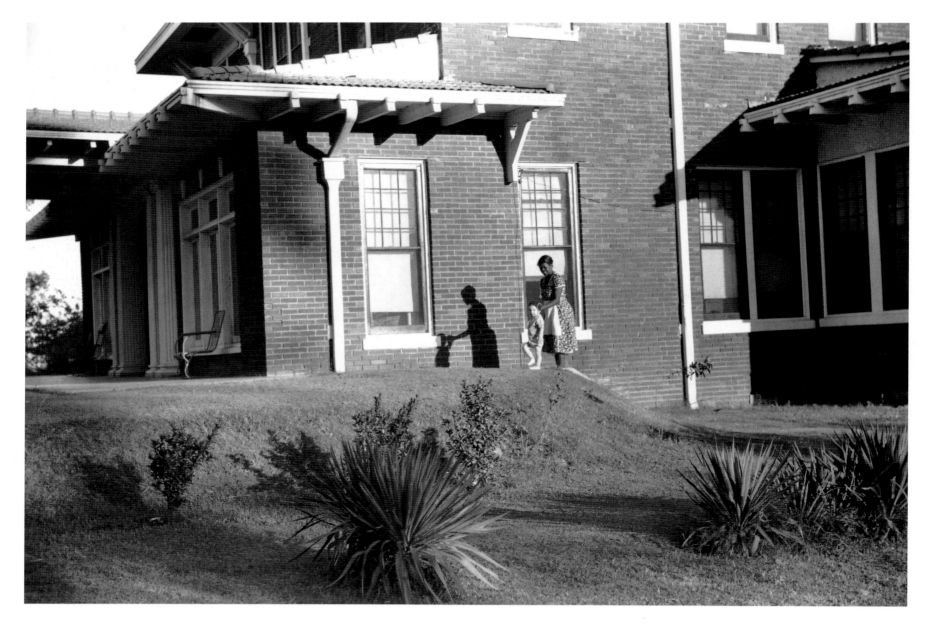

The Knowlton home, Knowlton Plantation, Perthshire, Mississippi Delta, Mississippi
MARION POST WOLCOTT, OCTOBER? 1939

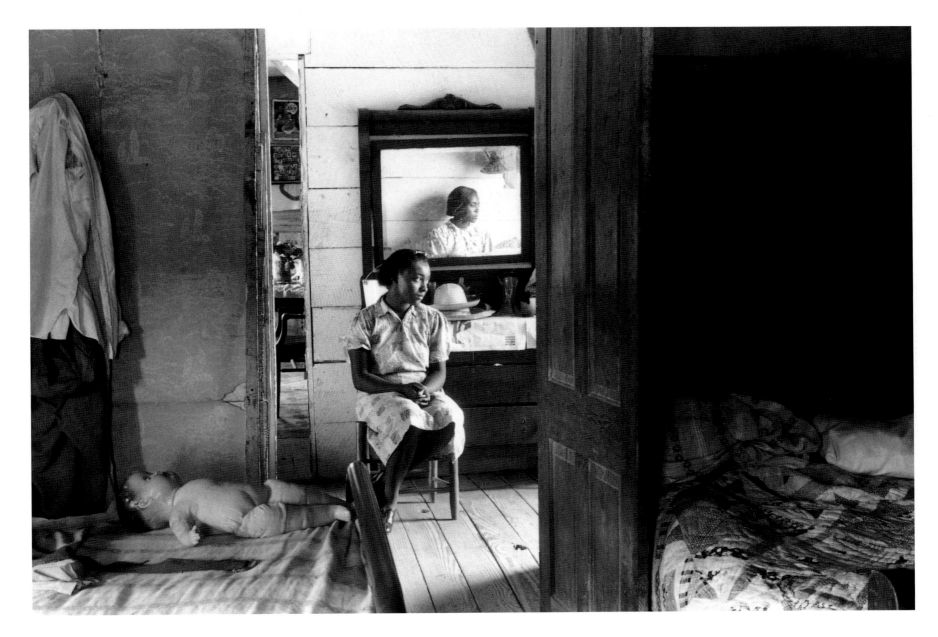

Untitled (Daughter of an FSA client, Greensboro, Greene County, Georgia)
JACK DELANO, JUNE 1941

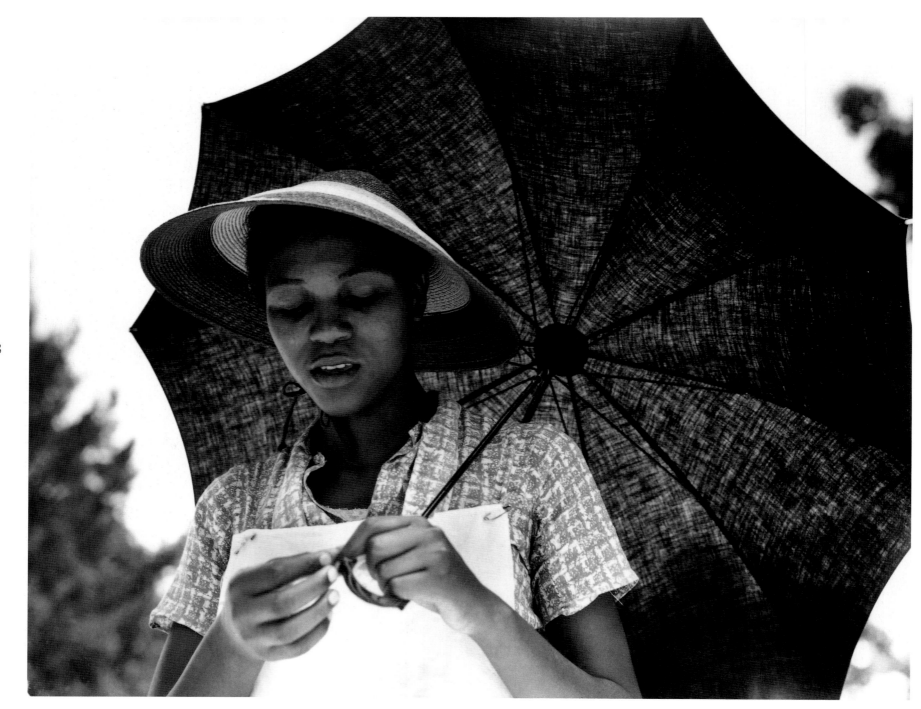

Louisiana Negress
DOROTHEA LANGE, JULY 1937

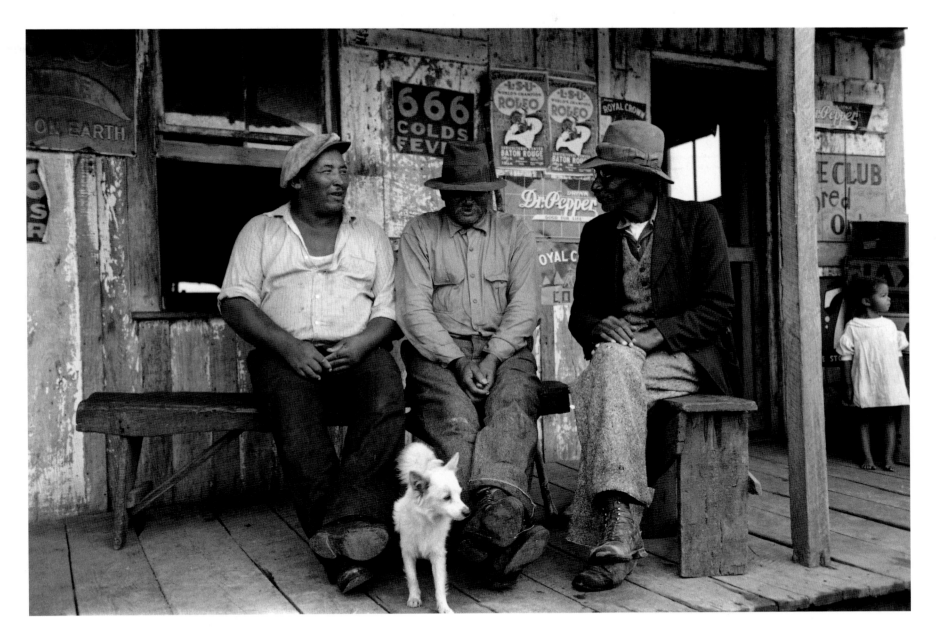

Negroes talking on porch of small store near Jeanerette, Louisiana
RUSSELL LEE, OCTOBER 1938

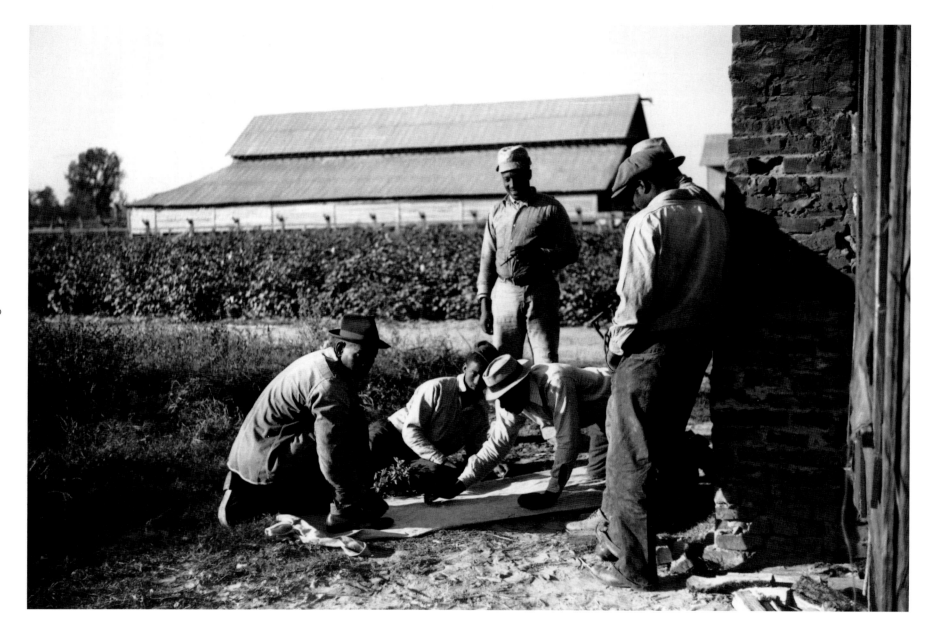

Untitled (Day laborers shooting craps after being paid, Saturday afternoon, Mileston Plantation, Mississippi Delta)
Marion Post Wolcott, October ? 1939

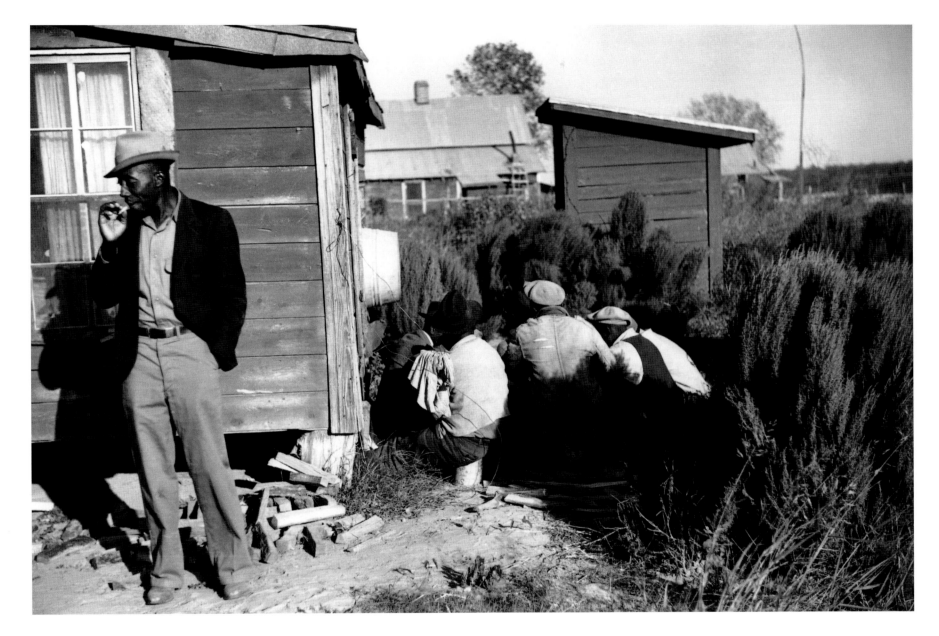

Day laborers gambling with their cotton money on Saturday afternoon, Mileston Plantation, Mississippi Delta, Mississippi

MARION POST WOLCOTT, OCTOBER? 1939

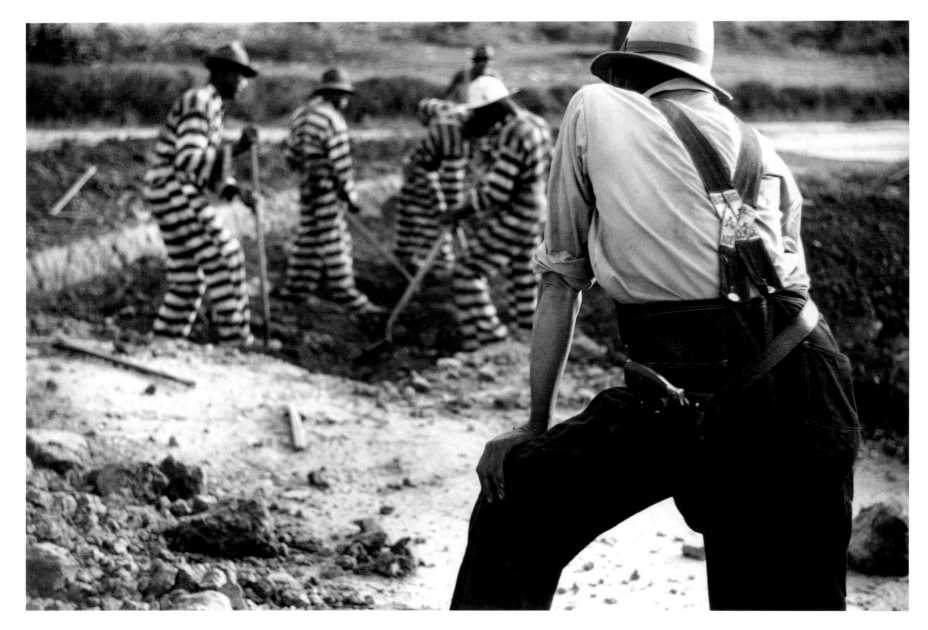

Convicts and guard, Oglethorpe County, Georgia

Jack Delano, May 1941

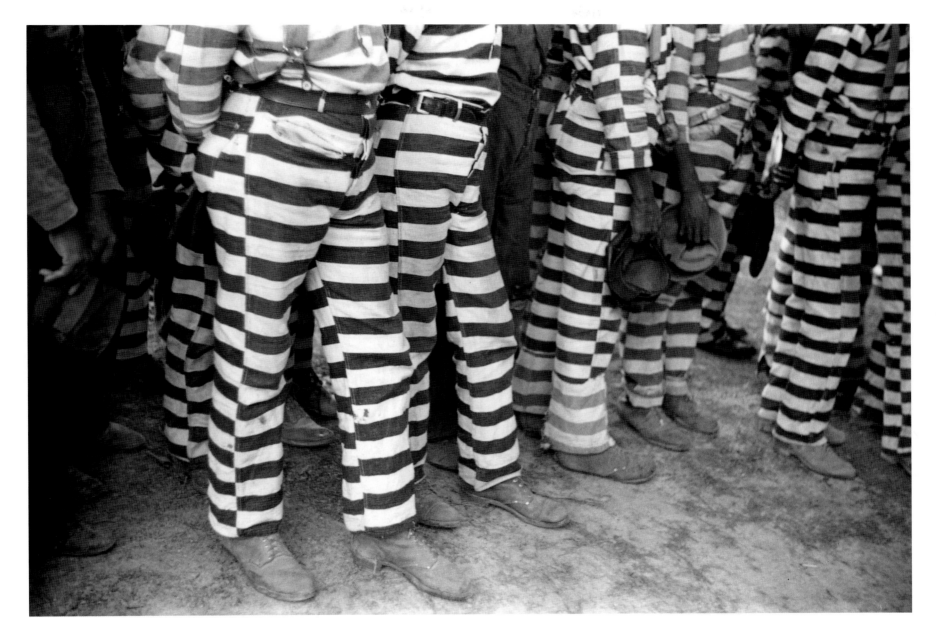

Convicts from the Greene County prison camp at the funeral of their warden who was killed in an automobile accident, Georgia

JACK DELANO, MAY 1941

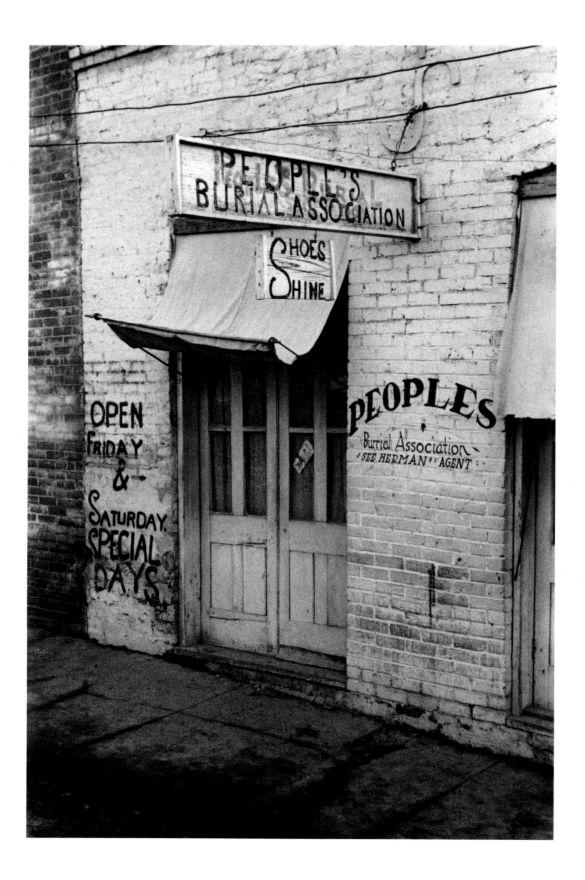

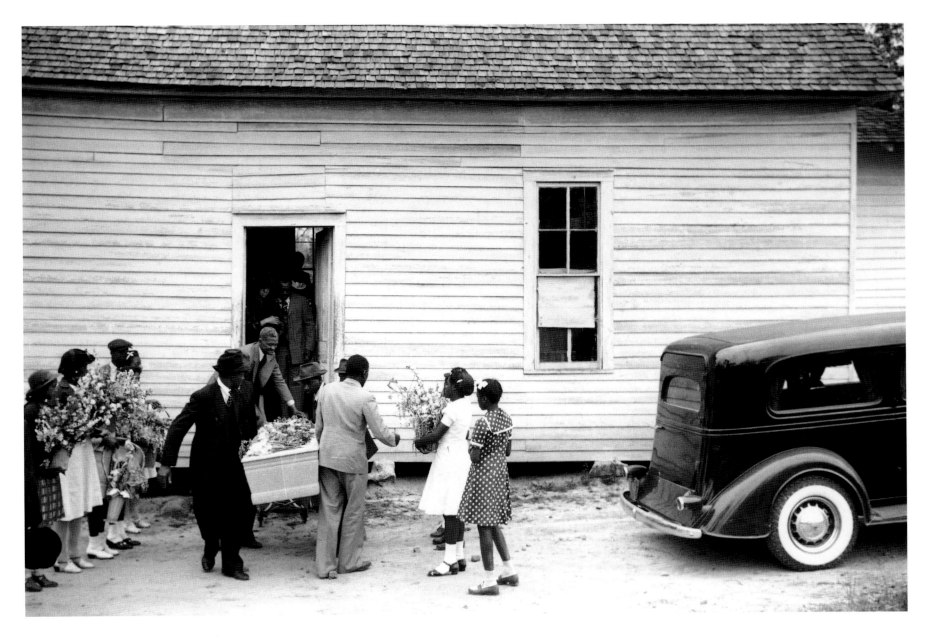

405

Above: Funeral of nineteen-year-old Negro sawmill worker in Heard County, Georgia

Jack Delano, April–May 1941

Opposite: Untitled (Mississippi)

Walker Evans, March 1936

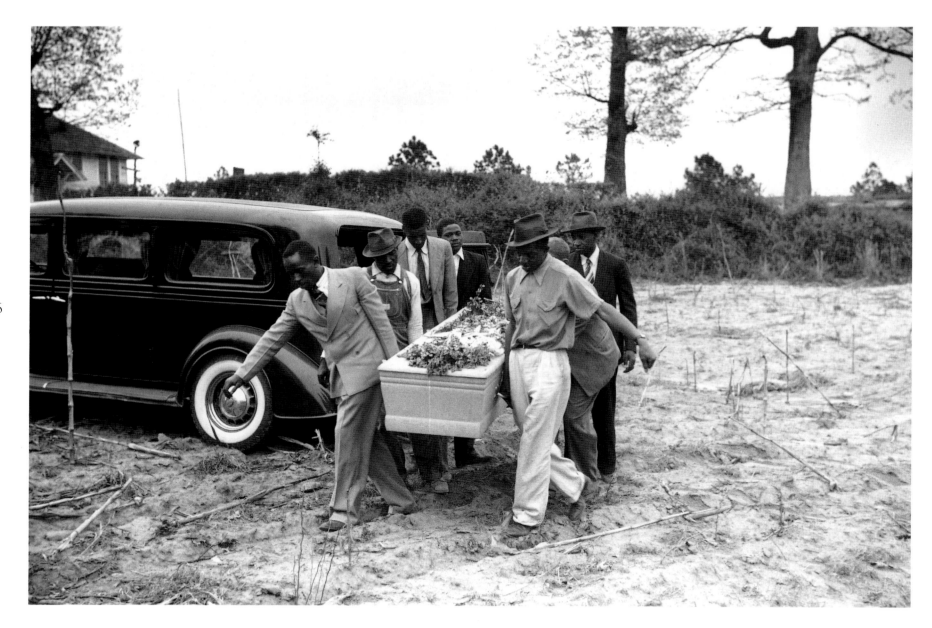

Funeral of nineteen-year-old Negro sawmill worker in Heard County, Georgia

Jack Delano, April–May 1941

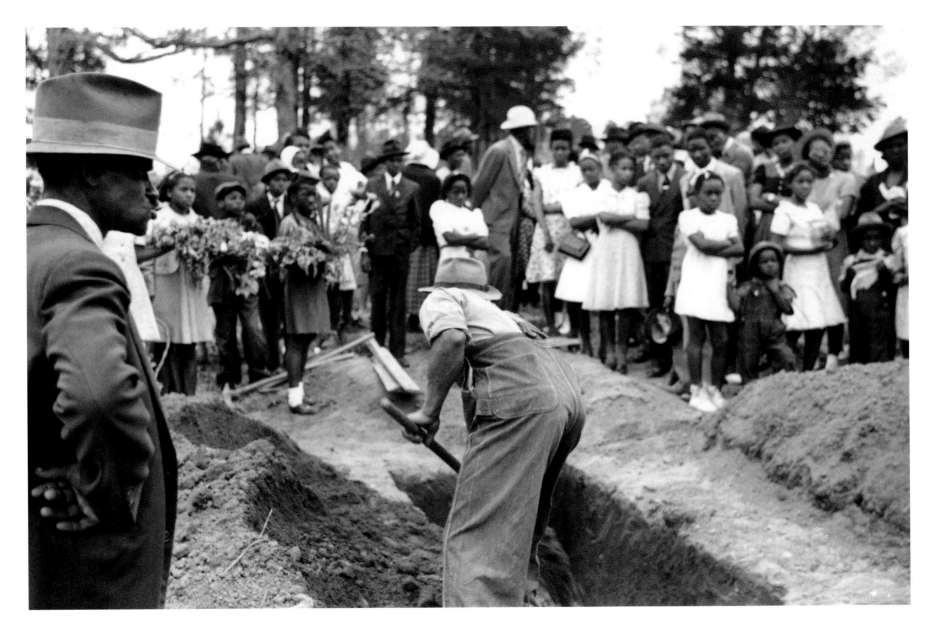

Funeral of nineteen-year-old Negro sawmill worker in Heard County, Georgia

JACK DELANO, APRIL–MAY 1941

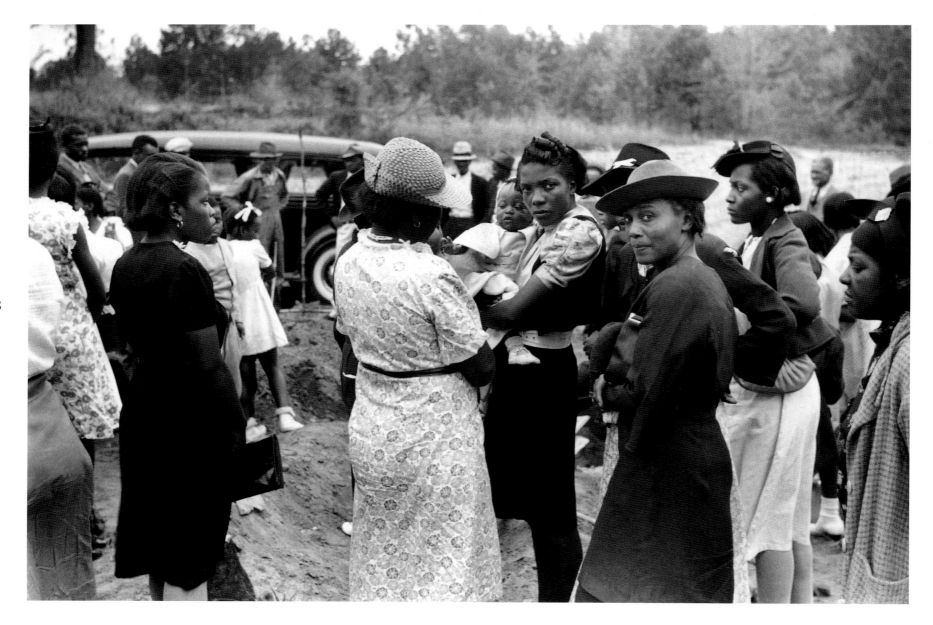

Funeral of nineteen-year-old Negro sawmill worker in Heard County, Georgia

Jack Delano, April–May 1941

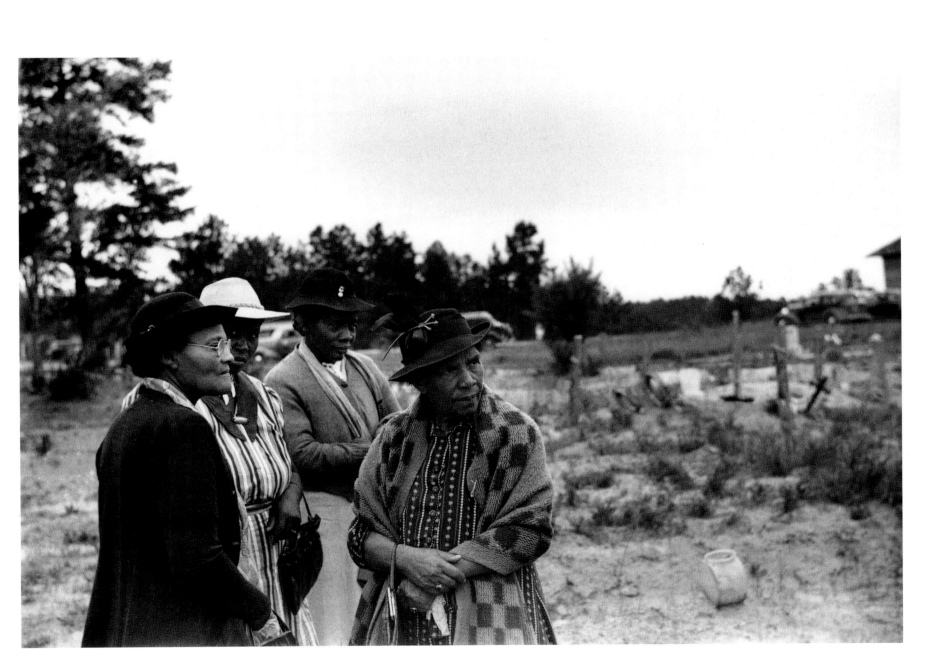

Funeral of nineteen-year-old Negro sawmill worker in Heard County, Georgia

JACK DELANO, APRIL–MAY 1941

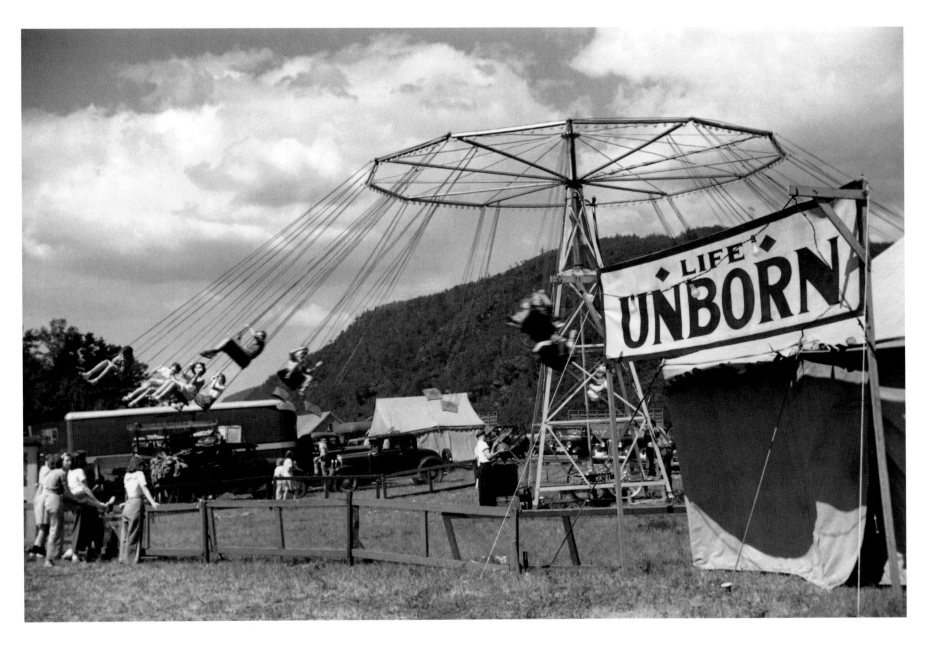

At a small American Legion carnival near Bellows Falls, Vermont

JACK DELANO, AUGUST 1941

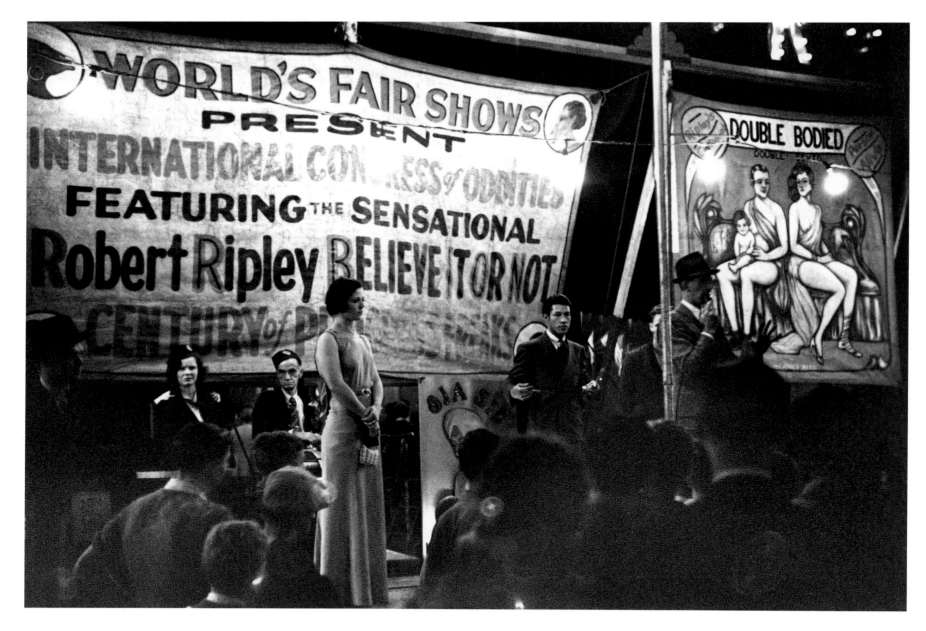

"Double bodied, both sexes." Believe it or not, outdoor carnival, Granville, West Virginia
MARION POST WOLCOTT, SEPTEMBER 1938

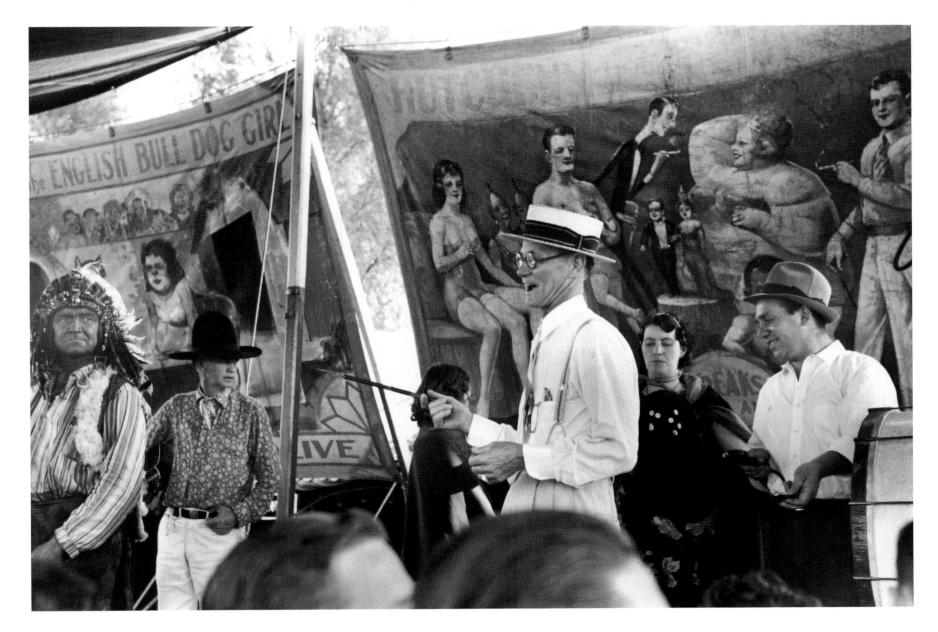

413

Barker at sideshow with performers, state fair, Donaldsonville, Louisiana

RUSSELL LEE, NOVEMBER 1938

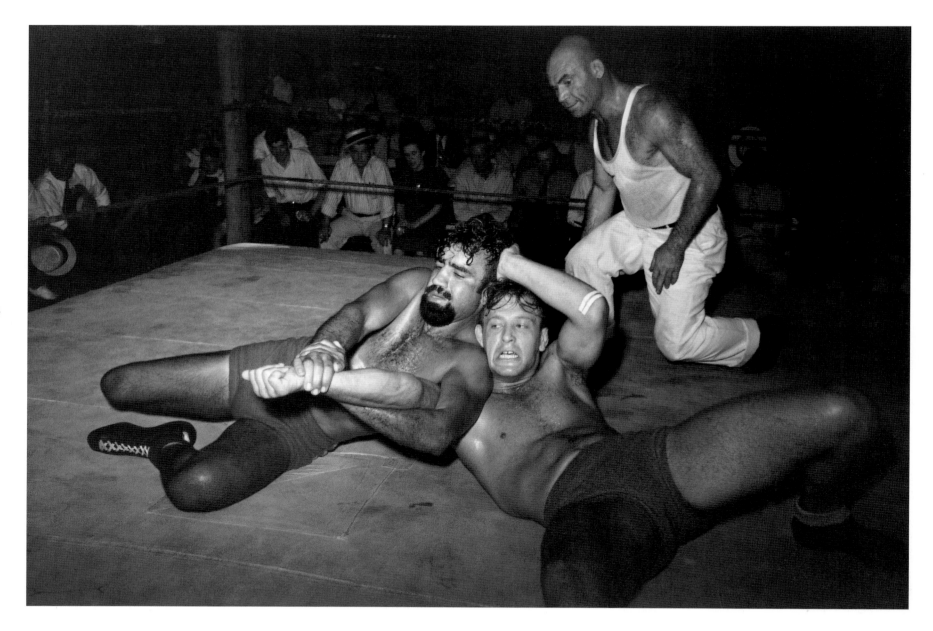

Wrestling match sponsored by American Legion, Sikeston, Missouri

Russell Lee, May 1938

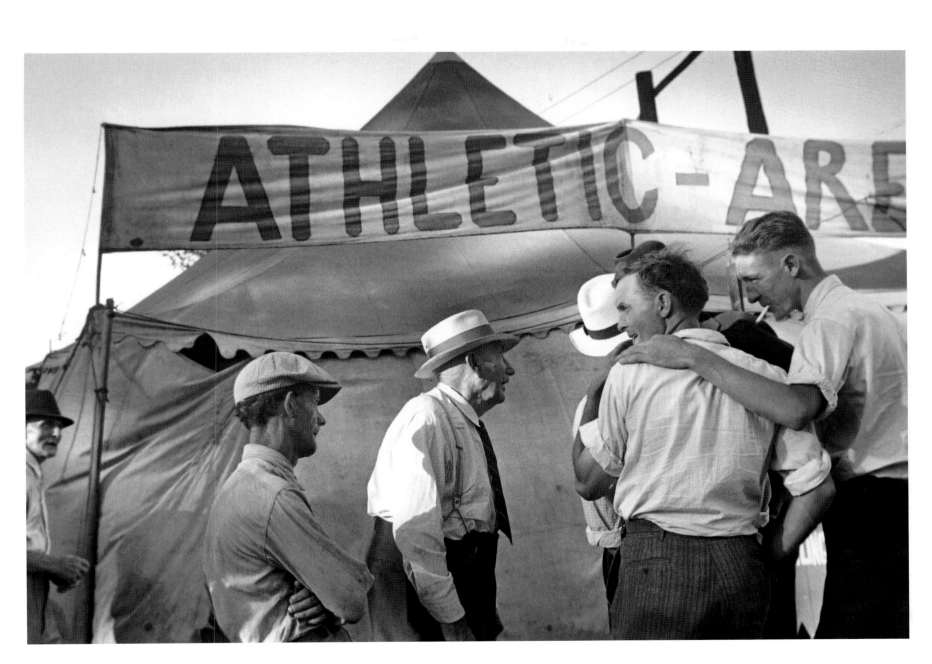

Wrestling matches, July 4th celebration, Ashville, Ohio
BEN SHAHN, SUMMER 1938

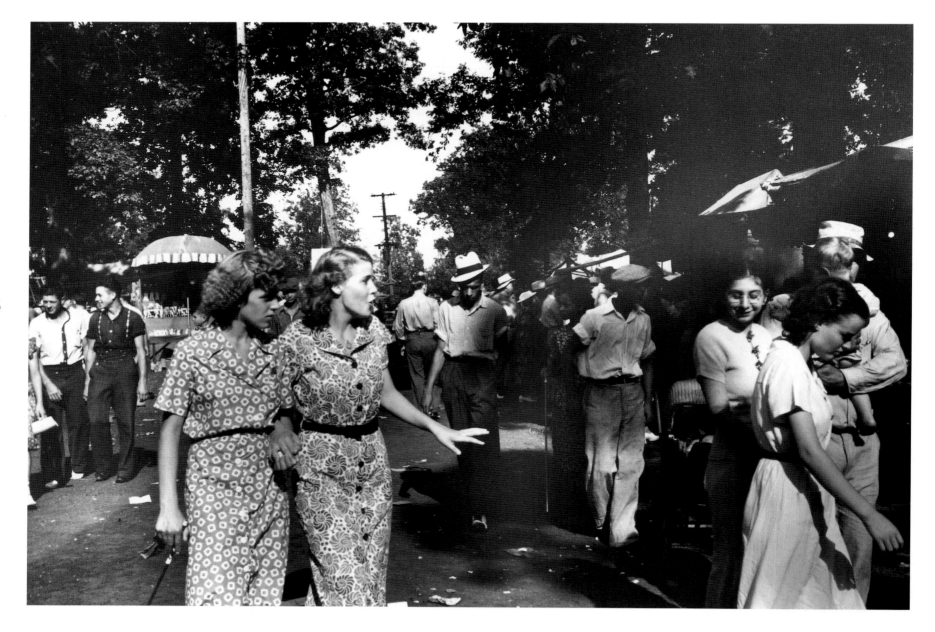

Untitled (County fair, Central Ohio)
BEN SHAHN, AUGUST 1938

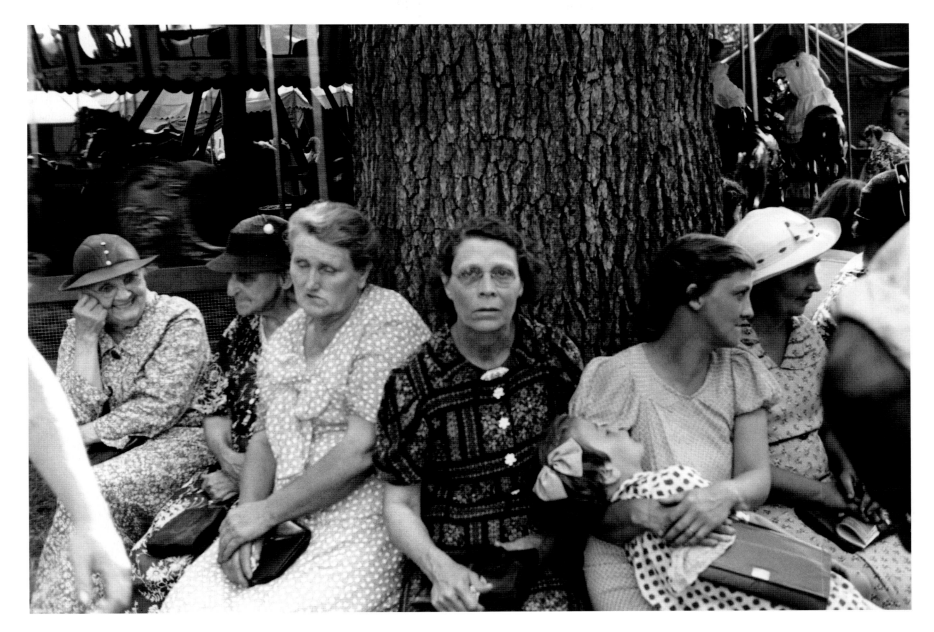

Farmpeople at county fair in central Ohio
BEN SHAHN, AUGUST 1938

418

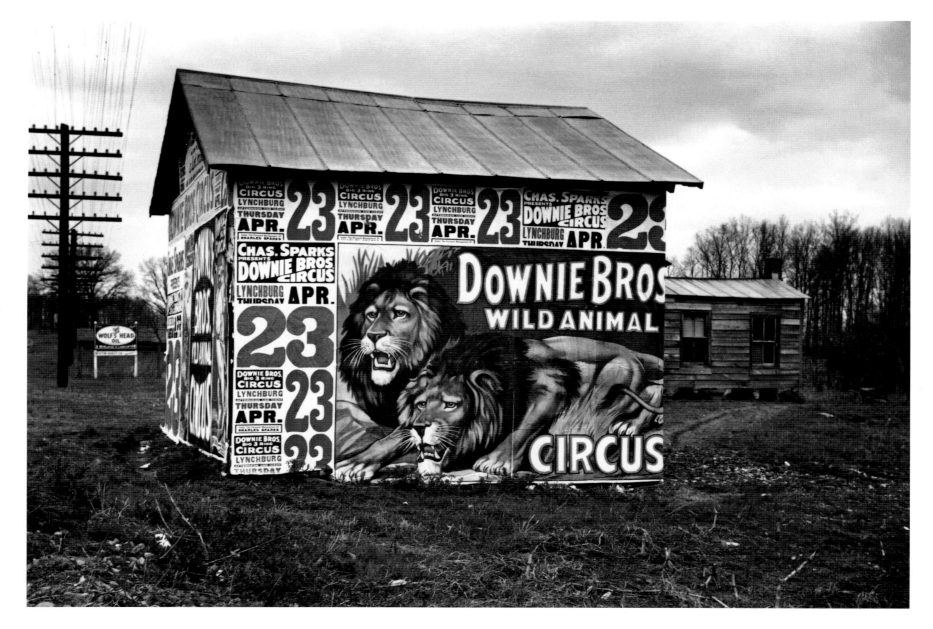

Untitled (place unknown)
WALKER EVANS, FEBRUARY 1937?

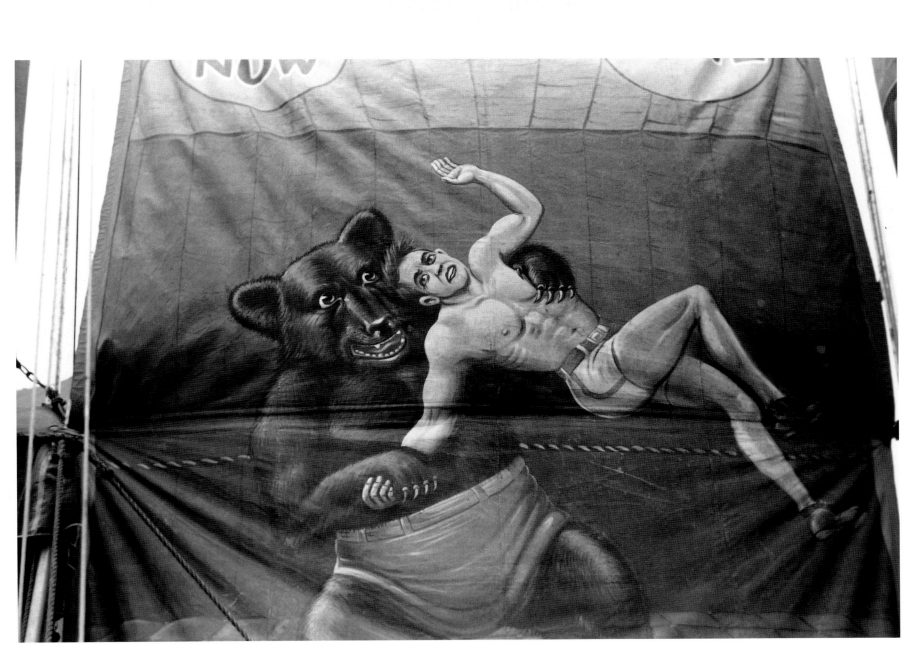

419

Poster advertising sideshow at the Rutland Fair, Rutland, Vermont

Jack Delano, September 1941

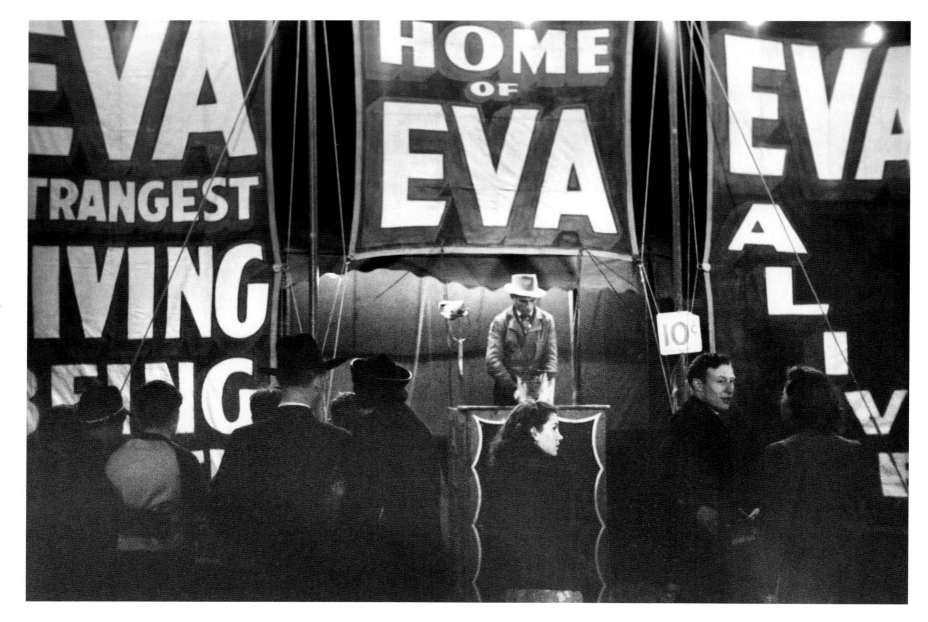

420

Untitled (Carnival sideshow, Bozeman, Montana)

Arthur Rothstein, Summer 1939

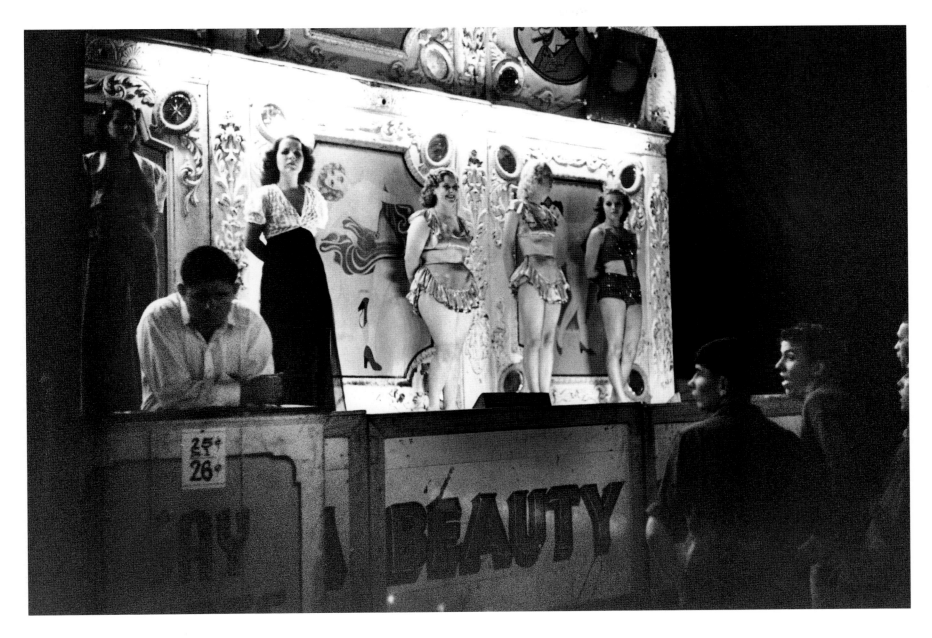

Untitled (Gramville, West Virginia)
Marion Post Wolcott, September 1938

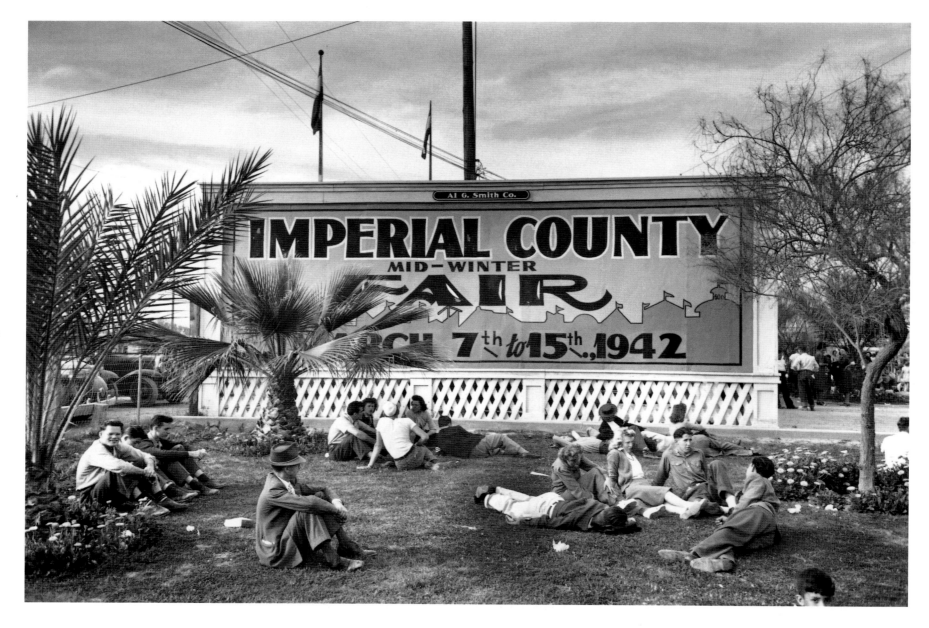

ABOVE: Resting at the Imperial County Fair, California

RUSSELL LEE, FEBRUARY–MARCH 1942

OPPOSITE: Amusement Park, Southington, Connecticut

FENNO JACOBS, MAY 1942

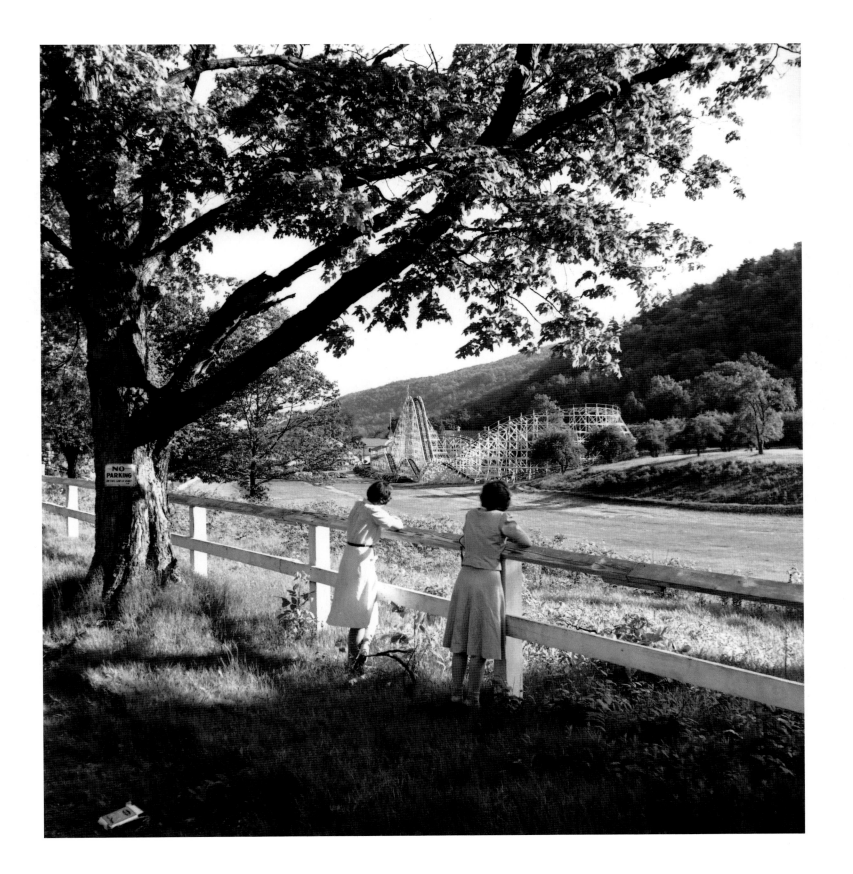

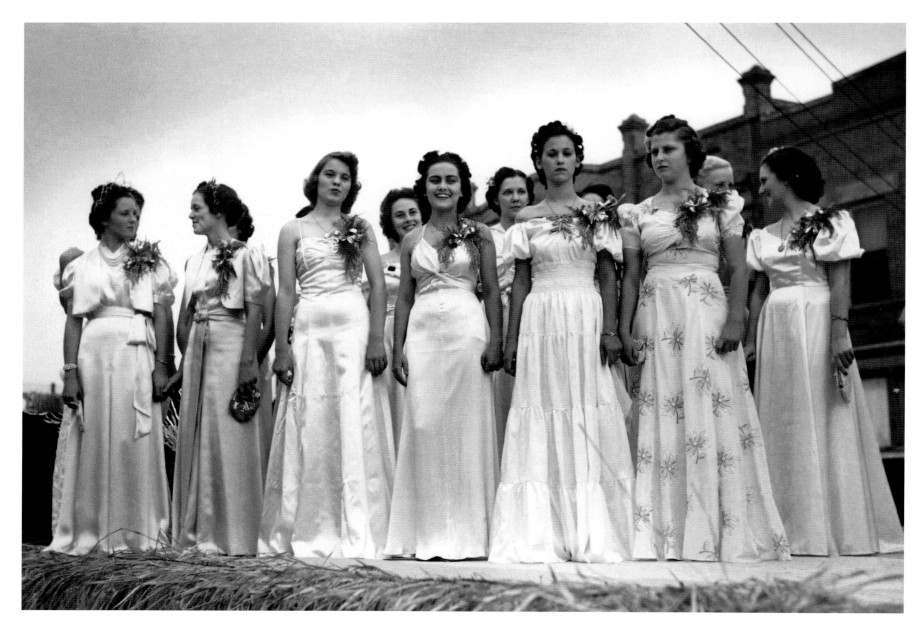

Untitled (Princesses at the National Rice Festival, Crowley, Louisiana)
RUSSELL LEE, OCTOBER 1938

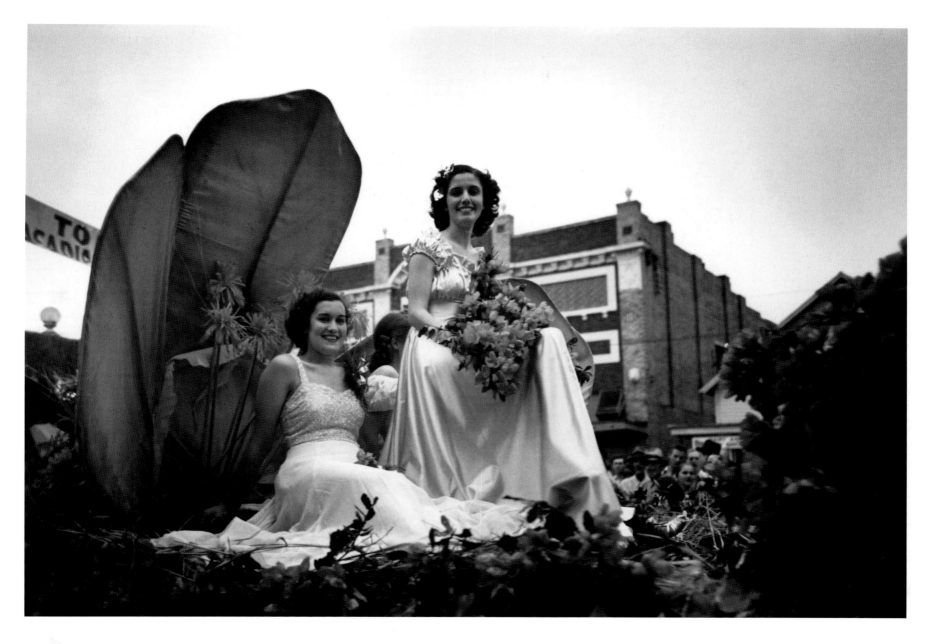

Untitled (National Rice Festival, Crowley, Louisiana)
Russell Lee, October 1938

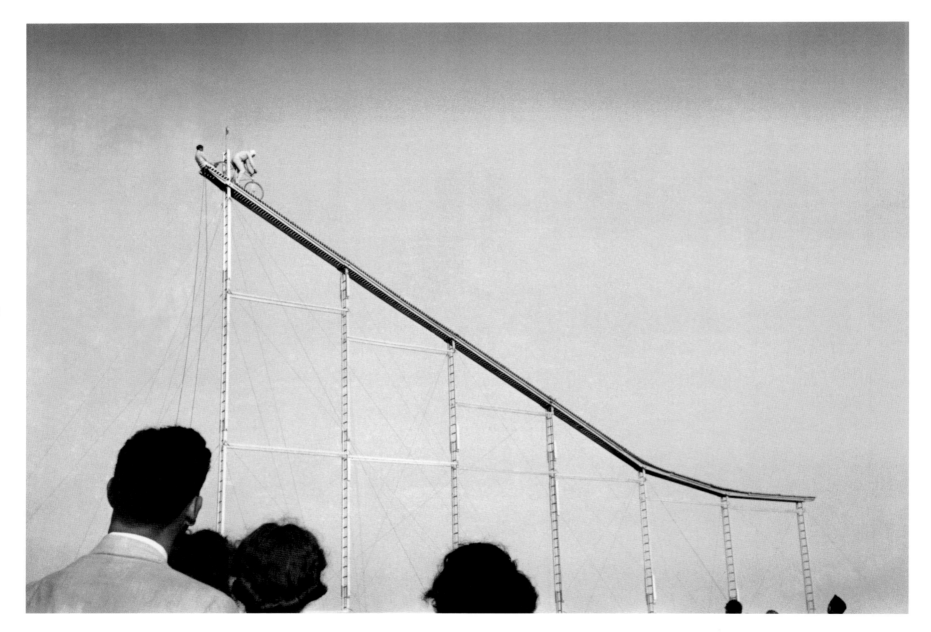

Crowd watch daredevil preparing to dive into water from cycle down elevated incline, state fair, Donaldsonville, Louisiana

Russell Lee, November 1938

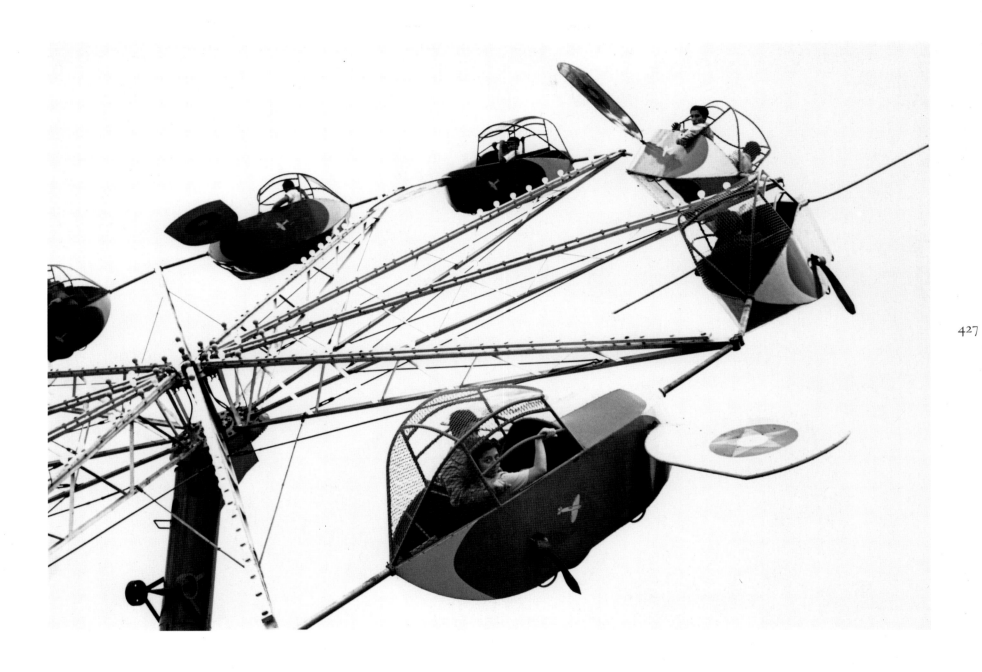

Carnival ride, Brownsville, Texas

Arthur Rothstein, February 1942

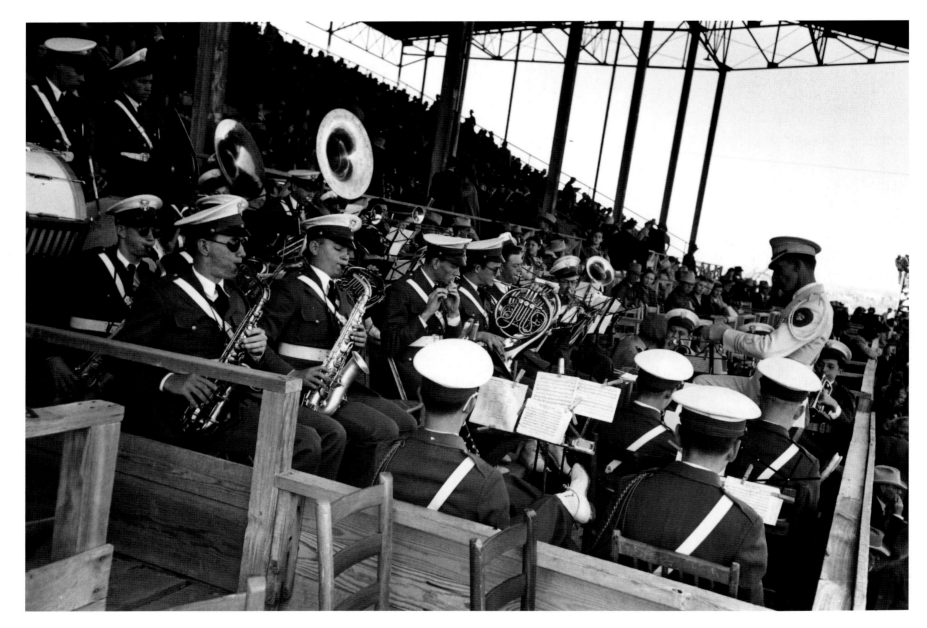

The band at the rodeo of the San Angelo Fat Stock Show, San Angelo, Texas
RUSSELL LEE, MARCH 1940

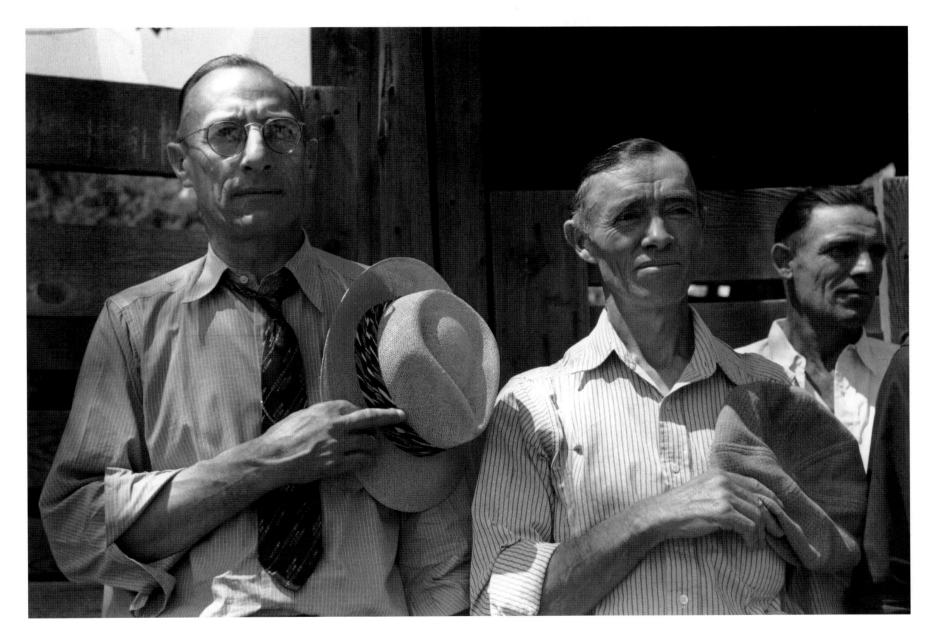

Citizens of Vale, Oregon take off their hats during the Pledge of Allegiance (radio program) on the Fourth of July
RUSSELL LEE, JULY 1941

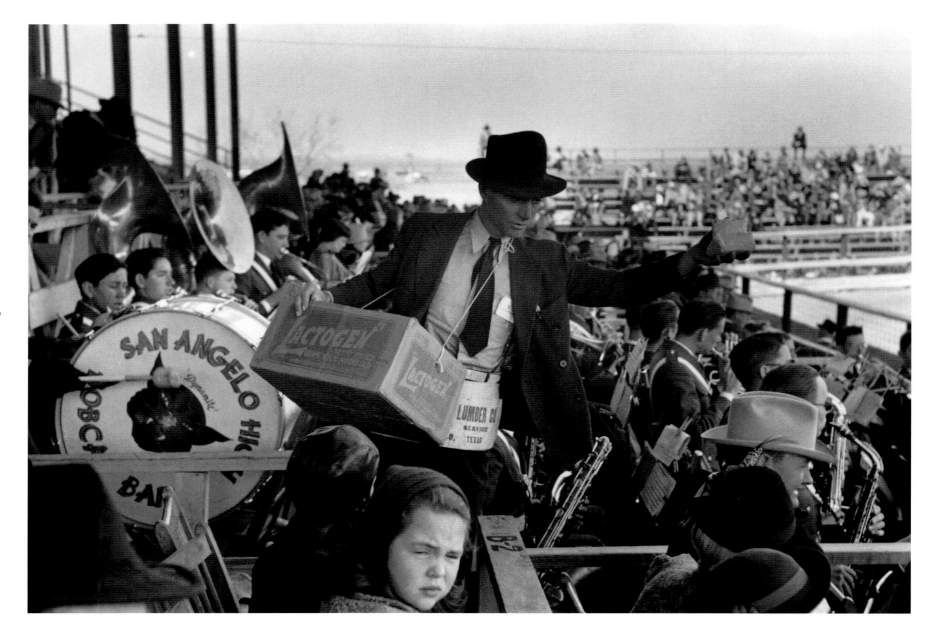

Peanut salesman in the grandstand during the rodeo at the San Angelo Fat Stock Show, San Angelo, Texas
RUSSELL LEE, MARCH 1940

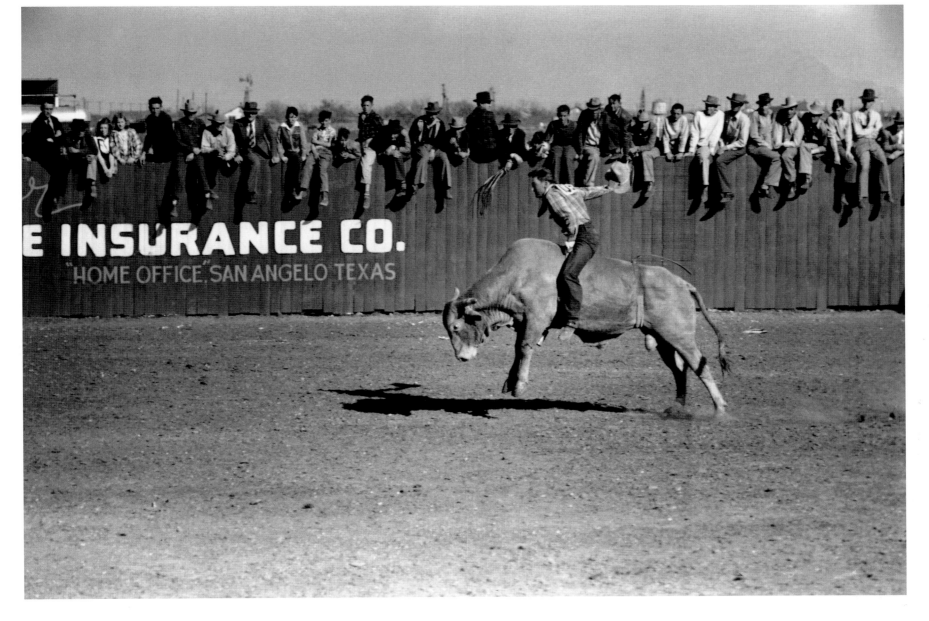

Rodeo performer riding Brahma bull at the rodeo of the San Angelo Fat Stock Show, San Angelo, Texas

RUSSELL LEE, MARCH 1940

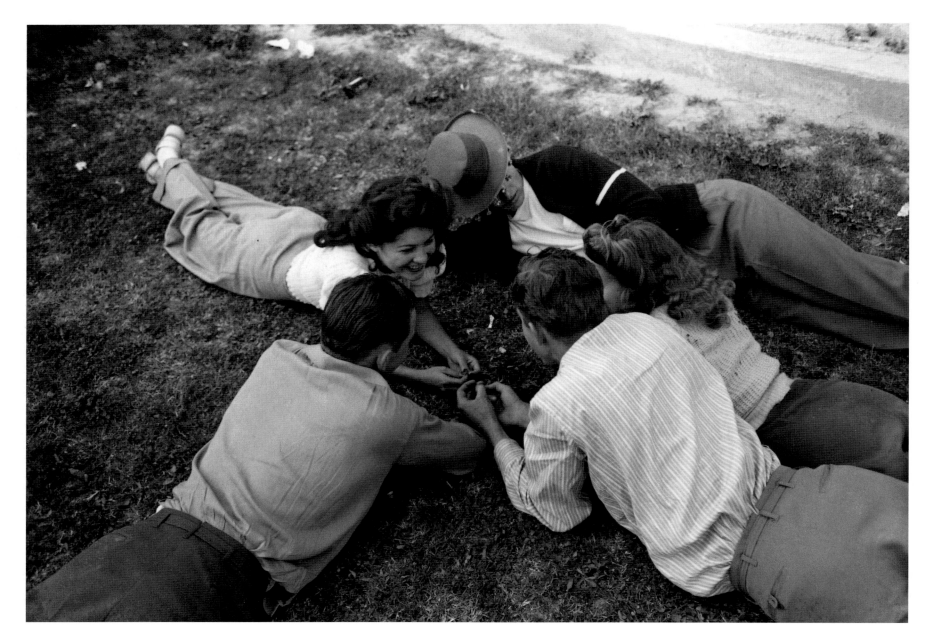

El Centro (vicinity), California. Young people at the Imperial County Fair

RUSSELL LEE, FEBRUARY–MARCH 1942

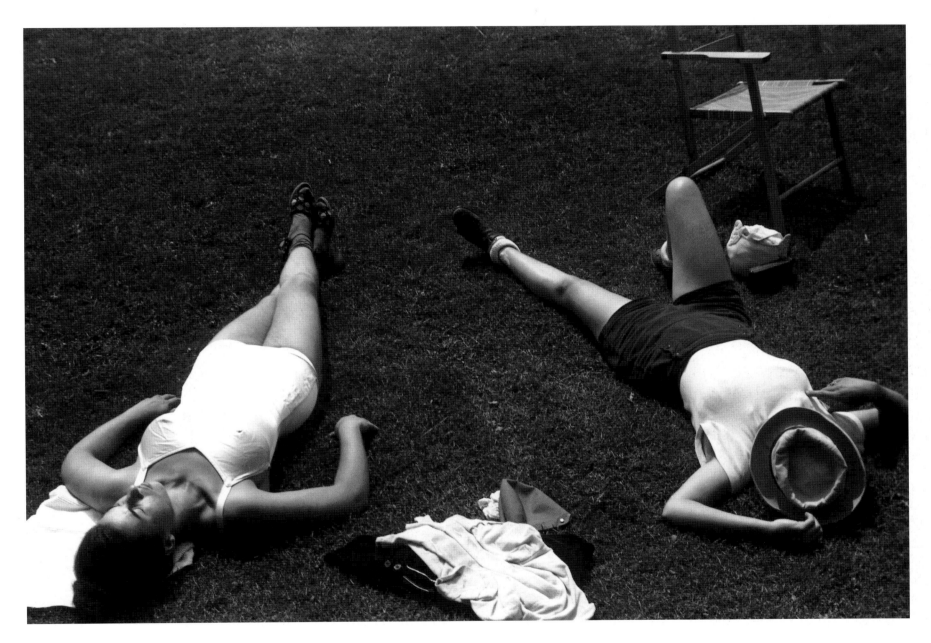

Untitled (Vergennes, Vermont)
Edwin Rosskam, August 1940

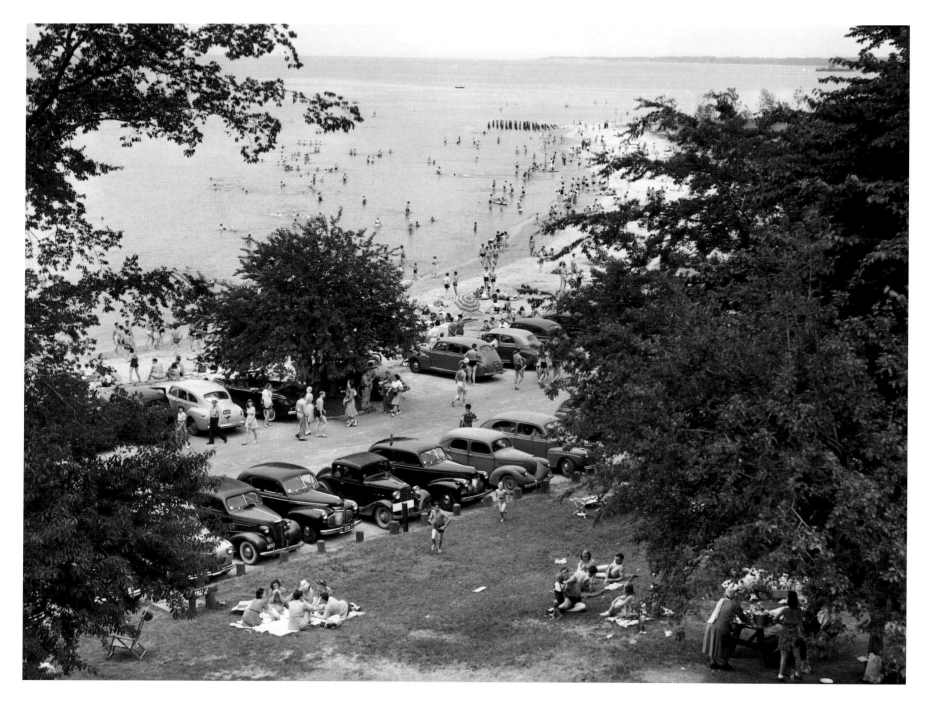

The beach at Yorktown, Virginia

JACK DELANO, JUNE 1941

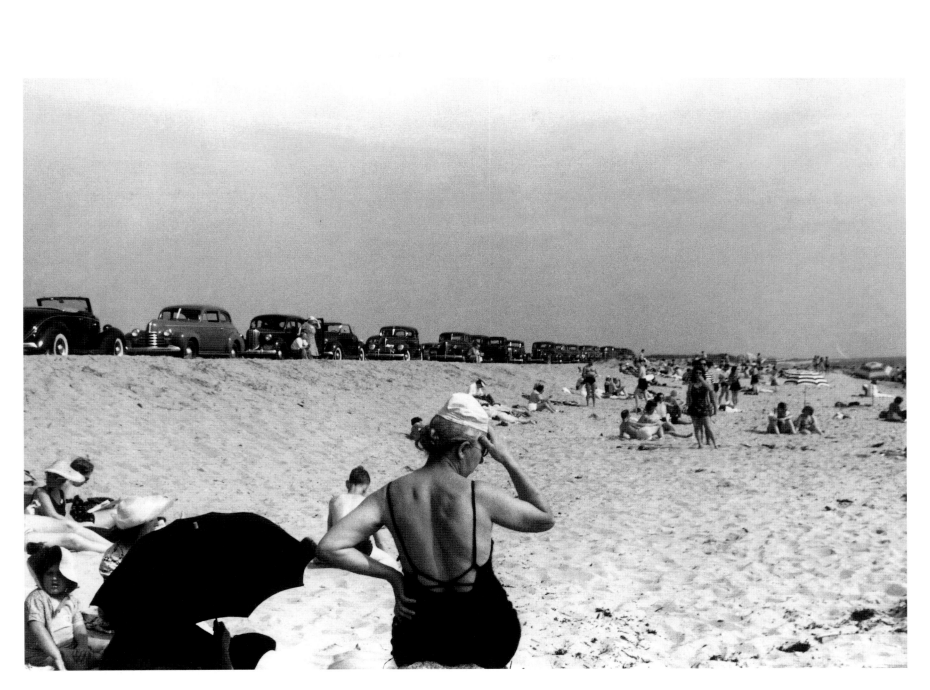

Untitled ("New Beach," Provincetown, Massachusetts)
EDWIN ROSSKAM, AUGUST 1940

436

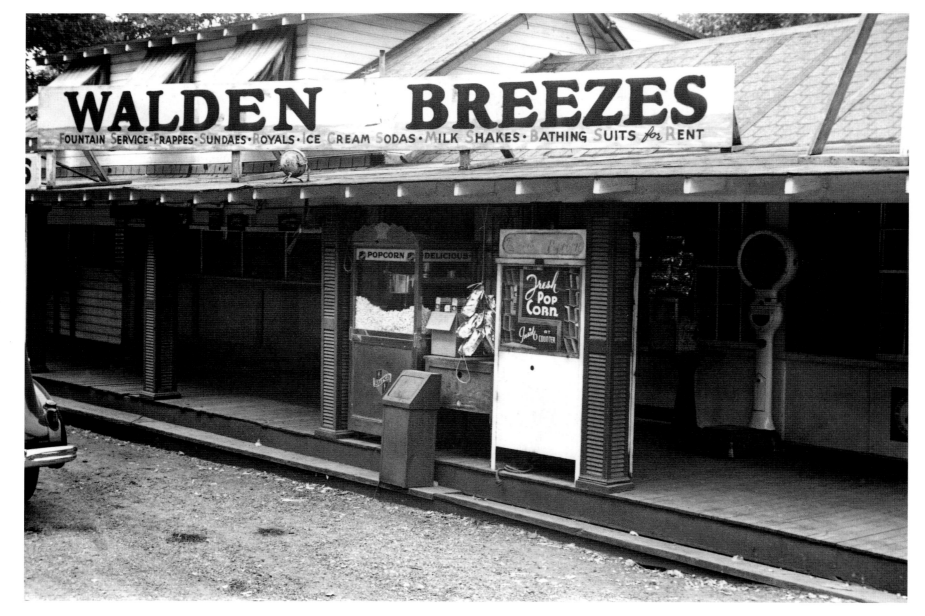

At Walden Pond, home of Thoreau, Concord, Massachusetts

Edwin Locke, September 1937

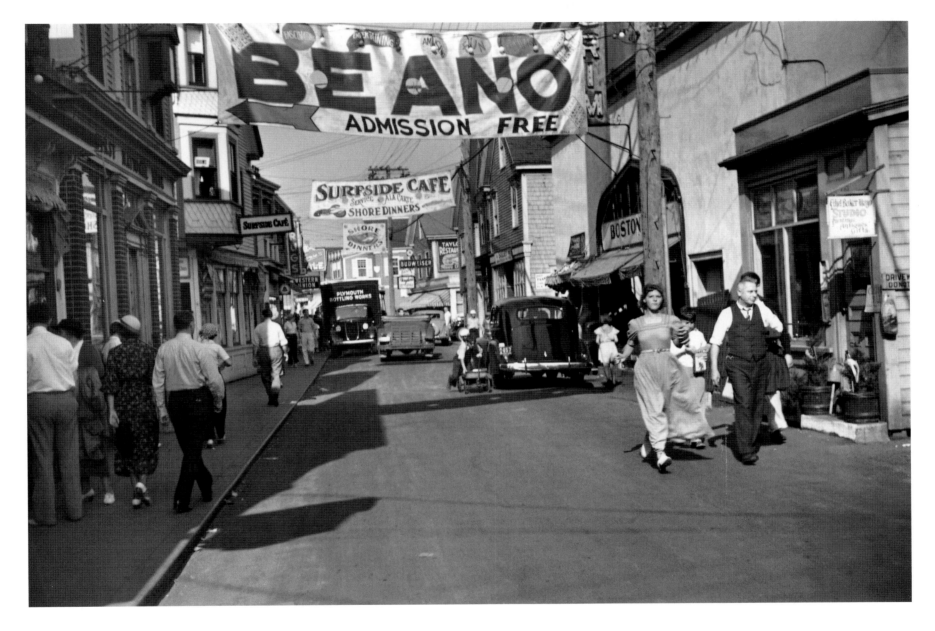

Street scene, Provincetown, Massachusetts

Edwin Rosskam, Summer 1937

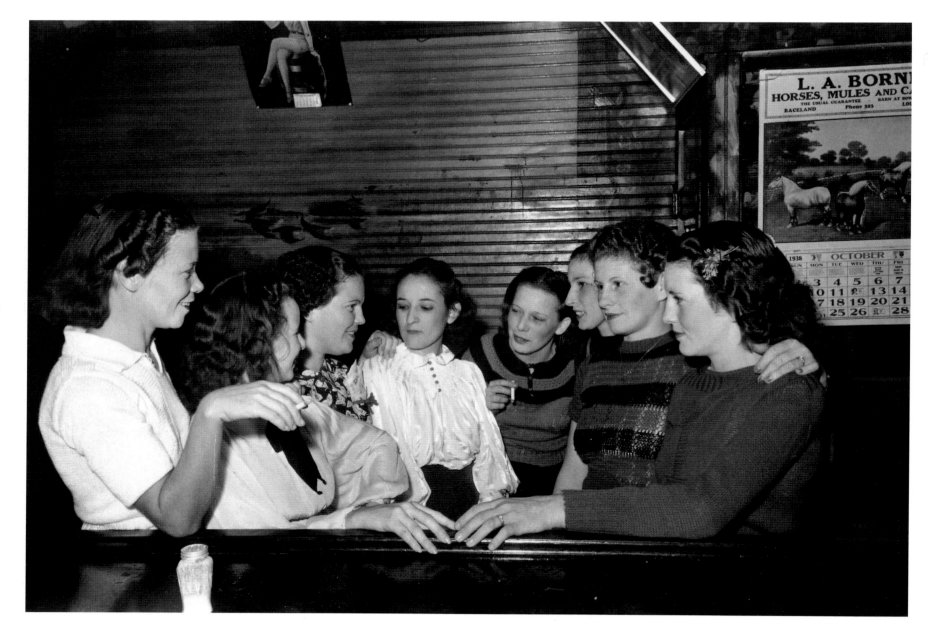

Girls from the Cajun country at Raceland, Louisiana

RUSSELL LEE, SEPTEMBER 1938

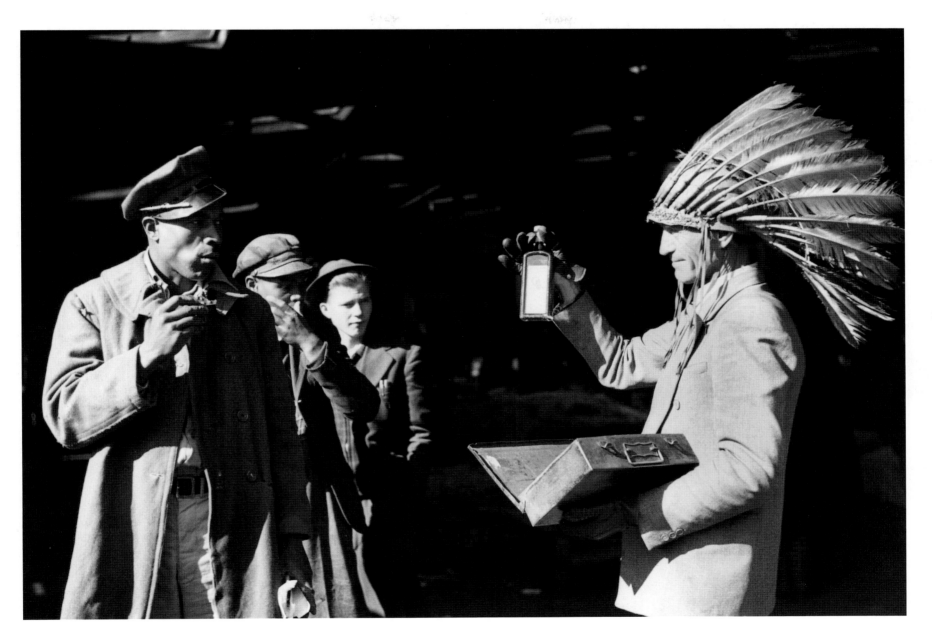

Patent medicine salesman waiting for farmers, outside tobacco warehouse where auction sales are being held, Durham, North Carolina

Marion Post Wolcott, November? 1939

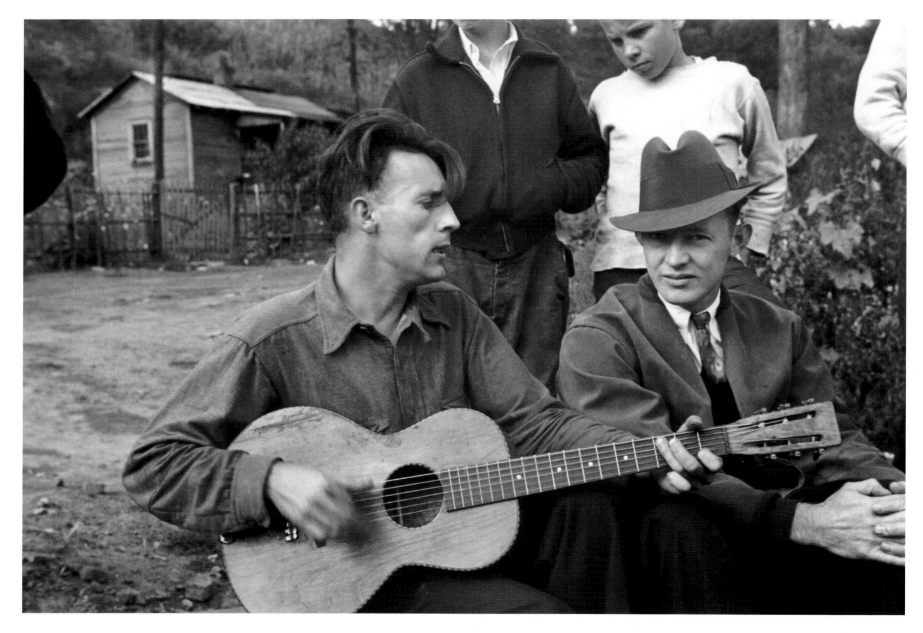

440

Above: Doped singer, "Love oh, love, oh keerless love," Scotts Run, West Virginia. Relief investigator reported a number of dope cases at Scotts Run
Ben Shahn, October 1935

Opposite: Itinerant musicians in a bar, Rio Piedras, Puerto Rico
Edwin Rosskam, December 1937

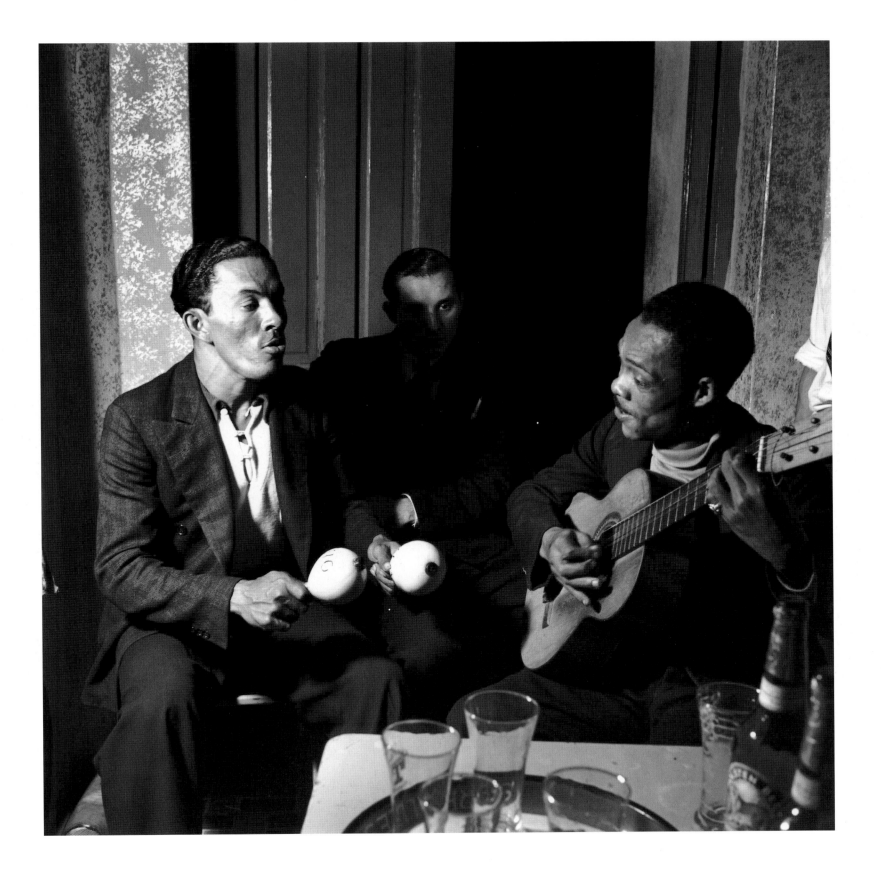

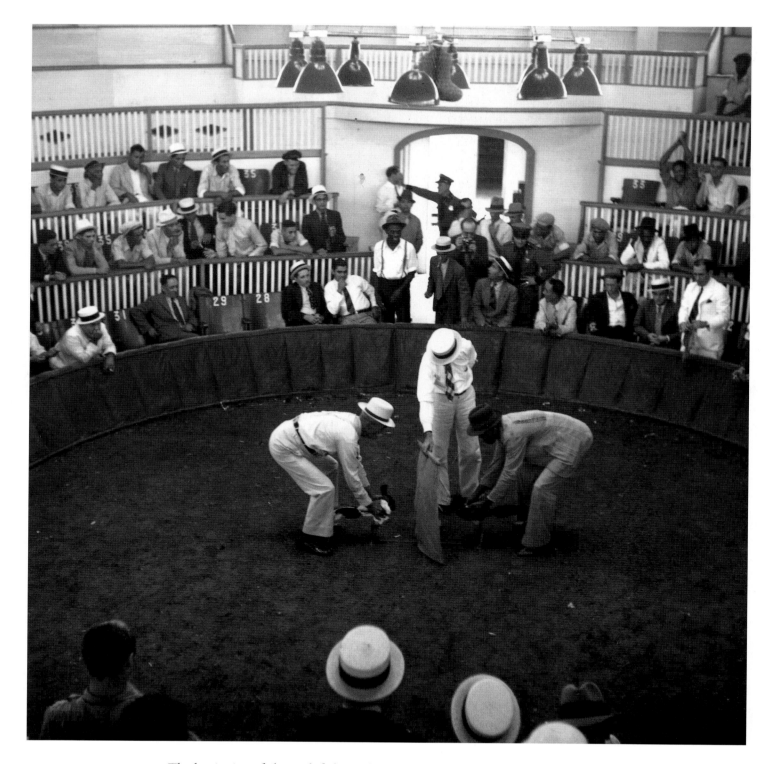

The beginning of the cock fight. When the man in the center raises the cloth,
the birds will see each other and begin to fight. Puerto Rico

EDWIN ROSSKAM, DECEMBER 1937

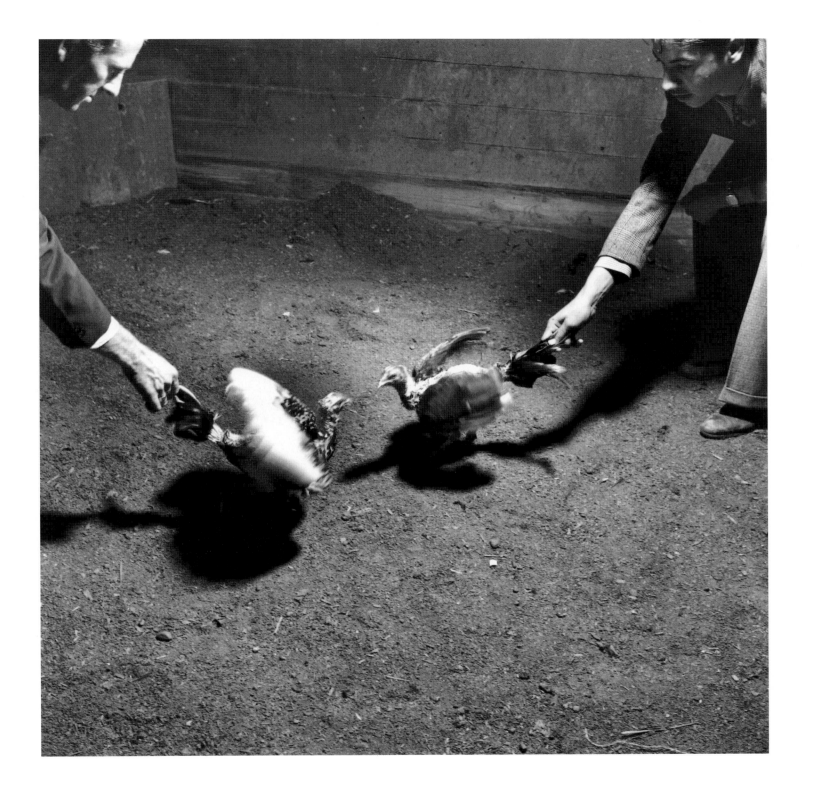

Cock fighting, Puerto Rico

Edwin Rosskam, December 1937

444

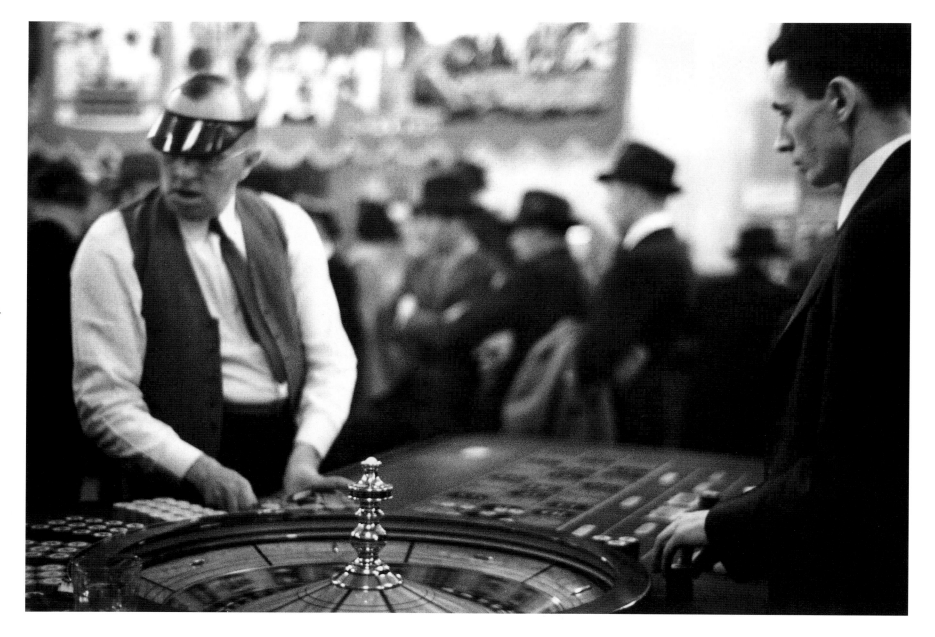

Untitled (Reno, Nevada)

ARTHUR ROTHSTEIN, DATE UNKNOWN

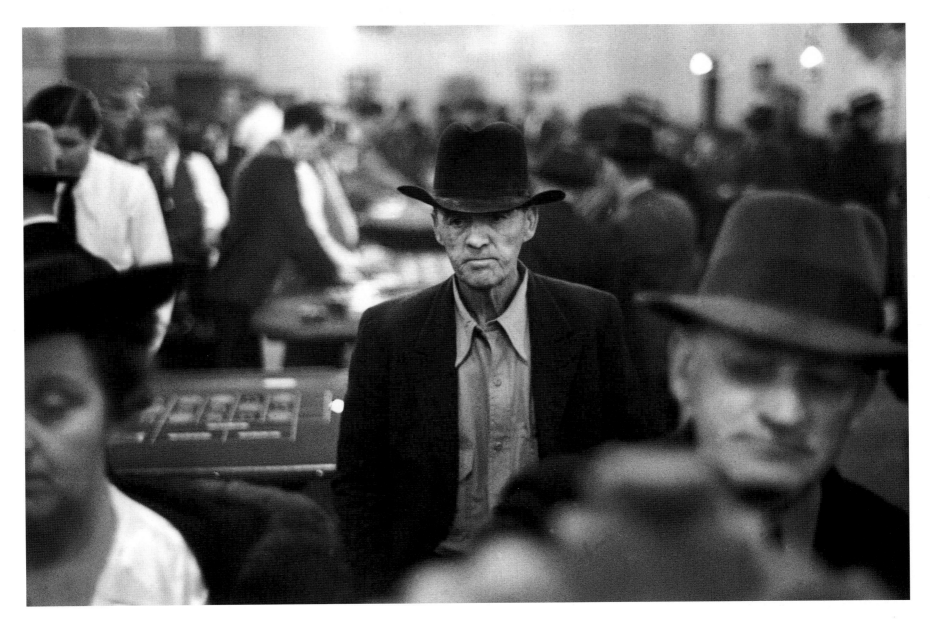

Untitled (Reno, Nevada)

ARTHUR ROTHSTEIN, DATE UNKNOWN

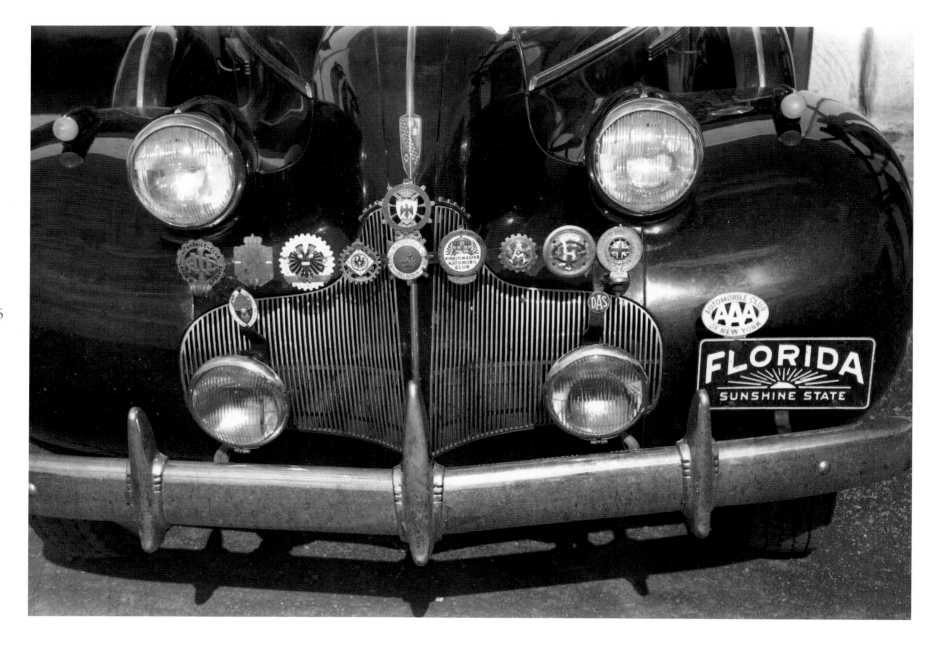

Untitled (Tourist's car, Silver City, New Mexico)
RUSSELL LEE, MAY–JUNE 1940

Polo mallets in front of automobile, Abilene, Texas
Russell Lee, May 1939

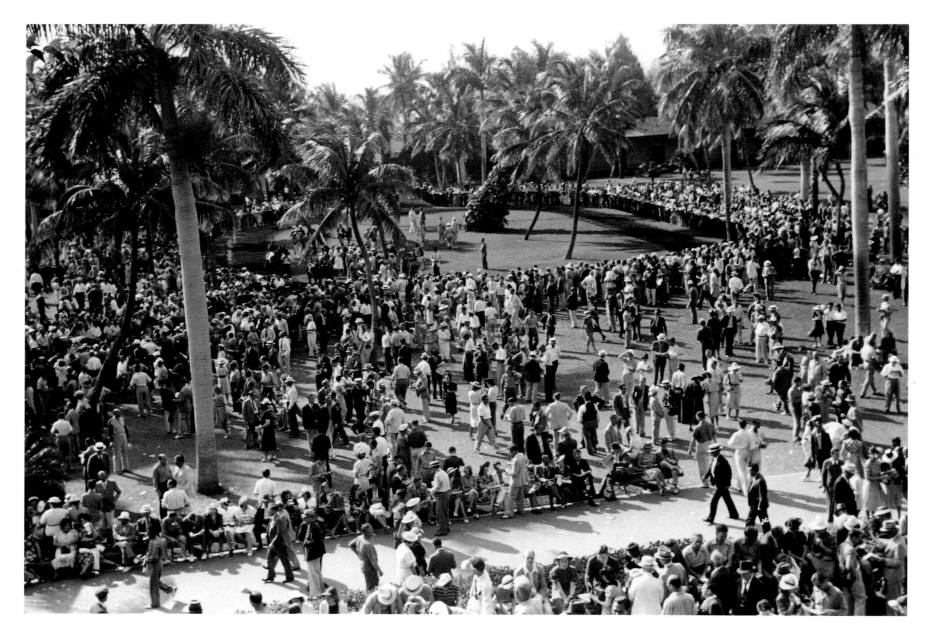

Horse races, Hialeah Park, Miami, Florida

MARION POST WOLCOTT, FEBRUARY? 1939

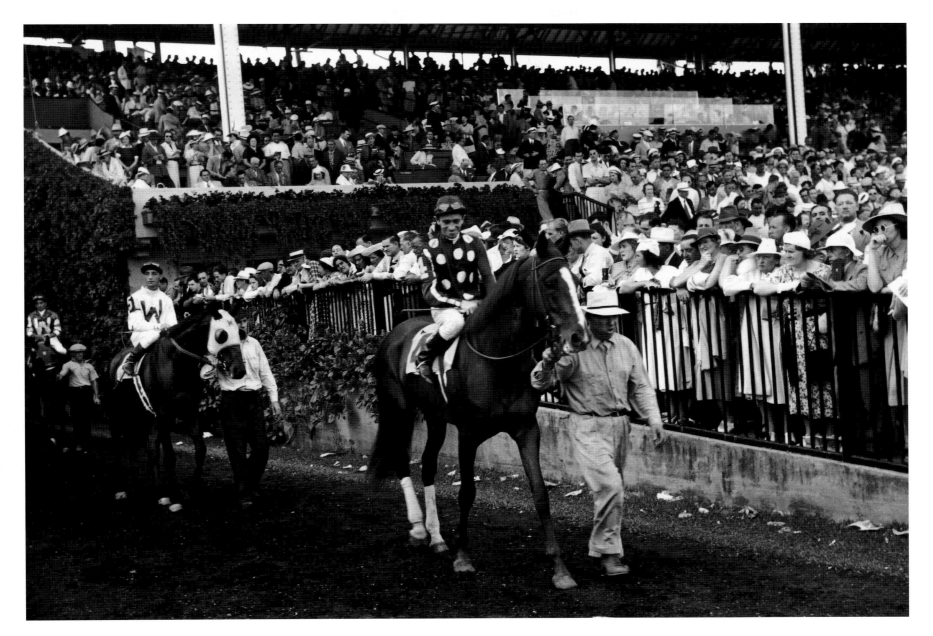

Horse races, Hialeah Park, Miami, Florida

Marion Post Wolcott, February? 1939

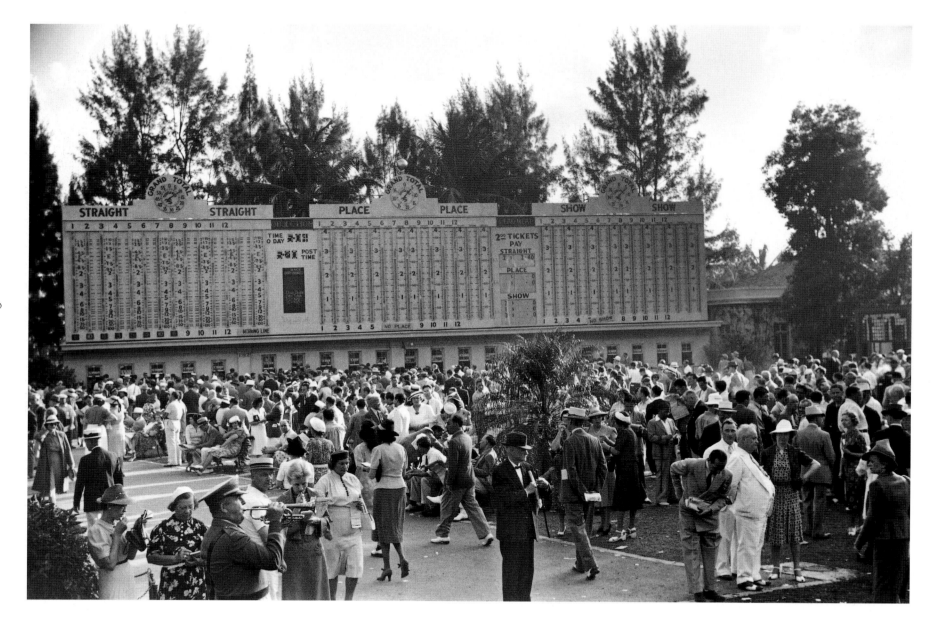

Horse races, Hialeah Park, Miami, Florida

Marion Post Wolcott, February? 1939

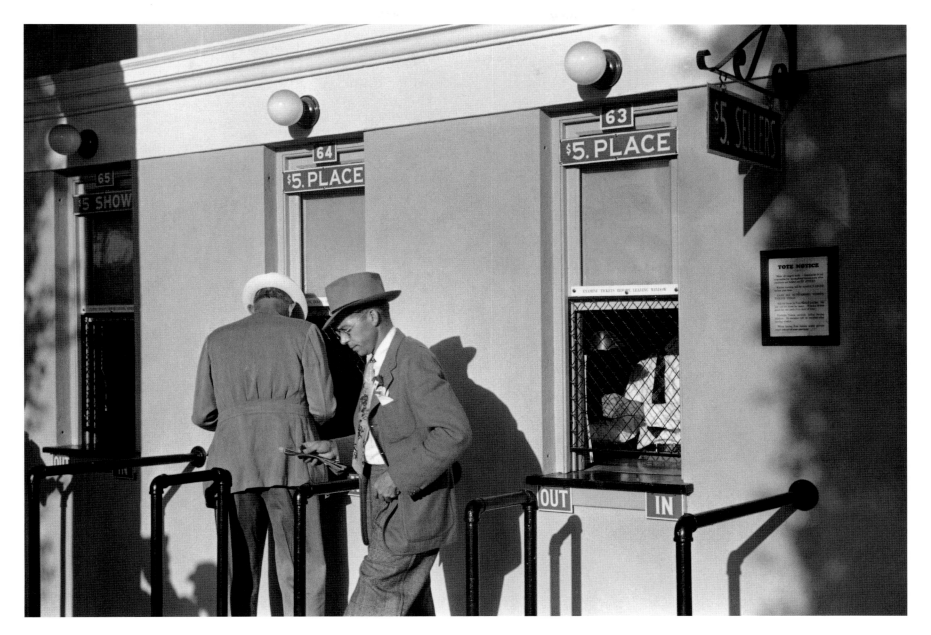

Untitled (Hialeah Park, Miami, Florida)
MARION POST WOLCOTT, FEBRUARY? 1939

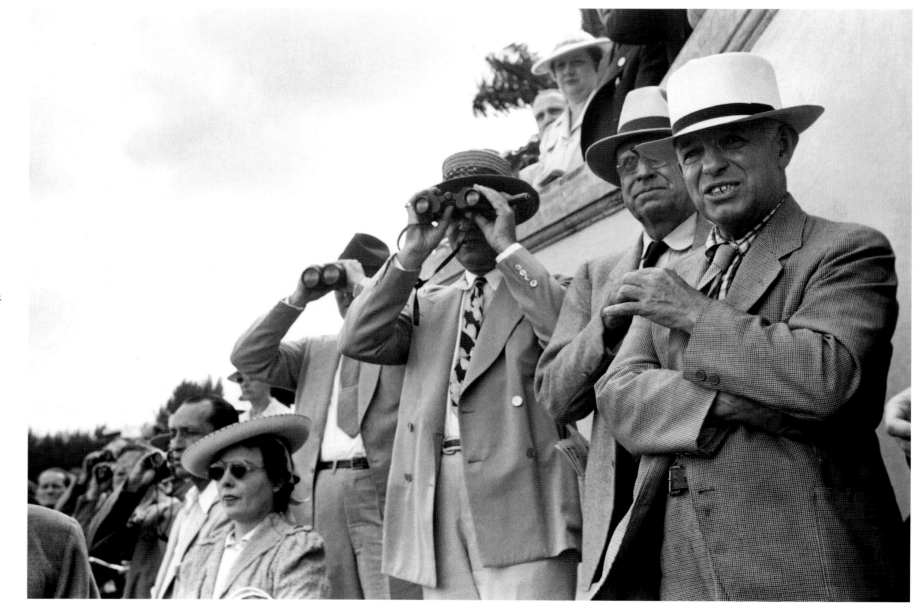

Horse races, Hialeah Park, Miami, Florida
Marion Post Wolcott, February? 1939

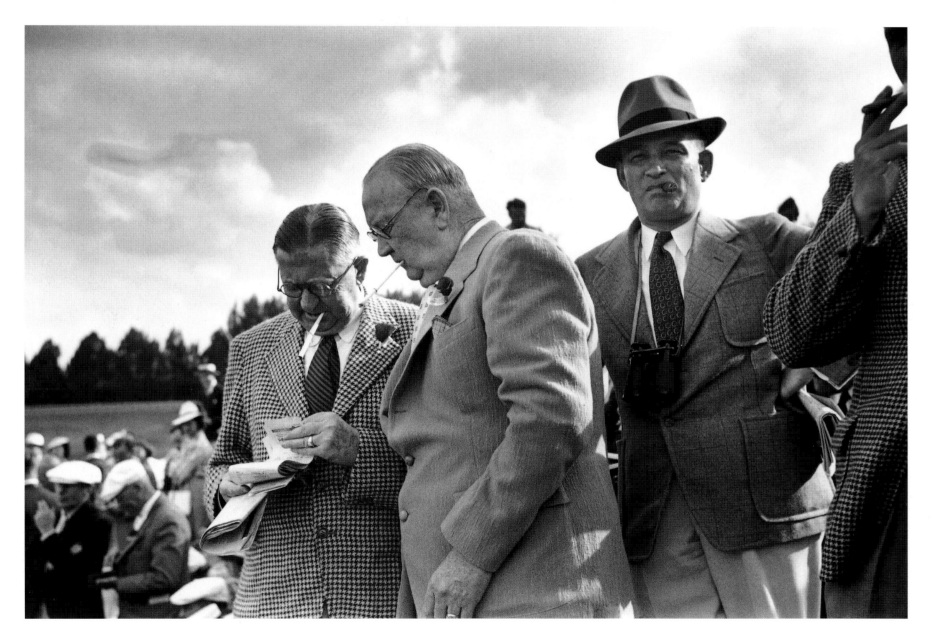

Horse races, Hialeah Park, Miami, Florida

MARION POST WOLCOTT, FEBRUARY? 1939

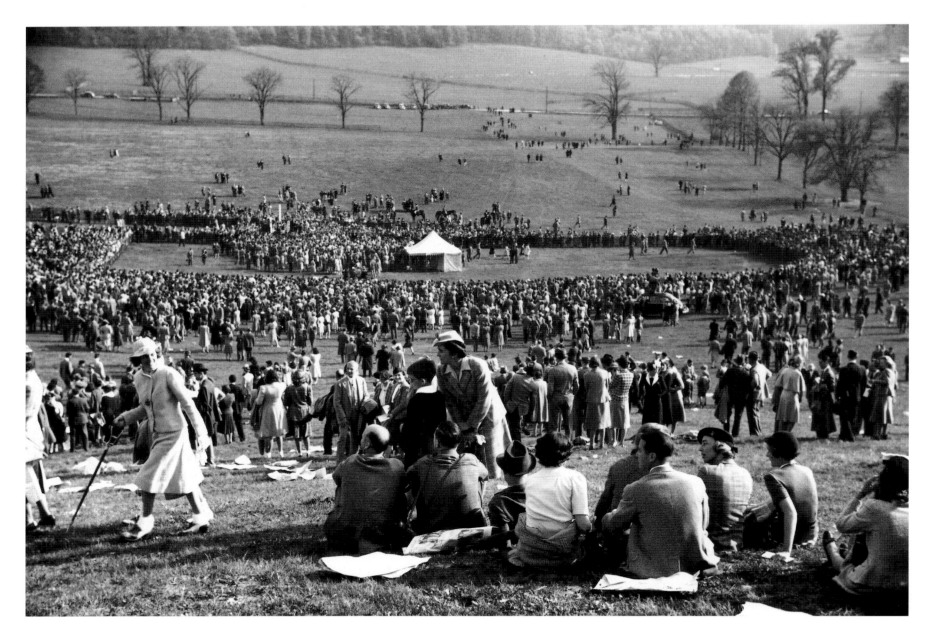

Spectators picnicking before the Point to Point cup race of the Maryland Hunt Club, Worthington Valley, near Glyndon, Maryland

MARION POST WOLCOTT, MAY? 1941

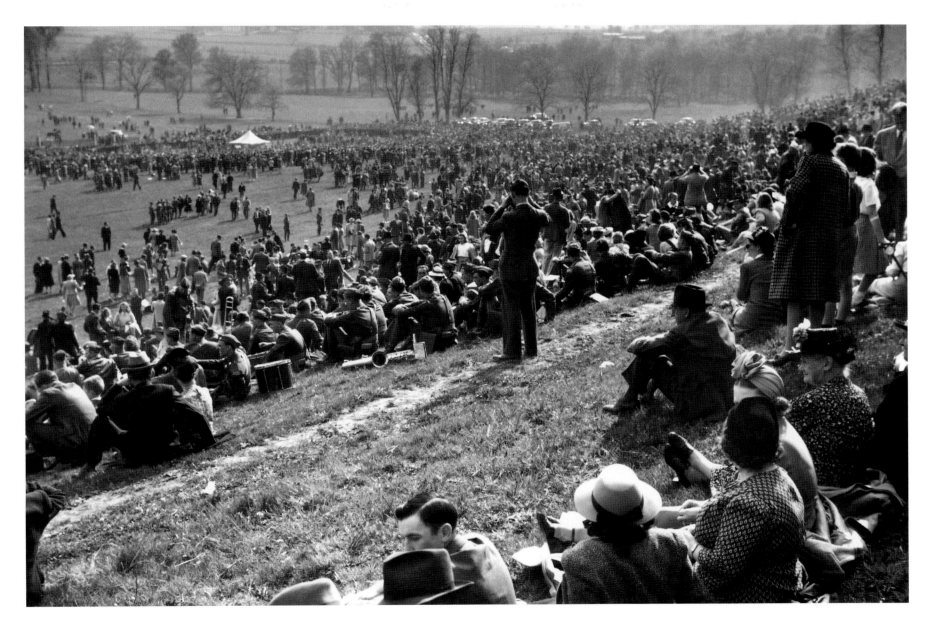

Spectators at the Point to Point cup race of the Maryland Hunt Club, Worthington Valley, near Glyndon, Maryland

Marion Post Wolcott, May? 1941

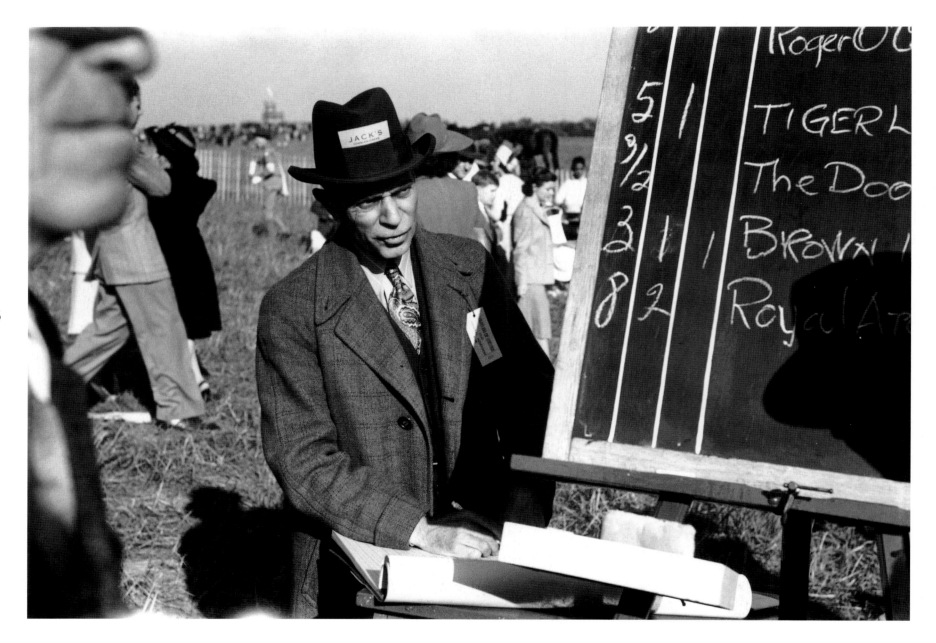

Bookies taking bets at horse races, Warrenton, Virginia

MARION POST WOLCOTT, MAY? 1941

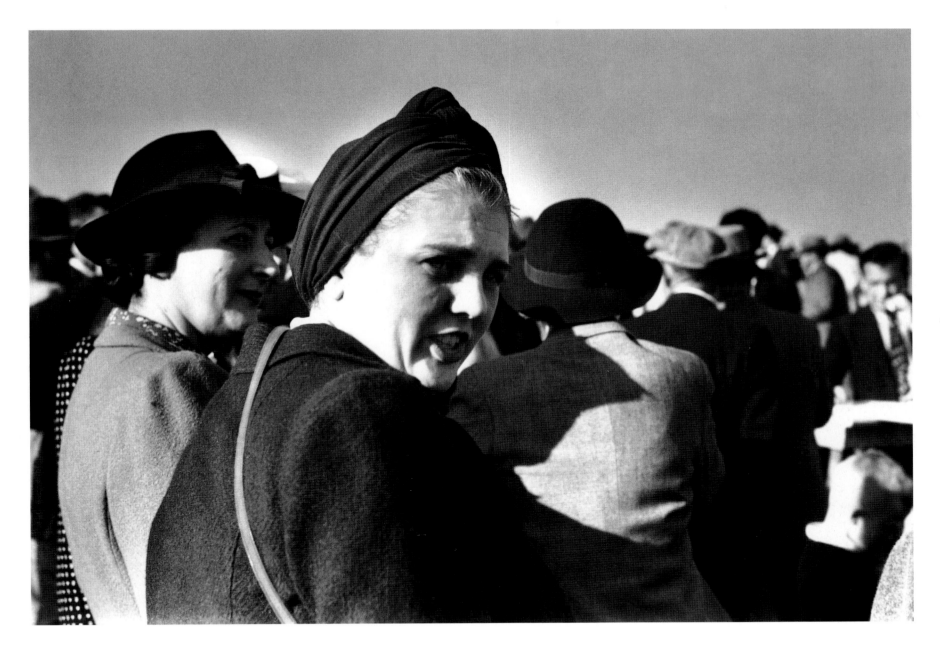

Untitled (Horse races, Warrenton, Virginia)
MARION POST WOLCOTT, MAY? 1941

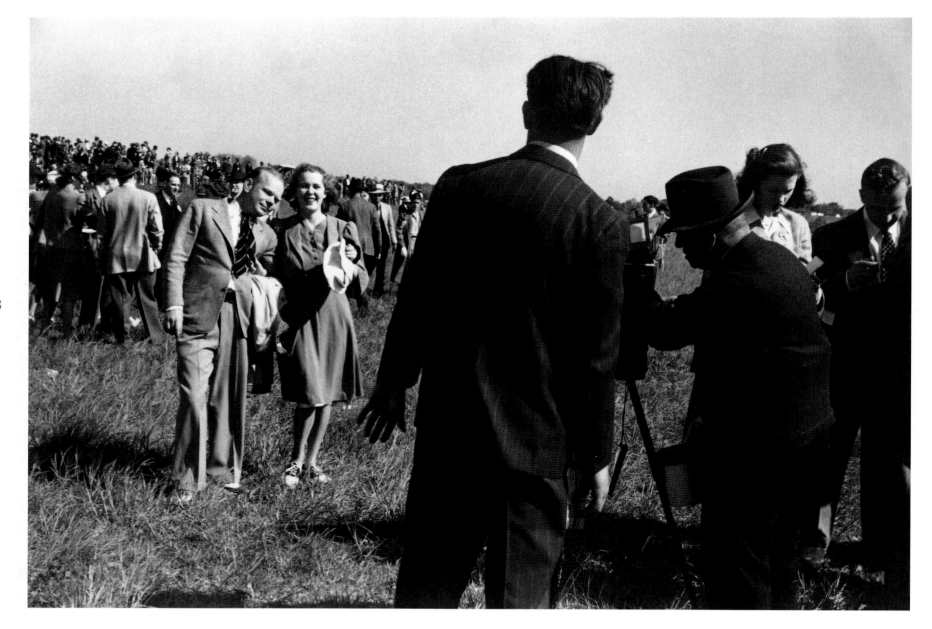

Spectators at horse races, Warrenton, Virginia
MARION POST WOLCOTT, MAY? 1941

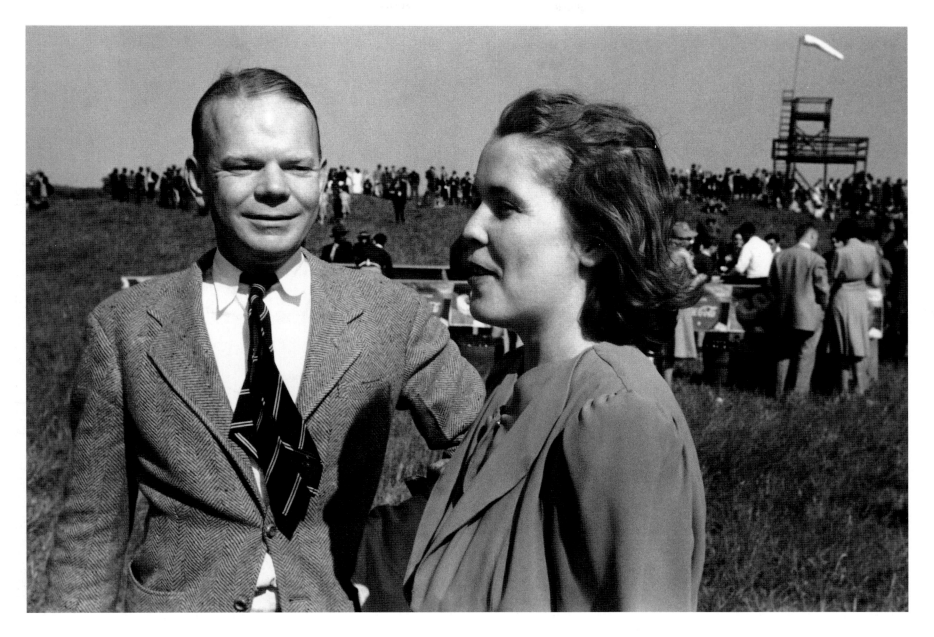

Spectators at horse races, Warrenton, Virginia
Marion Post Wolcott, May? 1941

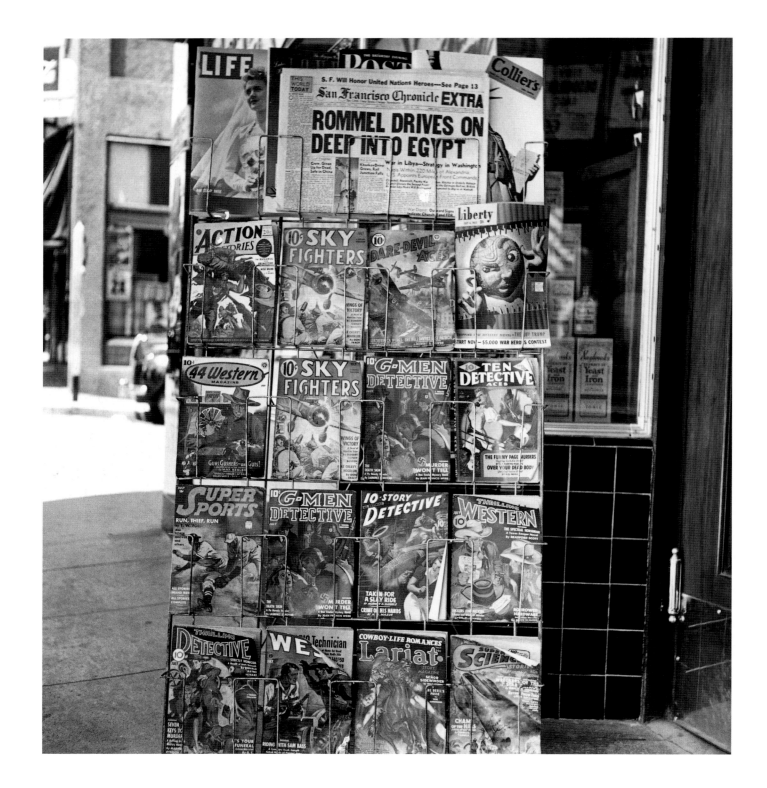

460

Magazine stand, Yreka, California

RUSSELL LEE, JULY 1942

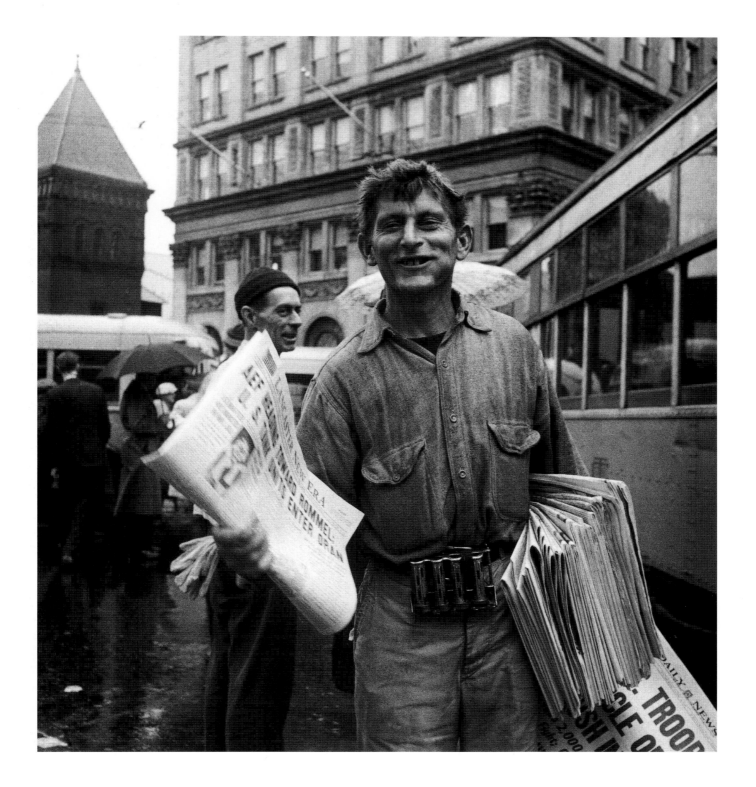

Newsboy at Center square on a rainy market day, Lancaster, Pennsylvania

MARJORY COLLINS, NOVEMBER 1942

"No matter how much came in, we still saw the gaps in the File. We wanted more things. I think that many a day and many a night, we dreamed of being able to reach out further. We dreamed of an enormous File. We had our dreams."

—*Roy Stryker interview with Thomas Garver, July 1, 1968*[1]

By the summer of 1937, the political ground had shifted more than once under Stryker's feet, and he'd begun to make plans for himself outside government. "Duke" Rex, Stryker's protector, had fallen from grace and resigned in the fall of 1937, just after the presidential elections. For almost two years, Tugwell had found himself in controversial—and losing—situations: first as the developer of utopian (and expensive) planned communities ("Greenbelt Towns"), then as the planner and builder of ineffective and expensive collective farms, and finally as the point man for an updated version of the ancient Pure Food and Drug Act. (Tugwell's new drug law finished him, politically: drug companies and food processors and their lobbyists called Tugwell a Bolshevik in public. The newspapers repeated the charges. As Al Smith said, "Who . . . in the name of all that is good and holy . . . is Tugwell and where did he blow from?") Inside the Department of Agriculture, Tugwell's power had drained away from him: in 1935, Tugwell and his protégés had lost a legal showdown between plantations owners' rights and tenants' rights. The owners won. All of Tugwell's protégés were fired and Tugwell offered to resign. Instead, the President created the Resettlement Administration for him as a refuge. From then on, whenever Tugwell caught a cold, Stryker got pneumonia. In October 1936, as the newspapers painted Tugwell red, Stryker's budget was cut. He laid off Lange, fired Evans, retained Rothstein and Lee, and braced himself. By the spring of 1937, the political ground had stopped shaking: Tugwell was gone. The Secretary of Agriculture, Henry Wallace, dreamer that he was, became Stryker's new protector. The RA got a new budget and a new name (the FSA) and disappeared into the depths of the Department of Agriculture. Stryker rehired Lange, sent Vachon out on assignment, kept Lee and Rothstein on the road. By 1938, he'd hired Marion Post, put Ben Shahn on the payroll to take pictures in Ohio, and brought in Edwin Rosskam as his photo editor.

Flush times. Happy days. But if the ground had moved once, it could and would move again. Stryker began to look around. In August 1937, he wrote a letter to his old American history teacher at Columbia, Harry Carman. Carman was the chairman of Columbia's History Department and a mentor of would-be historians. Locked in his office—to which he'd lend Stryker the key—Carman kept all fifteen volumes of Yale's *Pageant of America*, a wonderfully written, wonderfully illustrated topical encyclopedia, published in installments from 1925–29. The *Pageant's* integration of text and illustration profoundly influenced Stryker's understanding of how words, used with pictures, could animate American history.

"Dear Harry," Stryker began. "When I was in New York this last week, I had a very good talk with Miss [Romana] Javitz [director of the Picture Collection] of the New York Public Library. . . . she informed me that they would . . . be willing to loan you . . . prints for your courses next year. . . . She, of course, has probably the finest collection of [prints and photographs] in the United States. . . ."

Stryker paused to make a few personal remarks, and then announced the real purpose of his letter:

"I am more determined than ever to develop documentary photography. Some of the people with whom I talked this last trip [to New York] assured me that the time is ripe and funds are available for such a thing, and if somebody doesn't do it properly, somebody will do it improperly. I feel, definitely, Harry, that you and [Professor James] Shotwell, and Bob Lynd . . . must get together and give me some assistance on getting this thing started. . . . I see no reason why such a foundation, by every logic, cannot be located at Columbia University. We might start out in rather a modest way by collecting materials for the social science people to use in their classrooms; however, I think we could get just as far if we struck out in a bigger way and asked for more money for the large development. I have found that it will be quite easy to get the cooperation of the railroads, various companies, private enterprises, foundations, etc. Once a central place has been established with the backing of a good sponsoring committee, we could bring in an enormous amount of funds in small lots."

Stryker ended the letter by telling Carman that Arthur Rothstein would be stopping to see him soon, to be coached and advised before going to New England to take photographs.[2]

There are a few things to note about this letter: first, the implication that this wasn't the first time Stryker had written to Carman about his ambitions;[3] second, the academic allies whom Stryker named; and, finally the explicit and implicit pretense of Romana Javitz and her New York Public Library Picture Collection.

First, about Javitz:

By 1937, Javitz directed the largest (668,000 items), most variegated, most accessible, and most heavily used prints and photographs collection in the United States. "It may be likened to a giant encyclopedia where pictures are consulted instead of the printed word," Javitz wrote in her 1937 Annual Report. Ben Shahn and Walker Evans had introduced Stryker to her in 1936, and, from then on, whenever Stryker was in New York to talk to editors and publishers, he visited Javitz. Stryker was not alone: throughout the Depression, artists like Diego Rivera and Joseph Cornell, photographers like Evans and Shahn and Berenice Abbott, "used to hang out ... all day"[4] at the Picture Collection, trolling its files and bins, gathering images and inspiration for their art. Architects, graphic designers, advertising art directors, magazine illustrators, film producers, costume and clothing designers—all came and went from the collection, looking for examples and ideas. Twenty thousand Hollywood film stills (donated by studios who had offices and production facilities in New York), ten thousand photographs of paintings from the Frick Collection, current news photos (donated by the *New York Times* and *Newsweek*), railroad photographs (donated by companies like the Baltimore & Ohio), publicity stills from Broadway shows and vaudeville—all were accessible through methods of classification and retrieval that Javitz either invented or perfected.

Early on, Shahn had convinced Stryker to donate duplicate FSA prints to Javitz (a practice that continued into the early 1940s). In 1937, Javitz had persuaded Stryker to make a special effort to donate FSA prints of African-Americans to what was then known as the library's Division of Negro History (what would later become the Schomberg Collection). Javitz was a magpie genius, the daughter of Polish Jews, an artist trained at the Pennsylvania Academy of Art—and the latest in a succession of people whose big ideas filled Stryker's hospitable mind. Javitz's collection became Stryker's model; she was very likely one of the people who had persuaded Stryker ("assured me that the time is ripe....") to write, as he did, to Carman.

As important as Javitz was in Stryker's letter, even more important was the cast of characters Stryker named as his academic allies. Carman was not just a kindly old history professor—he and Robert Lynd and the European historian James Shotwell (who had been one of Wilson's advisers at Versailles) and an array of other Columbia academics were part of a group of pedagogues who, in the years after the World War, had reinvented Columbia's undergraduate curriculum. The foundation courses they developed—known collectively as "Contemporary Civilization"—paired careful reading of primary intellectual documents with analytic essays written by renowned scholars. Contemporary Civilization's faith in intellectual and scholarly breadth, depth, and interconnectedness made Columbia's curriculum a model for other American colleges and marked its planners—men like Carman—as influential and innovative teachers. The economics text that Rexford Tugwell and Thomas Monro had written in 1925, and that Stryker had helped illustrate, had been meant to serve as the economics component of Contemporary Civilization. On the basis of Stryker's intellectual and academic experiences at Columbia, he believed that photographs could and should be used to serve—and teach—ideas, and that Columbia was the right place to perfect that practice. Once perfected at Columbia, the use of photographs as primary documents would spread to other colleges.

Stryker turned out to be wrong: even though Columbia (and Barnard College) had contributed three people to Roosevelt's Brain Trust (Tugwell himself; Raymond Moly, professor of government at Barnard; and Adolf Berle, from Columbia's Law School), Columbia shunned Tugwell when he tried to return. Stryker had no academic status of his own, and without Tugwell, he had no sponsor. Worse yet, Romana Javitz may have known a great deal about picture collecting, but she was wrong about the time being "ripe" and funds being "available": 1937 was the year of the "Roosevelt Recession." Capital spending nearly stopped even as Roosevelt cut back on public works to balance his budget. Without private investment *or* public spending, the American economy stalled and then plummeted. To stop the fall,

Roosevelt and his economic advisers went back to deficit spending. The best place for Stryker and his ambitions turned out to be inside the only place that printed money.

Two years went by. Archibald MacLeish—Pulitzer Prize poet, *Fortune* magazine editor, and author of *In This Proud Land*—was asked by Roosevelt to take over the Library of Congress and drag it into the twentieth century. It had been only a year since *In This Proud Land*—a work that MacLeish described as "a book of photographs illustrated with a poem." Stryker had served MacLeish as a photo researcher and assignment editor, culling hundreds of images from the FSA File and ordering his photographers to make new ones to suit MacLeish's needs. Neither man had forgotten the other. Stryker recognized a new patron when he saw one. In late 1939, Stryker made his next move.

In a memo dated November 24, "Notes from Conference with Archibald MacLeish," Stryker set forth "The following suggestions relative to the creation of a photographic collection on the American scene in the Library of Congress...."[5]

Since the late nineteenth century, the Library of Congress had served as a copyright depository for prints and photographs, but Stryker advocated something much more ambitious—a fabulous creature, part Javitz Picture Collection, part federal image archive, part ongoing photographic survey.

Stryker listed seven "sources of material" to be transferred to the library either as prints or as copy negatives. The first source, to be obtained "by executive transfer," was the files of such federal agencies as—surprise!—the Farm Security Administration. The second, to be transferred as copies, was photo files from such nonfederal agencies as the New York City Tenement Commission, and the third, also to be transferred as copies, was files of archival images from such state historical societies as the one in Nebraska. The fourth, to be obtained "by gift and outright purchase," was corporate images from the files of such companies as Caterpillar Tractor; the fifth was news photos, from the morgues of daily newspapers; the sixth, as gift or purchase, was the files of such freelance photographers as Lewis Hine. Last, but not least, was the seventh source: "original material" made by the new collection's own staff of photographers. All these images—old and new, public and private, corporate and commercial, *plus* the FSA, born and reborn again—were to be housed, catalogued, processed, and disseminated by a modern Library of Congress.

MacLeish was intrigued. He asked for more detail. Stryker replied, a few weeks later, with a long, long memo marked "CONFIDENTIAL!":[6]

"We here, in the photographic section of the Farm Security Administration, after four years of limited experience, have begun to realize that the photograph is a raw product to be utilized as a tool to help express ideas. We assume our file has been important; if it has, then how much more important could a really well organized and adequate file be in such a strategic place as the Library of Congress." Stryker spent the next five pages describing what an "adequate file" might be:

In addition to the FSA's own file (of "some 25,000 negatives"), Stryker listed files at agencies like the Indian Bureau and the Agricultural Extension Service. To the archival images of early settlement from the Nebraska State Historical Society, he added images of early logging from Minnesota, cattle ranching from Texas, and gold mining from California. To his list of corporations, he added such agricultural implement makers as John Deere and International Harvester. "It even might be possible," Stryker wrote, "to prevail upon some historically minded person, like the president of the [Baltimore and Ohio railroad], to pay the expenses of a qualified photographer to travel over the railroad and ... take pictures." The files of the New York City Tenement Commission made another appearance. So did news photos—particularly from papers like the *New York Daily News*. Their files, wrote Stryker, contain "a pictorial history of the American labor movement that has never been touched...."

It was a memo written by a dreamer who, by some stroke of luck, had been asked by a powerful man to dream his dreams in public. Stryker's memo filled and rose, higher and higher, inflated by his hopes and schemes.

"All over the country," Stryker wrote, "are *family albums* ... tucked away in bureau drawers. Some of this most valuable material must be located and drawn into a central file.

"In addition ... the Library ... should maintain a staff of *permanent and part-time photographers* to obtain contemporary photographic material on especially determined topics, such as ... special racial groups in the United States, [for example] ... the Spanish American, the Indians, the Scandinavians of the cut-over states...."

"Money to pay part-time photographers . . . can be obtained, I am certain, from large foundations, such as the Rockefeller, the Carnegie, the Guggenheim. . . .

"The Duponts and the Eastman Company, with their interests in the photographic industry, should certainly give material aid. . . .

"I have an idea that since the [Federal] Writer's Project has been transferred to the Library, profitable arrangements could be made for writers and photographers to collaborate. . . .

"Extremely interesting material could be obtained if a photographer could accompany Mr. [Alan] Lomax on some of his [folk music recording] field trips. A strong set of pictures could be made . . . and would find important use in supplementing his recordings. . . .

"The Picture Collection at the New York Public Library . . . serves as many as 200 people a day. Practically every profession is represented among its users. A similar function should be served by the Library of Congress, and, in conjunction with microfilm, this service could be extended out, all over the country. . . ."

MacLeish replied soon after New Year's 1940. "Dear Roy," MacLeish wrote, "Your very swell memo has produced a reaction from the Chief of the Division of Fine Arts . . . which leaves me with a feeling that the thing to do is to proceed to appoint a committee. . . ." "Faithfully yours," was the way MacLeish ended his note. "Arch" was the way he signed his name. Stryker's balloon had gotten tangled in a branch. But only tangled.

Another year passed. It wasn't a good one for the world, but for Stryker and his staff, things kept getting better. Because of Lange and Rosskam, Stryker began to direct his survey into cities. Rothstein had left for *Look*, but Delano had replaced him. Lee, Vachon, and Marion Post were out on the road. In August 1941, Stryker hired yet another new photographer: John Collier. Collier would be the last photographer Stryker would ever hire for the FSA. The ground was about to move again.

Among Stryker's papers (now in an archive at the University of Louisville), in a section marked "Addresses/Essays, etc.," is a ten-page document that seems to have been written late in 1941, and that, in its grandiosity and detail, is an apotheosis of Stryker's "File" ambitions. There's no evidence of

who Stryker's audience or readers may have been, but the piece reads as if it had been written for a roomful of decision makers. It's entitled "The Face of America." It begins gravely and grandly:

"Right now, the United States is at one of the most critical moments of its history. Upon what is happening in this country may depend not only the future of our descendents, and ourselves but also that of the civilized world. Regardless of the outcome, the events of 1941 will be subject to intensive scrutiny by historians of the future. They will be interested not only in the broad outlines of policy and legislation, but also in the myriad of little things which make up the whole picture of America in time of crisis. . . .

"What we must try to do is preserve as complete a record as possible of what is taking place, discarding only what is obviously trivial and leaving it for the scholar of the future to make final judgments.

"This is a tremendous responsibility. It means the preserving of every type of source material. . . . The tremendous value of photographs in recording social history has been demonstrated repeatedly. The finest record we have of that other great crisis in American life—the Civil War—is to be found in the 20,000 photographs made by Brady and his associates. . . .

"It is vital to our social records that, in 1941, we follow the glorious tradition of Brady. . . . It is a difficult and many sided job, but it is one that can be done, and done, at a cost infinitesimal in relation to the value of the results to be achieved."

No matter that the photographers Brady deployed photographed troops and ruins; no matter that the official records of the "War of Rebellion" filled volumes, and that archives, public and private, were crammed with letters, diaries, memoirs, newspapers, and artifacts. Stryker believed that photography alone would be the primary means of recording the Great Crisis at hand.

What Stryker then proposed—in addition to deploying his own team of photographers to take pictures of "the people, the stories, the streets thronged with soldiers, the U.S.O. campaigns, the railroads, the buses, factories, mills, farms"—was a gigantic Central Archive that would gather, evaluate, classify, and preserve nearly the entire image output of nearly every private and public photographic source in the United States.

"As we have seen," Stryker declared, halfway through his description of the Archive, "the work of the Editorial Section consists of checking over the thou-

sands of pictures which are made in America each week, setting aside those which we believe have a permanent significance, and discarding the remainder. These pictures may be obtained from both government and private sources.

"Government sources would include the Army, the Navy, [the] Office of Emergency Management, the various divisions of Agriculture, Works Progress Administration, Office of Education, Social Security, Public Health Service, and Federal Housing Administration.

"The private sources will, of course, start off with the three major picture agencies: AP–World Wide, International News Photographs, and Acme, as well as such minor agencies as ... Underwood and Underwood, Black Star, Pix....

"Next would come the work of the magazine photographers, notably *Life*, *Look*, *Pix*, *Click*, *Collier's*, *Saturday Evening Post*, *Vogue*, *Harper's Bazaar*, *McCall's* and *Friday*.

"The third group would be the outstanding freelance photographers who are practically one man syndicates.

"Then would come the private non-commercial picture source, which includes the great foundations and universities.

"Finally would come the field of publicity and advertising photographs from which comparatively little can be expected.... Nevertheless, they should be checked over.

"Arrangements to receive the weekly take of Government photographs could be made without a great deal of difficulty.

"The photographs of the principal news picture services could also be gathered without many complications...."

The whole piece reads as if it had been written after consultation with Luis Borges and Samuel Beckett. Sixty years into the future, after any number of revelations about the American government's surveillance of its own citizens, Stryker's proposal seems both naive and a bit sinister. Back then though, Stryker's dreams of a vast central archive were more scholarly than intrusive— the utopian schemes of a man whose intelligence fed on images.

Things ended both well and badly for Stryker. By 1942, the war at home and abroad had cut into the Farm Security Administration's budget. Stryker kept his team of photographers employed by subcontracting them to the government's domestic propaganda agency, the Office of War Information (OWI). By late 1942, the Farm Security Administration could no longer afford the luxury of Stryker and his photographers, and it cut them loose. Stryker found refuge for himself and his team inside the OWI itself, but now he was the first among equals: the OWI had its own file, its own photographers, and its own editorial agendas.

Sometime in 1942, Stryker had begun to fear that his file would be dismembered or dissipated inside the OWI. He started sending anonymous packages of FSA images to Romana Javitz's Picture Collection. Stryker had been sending FSA duplicates to Javitz since 1937—a cumulative process that resulted in a transfer of forty thousand images—but his 1942 shipments were the acts of a frightened man, hiding his valuables before he fled. In the end, though, Stryker's friendship with MacLeish—who served as an associate director of the OWI while still running the Library of Congress—saved the File, if not Stryker's grand ambitions. In 1943, the intact File was transferred—along with its own archivist—to the Library of Congress, where it became the cornerstone of the library's new Prints and Photographs Division.

And Stryker? He resigned from the OWI and went looking for work. He was a file builder, but files were like dams and canals: only massive organizations commissioned projects on such a scale. Since Stryker had quit the government, who else was there to work for? The government itself supplied the answer.

In 1942, the Antitrust Division of the Justice Department began an investigation of collusion, in the form of cartel agreements, between U.S. and foreign corporations. The Justice Department's most publicized discovery was a 1929 agreement between Standard Oil and the German chemical firm of I. G. Farben. In return for Farben's pledge not to compete with Standard Oil in the United States, Standard Oil agreed not to research and develop synthetic rubber. By 1942, the Japanese occupied territories that had once supplied 90 percent of America's crude rubber needs. In March, the Senate Committee on National Defense listened to an Assistant Attorney General declare that Standard Oil's agreements "with Germany [were] the principal cause of the shortage of synthetic rubber." *Newsweek* reported: "The senators sat grim and visibly shocked as they listened to these revelations. Afterward, Senator Harry S. Truman, the Committee's usually placid chairman, exclaimed to a reporter: 'I think this approaches treason.'"[7]

Standard Oil began to look for ways to wrap itself in the flag. Its public

relations firm employed a man—a former Associated Press editor—who knew Stryker. The man admired what Stryker had done to "sell" the New Deal to the American people. Why not, the man suggested, hire Stryker to do the same thing for Standard Oil? After all, Standard Oil was just a bunch of people trying to help other people. Bus drivers and auto mechanics, wildcatters and truck drivers—the "story of oil" was really the story of all the folks who produced it and used it, and that, ladies and gentlemen, was the story of just about everyone.

Standard Oil of New Jersey offered Stryker a big job: assemble a team of photographers and build a file. Standard Oil's public relations people would use the pictures to tell the company's story. In fact, they'd let anybody use the pictures for free just as the government once did with its pictures.

Stryker looked around for some big university to help him set up a foundation or an institute or a center for documentary photography—but in 1944 he had no more luck or clout than he had in 1937, when Columbia had turned him down. The man whose father had prayed to God to "damn the Bankers of Wall Street, damn the Railroads, and double damn Standard Oil"[8] picked up his tools and went to work for the Devil.

The elaborate story began one night in Lucerne or London, in the early seventeenth century. A benevolent secret society . . . came together to invent a country. The first tentative plan gave prominence to "hermetic studies," philanthropy, and the cabala. . . .

At the end of some years of conventicles and premature syntheses, they realized that a single generation was not long enough in which to define a country. They made a resolution that each one of the master-scholars involved should elect a disciple to carry on the work. That hereditary arrangement prevailed; and after a hiatus of two centuries, the persecuted brotherhood reappeared in America. About 1824, in Memphis, Tennessee, one of the members had a conversation with the millionaire ascetic, Ezra Buckley. Buckley listened with some disdain as the other man talked, and then burst out laughing at the modesty of the project. He declared that in America it was absurd to invent a country, and proposed the invention of a whole planet.

—Jorge Luis Borges, "Tlön, Uqbar, Orbis Tertius," in Ficciones.

"There is a Party slogan dealing with the control of the past," he said. "Repeat it, if you please."

"'Who controls the past controls the future; who controls the present controls the past,'" repeated Winston obediently.

"'Who controls the present controls the past,'" said O'Brien, nodding his head with slow approval. "Is it your opinion, Winston, that the past has real existence?"

Again the feeling of helplessness descended upon Winston. His eyes flitted toward the dial. He not only did not know whether "yes" or "no" was the answer that would save him from pain; he did not even know which answer he believed to be the true one.

O'Brien smiled faintly. "You are no metaphysician, Winston," he said. "Until this moment you had never considered what is meant by existence. I will put it more precisely. Does the past exist concretely, in space? Is there somewhere or other a place, a world of solid objects, where the past is still happening?"

"No."

"Then where does the past exist, if at all?"

"In records. It is written down."

"In records. And—?"

"In the mind. In human memories."

"In memory. Very well, then. We, the Party, control all records, and we control all memories. Then we control the past, do we not?"

—George Orwell, 1984

"I guess I would have to say that I had a pretty good hunch that the pictures that were ignored then were what would prove most valuable in the end."

—Roy Stryker speaking to Nancy Wood [1]

Paul Vanderbilt was the archivist tethered to the file, who accompanied it to the Library of Congress. "I know where there is a job that you will love," Rosskam had told him. "Roy wants somebody to help him get that File of his down in Washington, organized. . . ."[2] Vanderbilt had been working for the Education Department of the Philadelphia Museum of Art when he and Rosskam met during Rosskam's days as a Sunday magazine columnist for the *Philadelphia Record.* Just as Rosskam had ended up in Philadelphia by way of Munich, Paris, Tahiti, and San Juan, Vanderbilt had come to rest there by way of art history at Harvard and library schools in London and Paris. "The particular line that I began to follow," Vanderbilt said, "was the *content* of works of art . . . in topography, in representation of social life, in the reflection . . . of . . . major trends of thought in relation to literature. . . ."[3] The Philadelphia Museum hired Vanderbilt to buy art books and organize them to form a research library. After that, Vanderbilt directed the creation of a gigantic "union catalogue" that indexed all the books (five million) in all the libraries (156 of them) in Philadelphia. "All of this," he said, "was aiming at something that was a little beyond immediate reach. I was always interested in theory, always interested in the long reach. . . . How do you include—in the general control apparatus of knowledge—things other than published books . . . unwritten material, things in people's own, private homes, their lifework and their notes, the unformed things, the things that are in their heads, unexpressed . . . the great frontier of research."[4] "Rosskam planted this idea I might work for Roy [Stryker] in my head. . . . I think it was seeing the [File], rather than talking with Roy that really excited me. . . . It wasn't that I wanted *any* job. I wanted *that* job!"[5]

Once Vanderbilt was hired, it took him four years to turn the File into a research "apparatus." His staff would find him, on Monday mornings, collapsed at his table, unconscious, his mind saturated with images, drunk from days and nights of looking. For four years, Vanderbilt sorted and resorted the

File, preserving its original order on microfilm, then untangling it, dismantling its mass of images, shoved together by time, place, and photographer, and creating, instead, an open architecture of visual meaning. The archetypal categories into which Vanderbilt organized the images, region by region—categories like "The Land," "Work," "Organized Society"—were so broad that an anthropologist from Mars or a Transcendental philosopher or a recording angel might have devised them. Endowed with a memory and a curiosity, an intellect and a playfulness that architects like Buckminster Fuller or Paulo Solari would have recognized, Vanderbilt built the palace of Stryker's dreams.

Sixty years later, the palace's enormous doors open as easily, its great rooms are as light and airy, its branching corridors are as spacious as they were when Vanderbilt first designed and built them. Because Vanderbilt understood that photographs have surfaces *and* depths, and that, like Renaissance emblems and waking dreams, they encompass and elicit multiple meanings, his reorganization of the File—by region and by category within each region—still serves as many visions as there are visitors. Like an oracle that will give an answer based on the quality of the question it's asked, the File has spoken (and still speaks) to thousands and thousands of citizens, academics, artists, and activists, in much the same way that Javitz's Picture Collection once did.

"A monumental document, comparable to the tombs of the Egyptian pharaohs or to the Greek temples, but far more accurate," was the way Vanderbilt once described the File.[6] "A stockroom of parts," "the assembled, useful machine," the "menu of a well balanced meal" were some of the other metaphors Vanderbilt used to describe what he'd built.[7] But Vanderbilt made what he made only from the materials he'd been given. He designed a palace, and built it with his own implements—but Stryker supplied the stone, and that stone had been very carefully chosen: the photographers had quarried it and sent it chunk by chunk, to Washington, but Stryker decided what to keep and what to throw away.

From the mid-Thirties until the Forties, Stryker punched holes through negatives he believed weren't worth printing. The practice appalled people like Evans and Lange. Lange avoided Stryker's hole punch by setting up her own darkroom in California; Evans usually carried two cameras—one with film for Stryker; one with film for himself. Most photographers mailed their film to Washington, where negatives were developed, numbered, and contact-printed. Stryker reviewed the contact sheets, punched his holes, and then selected images he considered worth enlarging. These proofs, called "first prints," plus the contact sheets, were sent back to the photographers, who were expected to write captions for the proofed images. The photographers sent their captions back to Stryker; he edited them; the proofed images he'd selected were then carefully printed and mounted; typed captions were affixed to the mounts, and the titled images entered the File. The "untitled"/unselected negatives, plus some of the negatives Stryker had "killed" with a hole, were filed in negative files, along with their titled/captioned brothers and sisters. For all practical purposes the untitled negatives and the information they carried became invisible.

Curators at the Library of Congress now estimate that there were 77,000 "titled" File prints made under Stryker's direction. Curators also estimate that the *total* number of negatives, "titled" *and* "untitled," made by Stryker's photographers number 145,000.[8] That means 68,000 images never saw the light of day. Some of these images were near misses or duplicates or inferior variations on pictures that were printed and titled. But some of them were more than that: 20 percent of the photographs in this book were originally untitled (what captions they now have are the result of investigating titled images adjacent to them).

Toward the end of Stryker's time in Washington, he gave his photographers more control over what was and wasn't consigned to oblivion, but from 1935 to 1943, there was never any doubt who was boss: Stryker made the assignments and carefully reviewed and edited all images before they were sent back to the photographers. Once those images were captioned, it was Stryker (and later Rosskam) who peddled them to publishers. In the case of a "taxonomist" like Russell Lee, Stryker rarely if ever "killed" an image or left it unprinted. In the case of such artists as John Vachon and Walker Evans, Stryker intervened often. For example, though the File now contains nearly five hundred Evans images, there are as many as two thousand Evanses that exist but were never captioned or enlarged.

As of this writing, more than sixty thousand images, titled and untitled, can be seen online, through the Library of Congress website. In the early 1990s the library began to digitalize its FSA/OWI negatives to create a video

disc for its reference service. The process of making that disc provided digital positives that could be archived and accessed online. The library's digitalizing process was not editorial, but curatorial and preservationist. Untitled images, freed from Stryker's editorial control, became visible for the first time in sixty years.

Stryker's editorial decisions were the result of complex interactions between political, ideological, academic, aesthetic, and personal agendas. At his worst, Stryker was a small-minded meddler who hectored Arthur Rothstein about corn in Iowa and nagged Marion Post about rail fences. Stryker was an accountant who preferred the word count of a speed typist like Russell Lee to the metric choices of a poet like Evans. Stryker's background as an academic textbook illustrator—a man who used images to teach people how and what to think—resulted in shooting scripts that read like inventories and, by 1938, in the firing and hiring of people to form a team that would do as he told them.

American cultural historians (Warren Susman, Alan Trachtenberg, and Lawrence Levine) have written persuasively that the turmoil and disruptions of the Thirties provoked a kind of national identity crisis—a crisis that resulted in a search for authentic roots, and for signs and symbols of perseverance and rebirth. Stryker and the photographers who worked for him carried marks of turmoil and suffering inflicted on them long before the Thirties: John Vachon, the file clerk turned photographer, was the alcoholic son of an alcoholic traveling-salesman father; Russell Lee had seen his mother killed before his eyes; Dorothea Lange's father had abandoned her and her family soon after she contracted polio; Gordon Parks had nearly died on the streets after his brother-in-law threw him out in the middle of winter; Walker Evans' and Marion Post's genteel families had been shattered by divorces; Edwin Rosskam had lost his father after his family had been interred as enemy aliens; Jack Delano's family were Russian Jewish refugees. Only Arthur Rothstein seems to have been directly marked by the onset of the Depression. As to Stryker, his father had failed as a farmer, first in Kansas, then in Colorado; Stryker had tried farming and cattle ranching and failed at both. He'd entered the Colorado School of Mines, but weak eyes and not enough money had forced him to withdraw. The tree-lined streets of a little town where there was a place for everyone and everyone was safe were a sweet dream that beckoned everyone who worked for the FSA.

In 1962, Edward Steichen, the photographer/curator responsible for the Museum of Modern Art's "Family of Man" exhibition, organized another exhibit called "The Bitter Years" based on images in the FSA File. Stryker was dismayed by the choices Steichen had made. Eleven years passed before Stryker organized his response: a book called *In This Proud Land*. Its introduction included a long monologue. "Steichen's approach," Stryker complained, "was to show misery in its finest hour.... Sure the kids looked grim, sometimes, so did their parents. Nobody had a dime, but they had a whole lot more. They had each other.... A family stuck together. It's all there was.... You could look at the people and see fear and sadness and desperation. But you saw something else, too. Determination that not even the Depression could kill.... The faces to me were the most significant part of the File. When a man is down and they have taken from him his job and his land and his home ... he's going to have the expression of tragedy on his face. But I have always believed that the American people have the ability to endure. And that is on their faces, too."[9]

Stryker's belief that suffering was ennobling (angry faces were photographed but seldom reproduced) was, at best, a matter of faith. At worst though, images of dignified suffering and "true grit" endurance formed a cliché—a kind of visual archetype—that could be displayed, in association with any policy, to ratify that policy, and, by ratifying it, to mobilize mass support for it. Norman Rockwell illustrated Roosevelt's "Four Freedoms" with photo-realist images that Stryker and his photographers might have envied. After the war, variations on photo-realist clichés became part of advertisements whose power was derived from the way an item or an enterprise had been embedded in the cliché. That was Standard Oil's strategy when it hired Stryker to build a new File full of faces of hardworking people doing their dead level best. Variations of the visual clichés perfected and promulgated by Stryker in service to the government are now used to illustrate and authenticate everything from the information product called "news" to the mass marketing of commodities and services. The use of images of the real to serve the unreal (fabricated "truth," fabricated "happiness," fabricated "safety") has become a strategy of American political, commercial, and foreign policy. Realist clichés have become equivalent to watermarks, notary seals, and passport stamps.

There is something else, though—something less malevolent:

Stryker, at his best, was an artist of the File, and as with any artist, the work he made changed him. The small-town refugee who tried to ignore the massive, variegated life of cities, the provincial academic who assigned a text as racist and xenophobic as *North America*, the editor/illustrator who never experienced the tidal currents of chance that sweep through every photographer—that man was transformed by years of looking at the images that poured into his File. The dreamer who dreamed of "an enormous File" was different from the petty little man who ordered one picture of this and another one of that. Stryker punched holes in negatives and consigned nearly as many images to oblivion as to visibility, but the totality of those images enabled him to see—and vicariously experience—a range of existence that was nearly transcendental. Ashes and diamonds, birth and desolation, old men and maidens, young men and hags, the living and the walking dead—Stryker eventually saw it all and was changed by it.

"If I could do it," wrote James Agee, Walker Evans' dear friend and co-conspirator, "I'd do no writing at all here. It would be photographs; the rest would be fragments of cloth, bits of cotton, lumps of earth, records of speech, pieces of wood and iron, phials of odor, plates of food and excrement.... A piece of the body torn out by its roots might be more to the point."[10]

Every new form of communication, every new kind of media, has been and will always be a blind, blunt, crippled effort to make the past into the present, the far into the near, the outside into the inside, to turn us all, for a moment, into supernal beings. Writers like Agee and Steinbeck and Wright and MacLeish—and the hundreds of thousands of people who sat, enthralled, every week, looking at the images in *Life*—all experienced the brief epiphanies produced by photographs, singly or in sequence. But the File produced something different: the File had the potential to create, over time, an experience of totality that felt boundless. The File—the whole File—will soon be online. It's as grand a thing, in its own way, as Yosemite or Yellowstone. It's the common property of every citizen of the United States. It belongs to us. It is us.

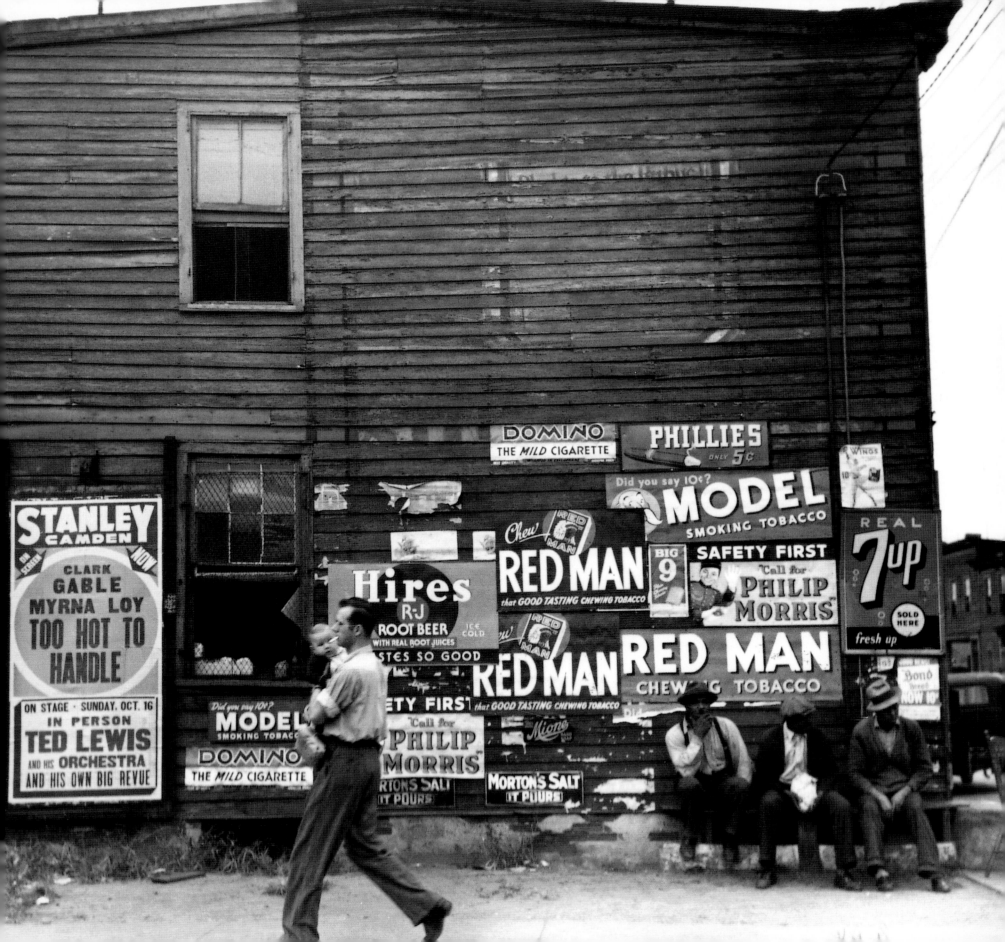

NOTES

INTRODUCTION

1. David M. Kennedy, *Freedom from Fear: The American People in Depression and War, 1929–1945*, (Oxford Univ. Press, 1999), p. 192.

2. Ibid., p. 141

3. Ibid., p. 200.

4. Ibid., p. 22.

A NOTE ABOUT THE PHOTOGRAPHS

1. Lawrence W. Levine, "The Historian and the Icon," in Carl Fleisher and Beverly Brannan, eds., *Documenting America, 1935–1943*, (Univ. of Calif. Press, 1988), p. 28.

ASSIGNED READING

1. Quoted in F. Jack Hurley, *Portrait of a Decade: Roy Stryker and the Development of Documentary Photographs in the Thirties* (Louisiana State Univ. Press, 1972), p.36.

2. Interview with Rexford and Grace Tugwell, 1965, Archives of American Art, Smithsonian Institution, p.7.

3. Ibid.,pp.7–8.

4. Quoted in Hurley, p. 58.

5. Ibid.

6. Quoted in Hank O'Neal, *A Vision Shared: A Classic Portrait of America and Its People, 1935–1943* (St. Martin's, 1976), p.116.

7. Interview with Roy Stryker by Thomas Garver, July 1, 1968, in *Just Before the War: Urban America from 1935 to 1941 as Seen by Photographers of the Farm Security Administration* (Rapid Lithograph Co., 1968), unpaginated.

8. Gordon Parks, *A Choice of Weapons*, (Harper & Row, 1966), p. 174.

9. Ibid., p. 213.

10. Ibid., p. 206.

11. Quoted in the exhibition brochure for "Half Past Autumn," Museum of the City of New York, 1998.

12. Quoted in Hurley, p. 158.

13. Jack Delano, *Photographic Memories*, (Smithsonian Institution Press, 1997), p. 27.

14. Ibid., pp. 28–29.

15. Ibid., p. 23.

16. Ibid., p. 19.

17. Quoted in F. Jack Hurley's *Marion Post Walcott: A Photographic Journey*, (Univ. of New Mexico Press, 1989), p. 21.

18. Paul Hendrickson, *Looking for the Light: The Hidden Life and Art of Marion Post Walcott*, (Knopf, 1992), p. 58.

19. Oral history interview with Dorothea Lange conducted by Suzanne Reiss, 1960–61, in Berkeley, Calif., Regional Oral History Office, Bancroft Library, Univ. of Calif., Berkeley, 1968, p. 17.

20. Hendrickson, p. 58.

SHOOTING SCRIPTS

1. "The value, and, if you like, the propaganda value for the government, lies in the record itself, which, in the long run, will prove an intelligent and farsighted thing to have done. NO POLITICS whatever," Evans had written in a 1935 memo to Stryker. Walker Evans, *Walker Evans at Work* (Harper & Row, 1982), p.112.

2. Robert S. Lynd and Helen Merrell Lynd, *Middletown: A Study in Contemporary American Culture* (Harcourt, Brace/Harvest, 1956), p. 129.

3. Reproduced in Walker Evans, *Walker Evans at Work*, p. 113.

4. Stryker letter to Jonathan Garst, November 30, 1939, Dorothea Lange Collection, Oakland Museum, Oakland, Calif.

5. Quoted in James Curtis, *Mind's Eye, Mind's Truth: FSA Photography Reconsidered* (Temple, 1989), p. 106.

6. Sherwood Anderson, *Home Town* (Alliance Book Corp., 1940), p. 144.

PUBLISHING AND THE FILE

1. The Hungarian expatriate Stephan Lorant had developed the form in the Twenties for the *Munich Illustrated Press*; the great Soviet editor Mikhail Koltsov and the brilliant designers Rodchenko and El Lissitsky had perfected it in the early Thirties in such publications as *USSR in Construction*.

2. By the time Caldwell died in 1987, his books had been translated into forty languages and had sold eight million copies worldwide.

3. The assistance Stryker gave to MacLeish—and the powerful effect the FSA File had on MacLeish—resulted in the File's finding a final safe haven in the Library of Congress after 1943, when MacLeish served as the library's director.

4. As early as 1934, *Fortune* had paired Agee with none other than Bourke-White, for an article about the drought that had spread across the country.

5. The book derived from this exhibition, Evans' classic, *American Photographs*, a book as laconic and Apollonian as Bourke-White and Caldwell's was demonstrative and dramatic, reprinted a total of eighty-seven images in carefully choreographed sequences. Forty of

the images were made while Evans was still a government employee.

6. And the collaboration that would follow its publication, when Twentieth Century Fox used many of the FSA's images to shape the look of the movie it made.

7. Interviewed with Edwin and Louise Rosskam by Richard Doud, 1965, Archives of American Art, Smithsonian Institution.

8. Louise's mother knew Rosskam's mother. Louise's father had been a banker, but the Depression ruined him and his family. In 1931, he was forced to sell his bank building. He died five days later.

9. Interview with Edwin and Louise Rosskam, 1965.

10. Reel 6, Roy Stryker Papers, Univ. of Louisville.

11. Gary Saretzky, "She Worked Her Head Off," *The Photo Review*, Vol. 23, Nos. 3 and 4 (Fall 2000).

12. Maren Stange, *Symbols of Ideal Life: Social Documentary Photography in America, 1890–1950* (Cambridge University Press, 1989), pp 108–11.

13. In 1937, Stryker sent Vachon to New York, to the 42nd Street branch of the New York Public Library, to learn how such things were done. Vachon consulted the curator of the library's Picture Collection, a remarkable woman named Romana Javitz. Ben Shahn and Walker Evans had introduced Stryker to Javitz and her collection. Evans had met Javitz years before when he'd worked as a clerk in the library's Map Room. Stryker's connection to Javitz and the New York Public Library Picture Collection is described later in this book.

14. By 1940, the File held forty thousand images. The process of looking through the File, again and again, trained Vachon's eye and turned him into a photographer. In the summer of 1937, Stryker sent Vachon out into the field for a few days, chaperoned by Arthur Rothstein. By the winter of 1938, Stryker trusted Va-

chon enough to send him to Nebraska for a month. Some of the images Vachon made of Omaha were used as illustrations in George Leighton's book *Five Cities: The Story of Their Youth and Old Age* (Harper & Brothers, 1939).

15. "Memo to Edwin Rosskam," July 13, 1939, Reel 2, FSA Office Files, 1935–44, Library of Congress.

16. Interview with Edwin and Louise Rosskam, 1965.

17. Ibid.

18. Ibid.

19. Rothstein went to Pittsburgh, on assignment, to shoot stills for Pare Lorentz's documentary film *The River*.

20. "Only 25% of the photographs in the . . . Collection depict subjects in towns of 50,000 or more inhabitants. Most of the urban photographs were made in 1942 and 1943." Lawrence W. Levine, "The Historian and the Icon," in Carl Fleischhauer and Beverly Brannan, eds., *Documenting America, 1935–1943* (Univ. of Calif. Press, 1988), p. 28.

21. Interview with Edwin and Louise Rosskam, 1965.

PICTURE PALACE

1. From *Just Before the War: Urban America from 1935–1941 as Seen by Photographers of the Farm Security Administration* (Rapid Litograph Co., 1968).

2. Reel 1, Correspondence, Stryker Papers, Univ. of Louisville.

3. In a letter in October 1935, Stryker had announced the time had come to "start making an historical picture of America in photographs." Quoted in Paul Hendrickson, *Looking for the Light: The Hidden Life and Art of Marion Post Walcott* (Knopf, 1992), p. 53.

4. Ben Shahn, quoted in Deborah Martin Kao, Laura Katzman, and Jenna Webster, *Ben Shahn's New York: The*

Photography of Modern Times (Fogg Art Museum, Harvard University Art Museums, 2000), p. 81.

5. Reel 2, Correspondence, Stryker Papers, Univ. of Louisville.

6. Ibid.

7. *Newsweek*, April 6, 1942, p. 46.

8. Stryker, quoted in "The Man Behind the Man Behind the Lens," *Minicam Photography*, November 1947.

THE WHOLE FILE

1. Quoted in Roy Emerson Stryker and Nancy Wood, *In This Proud Land: America, 1935–1943 as Seen in the FSA Photographs* (New York Graphic Society, 1973).

2. Interview with Paul Vanderbilt, Archives of American Art, p. 6.

3. Ibid., p. 2.

4. Ibid., pp. 2–4.

5. Ibid., pp. 7–8.

6. "*Standards of the Documentary File*," Paul Vanderbilt Papers, Archives of American Art, p. 4.

7. Paul Vanderbilt, "Preliminary Report, 1942." Stryker Papers, Univ. of Louisville, p. 6. Descriptive remarks quoted and cited by Alan Trachtenberg in his essay "From Image to Story," in Carl Fleischauer and Beverly Brannan, eds., *Documenting America, 1935–1943* (Univ. of Calif. Press, 1988), p. 54.

8. Fleischauer and Brannan, eds., p. 338.

9. Roy Stryker talking to Nancy Wood, in Stryker and Wood.

10. James Agee, *Let Us Now Praise Famous Men: Three Tenant Families* (Houghton Mifflin, 1988), p. 13.

13: LC-USF33-T01-001708-M1 DLC

14: LC-USF33-016072-M2

15: LC-USF33-016073-M3 DLC

16: LC-USF33-T01-001879-M1 DLC

17: LC-USF33-016072-M4 DLC

18: LC-USF33-021028-M1 DLC

19: LC-USF33-021051-M5 DLC

20: LC-USW3-007791-E

21: LC-USF33-T01-001962-M3 DLC

22: LC-USF33-015638-M4 DLC

23: LC-USF33-015605-M1 DLC

24: LC-USF33-T01-001035-M1 DLC

25: LC-USF33-020994-M5 DLC

26: LC-USF33-T01-002680-M3 DLC

27: LC-USF33-T01-001047-M4 DLC

28: LC-USF34-001831-E DLC

29: LC-USF33-016122-M2 DLC

30: LC-USF33-016076-M5 DLC

31: LC-USF33-T01-0013090M3 DLC

32: LC-USF33-016122-M4 DLC

33: LC-USF33-T01-001037-M1 DLC

34: LC-USF33-T01-001041-M3 DLC

35: LC-USF33-T01-001073-M3 DLC

36: LC-USF33-011022-M5 DLC

37: LC-USF33-011012-M5 DLC

38: LC-USF34-005680-E DLC

39: LC-USF34-005677-E DLC

40: LC-USF33-000162-M1

41: LC-USF34-014396-D DLC

42: LC-USF33-T01-001064-M3 DLC

43: LC-USF33-T01-001904-M1 DLC

44: LC-USF33-T01-001962-M1 DLC

45: LC-USF33-T01-001639-M1 DLC

46: LC-USF34-019274-E DLC

47: LC-USF33-T01-001276-M4

48: LC-USF33-T01-001283-M4 DLC

49: LC-USF33-016166-M4 DLC

50: LC-USF33-020754-M2 DLC

51: LC-USF33-020769-M3 DLC

52: LC-USF33-T01-001310-M5 DLC

53: LC-USF33-T01-001046-M3 DLC

54: LC-USF33-016151-M5 DLC

55: LC-USF33-013013-M3 DLC

56: LC-USF33-005220-M1

57: LC-USF33-005164-M3 DLC

58: LC-USF33-012345-M1 DLC

59: LC-USF33-012485-M2 DLC

60: LC-USF33-05127-M3 DLC

61: LC-USF33-05132-M3-DLC

62: LC-USF33-005169-M4

63: LC-USF33-005185-M2 DLC

64: LC-USF33-030639-M3 DLC

65: LC-USF33-030639-M1 DLC

66: LC-USF33-013005-M4 DLC

67: LC-USF33-011625-M1 DLC

68: LC-USF33-012996-M5 DLC

69: LC-USF33-013012-M4 DLC

70: LC-USF34-013489-C DLC

71: LC-USF34-012828-D DLC

72: LC-USF34-T01-000246-D DLC

73: LC-USF33-002819-M2 DLC

74: LC-USF33-T01-001560-M3 DLC

75: LC-USF34-016209-C DLC

76: LC-USF34-006063-D DLC

77: LC-USF34-006064-D DLC

78: LC-USF33-0099192-M3 DLC

79: LC-USF34-001842-E DLC

80: LC-USF33-016093-M4 DLC

81: LC-USF33-002886-M5 DLC

82: LC-USF34-005377-E DLC

83: LC-USF33-002837-M1 DLC

84: LC-USF34-006014-D DLC

85: LC-USF34-001830-E DLC

86: LC-USF34-001226-D DLC

87: LC-USF33-T01-001206-M2 DLC

88: LC-USF33-T01-000315-M5 DLC

89: LC-USF33-013011-M2 DLC

90: LC-USF33-T01-001279-M2 DLC

91: LC-USF33-002823-M1 DLC

92: LC-USF34-006045-D DLC

93: LC-USF33-002827-M3 DLC

94: LC-USF33-002885-M3 DLC

95: LC-USF33-002839-M4 DLC

96: LC-USF33-002897-M1 DLC

97: LC-USF33-002901-M3 DLC

98: LC-USF34-T01-000270-D DLC

99: LC-USF33-T01-001069-M3-DLC

100: LC-USF33-T01-001684-M1 DLC

101: LC-USF34-012533-E DLC

102: LC-USF33-021463-M3 DLC

103: LC-USF33-021426-M4 DLC

104: LC-USF34-012370-E DLC

105: LC-USF34-012372-E DLC

106: LC-USF34-012401-E DLC

107: LC-USF34-012387-E DLC

108: LC-USF33-021459-M4 DLC

109: LC-USF33-021433-M2 DLC

110: LC-USF34-012378-E DLC

111: LC-USF33-021277-M5 DLC

112: LC-USF34-012527-E DLC

113: LC-USF33-021272-M2 DLC

129: LC-USF33-030539-M5 DLC

130: LC-USF33-003343-M4 DLC

131: LC-USF33-T01-002792-M4 DLC

132: LC-USF33-012142-M3 DLC

133: LC-USF33-003530-M4 DLC

134: LC-USF33-011601-M1 DLC

135: LC-USF33-011603-M4 DLC

136: LC-USF33-011364-M3 DLC

137: LC-USF33-012452-M2 DLC

138: LC-USF33-006538-M3 DLC

139: LC-USF33-030576-M4 DLC

140: LC-USF331-030577-M2 DLC

141: LC-USF34-018198-E

142: LC-USF34-005514-E

143: LC-USF33-030641-M1 DLC

144: LC-USF33-012081-M5 DLC

145: LC-USF33-012061-M3 DLC

146: LC-USF33-006214-M5 DLC

147: LC-USF33-012506-M1 DLC

148: LC-USF33-013097-M2 DLC

149: LC-USF33-012207-M4 DLC

150: LC-USF34-008482-D DLC

151: LC-USF33-011796-M1 DLC

152: LC-USF33-012578-M5 DLC

153: LC-USF33-013078-M1 DLC

154: LC-USF33-021255-M1 DLC

155: LC-USF331-020841-M2 DLC

156: LC-USF33-030994-M3 DLC

157: LC-USF33-013090-M3 DLC

158: LC-USF33-013107-M1 DLC

159: LC-USF33-013073-M5 DLC

160: LC-USF331-011862-M4 DLC

161: LC-USF33-T01-001112-M4 DLC

162: LC-USF33-006544-M4 DLC

163: LC-USF33-006635-M4 DLC

476

331: LC-USF33-011136-M3 DLC

332: LC-USF34-018240-C DLC

333: LC-USF34-018799-E DLC

334: LC-USF33-011871-M1 DLC

335: LC-USF33-011153-M4 DLC

336: LC-USF33-003654-M5 DLC

337: LC-USF33-002922-M5 DLC

338: LC-USF33-011138-M5 DLC

339: LC-USF33-011076-M3 DLC

340: LC-USF34-010387-E DLC

341: LC-USF34-010411-E DLC

342: LC-USF33-003449-M2 DLC

343: LC-USF34-010383-E DLC

344: LC-USF33-011567-M5 DLC

345: LC-USF33-T01-001546-M4 DLC

346: LC-USF33-012316-M1 DLC

347: LC-USF34-009988-C DLC

348: LC-USF33-006140-M4 DLC

349: LC-USF33-011599-M2 DLC

350: LC-USF34-020985-E DLC

351: LC-USF33-012251-M4 DLC

352: LC-USF33-012276-M1 DLC

353: LC-USF33-012278-M3 DLC

354: LC-USF34-016334-C DLC

355: LC-USF34-009884-E

356: LC-USF34-018994-E DLC

357: LC-USF34-019488-E DLC

358: LC-USF33-T01-001973-M3 DLC

359: LC-USF33-001982-M1

360: LC-USF33-011260-M1 DLC

361: LC-USF33-T01-001991-M2 DLC

362: LC-USF33-011255-M3 DLC

363: LC-USF34-020345-E DLC

364: LC-USF33-013063-M1 DLC

365: LC-USF33-T01-001979-M3 DLC

366: LC-USF34-005844-E DLC

367: LC-USF33-003276-M2 DLC

368: LC-USF34-005845-E DLC

369: LC-USF33-011386-M1 DLC

370: LC-USF34-012398-E DLC

371: LC-USF34-012367-E DLC

372: LC-USF34-012581-E DLC

373: LC-USF34-012391-E DLC

374: LC-USF34-012403-E DLC

375: LC-USF34-012456-E DLC

376: LC-USF34-012433-E DLC

377: LC-USF33-021300-M4 DLC

378: LC-USF34-009402-E DLC

379: LC-USF34-017915-C DLC

380: LC-USF33-006022-M2 DLC

381: LC-USF34-009385-C DLC

382: LC-USF33-020949-M3 DLC

383: LC-USF34-019935-E DLC

384: LC-USF34-009765-E DLC

385: LC-USF33-006026-M1 DLC

386: LC-USF33-006020-M5 DLC

387: LC-USF34-017970-C DLC

388: LC-USF33-006208-M5 DLC

389: LC-USF33-006218-M3 DLC

390: LC-USF33-006029-M4 DLC

391: LC-USF33-030490-M1 DLC

392: LC-USF34-017061-C DLC

393: LC-USF34-017079-C DLC

394: LC-USF33-020947-M4

395: LC-USF34-T01-017335-C DLC

396: LC-USF33-030573-M1 DLC

397: LC-USF33-020955-M1 DLC

398: LC-USF34-017634-C DLC

399: LC-USF33-011849-M4 DLC

400: LC-USF33-030580-M3 DLC

401: LC-USF33-030579-M4 DLC

402: LC-USF33-020861-M5 DLC

403: LC-USF33-020875-M4 DLC

404: LC-USF33-009138-M2 DLC

405: LC-USF33-020833-M2 DLC

406: LC-USF33-020835-M2 DLC

407: LC-USF33-020837-M1 DLC

408: LC-USF33-020838-M4 DLC

409: LC-USF33-020836-M5 DLC

411: LC-USF33-021089-M1 DLC

412: LC-USF33-030297-M1 DLC

413: LC-USF331-011770-M3 DLC

414: LC-USF33-011528-M2 DLC

415: LC-USF33-006442-M1 DLC

416: LC-USF33-006695-M5 DLC

417: LC-USF33-006690-M2 DLC

418: LC-USF33-009207-M2 DLC

419: LC-USF33-021147-M1 DLC

420: LC-USF33-003125-M3 DLC

421: LC-USF33-030296-M1 DLC

422: LC-USF33-013280-M1 DLC

423: LC-USW 3-41777-E

424: LC-USF33-011740-M1 DLC

425: LC-USF33-011745-M5 DLC

426: LC-USF331-011770-M4 DLC

427: LC-USF33-003689-B-M4 DLC

428: LC-USF33-012605-M3 DLC

429: LC-USF33-013070-M2 DLC

430: LC-USF33-012591-M1 DLC

431: LC-USF33-012623-M1 DLC

432: LC-USF33-013282-M5 DLC

433: LC-USF33-005111-M1 DLC

434: LC-USF34-44836-D

435: LC-USF33-005094-M4 DLC

436: LC-USF33-004243-M4 DLC

437: LC-USF33-005068-M1 DLC

438: LC-USF33-011661-M3 DLC

439: LC-USF33-030740-M1 DLC

440: LC-USF33-006118-M5 DLC

441: LC-USF34-012504-E DLC

442: LC-USF34-012412-E DLC

443: LC-USF34-012597-E DLC

444: LC-USF33-031367-M3 DLC

445: LC-USF33-031364-M2 DLC

446: LC-USF33-012697-M1 DLC

447: LC-USF33-012293-M1 DLC

448: LC-USF33-030461-M4 DLC

449: LC-USF33-030470-M2 DLC

450: LC-USF33-030463-M5 DLC

451: LC-USF33-030469-M1 DLC

452: LC-USF33-030461-M1 DLC

453: LC-USF33-030469-M4 DLC

454: LC-USF33-031208-M4 DLC

455: LC-USF33-031213-M2 DLC

456: LC-USF33-031207-M2 DLC

457: LC-USF33-031205-M4 DLC

458: LC-USF33-031201-M3 DLC

459: LC-USF33-031201-M2 DLC

460: LC-USF34-073276-E

461: LC-USW E-10954-E

Names and page numbers in *italics* refer to featured photographers and their illustrated works.

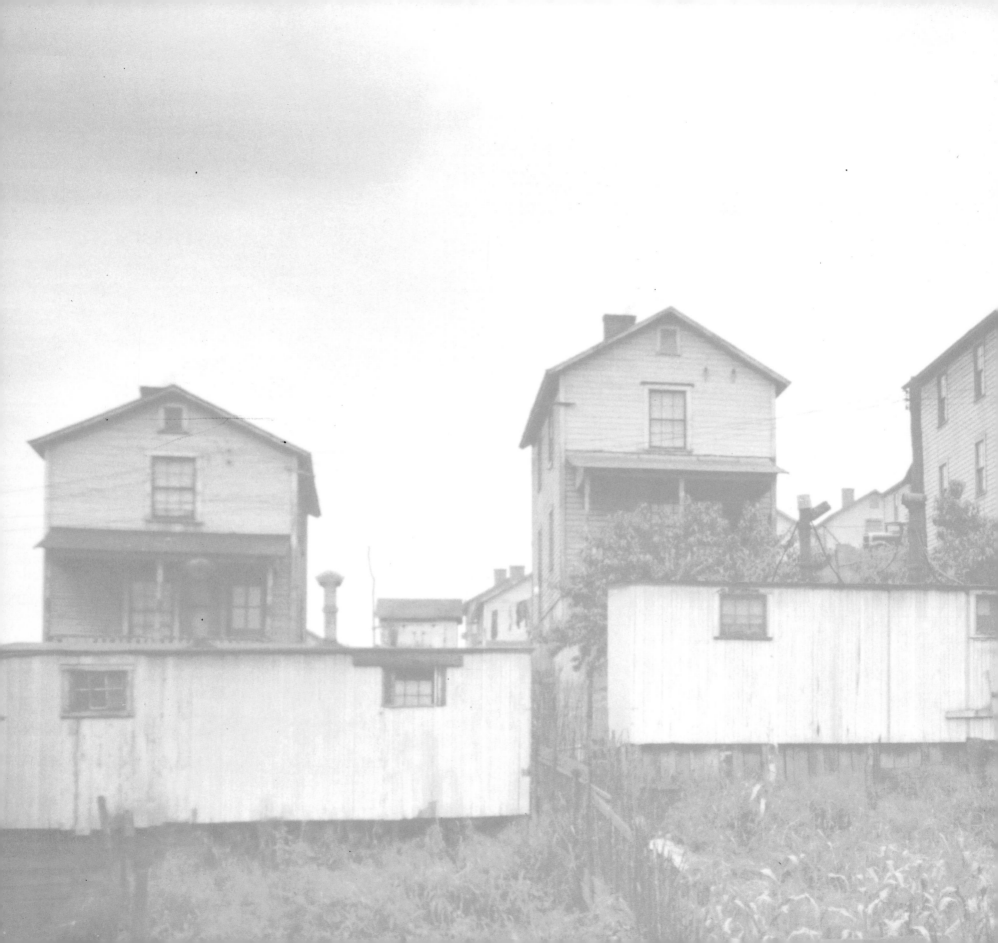